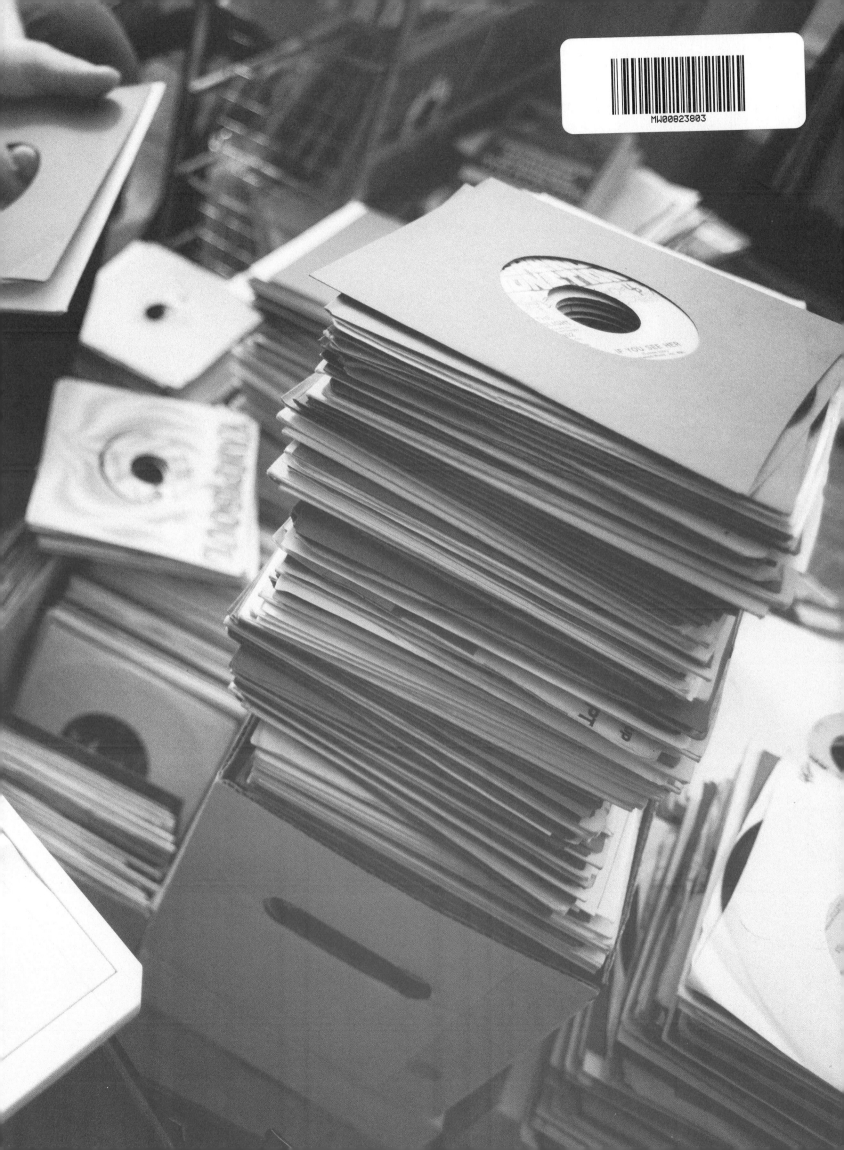

DUST & GROOVES

ADVENTURES IN RECORD COLLECTING

PUBLISHED IN THE UNITED STATES BY TEN SPEED PRESS, AN IMPRINT OF THE CROWN PUBLISHING GROUP,
A DIVISION OF PENGUIN RANDOM HOUSE LLC, NEW YORK.
WWW.CROWNPUBLISHING.COM
WWW.TENSPEED.COM

TEN SPEED PRESS AND THE TEN SPEED PRESS COLOPHON ARE REGISTERED TRADEMARKS OF
PENGUIN RANDOM HOUSE LLC.

ORIGINALLY PUBLISHED IN THE UNITED STATES BY DUST & GROOVES PUBLICATIONS, BROOKLYN, IN 2014.

LIBRARY OF CONGRESS CATALOGING-IN-PUBLICATION DATA,
PAZ, EILON.
DUST & GROOVES : ADVENTURES IN RECORD COLLECTING / EILON PAZ.—FIRST TEN SPEED PRESS EDITION.
 PAGES CM
"INCLUDES INTERVIEWS WITH QUESTLOVE, GILLES PETERSON, FOUR TET, THE GASLAMP KILLER, EGON AND
MORE."
INCLUDES BIBLIOGRAPHICAL REFERENCES AND INDEX.
1. SOUND RECORDINGS—COLLECTORS AND COLLECTING—INTERVIEWS. 2. SOUND RECORDINGS—COLLECTORS
AND COLLECTING—PICTORIAL WORKS. I. TITLE. II. TITLE: DUST AND GROOVES.
ML406.P39 2014
780.26'6075--DC23

 2014047318
HARDCOVER ISBN: 978-1-60774-869-4
EBOOK ISBN: 978-1-60774-870-0

PRINTED IN CHINA

DESIGN BY **JULIANO AUGUSTO AND MARCELO DANTE** (45JJ.ORG)
PHOTOGRAPHS AND ART DIRECTION: **EILON PAZ**
FOREWORD: **THE RZA**
EDITOR: **SHEILA BURGEL**
PHOTO EDITOR: **MARIE A. MONTELEONE**
RESEARCHERS: **JULIA RODIONOVA, SAM SWIG, LILY WEN**
CONTRIBUTING WRITERS: **SHEILA BURGEL, KEVIN FOAKES, APRIL GREENE, JAMISON HARVEY,
JEFF "CHAIRMAN" MAO, MARC MINSKER, JULIA RODIONOVA, DOM SERVINI, JOSIAH TITUS**
ASSOCIATE EDITORS: **APRIL GREENE, BILL ADLER, CELESTE HAMILTON DENNIS, SAM SWIG,
JOSIAH TITUS, LILY WEN**
TRANSCRIBER: **HARRIET NOTMAN**
PRODUCTION COORDINATOR: **JAMISON HARVEY**

10 9 8 7 6 5 4 3 2 1

FIRST TEN SPEED PRESS EDITION

ON THE COVER: ANDREW CARTHY (MR. SCRUFF)

DUST & GROOVES

ADVENTURES IN RECORD COLLECTING

EILON PAZ

INCLUDES INTERVIEWS WITH QUESTLOVE, GILLES PETERSON, FOUR TET,
THE GASLAMP KILLER, EGON, AND MORE

CONTENTS

I'M REALLY JUST A CASUAL RECORD COLLECTOR

PREFACE BY EILON PAZ

Make no mistake—I love music and I love vinyl, but *Dust & Grooves* wasn't born out of a personal obsession with records. I've never had a want list, nor have I ever paid much attention to the distinction between VG+ and M-, or sought out limited editions, one-off pressings, or acetates. My passion lies with music, photography, and, as I discovered, photographing those with an unshakable devotion to collecting records. Through *Dust & Grooves*, I've been able to meet over 150 of the world's most fervent collectors, photograph their prized collections, and ultimately connect to a world that has always been dear to me.

Like nearly every single person profiled in this book, I grew up in a household filled with music. My parents' collection of Argentine folk (Mercedes Sosa), tango (Carlos Gardel), and Pink Floyd LPs would be regular fixtures on the family turntable. I later discovered jazz via ECM Records and jazz-funk artists like Ramsey Lewis and Jimmy Smith, and have since accumulated a small but satisfying collection of records. Pink Floyd's *Animals* has been a longtime favorite, as much for the music as for the striking cover art. It was actually the dark, surreal mood of the cover photo that fueled my desire to pursue photography. I spent a good chunk of my twenties and thirties making a living as a photographer in my home of Tel Aviv, Israel, mostly covering food and travel, but also working with record labels and artists. I enjoyed the work, but I always had the nagging feeling that I wanted to embark on my own music photography project—something more personal, more creative, more inspiring.

In the summer of 2008, I left the comforts of my friends and family in Israel and moved to New York City. Of course, I didn't pick the ideal time—the recession was about to sweep through the city and take all the jobs with it. Being unemployed sucked, but it also left me with a lot of time to spend in record stores. Back then, the vinyl resurgence was in its early stages, and records were cheaper and much more plentiful in New York than in Israel. A couple of months after I arrived in NYC, a friend emailed me an unforgettable photo of a man in combat boots, holding an AK-47 machine gun, surrounded by masses of records. I was completely captivated by this exotic, intriguing image, and it somehow ignited my creative calling—to photograph record collectors. I read on to discover that the man was Frank Gossner, a German record collector who regularly travels to West Africa to dig for records. It turned out Frank was living in Brooklyn, and he was game to meet me for coffee.

When I told Frank about my idea to photograph the New York crate-digging scene, he went to the trouble of introducing me to some of the city's major vinyl-heads, including Joel Oliveira, once owner of the now-shuttered East Village record store Tropicalia in Furs. Joel welcomed me into his shop, and we spent the day talking about his Brazilian mainstays, rare Japanese Beatles pressings, and the "Crazy World" section of his shop—where X-rated LPs sat next to recordings by Pope John Paul II. Although this was officially my first interview, I didn't have any grand aspirations for this project yet—it was simply for my personal enjoyment, not for the public. It took one more step for the true nature of *Dust & Grooves* to come into focus.

Backtracking to 2005—during a brief visit to NYC, I saw DJ Cosmo Baker spinning this gritty, raw funk set at a Sharon Jones album launch party in Brooklyn. He completely blew my mind, and I asked if I could shoot him for a photo spread about the funk revival scene. The shoot never panned out, but when I contacted him a few years later to request an interview for

my new project, he happily obliged. He invited me to his home in Brooklyn, where I photographed him amongst the endless shelves of vinyl in his record room. And that's when everything clicked. In the comfort of the home—without any professional lighting or other people around—I watched my subject open up. My experience with Cosmo that day was truly up close and personal—a photographer's dream. And that's when I realized that I needed to share these photos with the world.

I started posting the photos and long, conversational Q&As online, and it quickly became apparent that there was a large community out there who identified with these pieces. I'd seen features on DJs' record rooms before, but few articles had really dug into people's personal collections in such an intimate way. Just through word of mouth, my blog's readership grew, and I felt like I was tapping into a hidden scene I never knew existed. While trying to earn a living as a freelance photographer, I continued working on the blog and started purposefully working layovers into my trips—in Paris, Istanbul, London—to track down collectors from outside the United States. As I began to interview more and more people, I found we had something in common—when they dig and make a new discovery, their desire to dig grows. In a similar way, one interesting interview prompted me to dig for another and then another.

The backing of the vinyl community was another major driving force. I absolutely wouldn't have taken the project this far if it hadn't been for the enthusiasm of so many devoted collectors who rated my work and bothered to tell me so. They made it clear that this was more than just a fun project—it was meaningful to people. In the beginning, I'd sometimes let the blog slide and not post for a few months, but readers started to nudge me if they saw it neglected. I realized I had a responsibility to the growing Dust & Grooves community to keep the stories coming.

Another turning point came in 2011 when King Britt—whose records I had loved and spun as an amateur DJ in Tel Aviv—sent word, giving his thumbs-up to the blog and expressing interest in being profiled. That was, to put it mildly, a nice pat on the back. That King believed I was doing something worthy reinforced my faith in karma; it showed me firsthand the power of doing what you love, sticking with it, and believing that it will someday pay off—maybe in a way you wouldn't have expected. It was King who suggested I publish a *Dust & Grooves* book. The vote of confidence was hugely appreciated, but I didn't feel quite ready to take on such a daunting job, and I must confess, I preferred to keep the blog small, without having to commit to anything bigger. I wanted to keep it easy. But in the back of my mind, I knew that if I wanted to make something great, it probably wouldn't be easy.

I had almost forgotten about the book idea until I found myself messing around with a few 5x7 photo prints in my studio one afternoon. When I saw the images in the flesh, laid out side by side, it struck me: *of course* this should be a book. The pictures had come to life on paper. From that point on, *Dust & Grooves* took over my life.

In 2012, I launched a Kickstarter campaign to fund the production of the book, which ended up reaching its goal with over six hundred backers. The financial support gave the project a major boost, but it was the truly spiritual experience of receiving so much love and commitment from people who didn't even know me that made the most profound difference.

I've come to think that there's something really pure and primal about collecting vinyl, and about the people who do it. It's the reason why I have been so adamant about sticking to vinyl collectors only, and have avoided cassette tape addicts and CD hoarders. Having a record collection in this digital-dominant climate is a very particular thing. It's a pain in the ass, frankly. It's not convenient, it's not necessary, and it makes little sense. I ask myself why I keep buying records. I move a lot, and records weren't built for dragging around the world. But even in this digital age, we humans still love to have objects, we love to have stuff—it's comforting. Music is comforting. And at the intersection of these timeless human comforts, we find this beautiful obsession called record collecting.

Playing vinyl is also a way to nourish and grow our passions. When we have to get up and flip the record, when we have to move boxes of 12-inches, keep them clean, and go digging for the ones we want, we're making everything a little harder on ourselves. It's a mental and a physical workout. It's acknowledging the importance of music and beauty in our lives, acknowledging that they can and should demand our attention. And it's a more rewarding experience when we know we've worked a little harder to get there.

Also, for me personally, getting to know collectors is a way to practice seeing without judgment. I've now met collectors from all walks of life: retired truck drivers, urban DJs, socialites, recluses, parents, punks, people who brag about their collections, people who are secretive. One guy buys records just so he can give them away, while another keeps them locked down in his basement. Most of the collectors I've met are male; most of them own cats; almost all of them have phenomenal memories, are naturally curious, and are possibly a little OCD. I don't even try to understand it all! I just notice and appreciate what makes each person unique, and use my camera to capture this passionate pursuit that links them all together. It feels to me as though music is an unspoken religion and the records are its texts. Two people who live thousands of miles apart and have never met will both cite Stevie Wonder or Curtis Mayfield albums among their comfort records, and it fills me with joy to see this. It illustrates how people are basically united, how we all have invisible threads connecting us. It allows me to drop my cynicism and feel naive again.

Since this project began, I've experienced both highs and lows. *Dust & Grooves* has been the optimal cure for the loneliness that accompanies being a newcomer in a big city, and it has given me the kind of motivation I never would have felt had I remained at home in Israel. But amidst all the positivity, there have been moments when I've felt very sad for people, and I've encountered times of major stress, awkwardness, and tension. I've made a few true friends through this project, and have lost a few as well.

Dust & Grooves has introduced me to scores of tremendous people who've given their time and energy to seeing this project succeed—collectors, of course, but also opinionated readers, anonymous donors, and people who have just walked up to me, introduced themselves, and said they wanted to help. This community mentored me, encouraged me creatively, improved my writing, and got me collaborating with wonderful, creative people. They have made the whole project bigger and better.

All together, and only together, we've made *Dust & Grooves* happen.

SWEET ANALOG SOUNDS

FOREWORD BY THE RZA

am delighted and honored to be writing the foreword for such a cool book about vinyl collectors. It was record collecting and DJing that led to my career as a music producer, and so I feel like a kindred spirit to all of the collectors featured here. When I was a young DJ and vinyl-head, there was nothing like the joy of going to record stores and digging up LPs and 12-inches that were instrumental in my musical evolution. Records like Kurtis Blow's "The Breaks," the O'Jays' *So Full of Love*, Diana Ross's "The Boss," Stevie Wonder's *Original Musiquarium I*, and Run DMC's *King of Rock* were life-changing and hugely influential on both a personal and a creative level. I remember the thrill of ripping off the plastic, taking the vinyl out of the sleeve, and gently placing it on the turntable, making sure not to get any fingerprints on it. Then, as the record played, I would study the cover and get lost in the liner notes. These were deeply personal, intimate moments with music, and that's something an mp3 just can't duplicate.

Science says the human ear cannot differentiate between analog and digital, with the differences being so subtle. But I do not agree. The calculated digital wave lacks the randomness of analog. While digital duplication will always yield a concise sonic print, it's that unpredictable essence of the analog wave that makes it so much more satisfying to the ear. As a creator and listener of music, I can hear the difference.

I started collecting vinyl at the age of eleven whilst living at my grandmother's house in Staten Island, New York. We had the turntable set up on the dining room table with crates of records stored underneath. I remember my first few purchases—the Sugar Hill Gang's "Rapper's Delight," Fatback Band's "King Tim III," and Jimmy Spicer's "Adventures of Super Rhyme." Some came from major chains or mom-and-pop stores, others from a merchant selling his wares on a city sidewalk. As far as buying records was concerned, I knew no limits. I'd pick up vinyl for any good reason—sometimes I'd be struck by the cover art; other times I'd try to track down an entire run of a rare label that existed long before my time.

I will never forget my first chance to go vinyl shopping in the Bay Area. It was 1997, and I was working on the *Wu-Tang Forever* double album. King Tech took me down to Haight Street in San Francisco, where I came across some of the coolest record stores I'd ever laid eyes on—Open Mind, Groove Merchant (and their Love N' Haight reissue label), and the original, coolest, greatest of them all, Amoeba Records. I think I spent close to 10k on records during that trip, paying hundreds of dollars for a single piece of vinyl—namely the original pressing of the *Black Caesar* soundtrack by James Brown and *Coffy* by Roy Ayers. It was these LPs that I sifted through looking for ideas to add to the production of *Wu-Tang Forever*. Sadly, I lost every single one of those records when I left Cali. I had boxed up the records and instructed my label to ship them to my East Coast residence, but ahahaha…I think I got dipped on. Funny thing, as I found that a lot of hip-hop productions released after that period sounded strangely similar to my style.

I continue to seek out vinyl all over the world. One of my coolest finds was from France, where I picked up a copy of Antoine Duhamel's "Belphegor," an old French TV show theme that led to the production of Wu-Tang's top 40 hit "Gravel Pit." At one point I had over ten thousand pieces of vinyl in my collection. While I still have a modest stash, most of my stock has been lost through time—partly due to flooding, theft, and giveaways.

Although the digital world dictates how we purchase and listen to music, it's great to see so many collectors and music fans still flying the flag for vinyl. We share in the knowledge that vinyl is still the unrivaled medium for music and has yet to be bettered. Each spin of a record offers a unique listening experience; each turntable has its own way of playing a record. There's just nothing like the sound of a needle hitting the groove, sending sweet amplified music straight to my ears.

OWN TOGETHER NOW

INTRODUCTION BY JEFF "CHAIRMAN" MAO

You hold in your hands a beautiful, lovingly constructed, and heartfelt celebration of a sense-less and punishing neurosis. If you've never experienced the self-inflicted pleasurable pain of record collecting as so described, consider yourself fortunate (or at least sheltered). Perhaps for you, the phenomenon of habitually buying vinyl would seem to be a harmlessly nerdy pastime—that quaint, curiously antiquated method of ingesting music that you're occasion-ally reminded still exists when you enter the front of an Urban Outfitters.

Contrary to what conventional wisdom would have you believe, however, record collecting isn't about music. Not entirely, anyway. True, it nearly always starts out about the music—an innocent gift or vinyl hand-me-down from some seasoned relative/friend/loved-one typically providing the seed of inspiration. Over time there's a decent-to-high probability that the records a record-collecting individual amasses will be played and the music heard—and, yes, enjoyed. A significant percentage of record collectors seek out music unavailable elsewhere except on long-out-of-print vinyl. But don't make the common mistake of fully equating record collecting with music appreciation. Having a record collection is about having records. *Possession* (aka, "nine tenths of the law") rhymes with *obsession.*

If record collectors were simply music lovers we'd probably be a little more pragmatic in our behavior. We'd have long swapped out our crammed Ikea Expedits and not quite legally pro-cured crates for the unmatched space efficiency of hard-drive-housed digital libraries (relieving stress on the support beams in our homes in the process). But we don't. Instead we do things that pretty much defy any reasonable person's standard of logic or proper social etiquette. We become preoccupied with owning first issues of records, referring to them as "originals"—even though they're technically mass-produced copies of the only true original, the master recording. We fixate on grading and condition even when each cherished spin of a beloved slab of wax incrementally deteriorates its sound quality. We buy the same song over and over again in differ-ent formats—album, 45, 12-inch single, test pressing, promotional, or commercial release—just because. We hemorrhage bank accounts and damage personal relationships in the competitive pursuit of—in some instances, if you do the math—more records than we have actual remaining living hours on this earth to listen to. We exhibit an unusually high tolerance for mold. When we're in a room with people and records, we instinctively believe that the records have more to offer us, and thus divide our attention accordingly.

And we're faithfully devoted to our vice of choice. To which those observing from outside the vinyl-adoring bubble inevitably ask, why? Well, because we like to look at things. And hold them. To paraphrase the great Brooklyn poet Antonio Hardy, we're beholden to the physical, mystical, and the very artistical. Tangibility matters. Presentation really matters. And despite the music industry's best long-con efforts to convince us otherwise with various guises of tapes, discs,

and compressed sound files, we're stuck on the fact that there's no greater audio-visual combo than a piece of music pressed onto vinyl, accompanied by the art enshrined on those perfect canvases that are its label, sleeve, and album cover. Records—of any age or era—may be relics (or relics-to-be). But for us they're irresistibly seductive ones.

We understand that our lifestyle often betrays a worldview that one might charitably describe as somewhere between severely judgmental and critically fascist. As the record store clerks of Nick Hornby's novel *High Fidelity* (1995) presciently observed years before social media came to dominate our existences, what truly matters is what you like, not what you are like. Only Hornby's characters didn't take it far enough. In an era in which we can't escape folks telling us what they "like," the act of "like"-ing is too easy. Real-life record people, though, have always maintained that what truly matters is both what you like and what you've got (Q: "You got this?" A: "Yeah, got it"). So, you "like" James Brown productions, or Sun Ra, or Italian library records and soundtracks, or Miami bass? How many of the hundreds of pieces of vinyl that fall into each of these categories are you willing to take the time and effort to acquire and share your limited personal space with? Whether it's two, twenty, or two hundred, the answer reflects a commitment most normal people would dismiss as impractical. We, on the other hand, like (not just "like") impractical. We take a twisted pride in impractical. (And we don't move homes unless it's absolutely necessary.)

Of course, maybe most significantly, there's also an emotional component to all this. Music may provide the soundtrack to one's life. But records—the physical manifestation of said soundtrack—are of such personal value to us because they provide indelible markers for our experiences. Your record collection is you. You are your record collection. It'll be your mirror, and reflect what you are (in case you don't know). Ask a person with records how he/she came upon any single piece that means something to him/her and the reply will undoubtedly be a well-detailed who/what/where/when/why and how much. Which is why the single realest scene in the history of cinema about the subject is the one from Barry Levinson's '50s period piece *Diner* (1982) in which Daniel Stern's character Shrevie berates his wife Beth, played by Ellen Barkin, about her failure to keep his records in order. "It's just music, it's not that big a deal," she protests in bewilderment. "It is! *This is* important to me," he yells, gesticulating at his modest record shelf, the one area of the young couple's home that's his personal domain. "When I listen to my records they take me back to certain points in my life." If record collectors tend to be hoarders, it may be because getting rid of records can feel like getting rid of memories. We'll be the first to tell you we're the types that don't let go easily—in any sense—for better or worse.

There are in theory healthier ways to deal with the world. But if we wanted "health," we'd hang out at Equinox and macrobiotic health food emporiums as much as we do record fairs/shops/fleas. We recognize what we want. It's right there, over in the next record bin. We just know it...

"RECORD COLLECTING
IS AN INFINITE JOURNEY
BACKWARDS."

ZACH COWIE

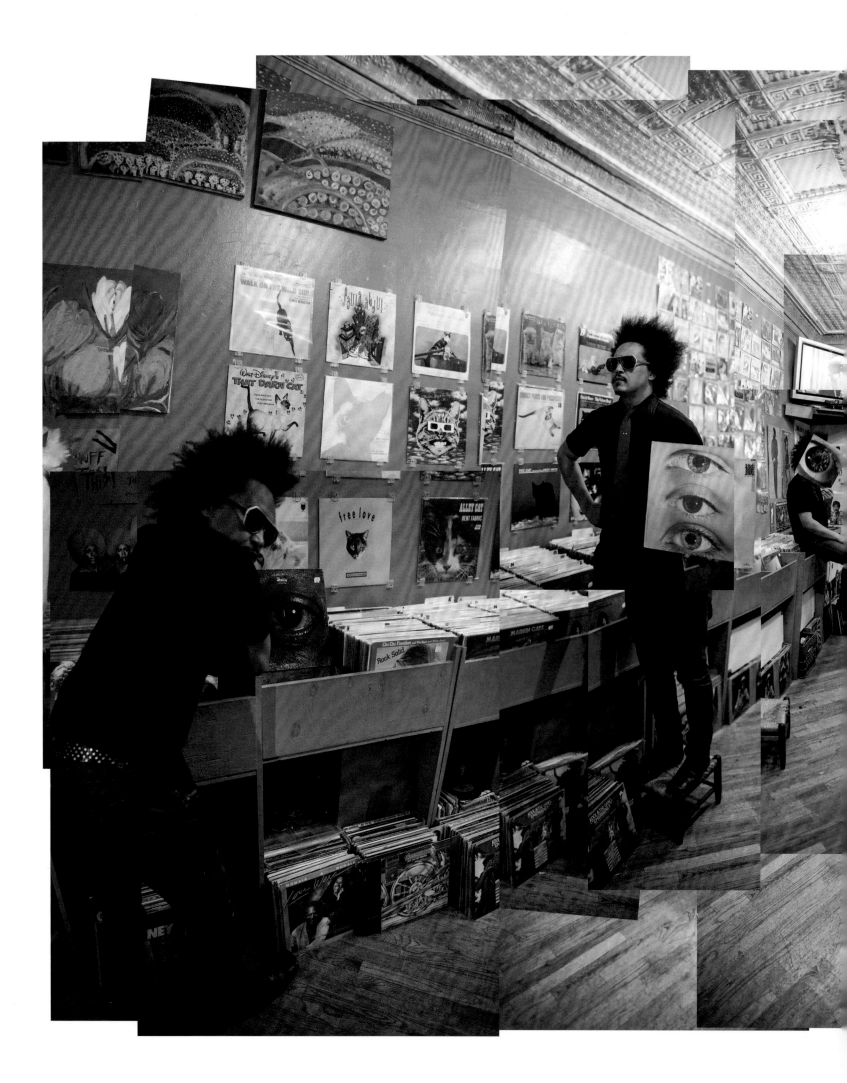

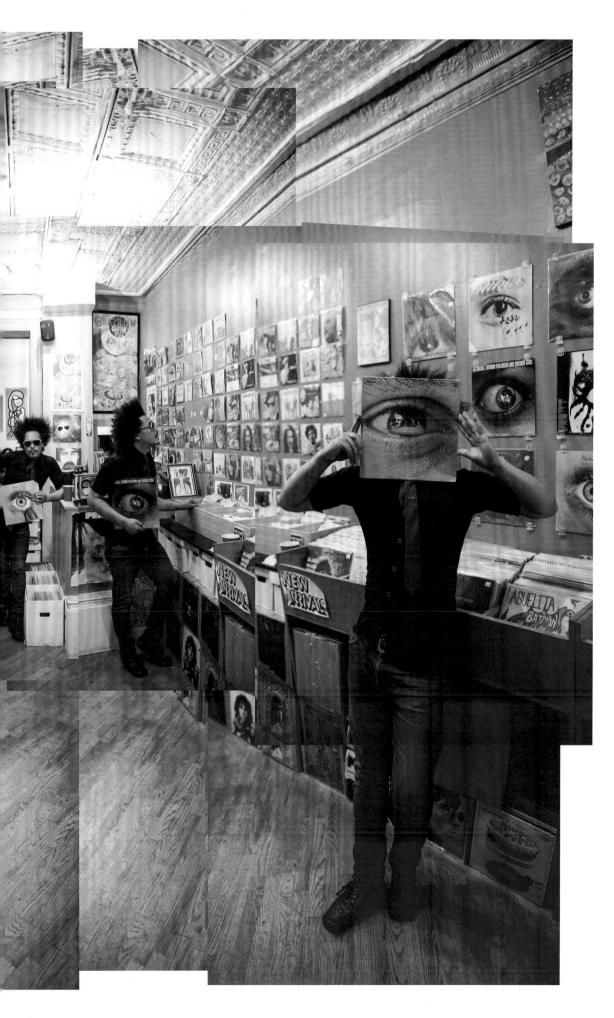

WHERE IT ALL BEGAN.

JOEL OLIVEIRA - NEW YORK, NY
Photographs taken at Tropicalia in Furs

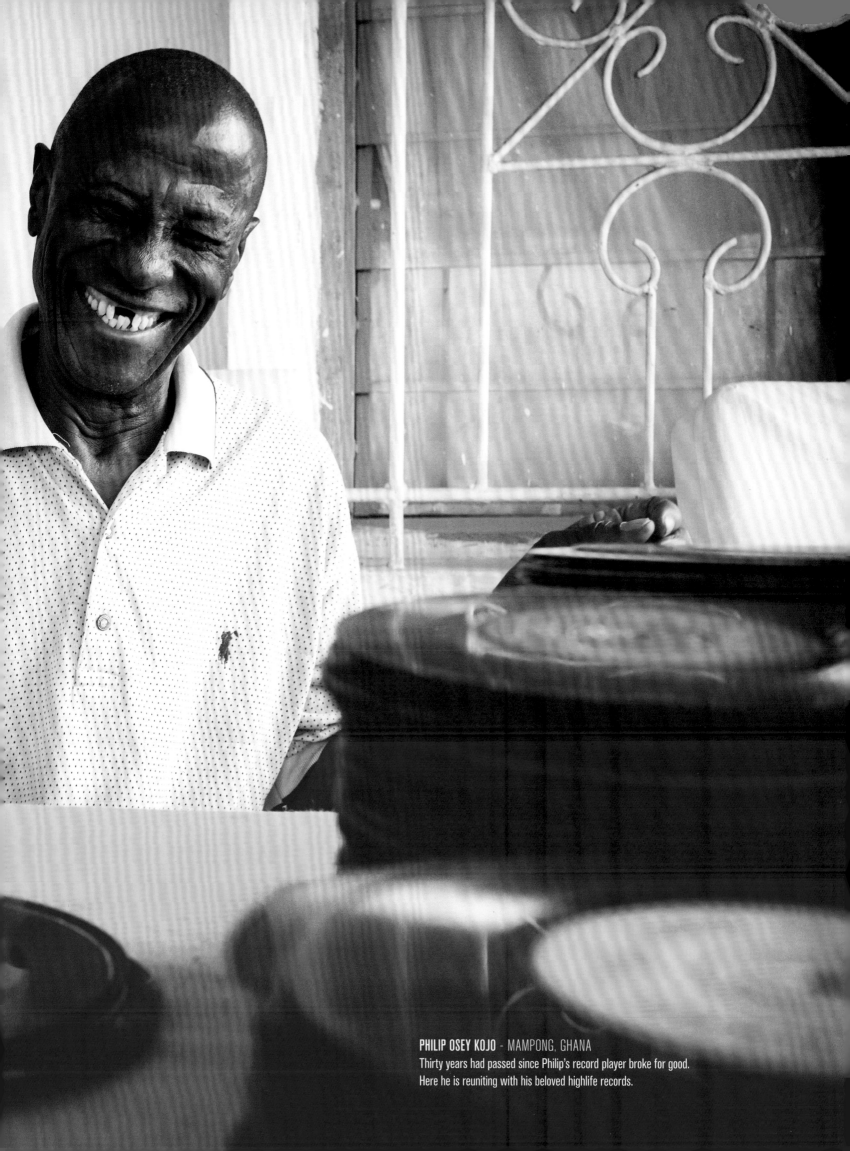

PHILIP OSEY KOJO - MAMPONG, GHANA
Thirty years had passed since Philip's record player broke for good.
Here he is reuniting with his beloved highlife records.

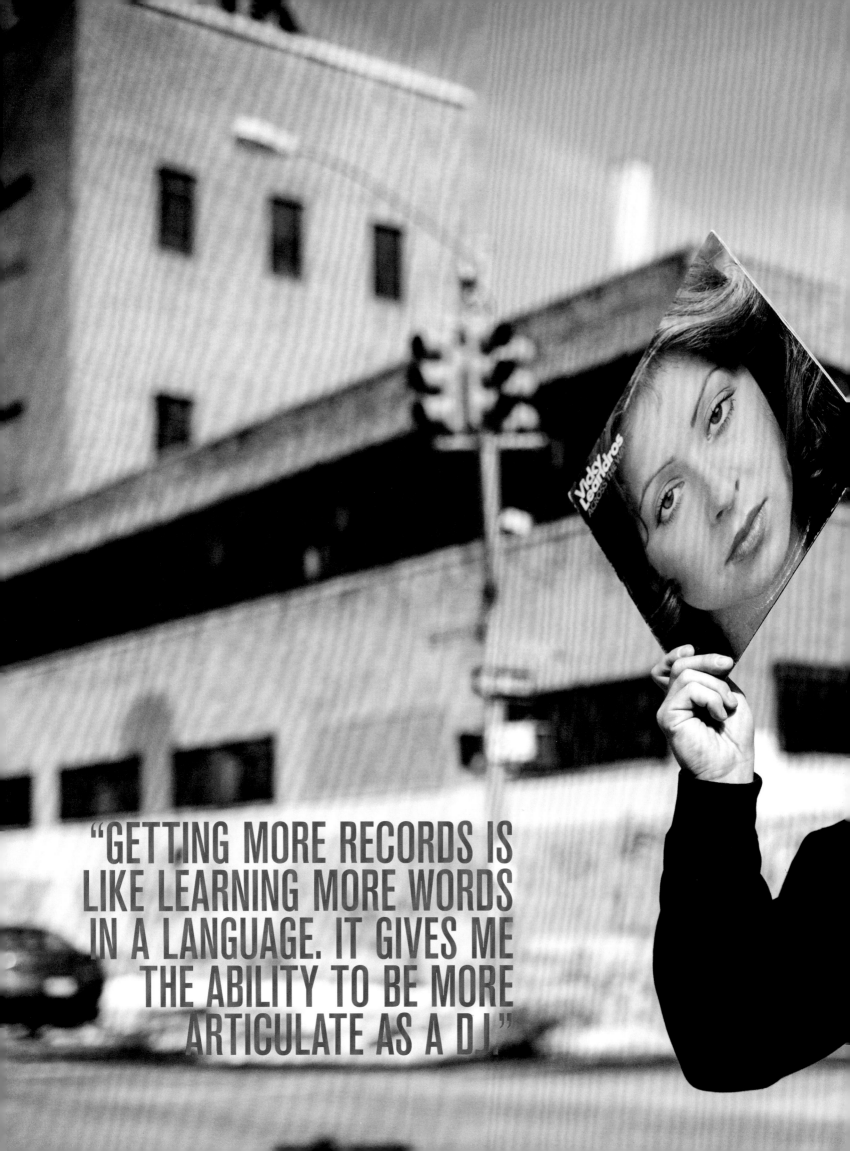

"GETTING MORE RECORDS IS LIKE LEARNING MORE WORDS IN A LANGUAGE. IT GIVES ME THE ABILITY TO BE MORE ARTICULATE AS A DJ."

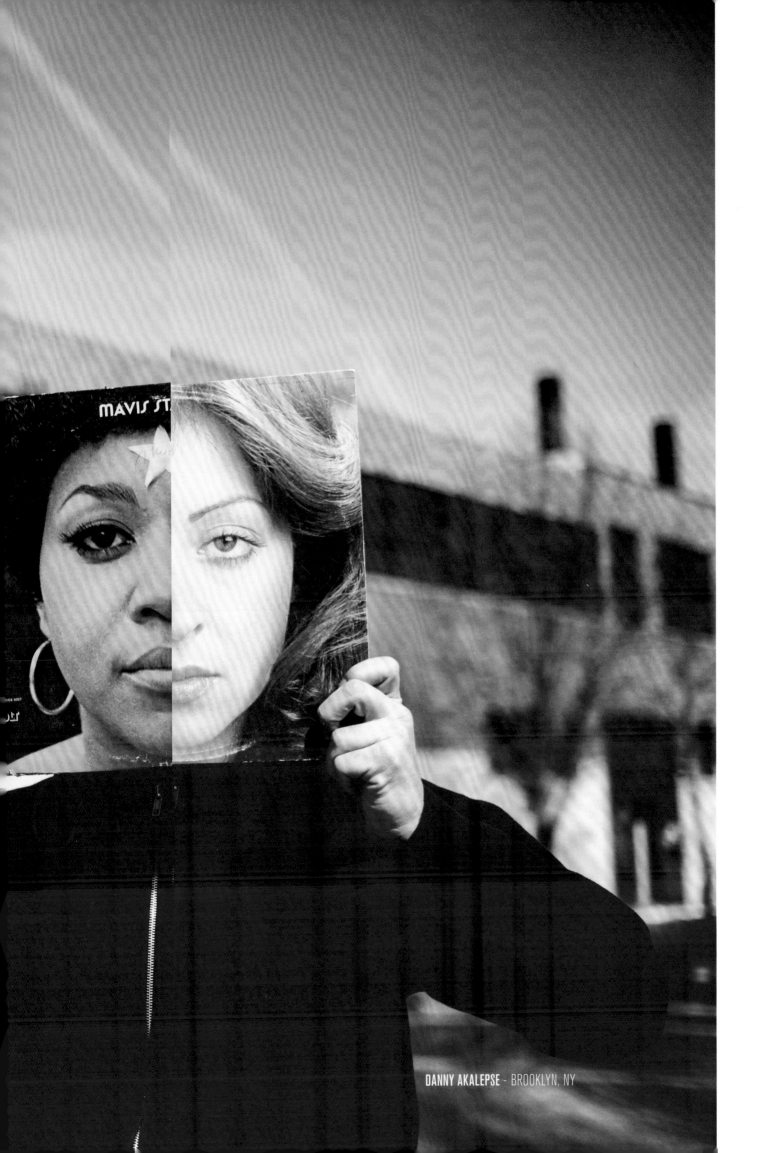

DANNY AKALEPSE - BROOKLYN, NY

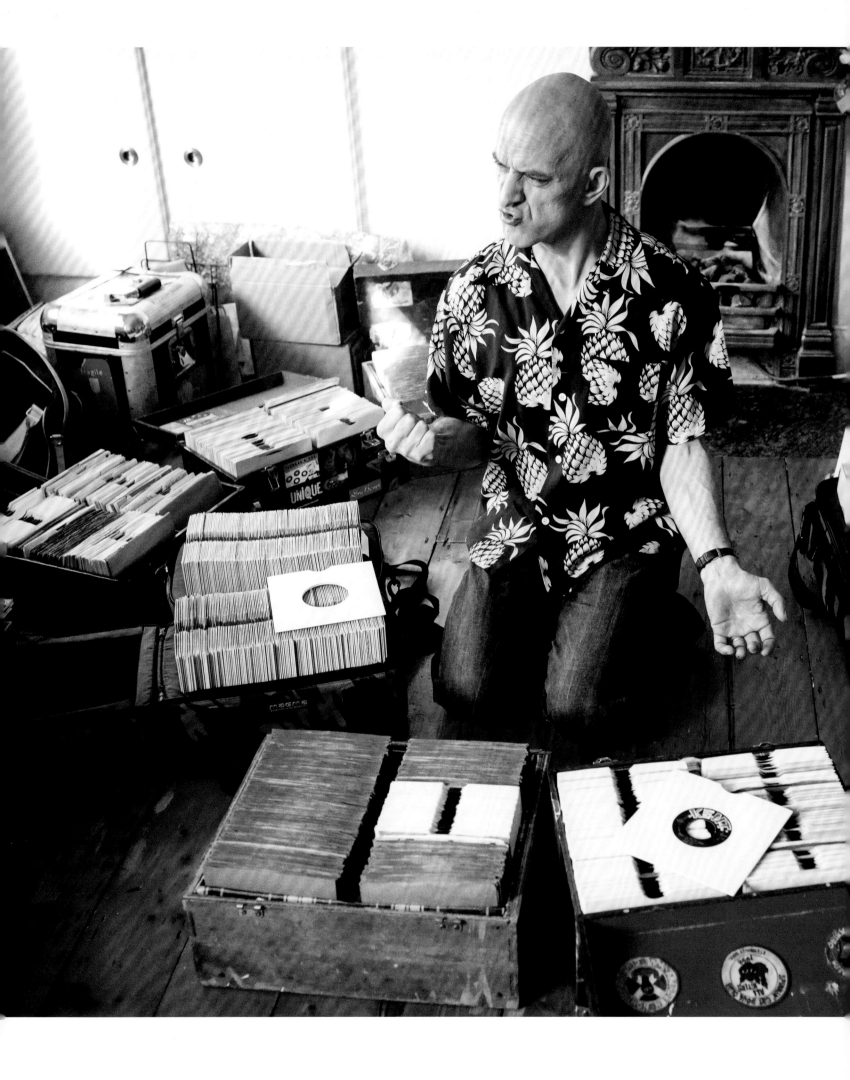

"THIS IS A TINY
COLLECTION,
A PITTANCE.
I USED TO
HAVE A HUGE
COLLECTION BUT
I GOT DIVORCED
THREE TIMES."

KEB DARGE - LONDON, UNITED KINGDOM

"ARETHA'S VOICE, A BRICK HOUSE MEDALLION DANGLING BETWEEN BREASTS, AND THE GODFATHER OF SOUL'S LEGS. NOW THAT IS ONE PARTY I WANT TO BE AT."

JAMISON HARVEY - BROOKLYN, NY
Aretha Franklin - *Aretha Now*
Most Requested Rhythm Band - *Got to Give It Up*
James Brown - *Hot Pants*

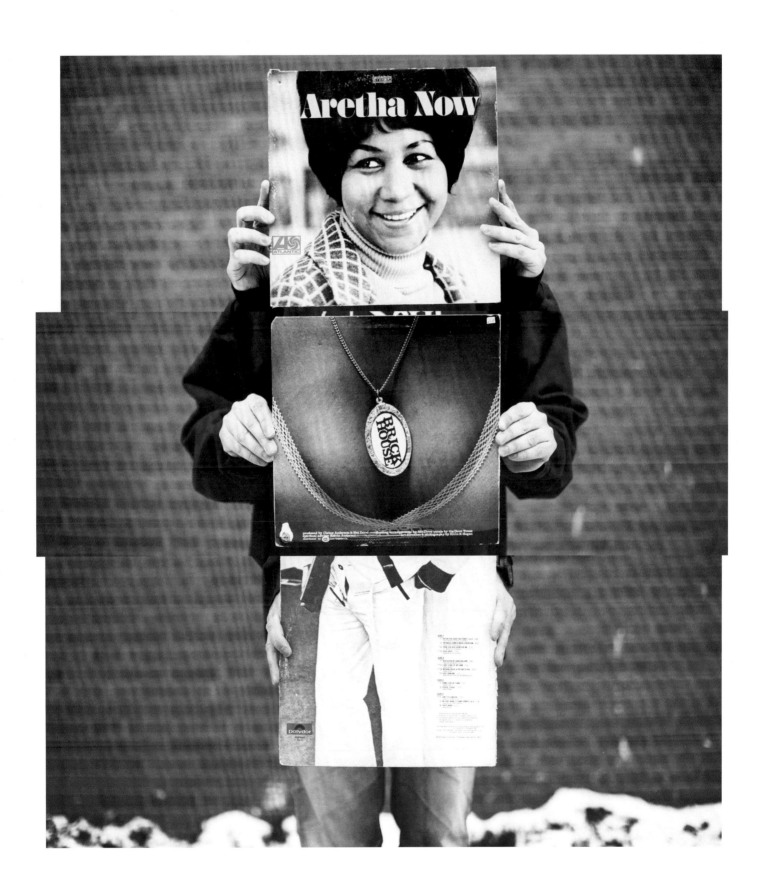

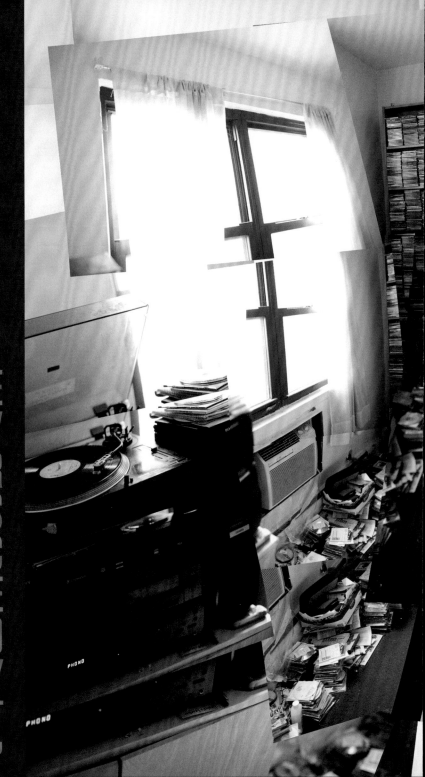

"QUESTIONS LIKE FAVORITE ALBUM/ARTIST/GENRE/LABEL/COVER ARE UTTER BULLSHIT. PEOPLE LESS CONSUMED WITH MUSIC CAN EASILY GIVE YOU THOSE ANSWERS, BUT I (AND THOSE OF MY TRIBE) SIMPLY CANNOT, AND THAT'S JUST THE WAY IT IS."

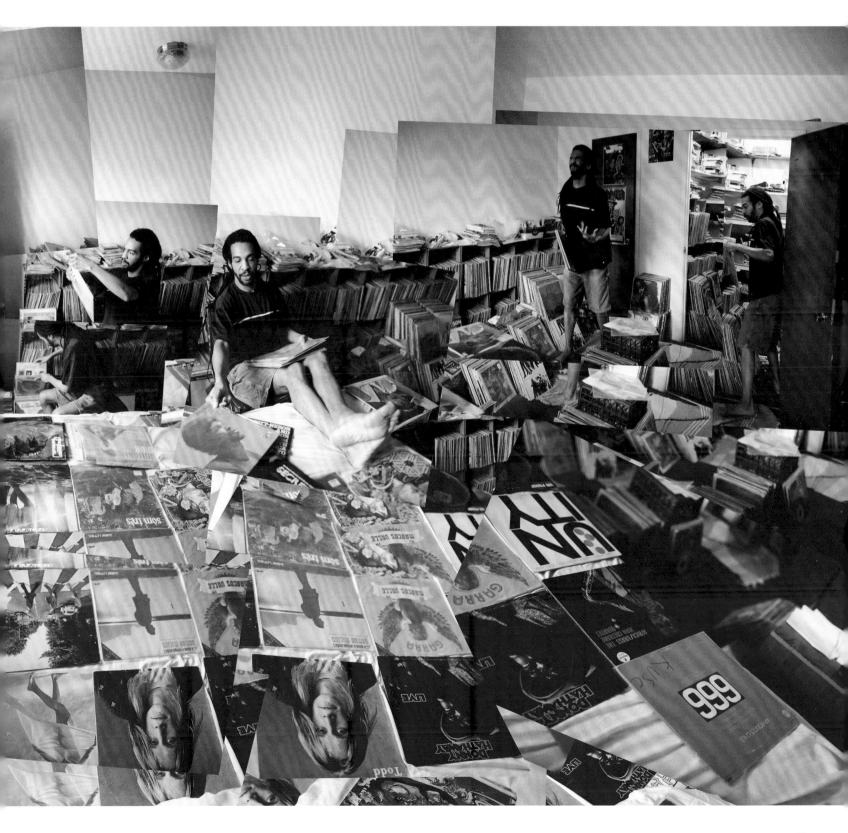

GILLES PETERSON
LONDON, UNITED KINGDOM

Herbie Hancock - *Mr. Hands*
"This was the album that introduced me to a more abstract type of jazz. I'll never forget the moment I first heard it. This copy is signed by Herbie, who I got to interview after chasing him for a long time. He's my all-time favorite musician."

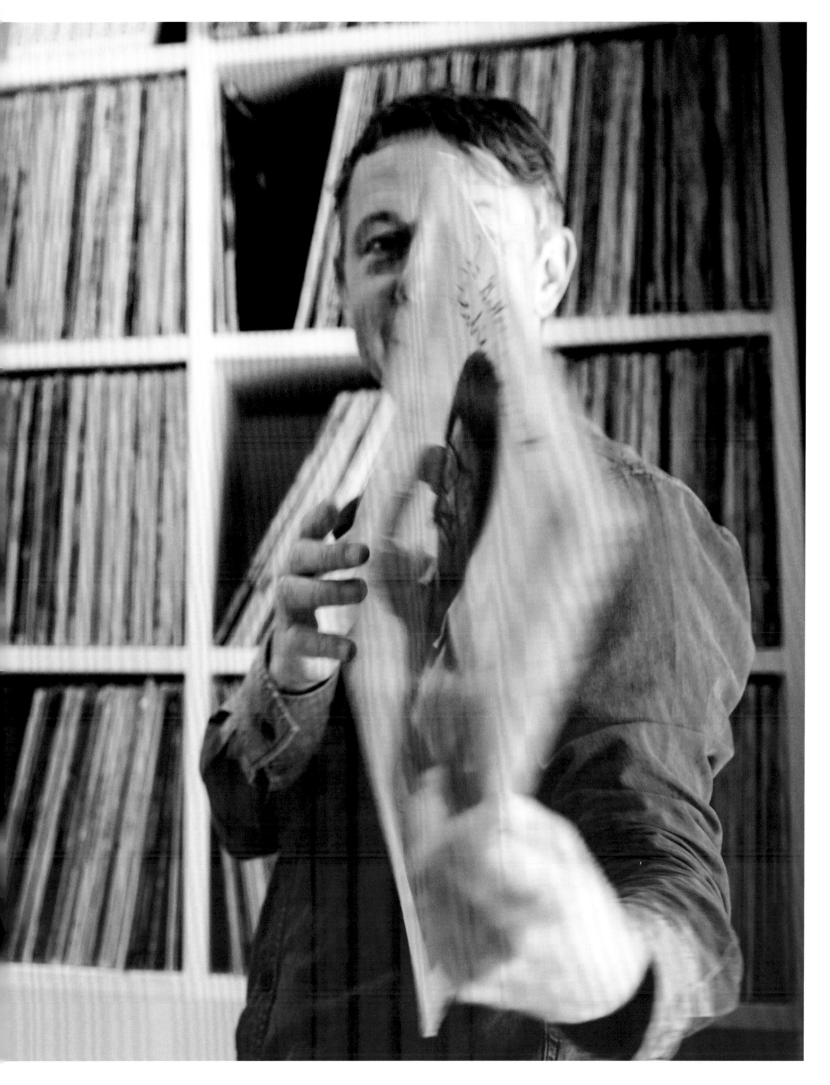

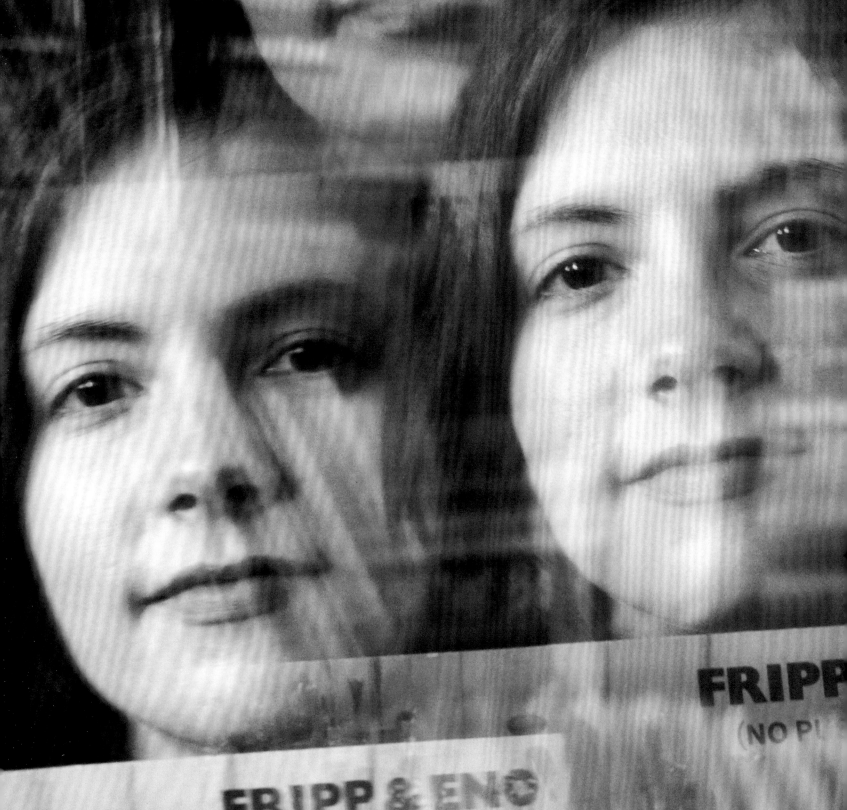

FRIPP & ENO
(NO PUSSYFOOTING)

FRIPP
(NO PU

MARGARET BARTON FUMO - BROOKLYN, NY
Fripp & Eno - *No Pussyfooting*
"Frippertronics, man! Very cool layered guitar loops.
I can't remember where I found this, but I know that
I bought it based on the cover alone."

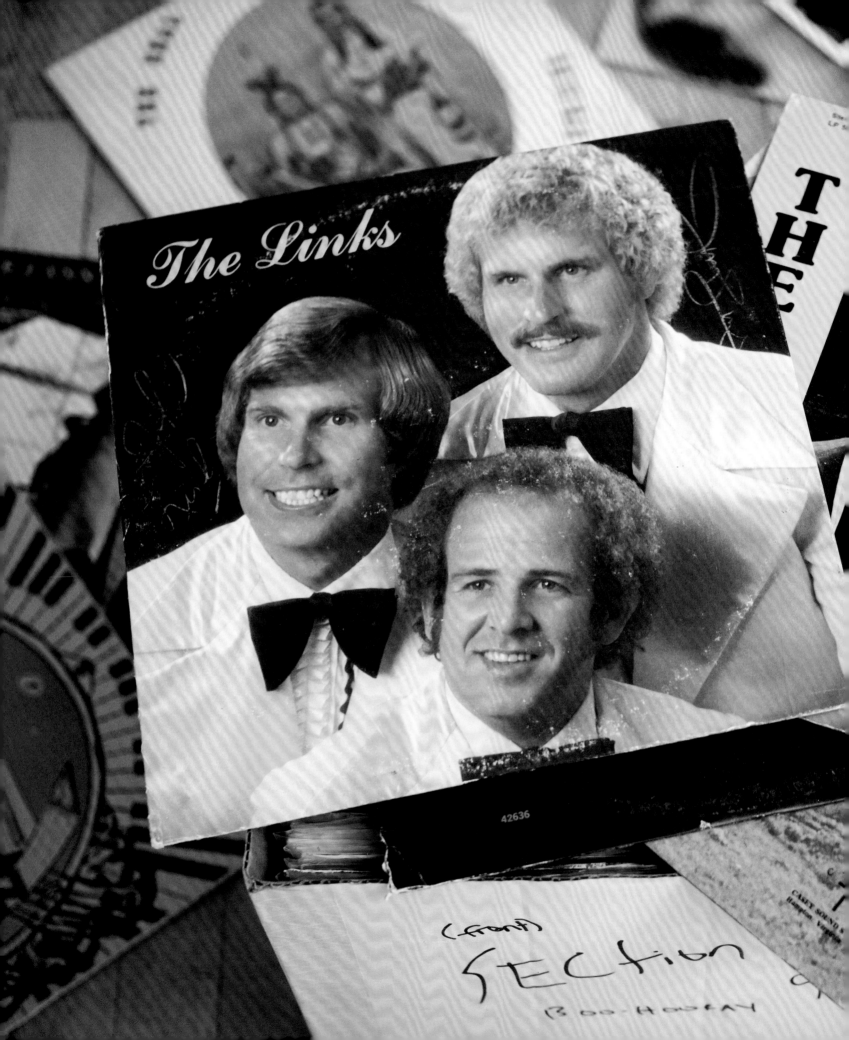

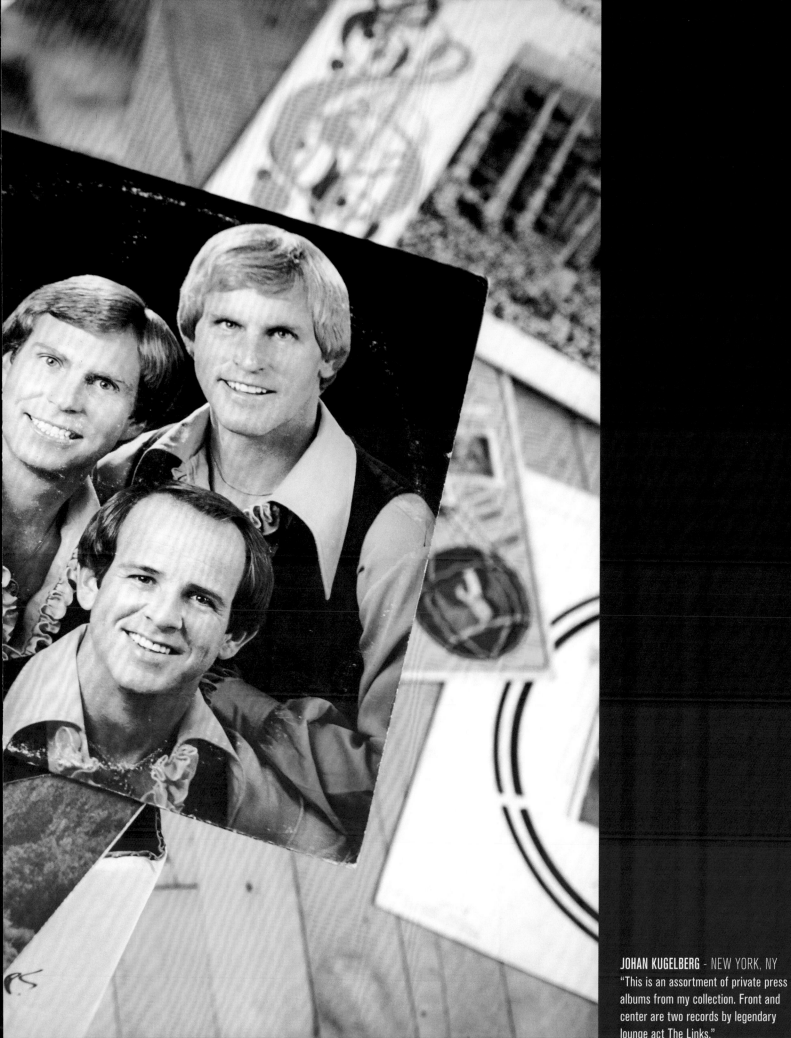

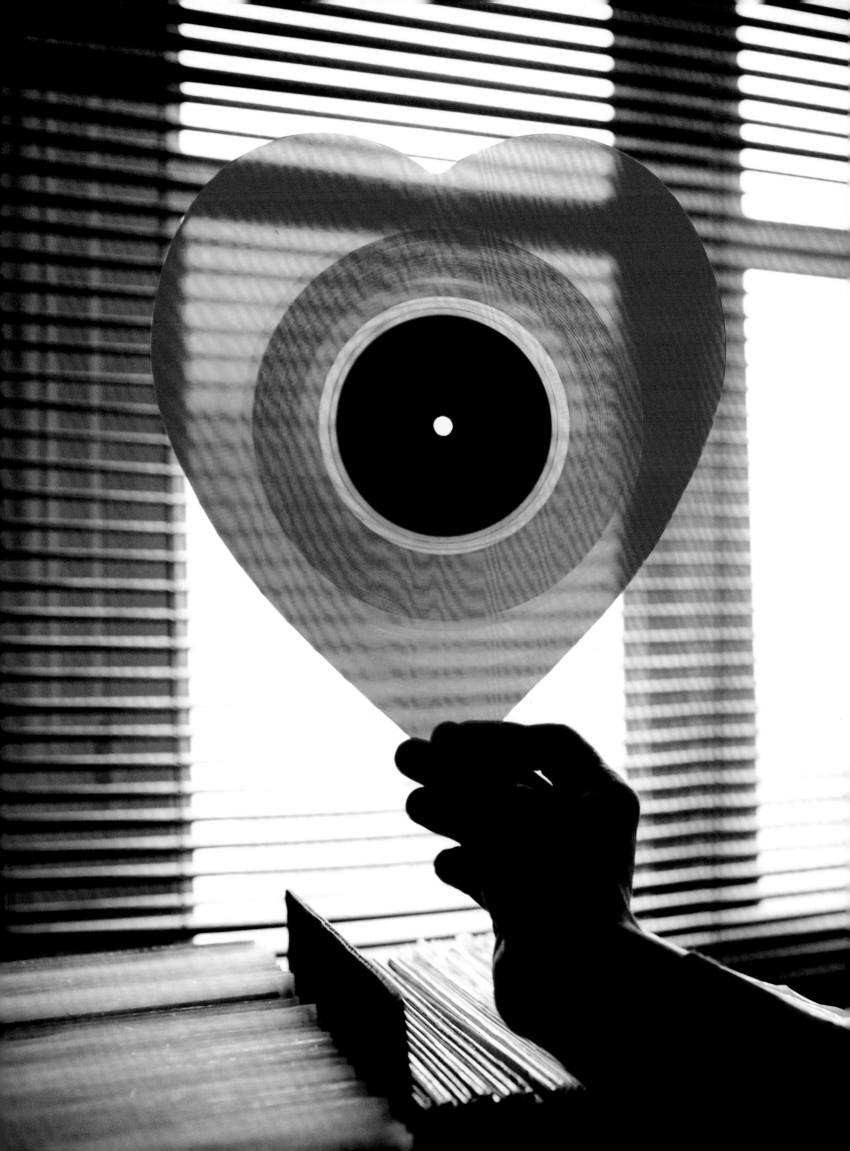

PHIL PERFECT - PARIS, FRANCE
Mayer Hawthorne - "Just Ain't Gonna
Work Out" 7-inch

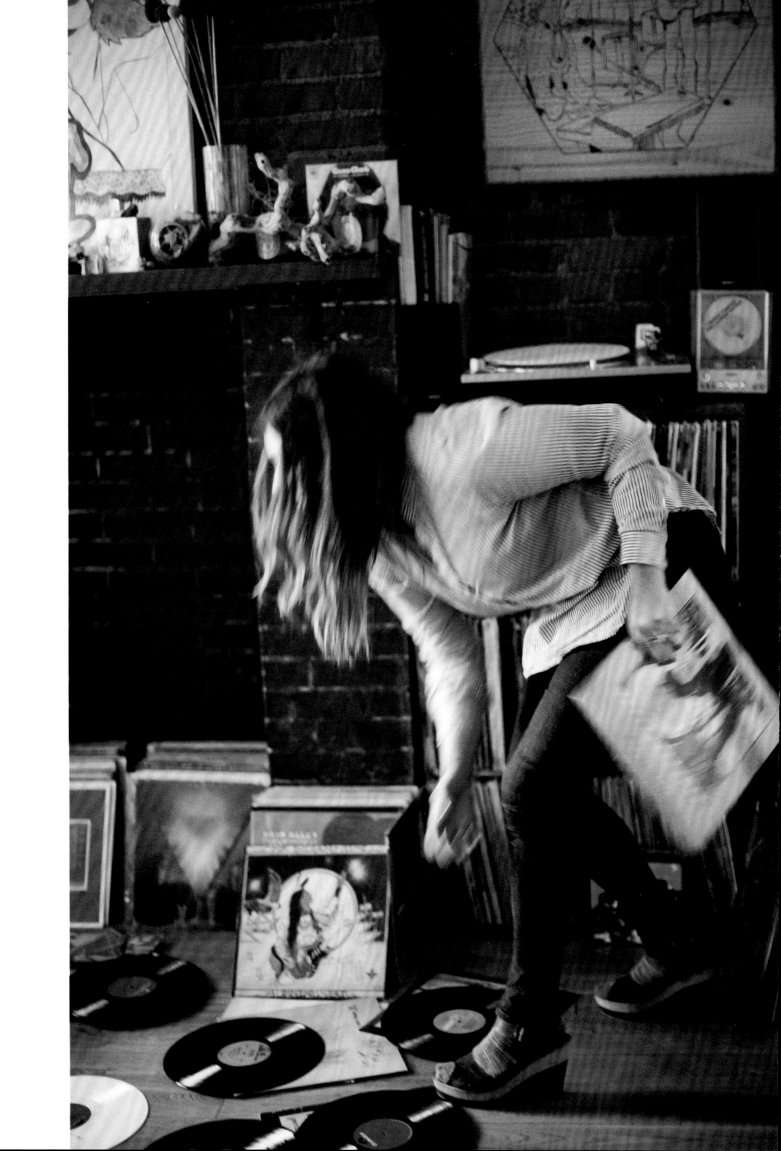

"THE BEAUTY OF VINYL IS THE ACT AND SOUND—NO OTHER FORMAT WORKS THE SAME. MUSIC BREATHES ON VINYL—IT HAS HEART AND FORCES YOU TO LISTEN IN A MUCH DIFFERENT WAY THAN AN MP3. I ENJOY THE PHYSICALITY OF THE EXPERIENCE."

JESS ROTTER - BROOKLYN, NY
"I am holding Christine McVie's 1970 solo record *The Legendary Christine Perfect*. It makes me want to sit back, just like Christine on the cover, while thoughtfully reflecting and drinking something fun in a mug."

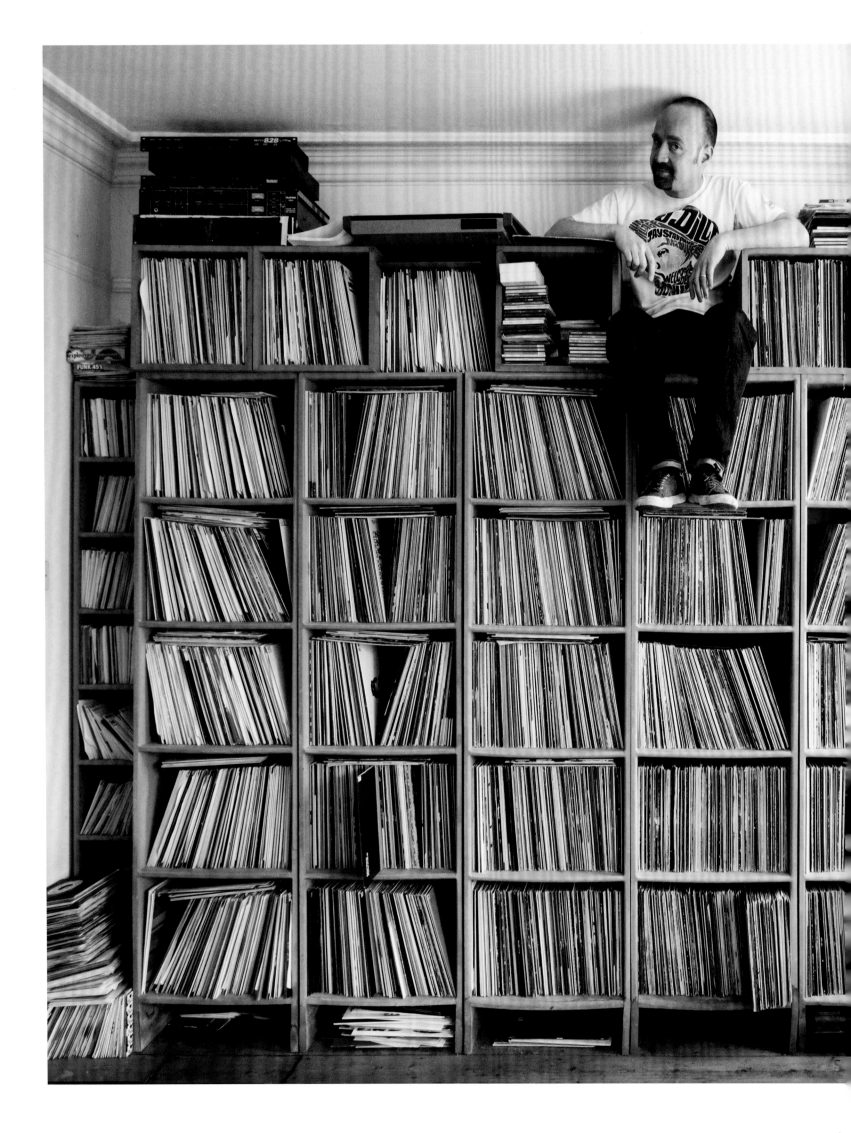

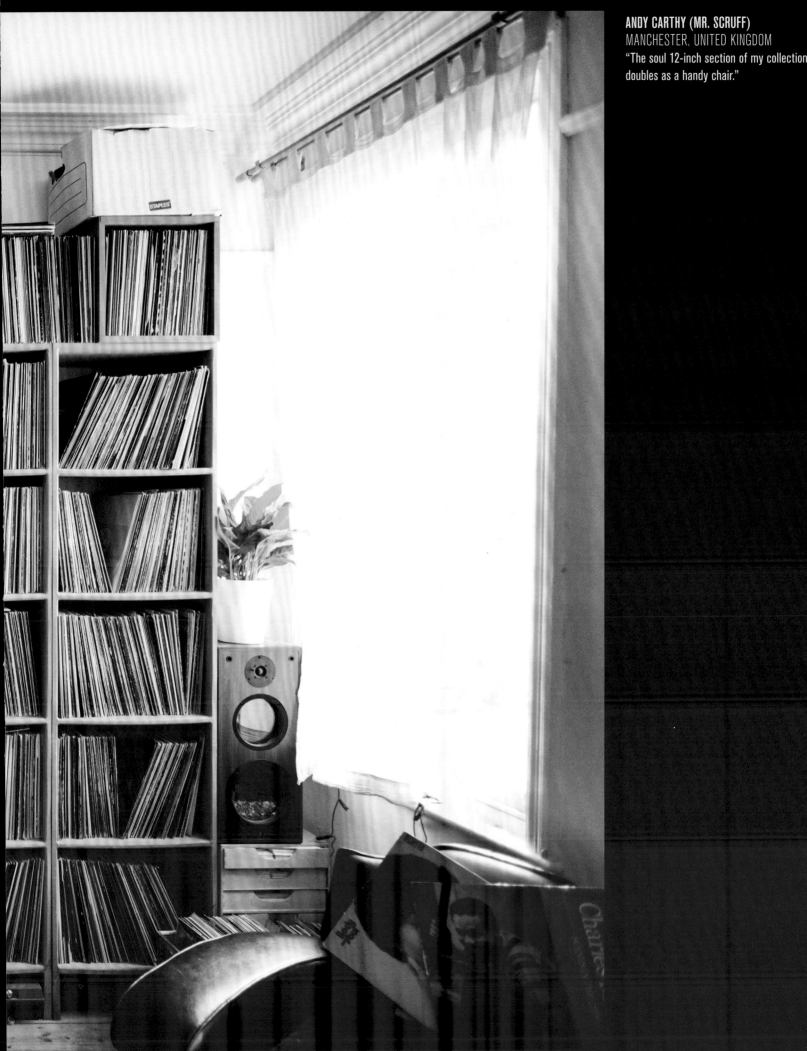

ANDY CARTHY (MR. SCRUFF)
MANCHESTER, UNITED KINGDOM
"The soul 12-inch section of my collection
doubles as a handy chair."

"I LOOK FOR THE SAME THINGS [IN RECORDS] I FOUND IN MY WIFE—AN ATTRACTIVE AND ENTICING FRONT COVER, AN INTERESTING BACK STORY, AND GOOD, HEAVYWEIGHT PRESSING (NO RELEVANCE TO MY WIFE ON THAT ONE)."

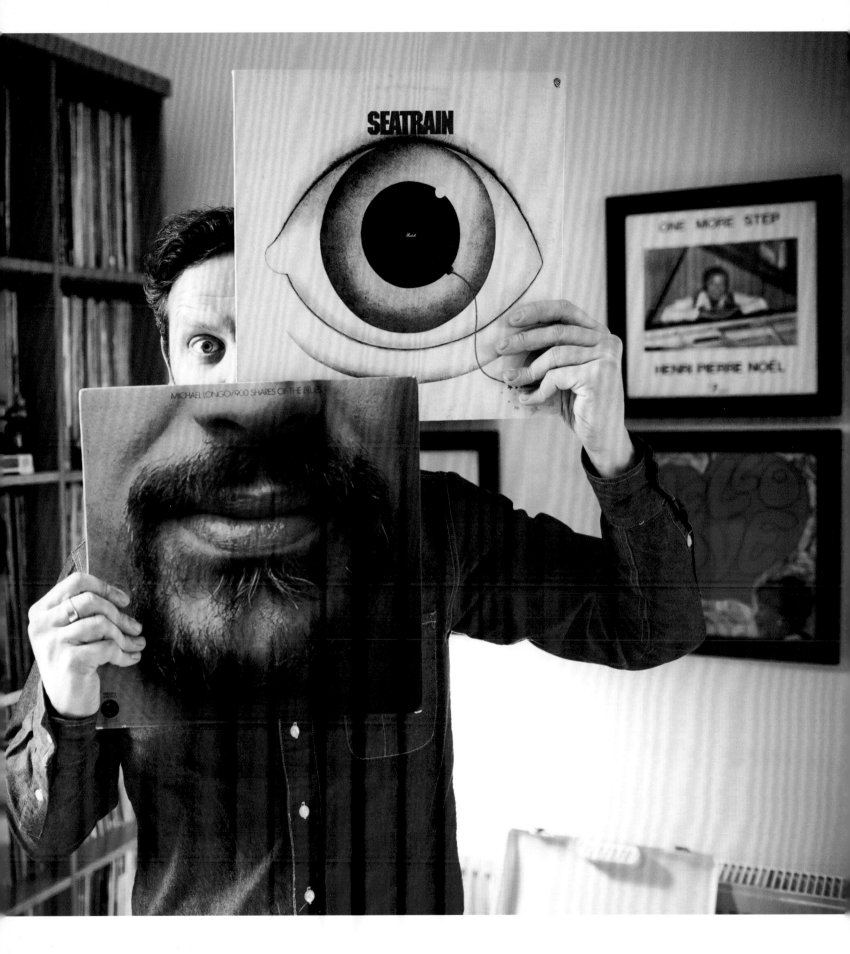

DOM SERVINI - LONDON, UNITED KINGDOM
Seatrain - *Watch*
Michael Longo - *900 Shares of the Blues*
"Doing a bit of vinyl surgery in my record room. *Watch* is a jazz-rock record; the track 'Flute Thing' was famously sampled by the Beastie Boys in 'Flute Loop.' Michael Longo's *900 Shares of the Blues* contains not only the fusion classic 'Like a Thief in the Night' but also a far better goatee than I've ever managed to pull off!"

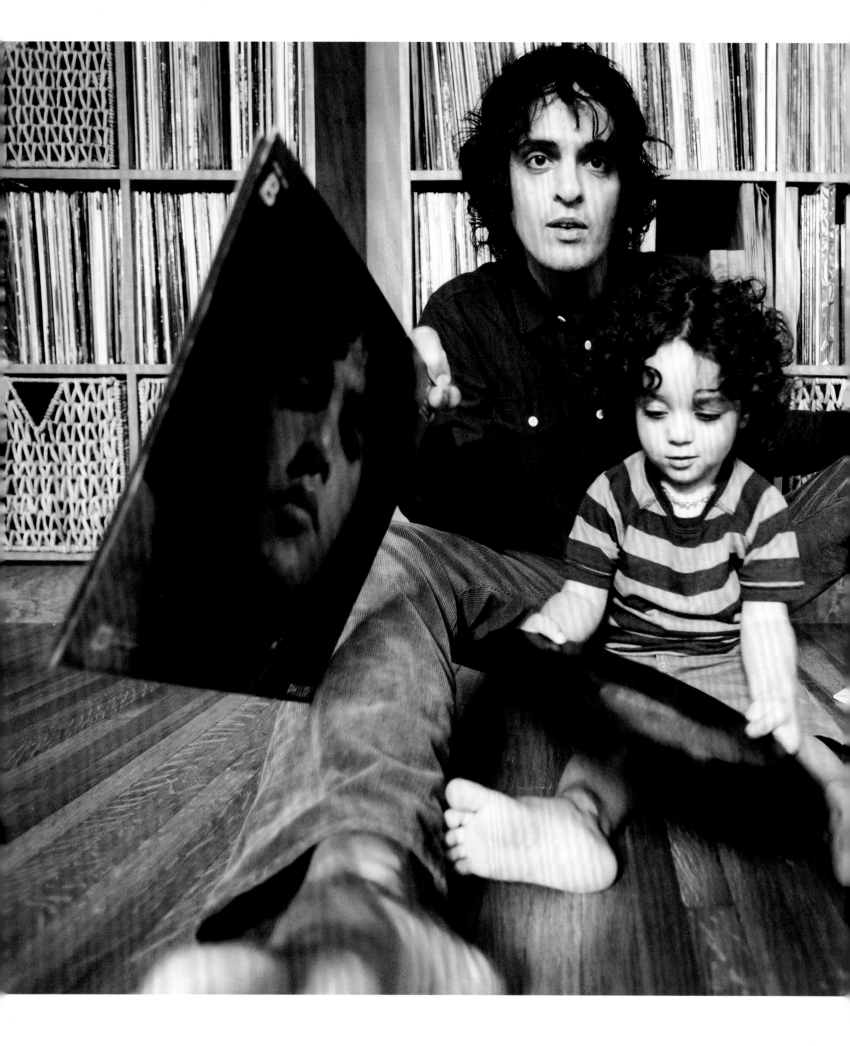

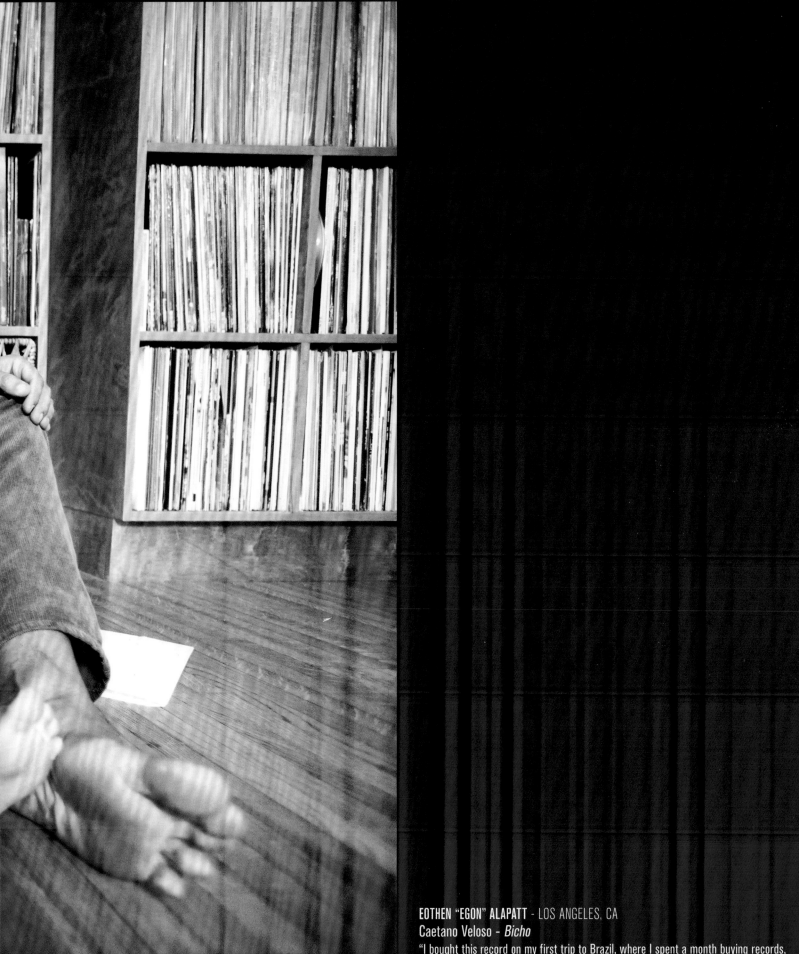

EOTHEN "EGON" ALAPATT - LOS ANGELES, CA
Caetano Veloso - *Bicho*
"I bought this record on my first trip to Brazil, where I spent a month buying records,

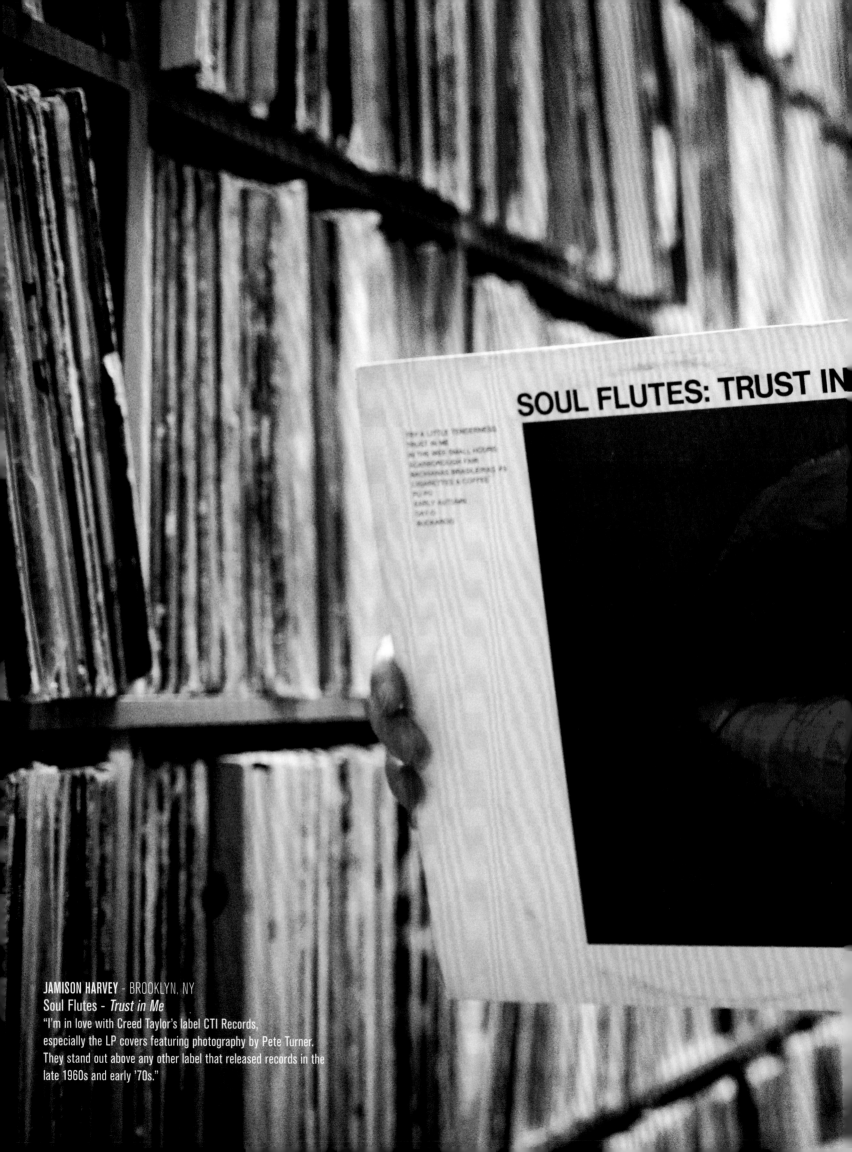

SOUL FLUTES: TRUST IN

JAMISON HARVEY - BROOKLYN, NY
Soul Flutes - *Trust in Me*
"I'm in love with Creed Taylor's label CTI Records,
especially the LP covers featuring photography by Pete Turner.
They stand out above any other label that released records in the
late 1960s and early '70s."

STEREO A&M SP 3009

SOUL FLUTES: TRUST IN ME

A&M
RECORDS

CTi

ARRANGED BY DON SEBESKY

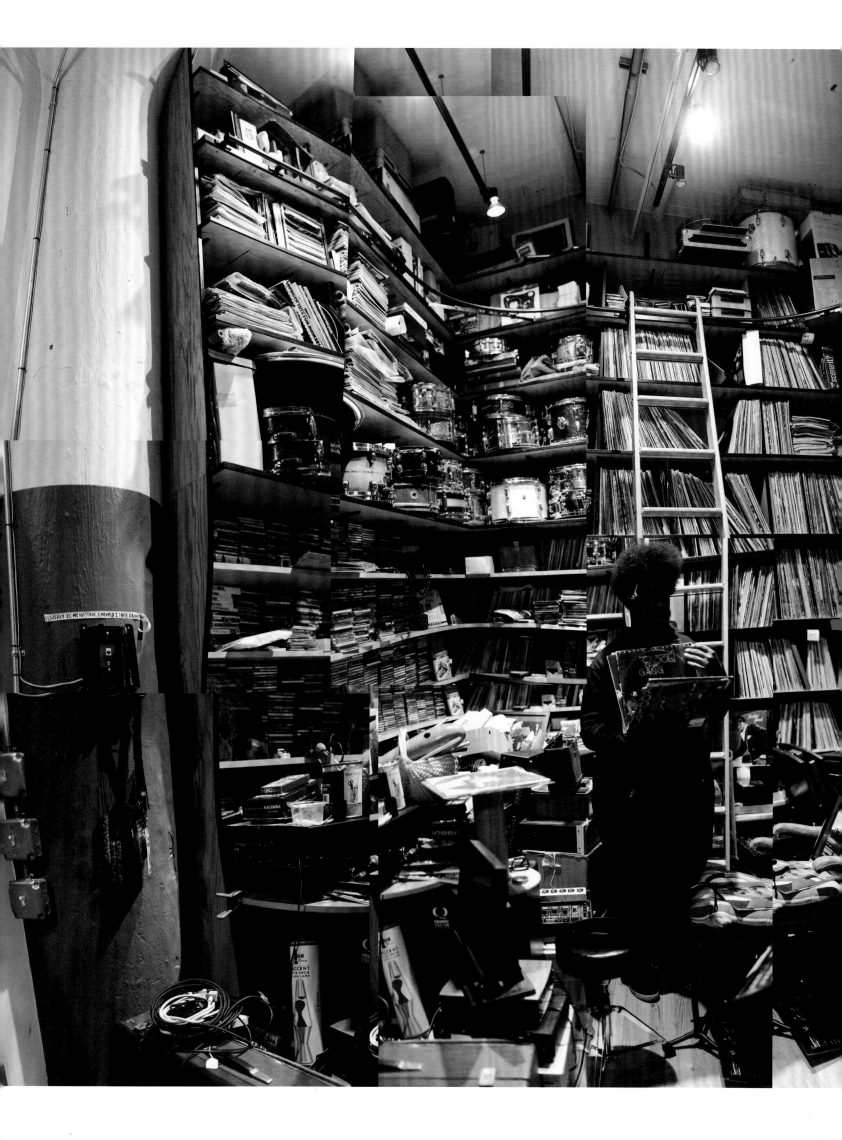

"I THINK ALL OF THIS—THE ROOTS AND DJING INCLUDED— WAS MEANT TO PREPARE ME FOR *THE TONIGHT SHOW.*"

AHMIR "QUESTLOVE" THOMPSON - PHILADELPHIA, PA
With his ever-present afro pick, Questlove sifts through the albums of his early collecting days.

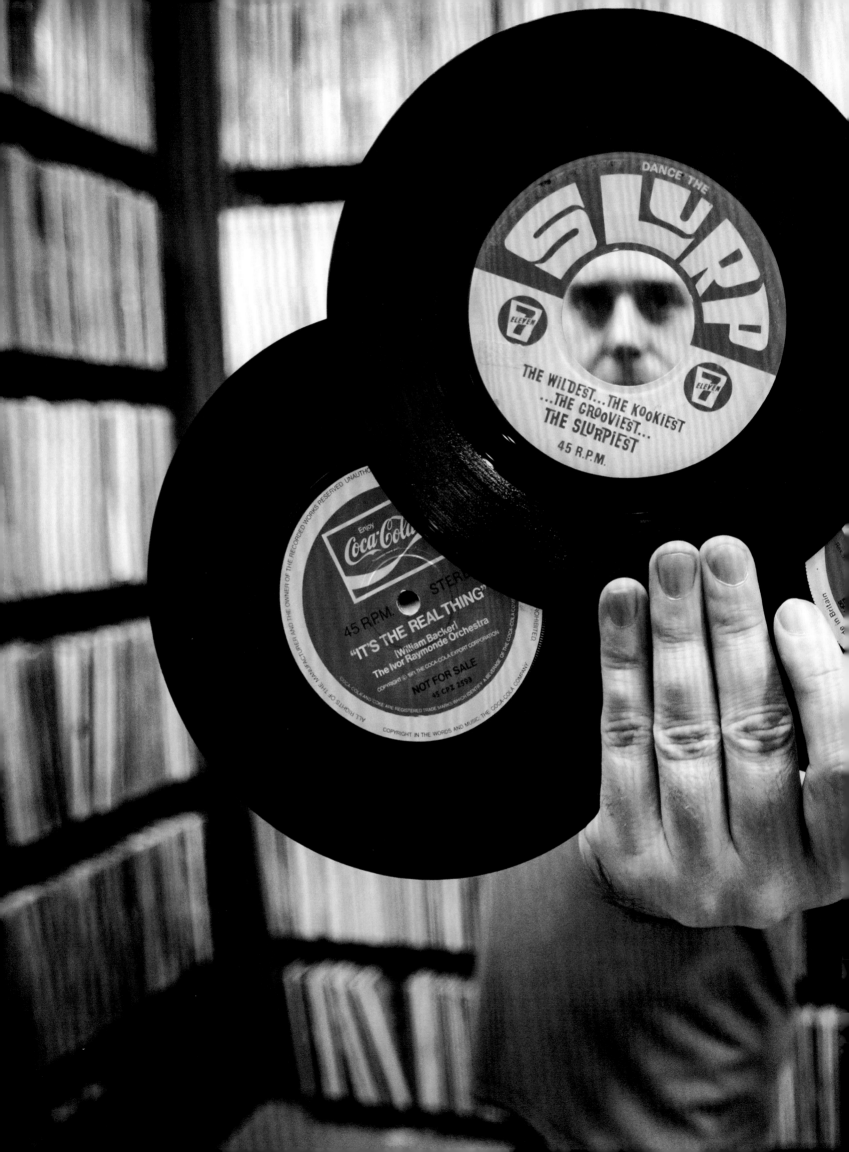

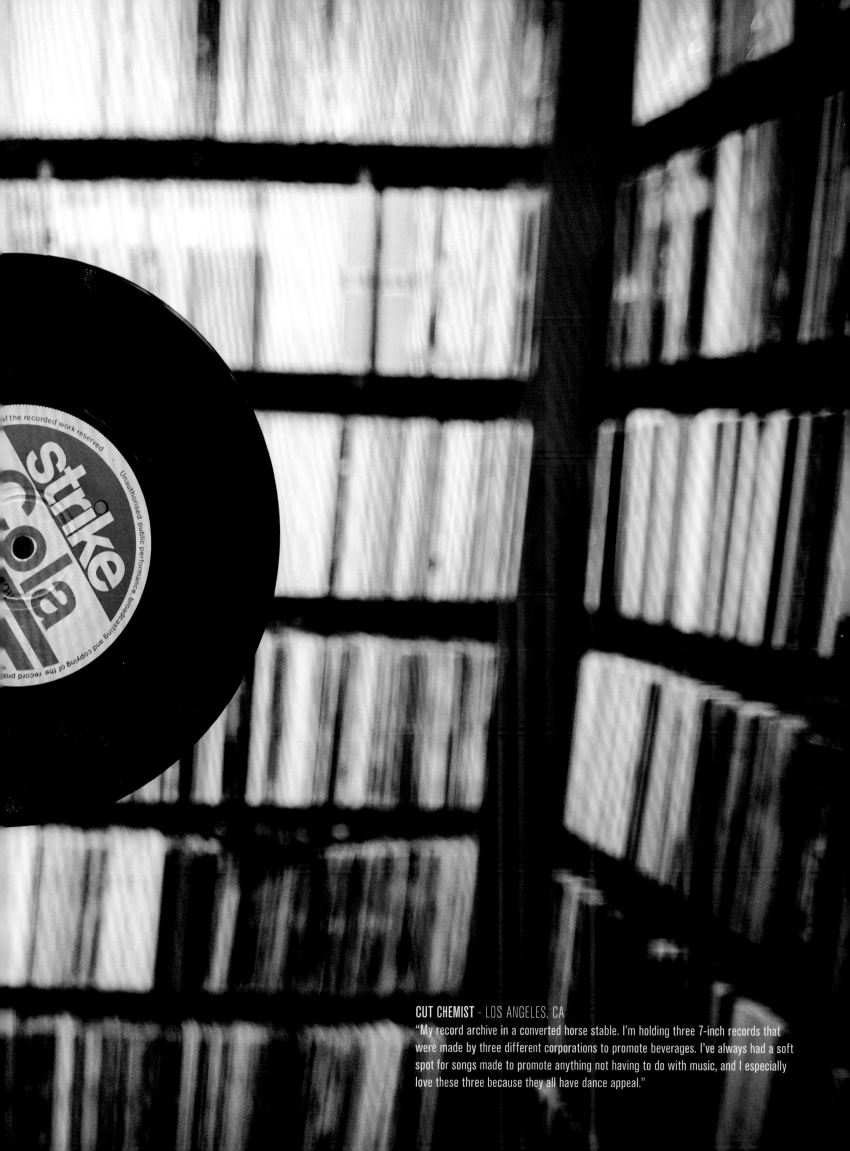

CUT CHEMIST - LOS ANGELES, CA
"My record archive in a converted horse stable. I'm holding three 7-inch records that were made by three different corporations to promote beverages. I've always had a soft spot for songs made to promote anything not having to do with music, and I especially love these three because they all have dance appeal."

"OVERALL, A RECORD
SHOULD CAPTIVATE YOU.
IT SHOULD ELICIT AN
EMOTION. IT SHOULD
TELL A STORY. THERE'S
NO BETTER FORMAT FOR
THE DISSEMINATION OF A
SONG THAN THE 7-INCH
45 RPM RECORD. THAT
WILL NEVER CHANGE."

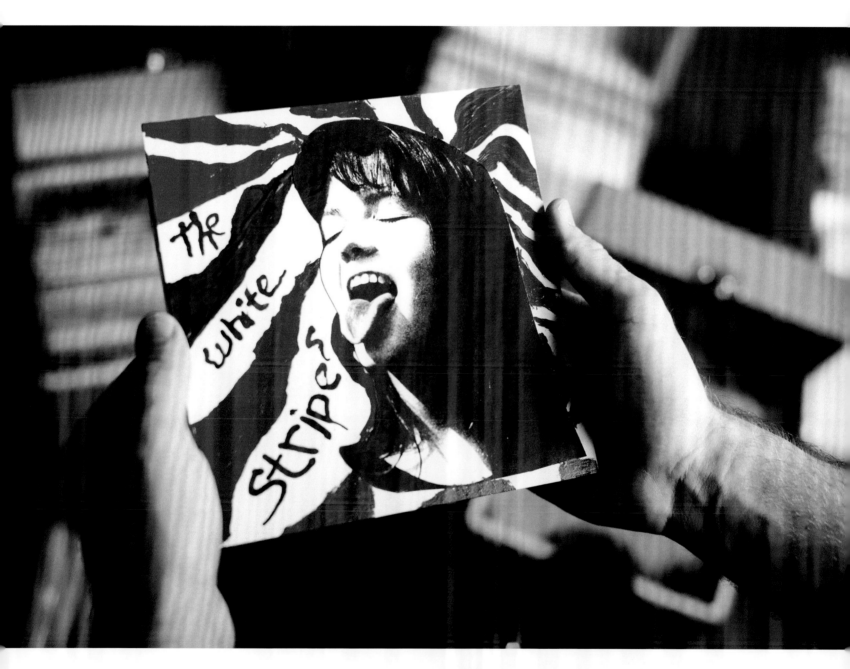

BEN BLACKWELL - NASHVILLE, TN
The White Stripes - "Lafayette Blues"
"This hand-painted copy of the White Stripes' 'Lafayette Blues' single is unique, one of only fifteen done for the record release show on October 23, 1998. If I had to cut my collection down to one record, I think this would be it."

"I WAS STARTING TO MAKE MY OWN MUSIC, AND I WAS BUYING RECORDS TO SAMPLE MYSELF. I'D DISCOVERED JAZZ, AND I REALIZED THAT EVERYTHING I HAD ONCE THOUGHT OF AS INCREDIBLY INNOVATIVE AND BRILLIANT HAD ACTUALLY ALREADY BEEN DONE IN LOTS OF WAYS—AND USUALLY MUCH BETTER!"

KIERAN HEBDEN (FOUR TET) - LONDON, UNITED KINGDOM
Tortoise - *Lonesome Sound* and *Mosquito* EPs
"Tortoise's first and second EPs have clever connecting artwork."

mosquito

"I WAS REALLY INTO 7-INCH LABELS. SO APPARENTLY, WHEN I WAS LITTLE, MY FIRST WORDS WERE THINGS LIKE 'DECCA' AND 'PARLOPHONE.'"

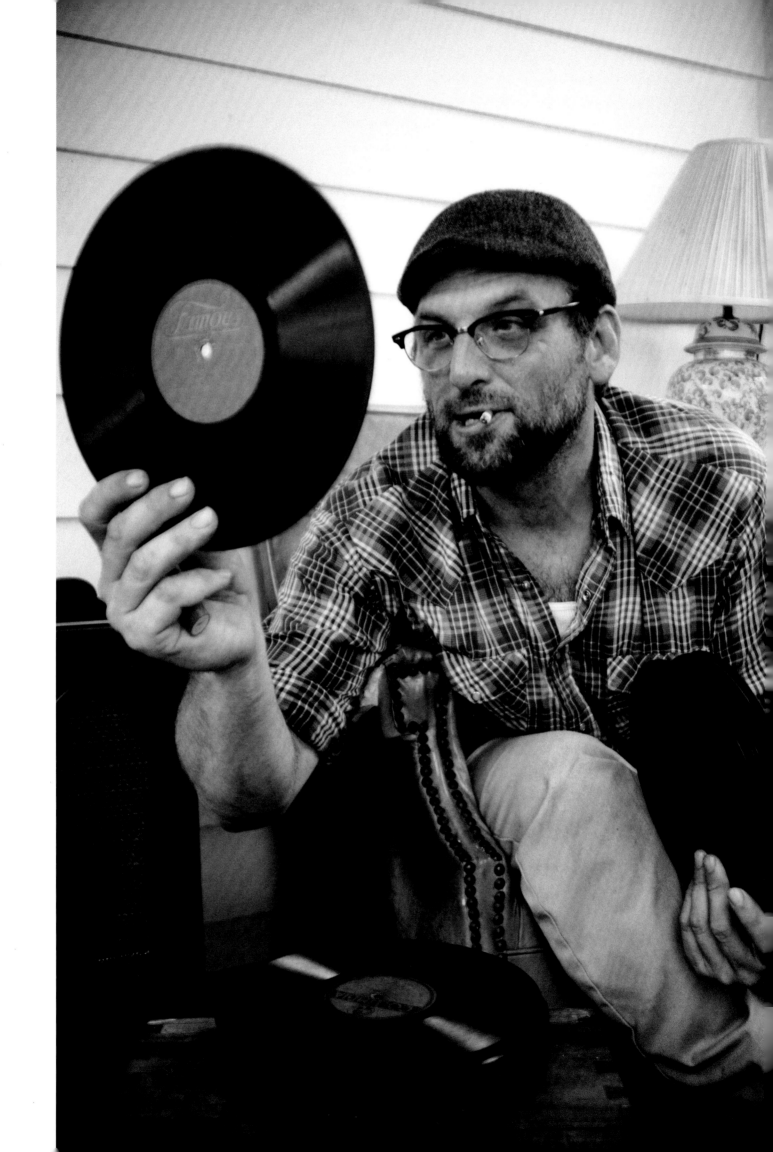

"BUY ANY RECORD. IF YOU DON'T NEED IT, GIVE IT AWAY."

MATT SCHERGER - LAFAYETTE, IN

"MY UNCLE WOULD GIVE ME MONEY TO GO TO PROSTITUTES, BUT I WAS ACTUALLY SPENDING ALL THE MONEY AT THE CONCERTO RECORD SHOP. I WAS MORE INTERESTED IN MUSIC THAN SEX."

PHILIPPE COHEN SOLAL - PARIS, FRANCE
"Some of my favorite David Bowie albums. Music always takes me higher.
It was my first love, and it will be my last."

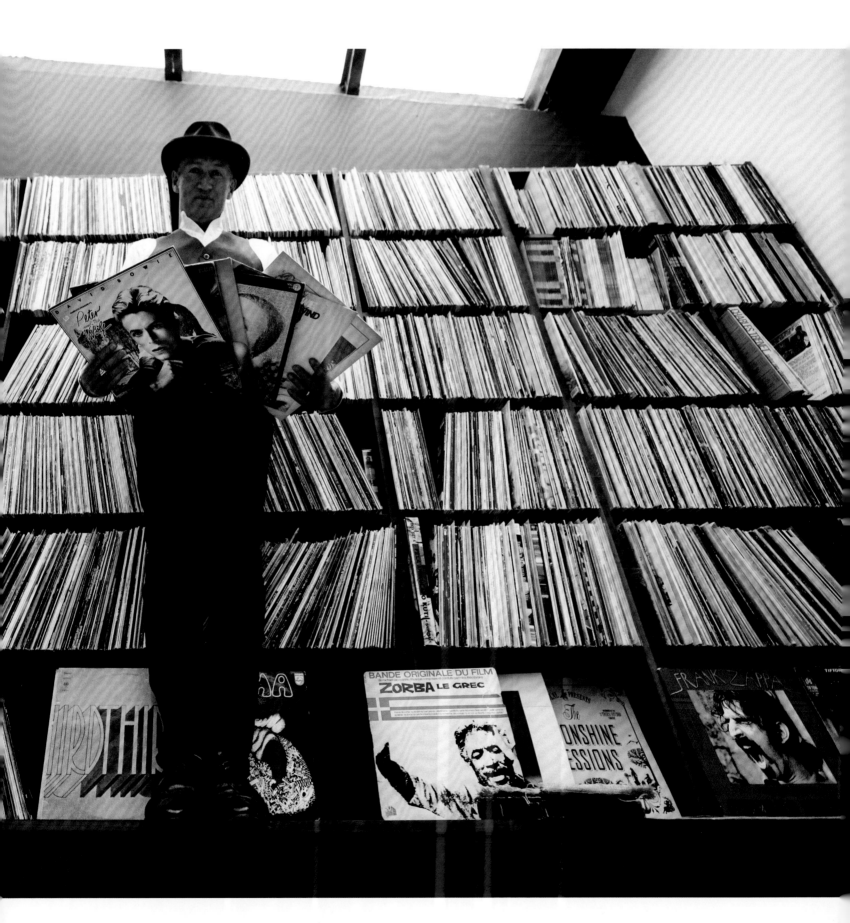

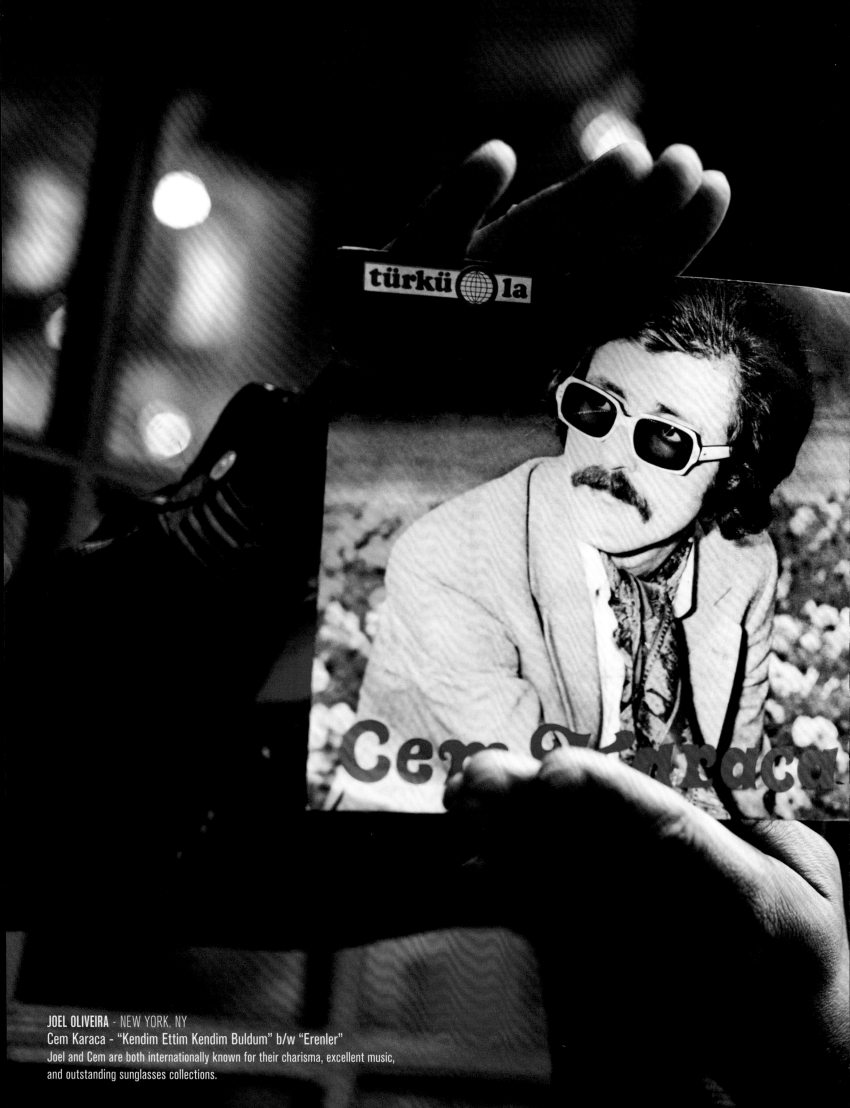

JOEL OLIVEIRA - NEW YORK, NY
Cem Karaca - "Kendim Ettim Kendim Buldum" b/w "Erenler"
Joel and Cem are both internationally known for their charisma, excellent music,
and outstanding sunglasses collections.

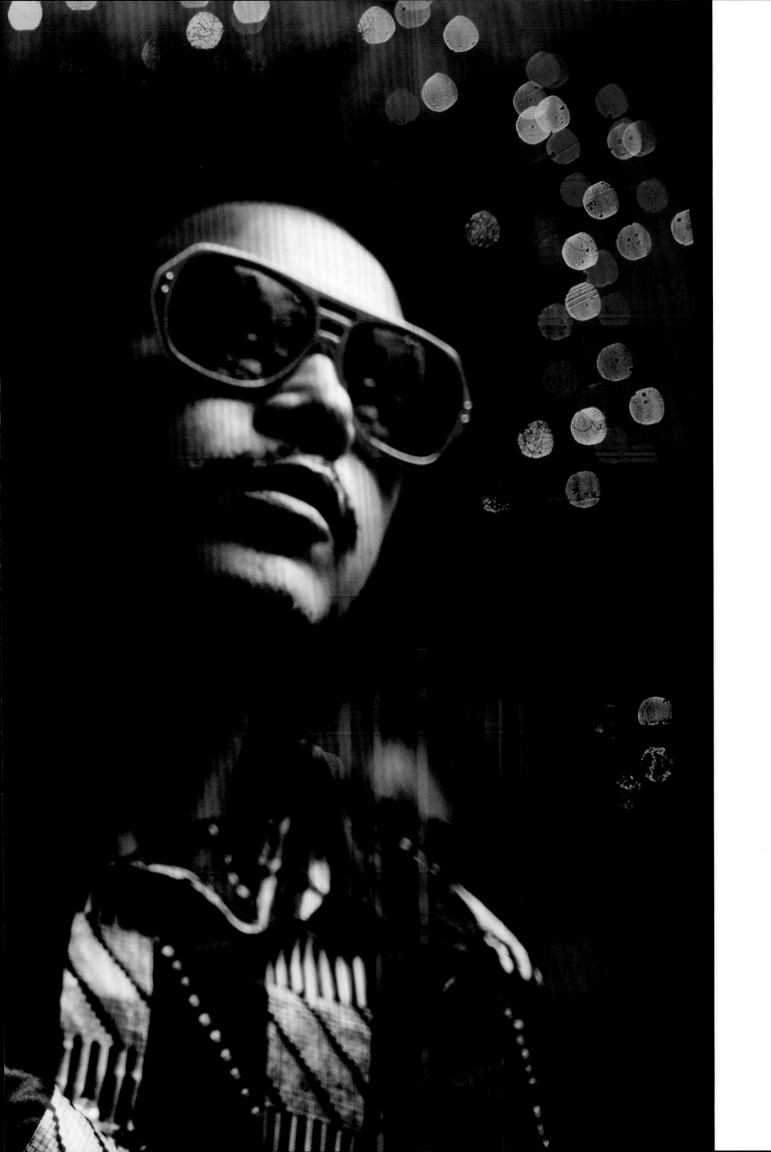

DB BURKEMAN - BROOKLYN, NY
The White Stripes - "You Don't Know What Love Is (You Just Do as You're Told)"

"IN THE WORDS OF FISCHERSPOONER, 'LOOKS GOOD, SOUNDS GOOD, FEELS GOOD TOO.'"

JASON "JAYTRAM" TRAMMELL - BROOKLYN, NY
Keith Hudson - *Playing It Cool*
"This was one of Keith Hudson's last records. I am particularly drawn to the song 'California,' because I like stony songs about journeys, and you don't often hear a Jamaican man singing about driving to California."

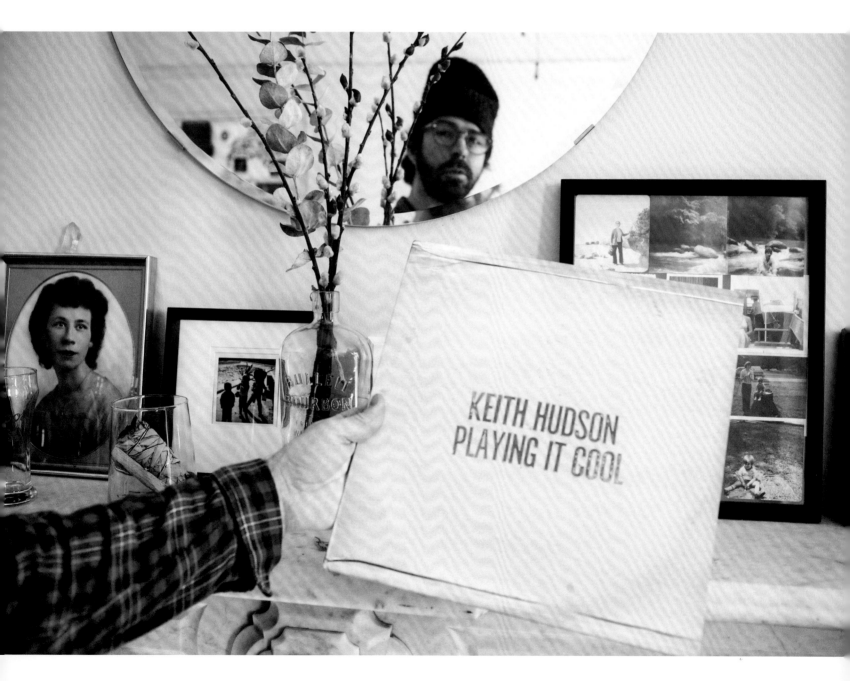

AHMED GALLAB (SINKANE) & JASON "JAYTRAM" TRAMMELL - BROOKLYN, NY
An impromptu DJ set during a photo shoot, inspired by pulling records and reminiscing.

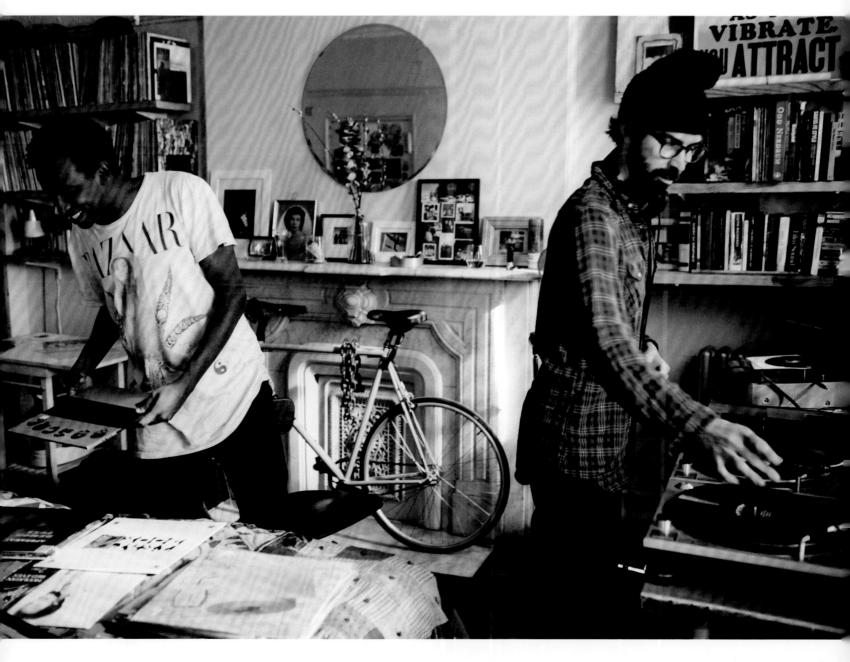

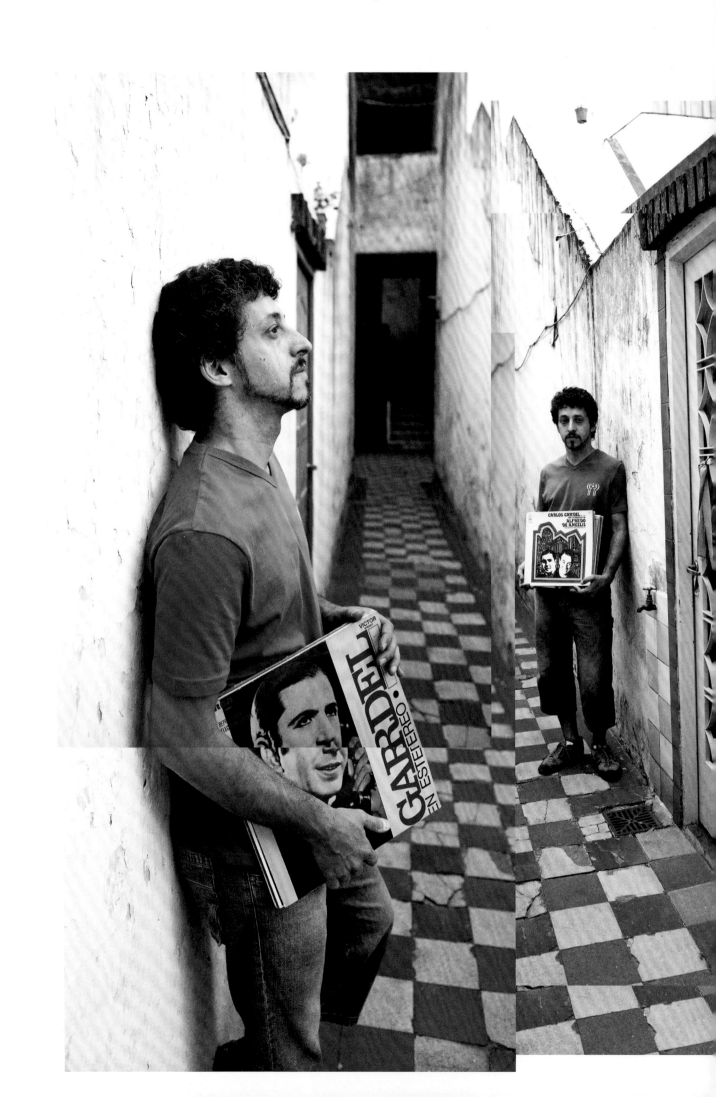

"THE JOY OF LISTENING FAR EXCEEDS MY NEED TO HAVE IT ON RECORD. THE SONG IS THE CAKE; THE ORIGINAL VINYL RECORD IS THE CHERRY ON TOP."

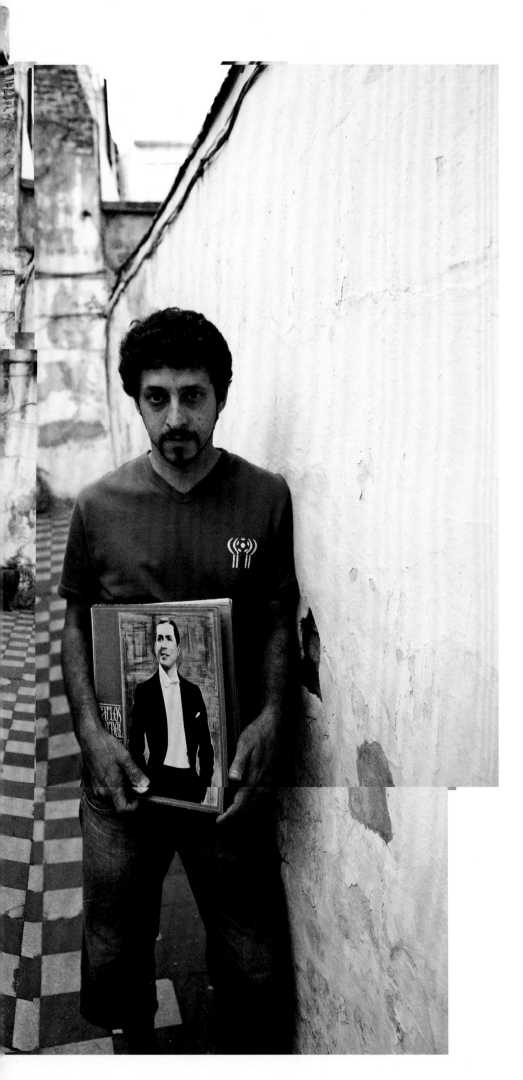

ALEJANDRO JORGE MOLINIER - BUENOS AIRES, ARGENTINA
"In the courtyard with a few of my favorite Carlos Gardel albums."

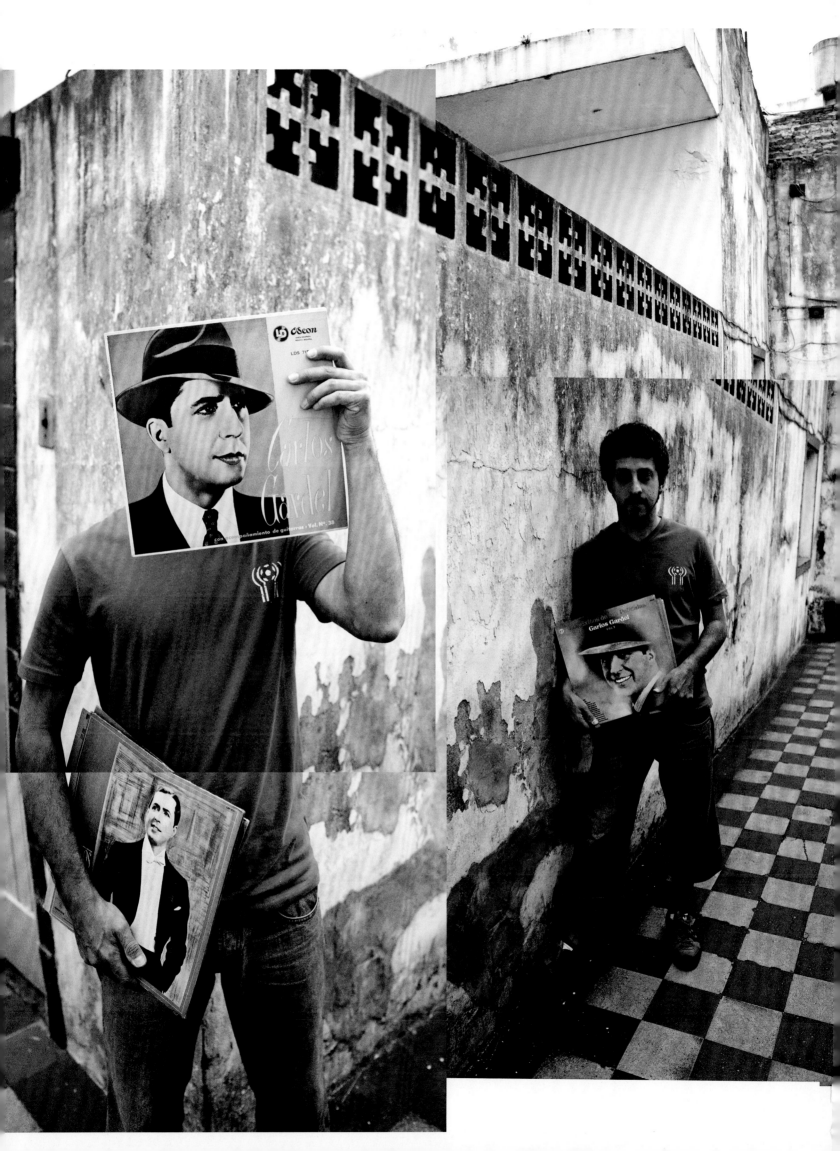

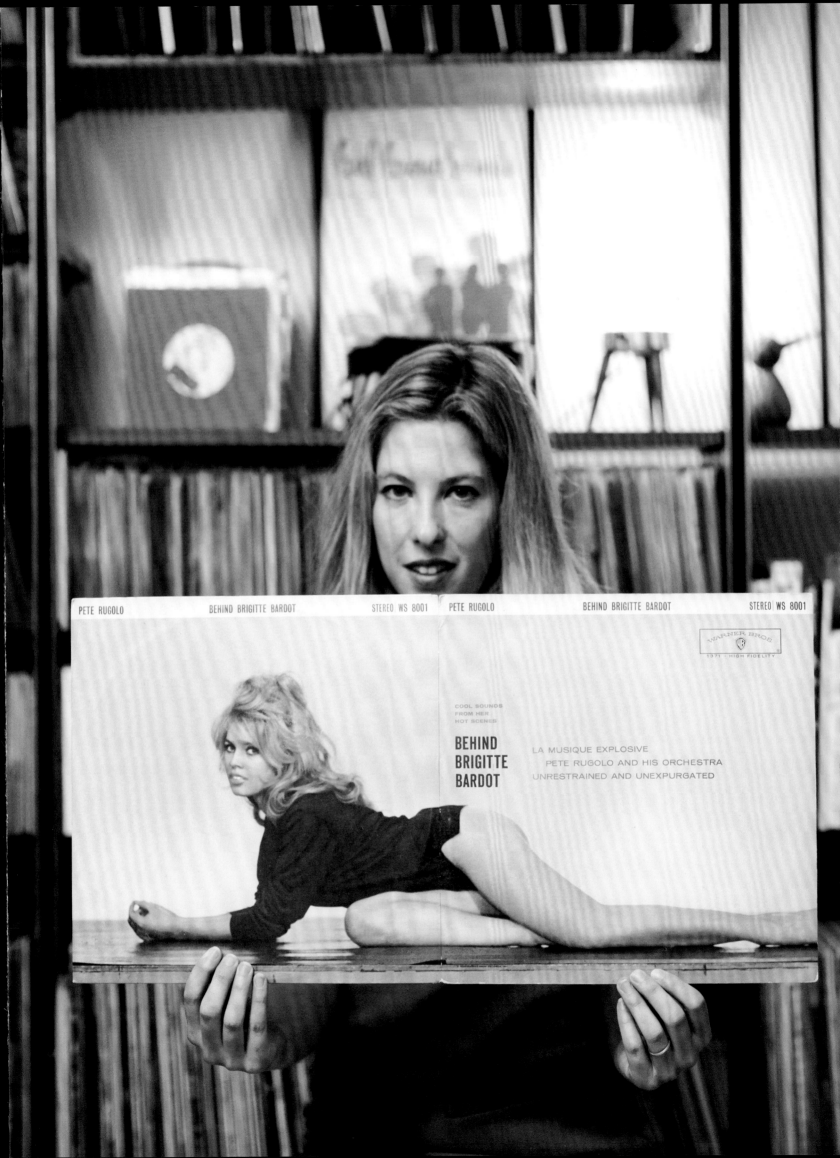

SHEILA BURGEL - BROOKLYN, NY
Pete Rugolo and His Orchestra - *Behind Brigitte Bardot*
"My Brigitte Bardot collection extends beyond her '60s pop recordings and includes anything remotely Bardot-related. I found this stunning tribute album with Bardot in a skimpy blue sweater spread across the gatefold. It's essentially jazzed-up rearrangements of her film themes, but I didn't buy it for the music."

"COLLECTING RECORDS IS LIKE VOLUNTARILY BECOMING A HISTORIAN OR A CHAPTER IN A LONG BOOK OF MUSICAL HISTORIES."

RICH MEDINA - PHILADELPHIA, PA
Henry Franklin - *The Skipper*
"I was one album shy of the entire Black Jazz Records catalog until I finally caught
the Kellee Patterson album *Maiden Voyage* to finish off the stash."

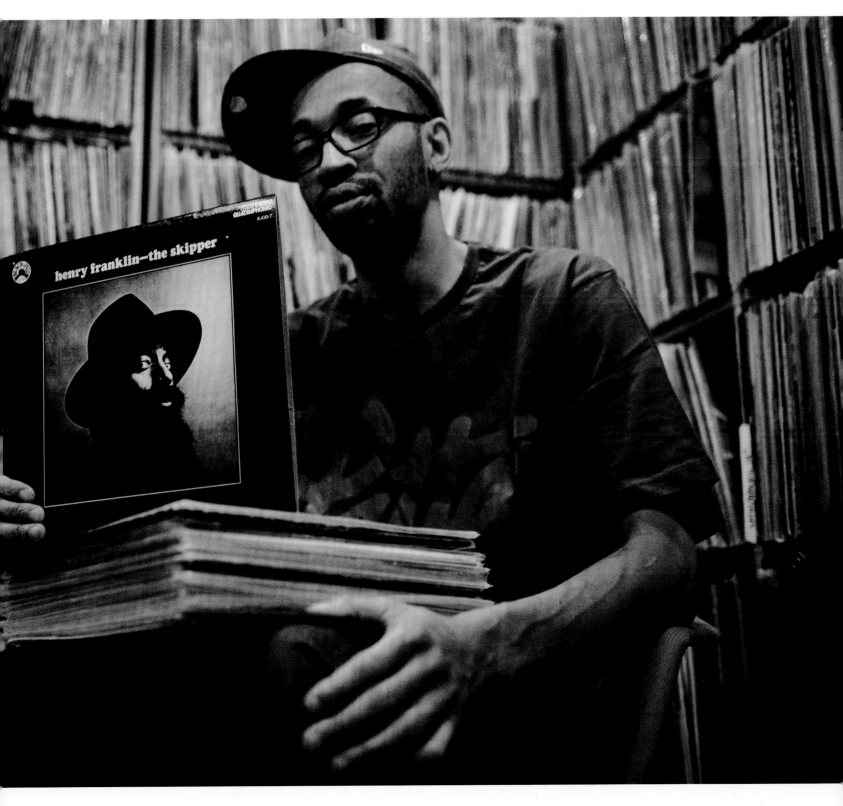

ZACH COWIE - LOS ANGELES, CA
Manfred Mann - "One Way Glass"
"The infamous Vertigo swirl label, seen here on an Argentinian 33 rpm 7-inch single."

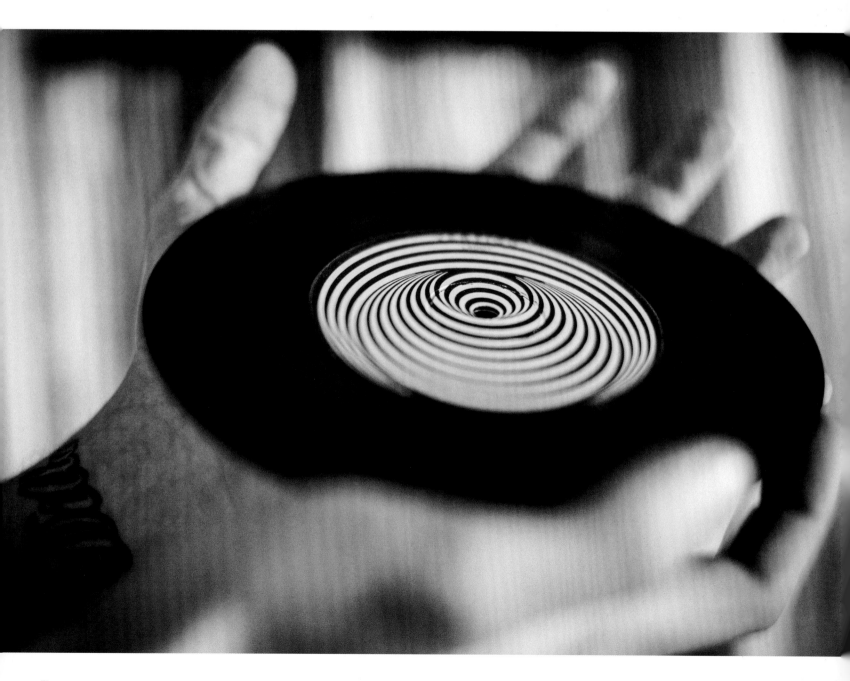

VALERIE CALANO - SEATTLE, WA
Pfizer Inc., 1966 - *Post-Graduate Seminars: Metabolic Abnormalities in Diabetes*
"The content of this record is extremely boring; it's a panel of old physicians discussing diabetes. I find it fascinating that the psychedelic aesthetic was so prominent during this time that it even infiltrated the medical world."

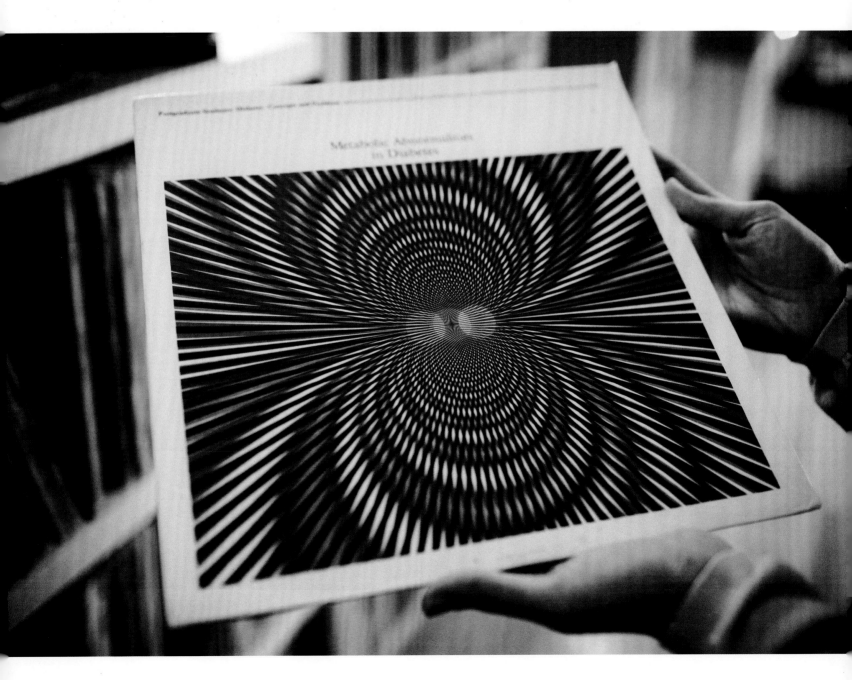

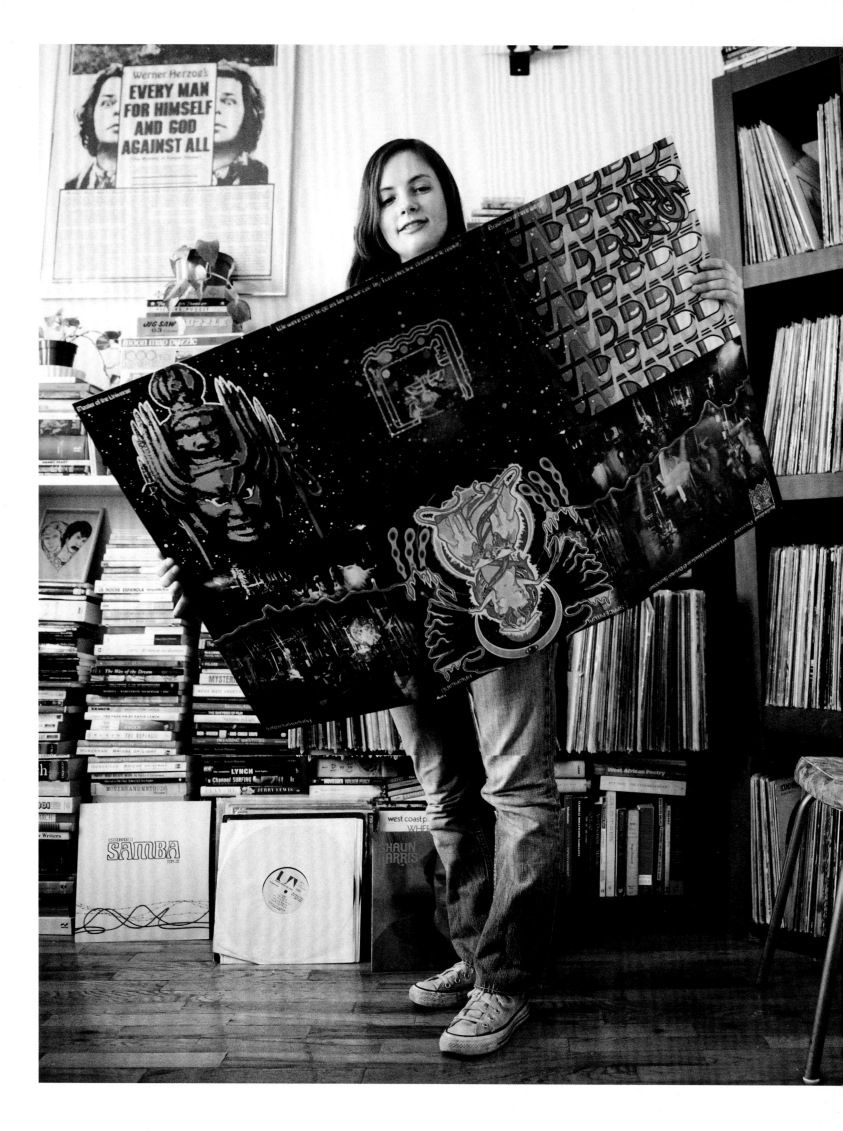

"SOME OF THE PACKAGING FROM THE '70s IS REALLY OUT THERE. THE HIPPIES GOT INDULGENT. HAWKWIND'S GIANT FOLDOUT COVER FOR *SPACERITUAL* IS SOMETHING ELSE—IT'S

THE PERFECT ARTWORK FOR A PINNACLE SPACE-ROCK ALBUM!"

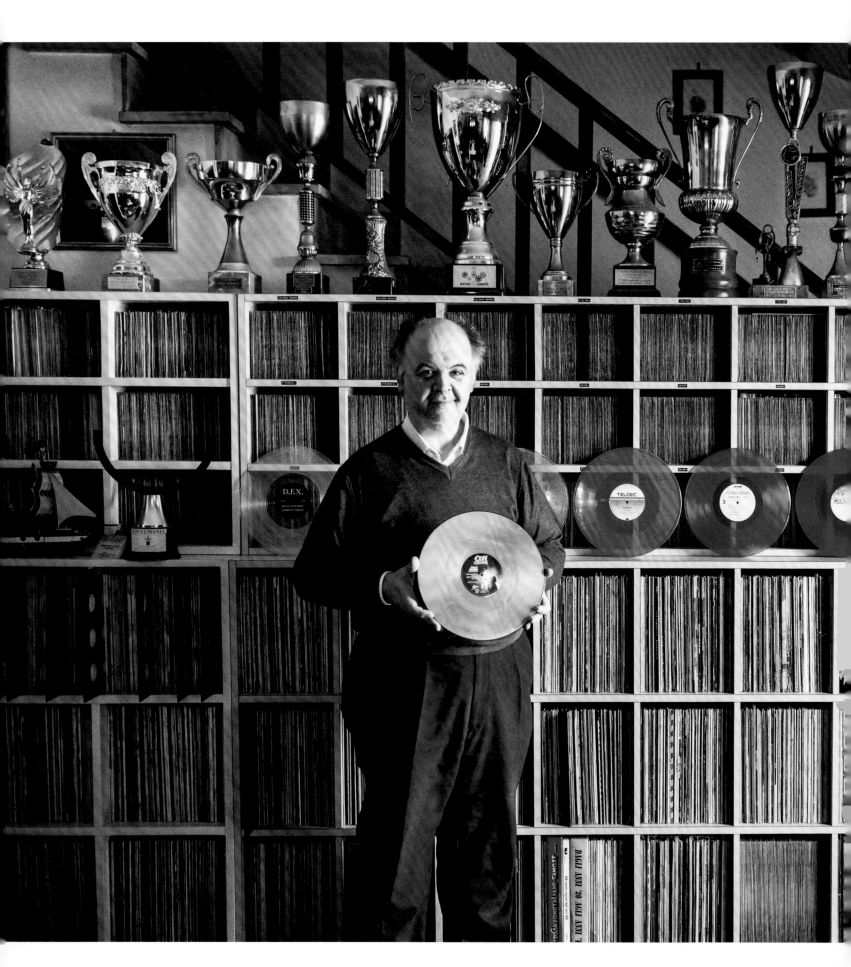

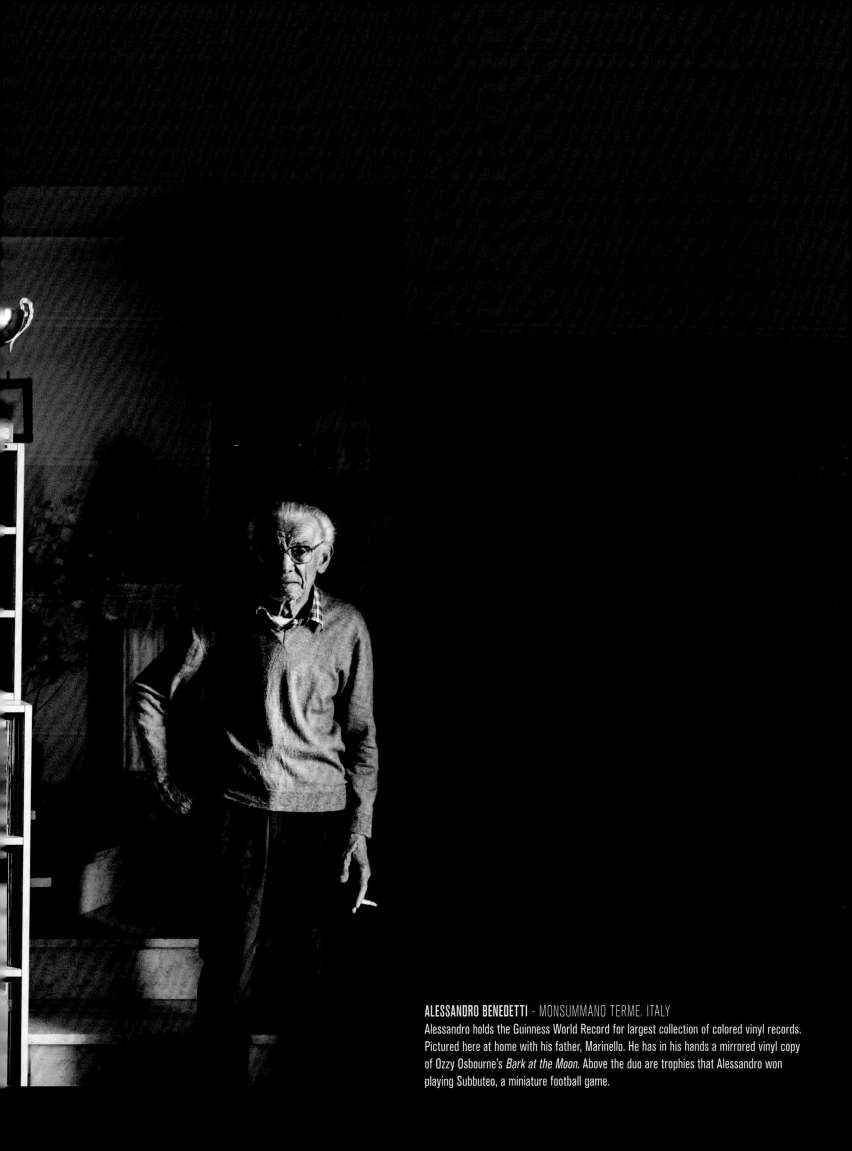

ALESSANDRO BENEDETTI - MONSUMMANO TERME. ITALY
Alessandro holds the Guinness World Record for largest collection of colored vinyl records.
Pictured here at home with his father, Marinello. He has in his hands a mirrored vinyl copy
of Ozzy Osbourne's *Bark at the Moon*. Above the duo are trophies that Alessandro won
playing Subbuteo, a miniature football game.

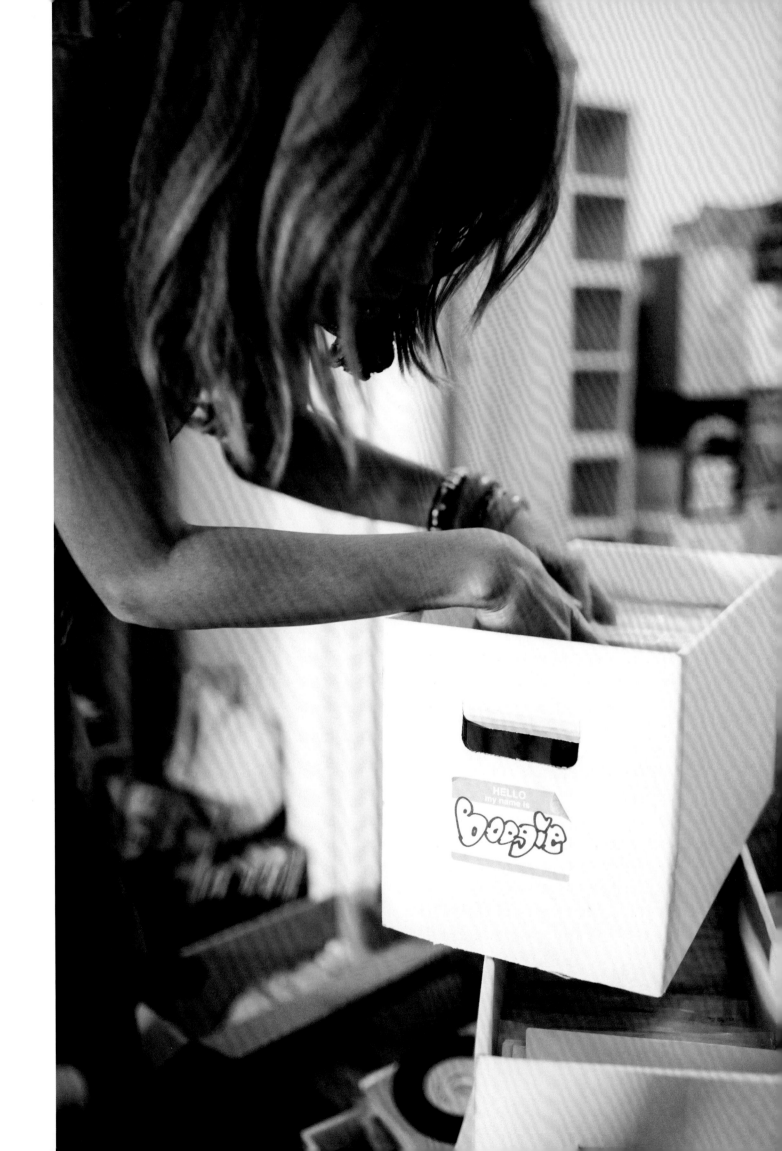

"THAT'S WHAT'S SO BEAUTIFUL ABOUT MUSIC. THERE IS SOMETHING FOR EVERY MOOD, THERE'S A SONG FOR ANY EMOTION. YOU CAN FEEL LIKE THE ARTIST IS SPEAKING TO YOU THROUGH EACH SONG."

NATASHA DIGGS - BROOKLYN, NY

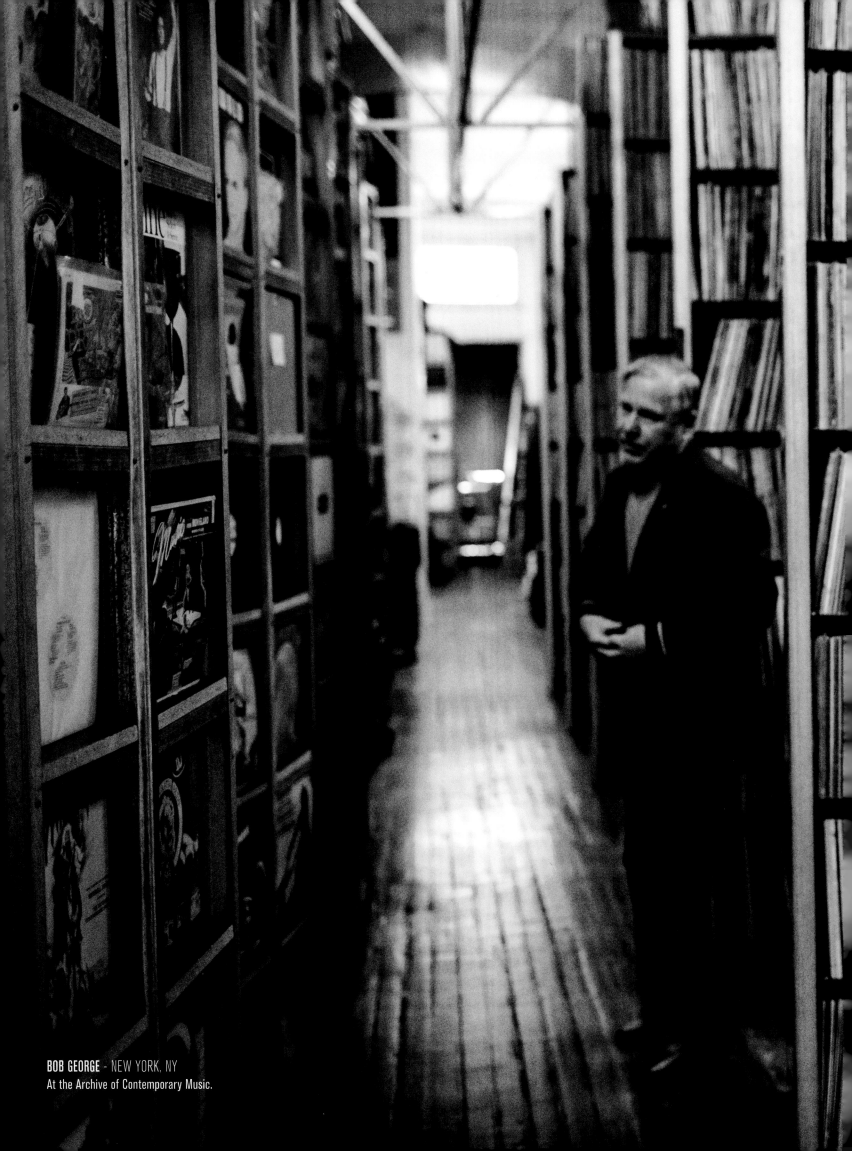

BOB GEORGE - NEW YORK, NY
At the Archive of Contemporary Music.

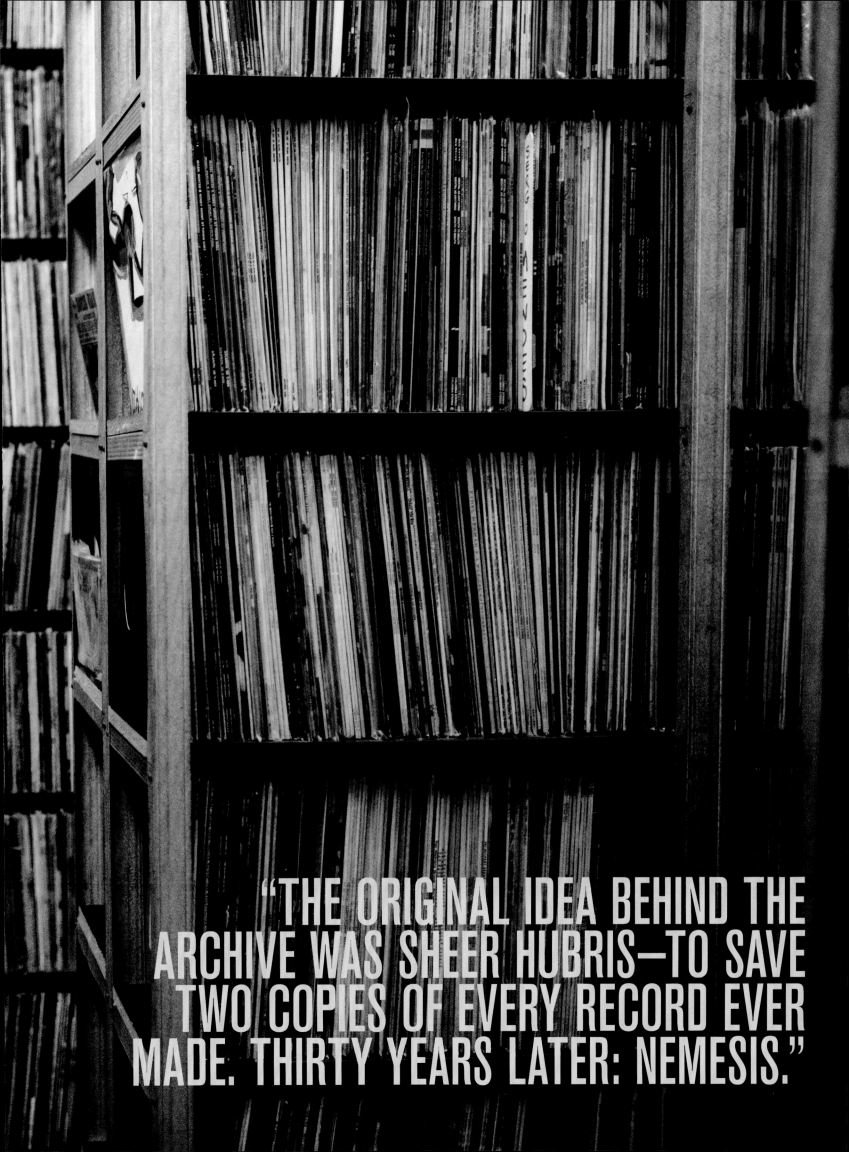

"THE ORIGINAL IDEA BEHIND THE ARCHIVE WAS SHEER HUBRIS—TO SAVE TWO COPIES OF EVERY RECORD EVER MADE. THIRTY YEARS LATER: NEMESIS."

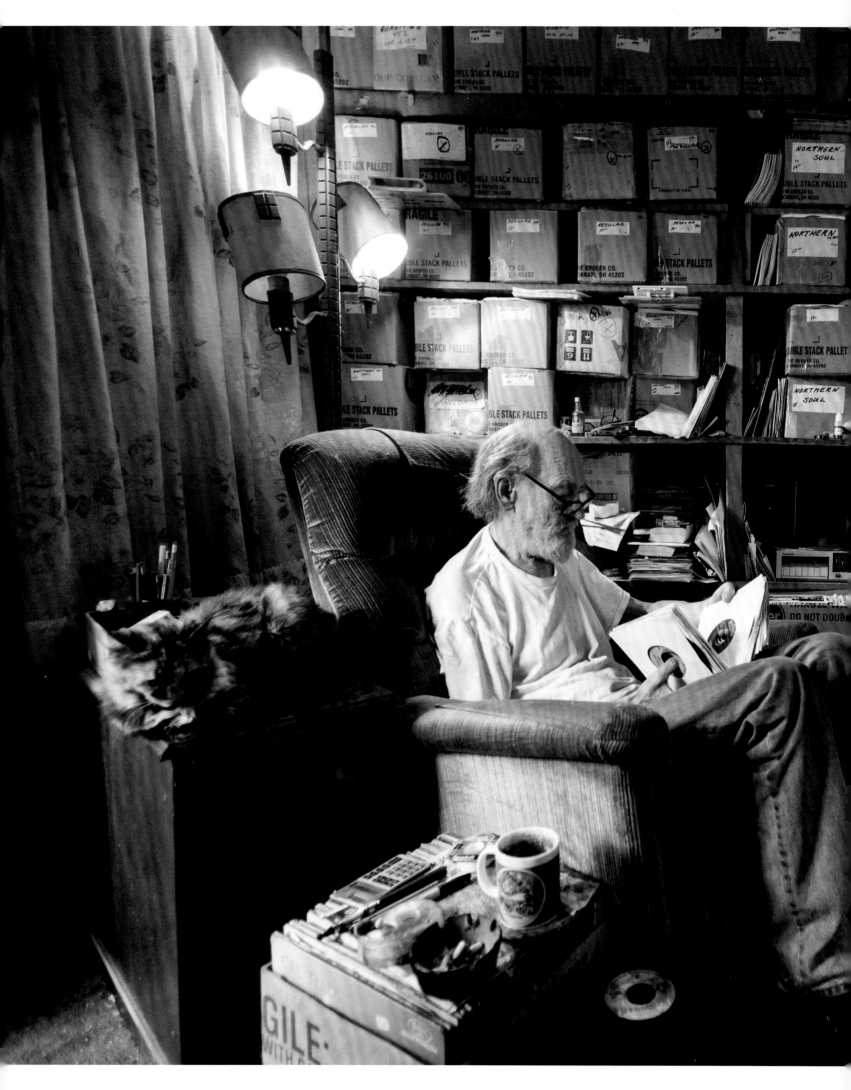

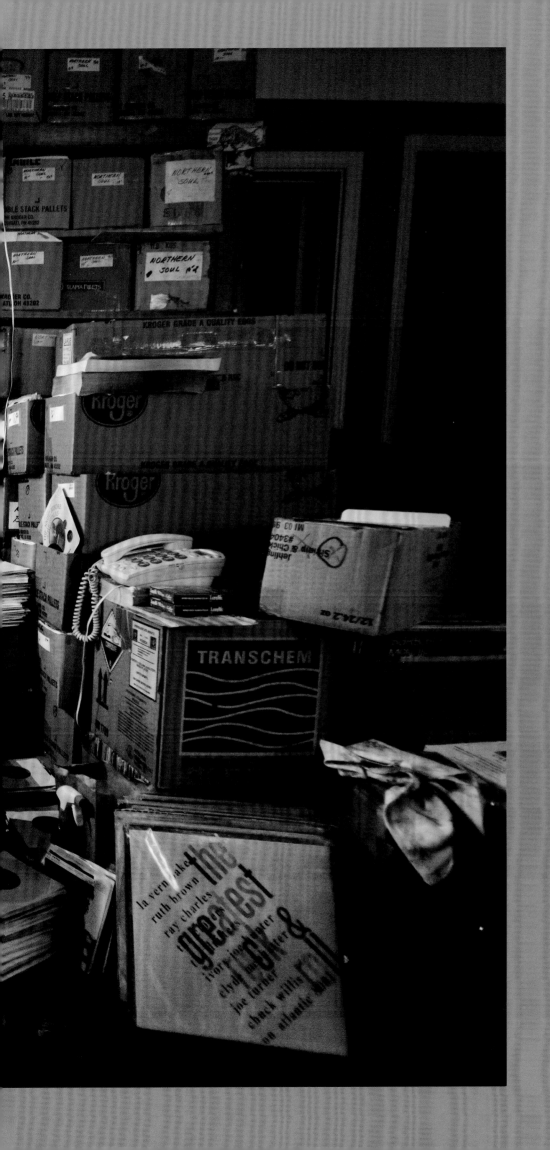

BOB MAYS - DETROIT, MI
The legendary record dealer at home rifling
through his favorite hillbilly 7-inches.

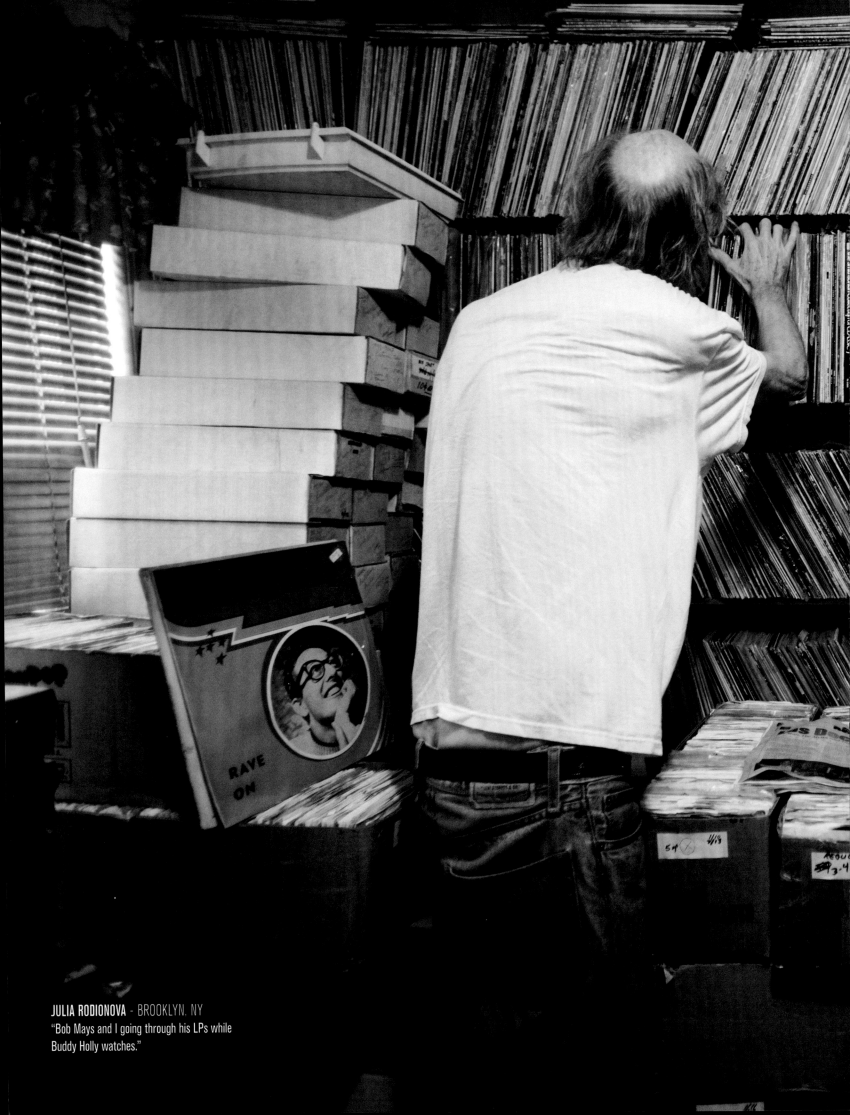

JULIA RODIONOVA - BROOKLYN, NY
"Bob Mays and I going through his LPs while
Buddy Holly watches."

DB BURKEMAN - BROOKLYN, NY
Steve Stoll - "Saw-blade"
"In the early '90s, while we were running a label called Sm:)e Communications,
we became obsessed with not simply putting out the best dance music but finding
ways to make our records visually stand out. This one was definitely cutting-edge!"

"A MAGIC DISC THAT, AS WELL AS LOOKING GREAT, MAKES A NOISE AND IS OFTEN CONTAINED WITHIN A BOOK FULL OF INFORMATION AND PICTURES. WHAT'S NOT TO LOVE ABOUT THAT?"

OLLIE TEEBA - LONDON, UNITED KINGDOM

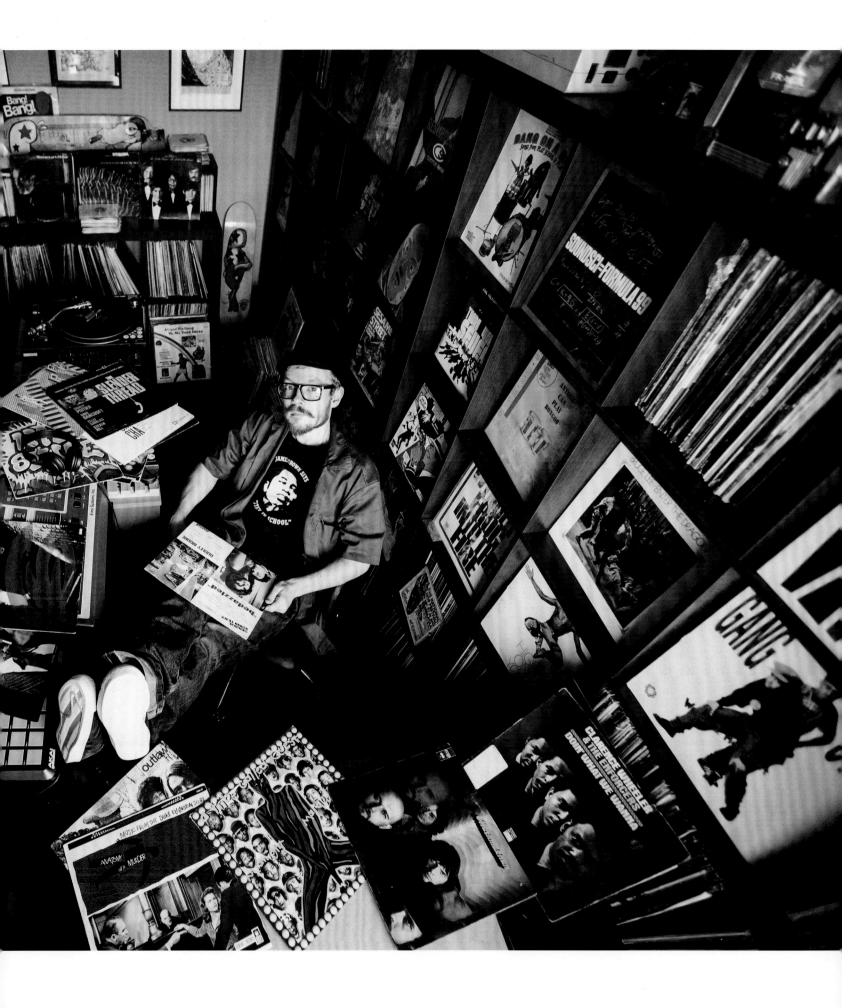

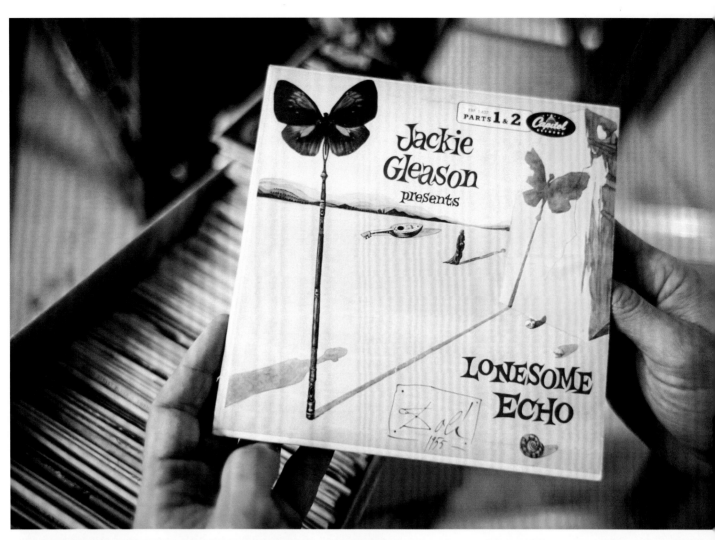

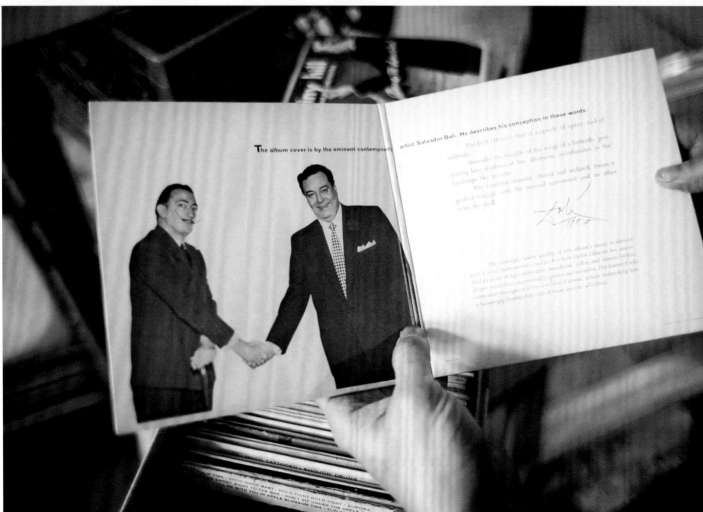

"JACKIE GLEASON'S SYRUPY
ORCHESTRAL SCHMALTZ
IS ABOUT AS
SURREAL
AS THE BREAKFAST BAGEL I EAT
EVERY DAY.

VERY NORMAL, WITH CREAM CHEESE."

MATT MIKAS - BROOKLYN, NY
Jackie Gleason - *Lonesome Echo* EP
"Jackie Gleason–a hard-drinking, pot-smoking, U.F.O. chasing wild man who was apparently
tight enough with Salvador Dalí to get him to knock out an album cover."

"GOING TO RECORD STORES IS NOT THAT ADVENTUROUS ANYMORE. I NEED TO GET OUT THERE IN THE WILD."

ANDY NOBLE - MILWAUKEE, WI
Pharoah Sanders - *Karma*
"This is one of the albums that started it all for me. My parents had a copy, and I remember hearing it while my mom made dinner. Comfort sounds for me to this day."

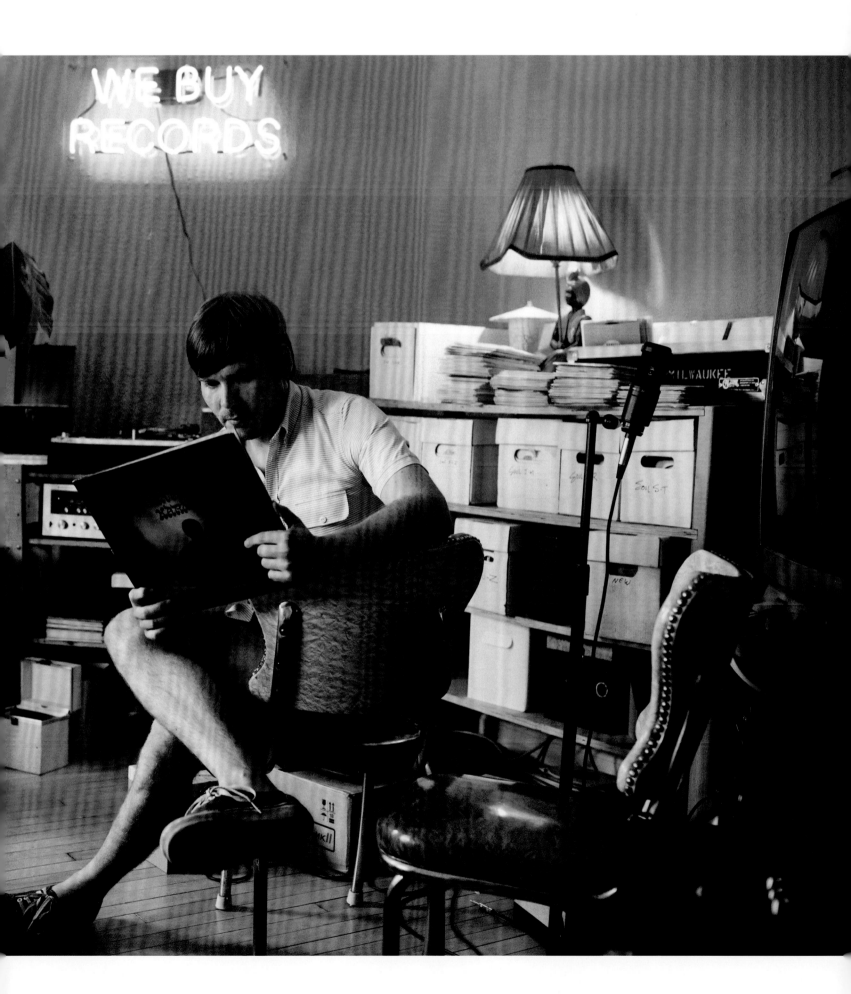

JOEY ALTRUDA - LOS ANGELES, CA
"Thumbing through a stack of bebop 78s in my Los Angeles living room. On the coffee table is an assortment of record cover art by David Stone Martin. On the sofa are LPs autographed by Mongo Santamaria, Israel 'Cachao' Lopez, and Horace Silver."

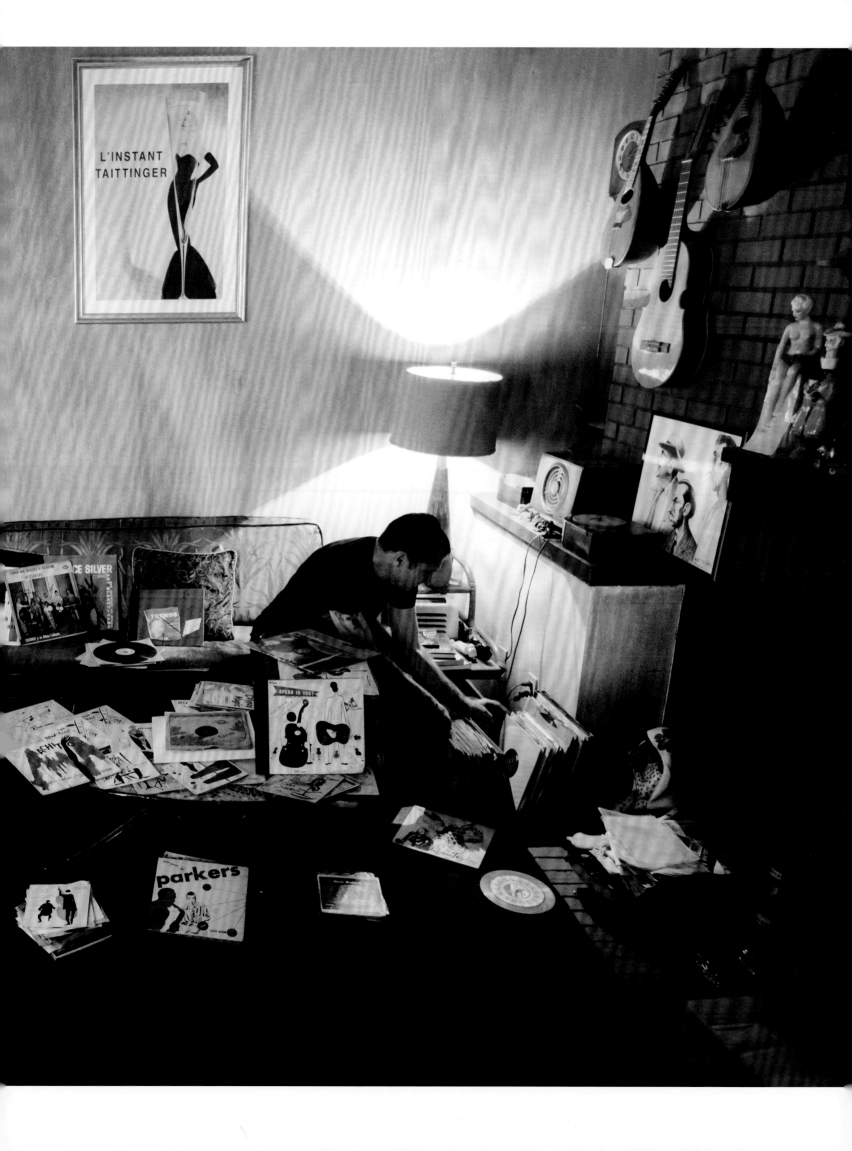

MUSTAFA ANAZ - ISTANBUL, TURKEY
Yildiray Çinar - "Benim Gibi Bu Dünyaya" b/w "Komşunun Kızı"
Mustafa is a former truck driver who lives in a quiet suburb. You would never guess that he houses an extraordinary collection of rare Turkish psychedelic rock records in his basement apartment.

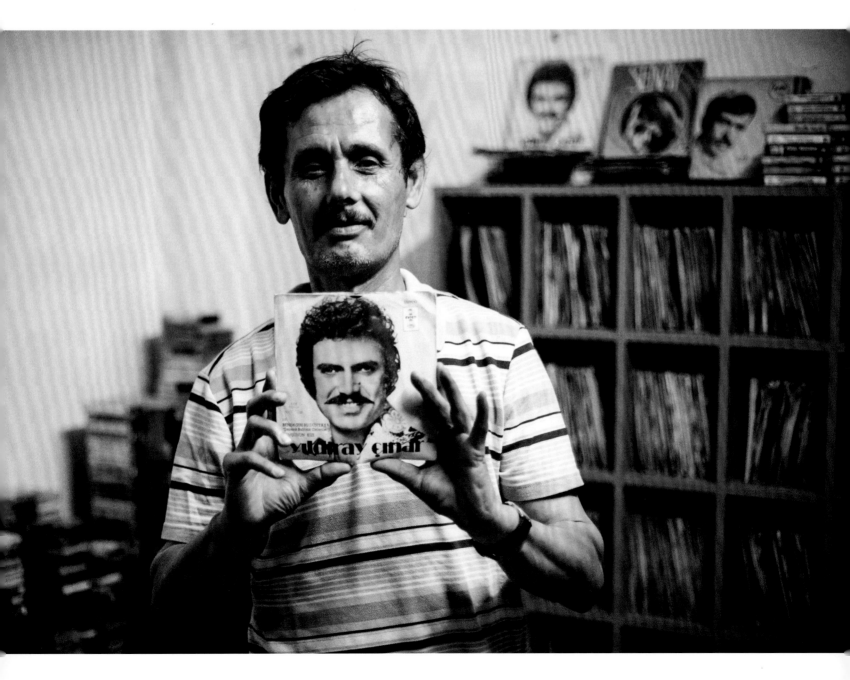

JONNY TRUNK - LONDON, UNITED KINGDOM
Music to Massage Your Mate By
"This 1970s instructional LP may not look dark, but it is. It comes complete with a booklet full of explicit photos of the sleazy man on the cover handling various front parts of the woman he's sitting on. Incidentally, I think the sleazy shorts/vest/mustache look is back in. It certainly is in Dalston."

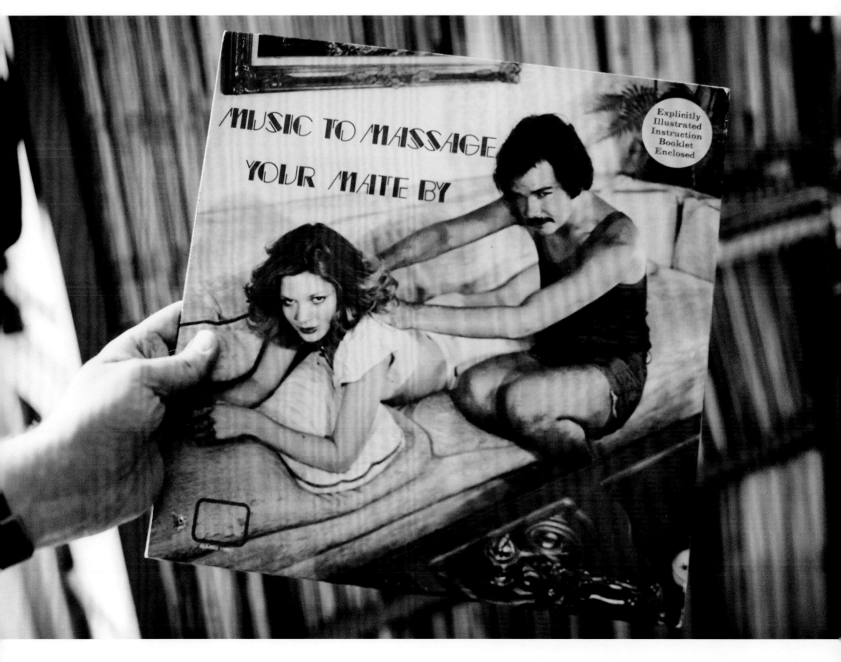

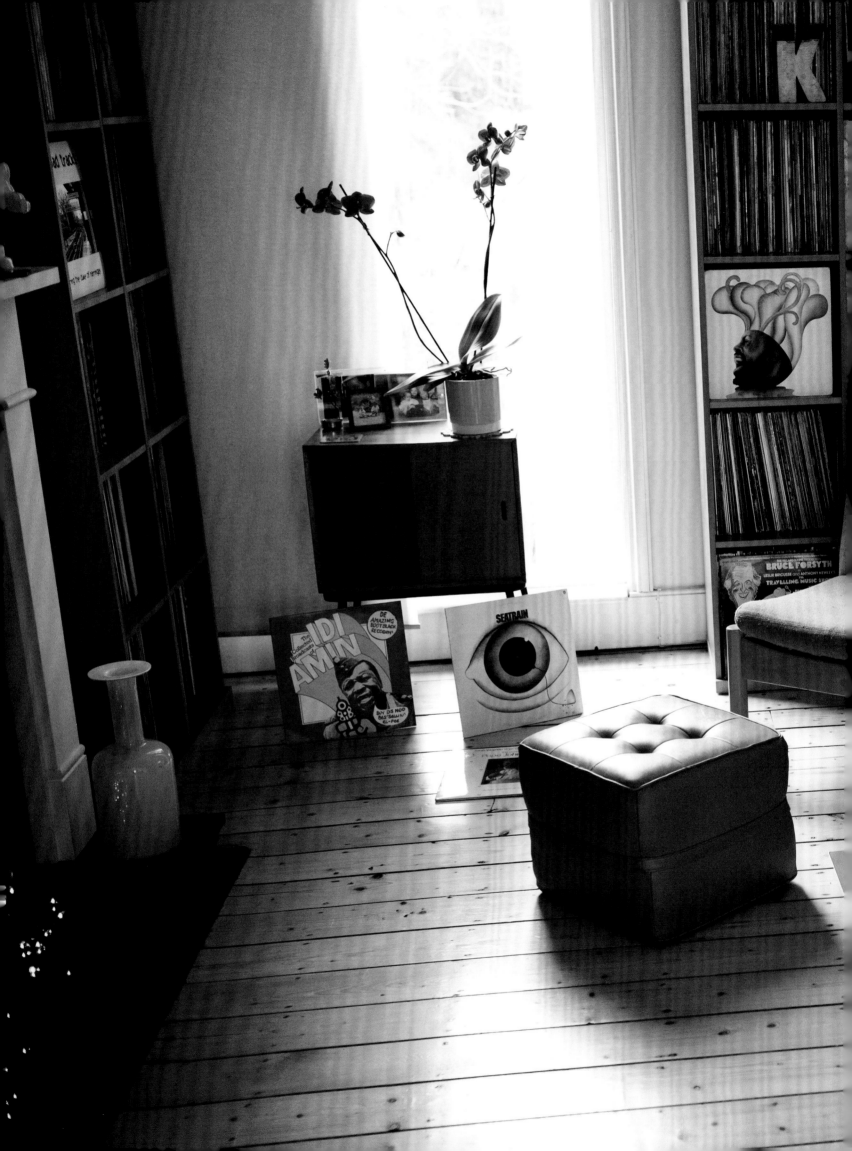

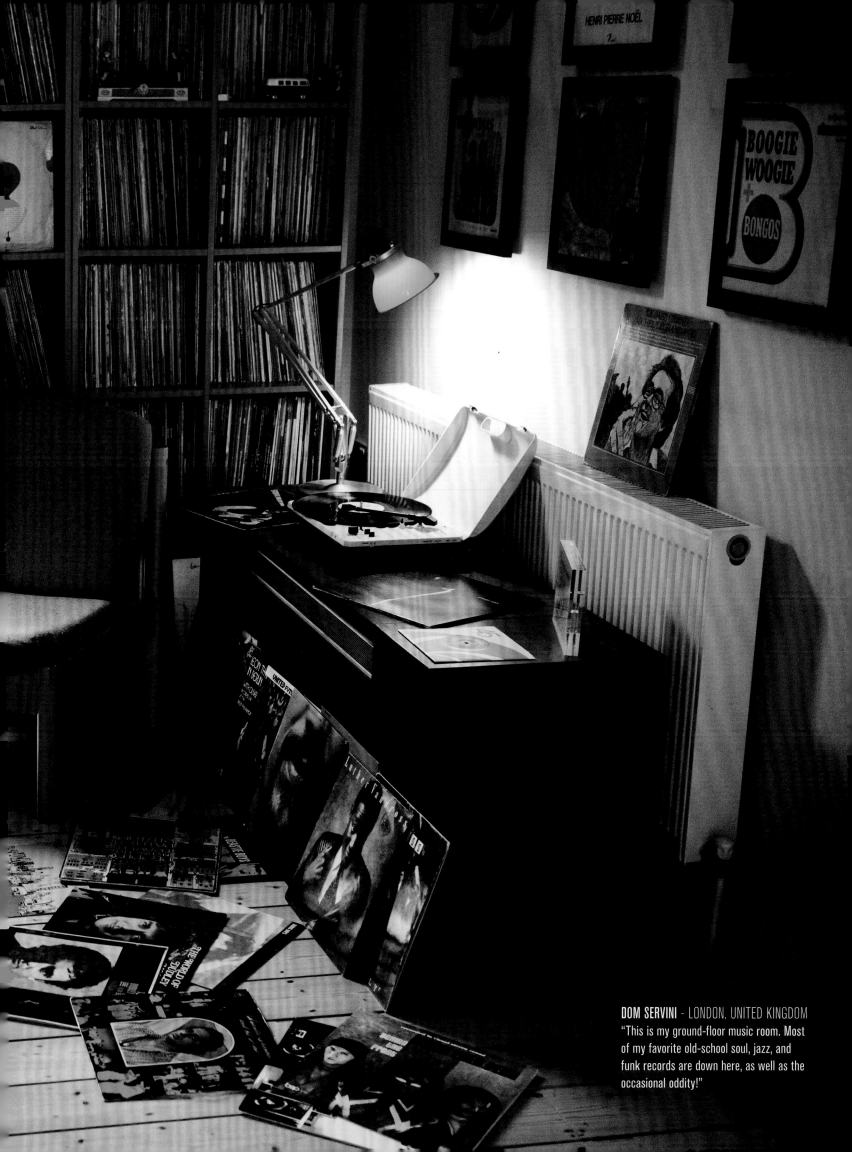

DOM SERVINI - LONDON, UNITED KINGDOM
"This is my ground-floor music room. Most of my favorite old-school soul, jazz, and funk records are down here, as well as the occasional oddity!"

JAY MALLS - PITTSBURGH, PA
Capitol Disc Jockey 1969, Volumes 1 (January) through 12 (December)
"These are all the puzzle pieces of the *Capitol Disc Jockey 1969* compilation series. They were released each month and formed this big picture. I've been picking them up for at least fifteen years now, and I finally got the last one that I needed in 2013."

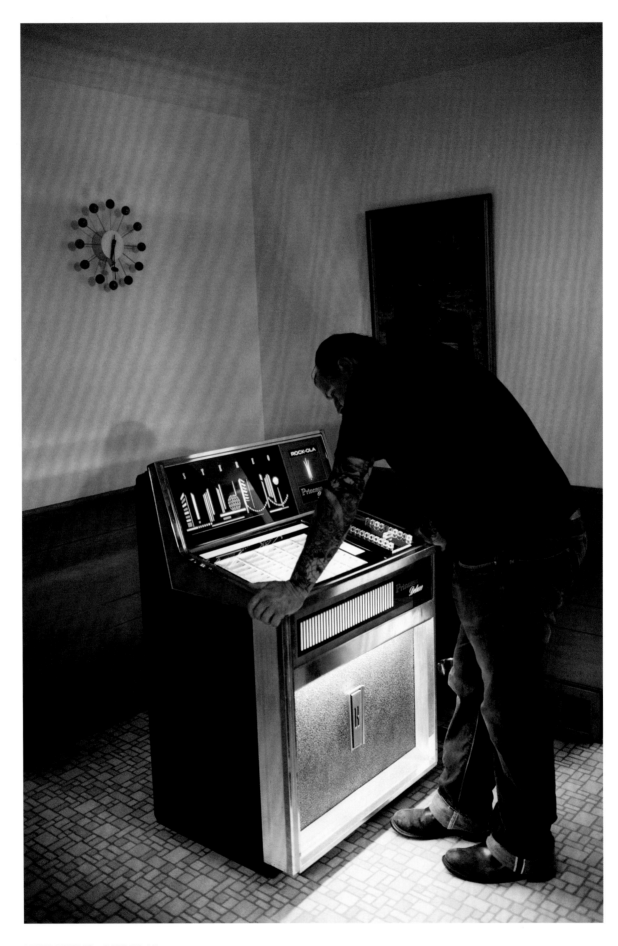

LONEY CHARLES - DETROIT, MI
"A 1967 Rock-Ola Princess Deluxe jukebox in my kitchen and a record rack in my
basement. Lots of miles and hunting for vinyl gold!"

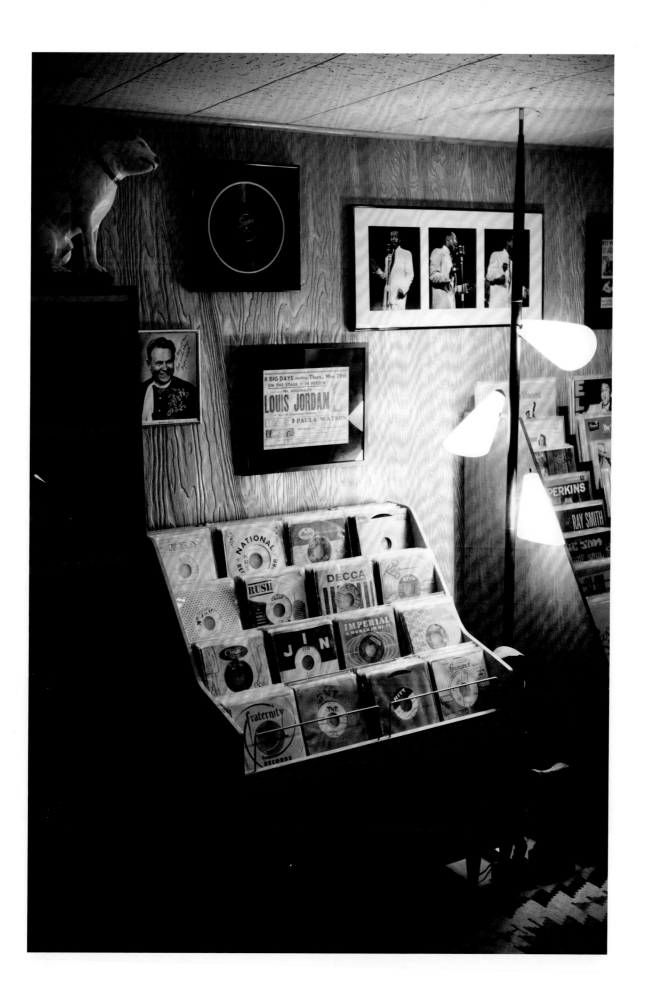

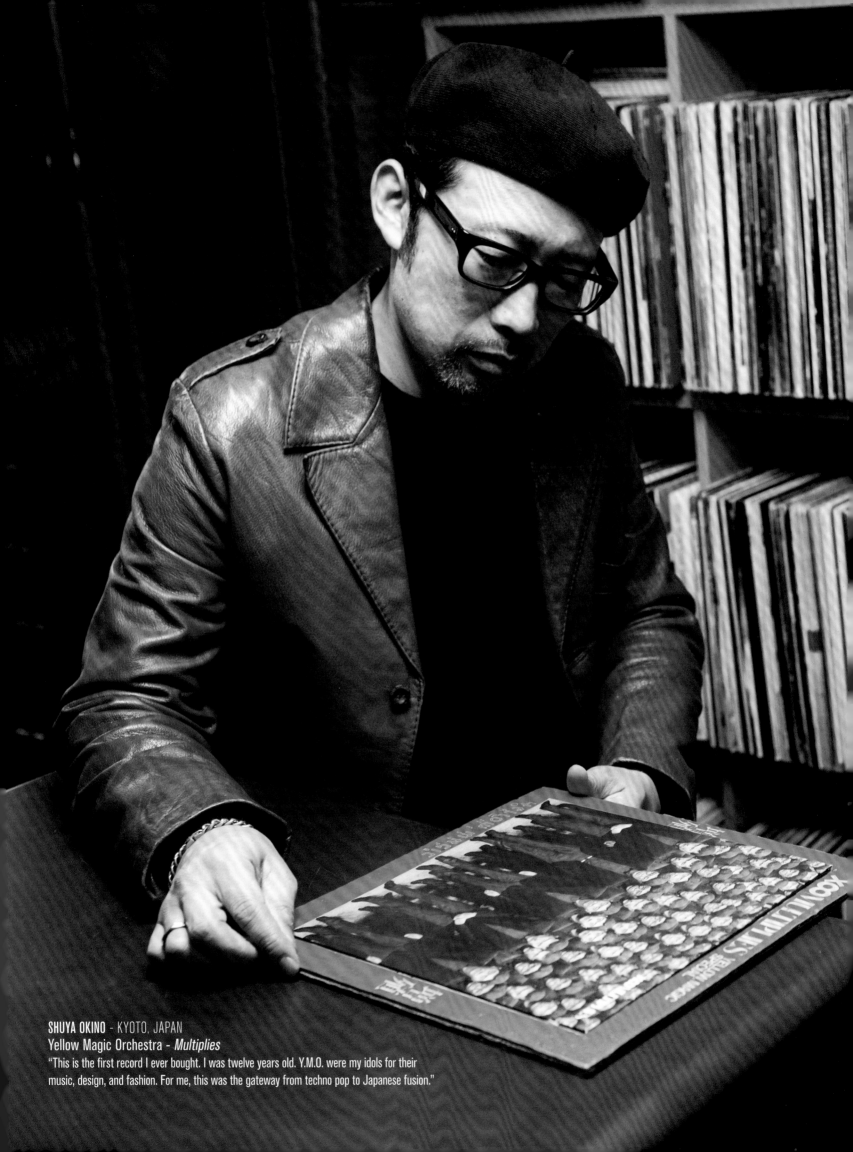

SHUYA OKINO - KYOTO, JAPAN
Yellow Magic Orchestra - *Multiplies*
"This is the first record I ever bought. I was twelve years old. Y.M.O. were my idols for their music, design, and fashion. For me, this was the gateway from techno pop to Japanese fusion."

MATT MIKAS - BROOKLYN, NY
Dick Hyman - *The Man From O.R.G.A.N.*
"Dick Hyman, the organ king of Command Records, is best known for his Moogy breakbeats, but he can also toss out some laid-back, funky soul. Like Roger Moore filling Sean Connery's shoes as Bond, this sixties spy-jazz record is campy and fun with just enough elegance and polish to make it all work."

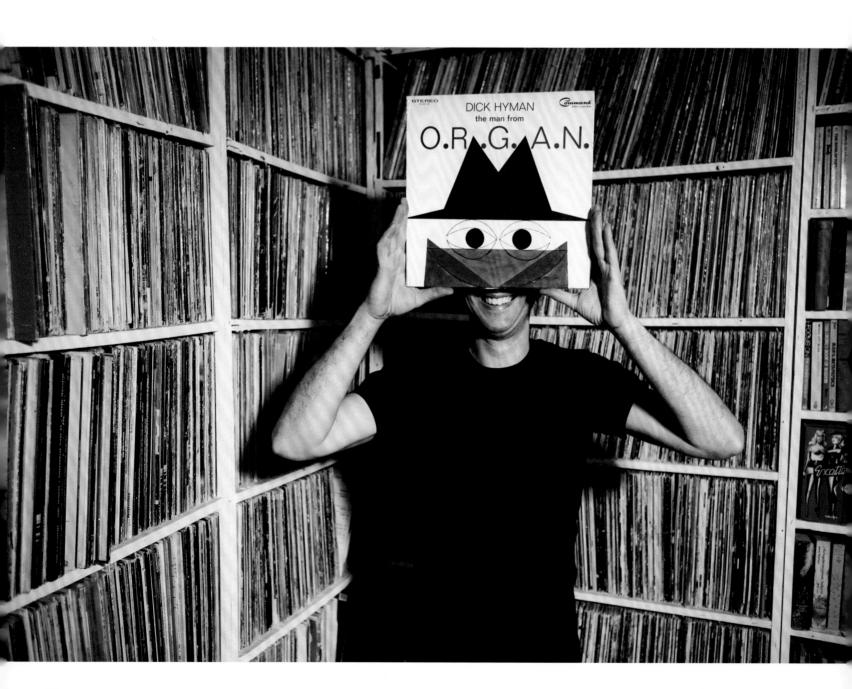

SCOTT BARRETTA - OXFORD, MS
Various Artists - *Please Warm My Weiner (Old Time Hokum Blues)*
"This is a 1974 compilation on Yazoo Records of 'hokum' blues (songs rife with double entendres) from the late 1920s and early '30s. The cover's cheeky, politically incorrect art was done by illustrator and 78 collector R. Crumb. With its bawdy title and minstrel-like images, this record could be seen as a thumb in the face of the overly serious social and political analysis of the blues typically found on other reissues."

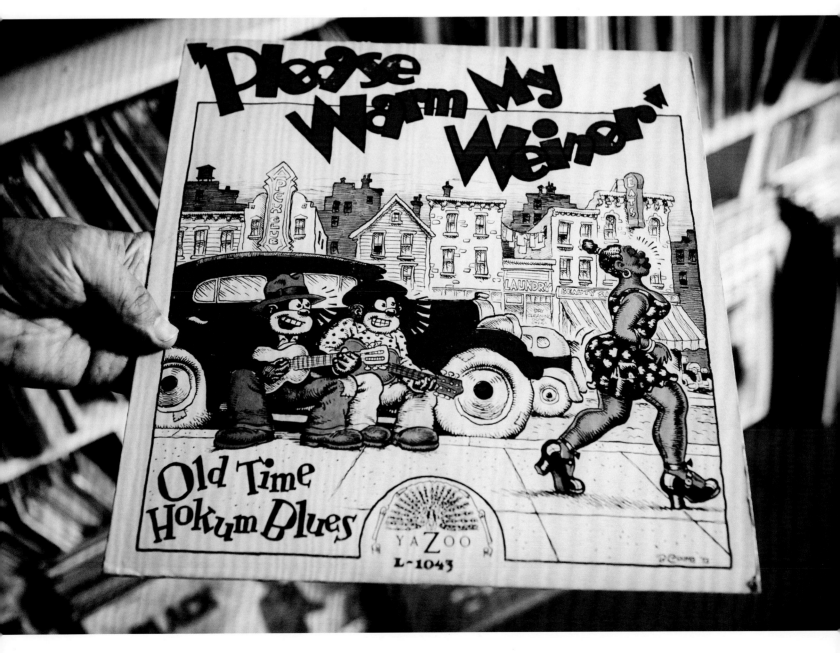

COSMO BAKER - BROOKLYN, NY

"My collection is so disorganized right now, it's terrible. But usually it's split into two sections: 'hip-hop' and 'not hip-hop.'"

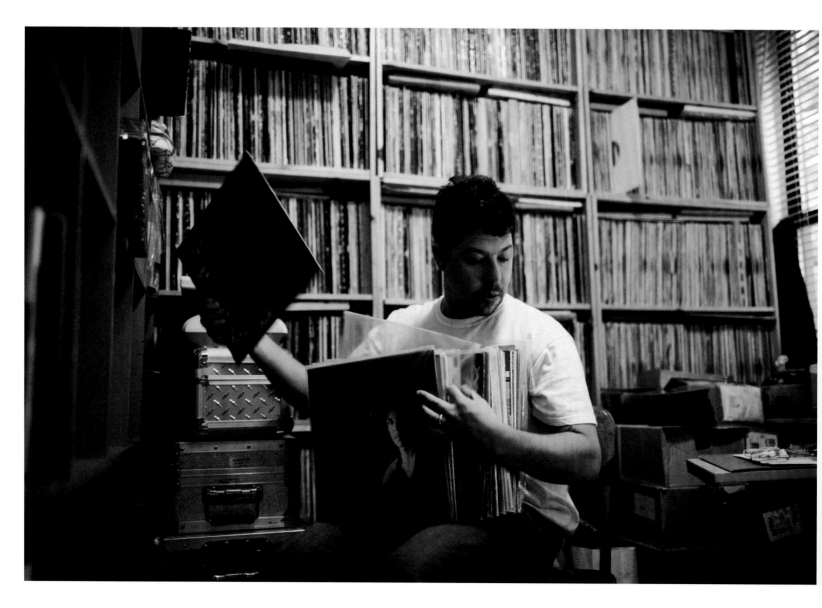

MELISSA "SOUL SISTER" WEBER - NEW ORLEANS, LA
"Early records I had influenced my love of funk. When I was very small, my dad took me to a record store and said, 'What do you want?' I said, 'I want "Oops Upside Your Head."' He and his friend laughed for days."

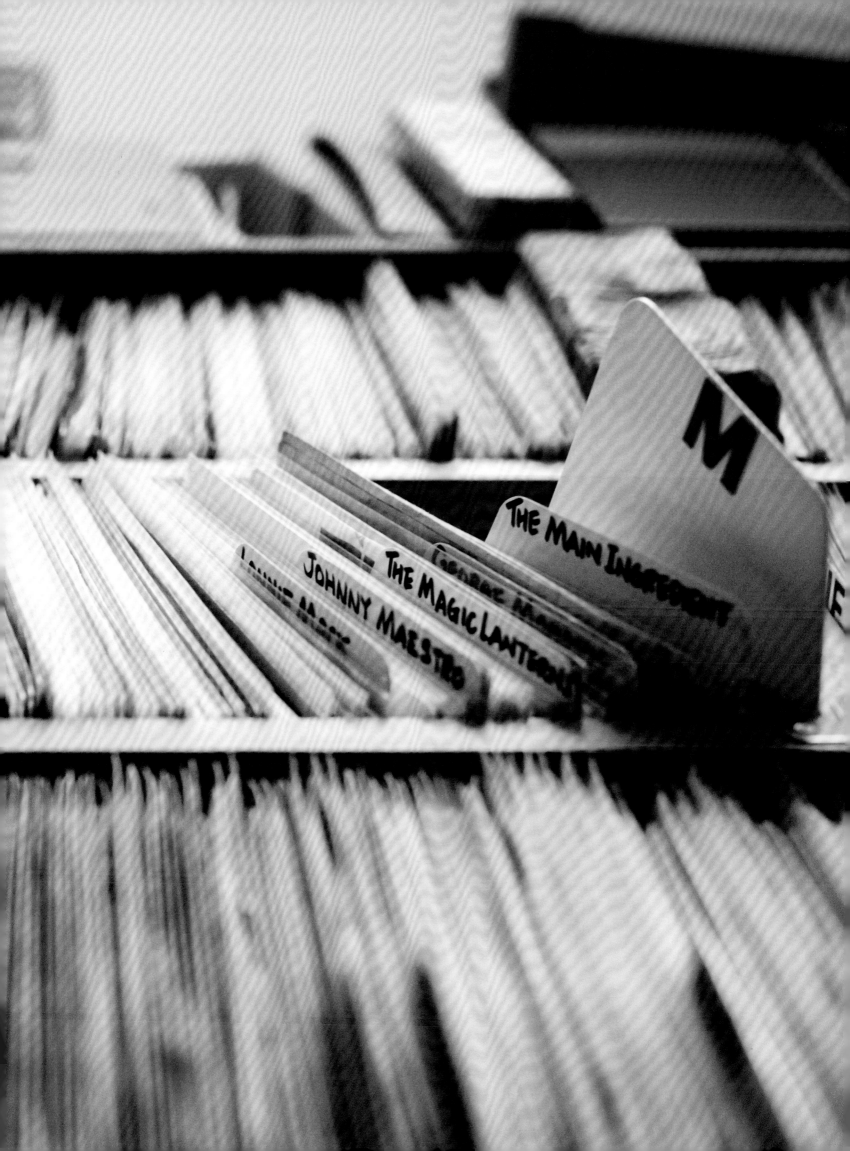

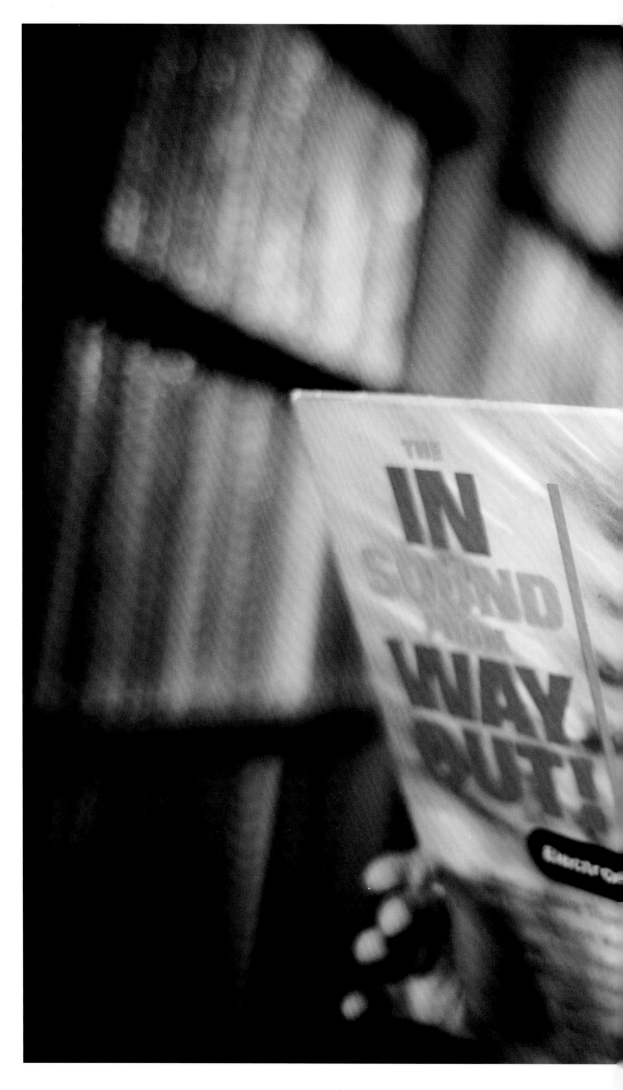

PAT. JAMES LONGO - JERSEY CITY, NJ
Perrey-Kingsley - *The In Sound from Way Out!*
"This is my son, Hank, with his first favorite record. The grooves on *The In Sound from Way Out!* have shaped his listening to this day. He can usually be found reading with the electronic sounds of video game soundtracks leaking from his headphones."

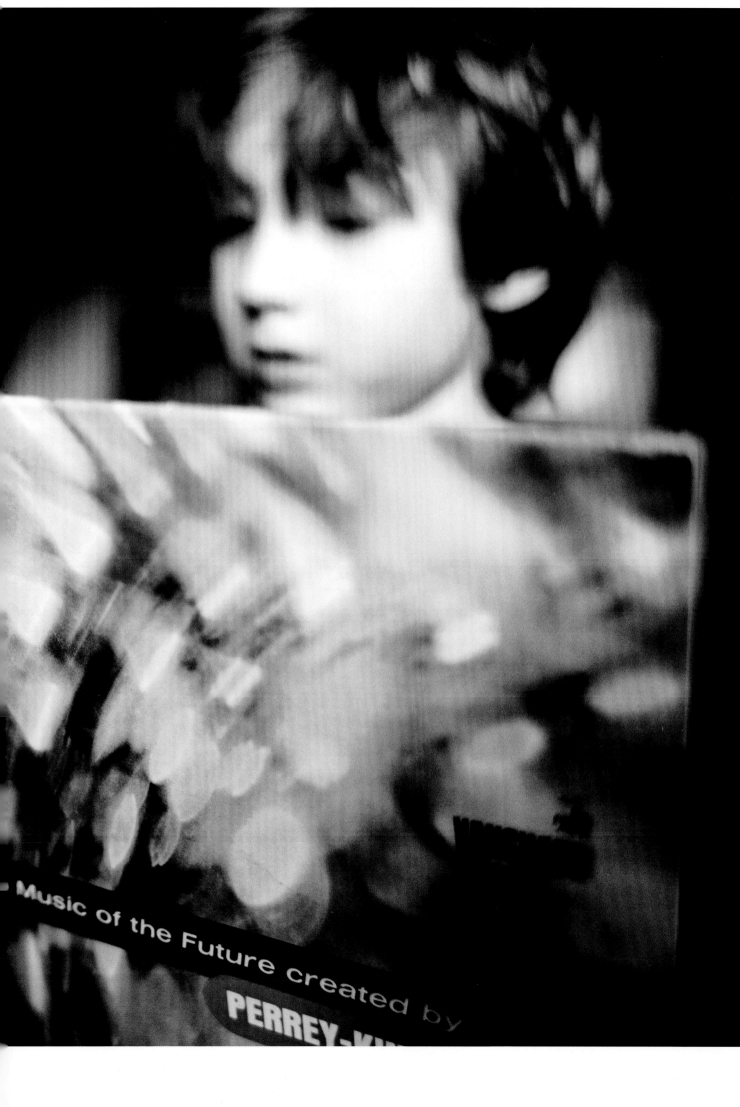

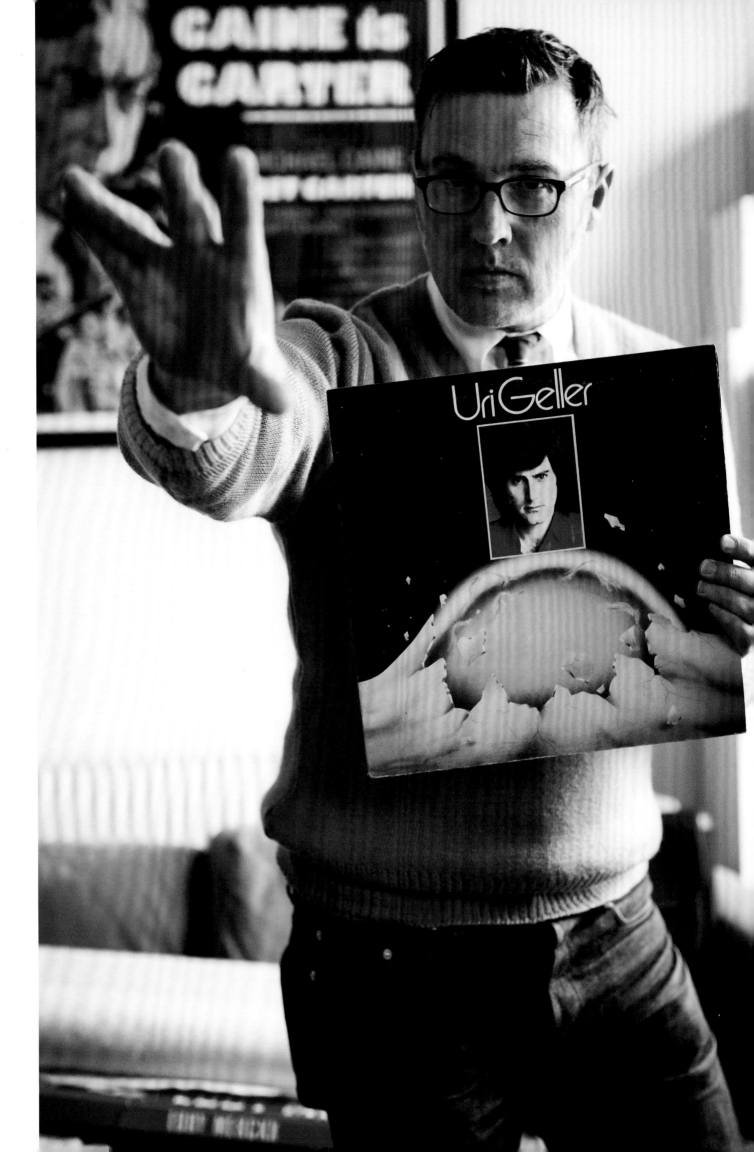

"JUST WHEN YOU THINK YOU'VE FOUND A REALLY STRANGE ALBUM, AN EVEN WEIRDER ONE IS JUST AROUND THE CORNER."

JONNY TRUNK - LONDON, UNITED KINGDOM
Uri Geller - *Self-titled*
"A terrifying journey into Uri Geller's huge ego."

BEN BLACKWELL - NASHVILLE, TN
The Velvet Underground - "Sunday Morning"
"I had this record custom-made in order to propose to my wife in a really special way.
It plays the Velvet Underground's 'Sunday Morning,' and then I added a recording of my
voice saying, 'Malissa, will you marry me?' in a locked groove at the end."

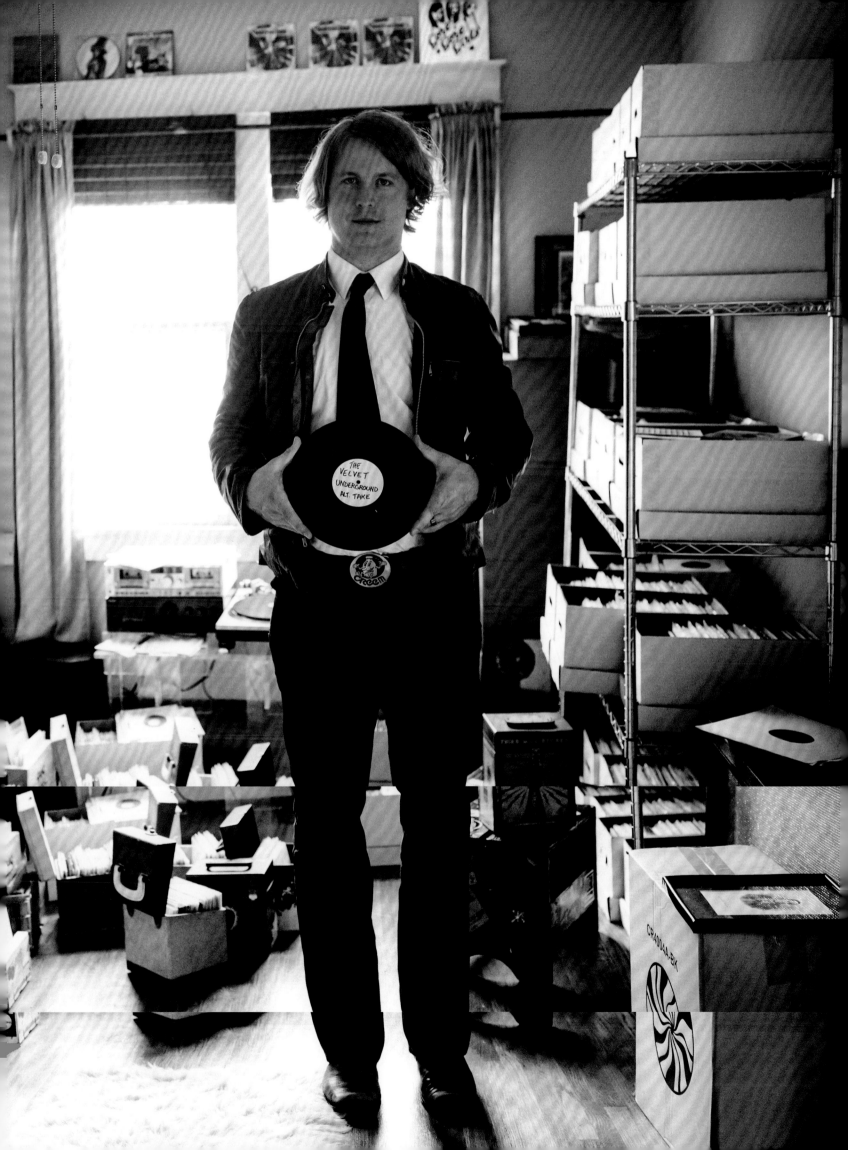

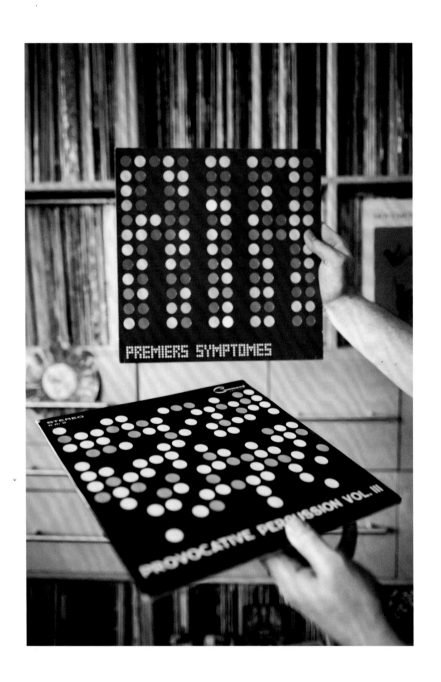

KEVIN FOAKES (DJ FOOD) - LONDON, UNITED KINGDOM
Air - *Premiers Symptômes*
Enoch Light and the Light Brigade - *Provocative Percussion Volume III*
"I collect albums on the Command label for their gorgeous abstract sleeve designs, mostly art directed by Charles E. Murphy. The Air album has holes punched in the cover that show the colors on the inner sleeve. If I could only keep one of their records, it would be this one."

"This is the 'Wall of Sound' in my home studio. The shelves were custom built and consist of nine connecting sections. Soon after I moved into the house, I realized that we'd need to get the floor reinforced to support this lot as there were cracks appearing. There are now three beams holding up the floor instead of one."

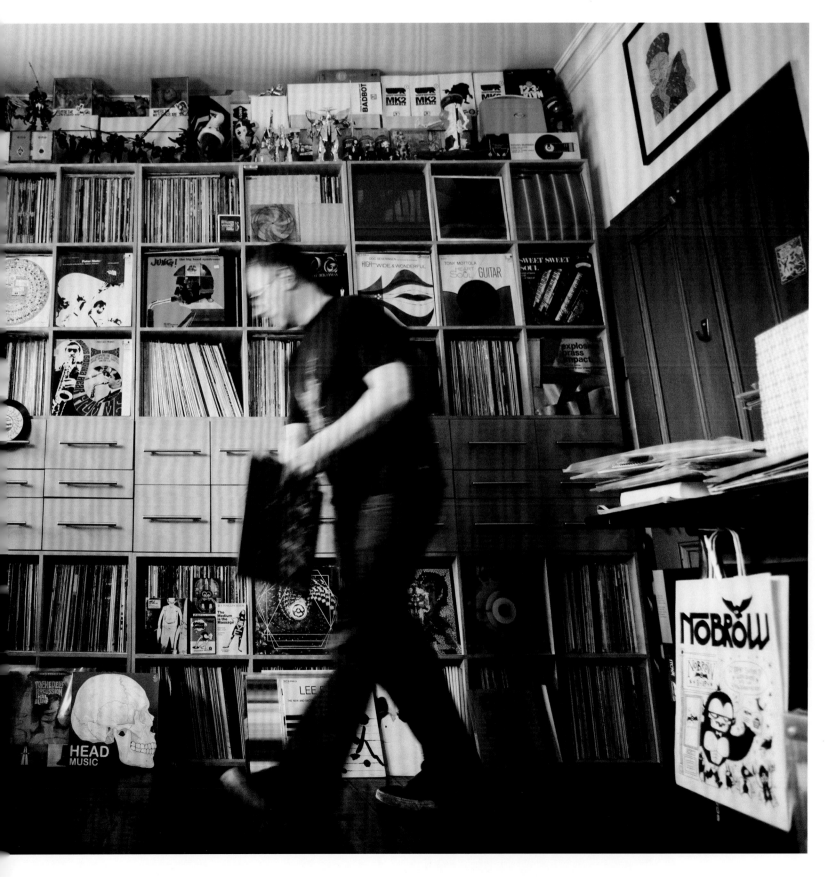

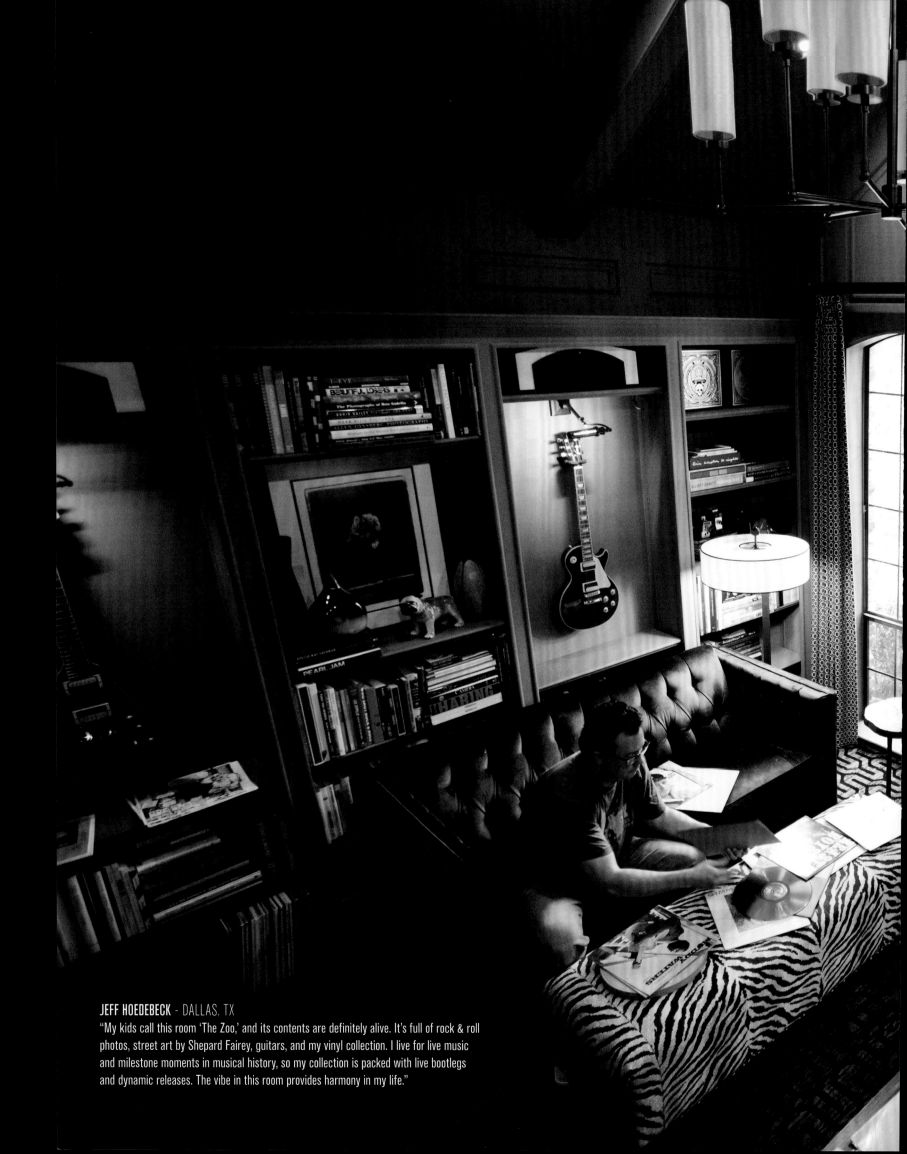

JEFF HOEDEBECK - DALLAS, TX

"My kids call this room 'The Zoo,' and its contents are definitely alive. It's full of rock & roll photos, street art by Shepard Fairey, guitars, and my vinyl collection. I live for live music and milestone moments in musical history, so my collection is packed with live bootlegs and dynamic releases. The vibe in this room provides harmony in my life."

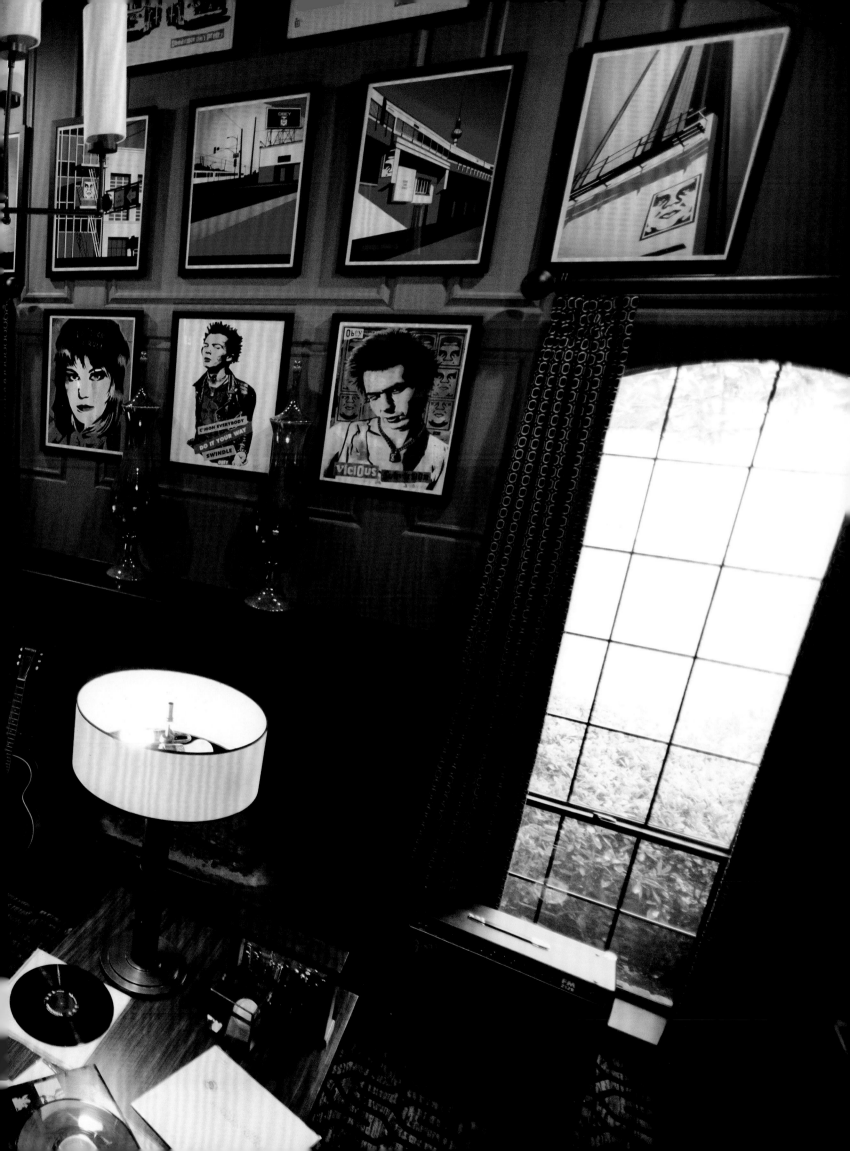

SAM SWIG & ERIC BOSICK - OAKLAND, CA
Osamu - *California Roll*
Masayoshi Takanaka - *T-Wave*
"Most of the walls in our house are lined with dollar bin albums that have particularly interesting or ridiculous cover art. An entire wall in this room is devoted to stylish Japanese guys. We know we'll never be as cool as Osamu and *T-Wave,* but that doesn't mean we're gonna stop trying."

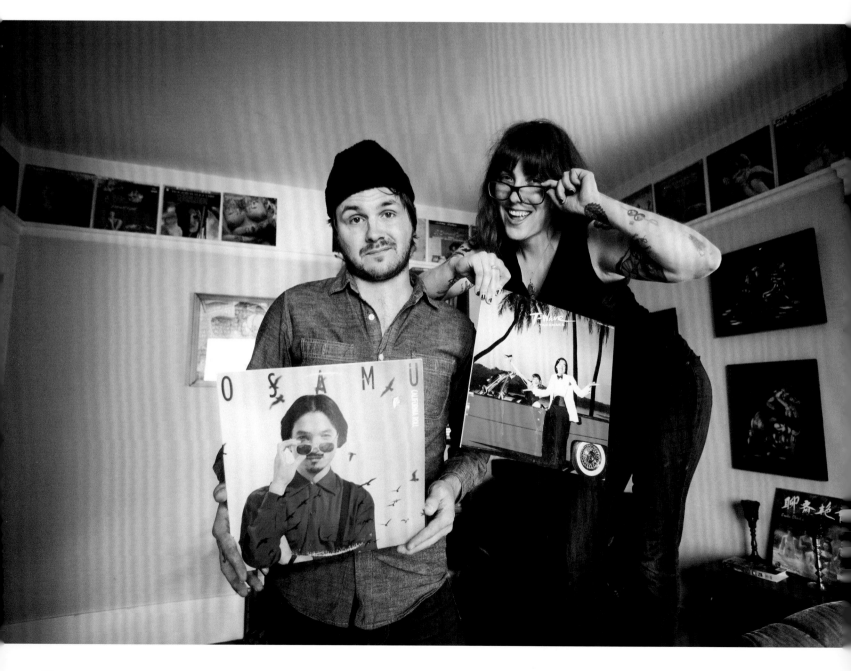

MICHAEL CUMELLA - NEW YORK, NY
Richard M. Nixon - "Nixon's the One" (card-backed flexi-disc, 1968)
"Richard Nixon must have had millions of these records directly mailed to American homes
during his 1968 presidential campaign. I would not be surprised if he air-dropped them
on Vietnam! I've heard it said that this record could have been responsible for his narrow
presidential victory. I tried to find out if that was true, but the FBI records are still sealed."

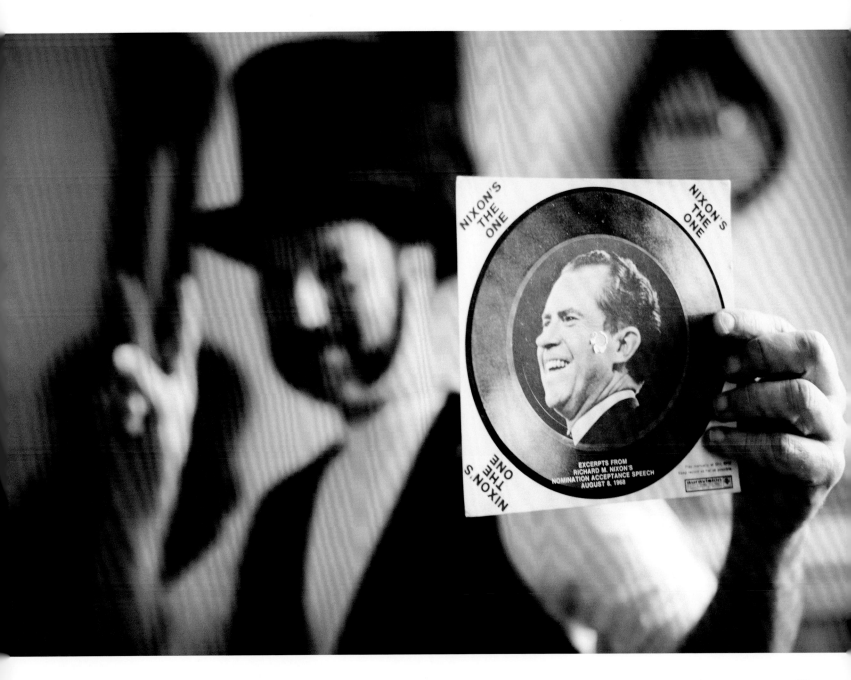

"I LIKE THE IDEA OF DESTRUCTURED ORGANIZATION; IT ALLOWS YOU TO DIG IN YOUR OWN CRATES."

MIKE CINA - MINNEAPOLIS, MN
Shigeto - *No Better Time Than Now*
"I designed the vinyl and artwork for this album. For the vinyl's unique coloring, I mixed
the solid white with the regular black and this is what happened. I felt like it was really
close to what I was doing for the actual cover, too."

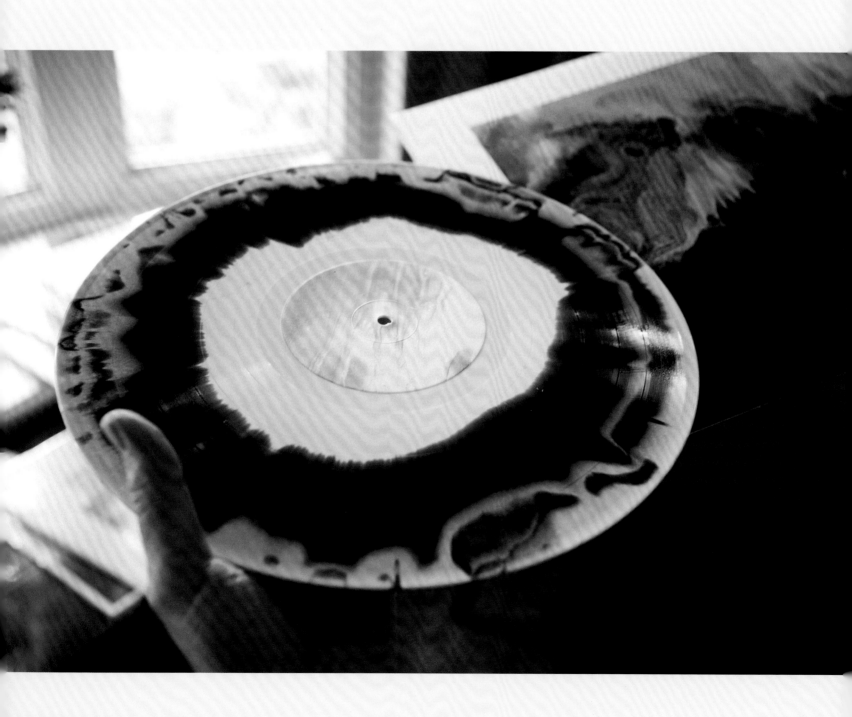

JOHAN KUGELBERG - NEW YORK, NY
Hydraulic Funk - "Wild Style"
"A dubplate from the collection of Afrika Bambaataa covered in some really epic schmutz."

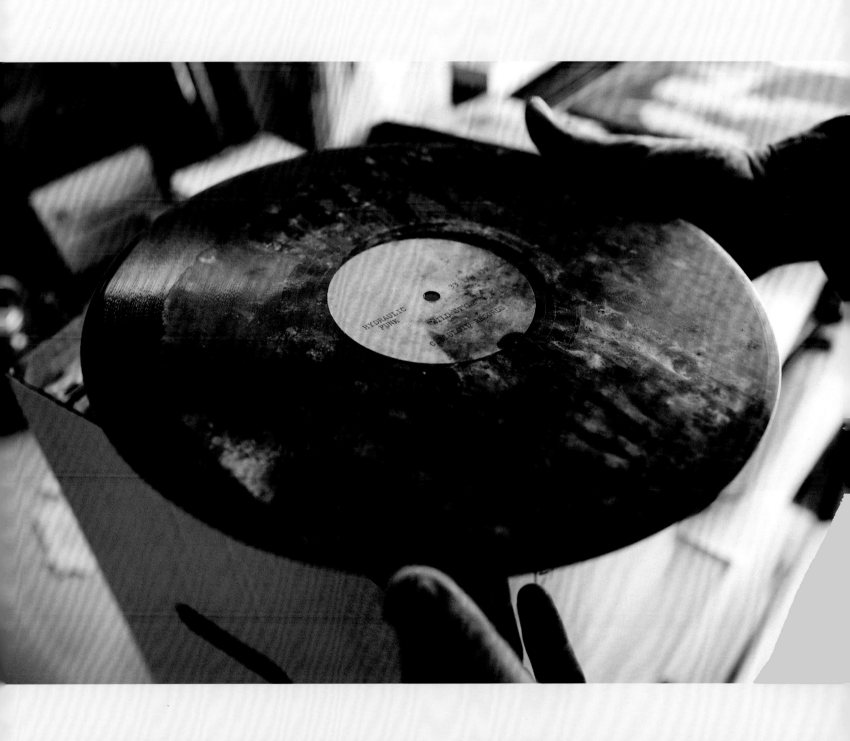

JERRY WEBER OF JERRY'S RECORDS –
PITTSBURGH, PA
Every day is casual Friday at Jerry's.

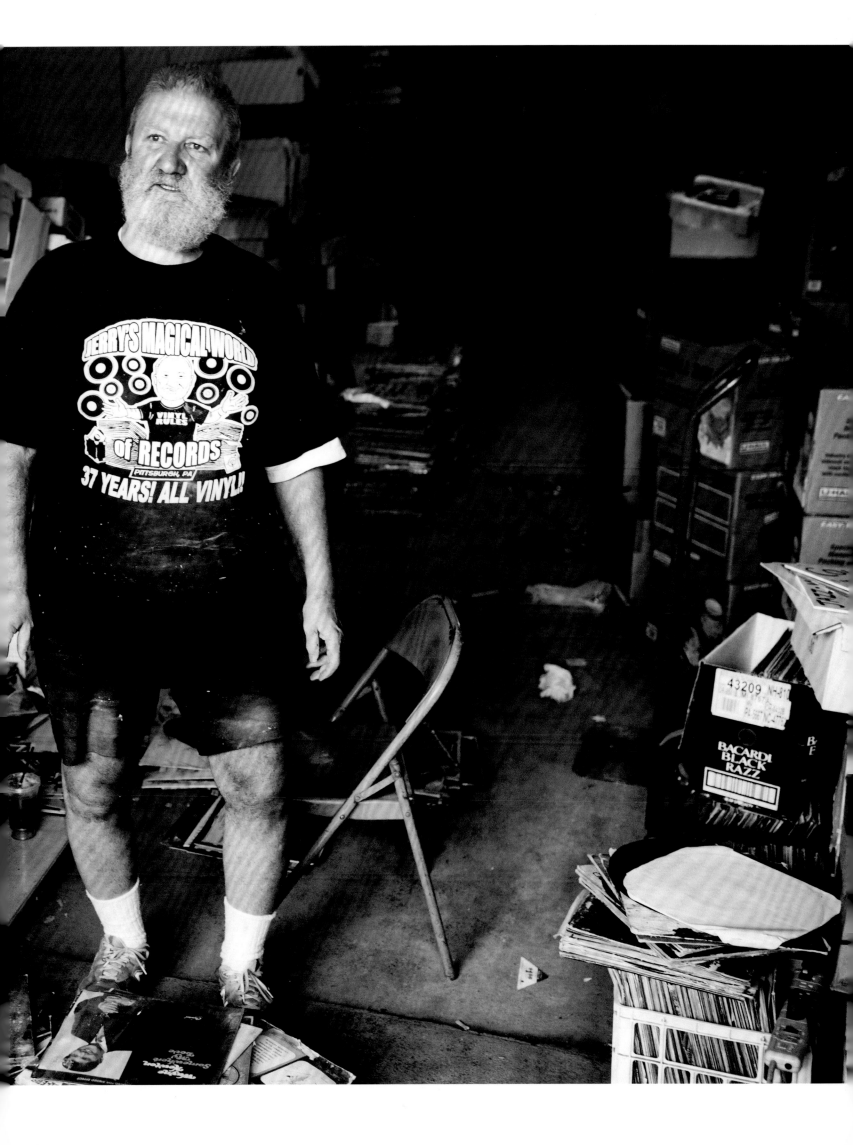

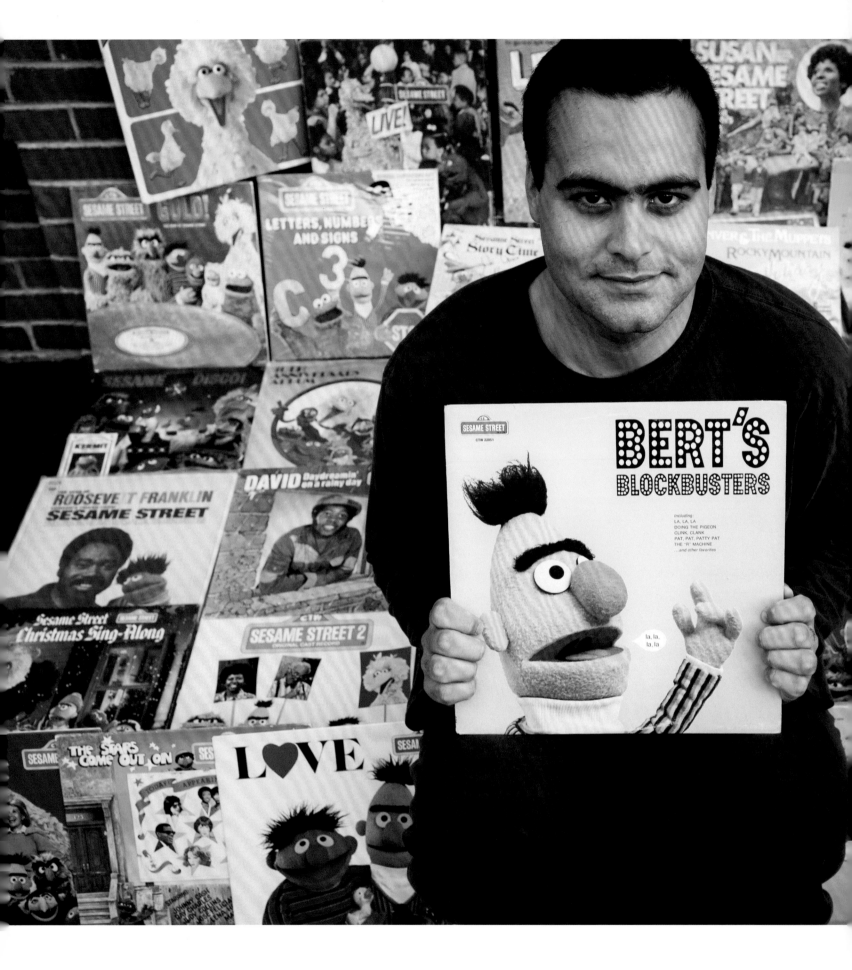

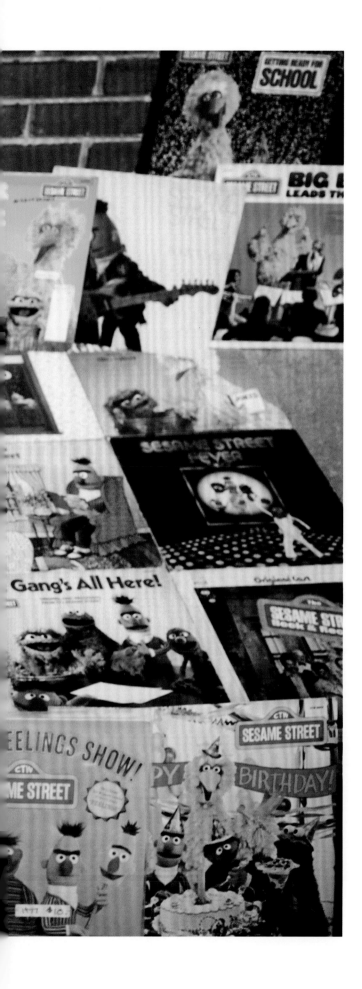

"BERT. HE'S SMART, LIKE ME, AND YELLOW. YELLOW IS MY FAVORITE COLOR."

DANTE CANDELORA - PHILADELPHIA, PA
Bert - *Bert's Blockbusters*
Dante has been collecting *Sesame Street* records since he was thirteen and has amassed an impressive collection. *Bert's Blockbusters* was one of his first.

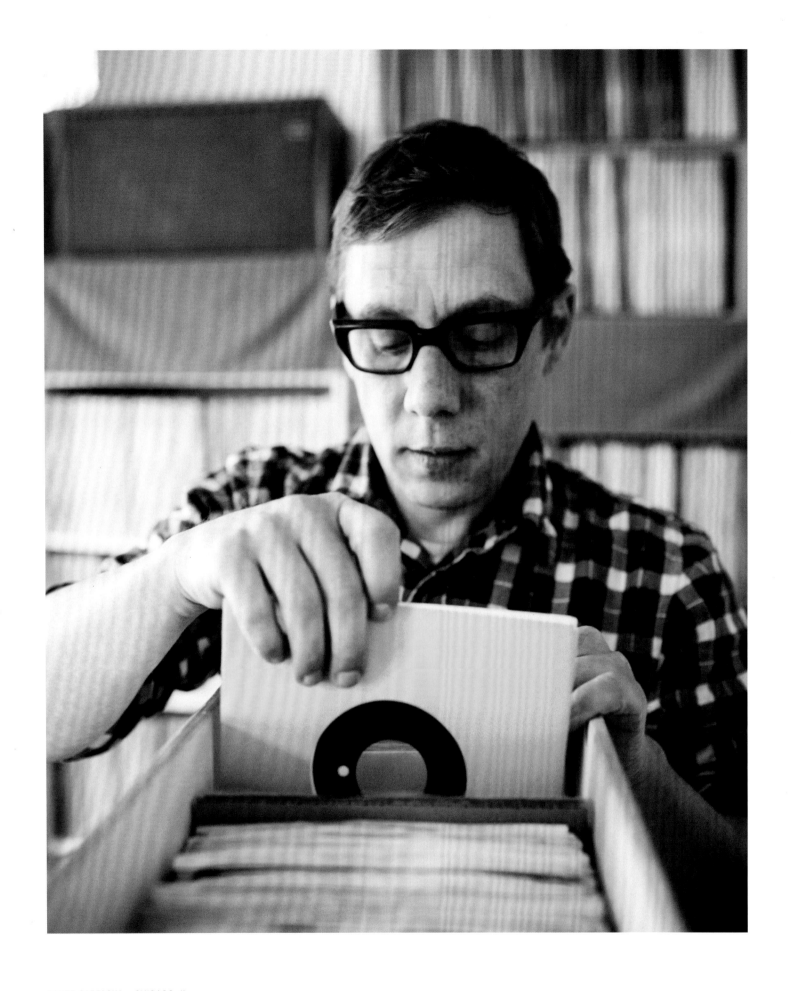

DANTE CARFAGNA - CHICAGO, IL
"A 45 acetate in my box of psych and garage 45s."

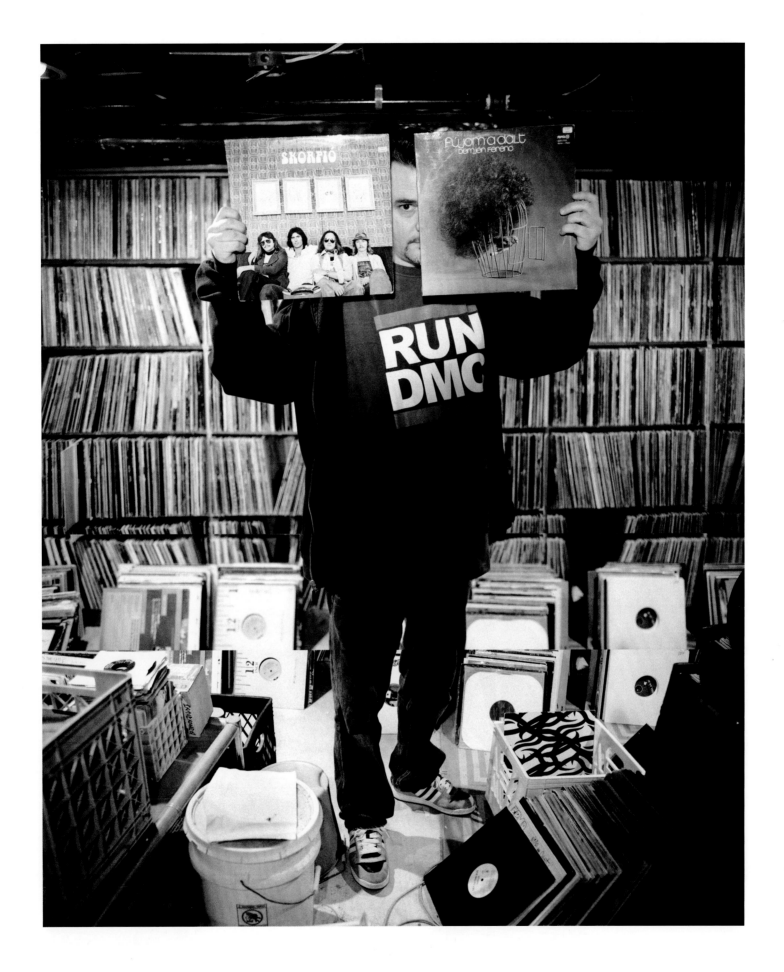

ANDREW MASON - BROOKLYN, NY
Skorpió - *Gyere Velem!*
Demjén Ferenc - *Fújom A Dalt*
"When I was looking to buy a house, the only prerequisite was that it have a place I could put my records. I fitted my basement with homemade shelves. As you can see, I obviously didn't build enough of them."

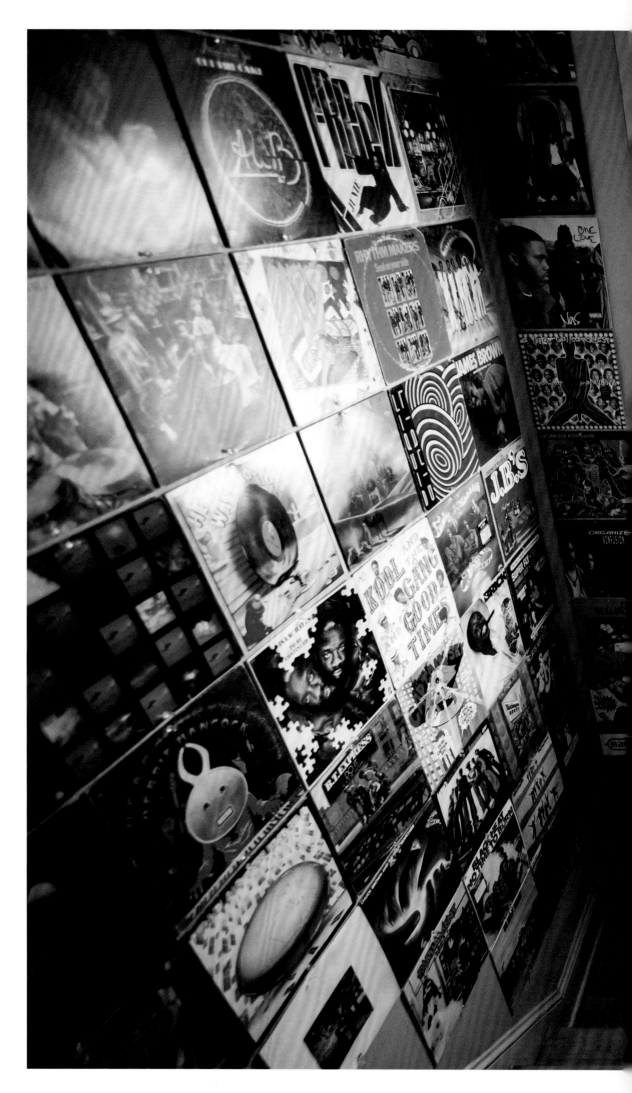

SCOTT DINSDALE (DJ SHAME)
WORCESTER, MA
"This is the album-lined stairway in my house. On the left wall are jazz, soul, funk, and rock covers. On the center and right walls are hip-hop covers. The right wall is structured with a different artist taking up each row."

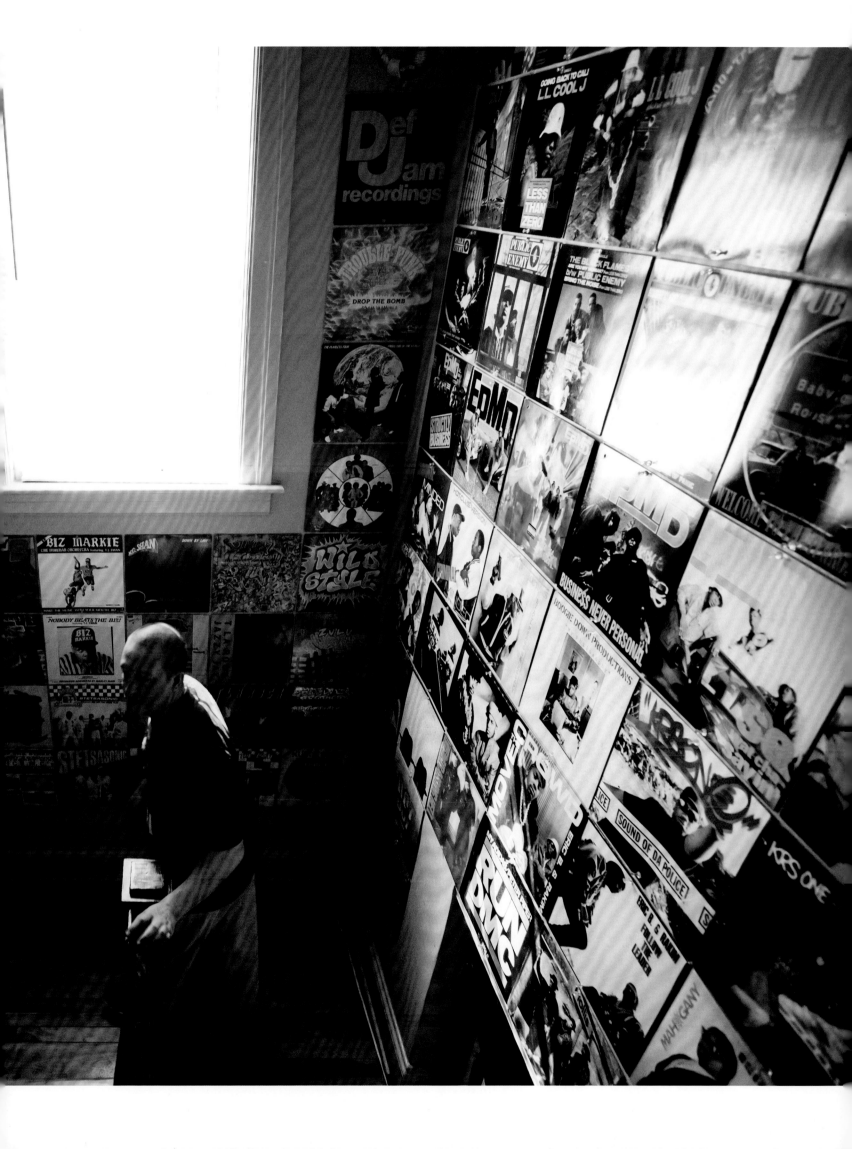

SAM SWIG - OAKLAND, CA
Gefilte Joe & the Fish - *Hanukah Rocks* EP
"In addition to the title track, these bad boys (the self-described 'world's only senior-citizen, Jewish rock band') get down with some clever parody songs called 'Matzoh Man,' 'Walk on the Kosher Side,' and 'Napper's Delight.'"

KEN ABRUZZI - LINDEN, NJ
Charlie Feathers - "One Hand Loose" b/w "Bottle to the Baby"
"A brutal slab of pure savage rockabilly bop on a rare multicolored wax pressing!
All killer, no filler! All bop and no slop!"

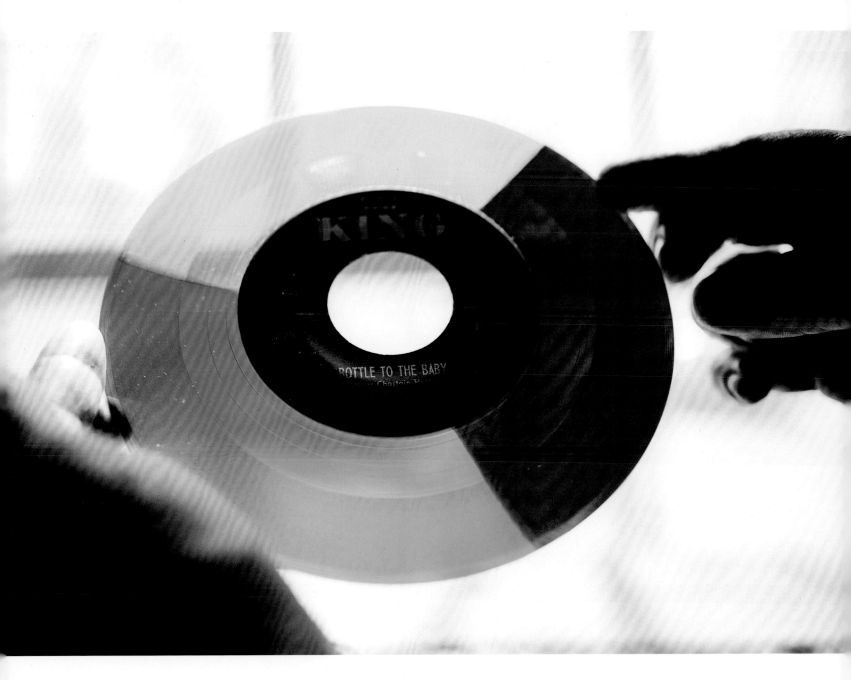

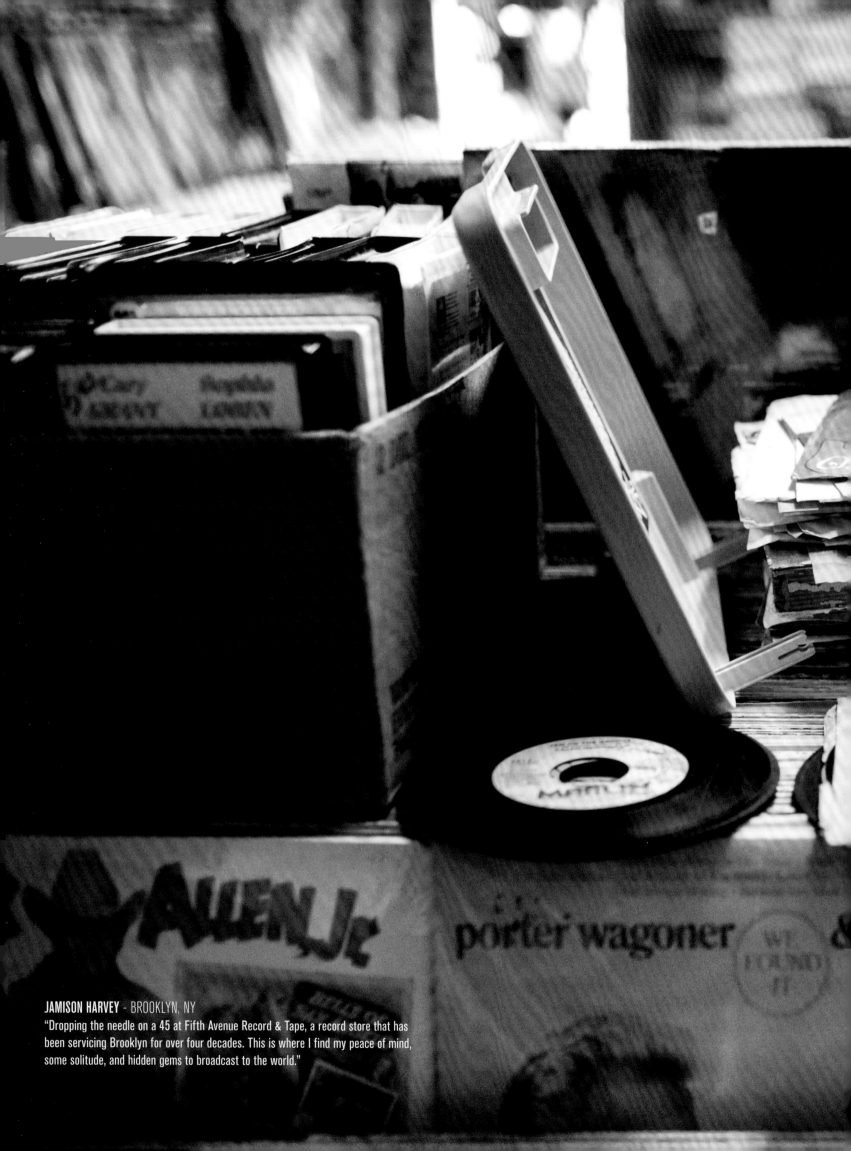

JAMISON HARVEY - BROOKLYN, NY
"Dropping the needle on a 45 at Fifth Avenue Record & Tape, a record store that has been servicing Brooklyn for over four decades. This is where I find my peace of mind, some solitude, and hidden gems to broadcast to the world."

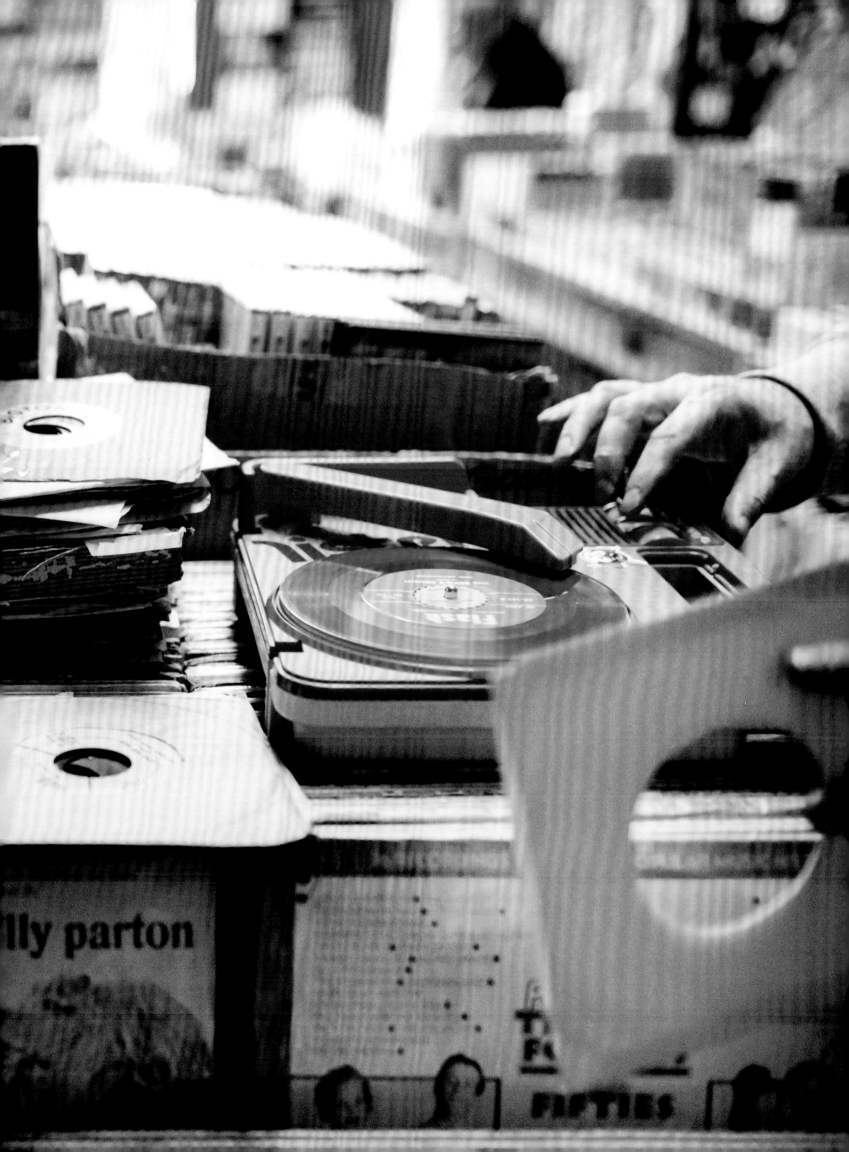

ALEXANDRA HENRY - NEW YORK, NY
Jorge Ben - *Samba Esquema Novo* and *Força Bruta*
"I fell in love with Jorge Ben's first album, *Samba Esquema Novo*, the very first time
I heard it. My friend left the record playing for me while I was taking a nap in Curitiba,
Brazil. It was one of the most peaceful moments of my life. *Força Bruta* showcases
his unique vocals and happy guitar playing."

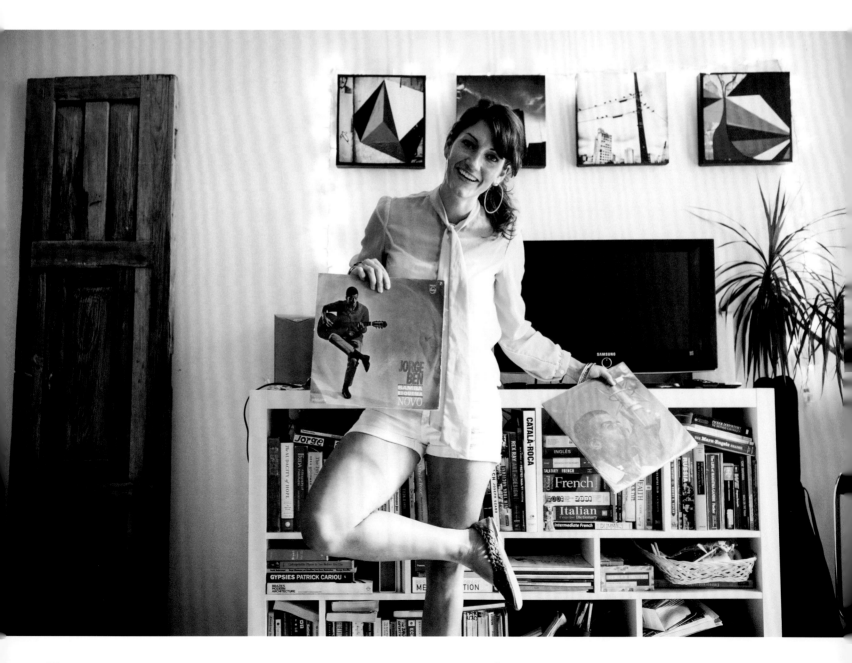

ZACH COWIE - LOS ANGELES, CA
"Me and my production partner, Sunny Levine, proudly displaying our shared love of the Blue Nile LP *Hats*."

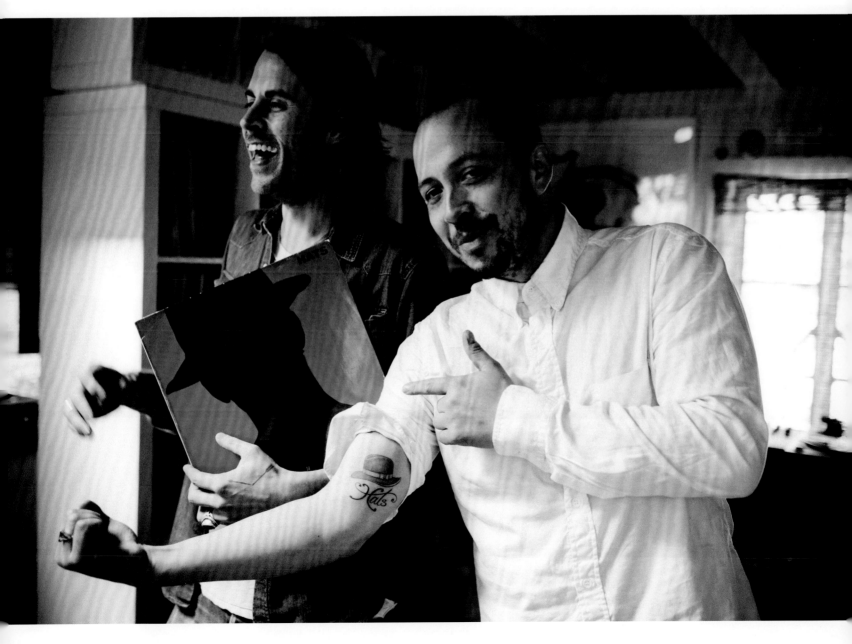

"MY RECORD COLLECTION PROBABLY TELLS THE STORY OF MY LIFE BETTER THAN I COULD IN WORDS."

COLLEEN MURPHY - LONDON, UNITED KINGDOM
Joni Mitchell - *Blue*
"This is one of my favorite Joni Mitchell albums and, surprisingly, an album often
requested by my eight-year-old daughter. One of the reasons it is so poignant to me is
because Joni sings about the baby daughter she gave up for adoption in 'Little Green.'
This song easily reduces me to tears, and I am in awe of how she is able to perform
the song when the emotions are so painful."

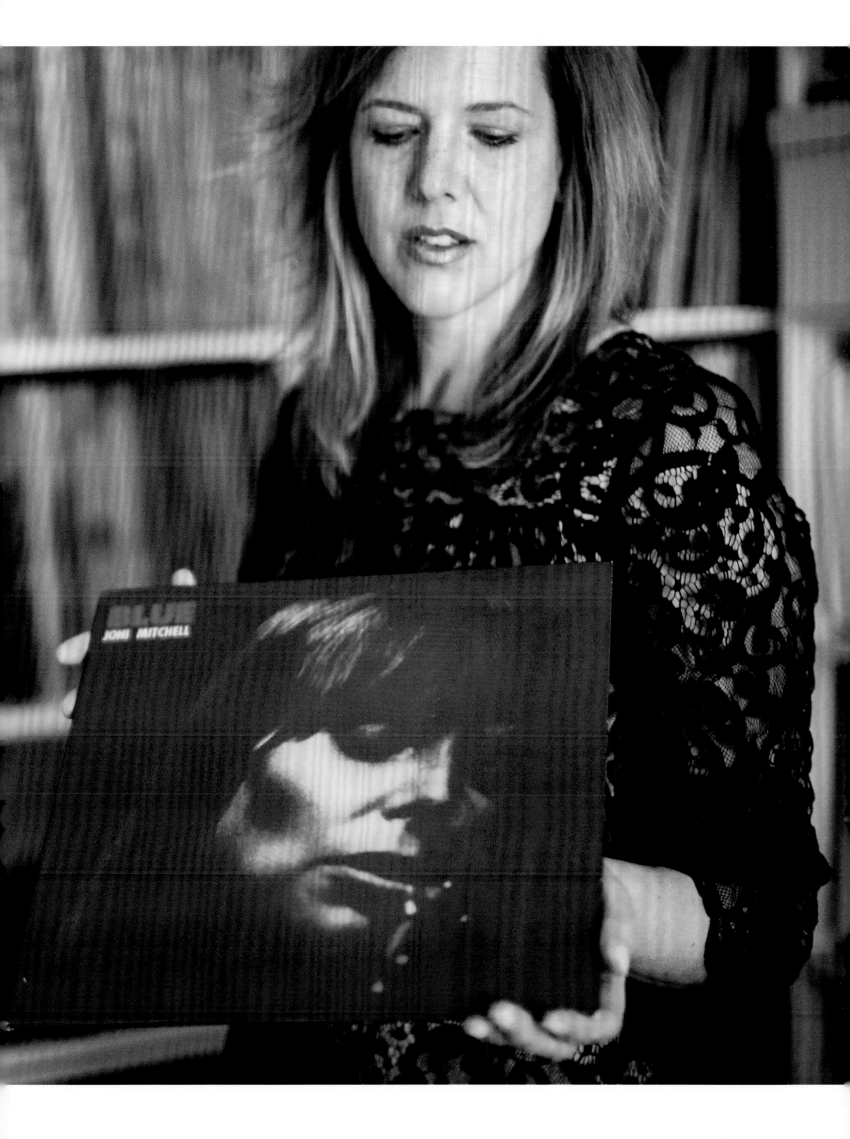

MARK JOHNSON - PHILADELPHIA, PA
"Five a.m. at a flea market near
Philadelphia. I'm getting a first look
at a truckload of records before they
hit the bins."

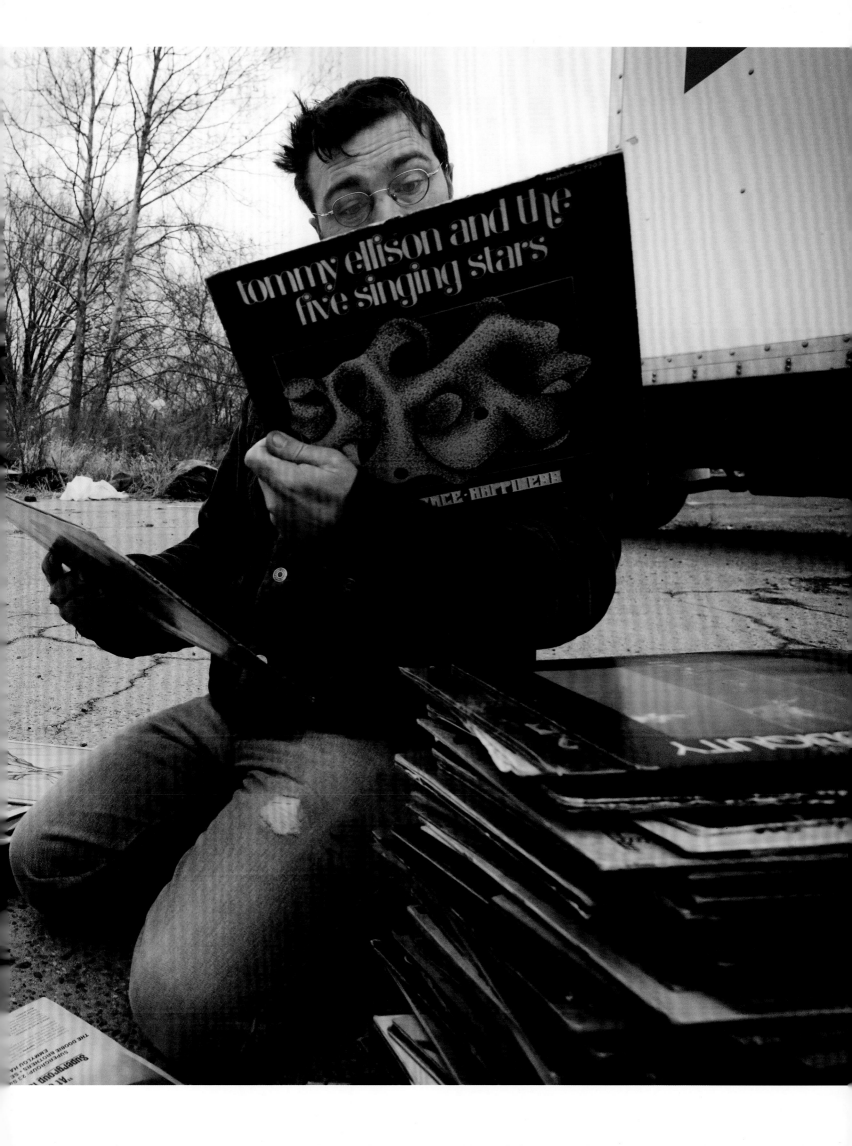

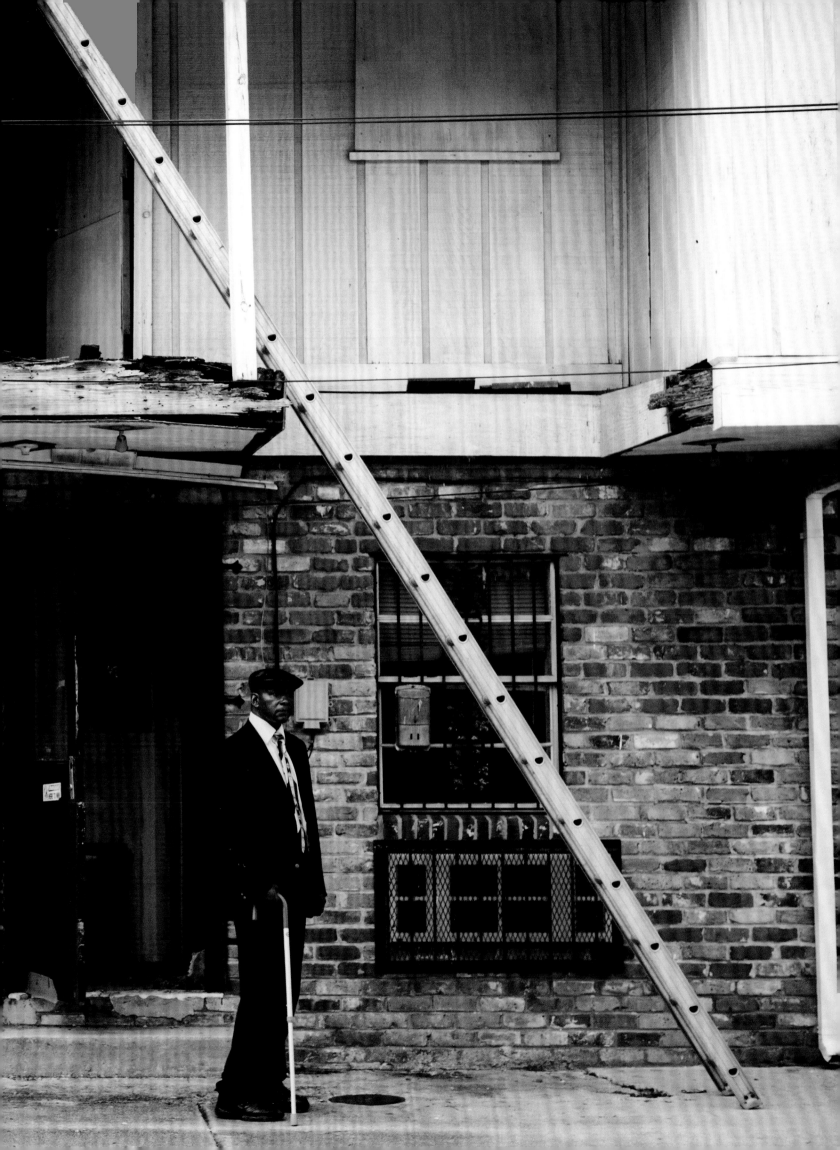

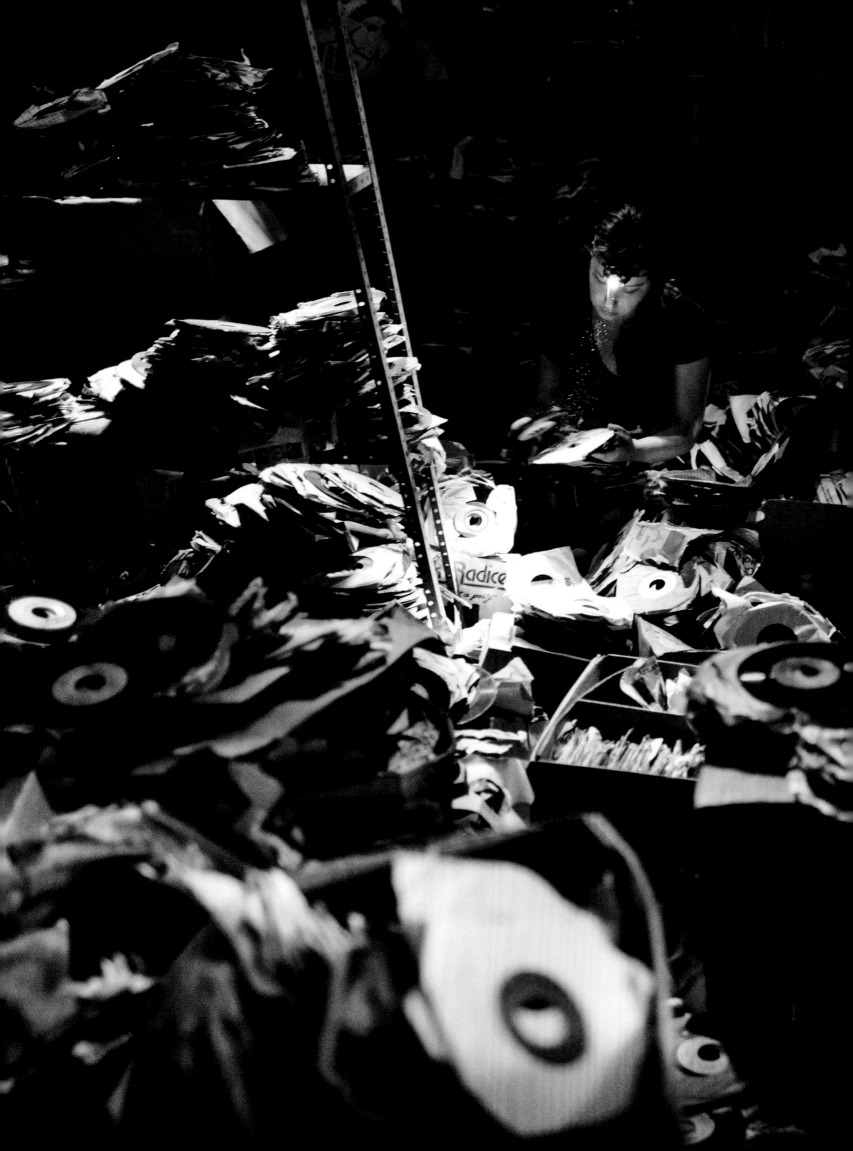

JULIA RODIONOVA - BROOKLYN, NY
"Even after thirty years, there is still more to find in Eddie 3-Way's New Orleans attic. With extra time, extra patience, a headlight, and at least a hundred dollars, you could come away with as many gems as splinters."

MICHAEL CUMELLA - NEW YORK, NY
Various Artists -
The Nothing Record Album
"There is nothing on this record that I can tell you about that you don't already know. You cannot imagine the sounds that will emanate from these grooves! This LP will help clear your mind of unnecessary noise. Put this record on in the forest and you will hear the sound trees make when no one is there."

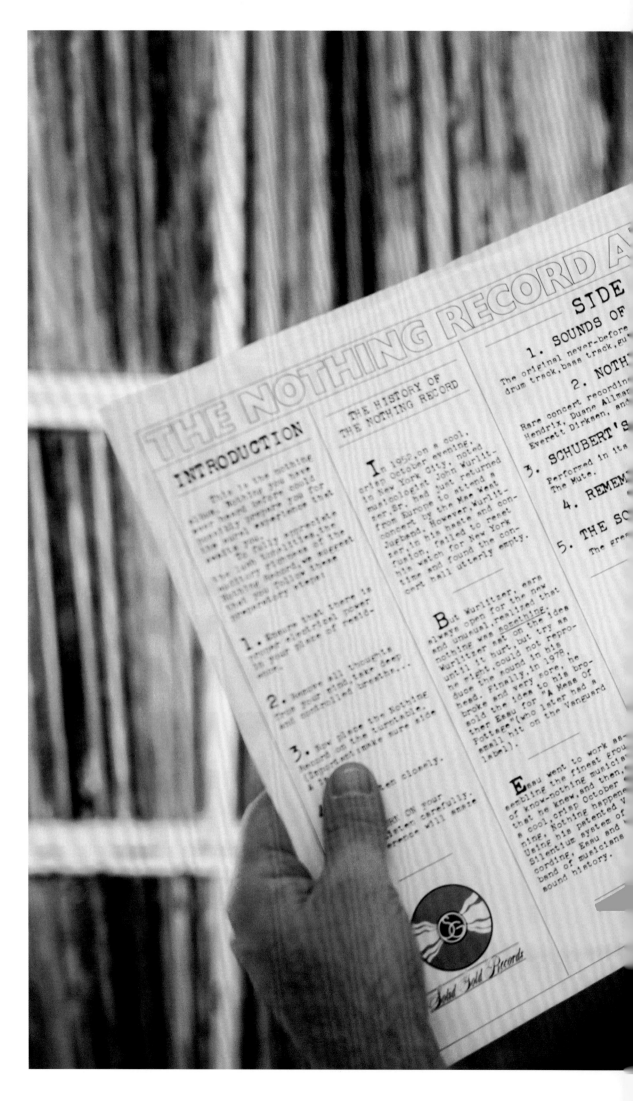

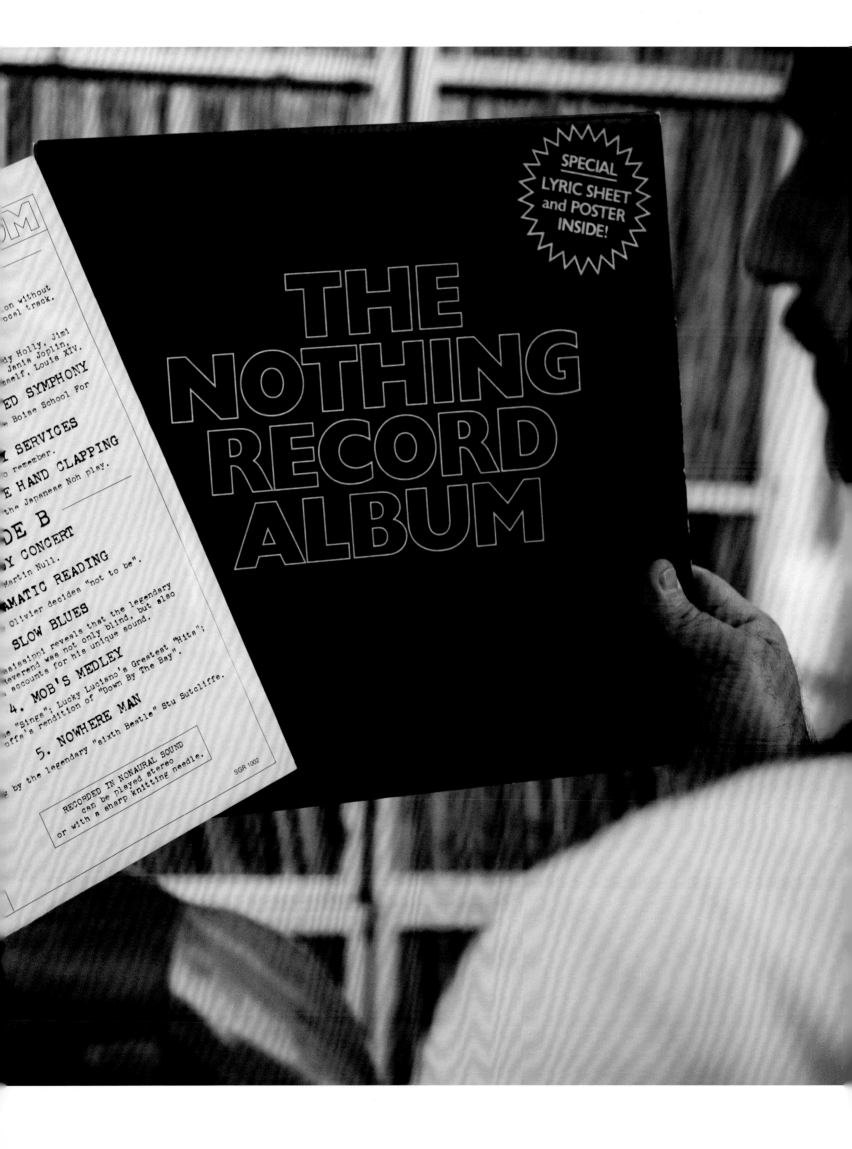

KIERAN HEBDEN (FOUR TET) - LONDON, UNITED KINGDOM
Heldon - *Heldon IV: Agneta Nilsson*
Dedalus - *Dedalus*
"A French synth prog band and Italian jazz fusion band, both with intense and eerie album art."

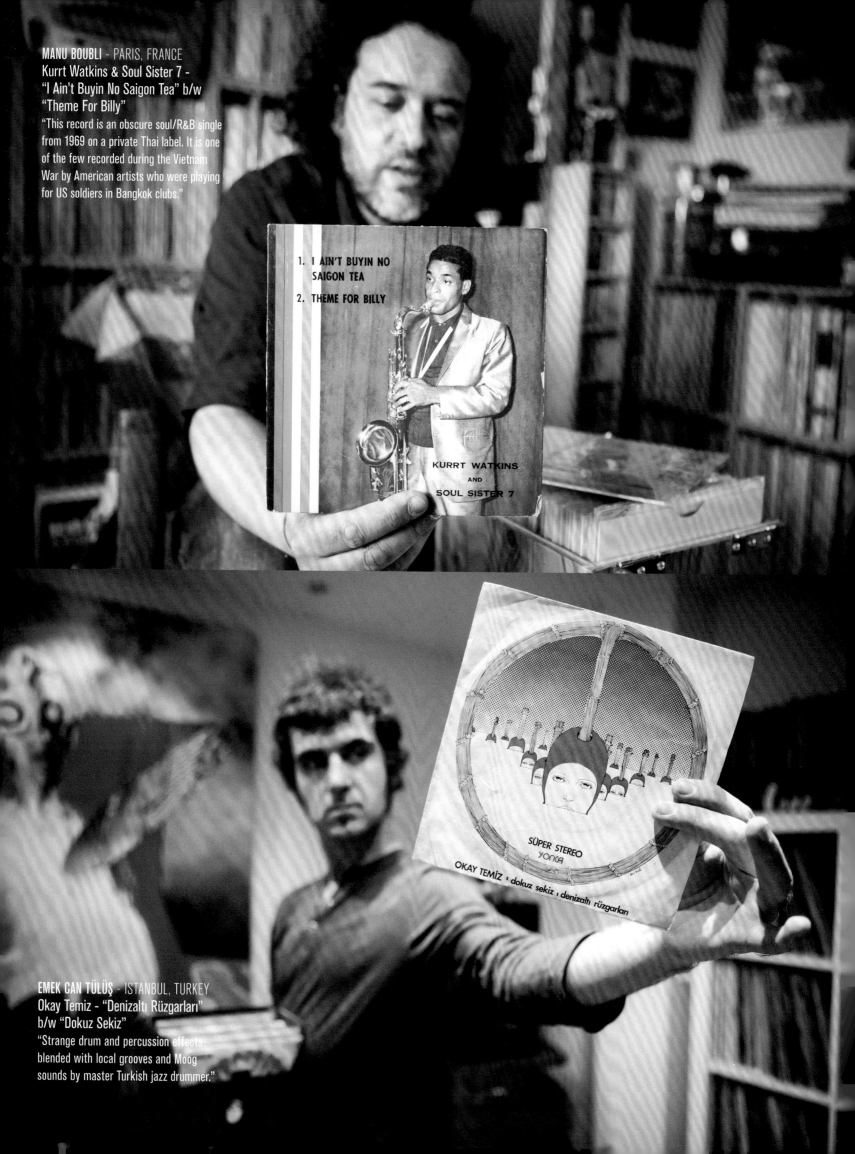

MANU BOUBLI - PARIS, FRANCE
Kurrt Watkins & Soul Sister 7 -
"I Ain't Buyin No Saigon Tea" b/w
"Theme For Billy"
"This record is an obscure soul/R&B single
from 1969 on a private Thai label. It is one
of the few recorded during the Vietnam
War by American artists who were playing
for US soldiers in Bangkok clubs."

1. I AIN'T BUYIN NO SAIGON TEA
2. THEME FOR BILLY

KURRT WATKINS
AND
SOUL SISTER 7

SÜPER STEREO
yonca

OKAY TEMİZ · dokuz sekiz · denizaltı rüzgarları

EMEK CAN TÜLÜŞ - ISTANBUL, TURKEY
Okay Temiz - "Denizaltı Rüzgarları"
b/w "Dokuz Sekiz"
"Strange drum and percussion effects
blended with local grooves and Moog
sounds by master Turkish jazz drummer."

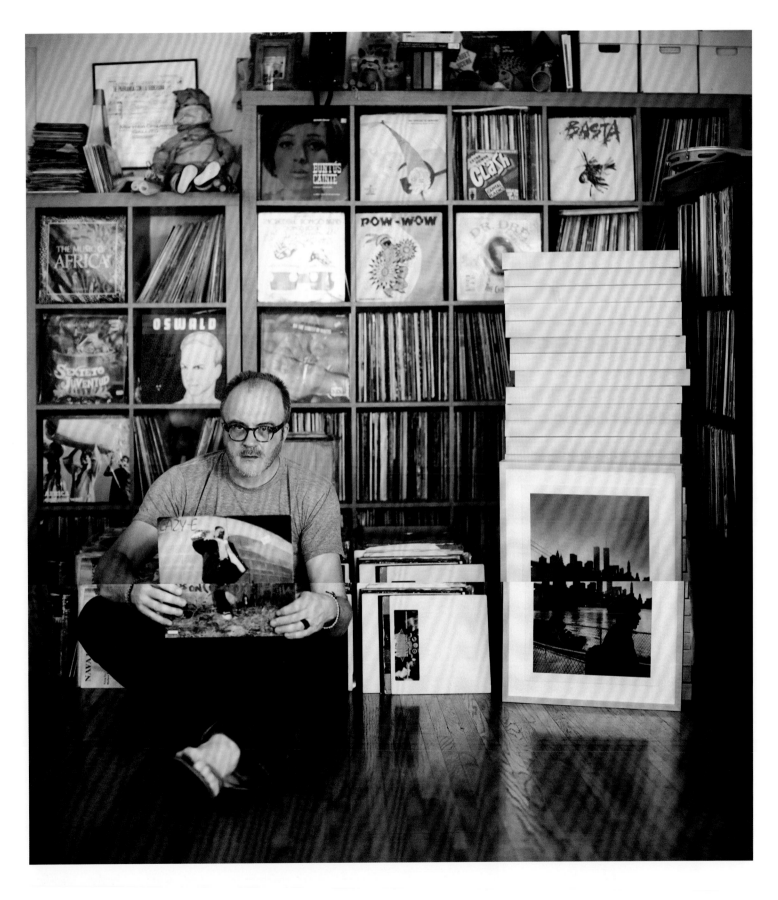

BRIAN "B+" CROSS - LOS ANGELES, CA
"I'm holding Eazy E's *It's On (Dr. Dre) 187um Killa* EP. It's the first album cover I ever did.
The framed photo on the right is from Mos Def's *Black on Both Sides* album."

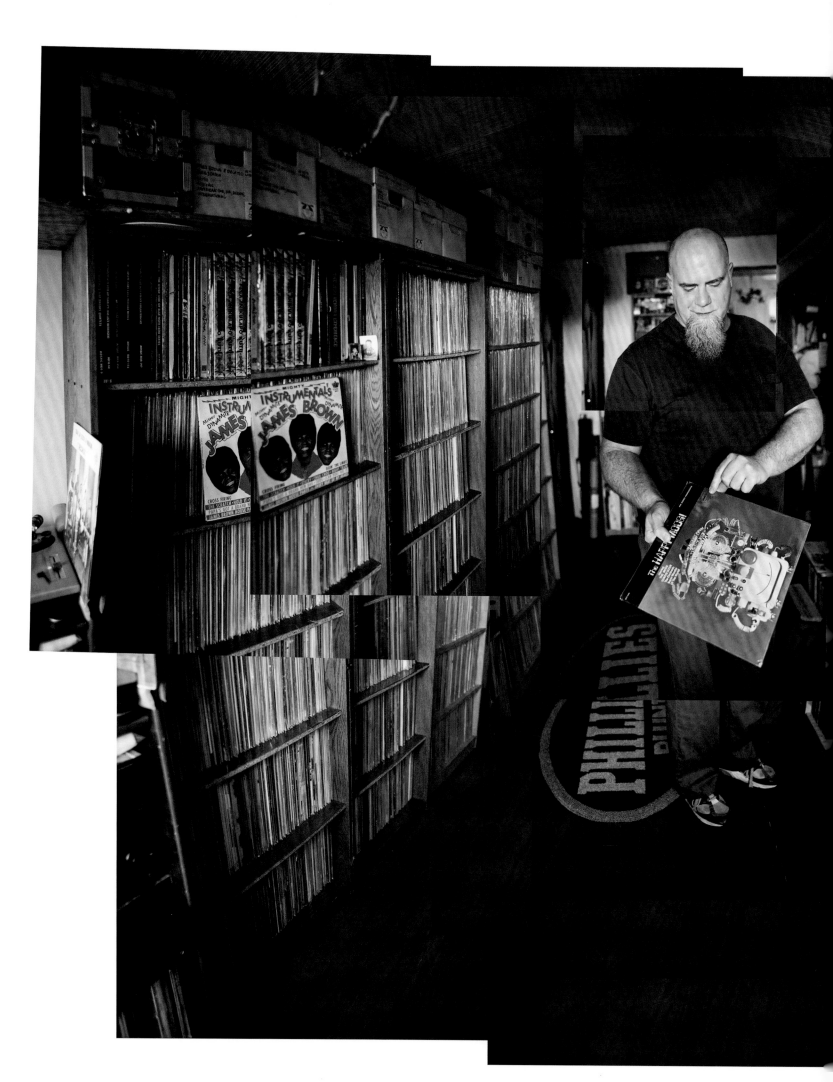

PAT. JAMES LONGO - JERSEY CITY, NJ
"Seventy boxes of 45s, three boxes of 78s and 10-inches, twenty-nine shelves of LPs, five boxes of not-so-hidden records, and a two-hundred-count odyssey case filled with lounge music LPs and rock 12-inches. Over fifty genres, forty years of collecting, and only one turntable. So what do you want to listen to?"

RED BUS MUSIC LIBRARY
RED BUS MUSIC LIBRARY
RED BUS MUSIC LIBRARY
RED BUS MUSIC LIBRARY

TIME AND MOTION
UNDERCURRENTS
UNDERCURRENTS
THEMES FOR A ONE-MAN BAND, VOL 1

PM 009 STEREO

FURTHER FACES

ATMOSPHERE

DEREK AUSTIN

TREVOR BASTOW

ROCK: DRAMATIC MOODS 004

PM 005 STEREO

Catalogue	Title	Label
BRI 23		BRUTON
BRI 17	FANFARES, LINKS, BRIDGES, STRINGS, VOLUME 1	BRUTON MUSIC
RRA1	EKLEKTIK	BRUTON MUSIC
BRI 3	FORCEFIELD	BRUTON MUSIC
RRI 6	CITY OF THE FUTURE SUITE/EQUINOX	BRUTON MUSIC
BRI 8	FRONTIERS OF SCIENCE	BRUTON MUSIC
BRN 2		BRUTON MUSIC
BRI 21		BRUTON MUSIC
BRI 19	ENERGISM	BRUTON MUSIC
BRI 4	SUSPENSIONS/GALAXY	BRUTON MUSIC
BRI 5	CITY OF THE FUTURE SUITE/EQUINOX	BRUTON MUSIC
BRI 1	WILDLIFE	BRUTON MUSIC
	HEAVY ROCK	
	THOUGHT PATTERNS	
	TOMORROW'S WORLD	
	KINETICS/VISION	
BRN 9	TERRESTRIAL JOURNEY	BRUTON
BRN 11	THE VIDEO ORCHESTRA VOL. 3	
BRN 12	PRESTIGE	
BRN 7		
BRP 3	MASTERWORKS, IMPRESSIONS	BRUTON MUSIC
RRR1	FRANCE	BRUTON MUSIC
	TRAVEL IN STYLE	
A 2	FANFARES, LINKS, BRIDGES, STRINGS.	
BRB2	FANFARES, LINKS, BRIDGES, STRINGS, VOLUME 1	BRUTON MUSIC
BRB3	JINGLES VOL. 3	BRUTON MUSIC
BRB4	JINGLES VOL. 4	BRUTON MUSIC
BRB 5	JINGLES VOL. 5	BRUTON MUSIC
BRB 7	JINGLES VOL. 6	BRUTON MUSIC
BRB 8	JINGLES VOL. 7	BRUTON MUSIC
BRB 9	JINGLES VOL. 8	BRUTON MUSIC
BRB 10	JINGLES	BRUTON MUSIC
BRB 11	JINGLES	BRUTON MUSIC
BRB 12	JINGLES VOL. 1	BRUTON MUSIC
	JINGLES	
BRB 16	JINGLES	BRUTON
BRB 15		BRUTON MUSIC
BRB 17	VOCAL JINGLES	BRUTON MUSIC
BRB 18	JINGLES VOL. 20	BRUTON MUSIC
PRS 19	JINGLES VOL. 21	BRUTON MUSIC
BRB 20	JINGLES VOL. 22	BRUTON MUSIC
BRB 21	HARPSICORD	BRUTON MUSIC
BRB 22	PERCUSSION VOLUME 1	BRUTON MUSIC
PRS 9	PERCUSSION VOLUME 2	BRUTON

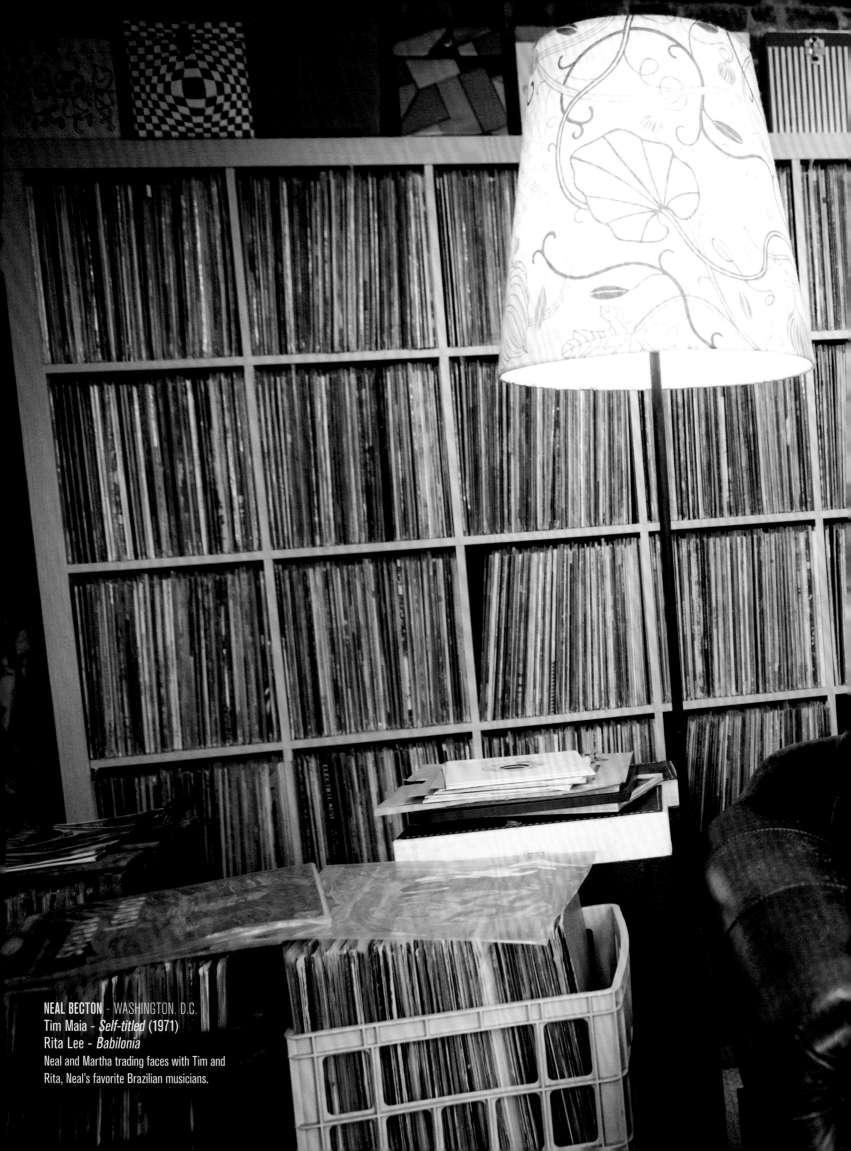

NEAL BECTON - WASHINGTON, D.C.
Tim Maia - *Self-titled* (1971)
Rita Lee - *Babilonia*
Neal and Martha trading faces with Tim and
Rita, Neal's favorite Brazilian musicians.

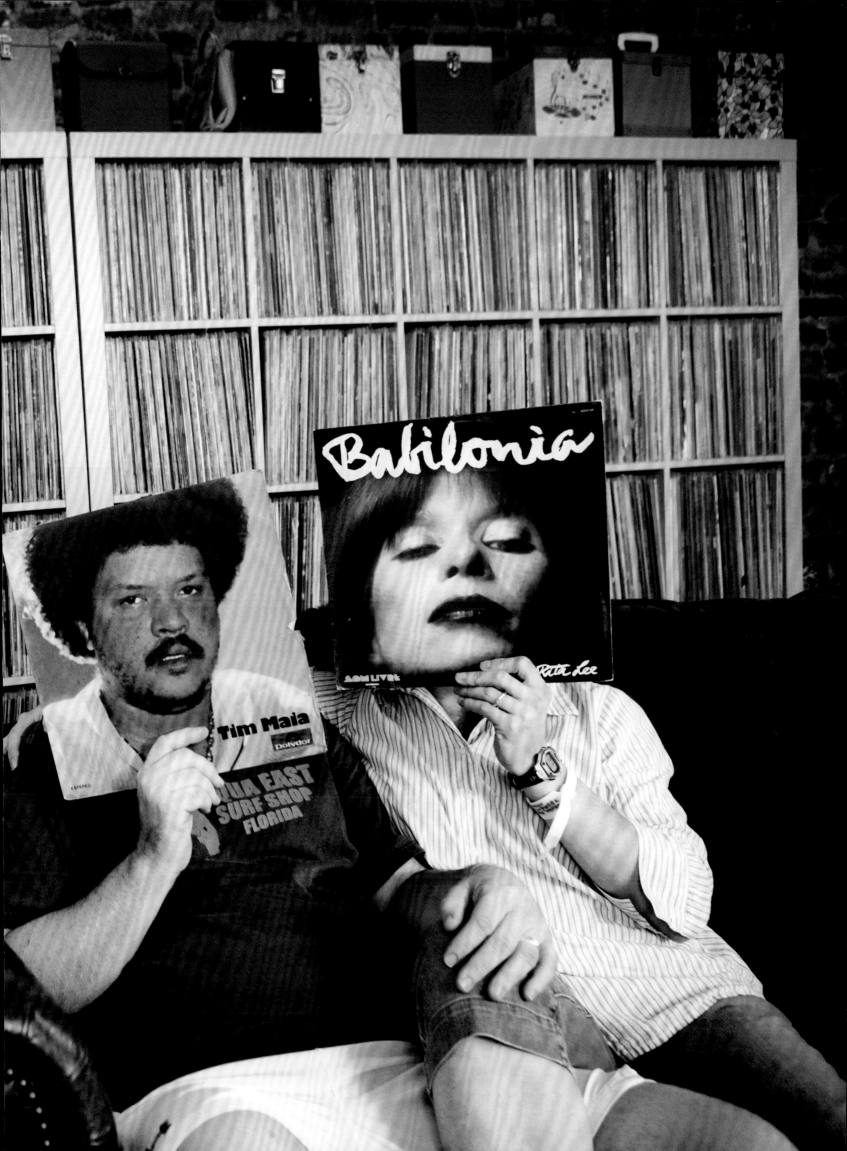

MARKEY FUNK - JERUSALEM, ISRAEL
Esther Jungreis Presents: You Are a Jew . . . An Historic Moment at Madison Square Garden
"A Jewish female preacher with some serious passion. This is the kind of record (and kind of character) that you can hardly believe exists."

DOM SERVINI - LONDON, UNITED KINGDOM
John Bird - *The Collected Broadcasts of Idi Amin*
"A strange one this, as British political satirist John Bird does his best Idi Amin impression and dips into a little political incorrectness as he parodies the Ugandan dictator. I bought this at a local charity shop and chose it simply because I love the typography and the inclusion of Roy Lichtenstein's famous 'Gun.' I'm no fan of Amin or guns, it's just one crazy cover!"

J. Garland McKee - *Laughin' With 'Em:*
Southern Negro Humor in Dialect

Erna Caplow-Lindner, Leah Harpaz,
and Sonya Samberg - *Special Music
for Special People*
What's an afternoon without a little bit of
politically incorrect humor?

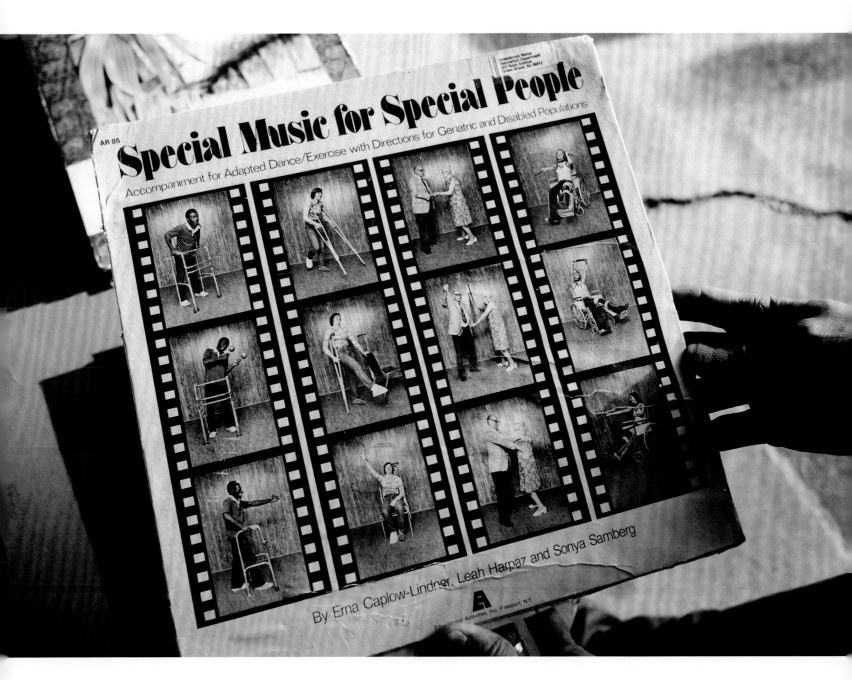

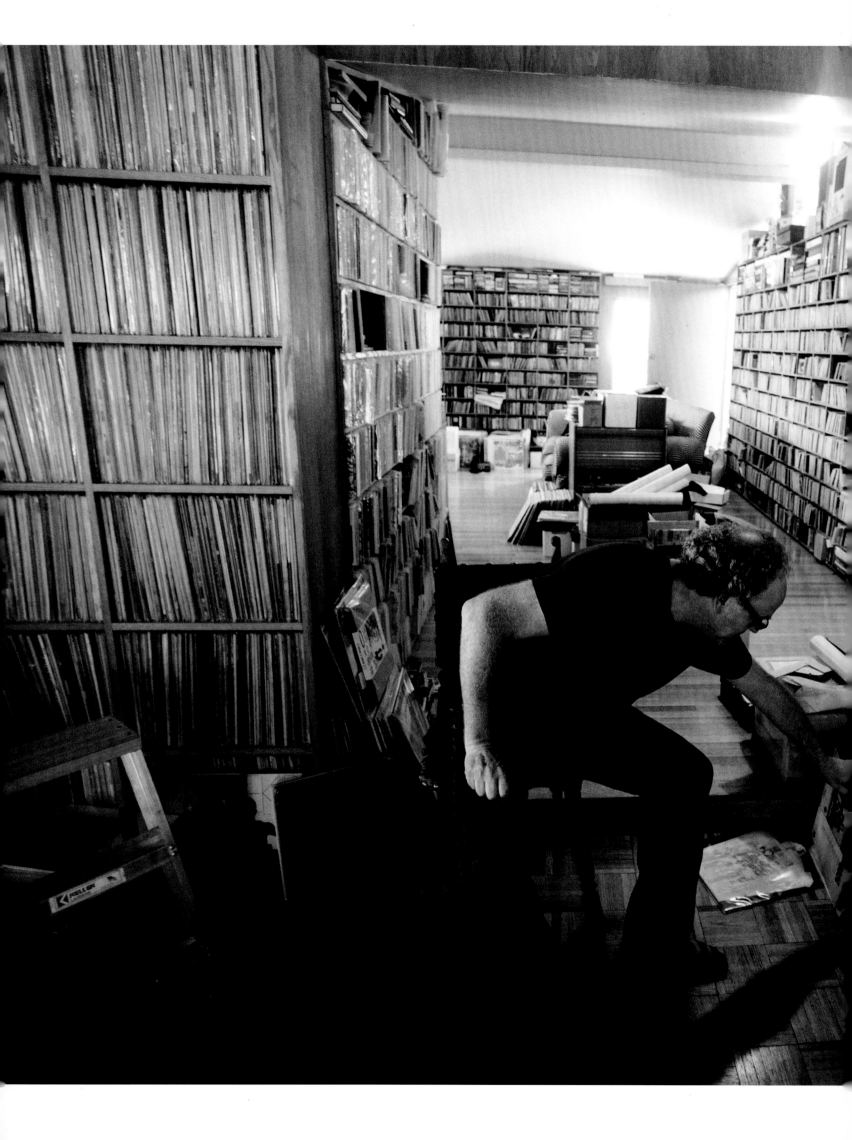

GEOFFREY WEISS - LOS ANGELES, CA

"This is me doing what I do every day—organizing and listening in my record room. I probably spend the most time working on the 45 section. Behind the 1950s Telefunken record changer is the couch on which I like to sit and listen."

LOGAN MELISSA - LOS ANGELES, CA
Jackie McLean - *Destination Out!*
"I saw the documentary *Jackie McLean on Mars* when I was thirteen, and that did it for me.
True love. I'm pointing at a stereo pressing of 1963's *Destination Out!*, which opens with
the masterpiece 'Love and Hate' and builds from there. It is a perfect jazz album and one of
my most prized possessions because it was, at one point in time, *actually held in Jackie's
hands.* His signature is on the back, dedicating it 'to Carl.' I'm changing my name to Carl."

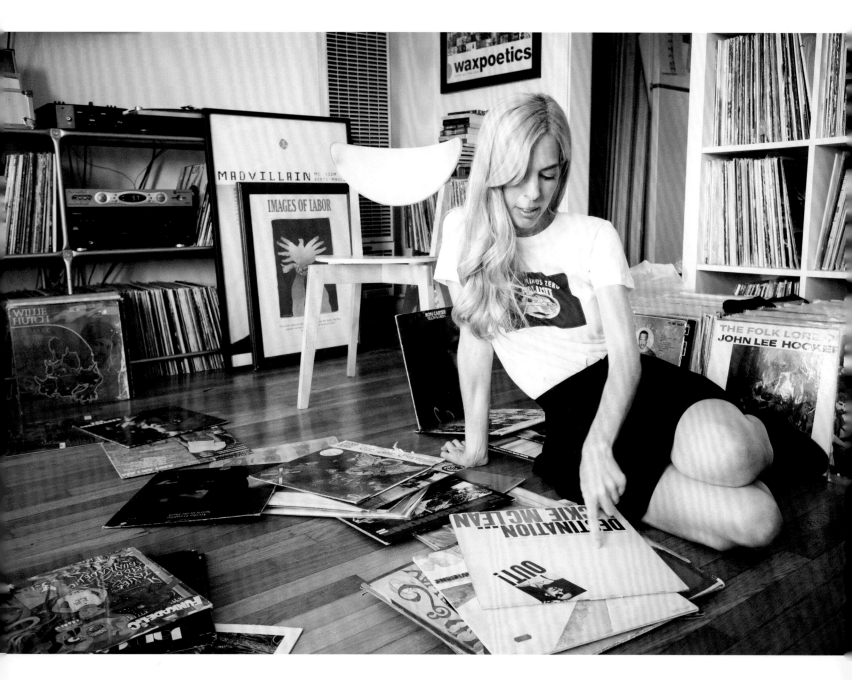

BRENDON RULE (DJ ANDUJAR) - GREENFIELD, MA

"Some collectors are very boxed 'inside a listening room,' but my listening room has actually served as a window to the real world. I have learned so much about people, culture, politics, and geography just from the records and their grooves. The world opens to me from there."

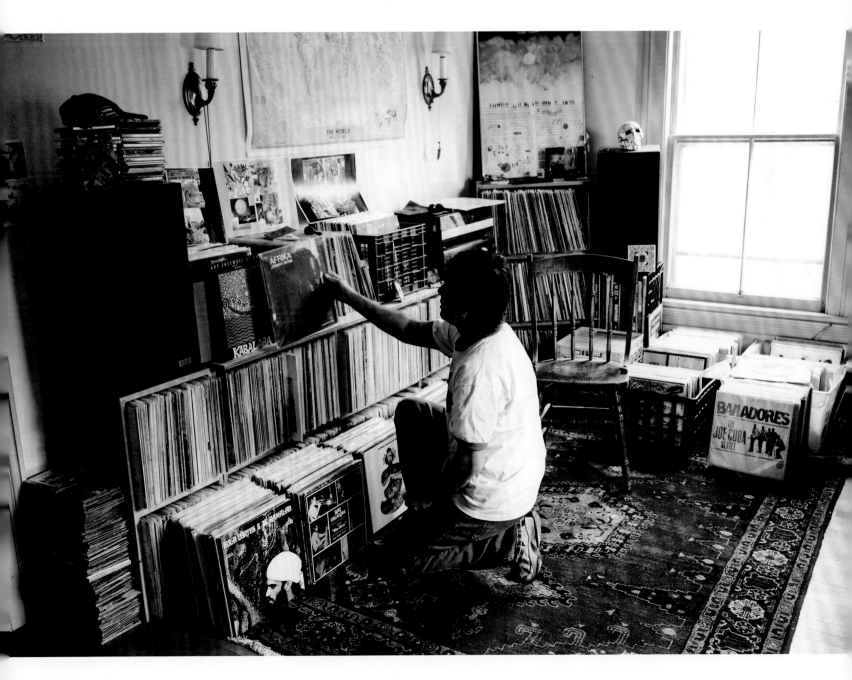

"THE 45 IS SUCH A PURE OBJECT, ITS FORM COMPLETELY MATCHED TO ITS FUNCTION . . . AND MAGICALLY, WHEN YOU PLACE IT ON A SPECIAL DEVICE, IT PLAYS A SONG. AS AN ADDED BONUS, IF YOU FLIP IT OVER, IT USUALLY PLAYS ANOTHER SONG."

MATT WEINGARDEN (MR. FINE WINE) - BROOKLYN, NY

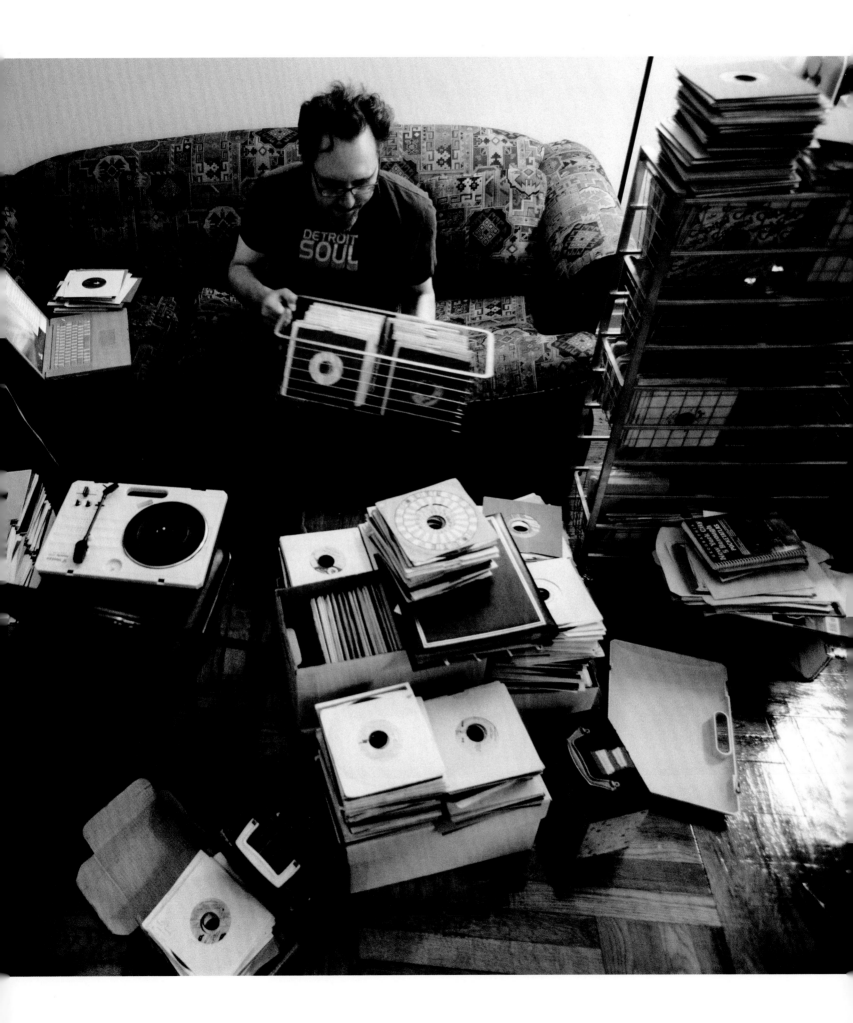

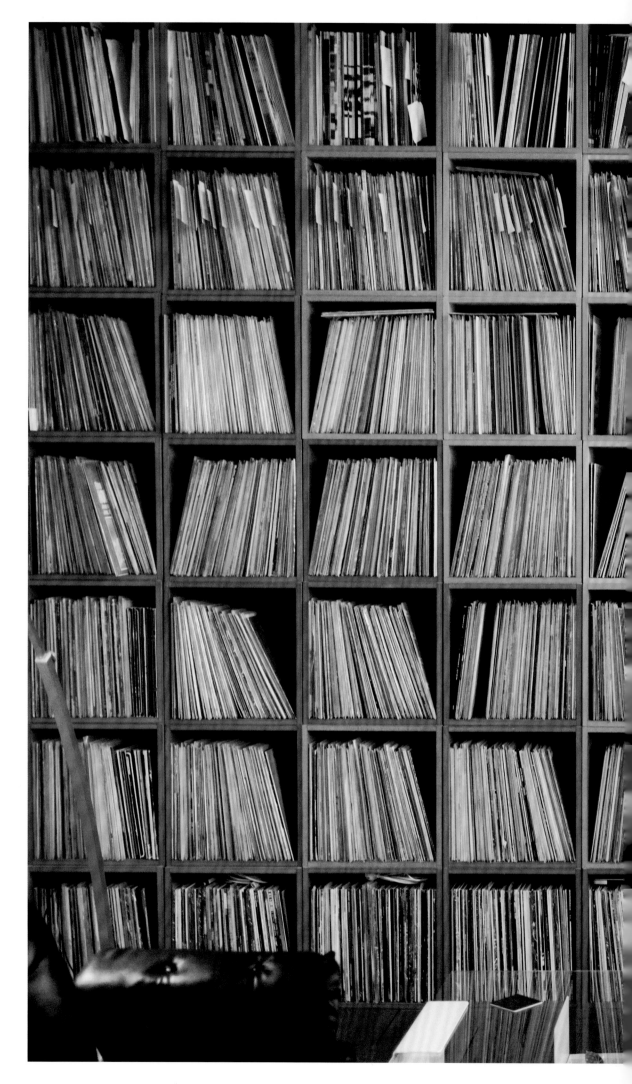

CLAAS BRIELER - BERLIN, GERMANY
"Searching for something in the soul section of my record collection. The one problem with having so many records is, how do you keep them filed? I have a system based on genres, countries, and other criteria."

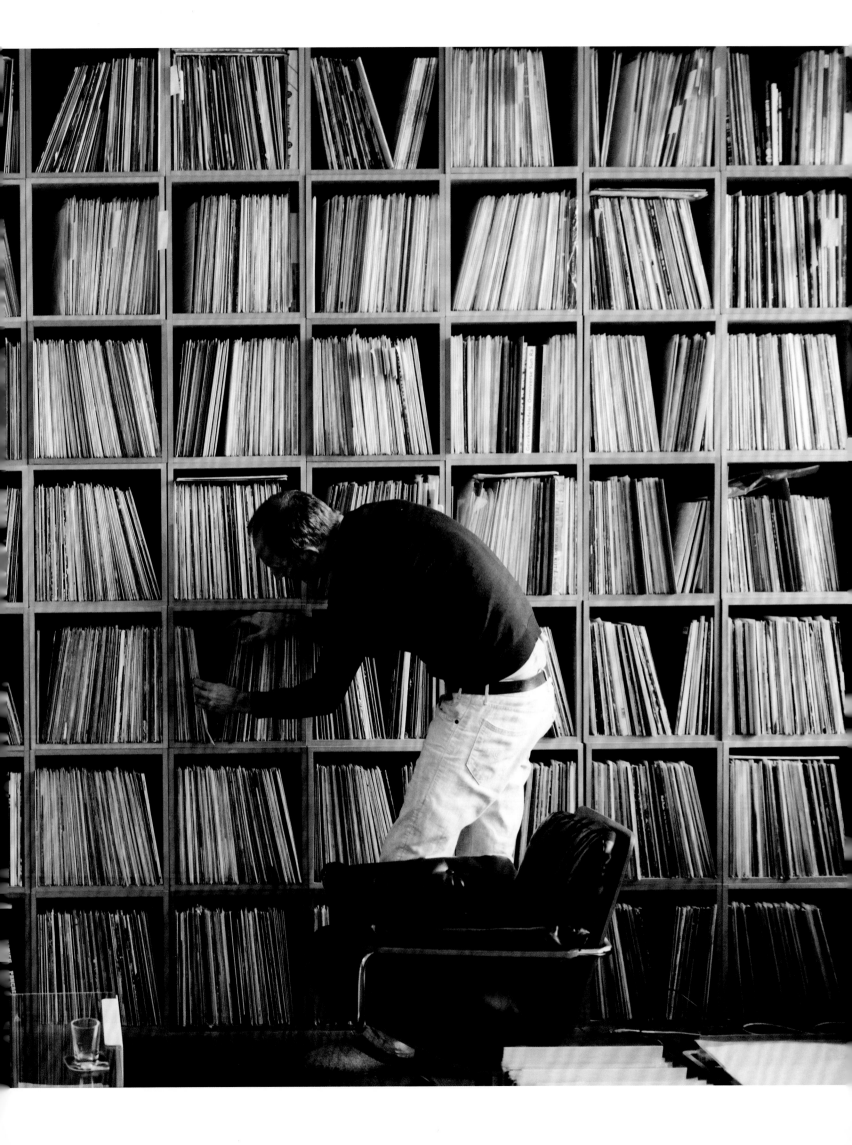

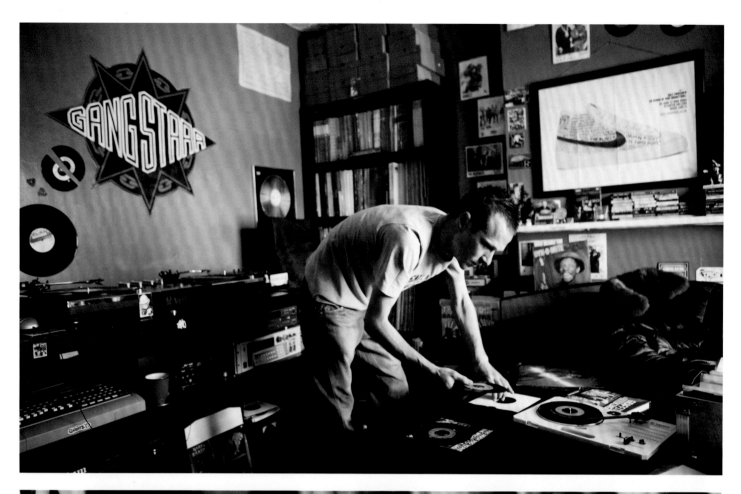

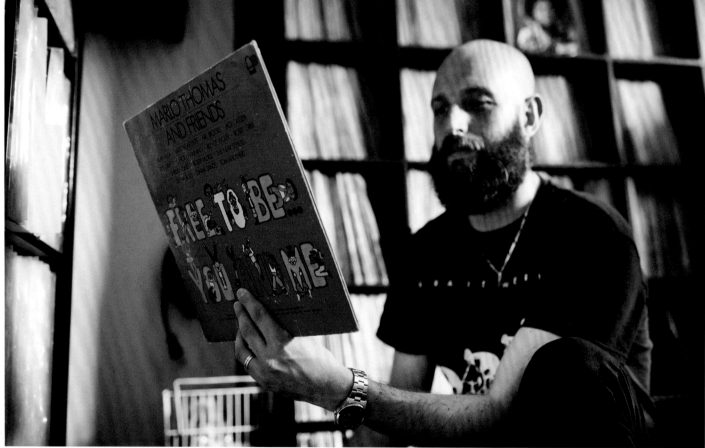

KID DYNO - LONDON, UNITED KINGDOM
"I have my 12-inches racked nicely, but my 45s demand daily love and affection."

BEN GOLDFARB (DJ SCRIBE) - BROOKLYN, NY
Marlo Thomas and Friends - *Free to Be . . . You and Me*
"I loved this record when I was a kid. It came out when I was about a year old, so it must have been one of my very first records, if not *the* first. Its overall message of gender equality had a strong impact on me."

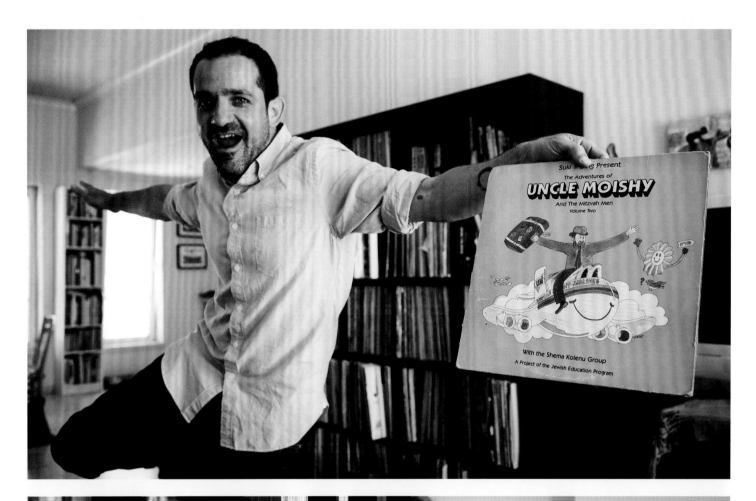

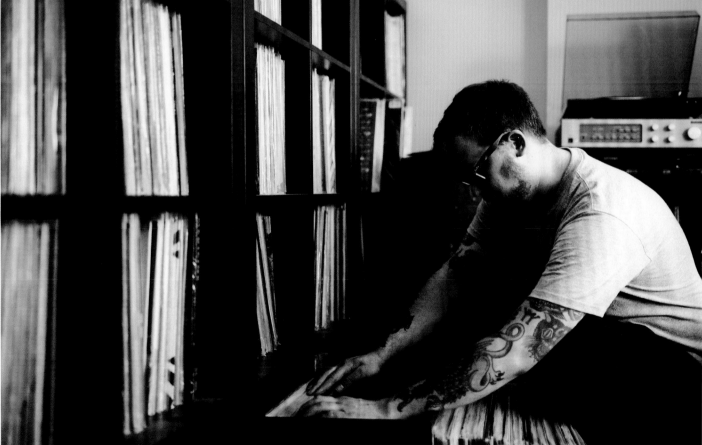

EYAL ROB - TEL AVIV, ISRAEL
The Adventures of Uncle Moishy and the Mitzvah Men, Volume 2
"A Jewish superhero presented as a flying Rabbi backed by his Mitzvah boys? Hell yes! It's an early '80s record for North American Jewish kids, and it has great sampling material. I found it in a half-shekel bin in Tel Aviv."

JEFF OGIBA - BROOKLYN, NY
"The record-hunting adventure continues even in my own home, where I often forget what I've bought and where I filed it."

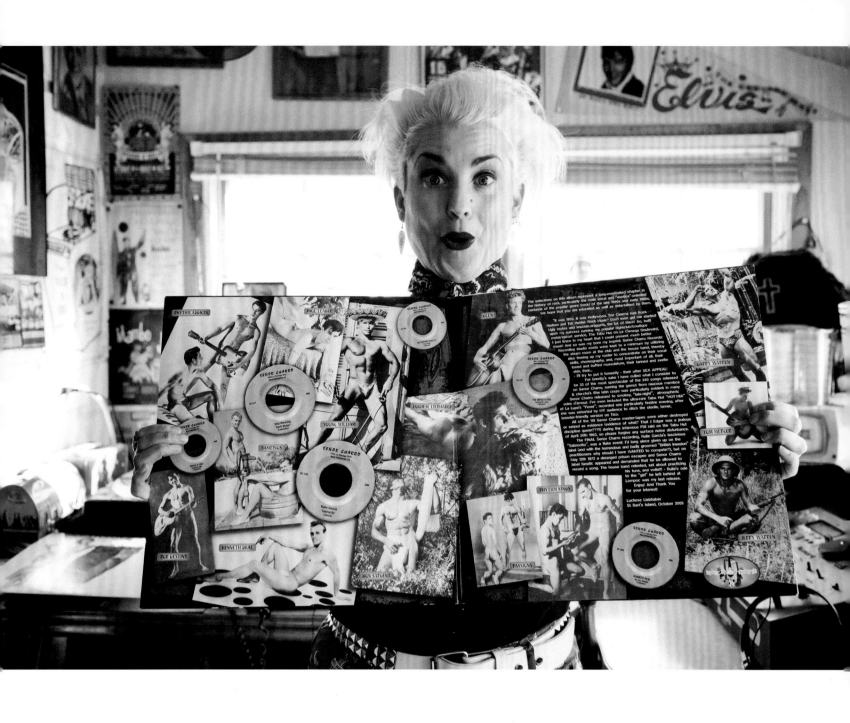

DEBRA DYNAMITE - LINDEN, NJ
Charlie Feathers compilation by
Norton Records

"12-INCH, 10-INCH, 7-INCH . . .
WHO SAYS SIZE DOESN'T MATTER?!"

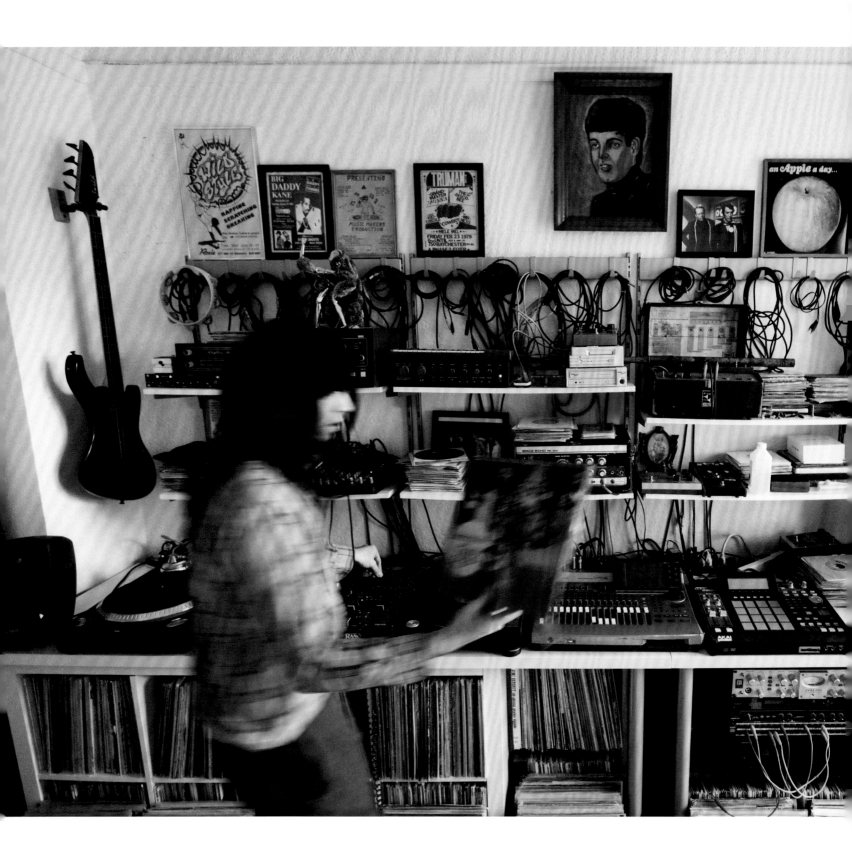

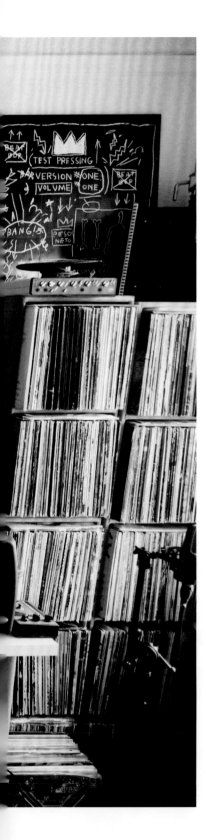

EDAN - BROOKLYN, NY
"Badly drawn Paul sees all . . . "

"The all-in-one microwave-turntable—no kitchen is complete without one. All jokes aside, the people at Emerson did have the strange foresight to tout the merits of TURNTABLE COOKING."

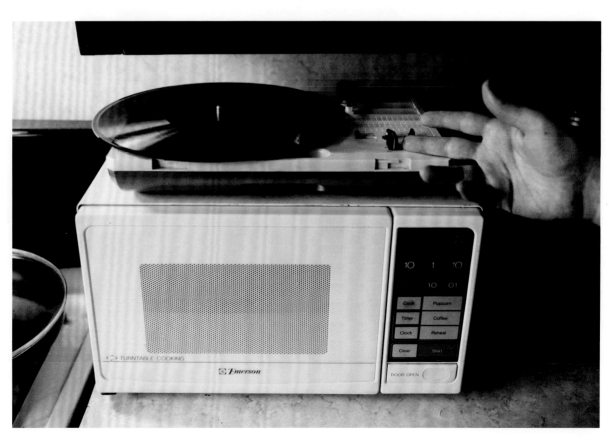

SKEME RICHARDS - PHILADELPHIA, PA
The Persuaders - *Self-titled*
"This album reminds me so much of my childhood, a time when male soul groups were so popular. One of the first times that I remember hearing this album was when I was a kid riding the school bus. The driver used to play 8-tracks. He had this album and played other groups like the O'Jays and Harold Melvin & the Blue Notes."

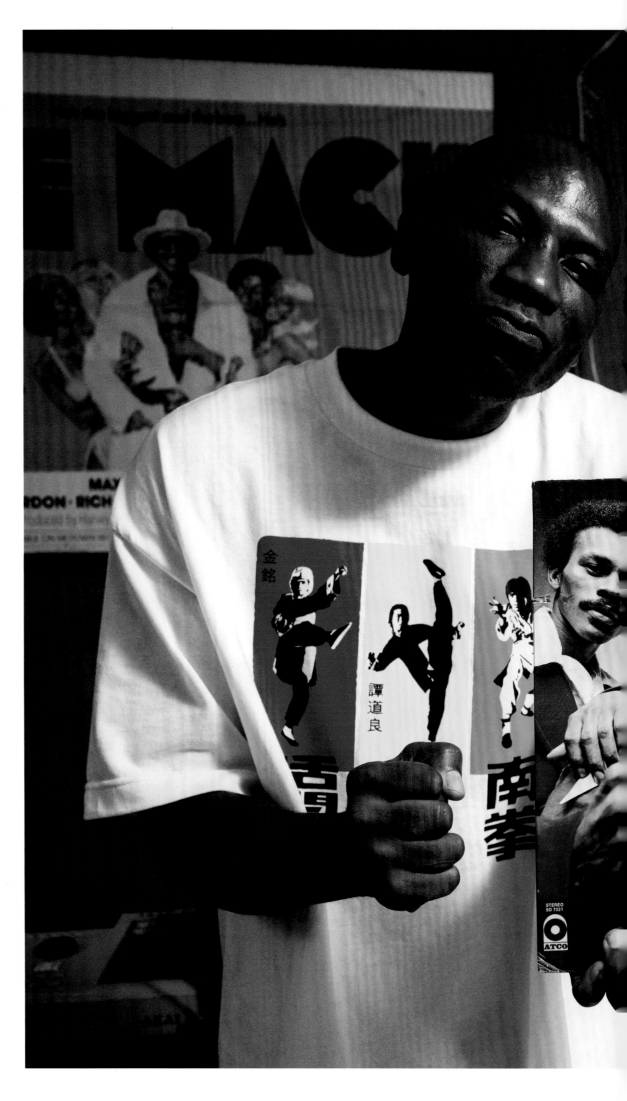

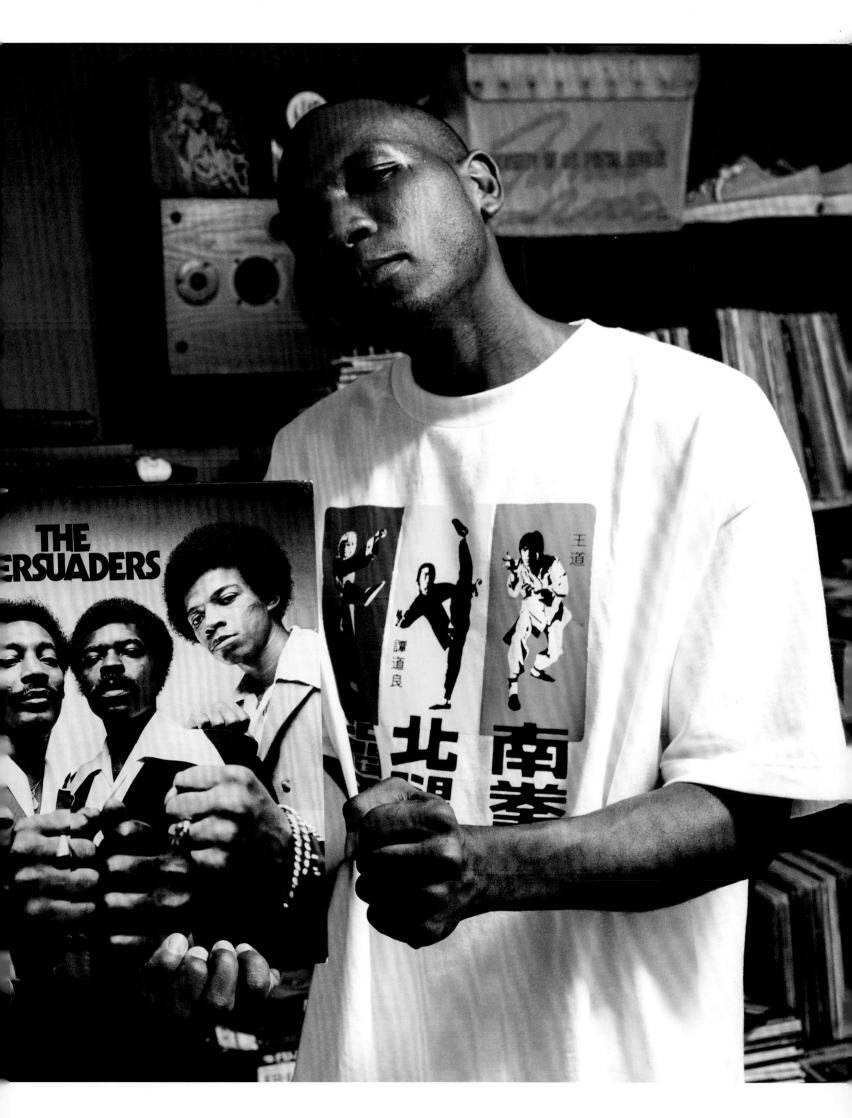

THE BAMBAATAA COLLECTION
Johan Kugelberg and the Boo-Hooray
staff, aided by volunteers, alphabetized
and organized Afrika Bambaataa's
43,000+ record collection to prepare it
for a move to Cornell University's Hip-Hop
History Archive.

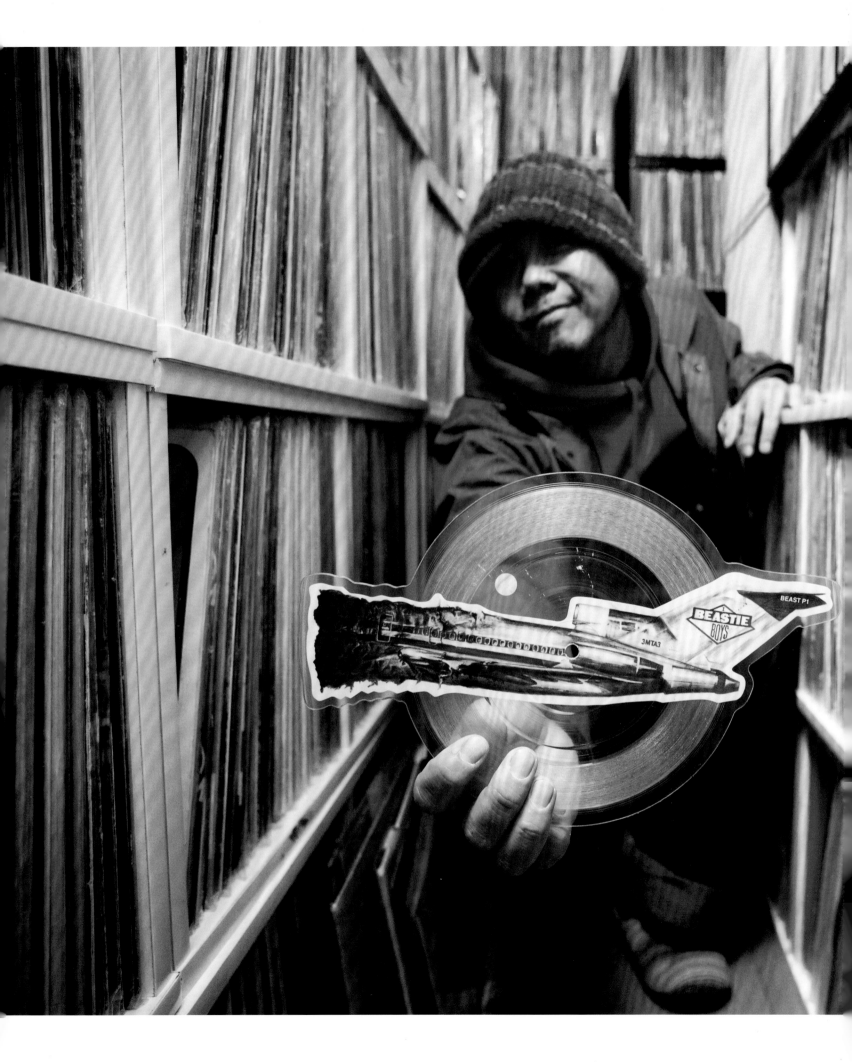

DJ MURO - TOKYO, JAPAN
The Beastie Boys'-"No Sleep Till
Brooklyn" (picture disc 45 single)

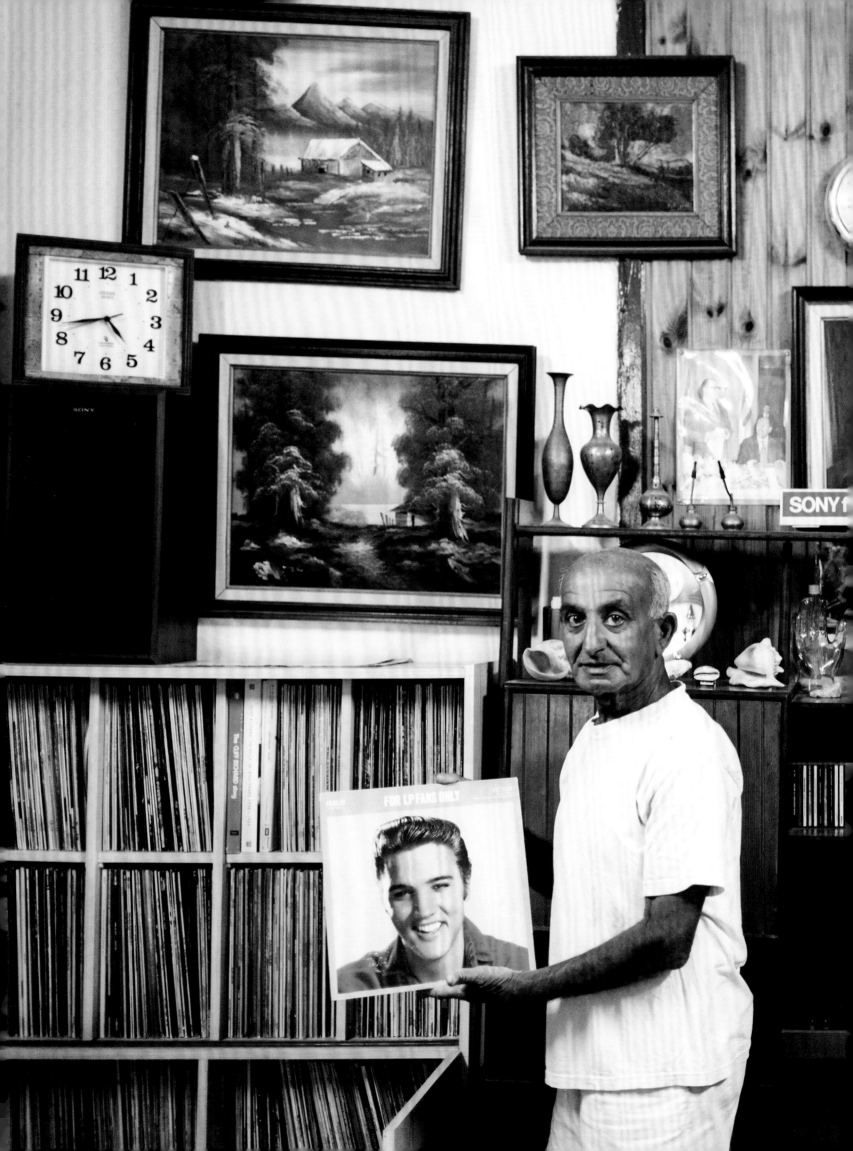

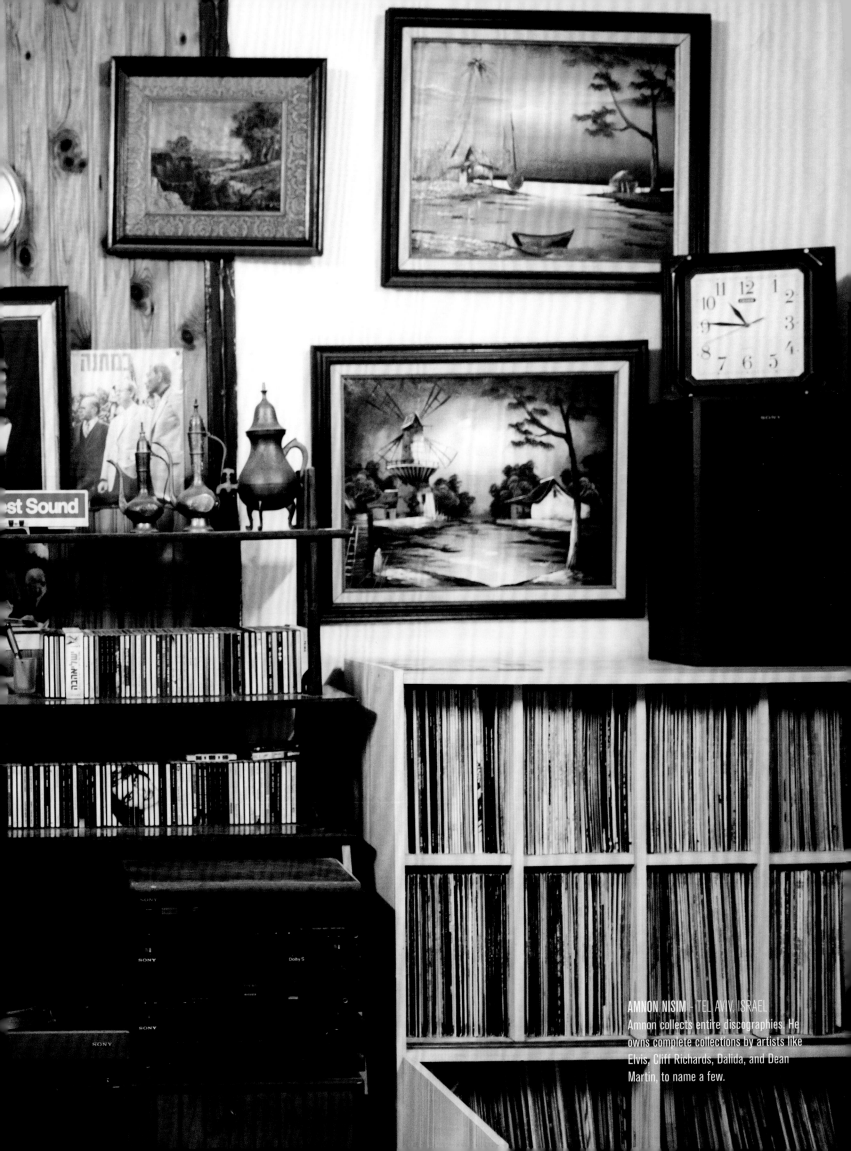

AMNON NISIM — TEL AVIV, ISRAEL
Amnon collects entire discographies. He owns complete collections by artists like Elvis, Cliff Richards, Dalida, and Dean Martin, to name a few.

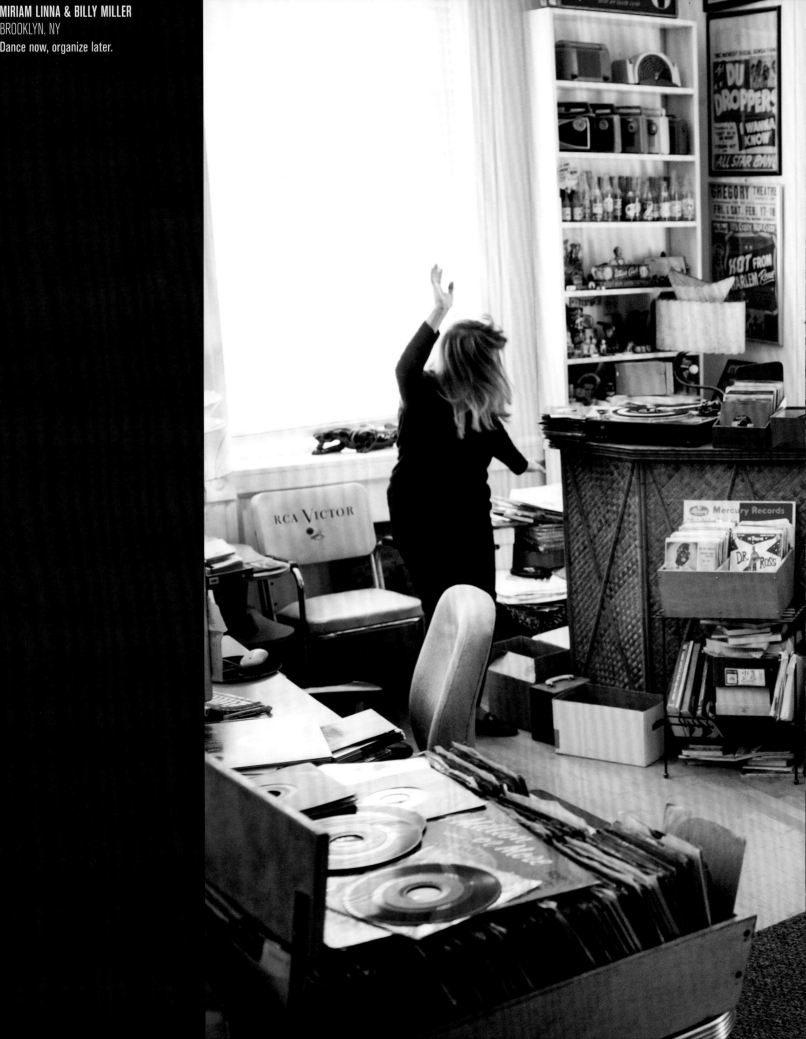

MIRIAM LINNA & BILLY MILLER
BROOKLYN, NY
Dance now, organize later.

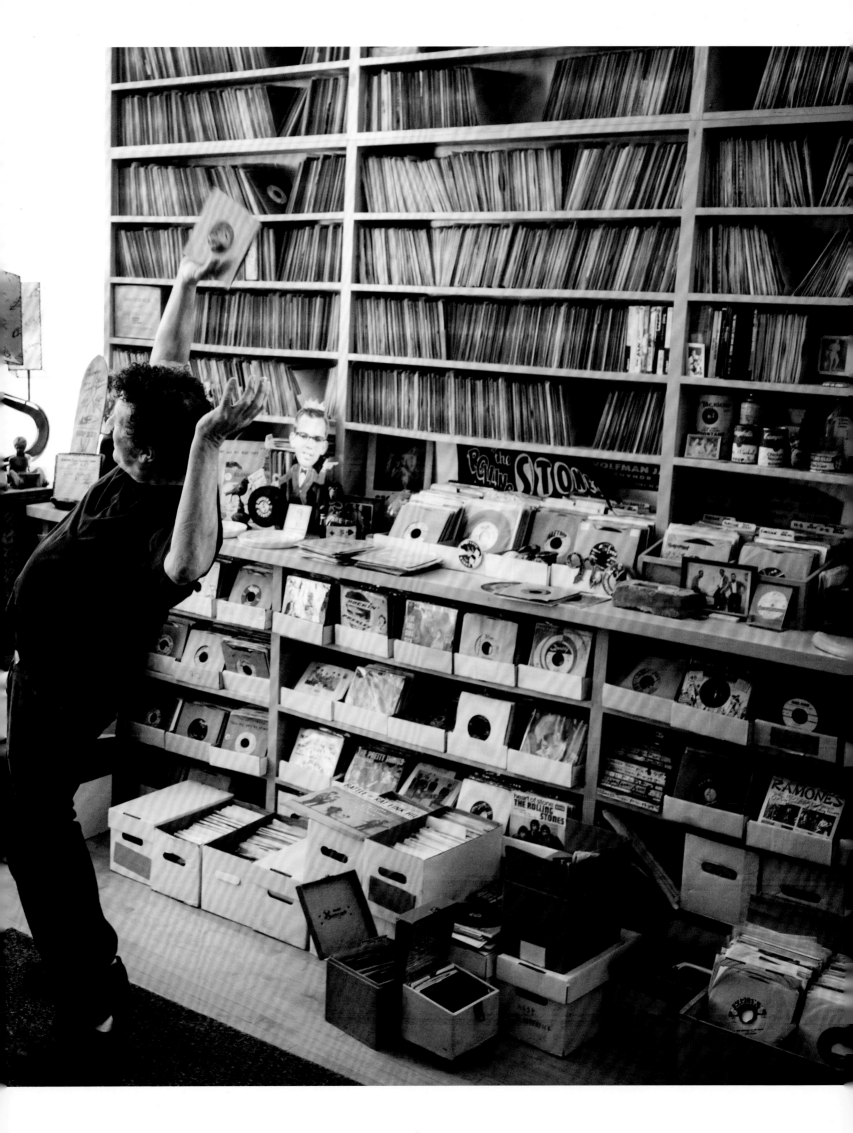

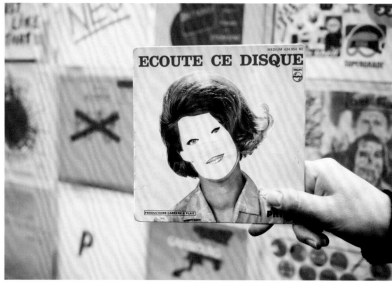
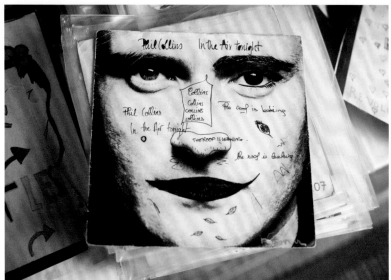
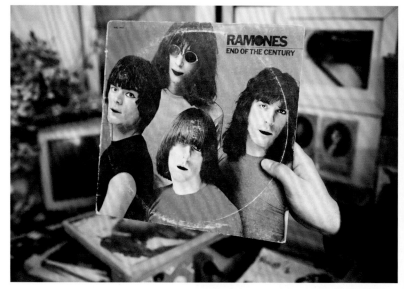
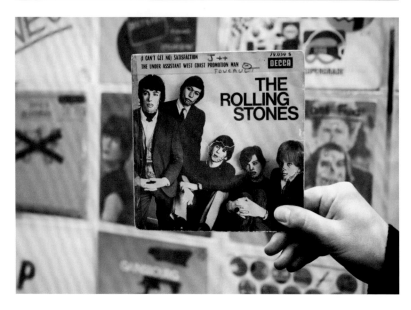
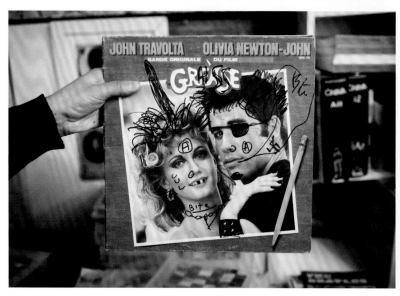

PATRICE CAILLET - PARIS, FRANCE
In his basement office, Patrice talks about his unusual collection of altered and defaced album covers.

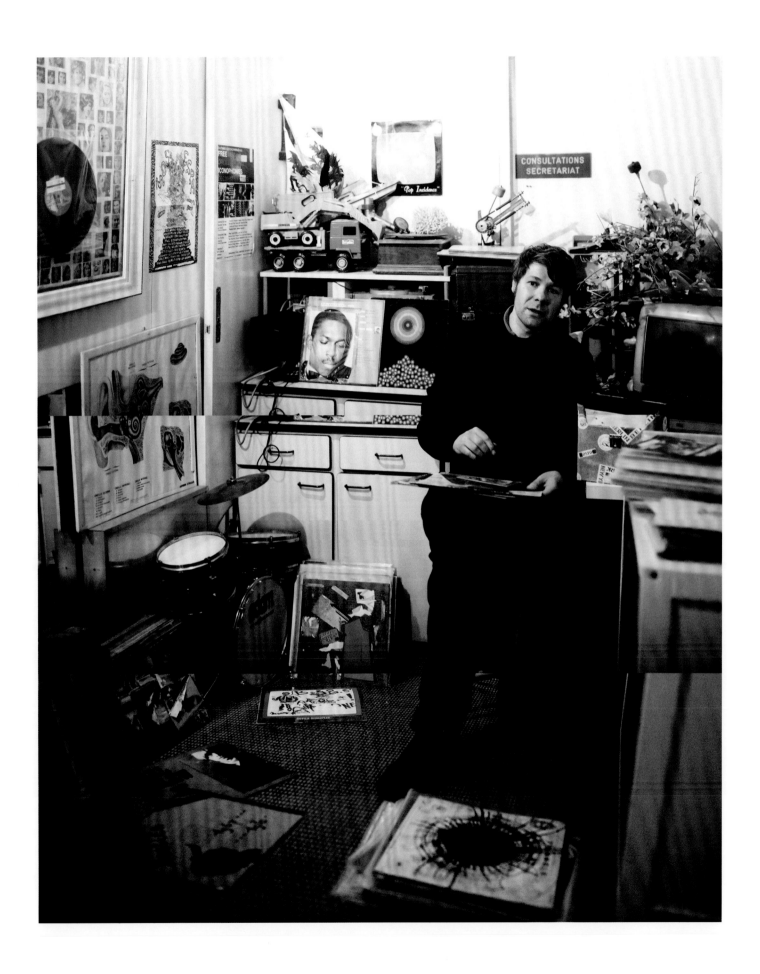

OFER TAL - RAMAT GAN, ISRAEL
**Israeli Armored Corps Variety
Ensemble -** *DiscoTank*
"This is an example of the music made by
military bands, which was very popular
in Israel until the mid-'70s. This album
includes rock-influenced music, moody
Mediterranean psychedelics, and uptempo
celebration songs. The cover drawing of
the soldiers having a party inside the tank
is disturbing and beautiful. One specific
track called 'Karev Yom' stands above all
the others and talks about Armageddon."

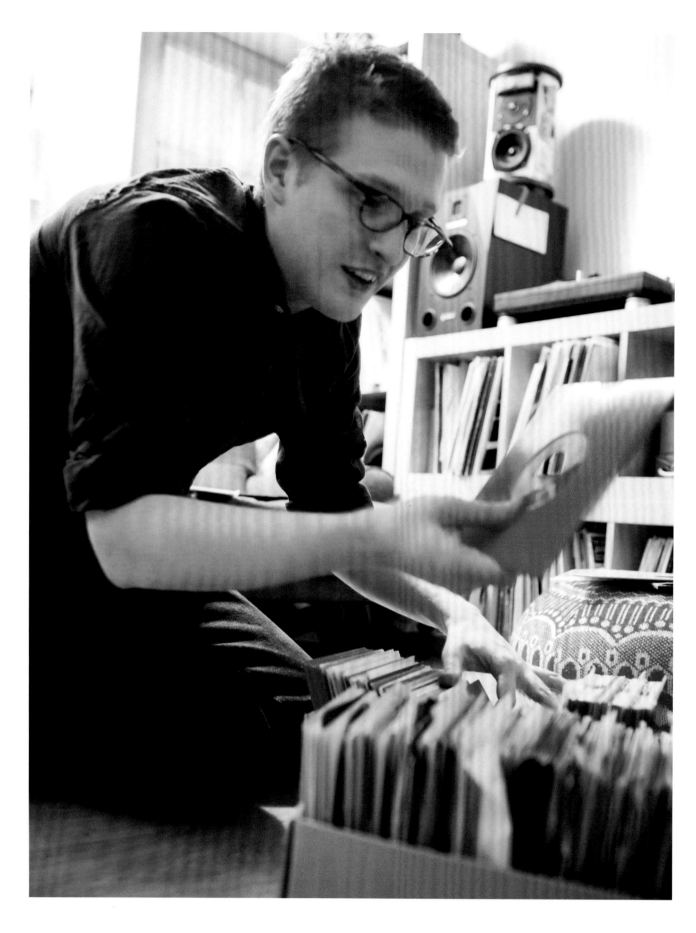

SAM "FLOATING POINTS" SHEPHERD - LONDON, UNITED KINGDOM
Aged in Harmony - "You're a Melody"
"I had been bugging everyone about this record, and finally my friend Jim sent me towards a friend of his who had two copies! Mission complete! That night I played this record five times at the party I do at Plastic People."

"The mixer is an E&S DJR 400. I use it for my touring gigs because
it's light, sounds decent, and is a lot of fun to use."

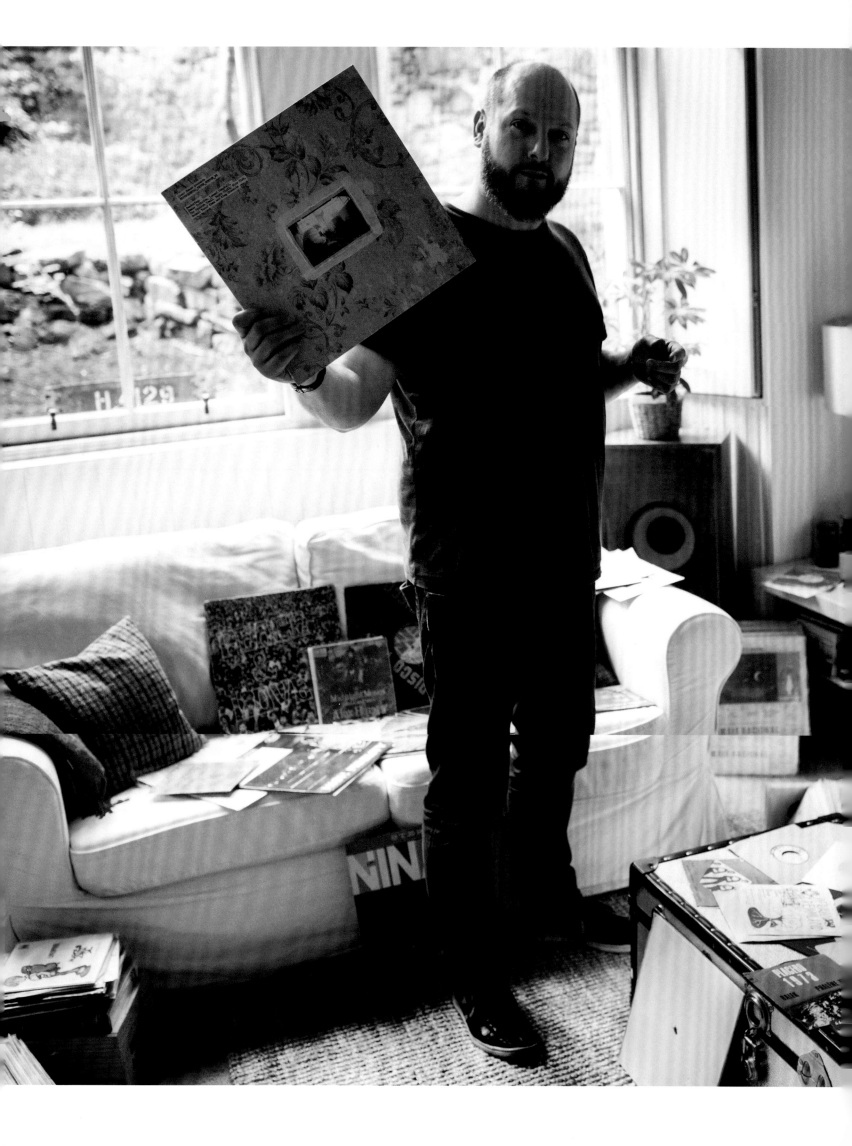

STEPHEN MARSHALL - EDINBURGH, SCOTLAND
Experimental Batch No. 26
"This is a pretty rare record by a group of folk collaborators—King Creosote, Lomond Campbell, James Yorkston, Suhail Yusuf Khan, and more, and was produced by Scottish legend Paul Savage. It was recorded in one week in Edinburgh. I especially love the photography by Sean Dooley, taken with an ancient long-exposure camera."

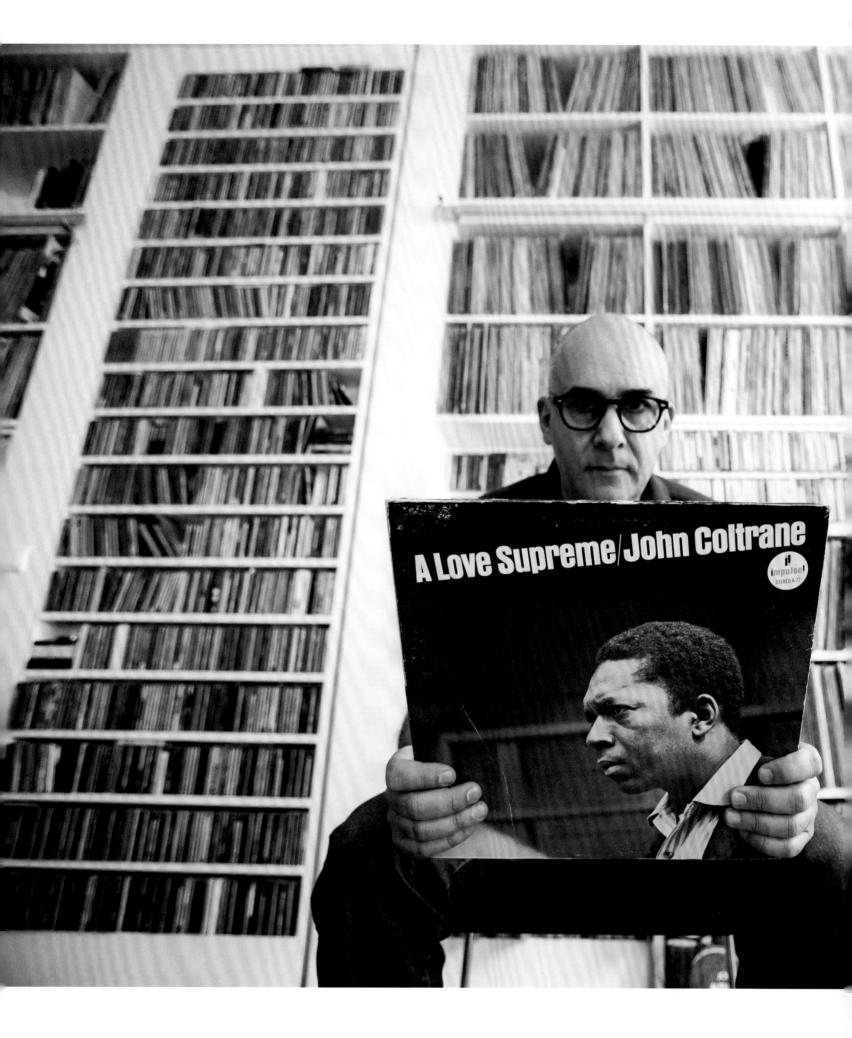

JOAQUIM PAULO - LISBON, PORTUGAL
John Coltrane - *A Love Supreme*
"This is the record of my life, my favorite album. I'm holding an original Impulse! Records pressing. I bought my first copy of this record in 1980; now I have several copies and one sealed original pressing."

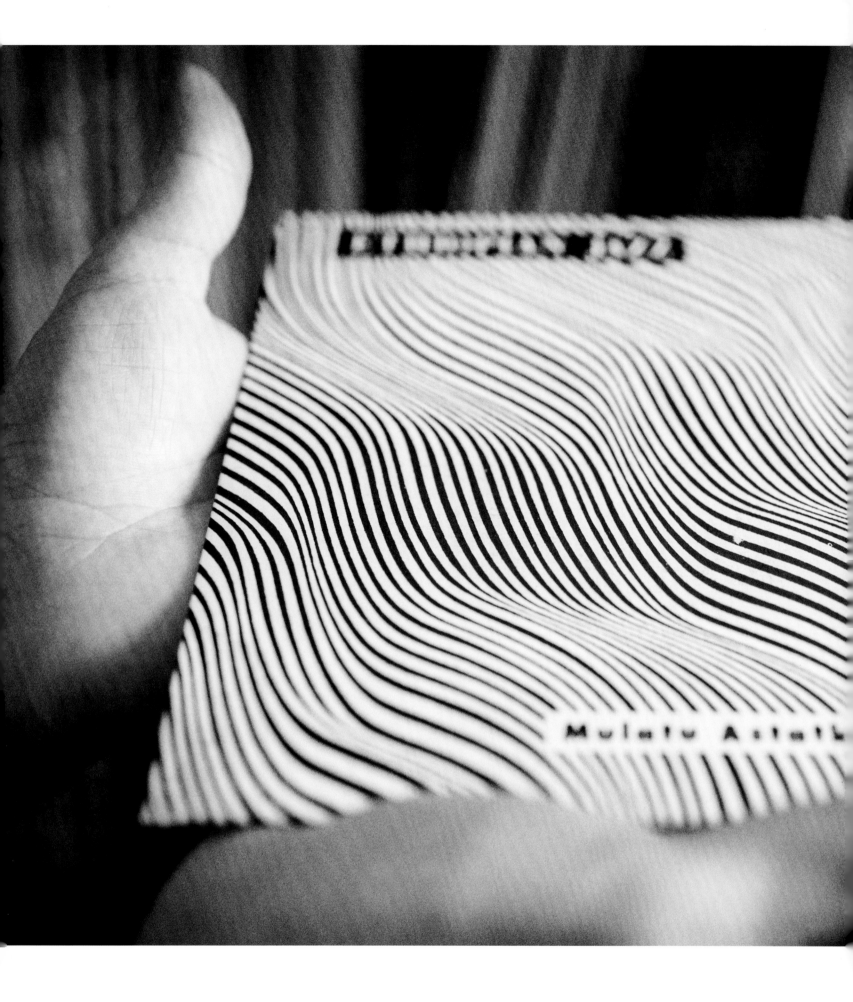

DANNY AKALEPSE - BROOKLYN, NY
Mulatu Astatke Quartet - *Maskaram Setaba* EP

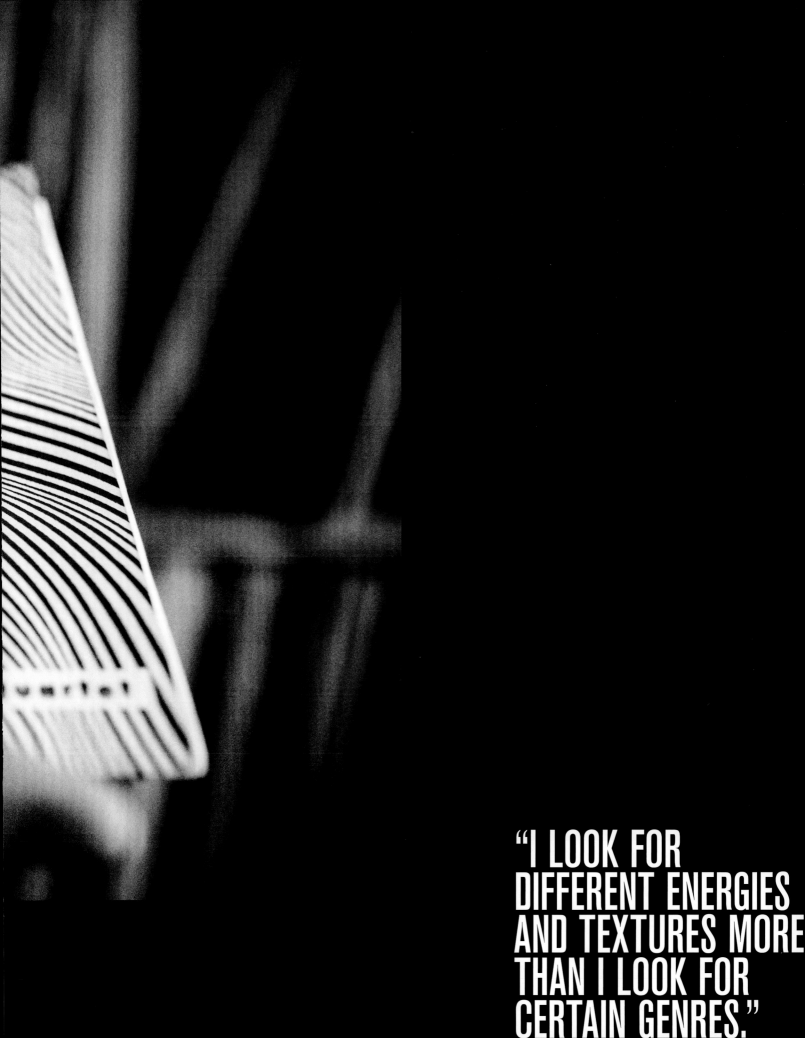

"I LOOK FOR
DIFFERENT ENERGIES
AND TEXTURES MORE
THAN I LOOK FOR
CERTAIN GENRES."

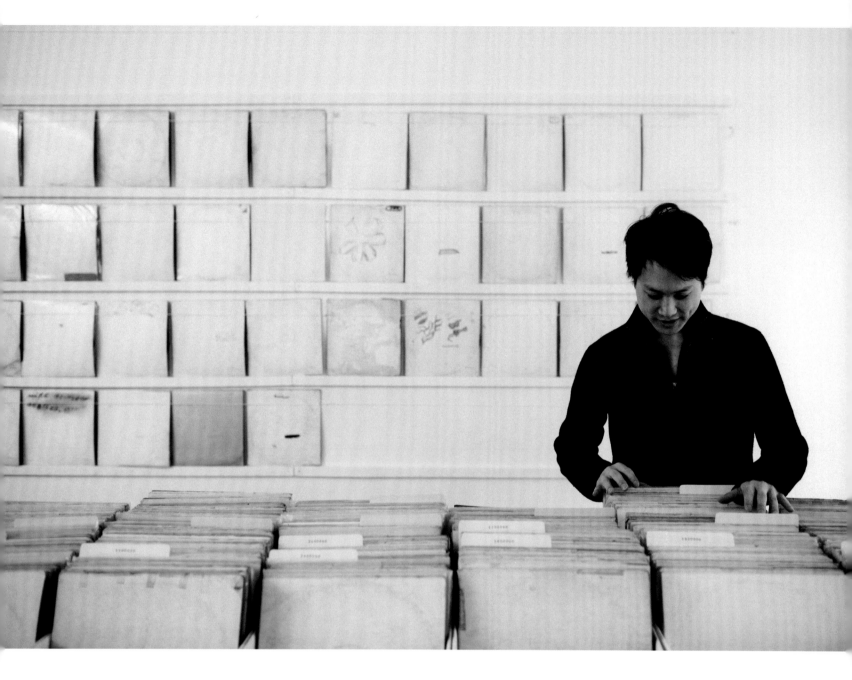

"THE WHITE CANVASES HAVE BEEN PERSONALIZED WITH EVERYTHING FROM SCRIBBLED NAMES TO ELABORATE PAINTINGS. I KEEP WONDERING IF RICHARD HAMILTON FORESAW THAT ALL THIS WOULD HAPPEN TO THE COVERS WHEN HE DESIGNED IT BACK IN 1968."

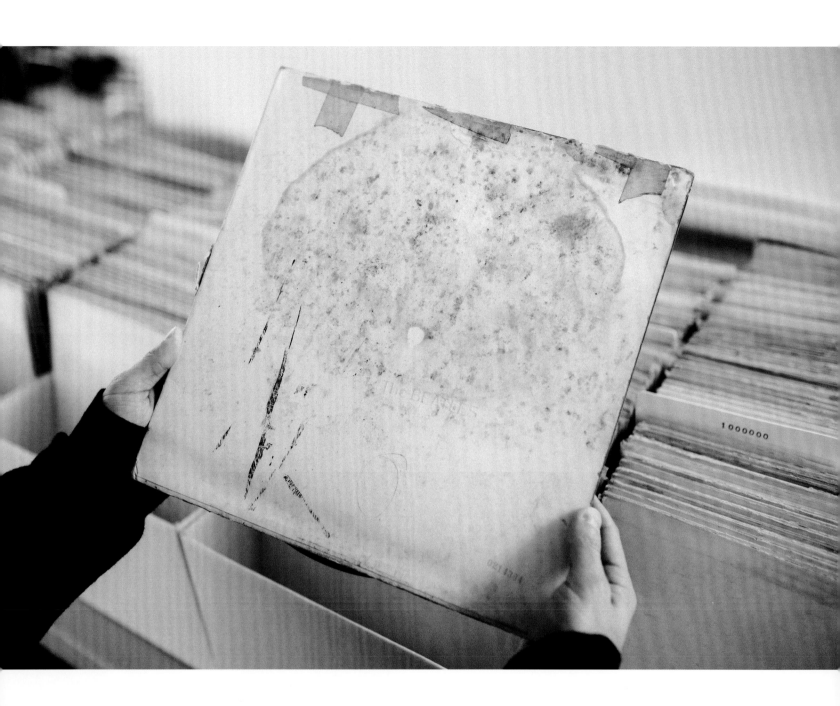

RUTHERFORD CHANG - NEW YORK, NY
"Rutherford Chang: We Buy White Albums" art installation

OLIVER "O-DUB" WANG - LOS ANGELES, CA

"WHEREAS OTHER MUSICAL MEDIA GENERALLY HIDE THE MECHANISMS THAT RE-CREATE MUSIC, WITH VINYL IT'S ALWAYS THERE IN FRONT OF YOU."

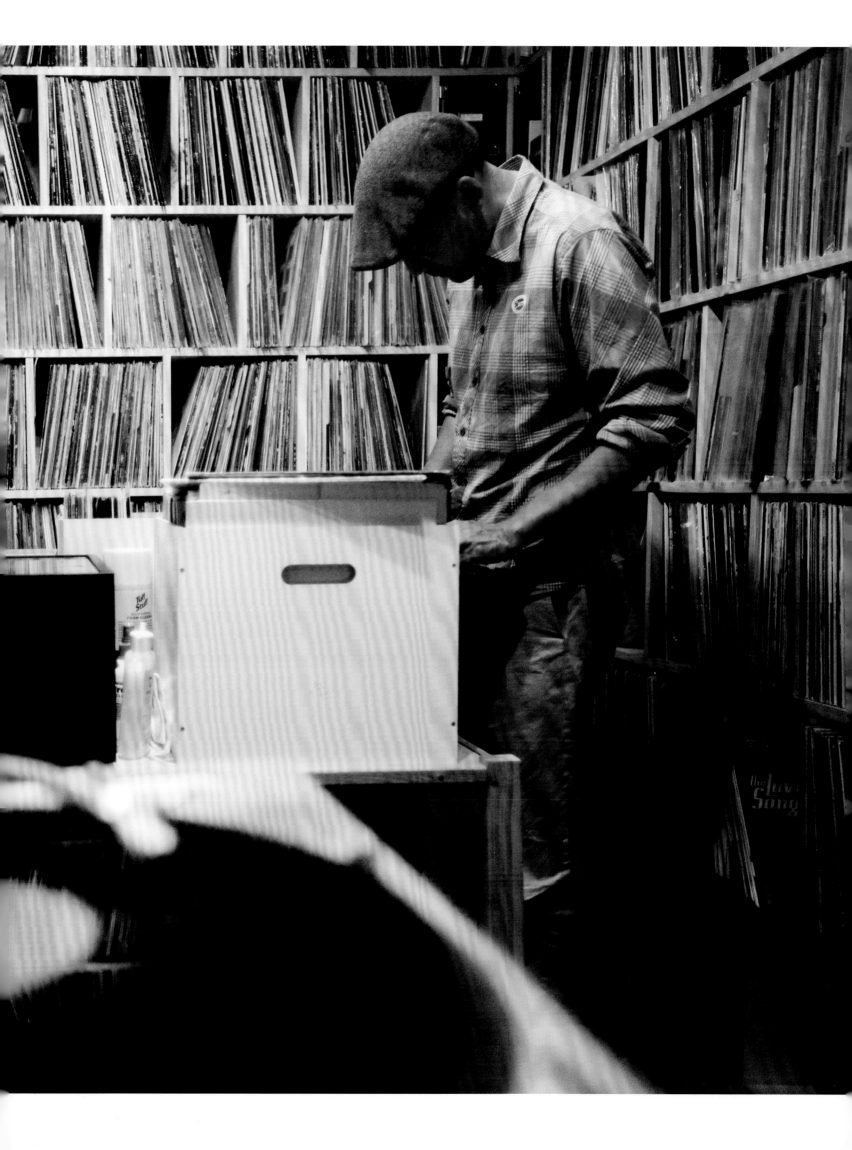

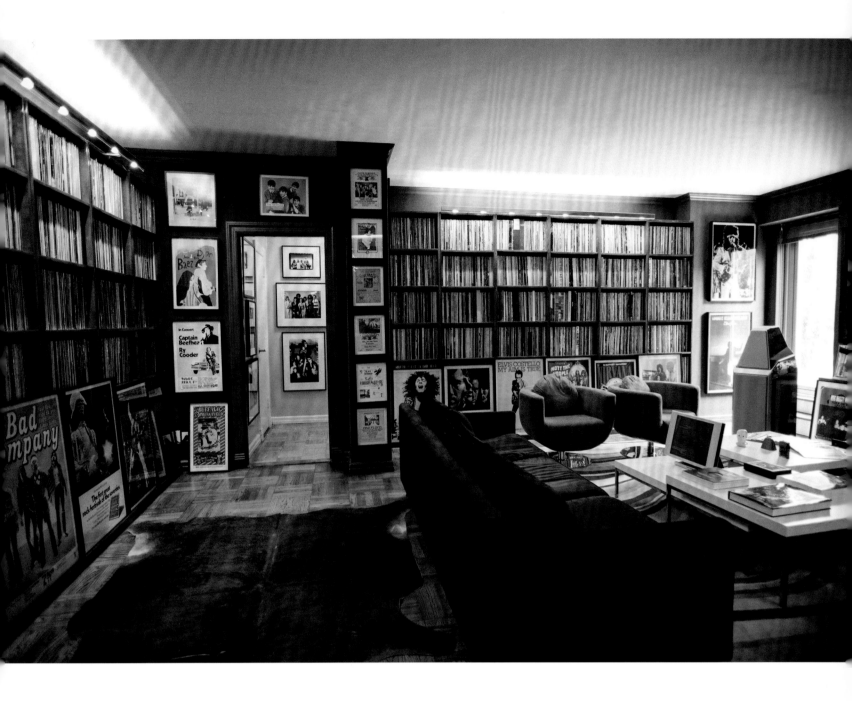

CRAIG KALLMAN - NEW YORK, NY

"This is my listening room, a great source of inspiration for me. Being surrounded by the artists I love brings me back to all those days when, as a kid, I'd rush home from the record store with a new album and would study the credits and marvel at the cover art while I listened to it from start to finish."

Tony Sheridan and the Beat Brothers - "My Bonnie"
"The Beatles' very first appearance on vinyl in America was as the backing band for Tony Sheridan. It's always fascinating to go back to the origins of an artist and try and understand their evolution."

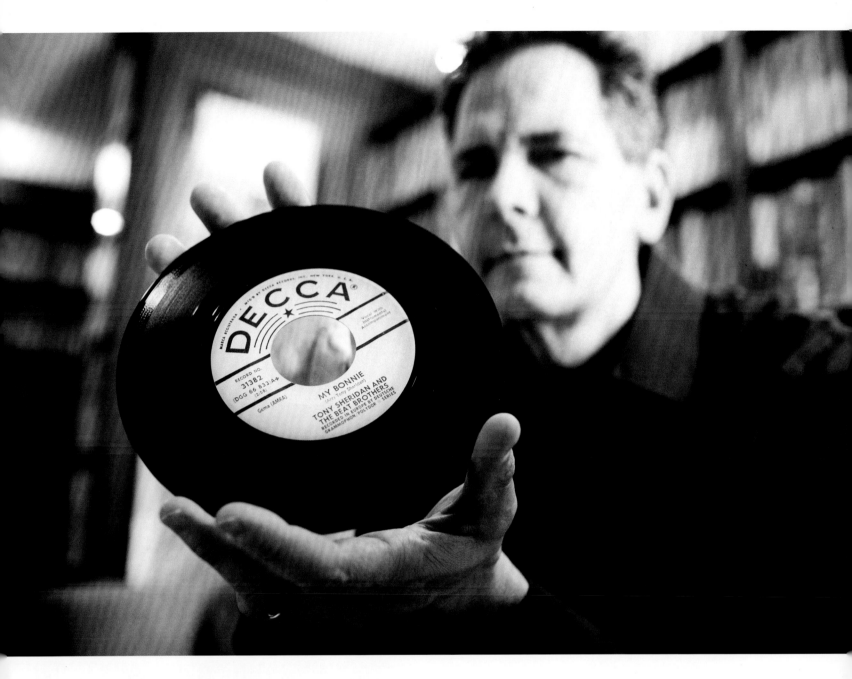

"THE MUSIC INDUSTRY DECLARED VINYL DEAD. FROM THAT MOMENT ON, I HAD TO FIND EVERYTHING I LOVED ON VINYL BEFORE IT DISAPPEARED."

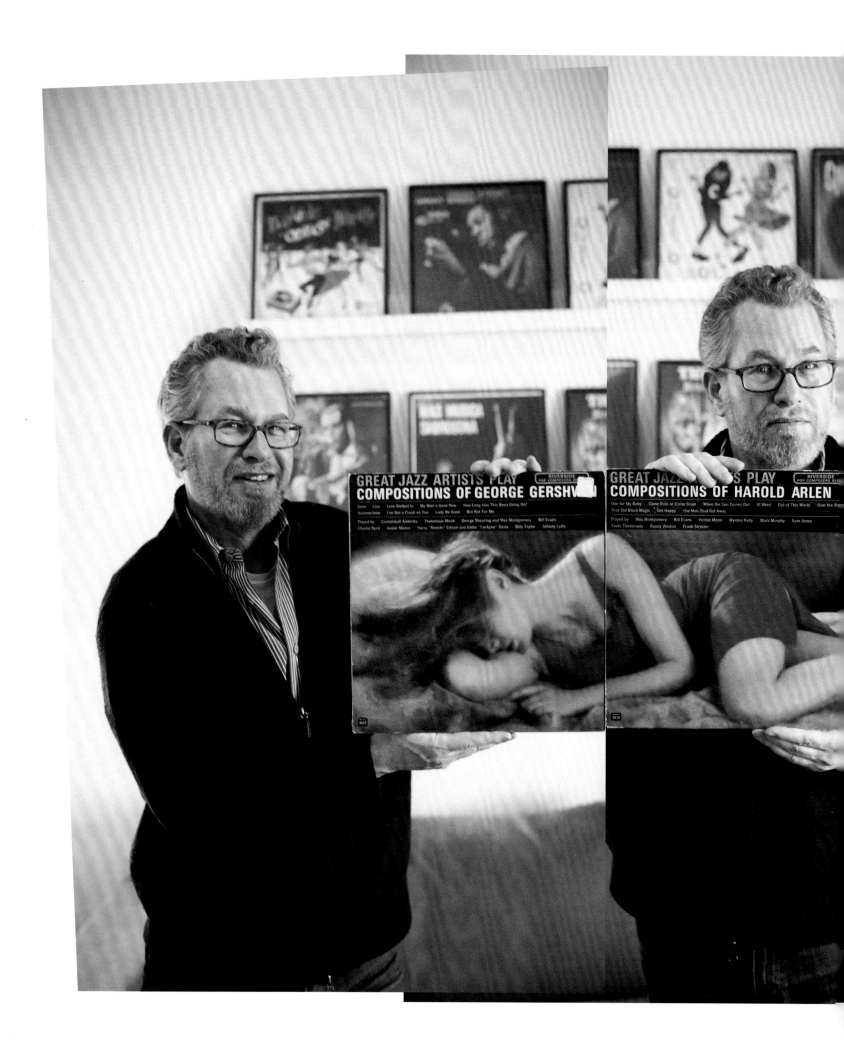

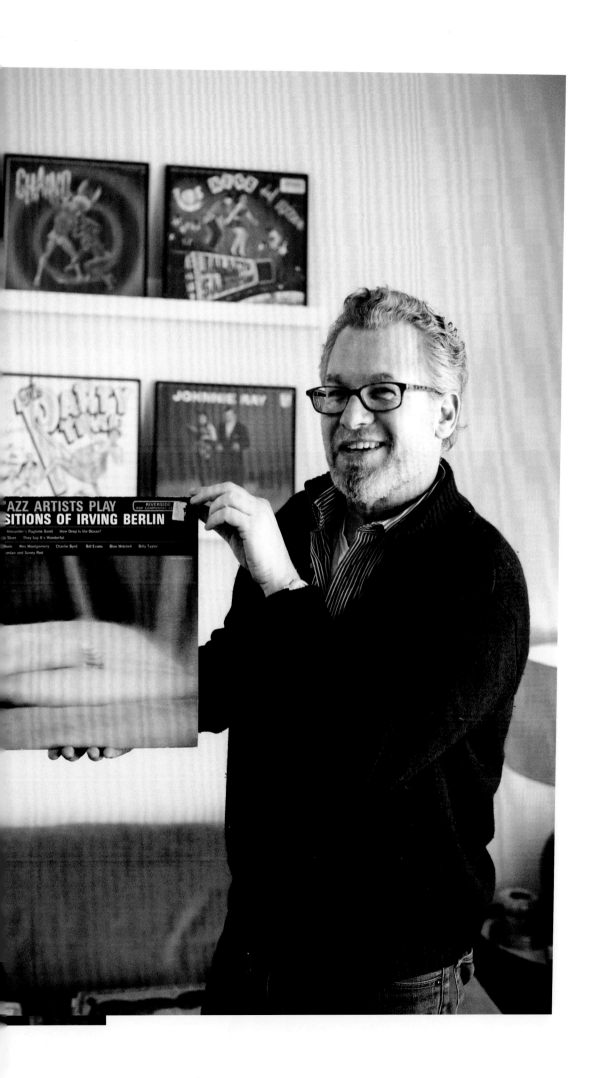

MATTHEW GLASS - NEW YORK, NY
Riverside Records marketing catalog
"This cover puzzle is one of three put
out by Riverside Records to market the
label's incredible catalog of jazz versions
of Great American Songbook classics.
The series included nine records, each
with a piece of a sexy babe to put
together. What a package!"

VICTOR KISWELL - PARIS, FRANCE
Floh De Cologne - *St. Pauli Nachrichten*
"Salacious stories over psychedelic and groovy organ sounds, sold at German sex shops.
Among the tracks are some great krautrock tunes and the intense "Sexologie" by Rita,
overdubbed with screaming animals. Wild!"

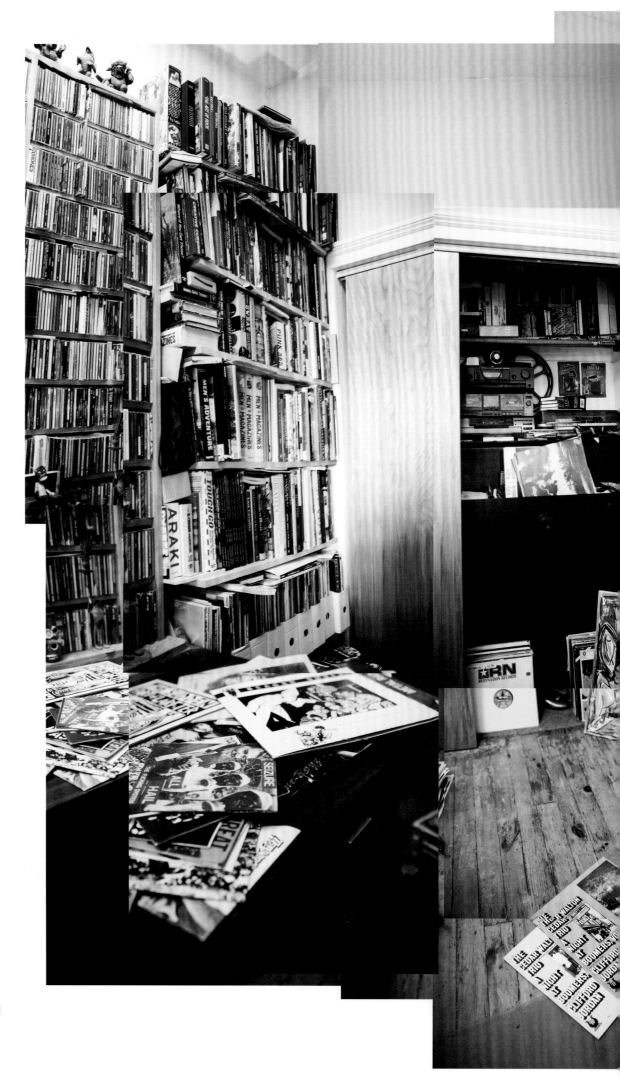

NOAH UMAN - JERSEY CITY, NJ
"This is my cozy corner! There are so many things in this photo that are dear to me and sum up a large part of my life. My cat, Chavo; three jazz LPs that were recorded in the 1970s at my dad's club, Boomers; a promo poster for a Queen Latifah 12-inch that my brother painted; a painting by Billy Childish; a Vaughn Bode print; several hardcore records; and an LP by my all-time favorite musicians, Milt Jackson and Coleman Hawkins."

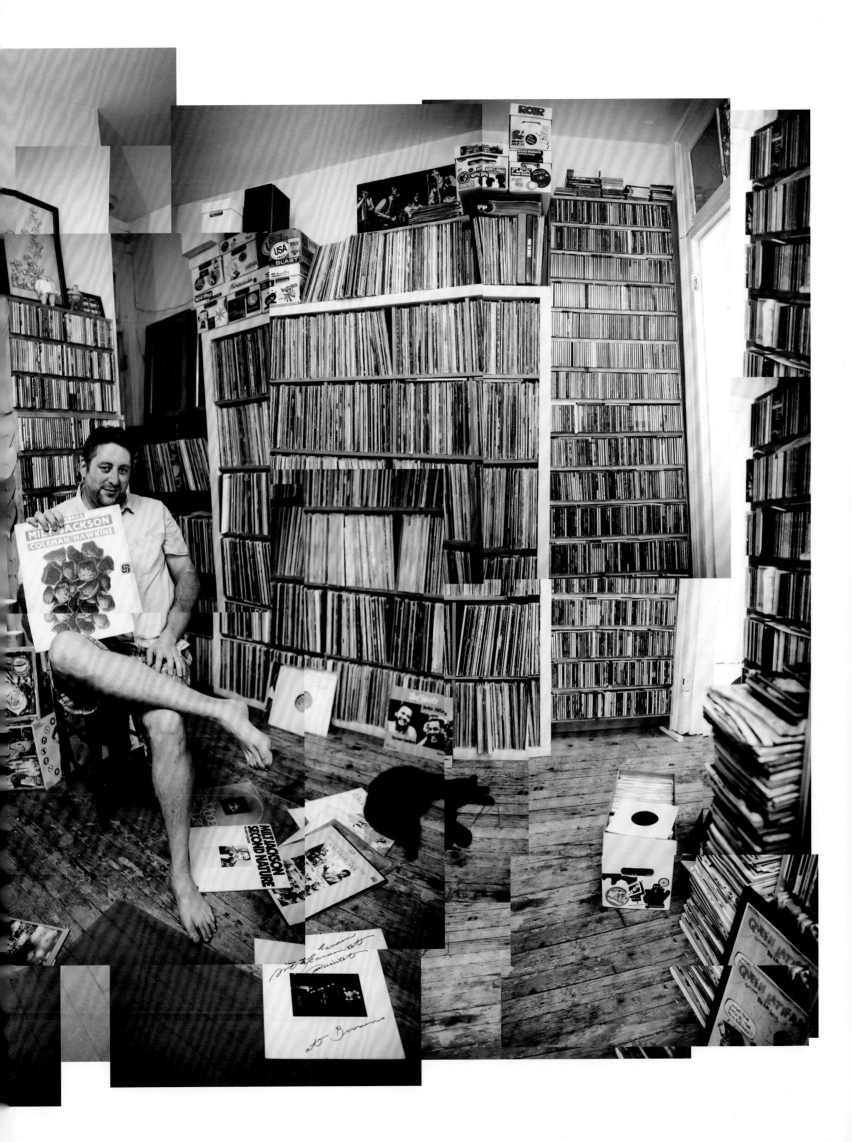

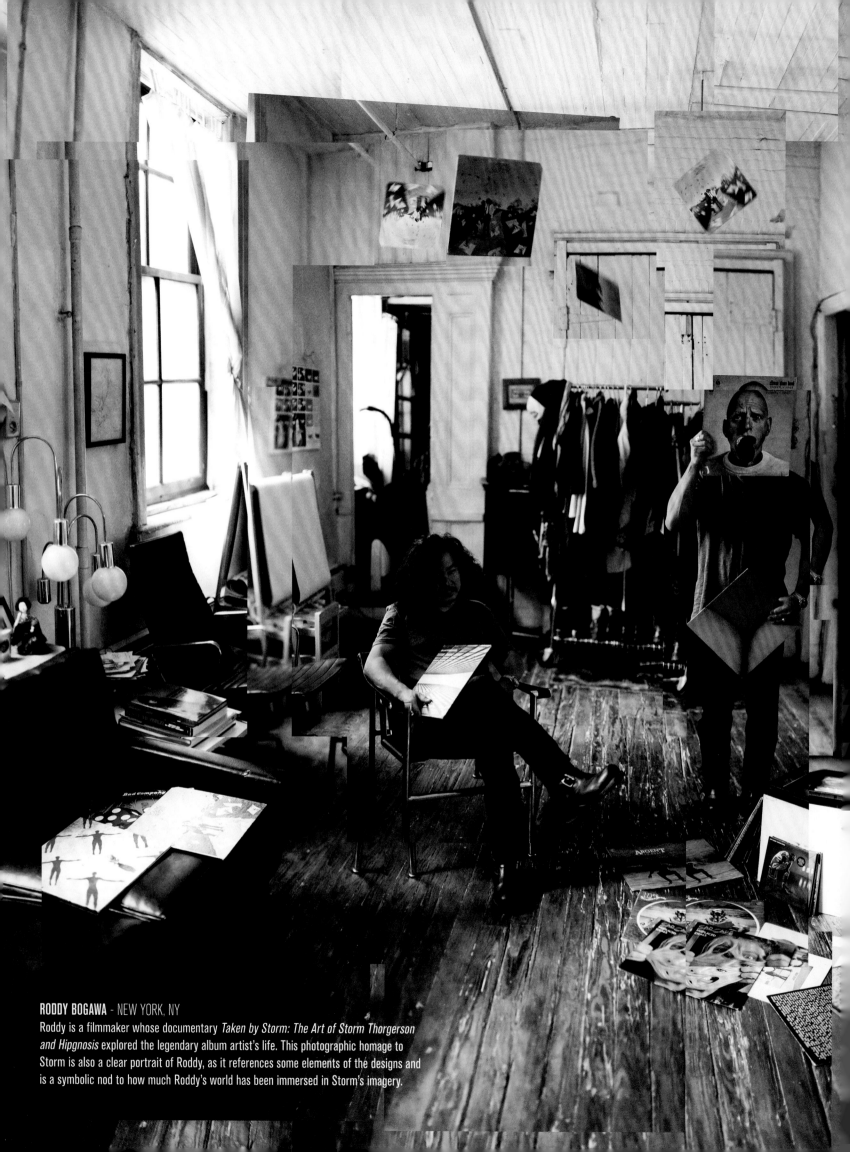

RODDY BOGAWA - NEW YORK, NY
Roddy is a filmmaker whose documentary *Taken by Storm: The Art of Storm Thorgerson and Hipgnosis* explored the legendary album artist's life. This photographic homage to Storm is also a clear portrait of Roddy, as it references some elements of the designs and is a symbolic nod to how much Roddy's world has been immersed in Storm's imagery.

"WE SHOULD FEEL LUCKY FOR THE STUFF THAT SURVIVES THE GNAWING TEETH OF TIME."

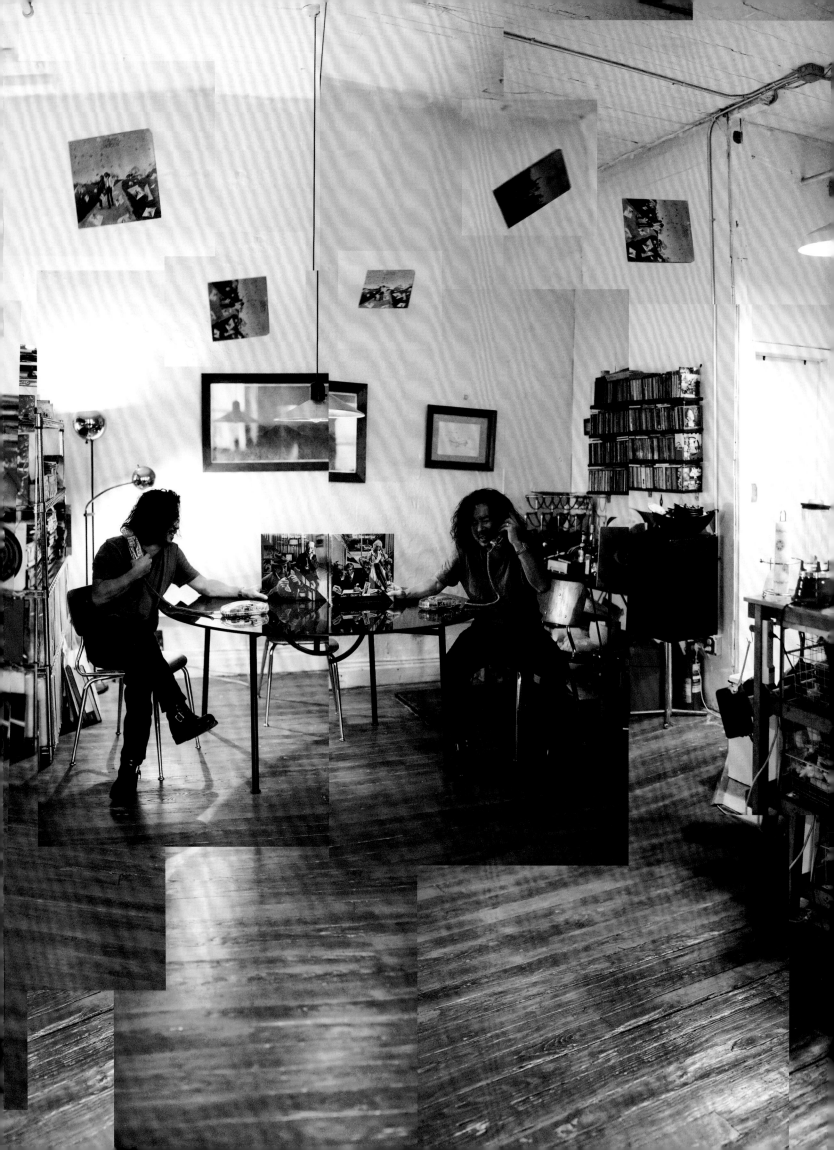

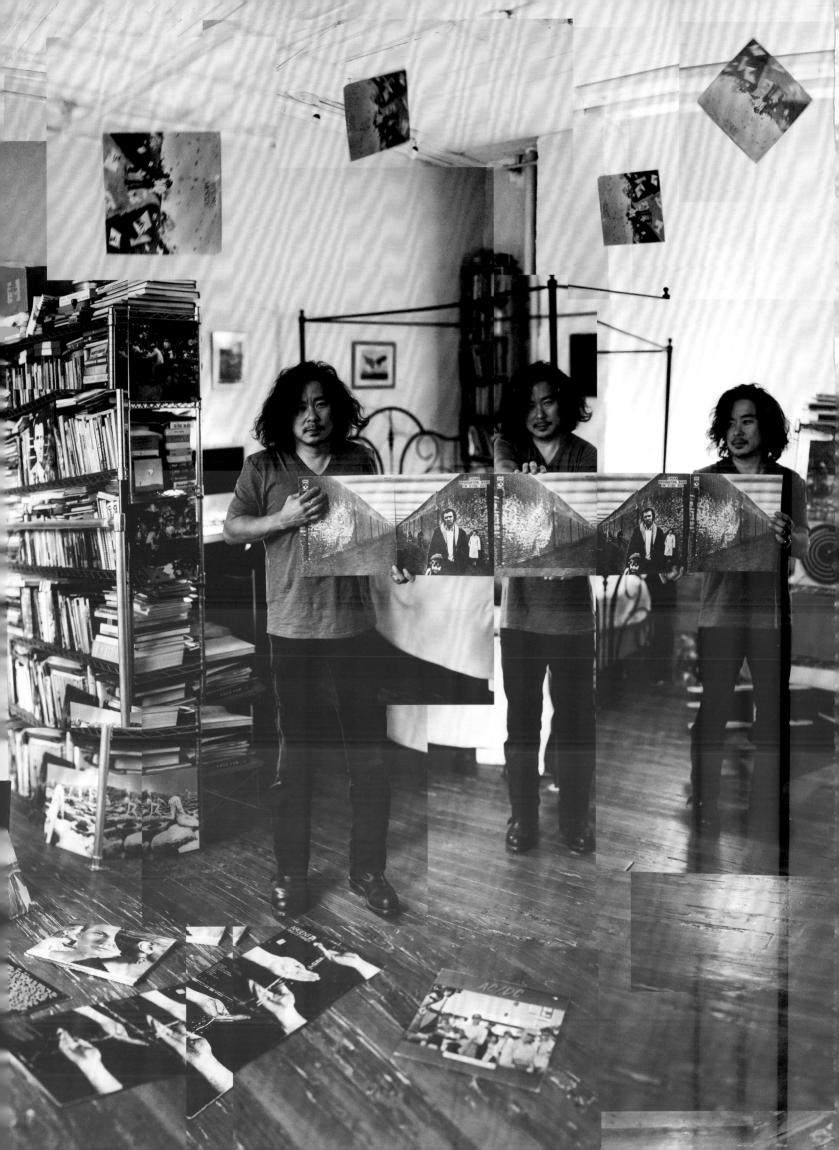

JOHAN KUGELBERG - NEW YORK, NY
"A few generic sleeves from private pressings. During the process, the recording artist was provided with a choice of sleeve designs, on top of which they could then add their text."

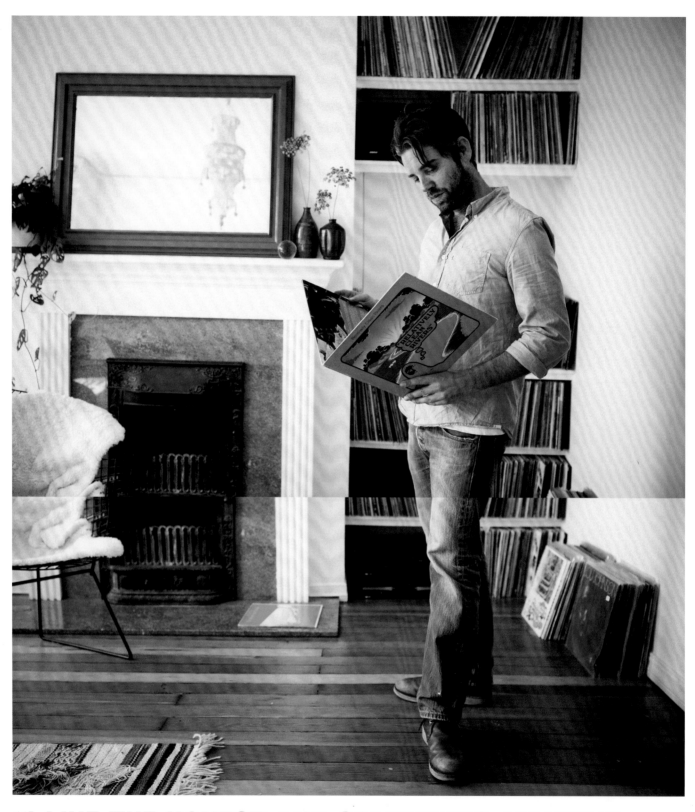

"I LIKE THE HONEST AND SOMETIMES AMATEUR SINCERITY OF A PRIVATE PRESS LP AS MUCH AS THE PRODUCED POLISH OF A MAJOR LABEL EFFORT."

CHRIS VELTRI - SAN FRANCISCO, CA
Relatively Clean Rivers - *Self-titled*

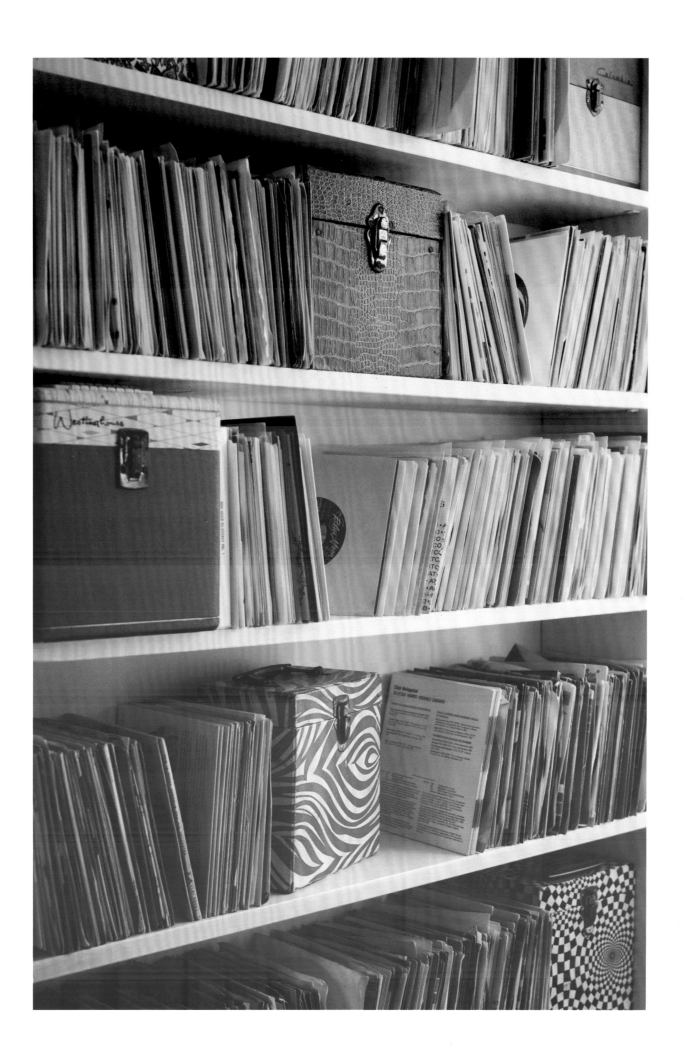

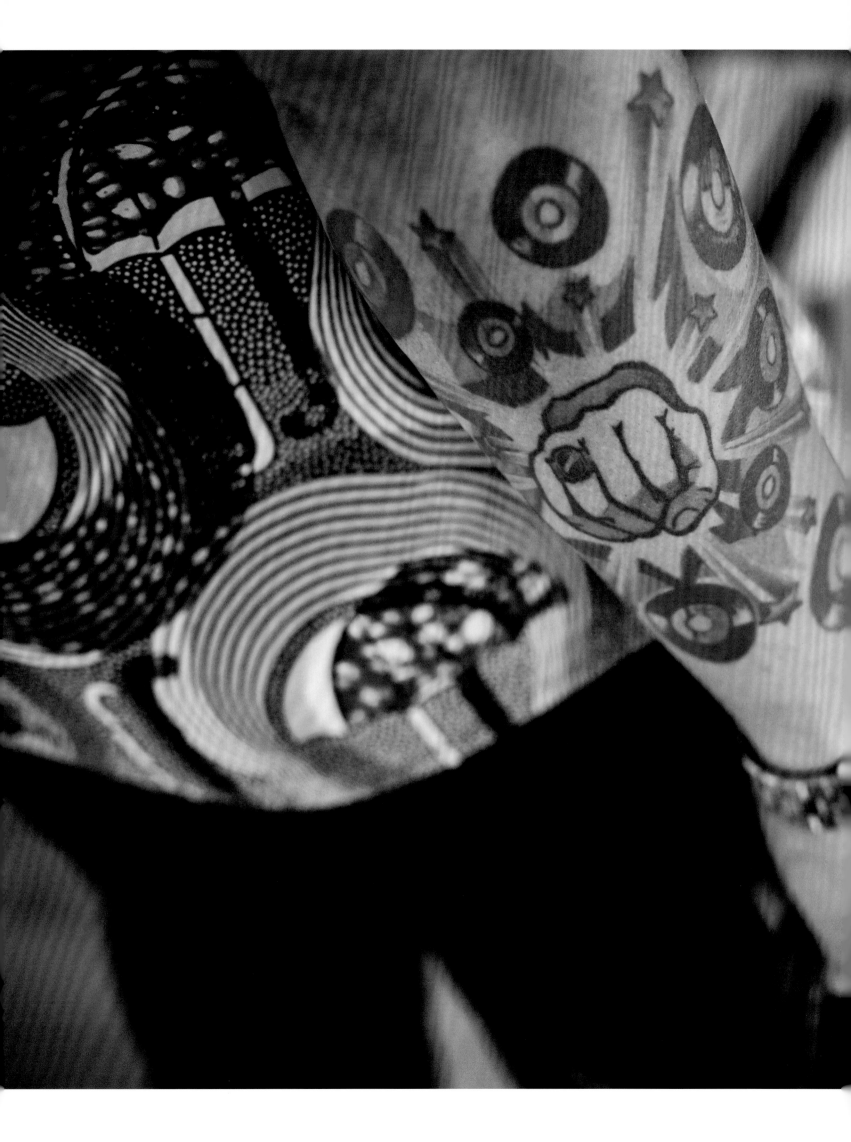

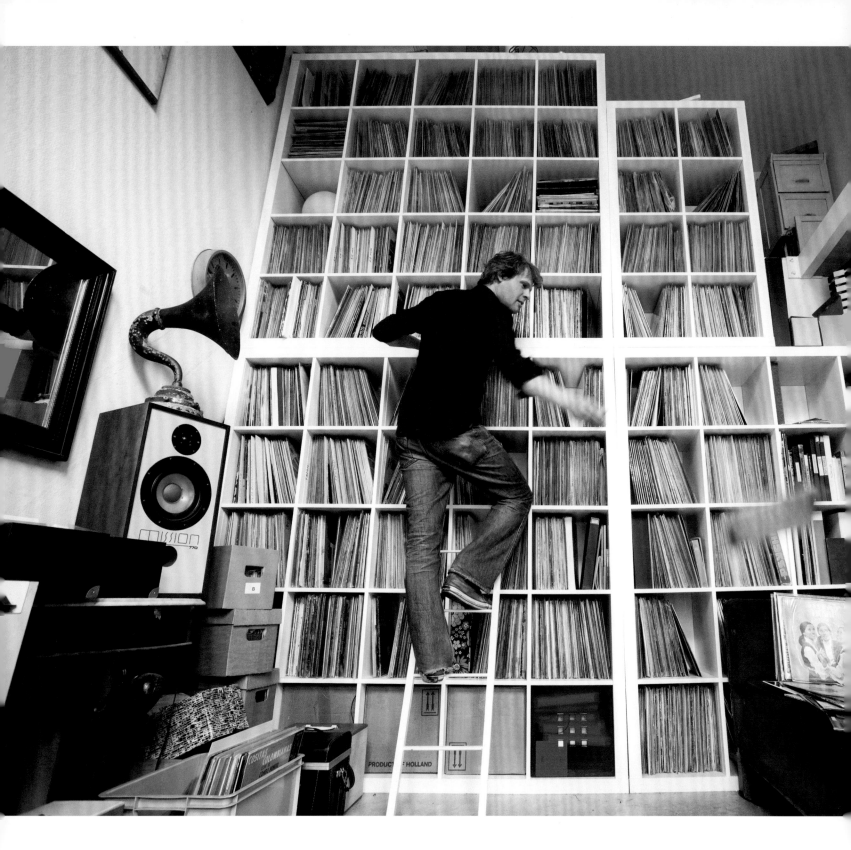

EDO BOUMAN - AMSTERDAM, THE NETHERLANDS
"Climbing in my Amsterdam apartment and pulling out some records from my Bollywood archive."

Ilaiyaraaja - *Sakalakala Vallavan*
"This is the soundtrack to a 1982 Tamil disco flick by brilliant South Indian composer Ilaiyaraaja."

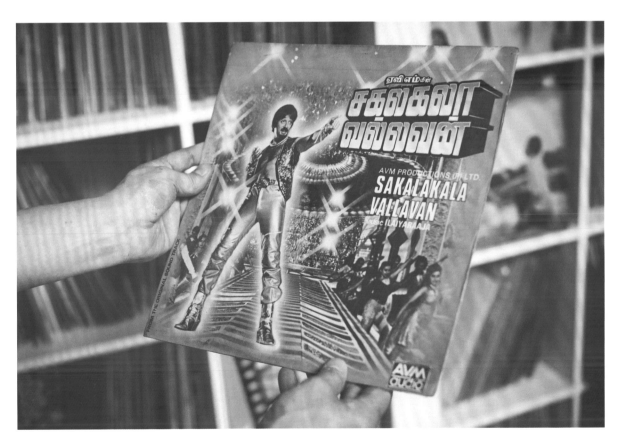

SUPREME LA ROCK - SEATTLE, WA
Ultramagnetic MCs - "Give the Drummer Some"
Marley Marl - "He Cuts So Fresh"
X-Clan - "Funkin' Lesson"
Chill Rob G - "Let the Words Flow"
"Sitting in front of one of the walls in my collection holding four
rare rap 7-inches. I picked these not only because they all have
picture sleeves, but because a lot of hip-hop DJs try to argue with
me over their very existence."

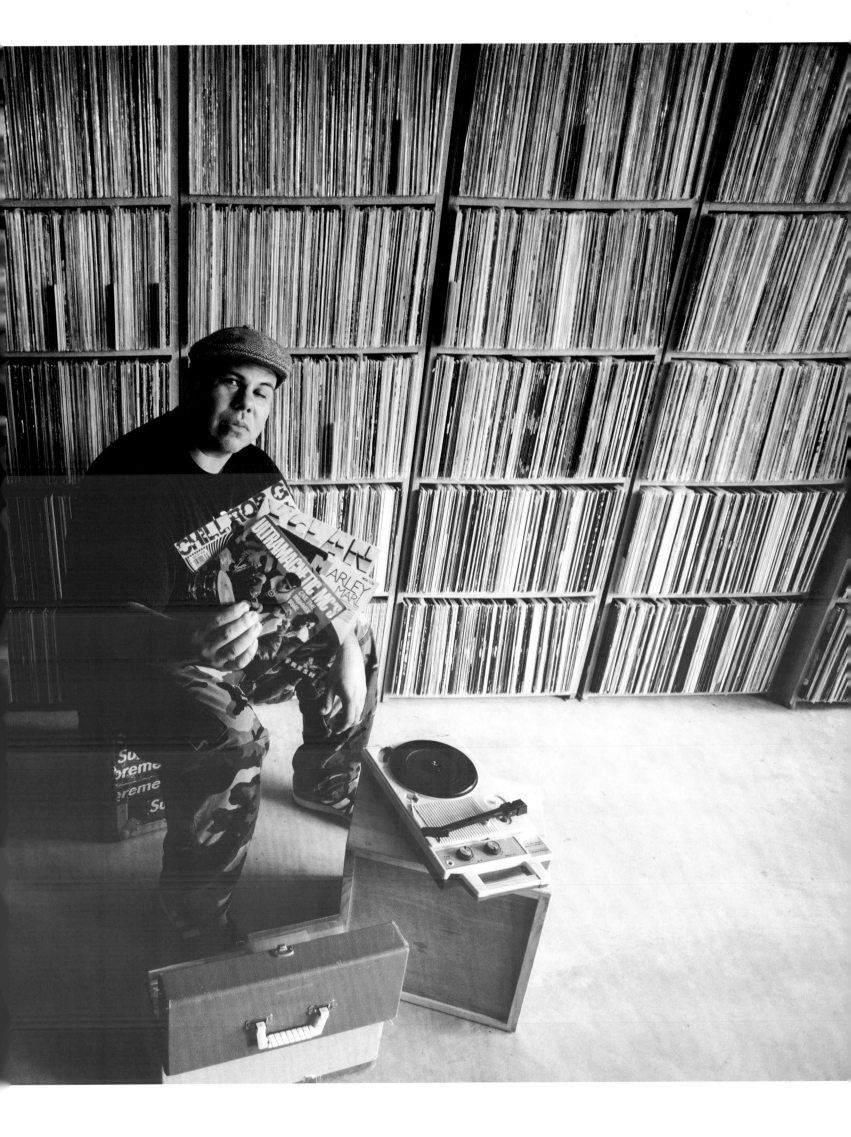

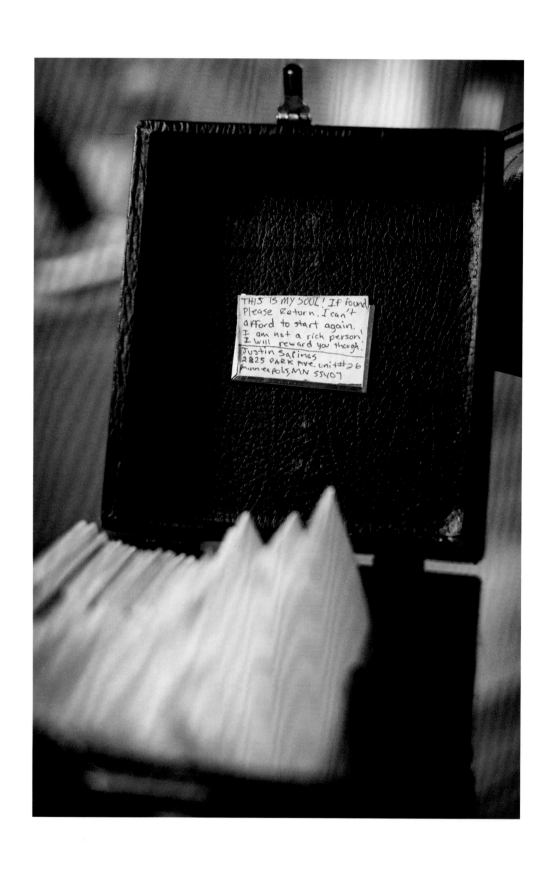

JUSTIN "RAMBO" SALINAS - MINNEAPOLIS, MN
"One of my precious 45 boxes with a special note attached."

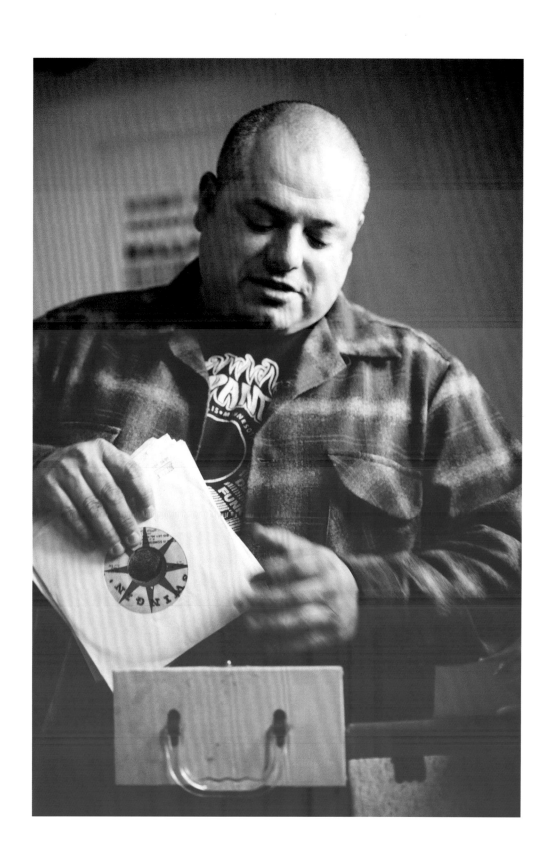

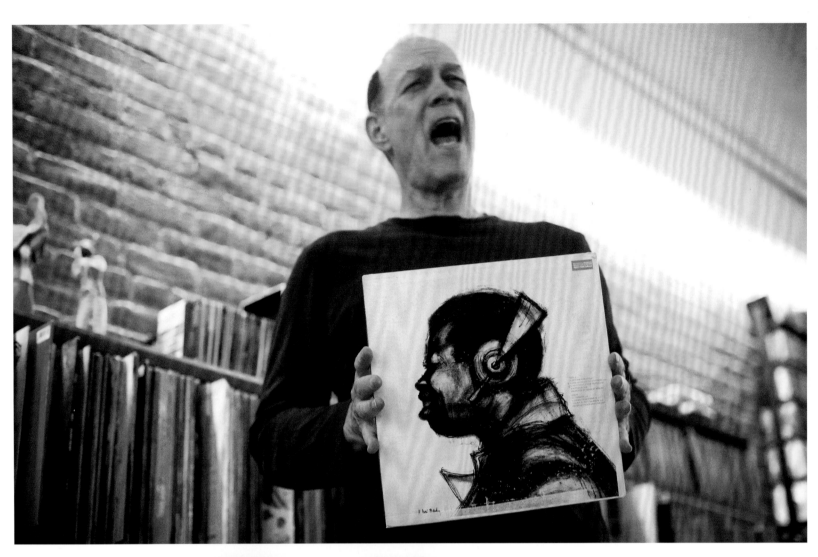
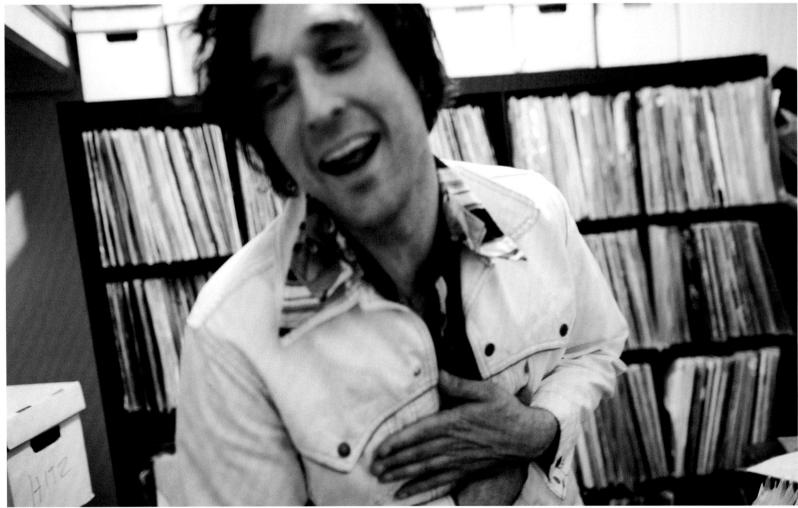

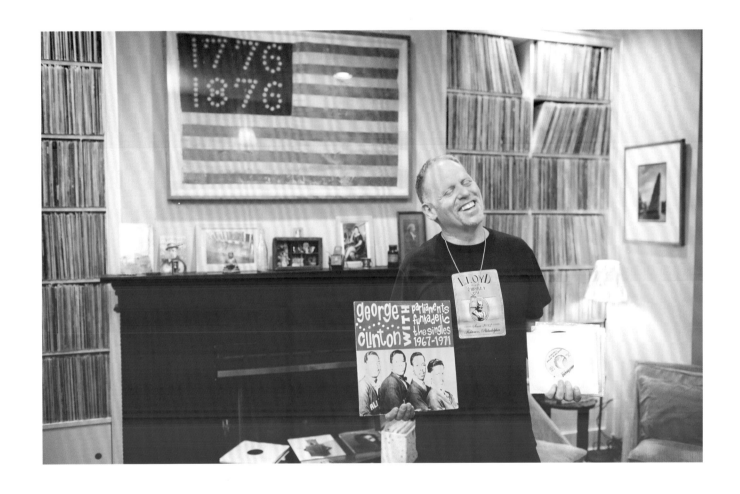

BILL ADLER - NEW YORK, NY
Charles Wright - *Ninety Day Cycle People*
"Singing along to the title track from one of my favorite recordings of all time."

JONATHAN TOUBIN - BROOKLYN, NY
Getting in touch with his soul.

AARON "THE KOSHERICAN" LEVINSON - PHILADELPHIA, PA
"Here is a European vinyl bootleg of a cassette compilation that I made from this stack of Parliament 45 singles. It was the first time in my life that music I had 'rescued' became the basis for other collectors around the world to explore a virtually unknown body of work by a well-known artist, namely George Clinton and the P-Funk dynasty."

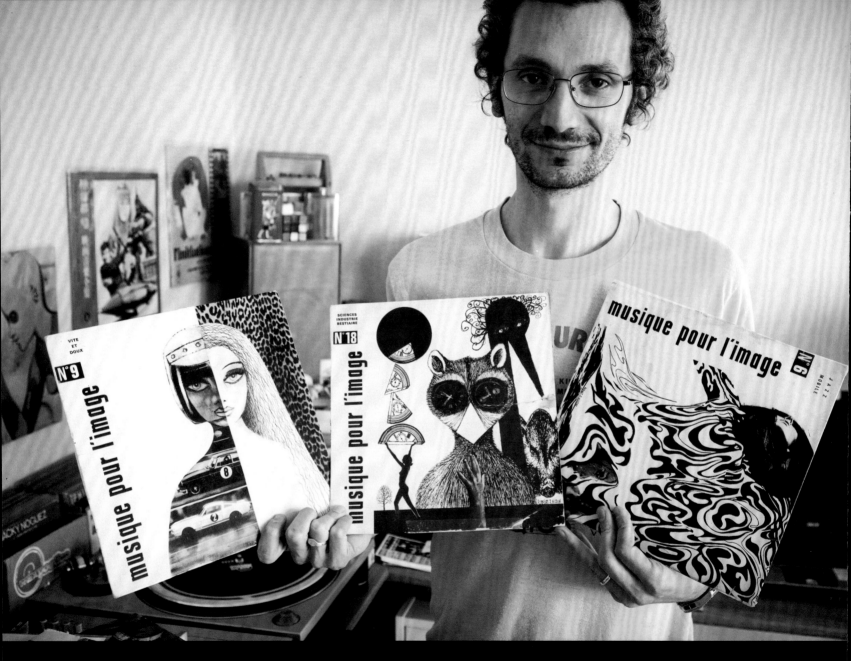

THOMAS PASQUET - PARIS, FRANCE
"These are three 10-inches from MPI, a French library label. It took me a couple of years
of digging and trading, but I've managed to complete my collection of the catalog."

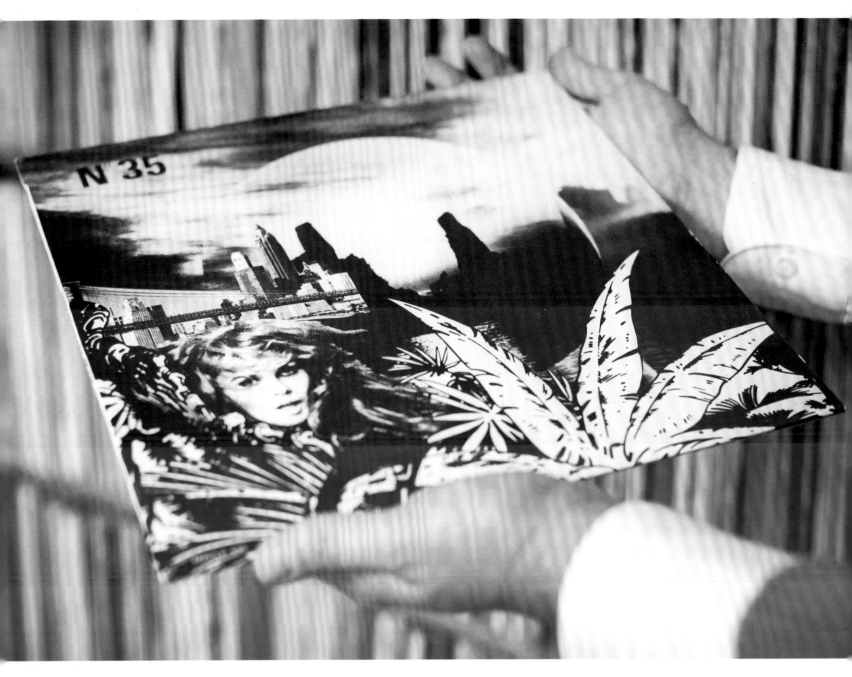

JONNY TRUNK - LONDON, UNITED KINGDOM
Vincent Geminiani - *Music pour un Voyage Extraordinaire*
"Beautiful library music based on Greek mythology that was written and composed
by an artist who made his own musical sculptures."

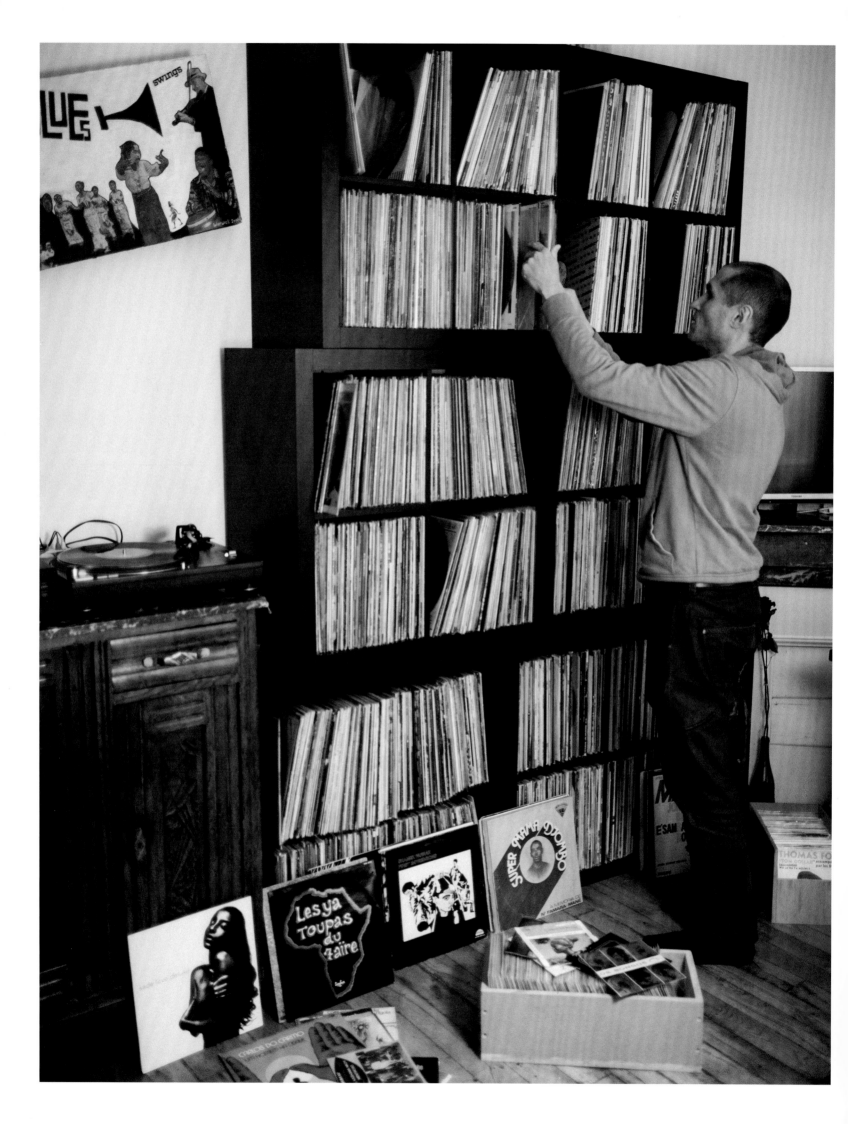

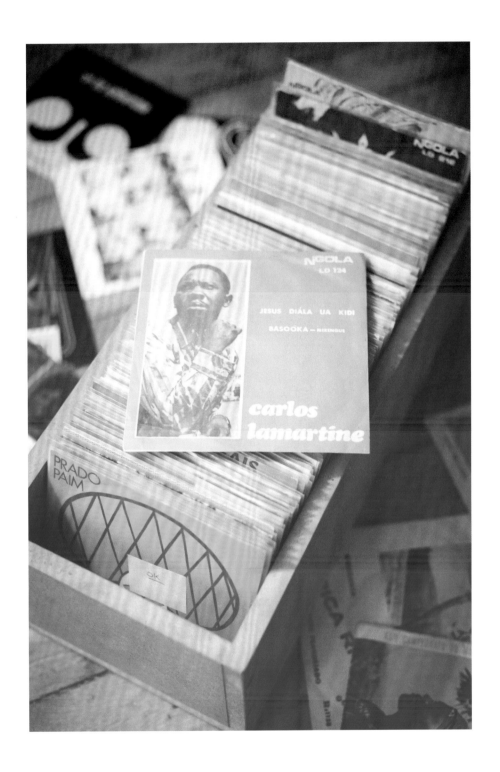

PAULO GONCALVES - PARIS, FRANCE
Carlos Lamartine - "Basooka"
"My Angolan 45s box. This is one of those finds that makes you feel like sunshine is coming straight out of your eyes as soon as the needle drops. Angolan music from the golden era (1972–76) mostly came out on 45, and they were all pressed in very small numbers."

"THE GOOD NEWS IS
MY KIDS GET
EXCITED TO SEE
A RECORD SPINNING
ON THE TURNTABLE.

THE BAD NEWS IS
MY KIDS GET EXCITED
TO SEE A RECORD
SPINNING ON
THE TURNTABLE."

JEFF "CHAIRMAN" MAO - NEW YORK, NY
The Ramones - *Self-titled*

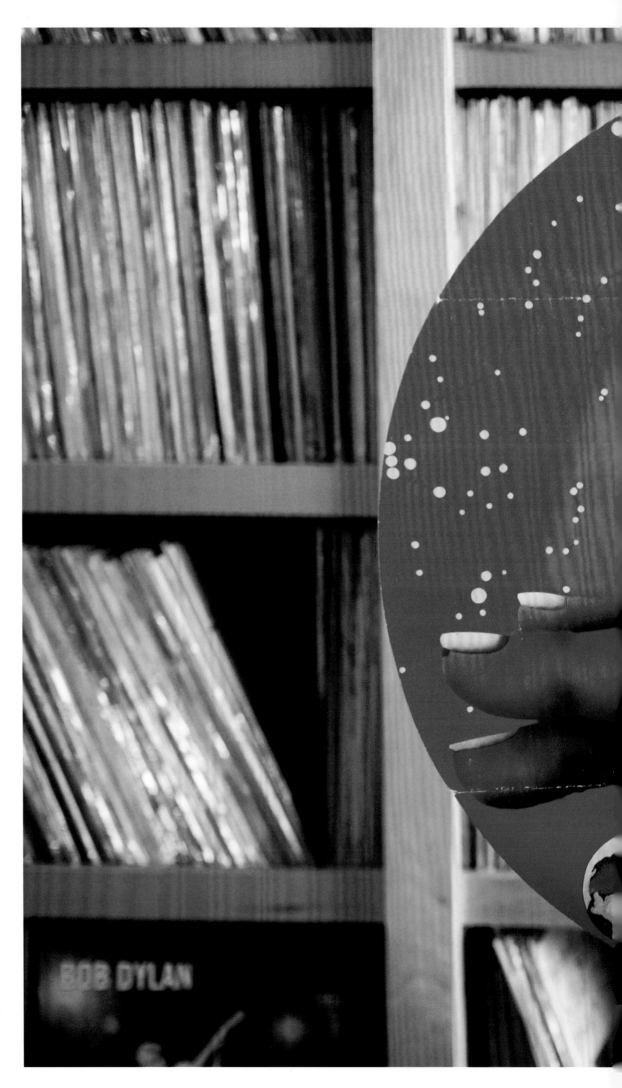

JEFF GOLD - VENICE, CA
David Bowie - *The Man Who Sold the World*
"The original cover, featuring Bowie in a dress, was evidently too much for his US and German record companies to take. Both released the album with their own unique covers. This is the German one, which folds out into a two-foot-diameter circle."

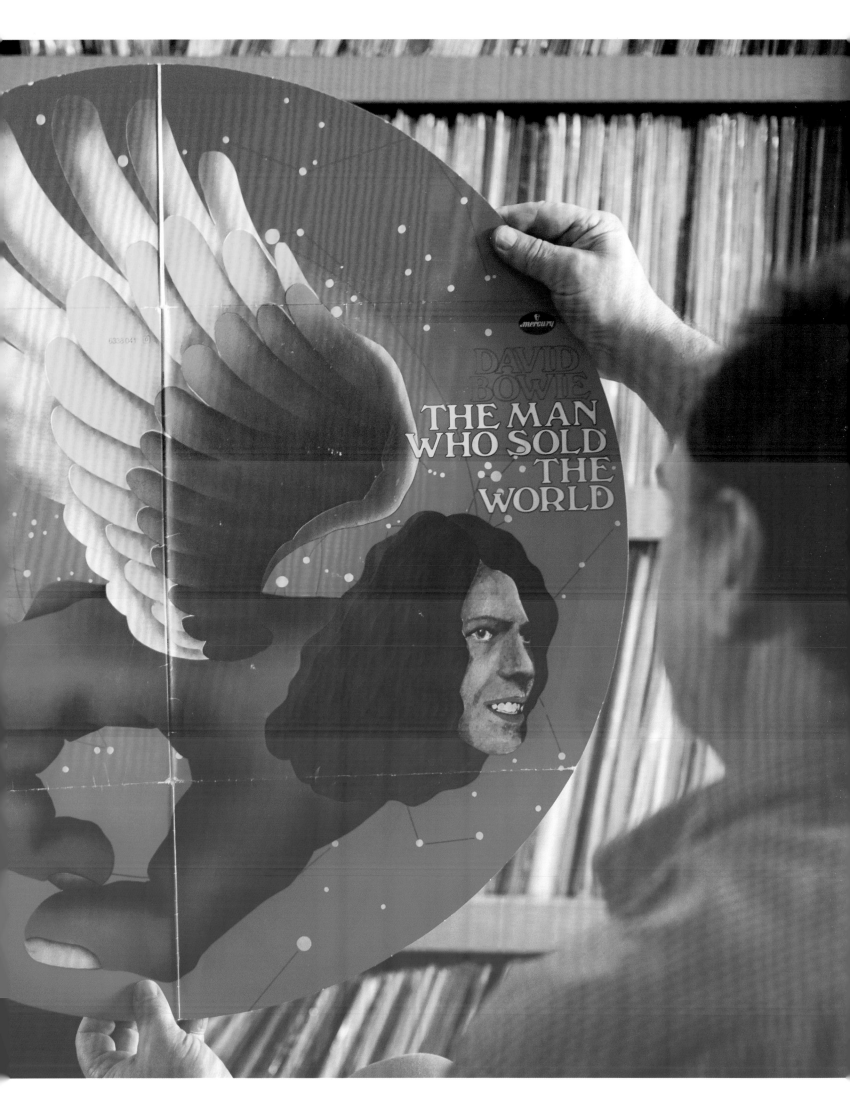

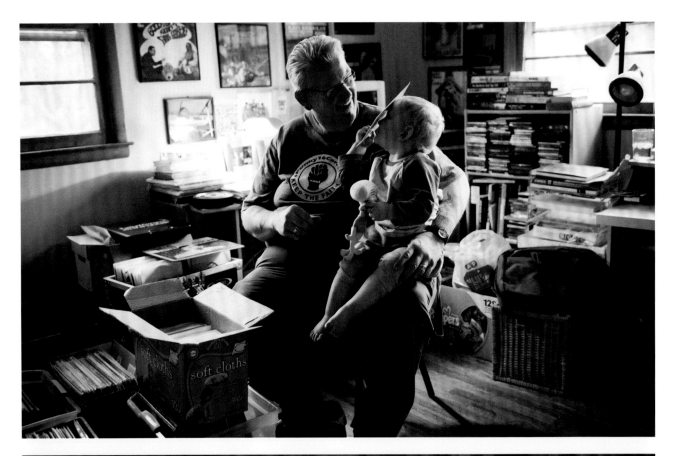

LARRY GROGAN - BRICK, NJ
"In the Funky 16 Corners record room with my son Sean, sharing a 45 straight out of the diaper box."

STEVEN BLUSH - NEW YORK, NY
Nirvana - "Love Buzz" 7-inch
"The very first Nirvana single. This record is special not just because of its significance in musical history but also because of its value. So if I ever go broke, this will be the very first record I ever sell, because I own two of the original one thousand copies!"

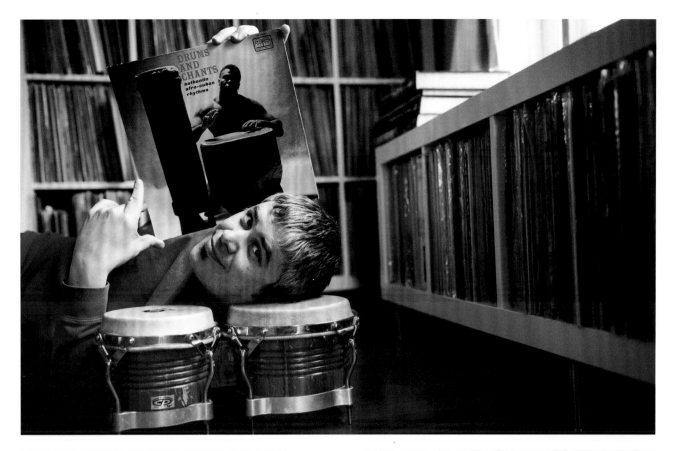

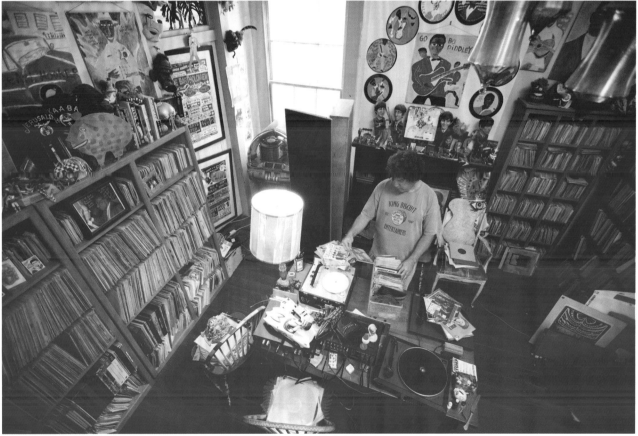

PABLO YGLESIAS - NORTHAMPTON, MA
Mongo Santamaria - *Drums and Chants*
"Probably one of the most reissued records in the Tico catalog. I have five versions, each with a different cover. It's a real deep collector's item."

IRA "DR. IKE" PADNOS - NEW ORLEANS, LA
"This is my record room, where I listen to records and plot and work on the Ponderosa Stomp. The walls are adorned with paintings of musicians by my wife, Shmuela."

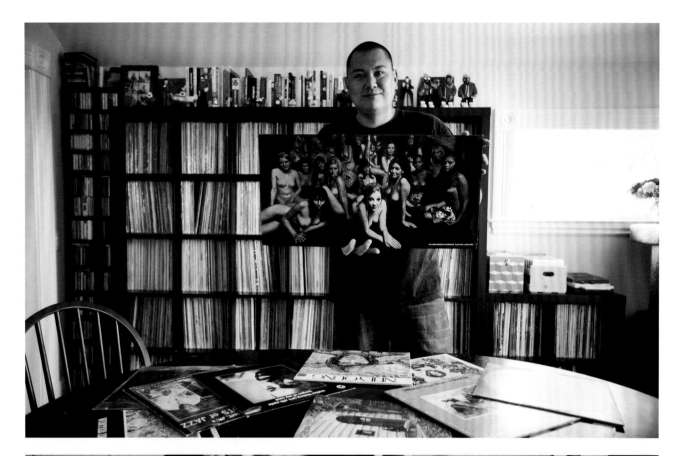

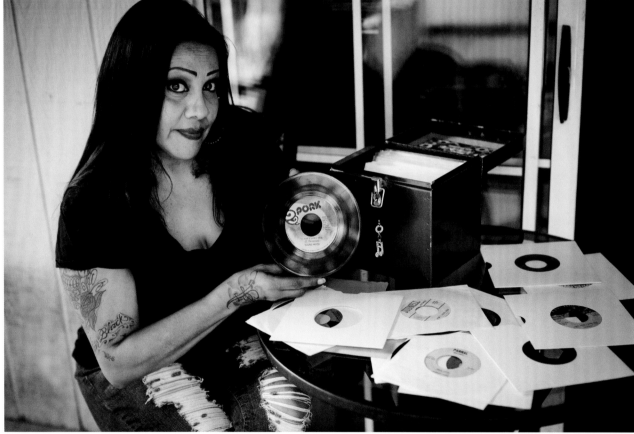

BRIAN HO - OAKLAND, CA
The Jimi Hendrix Experience - *Electric Ladyland*
"Without him, my love for music and records wouldn't be the same."

ARLENE "SOULERA 5150" SEPULVEDA - LOS ANGELES, CA
The Young Mods - "To Say I Love Her" 7-inch
"This is out of Ohio—one of my favorite states for soul records.
The Ohio sound and harmony has touched my heart and keeps me
digging for these gems. I found this in a pile of junk records and
made that gasping sound that got the attention of the dealer.
I, of course, paid the price—all for the love of soul music."

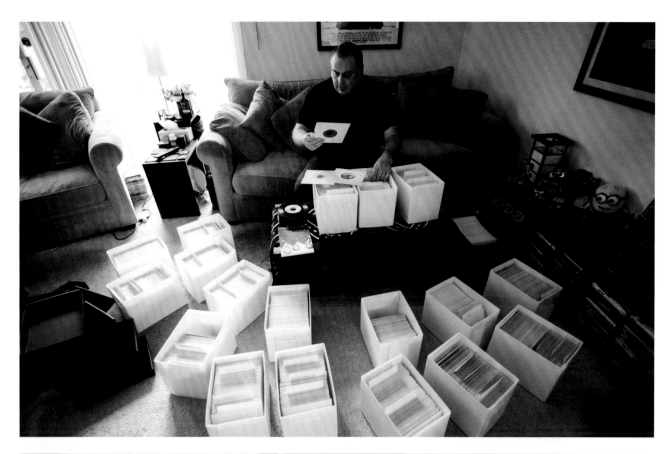

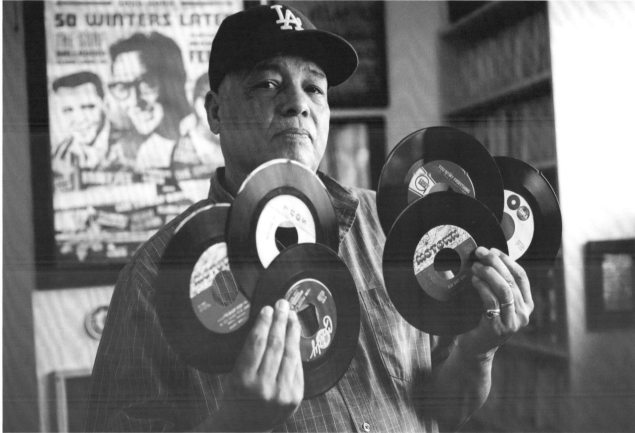

GREG BELSON - LOS ANGELES, CA

"These boxes represent a portion of my gospel 7-inch collection, which focuses on rare and elusive black gospel recordings from the mid '60s to the late '80s. I currently have around forty of these boxes."

RUBEN MOLINA - LOS ANGELES, CA

"A bus trip downtown with a couple of bucks in your pocket and you could have your fix of ear candy by the Temptations, Miracles, Supremes, Mary Wells, and many more. These are some of the 45s that made their way into my collection. I virtually grew up on Motown."

ROB SEVIER - CHICAGO, IL
Luis Laffer - *Sinamaica y Perija*
"This LP was issued on the Laffer label in the mid-1970s. It's a collection of field recordings by a filmmaker living and working in Venezuela in the '60s and '70s. I became aware of it by reading an excellent discography of South American field recordings, but it took years to track down a copy."

DAN SHIMAN - MARFA, TX

"In the adobe-walled room that serves as my office and record lair, 45s are my focus as a collector; with 45s I feel like I'm slowly building up an entire lost and atmospheric world of sound. To play them in the right sequence is to sink into that world."

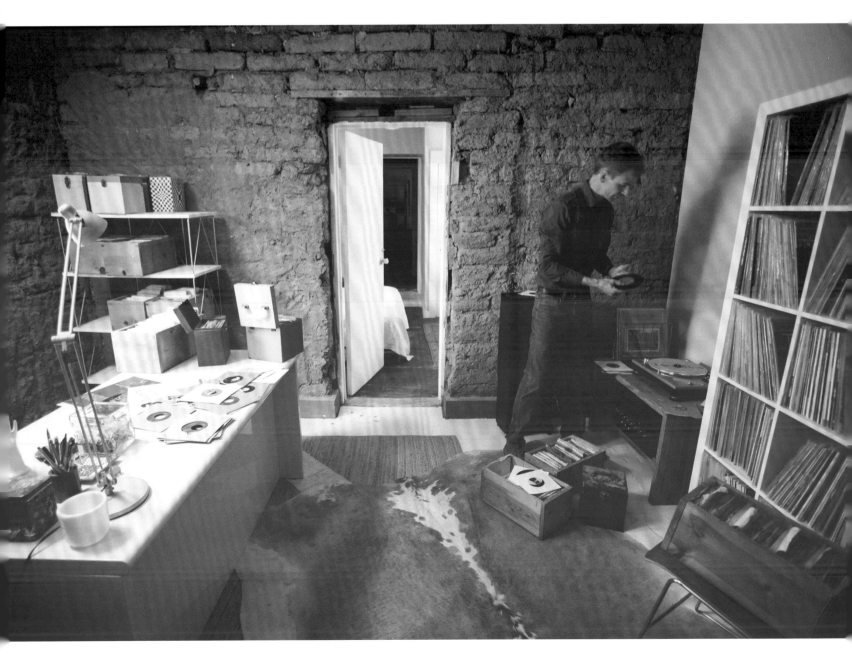

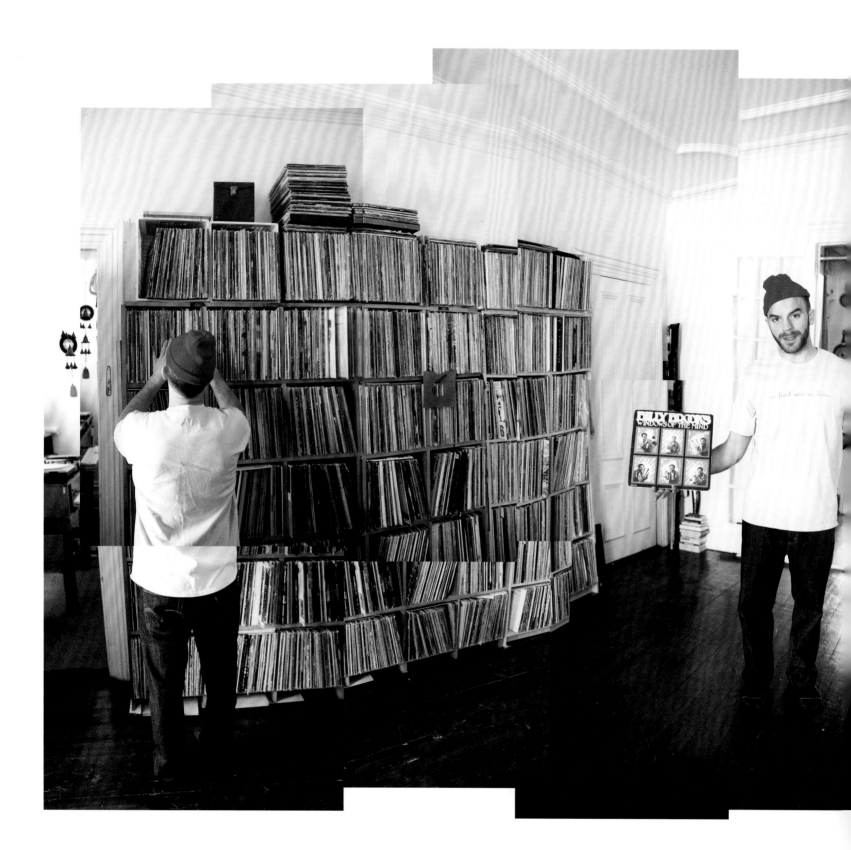

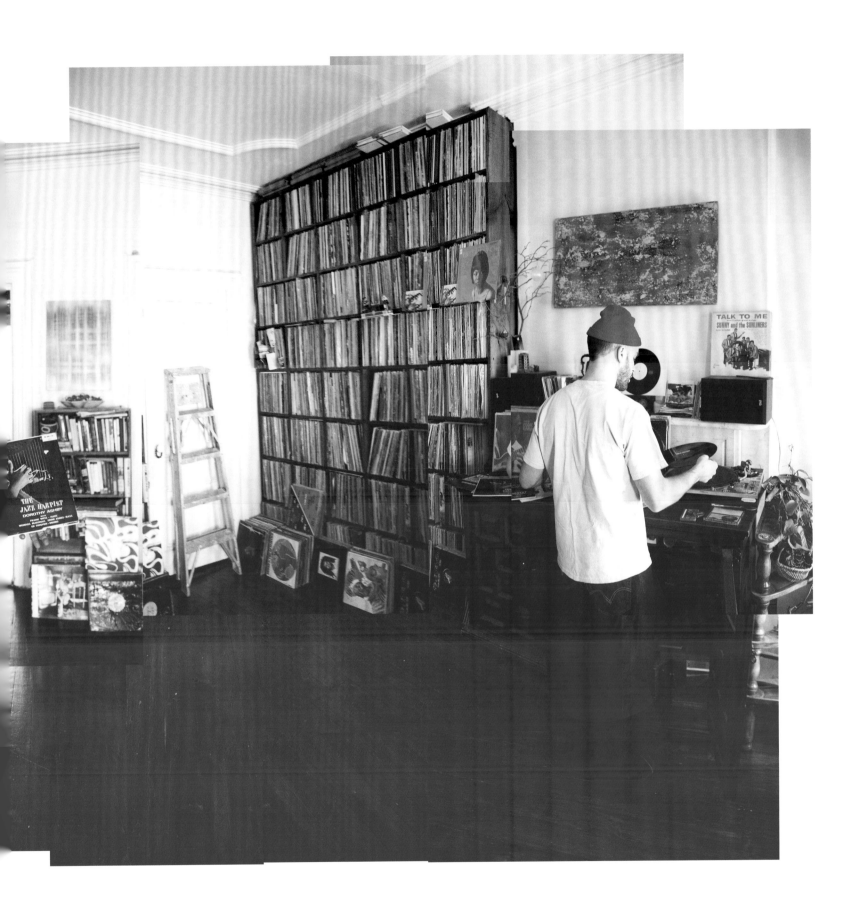

DANNY AKALEPSE - BROOKLYN, NY
"My living room in Brooklyn and a few shelves full of music. The lab is the door on the left; there's more music in there."

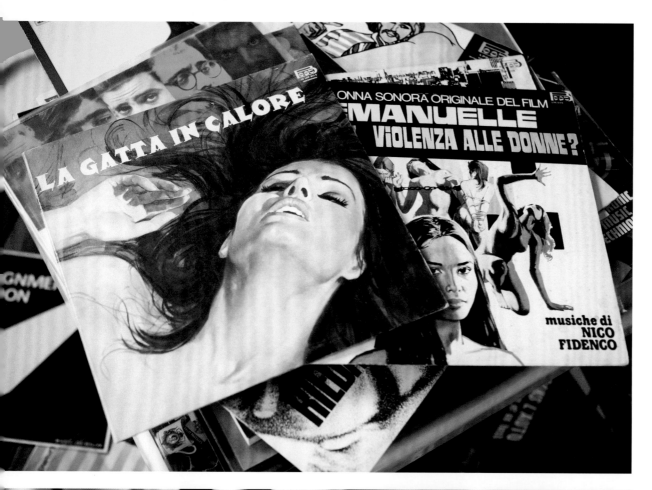

JONNY TRUNK - LONDON, UNITED KINGDOM
"Sex records. Many exist and I've always bought them. I've found anything from instructional records, to XXX stag-party LPs, to porn stars singing or talking, to Japanese Pinky-based LPs, and of course there are many soundtracks to rude, exotic, and erotic films, from *Deep Throat* to erotic horror. Italian albums always seem to have slightly more magic and madness than the others."

SHEILA BURGEL - BROOKLYN, NY
Diana Dors - *Swingin' Dors*
"My go-to LP for the early side of a cocktail party."

PHILIPPE COHEN SOLAL - PARIS, FRANCE
Lemon Jelly - "Soft" b/w "Rock"
"This is actually not credited to anybody, but it is Lemon Jelly. Because of the illegal Chicago and Black Crowes samples that they couldn't be bothered to clear, they released this themselves in 2001. The first run (five hundred copies) came in a denim sleeve with a pocket and a condom in it. You had to know the seller very well to even be allowed to buy it."

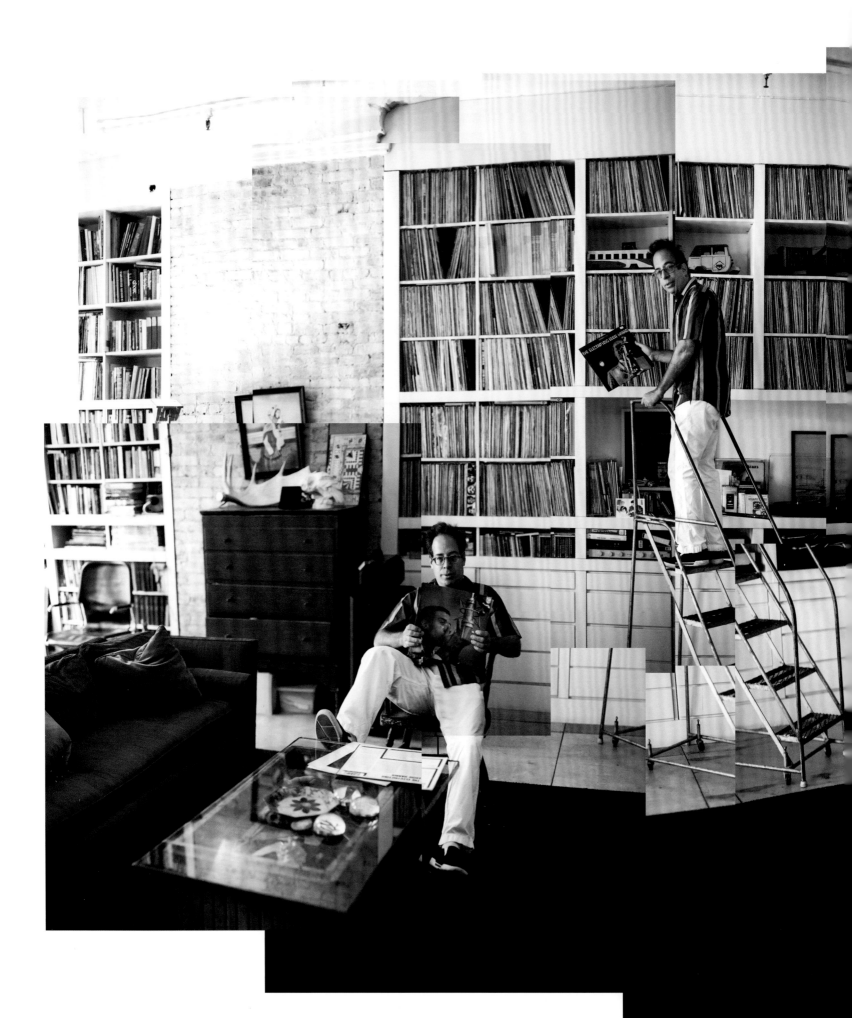

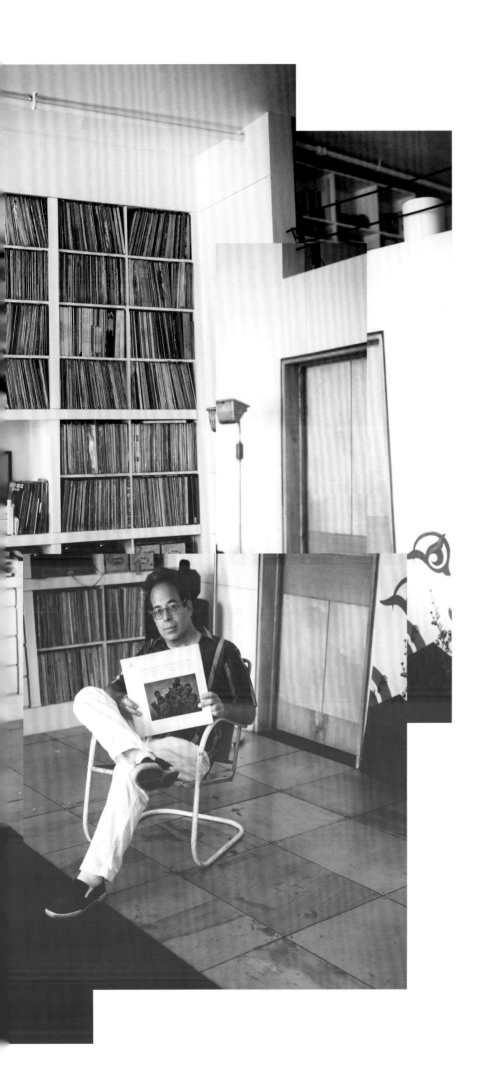

"VINYL ISN'T SOME HOUSE ON A HILL. IT IS FLAWED. PEOPLE HAVE COME TO LIKE THOSE FLAWS. I HAVE AS WELL, BUT IT'S NOT A MYTH FOR ME. THAT DOESN'T MEAN IT'S NOT SPECIAL, OR THAT I DON'T LOVE IT. I GUESS, JUST AT SOME LEVEL, I LOOK AT THE IN-FASHION-NESS OF IT WITH A JAUNDICED EYE."

YALE EVELEV - NEW YORK, NY

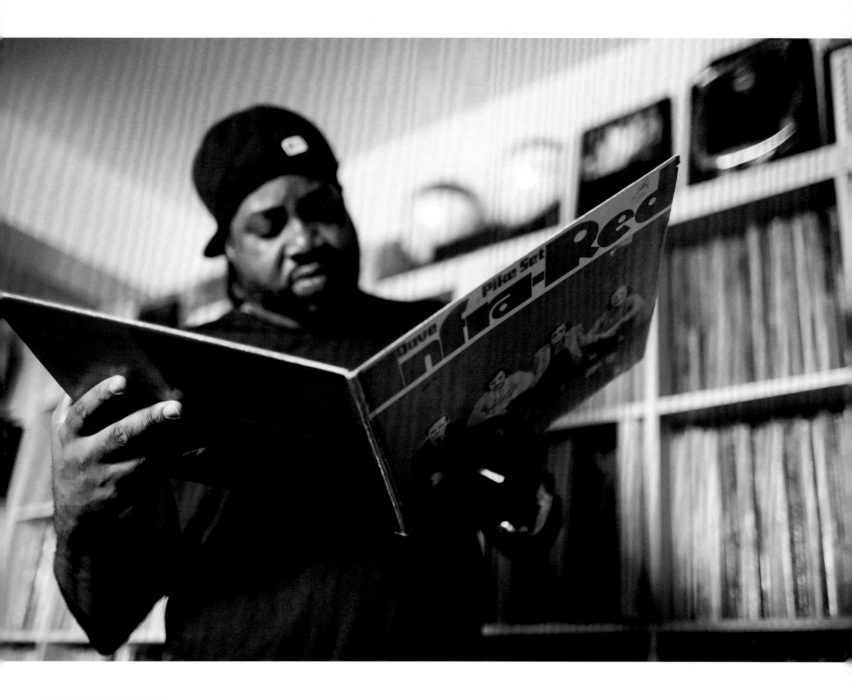

LORD FINESSE - BRONX, NY
Dave Pike Set - *Infra-Red*
"I'm a big fan of MPS Records, and this Dave Pike Set album is just one of many jazz classics that can be found on this German label."

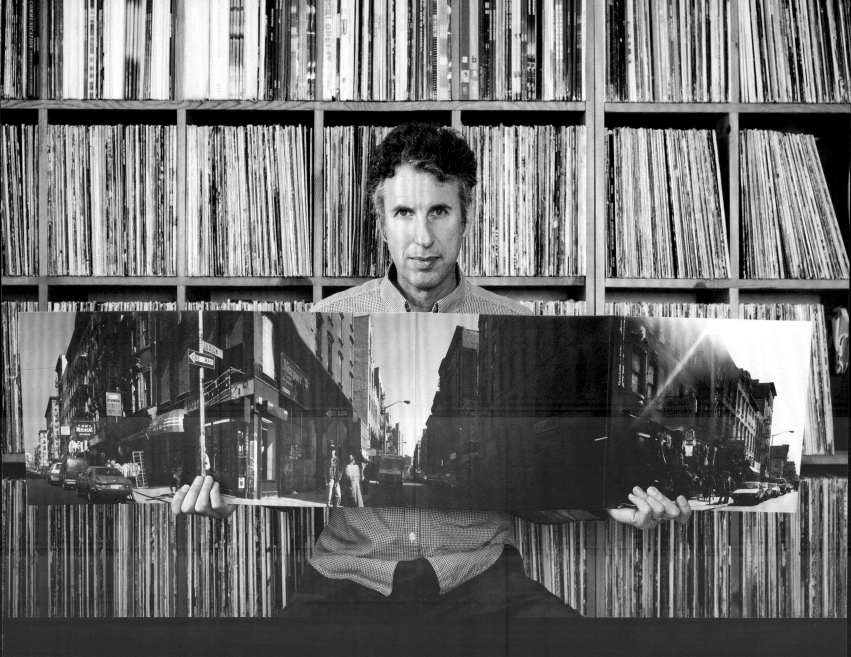

MARIO CALDATO JR. - LOS ANGELES, CA
The Beastie Boys - *Paul's Boutique*
"I worked on this record and was given this special double vinyl version. The photo is a street corner in New York City and was taken by Adam Yauch with a special 360-degree camera for land surveying. With the first 180 degrees on the outside and the other 180 degrees on the inside, you need two copies to put it all together. I love the picture and the layout. It's very clean and natural, and the spirit captured in the picture works well with the music."

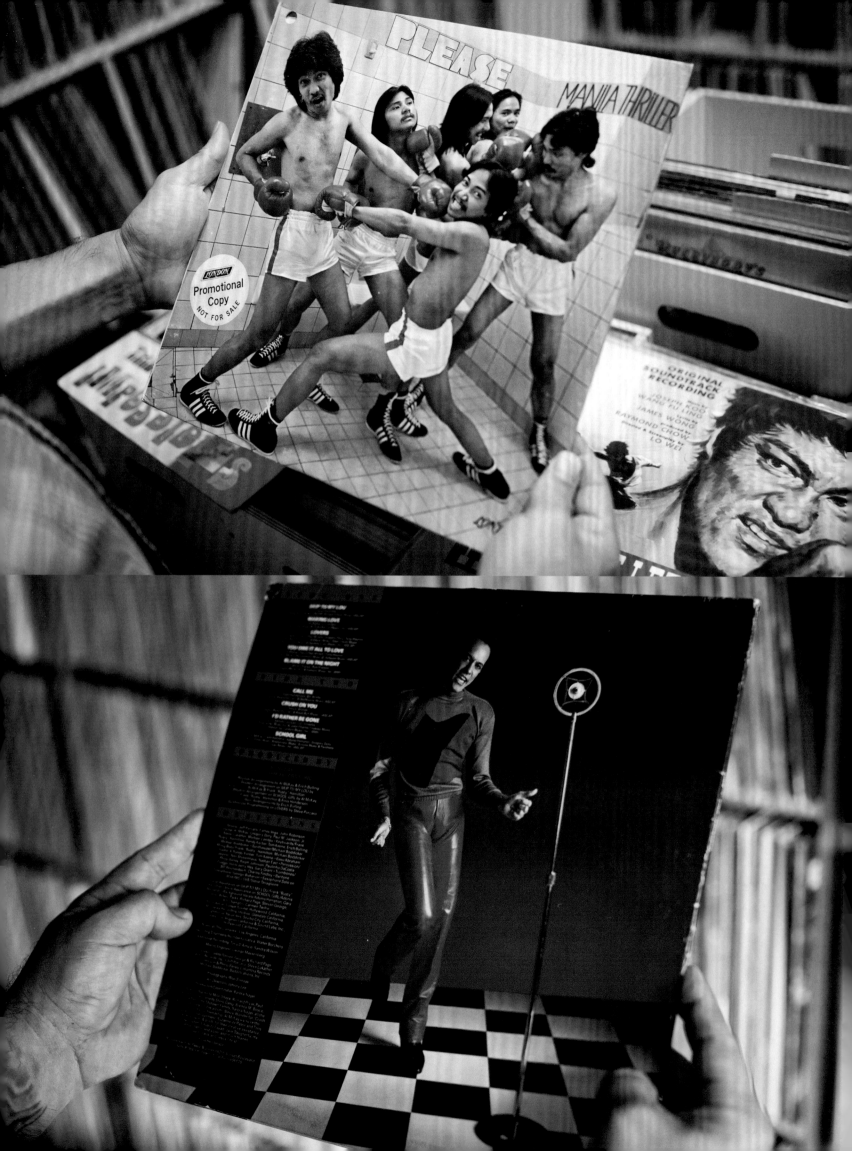

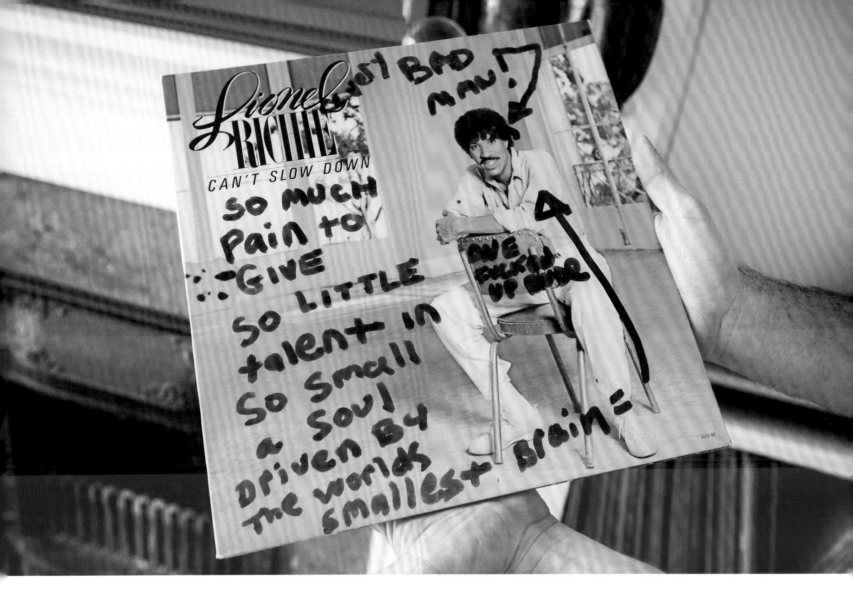

OLIVER "O-DUB" WANG - LOS ANGELES, CA
Please - *Manila Thriller*
"Please was a group of Filipino soul/
funk musicians who ended up recording
in Europe. They do have a musically
superior record, but it's hard to beat the
entertainment value of this album's cover."

SUPREME LA ROCK - SEATTLE, WA
Finis Henderson - *Finis*
"The day I found this, I couldn't stop
laughing. Those red leather pants are
pulled up way too high."

CHRIS VELTRI - SAN FRANCISCO, CA
Lionel Richie - *Can't Slow Down*
"I get a kick out of altered sleeves that
give you a glimpse of the original owner. I
have tons of them, ranging from lowrider
art and cholo block letters to graffiti and
tags, comic characters, naked ladies, LSD
trip art, collage, and more. This particular
one is hilarious because of the over-the-
top distaste for Lionel Richie. Obviously
personal, but why?"

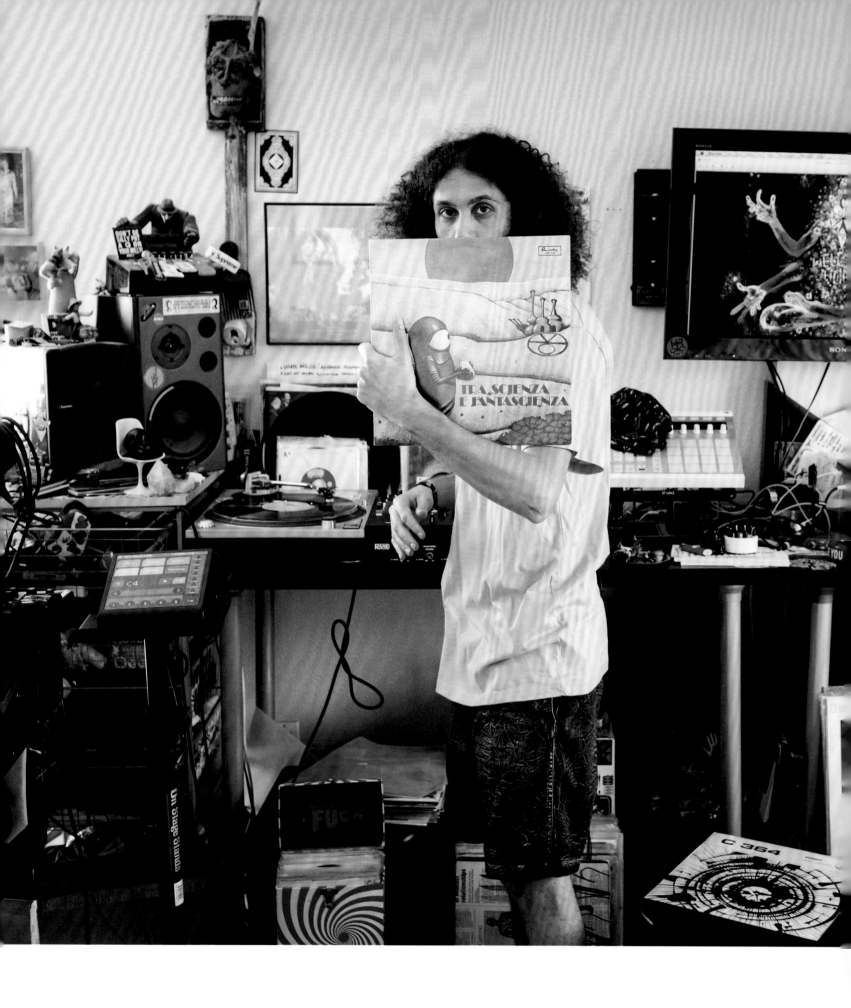

WILLIAM "THE GASLAMP KILLER" BENSUSSEN - LOS ANGELES, CA
Moggi - *Tra Scienza e Fantascienza*

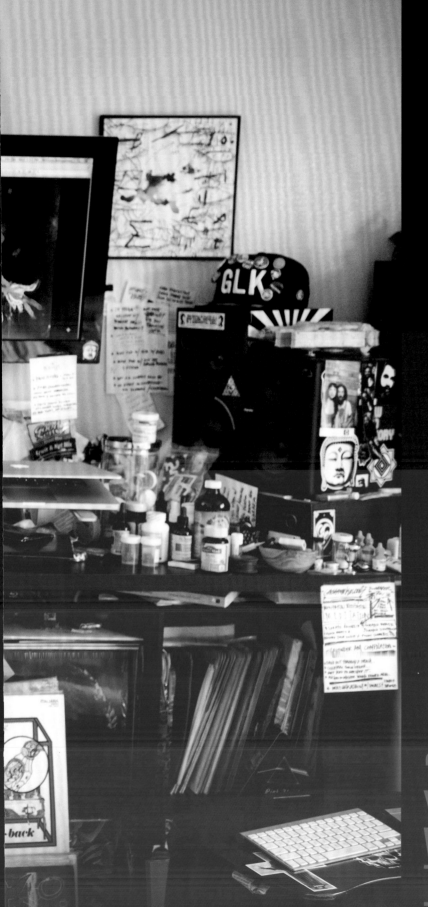

"EVEN AFTER THE APOCALYPSE
YOU COULD STILL GET
VEGETABLE OIL AND RUN
TWO TABLES AND SPEAKERS.

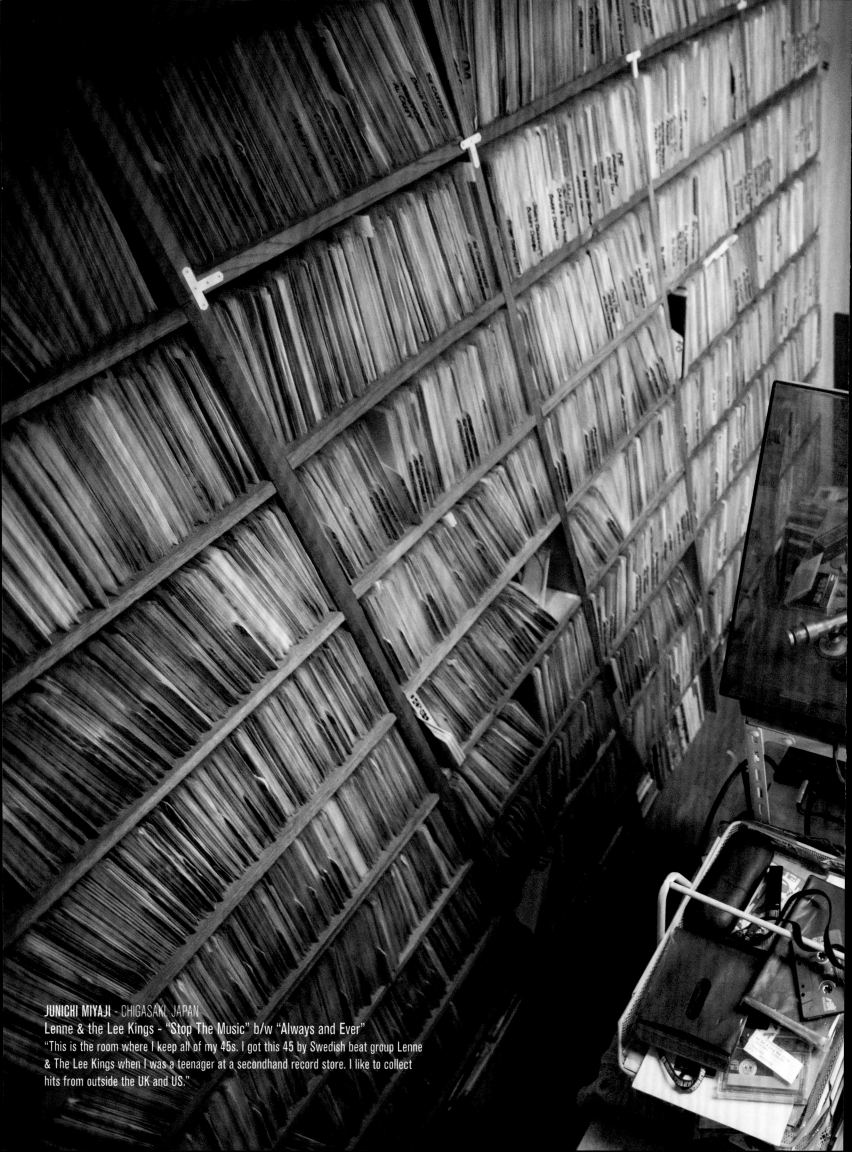

JUNICHI MIYAJI - CHIGASAKI, JAPAN
Lenne & the Lee Kings - "Stop The Music" b/w "Always and Ever"
"This is the room where I keep all of my 45s. I got this 45 by Swedish beat group Lenne & The Lee Kings when I was a teenager at a secondhand record store. I like to collect hits from outside the UK and US."

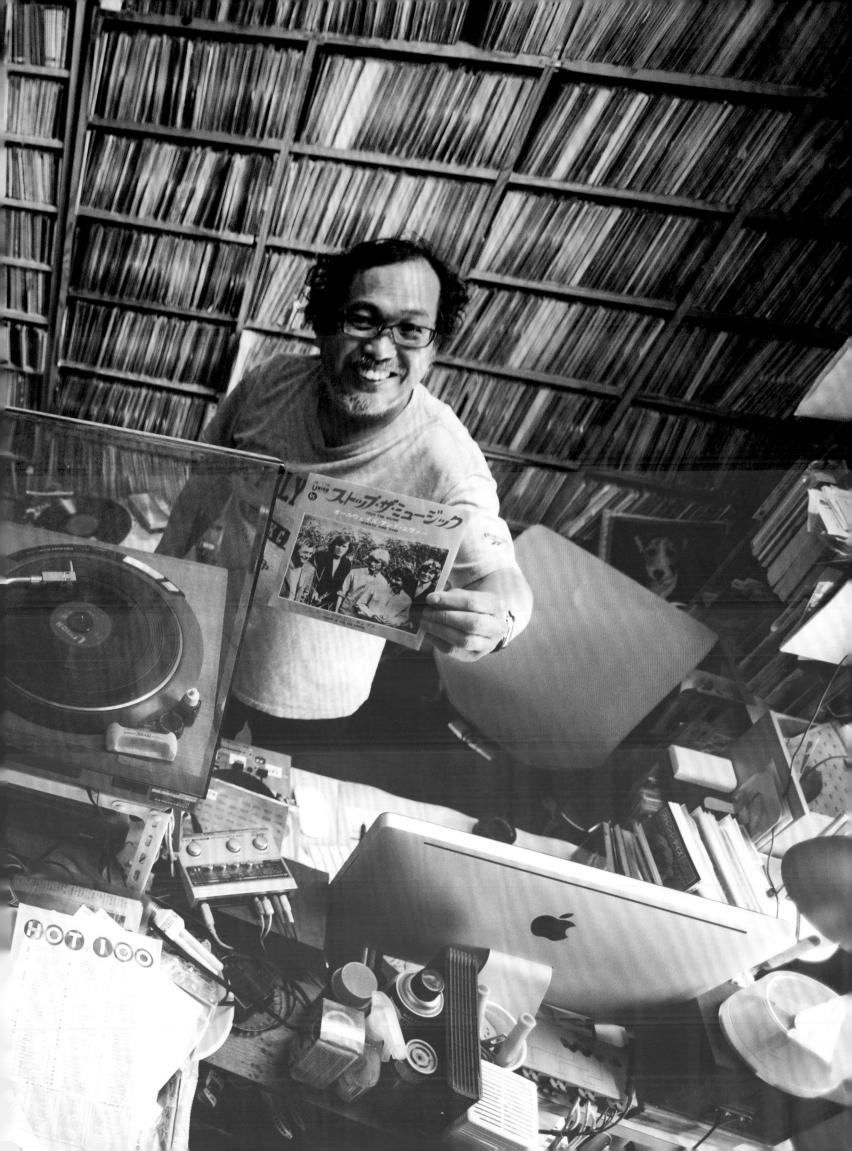

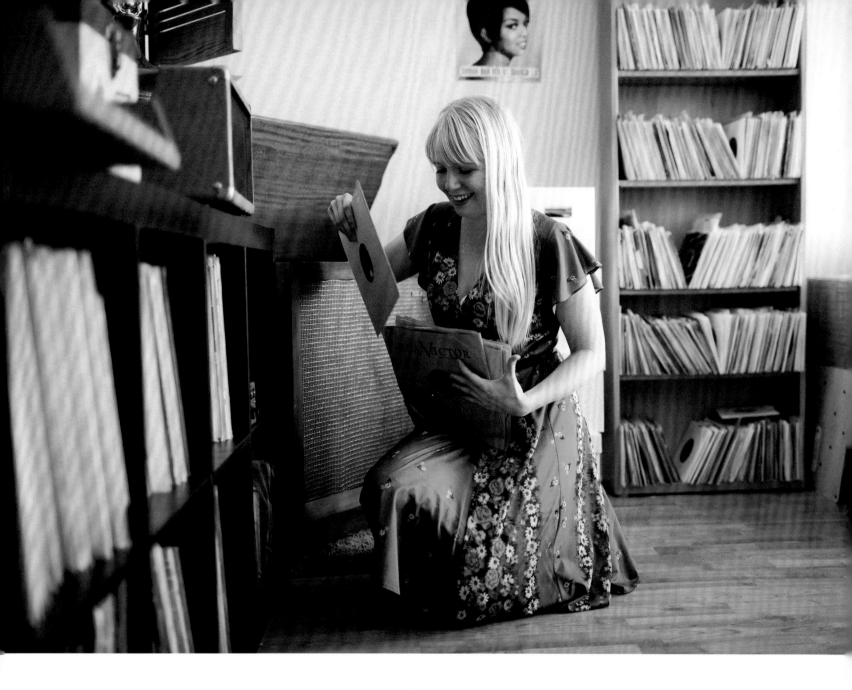

REBECCA BIRMINGHAM - BROOKLYN, NY
"I started collecting 78s to be able to explore their unique place in musical history.
Many of these recordings can't be found in any other format."

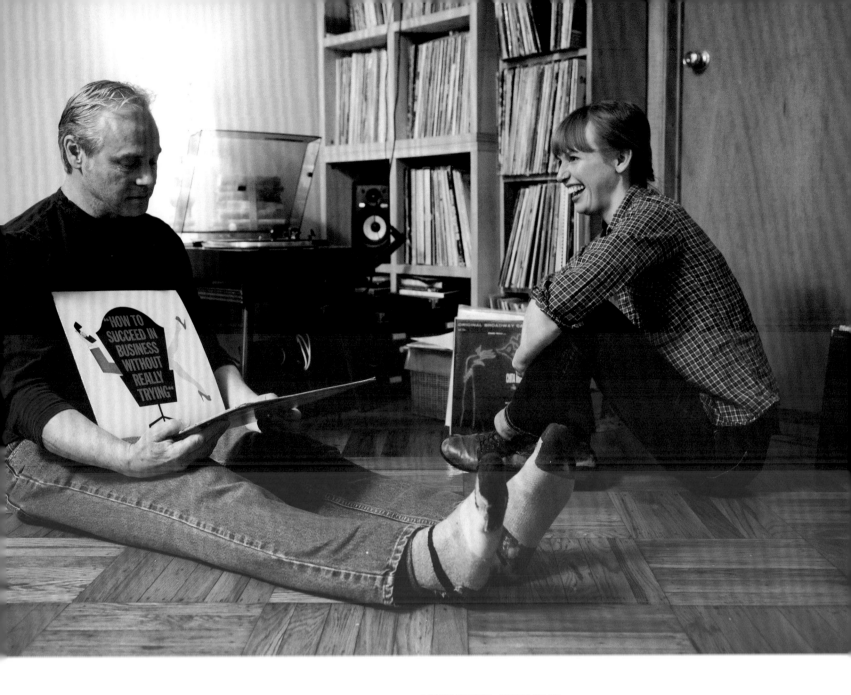

LAVINIA WRIGHT - BROOKLYN, NY

"My dad, Karl, and me in my living room in Brooklyn. He's holding some Broadway musical soundtracks from the 1960s that he gave me. They're all from shows that I performed in during high school."

JOE BUSSARD - FREDERICK, MD
Joe Bussard sitting in his basement with
some of the rarest 78s in existence. The
brown paper record jackets behind him are
all uniformly discolored in the middle as a
result of Joe's hands sorting and searching
through them for the past sixty years.

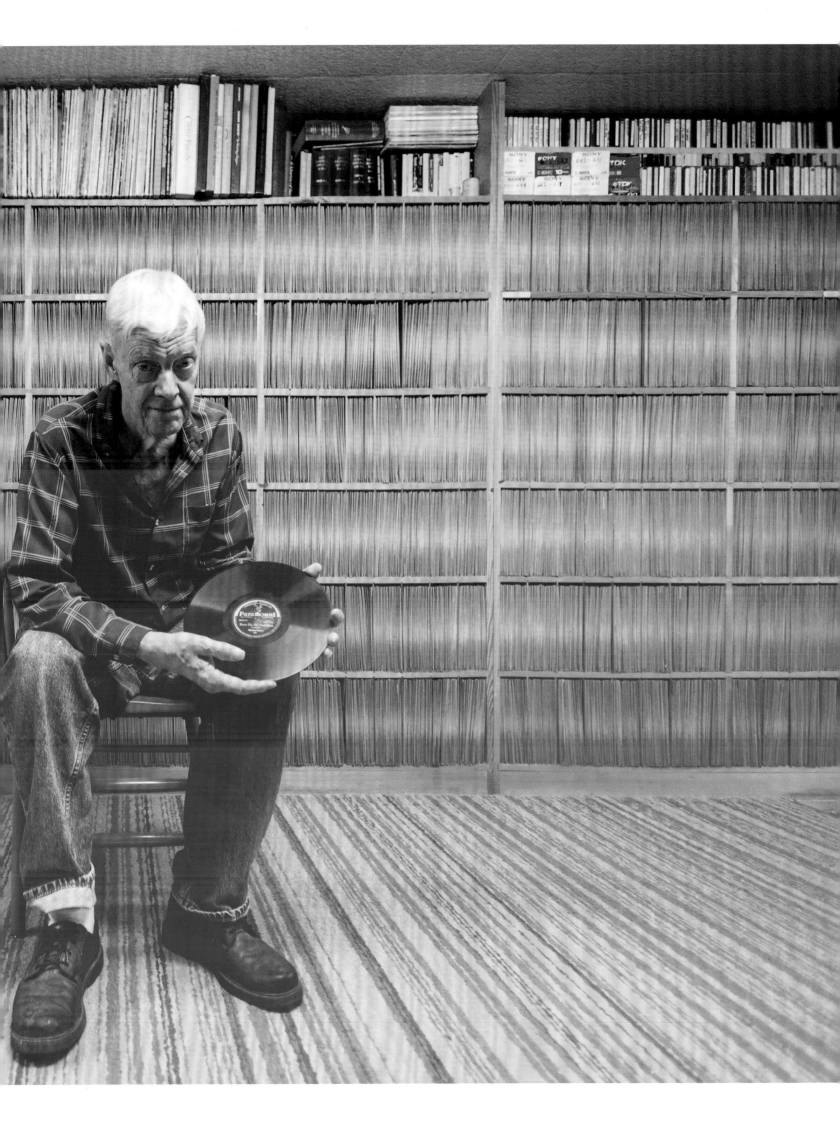

THE THING - BROOKLYN, NY

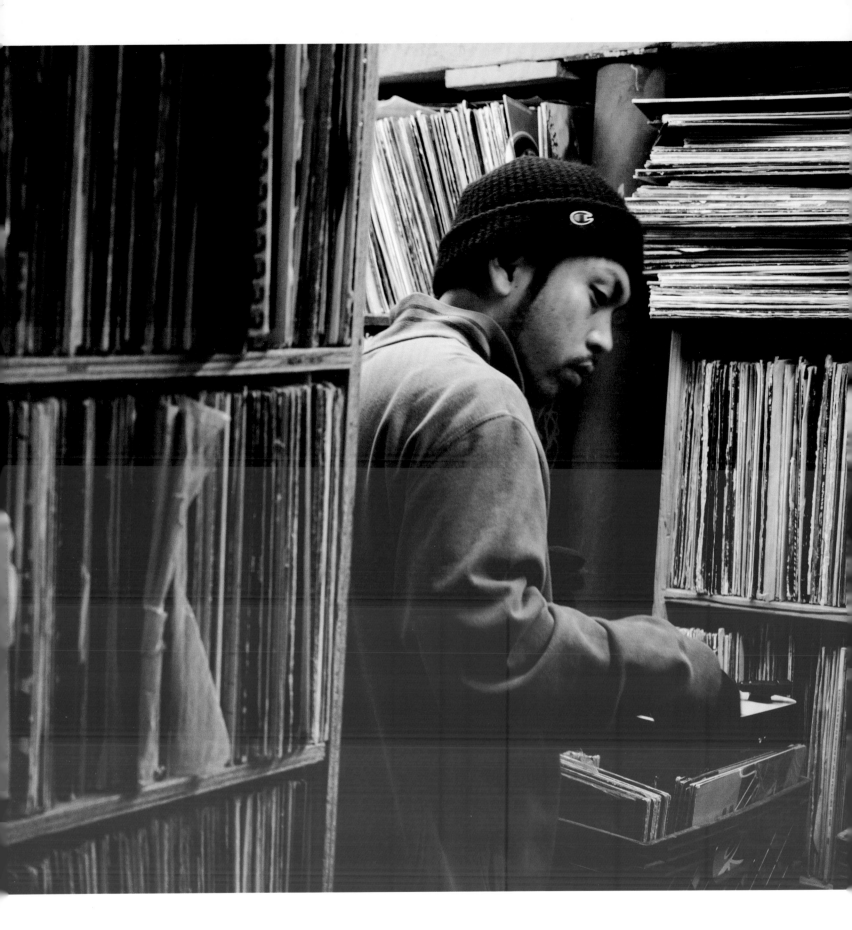

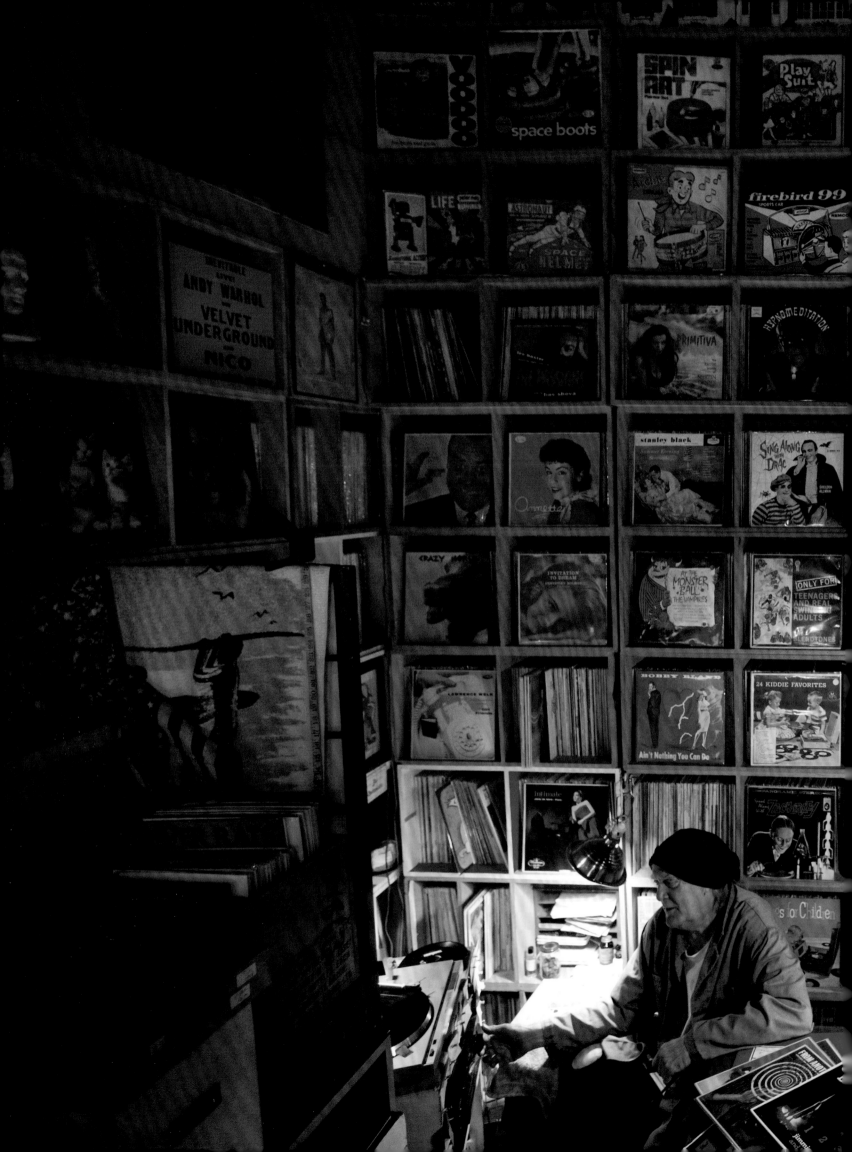

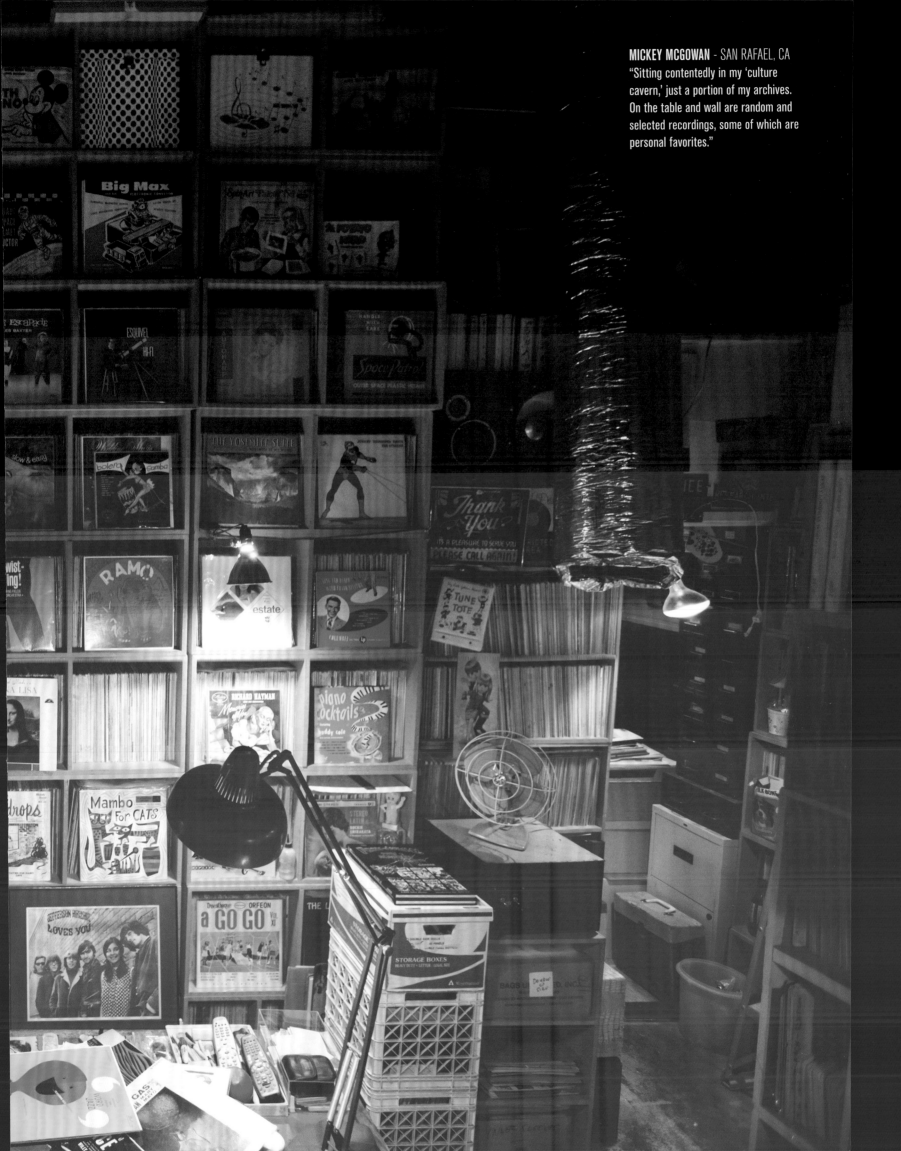

MICKEY MCGOWAN - SAN RAFAEL, CA
"Sitting contentedly in my 'culture cavern,' just a portion of my archives. On the table and wall are random and selected recordings, some of which are personal favorites."

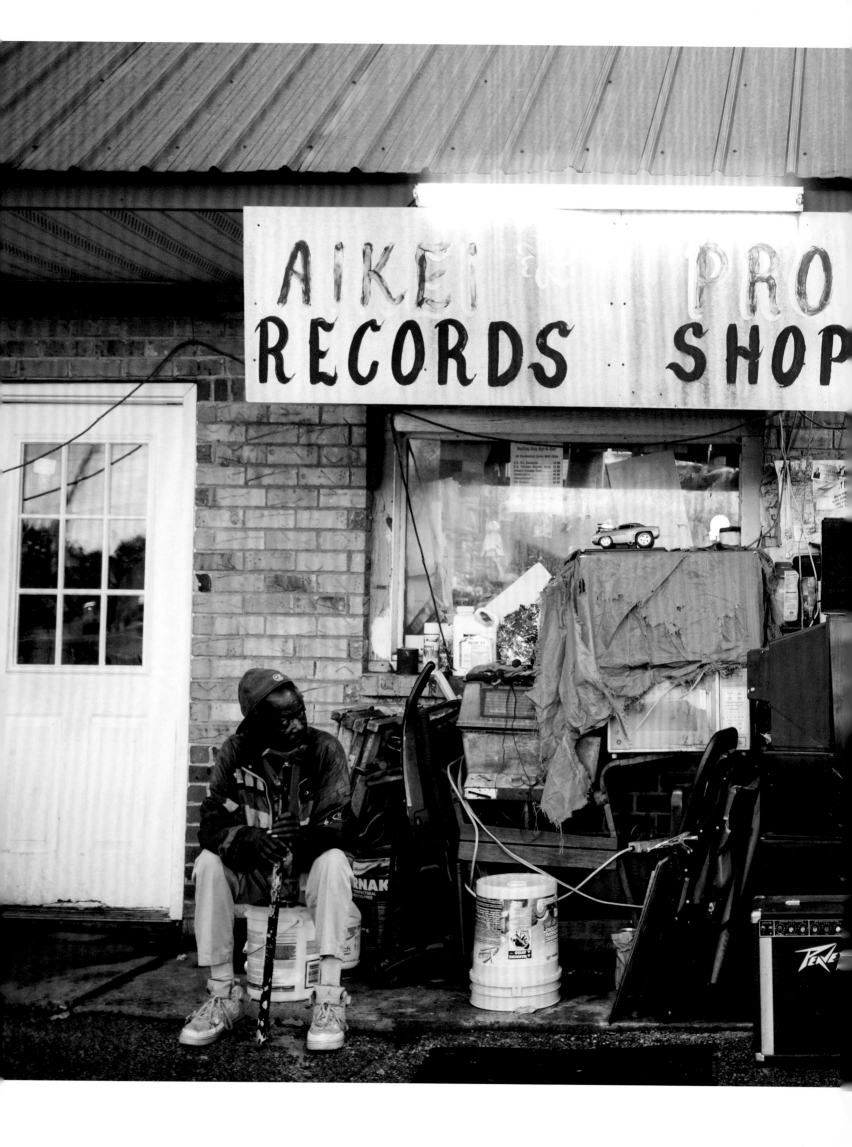

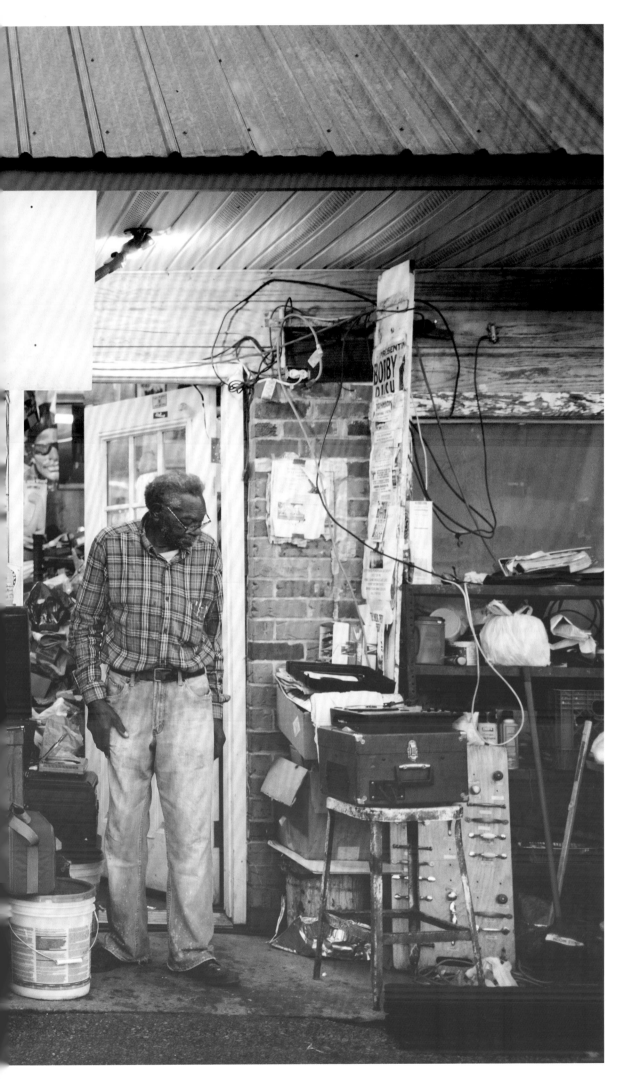

AIKEI PRO'S RECORDS SHOP
HOLLY SPRINGS, MS
Mr. Caldwell's Aikei Pro's has to be experienced to be believed. It took a solid hour just to clear away enough boxes and debris to allow cramped entrance to the store. The shelves are stuffed with musty records and old mail, and various posters hang from the rafters. Stashed next to some LPs by the door is an old handgun wrapped in a plastic bag. He may be old, but Mr. Caldwell is still sharp as a tack.

MIKE CINA - MINNEAPOLIS, MN
Just Music - *Self-titled*

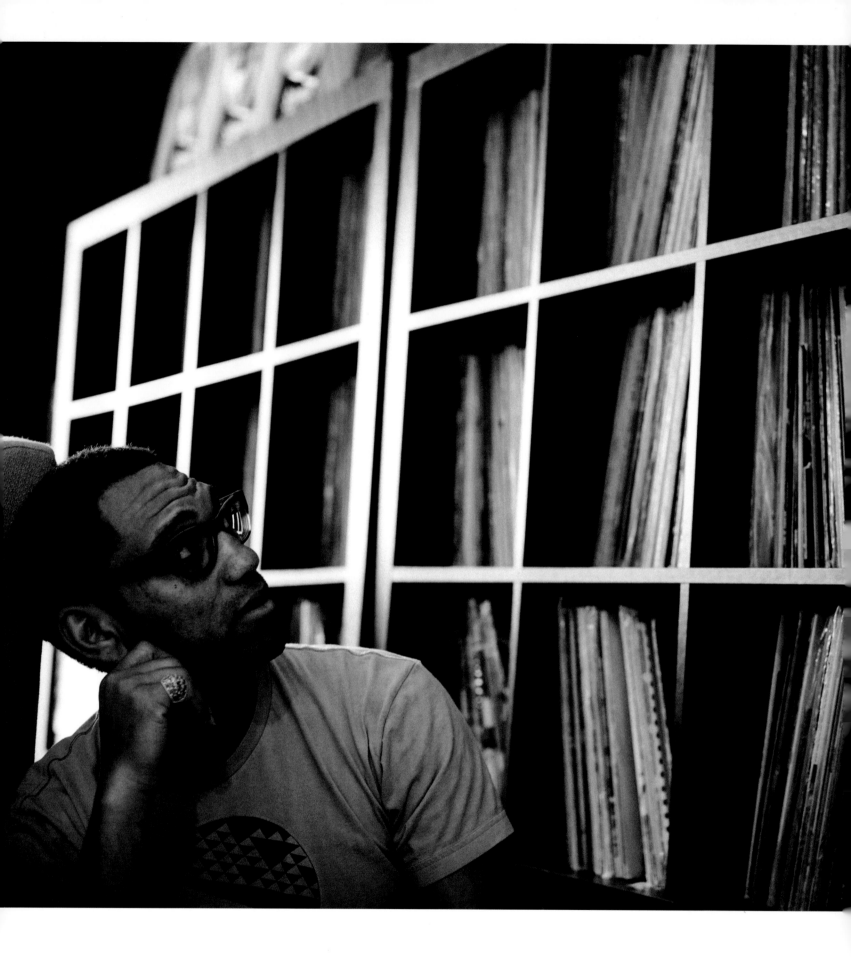

"WITHIN THESE GROOVES LIES THE COMPLETE STORY OF MY LIFE."

KING BRITT - PHILADELPHIA, PA

MYSTERY TRAIN RECORD STORE
AMHERST, MA

"RECORD COLLECTING IS LIKE ANY OTHER ADDICTION: IT DOESN'T TURN OFF EVEN WHEN YOU'RE BROKE."

RICH MEDINA

VINYL LINGO

NOBODY'S HOME - FINDING A RECORD JACKET THAT IS MISSING THE ACTUAL RECORD (JEFF OGIBA) | **FORAWHILE** - THE GROOVE AT THE END OF THE RECORD THAT THE NEEDLE STAYS IN (DANNY AKALEPSE) | **FROSTING** - ALL THE FREE INSERTS YOU GET WHEN YOU BUY A RECORD (ALEX BOOTH) |

ORPHANS - LPS WITHOUT COVERS (JONATHAN BELL) |

COASTER - A 7-INCH THAT IS SO BAD THAT ITS ONLY SUITABLE FUNCTION IS TO BE A DRINK COASTER (KATHARINE HINDS-PAYNE and DOM QUINTON) | **MATRIX** - THE AREA ON RECORDS BETWEEN THE LAST TRACK AND THE LABEL WHERE CATALOG NUMBERS, ENGINEER COMMENTS, ETC, ARE OFTEN ETCHED INTO THE WAX (DJ DANKO and DOM QUINTON)

TITTYSHAKER - AN UPTEMPO ROCK & ROLL DANCE RECORD THAT EVOKES THE URGE TO SHAKE ONE'S TITTIES (FRANK ENGLER and KEN ABRUZZI) |

COMPED - A SONG THAT HAS BEEN RELEASED ON A COMPILATION ALBUM (CONSTANTINOS MANGLIS) |

EGGS AND BACON (aka *FRY-UP* or *BURNED*) - THE CRACKLE, HISS, AND POP ON VINYL REMINISCENT OF SOMEONE FRYING EGGS AND BACON IN THE BACKGROUND (JEFF OGIBA) |

BEATER - A 45 IN TOUGH SHAPE THAT STILL PLAYS DECENTLY ENOUGH TO DJ WITH (RAMBO SALINAS) |

FLOP SIDE - A PLAY ON THE TERM "FLIP SIDE," WHICH REFERENCES THE B-SIDE OF A SINGLE THAT DOES NOT DELIVER (JEFF OGIBA) |

FOUND IN THE FIELD - A RECORD FOUND AT A FLEA MARKET, GARAGE SALE, THRIFT STORE, ETC, AS OPPOSED TO ONLINE OR AT A PROPER STORE (ALLEN THAYER) |

DOG-EAR (aka *FURRED*) - A RECORD FOUND IN A COLLECTION THAT'S IN HORRIBLE CONDITION (KATHARINE HINDS-PAYNE) | **CURB FRUIT** - A BOX OF RECORDS FOUND ON THE STREET (AARON LUIS LEVINSON) |

HEARTBREAKER - A RARE RECORD FOUND IN A COLLECTION THAT'S IN HORRIBLE CONDITION (KATHARINE HINDS-PAYNE) |

DEADWAX (aka *RUN-OUT* or *MATRIX*) - THE AREA ON RECORDS BETWEEN THE LAST TRACK AND THE LABEL WHERE THE LABEL LOOKS LIKE ONE THING AND SOUNDS TOTALLY DIFFERENT (DAVID MENDOZA) | **BARKING CAT** - A RECORD THAT LOOKS LIKE ONE THING AND SOUNDS TOTALLY DIFFERENT (DAVID MENDOZA) |

VOLLENWEIDER - A RECORD THAT LOOKS LIKE SOME OBSCURE PSYCHEDELIC PROG ROCK ALBUM BUT IS ACTUALLY SOME NEW AGE SHIT FOUND IN THE 25¢ BIN IN EVERY RECORD STORE WORLDWIDE (HUGO VEEBER) | **WHITE LABEL** - BOOTLEG/HARD-TO-FIND PRESSING (TYLER CHRISTIE) |

NOTCHED (aka *EMO'D* or *CUT-OUT*) - A RECORD SLEEVE WITH A PUNCHED HOLE OR A NOTCH CUT FROM THE BRIM OF A COWBOY HAT SO THAT IT RESEMBLES (CHRISTOPHER MAYNARD) |

CREAMED - A PILE OF RECORDS THAT HAS BEEN THOROUGHLY PICKED THROUGH AND HAS NOTHING WORTHWHILE LEFT OVER (CARL SCHALCK) |

BISCUIT SQUISHER - A RECORD PRESS OPERATOR (KATHARINE HINDS-PAYNE and CHRISTOPHER MALONY) |

NEEDLEBEARD - THE LITTLE BALL OF FLUFF THAT ACCUMULATES ON YOUR STYLUS (CHRISTOPHER MALONY) |

PIGGYBACK - TO CONFIRM A RARE OR EXPENSIVE RECORD FOR A GREAT PRICE (CHRISTOPHER MICHAEL MALONY) |

TOP LOCK - INSERTING A SLEEVE UPRIGHT INTO THE JACKET SO THAT IT HAS BEEN IMPORTED OR MARKED TO BE SOLD AT DISCOUNT (KATHARINE HINDS-PAYNE) |

MOBY DISC - THE WHITE WHALE THAT EVERY COLLECTOR DREAMS OF FINDING (CHRISTOPHER MAYNARD) | **MINTY** - A WAY OF DESCRIBING VINYL IN NEAR MINT CONDITION (FRANK ENGLER) |

CRUSTY - A COLLECTOR WHO IS NOT SPECIFICALLY LOOKING FOR RECORDS IN PRISTINE CONDITION AND WHO ISN'T AFRAID OF SURFACE NOISE (JON BOOK) |

PINK-EYE FIEND - A COLLECTOR WHO ALWAYS MAKES SURE TO LOOK AT THE INFORMATION IN THE RUN-OUT GROOVE TO BE SURE IT IS THE RIGHT PRESSING (FRANK ENGLER) |

(aka *STAR TREKKED*) - A RECORD THAT IS WARPED SO BADLY THAT IT (AARON LUIS LEVINSON) |

COWBOY HAT (aka *STAR TREKKED*) |

DUPE - A DUPLICATE OF A RECORD FOR SALE OR TRADE (RAMBO SALINAS) |

VIRGINS - REISSUES (ANTONIO DAVID VERGARA) |

GROOVE CHEESE - WHAT GETS DUG OUT OF THE GROOVES ON GRUBBY VINYL AS IT PLAYS (MATT SHARP) |

SLEEPER - A GREAT RECORD THAT MOST PEOPLE DON'T KNOW ABOUT (MIKE CINA) |

(COLLEEN "COSMO" MURPHY)

(JON BOOK)

283

THE INTERVIEWS

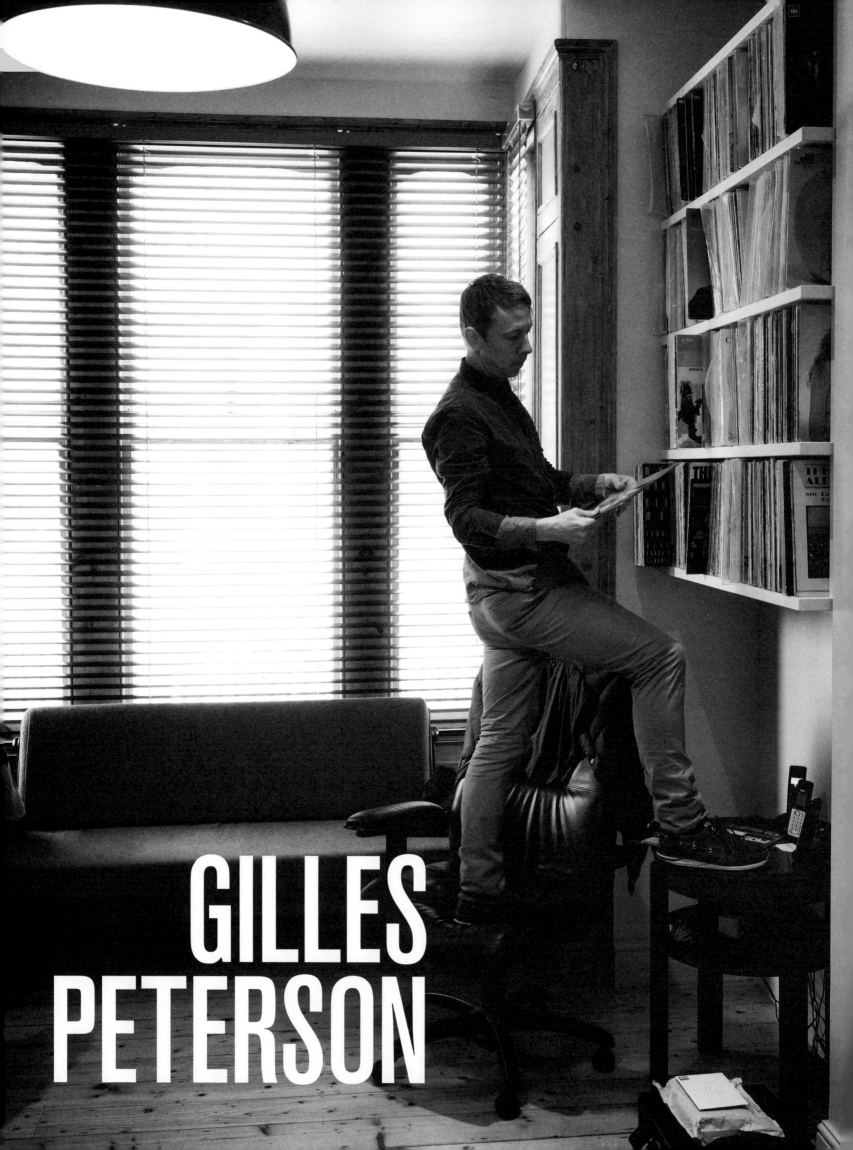

GILLES PETERSON

TALES OF A TRAILBLAZER

BY DOM SERVINI

O ver the past twenty-five years, the name Gilles Peterson has gradually become synonymous with his self-styled "worldwide" sound and his eternal quest for the perfect beat. Coming from French-Swiss parentage in South London, Gilles worked his way up the greasy pole of the music industry, taking on lowly jobs at record labels and setting up his own pirate radio station, to eventually become one of the most revered tastemakers in the United Kingdom and beyond. Since his emergence during the "acid jazz" years, his Talkin' Loud and Brownswood labels, legendary DJ sets, and globally popular radio shows have made Gilles a leader in his field. How to describe the music in that field was always the rub, though. "Bass-heavy, soulful, cutting-edge, often tropical, and always with a jazz flavor" doesn't read easily as a genre type, and yet he's managed to create an underground swell of broad, diverse music that has come to embody the man himself.

I've known Gilles personally for the better part of two decades, and so it was with a combination of familiarity, excitement, and trepidation that I entered the fabled Brownswood Recordings' basement one morning in the summer of 2013. Familiarity as I'd visited a number of times before, be it to deliver him some new releases from my label or to have a cup of tea and a chat about the Arsenal; excitement because during all those visits, I'd never had the time—or, to be more precise, Gilles had never had the time to sit down and go through his favorite, rarest, and most interesting records; and finally, it was with trepidation as I knew only too well how disorganized the man's record collection could get, and how bad he is at looking after even his most treasured vinyl. But that's Gilles!

Pitching up at Brownswood on that Monday morning in June, I had already forgiven him his tardiness, and the fact that some of the important records we were to discuss would be lost, missing, or at his "other place." Even though I'd discussed music with the man more times than I can remember, I was overwhelmingly excited to hear the stories behind the records that in turn tell the story of Gilles Peterson, a living legend of musical eclecticism.

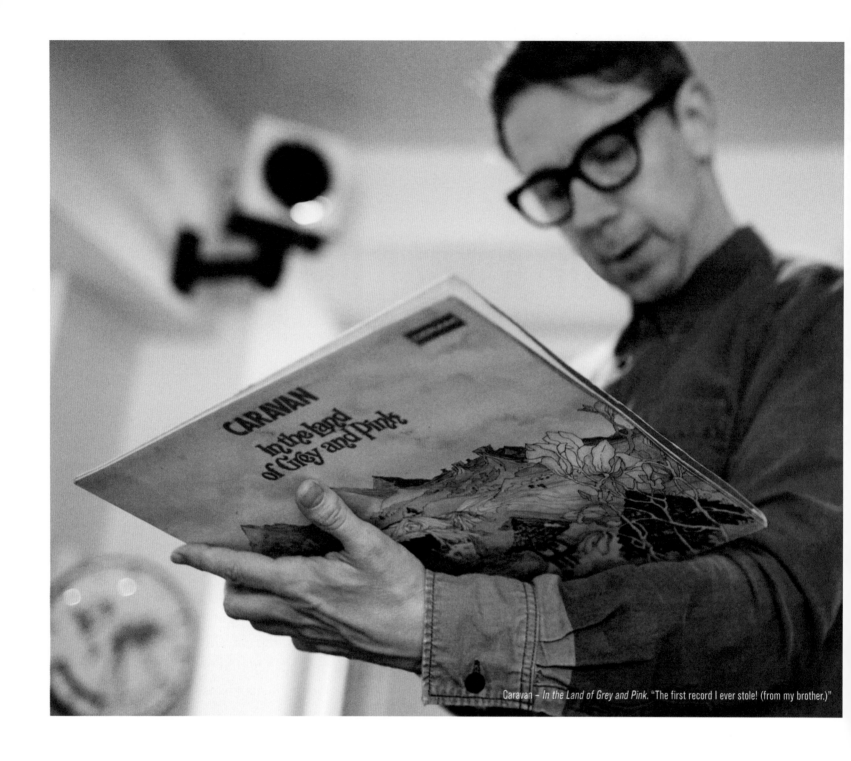

Caravan – *In the Land of Grey and Pink*. "The first record I ever stole! (from my brother.)"

What was the first album in your collection?

It's probably Caravan's *In the Land of Grey and Pink*. It's not really the first record I ever bought, but it's the first record I ever stole! I "borrowed" it from my older brother's bedroom and never gave it back. This was in Sutton, South London, in 1973, and I would have been nine years old. It was the moment I realized I loved music and I *needed* music in my life, because I had to get home from school as fast as I could and listen to this record in full every day.

I guess your brother was a huge influence on you musically, then?

All my siblings were. My sister was into singer-songwriters—she loved the Beatles, Simon & Garfunkel, and so on. My brother was into prog rock—Black Sabbath, Pink Floyd, Caravan, Camel, and all those interesting groups. He even touched on the Mahavishnu Orchestra and Miles' *Bitches Brew* at times, so there was definitely an influence there. He was quite a sophisticated person, and I do owe him a lot.

Do you feel like you pushed the envelope of what your brother was into even further?

In a way, but I suddenly switched when I heard jazz-funk. I was learning about the fundamentals of music through my family. My dad was into classical music. I'm not sure I enjoyed it, but I liked the atmosphere, the smell of his cigar, and so on. My mum is French and we listened to a lot of French radio at home, so the *chanson* thing was always happening. And when French artists came to London, we would go and see them.

So when did the big switch to jazz-funk happen?

It was when I was about eleven years old and I moved from a French to an English school. This was a very big deal and *the* big change in my life. Both my brother and sister had gone through the French system, and so even though we lived in England, we hadn't interacted so much with English people. We were in a French social circle until then.

So when I went to my first English school, I found myself in a very different situation with music and fashion, and very quickly realized that I had to find my people and the movement

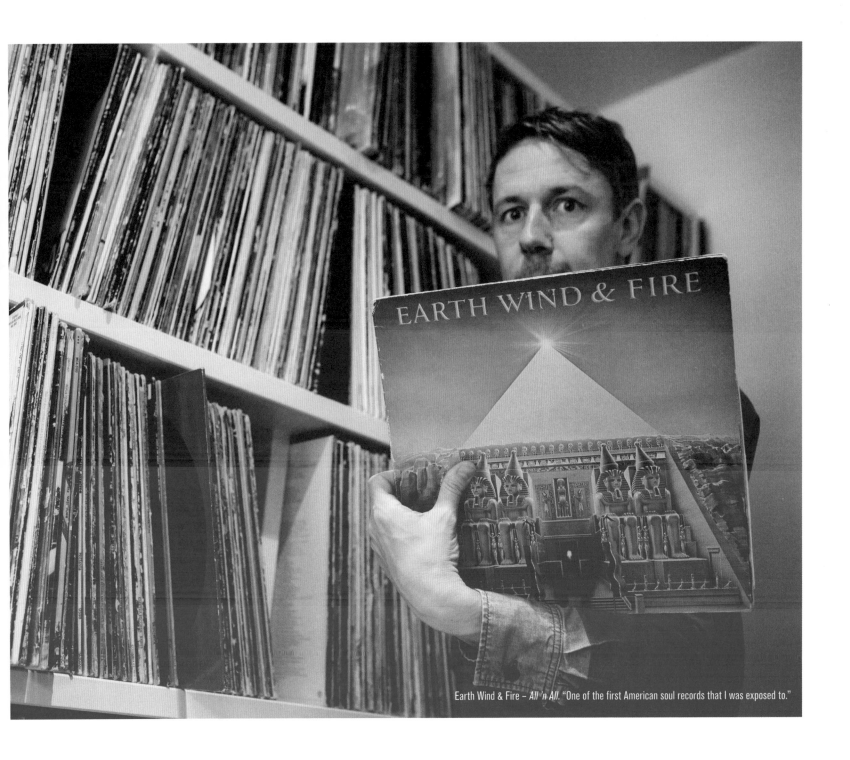

Earth Wind & Fire – *All 'n All*. "One of the first American soul records that I was exposed to."

that I would follow. You had to be part of a scene—be it punk, mod, heavy metal, and so on. Unlike in the French school, now that we had uniforms, people had to show what scene they were into.

Did American jazz-funk or Brit funk hit you first?

It was the American music first. I went to my new friend Andrew Crossley's house and met his sister, who, it turned out, was something of a soul girl. She had lots of great records by artists like Bobby Caldwell, Earth Wind & Fire and Leroy Hutson, Maze's *Live in New Orleans*—amazing records! I was immediately inspired by her record collection.

Did you manage to encourage many of your classmates to get into jazz-funk?

When I was fifteen years old, I discovered an awesome record by Tony Rallo & the Midnite

"MY MUM DIDN'T UNDERSTAND IT. SHE WAS DISTRAUGHT BY MY VINYL ADDICTION, SO MUCH SO THAT I USED TO HAVE TO HIDE RECORDS FROM HER. BUT MY DAD SAW THAT THERE WAS NO TURNING BACK. HE GOT IT."

Band called "Holdin' On." It was a crossover hit, and I'd heard that he was going to be performing it live on *Top of the Pops* one

Thursday, so I told the whole school. When he came on the television, not only was he a terrible singer, it was one of the campiest performances any of us had ever seen! Needless to say, the next day I got completely battered by my classmates. He only made one more record after that, thankfully.

So, we've talked about the US side of jazz-funk, but who was the first British artist you heard that really struck you?

That was without a doubt Level 42. The first record that struck me was the 12-inch of "Sandstorm." It was released on Elite, which is my favorite Brit-funk label.

"ENGLAND HAS ALWAYS BEEN A ROCK & ROLL COUNTRY, AND THINGS WERE KIND OF DARK IN THE LATE 1970S AND EARLY 1980S. THATCHER WAS IN POWER, AND THE PUNK MOVEMENT WAS STRONG. THERE WAS A LOT OF VIOLENCE, MUCH MORE THAN YOU SEE TODAY, SO FOR ME TO FIND MUSIC THAT WAS UPLIFTING AND HAD POSITIVE MESSAGES AND MELODIES WAS INCREDIBLE!"

This 12-inch was also the first promo I ever got sent as a DJ, when I was just sixteen years old.

I had written to the Level 42 fan club (I used to write to all the fan clubs!), and they sent me what was my first-ever "free record." My mum didn't understand it. She was distraught by my vinyl addiction, so much so that I used to have to hide records from her. But my dad saw that there was no turning back. He got it.

I also wrote to Bluey from Incognito, asking him to do an interview with me at my own little pirate radio station. I'd set up my own station in the back garden of our house, and my dad used to help me put the aerials up. Incognito had just put out their album *Jazz Funk,* and I loved it. Bluey was living in Tottenham and he came all the way to Sutton to be interviewed by this sixteen-year-old kid. Amazingly and happily, fifteen years later, when I set up my Talkin' Loud record label, the first act I signed was Incognito, and not only that, they turned out to be my most successful signing!

Were you going to live gigs at this point?

I've seen Level 42 innumerable times. I was their biggest fan. I used to go and see them everywhere I could, and I'd be backstage at every gig, waiting to see Mark King when he came out. He was my hero.

They were a brilliant live band in the early days, before they became a stadium rock act.

Brit funk was really important to me, and it was a really interesting time. You had an underground club scene based on US funk, soul, and disco, and then the British bands began to copy that, creating their own sound—bands like Light of the World, Hi Tension, and Hudson People were incredibly important.

Hudson People's "Trip to Your Mind" was the first record I ever received at a gig. I was at the Pearly All-Dayer, and I was about sixteen years old. The place was full of amazing dancers, but I never danced and instead used to stand at the side watching them all. When Hudson People were on stage doing a PA of "Trip to Your Mind," they threw a record out into the audience and I caught it! It's another prized record of mine, and it still sounds good today. I can play this now and the kids will dig it.

Why jazz-funk rather than another style or more popular music scene?

England has always been a rock & roll country, and things were kind of dark in the late 1970s and early 1980s. Thatcher was in power, and the punk movement was strong. There was a lot of violence, much more

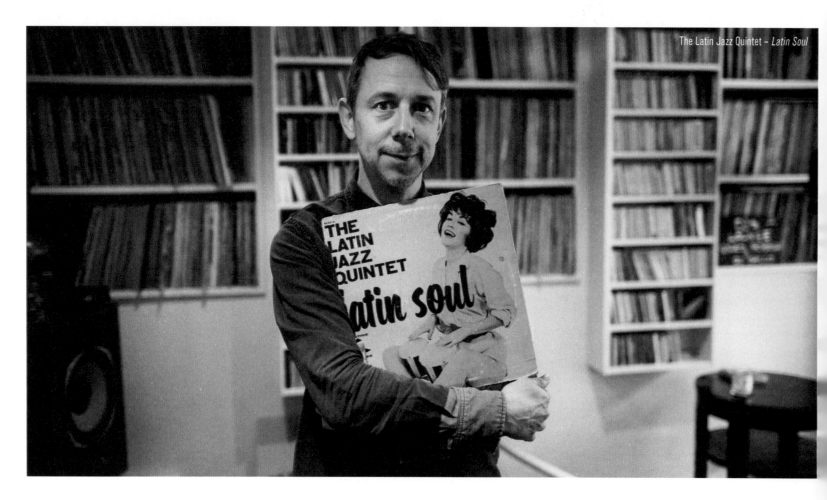

The Latin Jazz Quintet – *Latin Soul*

than you see today, so for me to find music that was uplifting and had positive messages and melodies was incredible! The tunes were jazzy but still had that disco thing going on. It was also more interesting to me because black people and girls would be at the parties. There was a kind of sexiness to it, and dancing (even though I was rubbish at it) was important. For me it was like I'd found my own piece of heaven. I'd found the place I belonged.

Were you exposed to the gay side of the disco scene as well?
Early on I used to play at a gay night in a club in Croydon. It was every Sunday night, and I used to tell my mum I was going to see friends. The crowd loved me there. I looked very young—sweet and innocent—and I was perfect for them. I'd play only gay disco music like Carol Jiani's "Hit 'N Run Lover"—it was kind of the other side of "Y.M.C.A."

Was the jazz-funk scene a central London or more suburban one?
The soul and jazz-funk scene was largely a suburban scene. There wasn't a lot going on in the West End of London. There were clubs like The Lyceum and Crackers, but the outer London scene was where it was really happening. We would go to clubs like the Cat's Whiskers in Streatham, Bogarts in Harrow, the Goldmine in Canvey Island, or the Royalty in Southgate. You would have to drive to these places, though, and I was good at mobilizing people. So to help pay for my vinyl addiction, I'd bring a busload of people to an event where I was DJing. We were called the Sutton Soul Patrol. This would, of course, please the venue, and not only would they pay me for DJing, but they'd rebook me. That's how I got known. Not because I was a good DJ (I wasn't), but because I could bring the crowds. The music is important, but the way to become popular is to bring people to you. It's about being enthusiastic and having a good network. I knew this was how I would become a better-known name.

What was your first big DJ break?
It was when I first got asked to play a Bognor Regis Weekender with all the big soul and jazz-funk DJs of the time—people like Chris Hill, Robbie Vincent, and Pete Tong.

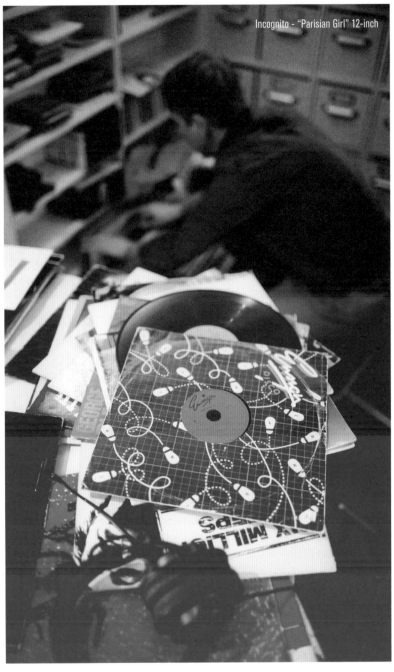

Incognito - "Parisian Girl" 12-inch

"THAT'S HOW I GOT KNOWN. NOT BECAUSE I WAS A GOOD DJ (I WASN'T), BUT BECAUSE I COULD BRING THE CROWDS. THE MUSIC IS IMPORTANT, BUT THE WAY TO BECOME POPULAR IS TO BRING PEOPLE TO YOU. IT'S ABOUT BEING ENTHUSIASTIC AND HAVING A GOOD NETWORK. I KNEW THIS WAS HOW I WOULD BECOME A BETTER-KNOWN NAME."

When did you start playing dancefloor jazz?

What I was listening to, which was jazz-funk, was essentially jazz with a disco beat. The record that led me from that into jazz for the dance floor was George Duke's *A Brazilian Love Affair*. George Duke going to Brazil meant that I discovered Milton Nascimento, Flora Purim, and so on. It was a hugely important record for me and opened the floodgates.

Another important record was Herbie Hancock's *Mr. Hands*. Herbie is my all-time favorite musician.

What was your best "toilet break record?"

When I was about nineteen years old I was DJing regularly at the Electric Ballroom in Camden. I used to get there at the start of the night, but I was always hungry, as it was a long way on the bus from Sutton to Camden. So I'd always put on Art Blakey's "A Night in Tunisia" and then go round the corner to KFC. I'd buy my dinner, eat it, come back, and it'd still be playing! It was seventeen minutes long. This was my weekly routine.

More recently I did a gig on the beach in Antalya, Turkey. It was the end of my set and I put on "Springtime" by Eric Dolphy. It's the most incredible song, and more important, it's about fourteen minutes long. I put it on, jumped in the sea, had a swim, got out, and then played A Tribe Called Quest's "Excursions."

I just want to clear up the story of acid jazz and how the term came about . . .

Here's the story: Chris Bangs and myself used to DJ in clubs as the Baptist Brothers. We were playing after Paul Oakenfold one night at the Brentford Arts Centre circa 1987. All the DJs used to be soul boys, but suddenly they'd changed to headband-wearing ravers playing very different music. So Chris Bangs and I felt under a little pressure, as we were always the more radical ones in that scene, and the soul boys were more straight and conservative. But suddenly, after discovering ecstasy, Ibiza, and acid house, they were more mad than us, and so we were really worried about what we were going to play.

At the time, the rare groove scene was emerging, so Chris Bangs went on and played "Iron Leg" by Mickey & the Soul Generation, which is a funk record. He vary sped the guitar intro on the front, got on the microphone, and said, "Fuck acid house, this is acid jazz!" and that was it. He coined the phrase.

What do you think the biggest regret of your career has been so far?

When I first started working for StreetSounds,

> ## "WHEN I WAS ABOUT NINETEEN YEARS OLD I WAS DJING REGULARLY AT THE ELECTRIC BALLROOM IN CAMDEN. I USED TO GET THERE AT THE START OF THE NIGHT, BUT I WAS ALWAYS HUNGRY, AS IT WAS A LONG WAY ON THE BUS FROM SUTTON TO CAMDEN. SO I'D ALWAYS PUT ON ART BLAKEY'S 'A NIGHT IN TUNISIA' AND THEN GO ROUND THE CORNER TO KFC. I'D BUY MY DINNER, EAT IT, COME BACK, AND IT'D STILL BE PLAYING! IT WAS SEVENTEEN MINUTES LONG. THIS WAS MY WEEKLY ROUTINE."

the label that released the *Electro* albums, the *Jazz Juice* compilations, and so on, there was a guy working there called Andros Georgiou, who, it turned out, was the cousin of George Michael. He asked me to set up a little record label with him, through StreetSounds, which became Hardback Records. We released three singles, but none of them sold particularly well at all. StreetSounds removed their backing of this failing imprint, but Andros told me that his famous cousin was interested in releasing a single with us, under another name, and that all we had to do was invest £5,000 each into the release. I refused, as George Michael wasn't 'cool' in my eyes, so Andros released it himself without my involvement. The record was a cover of the Bee Gees' "Jive Talkin'" and it went to number one all across the globe! It was the first of many mistakes I've made in the music industry.

Is there a record that you're proud to have "broken" in the jazz scene?

After StreetSounds I started working for Ace Records, which specialized in compilations. The owner of Ace, Roger Armstrong, had bought the catalog of California labels Prestige, Fantasy, and Milestone and brought me in to put compi-

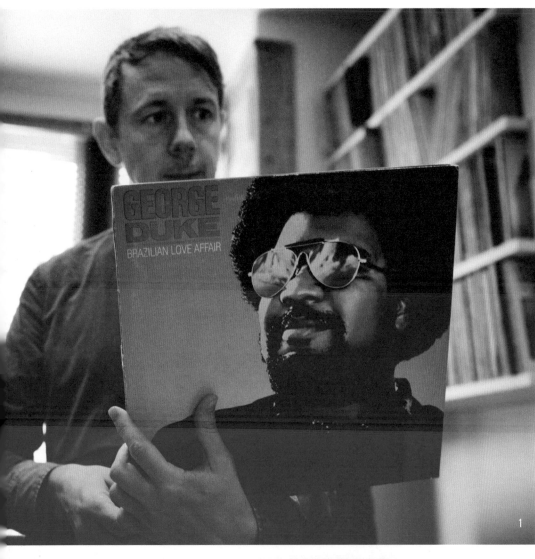

1. George Duke – *A Brazilian Love Affair.* "Funnily enough, the Brazilian version of this album doesn't have the title track on it." 2. Herbie Hancock – *Mr. Hands* 3. Eberhard Schoener – *Flashback.* "Not a rarity, but a surprise record that features the vocals of none other than Sting!" 4. Sarah Vaughan – *The Planet Is Alive . . . Let It Live!* "Contains the gorgeous 'The Mystery of Man.'" 5. Bethlehem Progressive Ensemble - *Mod Lit* 6. Arthur Blythe – *Basic Blythe.* "My 'comfort record' for a sleepy Sunday morning."

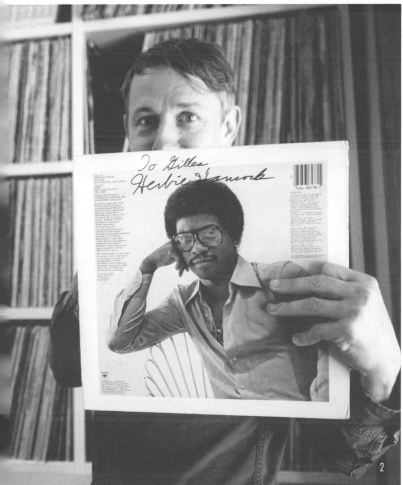

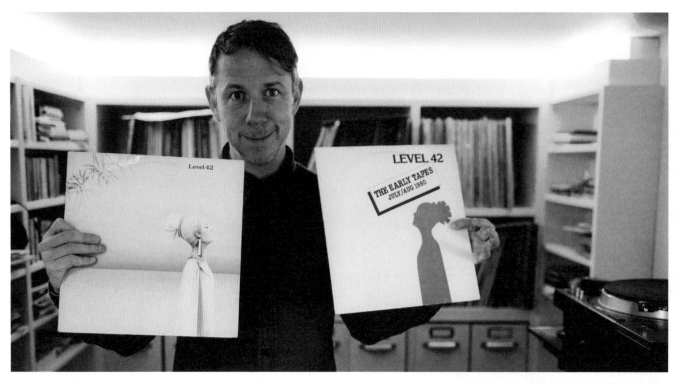

Level 42 – *Self-titled* and *The Early Tapes*

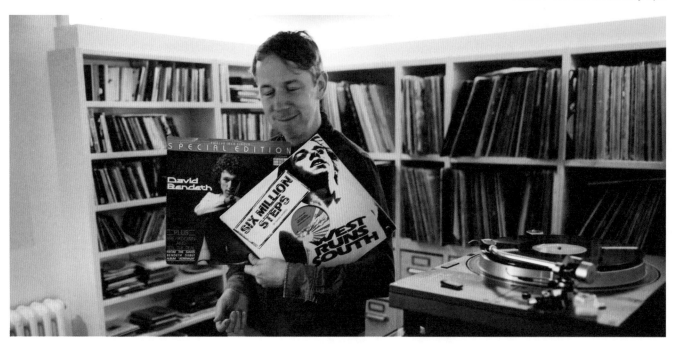

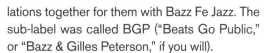

David Bendeth – "Feel the Real" and Rahni Harris & F.L.O. – "Six Million Steps." "Uplifting, positive disco that moved me in those early years."

lations together for them with Bazz Fe Jazz. The sub-label was called BGP ("Beats Go Public," or "Bazz & Gilles Peterson," if you will).

I was then told by Roger that there was loads more music in a warehouse in Berkeley, California, and he wanted me to go over and take a look at it. I'd never been to the US before. This was about 1985, and I'd never even been on a long-haul flight! I had a friend who worked at the airport and he upgraded me to business class.

Start as you mean to go on!
Exactly. I never knew what economy was like!

I spent a week at their warehouse, and on that trip I discovered a record that is still one of my favorite records of all time—*Latin Soul* by the Latin Jazz Quintet. This was a really interesting, stunning record. It had never officially come out, and there were only five copies of it in Ace's library. The reason it was never officially released was because there was a fault with the lacquers. I have one of only a handful of original copies of this record. In the end we re-released it on BGP, but the original is exceptionally rare. And my copy needs some love, as it's really battered. I pretty much broke this tune.

DJs make a name for themselves by breaking a tune. I was never massively good at that—it was more the collectors who did that. People like Paul

Murphy discovered thousands of jazz-dance and fusion records that might have come out only in Poland, for example, but that destroy the dance floor. So he deserves a lot of respect. He was way ahead of the game. He discovered a big base of what I ended up playing as a jazz DJ. People like Paul were the generation before me. They were the guys that sadly didn't manage to survive in the business.

What is the rarest record in your collection?
It's another that I should be treating with much more respect, but this is my Picasso. This is the record that I will always treasure. This is

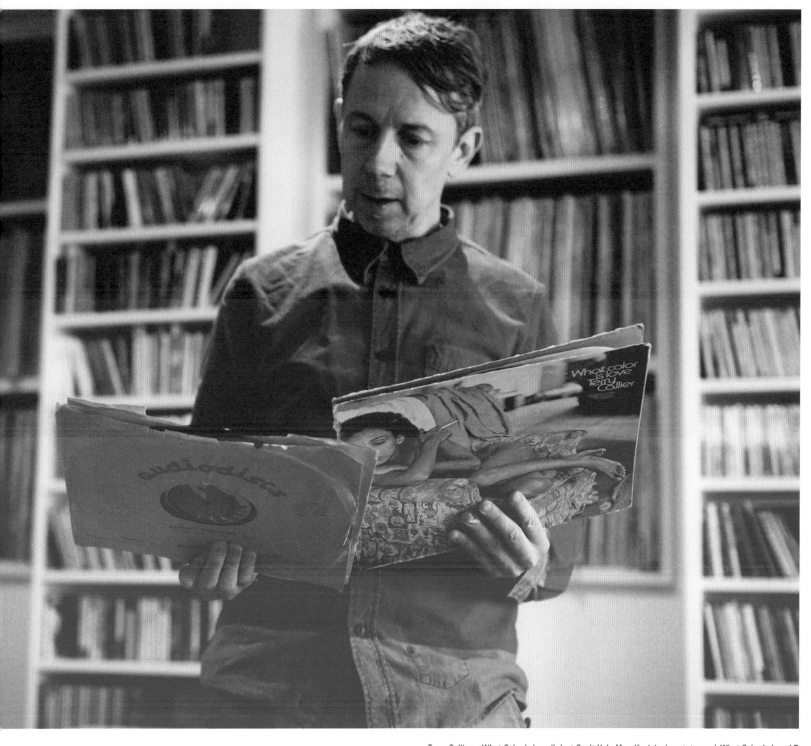

Terry Callier – *What Color Is Love/I Just Can't Help Myself* original acetates and *What Color Is Love* LP

the original version of *What Color Is Love* by Terry Callier, who tragically died last year.

Terry was signed to the Cadet label in Chicago, and when he played the record to the label bosses, rather than playing them a recording on a cassette, which would have been the norm, he had the record cut specially to acetate! And this is it—a double album acetate version of *What Color Is Love*. The label loved the record but wanted Terry to condense it into a single album. So this double album became a combination of his following album, *I Just Can't Help Myself*, and *What Color Is Love*. That's definitely the rarest thing I've got. It's the only copy in existence. It should be in a museum.

What's your most unusual record, with perhaps the most unusual story behind it?

Sarah Vaughan's *The Planet Is Alive . . . Let It Live!* is quite a wild one. It's an amazing record! It was funded by Alfa Romeo cars for Pope John Paul II, and it has an amazing lineup of musicians on it, including Sarah Vaughan and Francy Boland. The lyrics were taken from poems written by the Pope himself.

Not long after I'd got this record, I was traveling to do a gig in Cologne, Germany. When I arrived, there was no one to pick me up from the airport, and I ended up hungry, lost, and simply didn't know where I was going Suddenly, as I was walking past a restaurant, I heard "Gilles! Gilles!" It was a restaurant called Gigi's, and the people who had recognized me invited me in to eat with them. The guy who had called me turned out to be Christian Kellersmann, who ran Universal Jazz in Germany. So, during dinner I was telling him about this Pope John Paul II record, and he said to me, "Do you realize what restaurant you're in here? This is Gigi's! That's Gigi Campi, who produced that record!" He was also not only the guy behind Saba and MPS but was

295

Sun Ra - "A musician and an artist."

a chef, and this was his restaurant! So Gigi comes over to me and tells me he has the original program from the Sarah Vaughan show for the album . . . in the restaurant! He ended up giving it to me and even signing it, writing "Just in time!" It was an amazing coincidence and it's an incredible album.

What's the record that you've spent the most money on?

That would be Ebo Taylor and Uhuru Yenzu, the album with "Love And Death" on it. I was in Tokyo and went into a record shop in Shibuya. The guys who work in the shop always know when I'm there, and they often start showing off by playing rare records. One of them put on this record, and I started freaking out about how amazing it was and how I'd never heard a record like it before. It was like the Fela Kuti track he never made!

So do you still consider yourself a digger? Do you still have the time, energy, and passion to go digging for records today?

Hell yeah! But what I do now, due to time constraints, is arrange meetings with dealers when I'm in various countries. My favorite person at the moment is Victor Kiswell in Paris. When I do my regular Sunday gig in the city, I stay over on the Monday and spend the day with him in his beautiful apartment.

Is there a record you've found that's really surprised you when you've been with these dealers?

I bought a record from Victor by Eberhard Schoener called *Flashback*, which features vocals by our very own Sting. In fact, it features all three members of the Police. It's quite an obvious record in some ways, but I just

the most stunning jazz record featuring a string quartet. It's a very reflective album and one of those records I always go back to, because it's less obvious than Wayne Shorter or Miles or Coltrane but equally effective. Arthur Blythe was a super-underrated artist. I have three copies of this record. I get through with this one!

It's fair to say you're a DJ who likes to take risks. Do you have a safety-net record that gets you out of trouble?

Something like Cerrone's "Hooked on You" usually works, but it depends. The dance floors are ever-changing. Another great live album that has gotten me out of trouble a few times is by Les Amazones de Guinée. The track "Samba" is a 1980s afro-house monster. I got this, again, from Victor. I love playing these old records in a big club.

"DJS MAKE A NAME FOR THEMSELVES BY BREAKING A TUNE. I WAS NEVER MASSIVELY GOOD AT THAT IT WAS MORE THE COLLECTORS WHO DID THAT."

So I asked the guy how much it was and he told me that it wasn't for sale—it was his personal copy. I couldn't believe it. So I went back to my hotel room and went on eBay. I'd never used eBay before, but it was on there for about £300 and I bought it straightaway.

That's quite a reasonable amount for your most expensive purchase!

Yep, I've never bought a record for £1,000 or anything, but I have sold a record for £2,500. It was the original pressing of the album by Ricardo Marrero & the Group with "Feel Like Making Love" on it.

Is there a holy-grail record that you're still unable to find?

Not really, but there are a couple of records I've given away to people that I've never been able to find again, which I'm really annoyed about. Like Sabu Martinez's *Sorcery!* album, featuring the killer track "Sol," and Bobby Matos' *My Latin Soul* on Philips, which I just can't find again.

didn't know it. It's absolutely killer!

Do you have a favorite place in the world to go and dig vinyl?

I find that I'm very relaxed when I'm digging in Japan. Digging is always about where you're headed, and whenever I'm in Japan I'm always happy to be there.

When you made the *Digs America* albums, what gems did you discover whilst compiling them in the US?

When I did the second volume of *Digs America*, I went to Ubiquity Records, where Mike, the owner, told me he'd just bought a record collection off of some guy and he had all the boxes scattered about in his room upstairs. I was lucky enough to be the first person to have a dig through them. I got loads of stuff from that collection, including an album from the Bethlehem Progressive Ensemble called *Mod Lit*. It contains an amazing track entitled "Call to Worship."

What is your comfort record—the one that calms you down and makes you feel good?

That's Arthur Blythe's *Basic Blythe*. It's just

How many records do you have in your collection?

I've got about thirty thousand albums.

Among all those records, is there an artist you're particularly fanatical about?

I have to say Sun Ra. He was a painter as well as a musician and used to create the artwork for his own album covers. I'm a Sun Ra nut! Most of his records should be up in an art gallery.

Are you trying to complete your Sun Ra collection?

No. That's impossible. When I started collecting his records in the 1980s they were easy to find; now original copies of his albums are out of everyone's league. It's like collecting art now. I met a collector in LA the other day who had a most amazing hand-painted original—priceless!

What would you like to happen to your collection when you're gone?

I think my second son, Luke, is going to be really up for it. At least I hope he'll be really up for it!

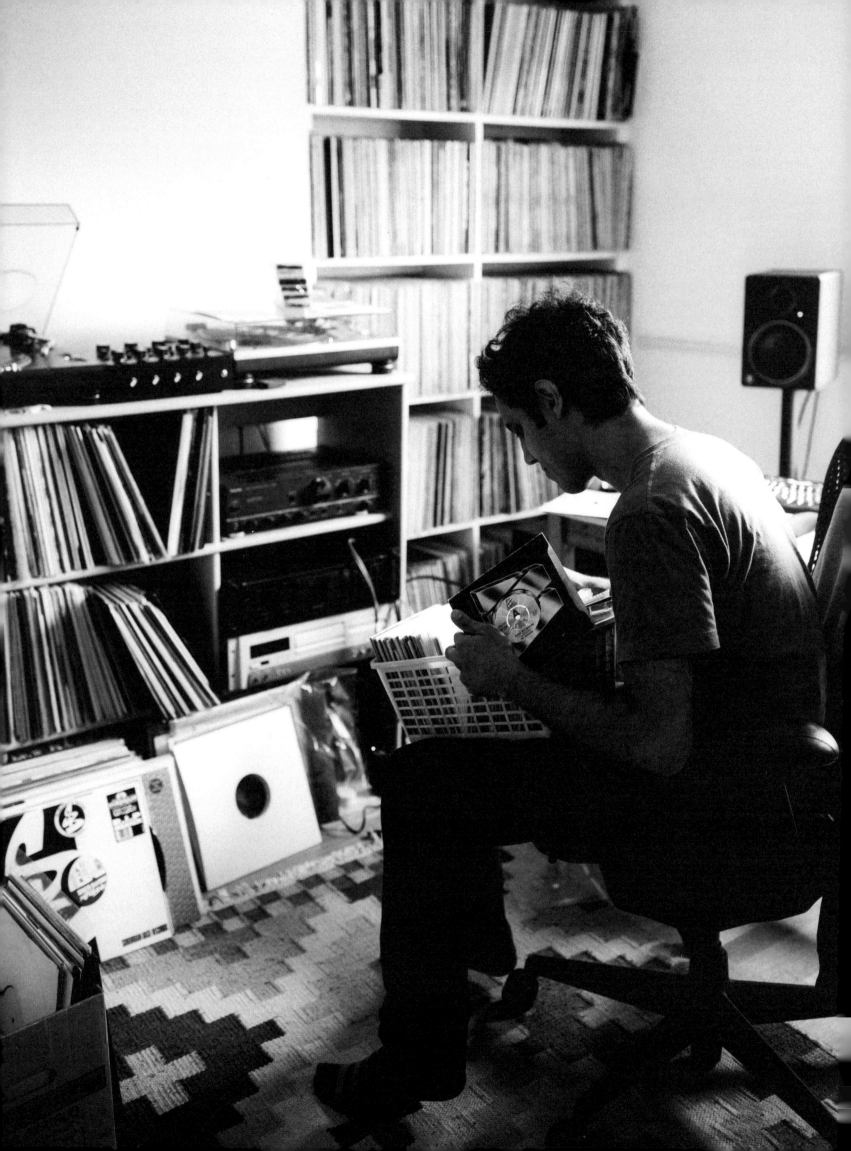

KIERAN HEBDEN (FOUR TET)
SHARED STEREO

BY KEVIN FOAKES (DJ FOOD)

Kieran Hebden first came to my attention with his post-rock band Fridge in the '90s, before pursuing a solo path under the name Four Tet. Shortly after 9/11, we toured North America together and became friends, bonding over a love of weird and wonderful records as we pillaged spots daily from east coast to west. He has since become an internationally renowned producer, remixer, and DJ, working with artists like The xx, Radiohead, Black Sabbath, Beth Orton, and Battles.

Eilon and I were invited to his North London home for a four-hour trek through Kieran's career and vinyl habits via his record collection. When we arrived, he quickly admitted to being a fan of Dust & Grooves, saying, "I discovered the website and stopped everything for about three days."

During our visit, Kieran peppered the descriptions of his records with adjectives like "amazing," "incredible," and "insane"—all delivered with a huge smile. The price paid or the monetary value of the records rarely came up. He isn't concerned with collecting as an investment, nor does he have an eye on resale values. Rather, he has an insatiable appetite for sound, new and old, regardless of its worth. He also recognizes the absurdity of his collecting habits. Showing us his three-volume set of the Sun Ra Arkestra's *Live at Praxis '84*, recorded in Athens, Greece, he quipped, laughing, "All Greek pressings."

What was your first record?

Tears for Fears' "Shout" was the first record I ever bought with my own money. Around the same time, I also bought Falco's "Rock Me Amadeus." I lived in Putney and there was an Our Price on the high street, where I remember buying that Tears for Fears record.

Was it the 7-inch?

Yeah, I was way more about the 7-inch than anything else. I also had my own copy of the English Beat's "Mirror in the Bathroom" 7-inch, which I was given long before I bought the Tears for Fears record. I still have my old copy of "Mirror in the Bathroom." My dad is a big record collector. He doesn't keep so many anymore, but at the time he had a lot. He was also trading at record fairs.

What did he do for a living?

He was a sociology lecturer, but records were totally his thing. We were surrounded by records all the time. He was going to car boot sales, and stuff was always coming into the house. I was always given records, even as a baby. I was given my own turntable when I was young, too, and I would make tapes of me playing a record and singing random stuff over it. When I was a teenager, and just starting to develop my own taste, I was learning to play my guitar, and I would read about Jimi Hendrix and then go downstairs and find that [the records] were all there.

By the time I was buying records for myself, it was already so normal to have them around that anything I got would just go into the family collection. I remember my dad would listen to lots of classic jazz and soul, and I was obviously a bit more interested in the modern music of the time. I remember things like "Blue Monday" coming out and us buying the 12-inch. I knew this would be something I was going to be into.

Did you pick out "Blue Monday" or your dad?

My dad. He was like, "You're going to love this. It's got all these drum machines on it."

Sounds like you had the coolest dad in the world.

He still is. He finds me amazing records all the time. When he comes out, he'll be at Plastic People until two o'clock in the morning. When he retired, he had this very Zen kind of moment where he said, "I'm going to get rid of all possessions," and he got rid of everything. He doesn't have books, records, anything. Now he mostly picks records up for me.

Were there any sleeves of your dad's records that you were attracted to?

I was really into 7-inch labels. So apparently, when I was little, my first words were things like "Decca" and "Parlophone." I knew how to identify the labels by the logos.

What was the first big, influential record you remember?

Our household anthem—which was played at every party and which I will always associate with my childhood—was "Needle in a Haystack" by the Velvelettes.

Also, my mum's the biggest Joni Mitchell fan of all time. Growing up, we were always listening to her records. Now that I've grown up, I've become obsessive. I've got all the audiophile pressings. I collect all the different pressings for the different sounds. When we did the Fridge album *Eph* on Go! Beat, we got the same weird grain texture sleeve [as Joni Mitchell's *Blue*]. When they didn't understand what I meant, I took *Blue* in and said, "You have to try and replicate this."

The Velvelettes - "Needle in a Haystack"

Is there any Joni Mitchell record that you're still looking for?

One of my grails is the Nimbus audiophile pressing of *The Hissing of Summer Lawns*. Can't find it anywhere.

Where did you get money to buy records?

The Tears for Fears record would be 50 pence and the record fairs would have ten pence boxes, so it wasn't very much. I'd help my dad if he had a stall and he'd give me some money. Later, when I was a

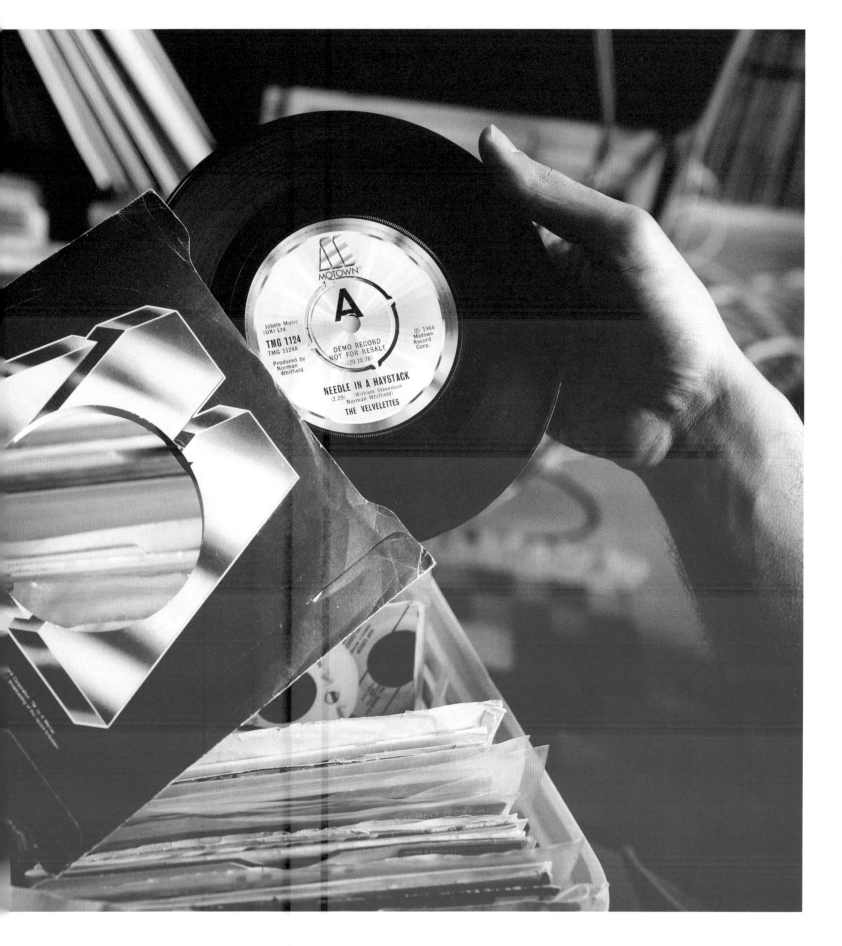

"I WAS REALLY INTO 7-INCH LABELS. SO APPARENTLY, WHEN I WAS LITTLE, MY FIRST WORDS WERE THINGS LIKE 'DECCA' AND 'PARLOPHONE.' I KNEW HOW TO IDENTIFY THE LABELS BY THE LOGOS."

teenager, I had a monthly allowance. But I knew how to buy records cheaply. Buying records in a shop didn't exist for me. If a new album was coming out, never in a million years was I going to buy it at Our Price for £15. I knew that at the Camden record fair the next week, I'd be able to get it for £5 from guys who had some wholesale deal going on. Because of that, I've always had a lot of weird promo versions of things.

Grunge was really when I started acquiring my own record collection, and that started opening up the doors to other worlds. I got into Sonic Youth, Smashing Pumpkins, and bands like that. I saw Quickspace Supersport in England, who were a life-changing band for me, and who Fridge was modeled after. It was from their records that I discovered Stereolab and Tortoise. Then I discovered krautrock and I started buying Neu! records.

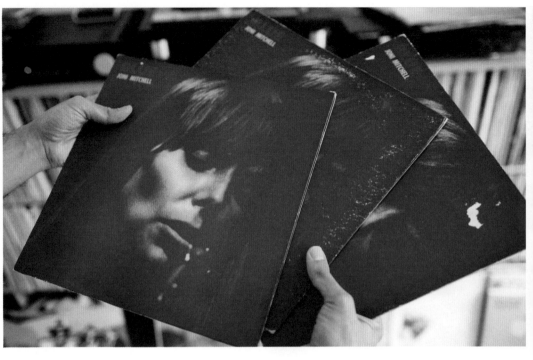

Joni Mitchell - *Blue*. "My mum's copy of *Blue*, a UK pressing, and an American pressing."

You're jumping ahead.
Yeah, the grunge thing happened in America and that led me to the lo-fi Riot Grrrl scene, and that's what really inspired me. It made me feel as if you could make records in your bedroom.

I was going down to Rough Trade in Covent Garden a lot, and I made friends with a few of the people there, including Darryl Moore, the head of Soul Static Sound. He was a sort of guru for me. The main shop I was going to, though, was Beggars Banquet in Putney, where Justin Spear worked. He's at BBC 6 Music now. He was friends with all the Stereolab, guys and he would recommend records to me.

Stereolab did two big tours around this time, one with Yo La Tengo and one with Tortoise, and I was traveling around the country, trying to catch all the shows. Tortoise's "Why We Fight" was another life-changing record for me.

There was this event at Dingwalls in London called the "Easter Egg-Splosion," organized by these guys called Piao! A compilation record was made just for that event, and it featured Quickspace Supersport, Lung Leg, Prolapse, and some other Riot Grrrl stuff. All of us from Fridge were there, and at this point, we were like, "We're in a band and we want to put out a record on this label." This was 1995, and we were a bit older. I'd seen Rage Against the Machine, Alice In Chains, and all these other shows, and suddenly I'm buying Rough Trade records and thinking, "This is what's really going on!"

So these were all the reference points for Fridge?
Yeah, but the other thing that happened around this time was drum and bass.

These guys were selling me Quickspace, Stereolab, and Tortoise 7-inches, and then the Metalheadz 12-inches started coming out. So, Tortoise come to London and Darryl's playing jungle records in between the bands at the show, and then I'm going into Beggars Banquet and this stuff is suddenly on the wall. Records like DJ Zinc/Ganja Kru's "Super Sharp Shooter" were all of a sudden being played.

It was all tapes of pirate radio. Every party I'm going to, I'm hearing this sort of thing. But I'm not going to any clubs—I had never even been to a club at this point. But I start buying these records, including LTJ Bukem's "Logical Progression," and then when Photek appeared, I was like, "He's my guy." Here is somebody who's taking all the sounds, but he's taking it to a whole other level that links to all the other stuff I'm into.

Did you have any Photek stuff from before "U.F.O."/"Rings Around Saturn"?
I have them all now, but this was my starting point for Photek. Things were all happening faster at this point. I was a bit older and had more money. The next thing I started checking out was Squarepusher, then Aphex Twin and all that stuff.

Where does the Warp label fit in with all this?
That all happened later on. This was '96, the same year we met Trevor Jackson from Output. I try to explain to people that what was happening

Jessamine - "Your Head Is So Small It's Like a Little Light." "After Sub Pop put out all these grunge records, they started releasing much weirder records like this drone record with a bolt through it."

around then was so wild because before drum and bass and jungle existed, you would never have been able to imagine it. Music that fast? But six months later, it was being used in shampoo advertisements on TV. It became so normal so quickly. Revolutions like that, as far as I was concerned, were happening in all kinds of music. Rock, hip-hop, and dance music were all evolving. It was happening in all these genres I was interested in. And I'm a teenager at this point, so I just think it's normal.

One way in which my dad's influence became important at this time was that he had helped me see the links between everything. When I became interested in something, I'd go, "What influenced this and how are they connected?" After listening to all these Tortoise records, I was thinking, "Well, this didn't just come out of nowhere. What are these guys listening to?" And that would lead me to my first Kraftwerk record.

Stereolab – "John Cage Bubblegum." "Still with bubblegum!"

Did hip-hop fit into any of this for you?

Yeah, a bit later. Hip-hop was the next big thing. When Cypress Hill's *Black Sunday* came out, you heard it at every party. When I heard it, I was like, "These are all just looped soul records." I knew those very soul records, as I'd heard them when I was a kid. I couldn't care less about the rapping. I was interested in the loops, how they turned something old into something new and futuristic. That's when I got interested in hip-hop. It was never about the vocals for me. It was always about the music.

Did you go back and check out stuff like Public Enemy or De La Soul?

Public Enemy I remember because they were so popular, but the samples were more just drums and noises. De La Soul had big loops of an eclectic range of records, so they totally appealed to me.

Somewhere around '97 or '98, I was buying all kinds of this stuff and learning about where all the samples came from, and that's when it hit me—I want to make music with samples! But I had no computer and no sampler, so I got a four-track tape machine and a little delay pedal, and for ages that's what I used. Samplers were really expensive then, and anything that was more than £150 was out of my league. This was on my mind for years—I had loads of ideas and it was driving me crazy. We were doing all the stuff with Fridge, and I kept thinking, "If I could just sample something, it would change the music I'm making completely."

When I went to college, I got a student loan and bought my first personal computer. I took a computer science course, and the guys from Simian Mobile Disco were in the same class. They gave me a floppy disk with a pirate copy of

Cakewalk. Suddenly, I was able to sample and sequence, and I made the first Four Tet records over the next two weeks. I knew exactly what I wanted to do. One of the first tracks I made was "Thirtysixtwentyfive." I was just ready. I'd been thinking about this for so long. When DJ Shadow's *Entroducing.....* came out, I was like, "Oh my god, it's not just a loop and a drum break from two records—he's sampling ten records!" As far as I was concerned, he'd made something more like Tortoise or Metalheadz—long tracks, trying to be more musical, not trying to be pop music. I didn't care about anything related to pop music. I didn't care about clubs or the audience. The idea of a "big tune" didn't exist to me.

So what were your big records from this time?

The record that floored me and changed everything and linked everything again was Bundy's record "Echoes" by Directions. It came out on the Soul Static Sound label and was the whole blueprint of what DJ Shadow was doing but much jazzier. At this point, I'd probably never heard a Ninja Tune record. Because I wasn't going to clubs, I had no connection to clubbing, so it just eliminated huge areas. I wasn't following any DJs; I was just pursuing the records I found. I didn't hear this and think, "Oh, loads of people are sampling jazz records at the moment." I heard this and thought it had come out of the Chicago/Tortoise kind of thing, and the next move was to take that and take music samples. For me, that's what made sense.

Quickspace Supersport 7-inches. "No one talks about them much, but they were the most influential for me."

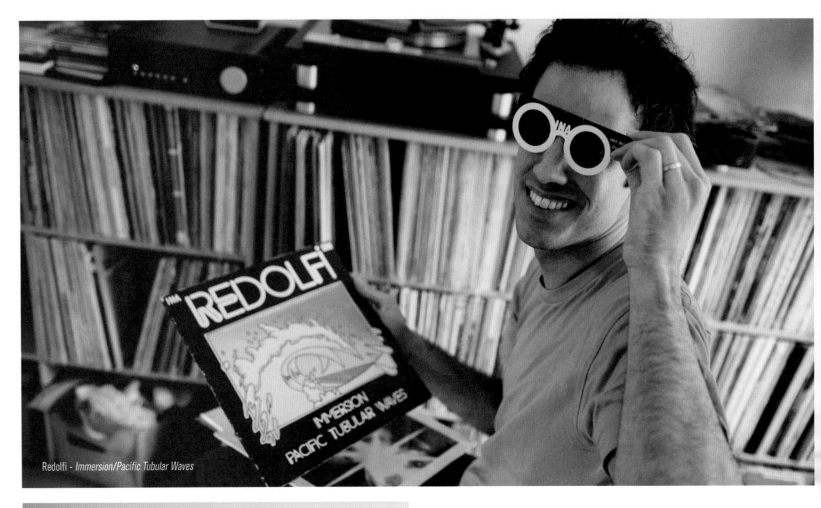

Redolfi - *Immersion/Pacific Tubular Waves*

Various Artists - *Universal Sounds of America*. "A compilation that changed my life."

I think that's a good example of how my idea of what was going on was warped, because I thought everybody was checking out "Echoes"—that it was a massive record. Tortoise were getting big and this was coming out on Darryl's label? What? I treated Soul Static Sound as one of the big labels. The composition on this is what was so influential to me—the way it's got this big breakdown. When I listen to my stuff from around this era, I notice the way it takes its time. I figured, because Bundy's coming from America and doing it, he's not referencing the electronic music going on in England at all. The pacing of it was very different. The stuff in the UK was more linked to dance music.

Did you clock the Tortoise remix record? At the time, that was a major link between the whole sampling thing and then the remix 12-inches they did later.
When it came out, I only had the money for that or their debut album, and I bought the debut. I only got the remix album recently—it eluded me for years. Because I had limited resources at the time, I'm just now getting around to buying all these records. I did have piles of cassettes, though. We were all trading tapes at school, listening to Walkmans, and listening to cassettes at friends' houses. CDs were crazy expensive as far as we were concerned, and the deal was that a few of you would buy a different CD and make tapes for each other. I was the guy in Fridge who bought records. The other guys would buy packs of tapes and give them to me, and I'd make my own compilations of all the Quickspace 7-inches. So basically, all the hip-hop stuff I had was on cassette. I wasn't DJing at all at this point, so I hadn't thought about the idea of needing the 12-inches to play out.

The key artists and releases for me were DJ Shadow's "What Does Your Soul Look Like?," Directions, Trevor Jackson—recorded as The Underdog—and New Kingdom's "Cheap Thrills." I always used to play "Cheap Thrills" fast. I was like, "This is so cool. It's on another level. The vocals sped up, all this jazz backing, the loop's so cool . . . " and then I met Trevor and I realized it's supposed to be played at 33 rpm, and that it was actually this gloomy, cracked-out kind of thing. And here I had thought it was this sunshine, De La Soul-style record.

The stuff Trevor was bringing out at that time was slightly more melodic than lots of the American guys. He was into Mo' Wax and all that, and they were using Eastern European jazz records. So, I bought *The Attic Tapes,* and it was life-changing. Then, a month or so later, I meet Trevor, and the next thing I know I'm on his label.

How did you two meet?

I met one of the guys from Gramme in a record shop and we got to chatting. He asked if I was in a band and I sent him a demo tape—the first demo we ever sent out. A few days later, I got a call from him and he was like, "This is great." He said he was working with this guy named Trevor Jackson, known as The Underdog, and I'm like, "I love those records." He said, "He wants to meet up with you," and a few weeks later it was all sorted out. Trevor just said to us, "What do you need to make a record?" We gave him a list of equipment—eight-track tape machine, effects boxes, and microphones—and he had it delivered to Sam, the drummer. We recorded all of the first Fridge records in a week.

Everything completely changed at this point. I didn't lose interest in this stuff, but it became much less important to me because now I was starting to make my own music, and I was

buying records to sample myself. I'd discovered jazz, and I realized that everything I had once thought of as incredibly innovative and brilliant had actually already been done in lots of ways—and usually much better! I slowed down pursuing current music and started focusing on music from the past. Trevor played me 23 Skidoo, electric Miles Davis, all for the first time. Music from all different directions.

So you're into krautrock by this time?

Yeah, I bought some Can records through the Stereolab connection, but the big turning points were when Sam, the drummer from Fridge, went to HMV and bought Miles Davis' *Bitches Brew* and Alice Coltrane's *Journey to Satchidananda.* I remember *Bitches Brew* being a little too much for us to get our heads around, and then we put *Journey to Satchidananda* on and I almost started crying. It absolutely floored me. It was like

Albert Ayler - *Bells*

music I'd dreamed of, had wished existed more than anything, and suddenly here it was. It did exist! All the jazz stuff from my dad was older. He wasn't playing any of the more spiritual jazz. But I did know some of the more extreme avant-garde stuff from going to the Bracknell Jazz Festival when I was a kid—where I saw Carla Bley and Don Cherry play mad, skronking stuff.

So then I bought *Universal Sounds of America*, a compilation that Soul Jazz put out, and that changed my life. It was everything. That's where I heard Steve Reid for the first time, Sun Ra for the first time; I heard artists from labels like Tribe and Strata East, and Pharoah Sanders and Art Ensemble of Chicago . . . everybody on that compilation in one go. Every track was a classic, and I thought, "I need to have every single record by every act on this compilation." When I started buying spiritual jazz—the Don Cherrys, the Coltranes—that's when I became a record collector.

Are there any labels or artists you still focus on?

I collect everything connected to Steve Reid. The other thing I always look for are records that mix together the cosmic, spiritual jazz sound with electronics. I'm always looking for anything that has synths, especially the ones where the artists actually collaborated. The records that Don Cherry did with Jon Appleton and things like that. It's this linking of things, the getting things together, that I really find exciting.

Tell us about a particular style of music you collect.

I've got a very intense collection of French prog rock. I discovered that France has this untapped, amazing goldmine of music that I really, really love. For example, this label called Pôle—their records have all been reissued on the label Tapioca. Mainly '70s stuff. One of the things you learn is that there are some real gems out there from unexpected periods. Mid-'80s jazz records only pressed in Africa, for instance.

Is it important for you to get the vinyl if there's a digital copy available?

I find I don't really listen to digital stuff. They just sit in these massive folders on hard drives, and I find it hard to penetrate. Whereas if I've got the actual record, I can cope with it.

1. Steve Reid - *Nova*. "My daughter's named after this record—her middle name is Nova. Steve died two or three weeks before she was born." 2. Besombes-Rizet - *Pôle* 3. Michael Czajkowski - *People the Sky* and Elias Tanenbaum - *Arp Art* 4. Janos Starker - *Bach Suites for Unaccompanied Cello.* "A $500–$600 record found on the street in New York." 5. Giordano Technique - *The Jazz Dance Workout* 6. The complete Nik Pascal. "These are good covers. They're odd solo Moog records—one was on Buddah, the others are on his own label, Narco."

Where do you buy records these days? Any favorite spots?

I go to the Utrecht record fair, eBay, Discogs, and I still buy a load in shops. I love buying in shops. Newer and older stuff. I made some good finds recently at a shop called Licorice Pie in Australia. For new stuff, I go to Honest Jon's, Phonica, and Soul Jazz. I've found that some places were good once, but that they never really leave the same impression again. I think the really consistent one would be Disc Union in Tokyo.

What comfort records do you listen to again and again?

Joni Mitchell's *The Hissing of Summer Lawns* is probably my favorite. *The Hissing of Summer Lawns*, *Blue*, or *Court & Spark*. Those are three of my favorite records. A lot of the jazz stuff, too. I always come back to Don Cherry. In terms of relaxing, his *Organic Music Society* LP. *Siamese Dream* by Smashing Pumpkins—I know every molecule of that record, and I'll put that on every now and again. Records like *Illmatic* by Nas I've played a zillion times, and I still come back to it again and again.

What have been some of your best finds?

I have a test pressing of *Spirits Rejoice* by Albert Ayler with a letter that came from the press company. It says "Advance review copy" on it. I like records where you know there's a story behind them, and where there's only a handful of copies.

There's a really good story connected to the Bach record—*Suites for Unaccompanied Cello No. 4 & 6*. While I was living in New York, I used to find amazing records dumped on the street all the time. One day there was this old couple who was putting out about twenty records, all classical stuff. They just dumped them on the front step. I went and grabbed a few, brought them home, and looked them up on Popsike. This one was $500 and another one—a box set of violin solos—was going for $800–$900. I went back to the house and explained to this couple how valuable these records were. They completely lost their minds. I said, "I just wanted to warn you, but if you want them back, that's fine." They were like, "Oh my gosh, really?" The funny thing is, they were throwing more out. I suggested that they check the values first, but they just kept the box sets, probably assuming they were the valuable ones. They put more and more records out and people kept coming and grabbing them. I went back every few hours and grabbed more myself.

Another time, I found an amazing jazz collection with loads of Strata East, just dumped on the street.

What are some of your weirdest records?

Redolfi's *Immersion/Pacific Tubular Waves* is a whole album of electronics, where they're putting the speakers in and out of water. The music's incredible. It's on the INA-GRM label and it comes with 3D glasses. What's funny is that this guy is aware of my music now because we asked him if we could license a track for a DJ mix. Can you imagine Fabric communicating with this guy?

Elias Tanenbaum's *Arp Art* has this track on it called "For the Bird," which is this guy doing early turntablism weirdness with a Charlie Parker record. It's absolutely bonkers. I think Michael Czajkowski's *People the Sky* is my favorite Buchla record. I kinda like it even more than the Morton Subotnick ones. It's music from a ballet. These are both electronic, and I think I should hold these up as two great examples of early electronic music that I like.

I collect dance records as well, made for people who do modern, contemporary dance. Lots of people, especially in France, released music for interpretative dance. I've got lots of records that are just drums, which were made for these sorts of things. Giordano Technique's *The Jazz Dance Workout* is my holy grail. It's one of the most amazing contemporary dance records of all time. I have the only two copies I've ever seen, and I don't know anyone else who's ever even seen them. What's weird is that the music actually differs on both of them— one has loads of synths on it, the other one doesn't. The version with synths is the one I've always had. Dusty Groove in Chicago recently found a copy and had it up on their website for $50. I bought it, and it has all the same tracks, but no synths, just the bass and drums.

Other weird ones are sound effects records—Macdonald Junior Reference Library's *Stars & Planets* has sounds of shooting stars recorded from radio waves. *Tapesongs* by Morton Subotnick's wife, Joan La Barbara, is made of just processed vocals. I played this on the radio when they asked me about the roots of cut-up vocals in music. Interspecies Music's *Whalescapes* is a band trying to re-create the sound of whales, using guitars and modular synths. These are the kind of records that I'll hear about and think, "I have to have that record!" Rolf Liebermann's *Symphonie Les Echanges* is made entirely from typewriters. It's a whole record of a typewriter orchestra, and then there's a jazz version by George Gruntz on the other side. This is a big Gilles Peterson record.

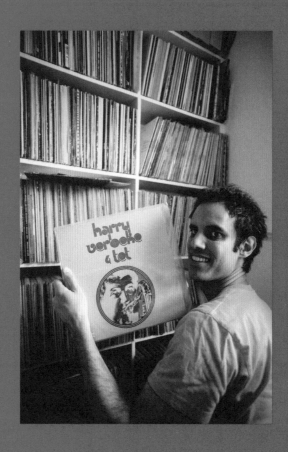

When it's time for Eilon and I to wrap things up, Kieran pulls out the final selection—the Harry Verbeke LP that he took his alias from.

Is it a good record apart from the fact that it has "4 Tet" on the cover?
I can't remember. There must be one good one on here.

He skips through the album. The first few tracks are cheesy sub–Boots Randolph jazz, but then he hits gold. The needle drops and a funky Rhodes workout appears, unlike anything preceding it, and that knowing smile creeps across his face.

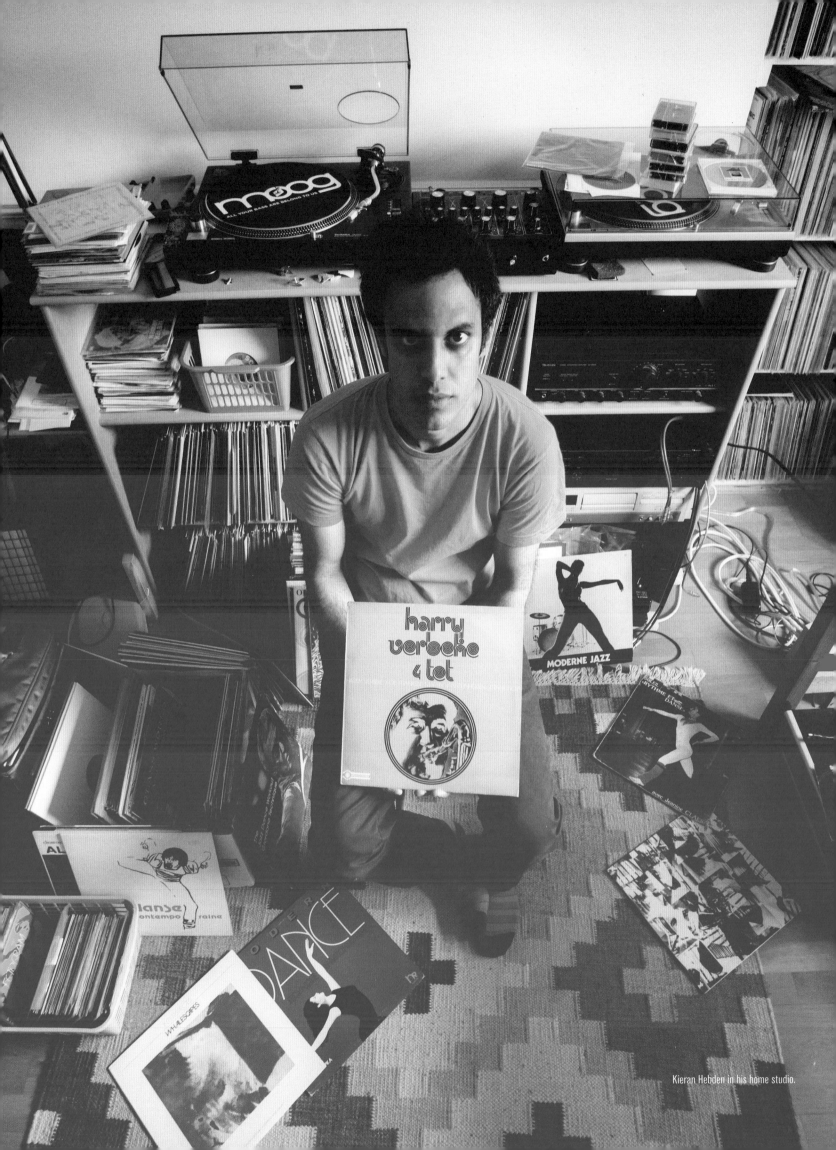

Kieran Hebden in his home studio.

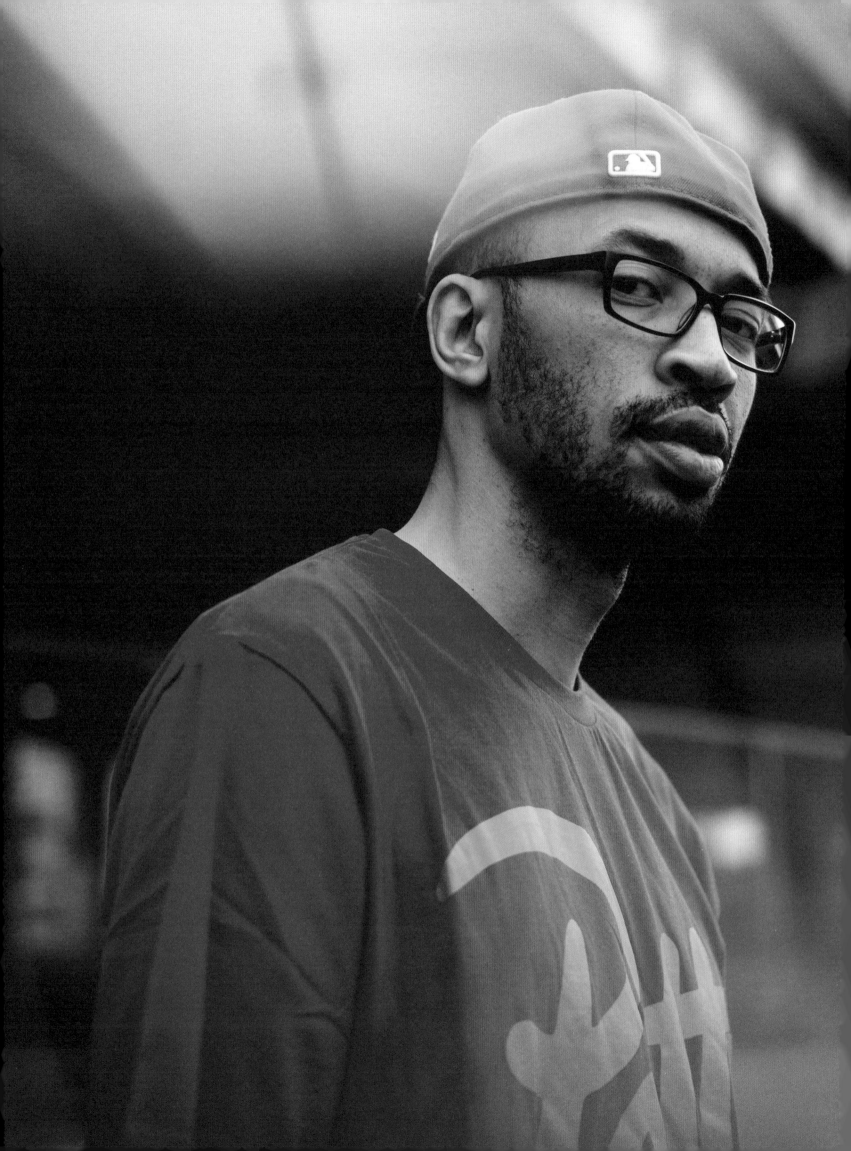

RICH MEDINA

I'M ALWAYS DIGGING, MAN

BY EILON PAZ

I met Rich Medina on record long before I met him in person. DJing at a nightclub in Tel Aviv in 2003, I slipped in the newly released King Britt *Adventures in Lo-Fi* LP and played a medium-tempo, spoken-word track called "Planetary Analysis." It opens with a sparse beat and then a man starts speaking, if not exactly rapping. The voice is deep, cool, and hypnotic—very reminiscent of Gil Scott-Heron.

But, of course, it's the words he spoke that sealed the deal:

So this is the world.
All questions have been asked and answered except your answer to the question:
And who the fuck are you?
A pebble on a beach or a boulder by the shore?
A hundred dollars a week in the bank or fifty dollars a day on whores?
Smells to me of morals at war.
So this is Mother Earth. Wow. We got some work to do here.

The one question I couldn't answer was, who was the man behind those words?

It had taken me several months to learn that the voice on "Planetary Analysis" belonged to King's longtime friend, Rich Medina. His recordings aside, Rich had long since established himself as a super hard-working DJ with a global reputation. Based in Philadelphia, he'd won some of his biggest props for several long-term, high-profile engagements in New York, including "Lil Ricky's Rib Shack," a weekly gig at APT, and "Open," his partnership with Q-Tip at Santos Party House. He has also taken several of his parties on the road, including "Jump N Funk," dedicated to the music of Fela Anikulapo Kuti. Then there are the concert gigs, which have seen Rich opening for Lauryn Hill, De La Soul, Erykah Badu, Tony Allen, Roy Ayers, Gil Scott-Heron, The Roots, Jill Scott, Zap Mama, and Femi Kuti.

Turns out that Rich, a 6'6" former varsity basketball player at Cornell, is even larger in person than he is on record. And he's nice as hell, too. We met at his house in Philly's Fishtown neighborhood—just next door to King Britt. After introducing myself to Rich and Kamaal, his three-year-old son, we trooped downstairs to his basement—home to two separate floor-to-ceiling libraries of records. One room is totally devoted to hip-hop. The second room holds everything else—jazz, soul, funk, gospel—plus Rich's recording studio. We hung out for most of the day, from eleven o'clock in the morning until six in the evening, when Rich had to get ready for his gig at Le Poisson Rouge in Manhattan.

While we were settling in, I remembered an interview I'd read with Rich for *Slam* magazine, in which he addressed the similarities between basketball and DJing. "The parallels are there," he said. "As a DJ, you have to be ready to present yourself to a room full of people—and it's the same in basketball. You see superstars get booed after one bad shot. You're always under the heat lamp. You've got to bring your A-game or keep your ass at home."

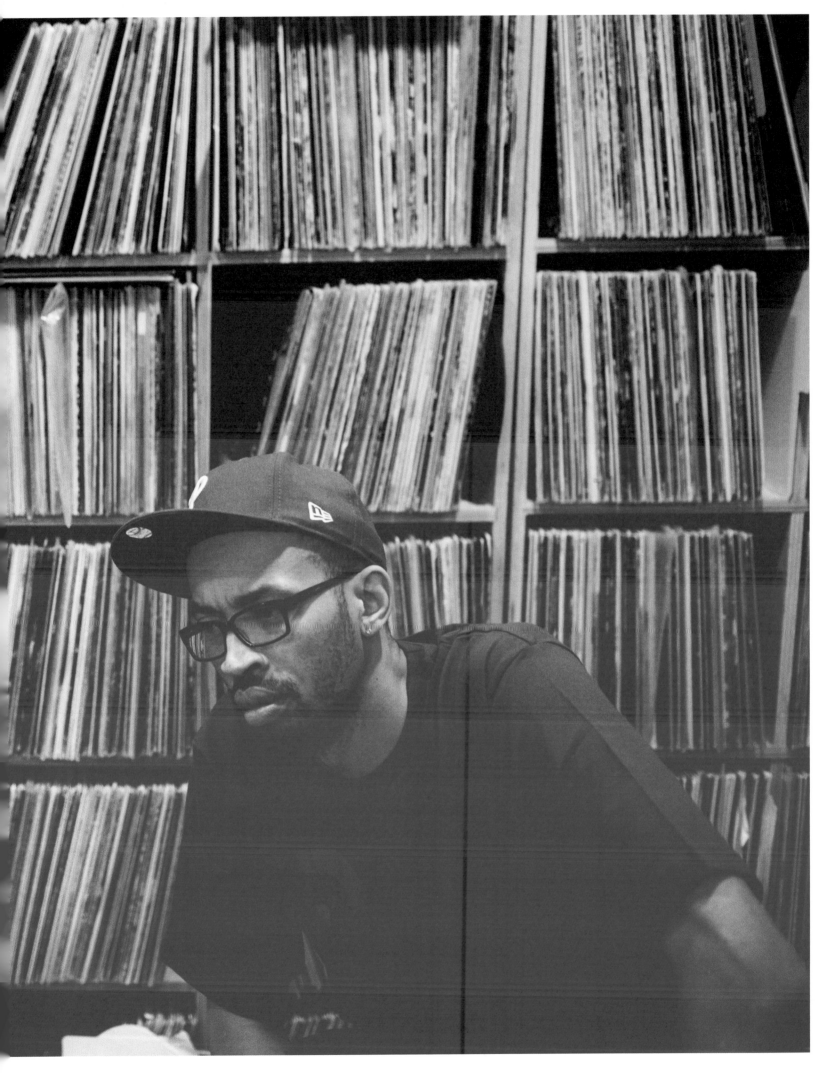

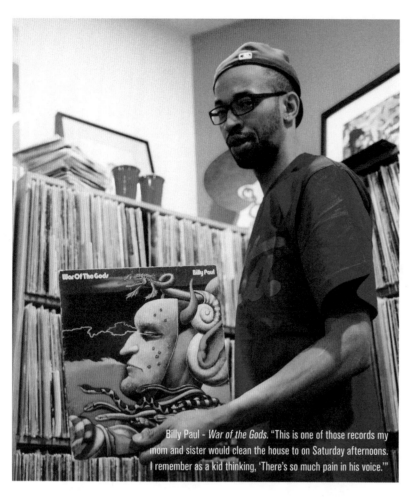

Billy Paul - *War of the Gods*. "This is one of those records my mom and sister would clean the house to on Saturday afternoons. I remember as a kid thinking, 'There's so much pain in his voice.'"

What was your first record?

Believe it or not, the first record I bought with "my own money" was a copy of the KISS *Alive!* concert LP. I bought it at Crazy Eddie's in Eatontown, New Jersey, after making some chore money. It was 1980, and I was getting more and more into rock & roll, while actively participating in the complete spectrum of hip-hop culture. KISS had the illest costumes at the time, next to Parliament Funkadelic. They looked like rock & roll supervillains with their makeup and all that! I remember vividly how that record made me feel—like I knew something that other kids didn't know, probably because I wasn't surrounded by family members who had a taste for rock music.

What prompted you to start collecting? Was there a specific time or event in your life where you recall transitioning from just a lover of music to a collector of music as well?

I come from a family of collectors, though their reasons for collecting were far different from mine when I started. My parents' parents migrated north from Alabama and the Kentucky/Ohio border near the turn of the century, via the Underground Railroad. So their need to keep and care for things they considered valuable stemmed from not truly having anything to call their own prior to migrating north.

Being privy to many an adult discussion on the topic at a young age, it was natural for me to want to keep things I considered valuable so that I could enjoy them for years to come. I really appreciate this gift from my family, because it taught me to care for my belongings and investments on a higher level now, as a man. I think I became a collector prior to leaving home for college.

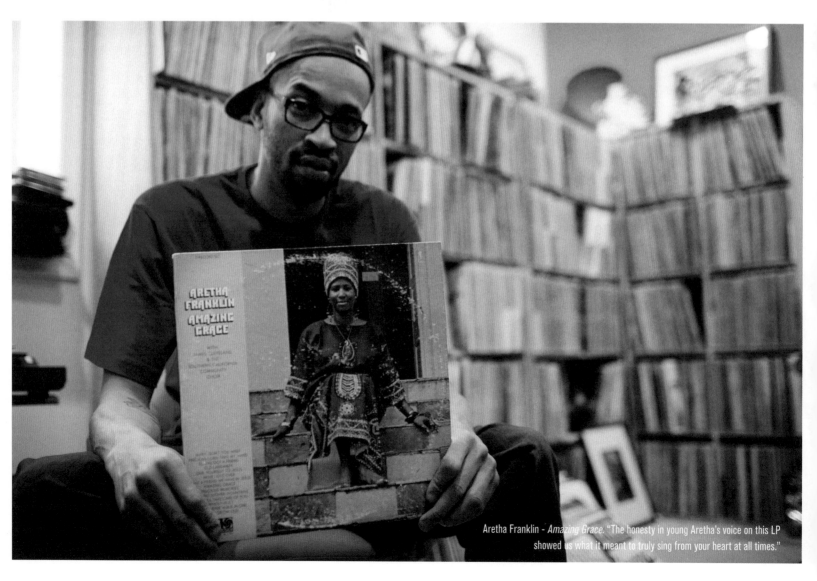

Aretha Franklin - *Amazing Grace*. "The honesty in young Aretha's voice on this LP showed us what it meant to truly sing from your heart at all times."

Basketball and academics had taken over my world at that point, but I was still busy DJing and buying records weekly. Having to step back from DJing and focus on passing classes and playing Division 1 hoops actually drew me much closer to my true passion, which I soon came to realize was chasing down music, and playing it for as many people as possible, as often as possible. College, basketball, and a real job were all interruptions to what I've come to believe I was born to do.

Why vinyl?

Vinyl is the origin of my personal love for music, aside from 8-track tapes, my grandparents' church, piano lessons, and '70s radio. I was simply born during a time when these were the primary consumer mediums for music. But I am not so much of a purist in that I have bad thoughts or words for other mediums. I think I went through that phase when the iPod hit the marketplace, for like a year. Then I found myself purchasing an iPod and strolling the streets with three hundred songs in this little machine. I found the merit in technology then, for sure. But beyond that, the sonic quality of the vinyl format is so warm and full when compared to all digital mediums; it's ridiculous. There is no reputable argument for that point. Storage space is not the baseline issue when discussing the collection of music; the music and your relationship with that music is the baseline issue. Records in abundance on any level, or in any format, will get in your way if you are not intimate with them. I just come from the school that says until you've experienced the sonic depth of vinyl on a regular basis, even if just at home alone, you are short-changing yourself on the main attraction at the musical circus.

Are you currently focusing on any specific genre in your collection? Are there other factors you consider when buying records? Producer? Pressing years?

I go after records whenever I have the bread to spend on them, plain and simple. Whatever I'm on the hunt for, I like to take my time and get as personal as possible with the shop and the joints I choose to listen to while I'm there. Sometimes relationships and conversations will bring you more bounty in your digging than just winging it and being a know-it-all. I gravitate toward different producers, vocalists, labels, genres, songs, and LPs for different reasons, depending on things like, Where am I playing next? What have I heard recently that inspired me to go find it for myself? What label

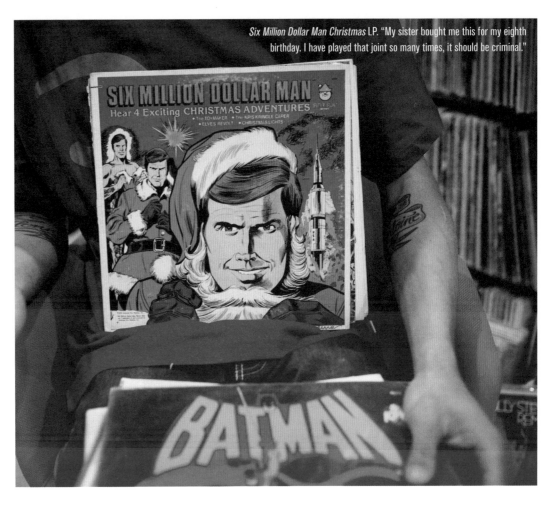

Six Million Dollar Man Christmas LP. "My sister bought me this for my eighth birthday. I have played that joint so many times, it should be criminal."

is the new joint that so-and-so just did that banging remix on? Do they have a section that represents a weakness in my stash? What's on the walls in here? What store would have copies? Is this a limited edition? I've been looking for this for years, etc. All of these things come into play for me when buying records, each and every time. I try my best to remain open to what I don't know,

> ## "COLLEGE, BASKETBALL, AND A REAL JOB WERE ALL INTERRUPTIONS TO WHAT I'VE COME TO BELIEVE I WAS BORN TO DO."

in order for my strengths to remain sharp, and to also be consistently filling holes in the areas of my collection that are not as strong as I would like them to be. As I've gotten older, I've grown more peculiar about what I may or may not buy, based on what my needs are, upcoming gigs, and money more than ever since my son was born.

Is there an artist or a label you're trying to complete?

I have all of the Fela Kuti catalog, Michael Jackson & The Jackson 5, Earth Wind & Fire, Stevie Wonder, Miles Davis, Biggie, Jay-Z,

A Tribe Called Quest, The Roots, Redman, James Brown, Femi Kuti, Joe Claussell, Blaze, Harold Melvin & the Blue Notes, and Gary Bartz.

I also have the entire Black Jazz Records catalog, Rawkus, Kindred Spirits, Soundway, Strut, the *Ultimate Deals and Breaks* series, and I am close to completing my Cobblestone and Impulse! jazz catalogs as well.

How do you organize your collection?

I've always tended to arrange my music by genre, fundamentally. Within each genre I tend to break things up by LP, EP, compilation, bootleg, 12-inch, and import. If it's shelved, I love it. If it's not shelved, it's either new and unfamiliar, fresh off rotation, or in consideration of being liquidated. Well, those are the rules anyway. None of us active DJs have perfect-looking stashes, or alphabetical, numerical, and astrological arrangement styles. When you are really using your records, it's difficult to maintain that level of constant organization.

Do you have any useful tips?

I would say never overpack your records into soft carrying cases, because you will undoubtedly

wreck sleeves and often bust edges off your vinyl as well. At home, store your records in the thick and clear library-grade plastic sleeves. They are expensive, but totally worth it for preserving the cosmetic and sonic integrity of your stash. I wish I knew this years ago. I learned the hard way over time that you will always end up with some kind of damage to your sleeves, your bag, or even worse, your records, without protecting them in as many ways as possible. I got mad valuable records with beat-up sleeves and dings in the wax because it took me so long to get my head around being consistent in protecting my tools. As a collector, you can easily decrease the equity of your stash by having beat-up wax. As a DJ, the record you disrespect in storage will soon embarrass you in front of a dance floor.

What do you look for in a record?
Honesty.

I see your son Kamaal (aka Mini-Me) roaming free in your studio, holding your records, and doing a few scratching moves on the turntables. It's pretty obvious you are proud to pass your knowledge and love for vinyl on to him. Can you tell us more about your relationship and your wishes for him regarding music?

Kamaal Nasir is my first-born son. With that, he is my greatest accomplishment, and I love him more than I've ever loved anything in life. He has access to my tools because my tools are a part of me, my workspace is in our home, and those tools also pay our bills and feed our family. In order to create the potential for him to respect my business, and possibly want to follow in my footsteps, I have to make his access to my tools and lifestyle easy for him to participate in. On a larger and possibly more selfish scale, he is

"AS A DJ, THE RECORD YOU DISRESPECT IN STORAGE WILL SOON EMBARRASS YOU IN FRONT OF A DANCE FLOOR."

allowed to roam free in my workspace because I work a great deal, and sometimes in order for me to spend the type of time we need together when I am not on the road, we are in the studio together. I want him to see the utilities, hear the music, be inquisitive about the interfaces, hear the sessions, bang on the keyboards and turn-

tables, and hopefully grow his own knowledge and desire to feed his own family with money he earns in the arts. But honestly, if he wanted to be something else, I'd spoil him regardless. My objective with him in that regard is to show him that you can make money doing something you really love, and it won't seem like work in the end. I just want him to look at achievement with an open mind. I have a fun job, and I can only hope that rubs off on him.

Do you buy him records? Does he have a favorite?
Yeah, he's got a gang of records already. He digs a lot of different things, but his favorite at the moment is just about any rap record played at 45 rpm. There's something about the Kanye West chipmunk voice that makes him go ape-shit! (laughs)

How often do you go out digging for records these days? Do you find yourself doing more digital digging on eBay or do you still hit the fleas and basements of people's houses? Or do you have a vinyl dealer who sells you choice pieces?

I'm always digging man, almost daily. One of the beautiful things about modern technology is that you can dig in faraway

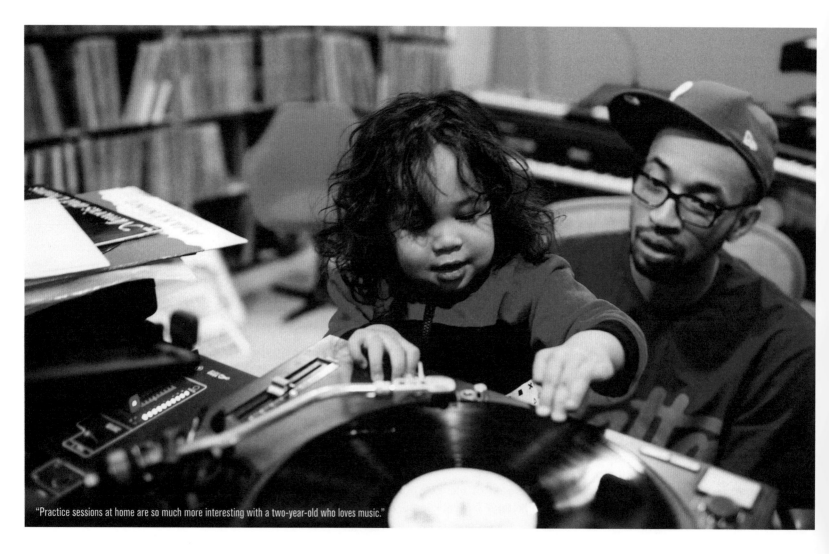

"Practice sessions at home are so much more interesting with a two-year-old who loves music."

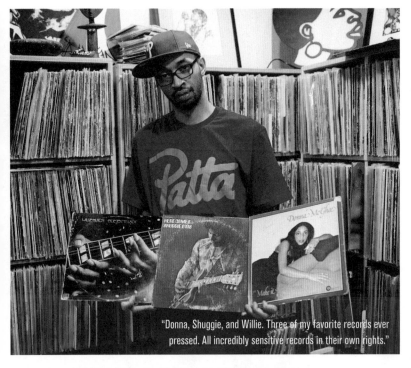

"Donna, Shuggie, and Willie. Three of my favorite records ever pressed. All incredibly sensitive records in their own rights."

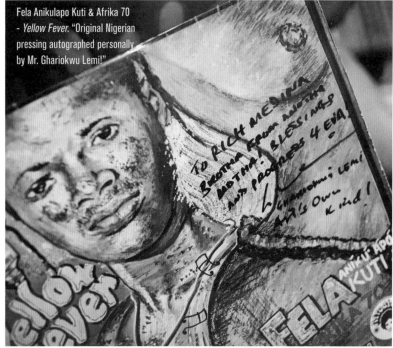

Fela Anikulapo Kuti & Afrika 70 - *Yellow Fever.* "Original Nigerian pressing autographed personally by Mr. Ghariokwu Lemi!"

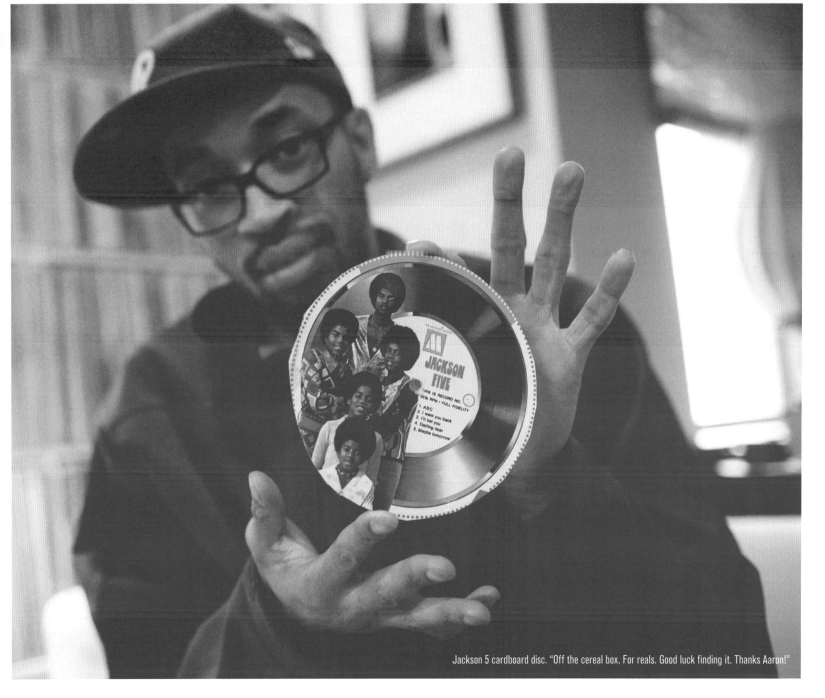

Jackson 5 cardboard disc. "Off the cereal box. For reals. Good luck finding it. Thanks Aaron!"

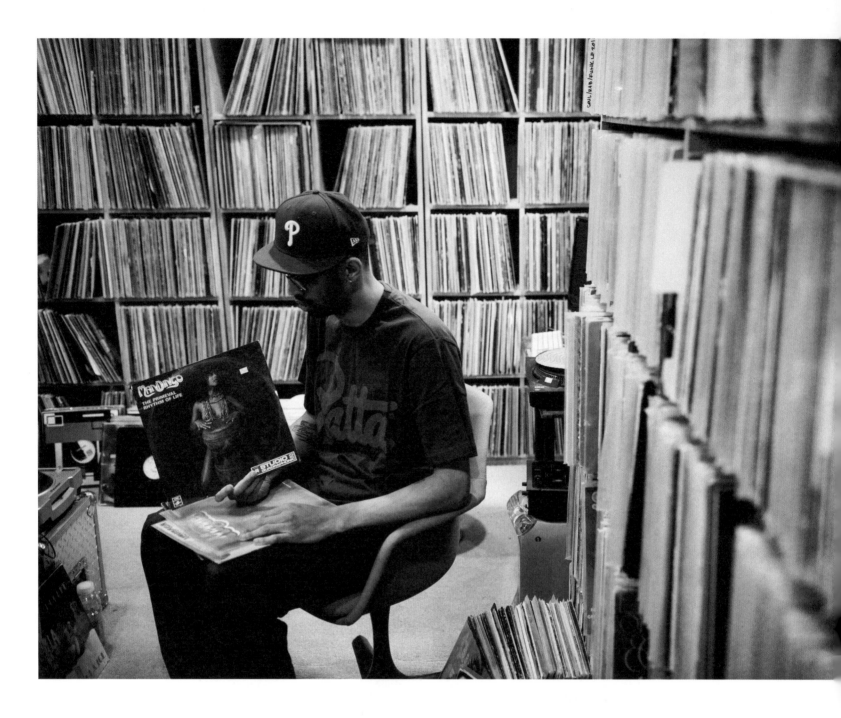

places without having to buy a plane ticket, and still get the damn records you want. I still, of course, go to warehouses known and unknown, basements, shops, estate sales, and whatever else I have the time and bread for, just like any other record freak out there. So yeah, it doesn't turn off even when you're broke. It's like any other addiction. The DJ's addictions just so happen to make everyone feel good when shared at the right time, you know? There are tons of incredible shops, dealers, labels, and retailers who have taken advantage of the ability to post stock online and sell more product than if they relied solely on a shop for foot traffic. I've copped some of my favorite pieces online. I've also tripped over nuggets by accident just waltzing into a store I'd never seen. We record hounds all have dealers and such that will turn us on to things we need or don't know. Some of us just won't share those resources.

Do you have a philosophy or routine when you enter a store with tons of vinyl for sale?
I always try to think of records I need that may possibly be there. Records I've been on the lookout for, records people have recommended to me after hearing me play, records the store buyer may recommend should they "know" me. I guess filling holes always comes before anything else when I see a large stash of records. There's something fulfilling about walking away from a long digging session with missing pieces of catalogs or genres. In those situations, it is more often than not about used or classic records rather than the newest thing on the shelves, for sure.

Out of your great collection, there must be a few records that you can always go back to time and time again. Name a few of them and why they are special.

Slick Rick & Doug E. Fresh – "La Di Da Di"
The quintessential crossover party record, no matter where you are playing. Everybody likes to hear themselves sing in the club, and Slick Rick's delivery and punchlines are so universally understood it's unbelievable.
Keni Burke – "Risin' To The Top"
The perfect mood changer to bring out the steppers before taking things into more aggressive waters, or the steady peak time cool out joint to rock between moods. A New York club staple since its original release.
Bob James – "Take Me to the Mardi Gras"
Fundamental b-boy staple for both top rockers and footwork b-boys, as well as one of the most recognizable samples in the world after Run DMC's "Peter Piper" 12-inch made it enormous. You can never lose with a well-placed drop of this record.
Soho – "Hot Music"
The house music record that to this day makes

people—who claim to not like house music—dance like they only listen to house music. The perfect example of what I like to call a "reverse crossover" record.

Fela Kuti – "Water No Get Enemy"
The most basic "knowledge of self" record from the Black President. We all need water, and water has no enemies. Fela Kuti illustrates that point perfectly in this difficult, beautiful song arrangement.

The Blackbyrds – "Rock Creek Park"
The perfect summertime driving or BBQ record that works on dance crowds of all shapes and sizes. It's one of those records that has never let me down in all the years I've been playing it. It screams of freedom, clear skies and good times, and "doin' it," which we all love to do.

James Brown – "The Payback"
One of the most recognizable samples ever, and an incredible piece of humanist song-writing from the Godfather of Soul. This song absolutely kills dancefloors worldwide.

The Mighty Ryeders – "Evil Vibrations"
De La Soul made this joint popular with their original mix of "Saturdays," but the original bangs superhard, front to back, on its own. It's one of those joints where you see people anticipating the rhyme until the real song comes on and they give you the happy "puppy head" look of confusion before realizing that they've been giving producers too much credit on certain rap records that they love. (*laughs*)

I could, of course, go on, but this ain't my book of opinions. (*laughs*)

Is there an album that gives you goose-bumps when you listen to it?
That would have to be Roberta Flack's *Quiet Fire* LP, namely "Sunday and Sister Jones." There is such incredible emotion in that song. Her tone is just so sincere and full of loss. I've been in love with that song for a very long time, and it is my very favorite song in the world.

Do you have any dirty secrets in your collection? Perhaps a "wall of shame?"
Vanilla Ice LP, Hammer LP, Eddie Murphy LPs, Engelbert Humperdinck's first Christmas LP. If I told you any more I'd hafta kill you.

Do you have any digging buddies that you share your spots with or do you go solo?
I have tons of friends who are incredible resources, solely because of their connection to records and digging for records. Guys and girls who don't see music and vinyl collecting as a hobby or phase in their lives. Without some of those guys and girls in my life, I would be far less learned about music, and my tastes would not have evolved at the same pace that they have evolved to date, I believe. At the same time, I am a student and a miner of

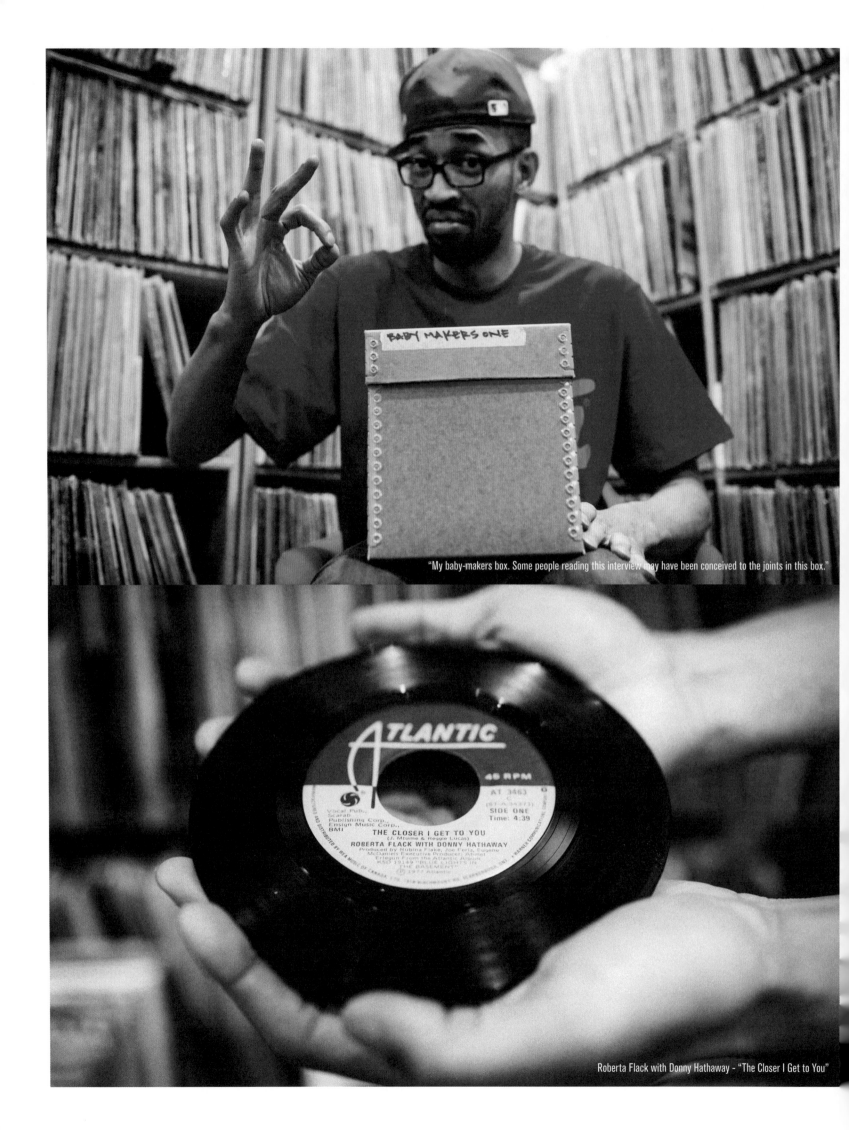

"My baby-makers box. Some people reading this interview may have been conceived to the joints in this box."

Roberta Flack with Donny Hathaway - "The Closer I Get to You"

my own volition, so I enjoy the idea of digging alone too. It can be sticky digging with friends because it's virtually impossible not to come across things the other one may want as much as you do.

Tell us a particularly sad record story.

I remember being at baggage claim, waiting for my bag and my case of records to come out on the belt. I ended up being one of the last six or seven people waiting for bags, and then a couple of albums come riding down the belt. Then more records come out, and then a broken flight case lid, and then more records. I panicked for like forty-five seconds as I waited for the pieces to come around the belt, but as they were making their way, another dude on the other side starts screaming at the top of his lungs, "Are you fucking kidding meeee!!!!!???? You have got to be kidding meeeeeee!!!!!" My case eventually came out in one piece and my stuff was fine, but I stayed and helped him pick up the records that came out on the belt, and helped him deal with baggage recovery until he had all the answers he could get. I can't remember the guy's name, but I think he was a pretty big techno guy. It was really sad to see him in that situation.

Name a record that's too weird to be believed.

Muhammad Ali & His Gang vs Mr. Tooth Decay. Fucking bonkers.

Tell us about a record that has healed heartbreaks.

D'Angelo's *Voodoo* LP kept my spirits up after a breakup. I can't really say that any record has ever made me feel worse about a relationship-gone-bad though.

What is the ultimate *sweet-loving-baby-making* song or LP in your collection?

"The Closer I Get To You" by Roberta Flack and Donny Hathaway on Atlantic.

Tell us about a record you still regret not picking up.

I truly regret not picking up a copy of Gap Mangione's *Diana in the Autumn Wind* LP years before Dilla used it for Slum Village's seminal "Fall In Love" 12-inch. I used to see it constantly and hear people buzz about it, but I just never saw it as a valuable record until the Zen master flipped it on the Slum joint. Then I felt like a small flaccid penis . . . until I caught it for forty bucks some years after that.

Is there a record you've been hunting for but feel you may never find?

Sometimes I don't believe there are any unattainable records, and other times I feel like I will never really get the mother lode record, you know? I go back and forth on that, because when you got bread to spend, even the nonnegotiable becomes negotiable. I've seen guys part with records that they said they'd never part with for the right price or the right trade. One that has been sincerely evading me to date though is Yami Bolo's "When A Man's In Love" 7-inch. Been checking for a first pressing of that for a good while now.

Do you have any advice for all the fellow diggers out there?

I'm not sure I'm worthy of advising anyone about records, aside from telling anyone new to be prepared to face the consequences of your newfound addiction. Take care of your records so you can put down your computer every once in a while, and interact with material music. Also, so you can have something redeeming left to share with your children and family when you are no longer actively utilizing your collection as a career.

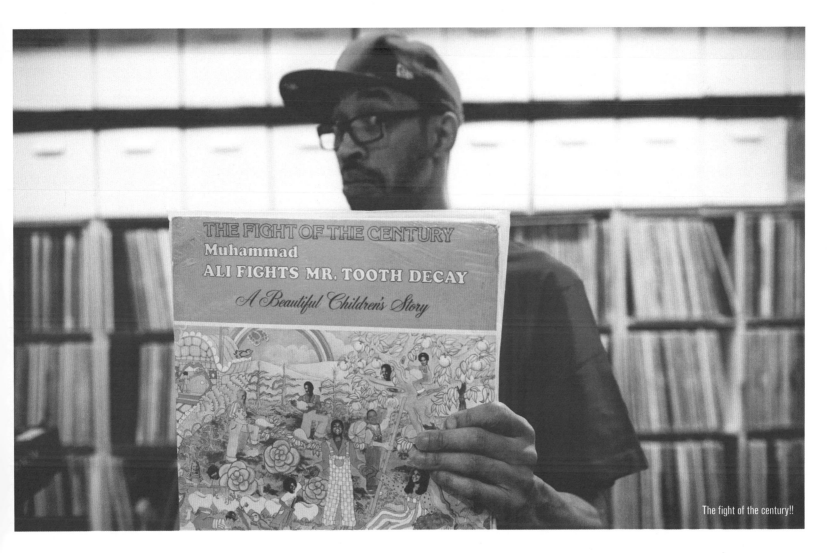

The fight of the century!!

JOE
BUSSARD KING OF 78s

BY MARC MINSKER

Few people have devoted as much of their life to records as Joe Bussard. Born in 1936 in Frederick, Maryland, he grew up listening to country and bluegrass records on his parents' phonograph and developed a full-blown record-collecting habit by the close of World War II. Much of his adult life has been spent trekking around remote towns across the mid-Atlantic and the South, in hot pursuit of jazz, blues, ethnic, and down-home/ bluegrass 78s. These expeditions have gone well beyond the typical digger routes of mining thrift stores or finding out-of-the-way record stores. For Bussard, record collecting has always meant driving into the backwoods, parking your car, and walking door-to-door to ask the locals if they have any records in the house and, if so, whether they'd be willing to sell them. It is not an exaggeration to say that over fifty thousand records have passed through Joe's hands or circulated through his collection.

From 1965–1970, he ran Fonotone Records, an independent 78 rpm record label responsible for documenting and preserving mid-century bluegrass, folk, and blues music (including the first recordings of guitarist John Fahey). A musician himself, Joe sings and plays guitar and banjo with his group Jolly Joe and His Jug Band, as well as performs and records with many other artists. He has also been hosting radio programs since 1956, when he set up his own pirate radio station out of his home. In 2003, he was the subject of an excellent documentary film, *Desperate Man Blues* by Edward Gillan.

Do you remember the first album you bought?

The first 78 that I went out and found was . . . God, you're going back fifty years or so! That's almost impossible to remember. I know that I found Gene Autry records early on, but it would probably be Jimmie Rodgers. When I heard him, that about did it. I was hooked.

What prompted you to start collecting? At what age did you start?

I had a phonograph at my house (still have it) and was playing records when I was six years old. Neighbors would bring records by the house that I grew up in, on Fairview Avenue in Frederick, Maryland.

How did you first become interested in music? Was your family an influence?

Not really. My family didn't have much interest in music. I listened to the radio a lot, and WFMD, our local station, used to have live stuff—mostly bluegrass. I got deeper into music when I got my driver's license—hitting up houses, going door-to-door. In those days

a lot of the roads around Frederick were still dirt, and I'd drive up and down every hollow throughout the county. Learned every day about some new musician.

Do you collect a specific genre? What about pressing years?

I got all types of music—everything from string bands and Southern artists to country blues and early jazz, gospel and bluegrass. In terms of pressing years, the best stuff is from 1929 to 1933, especially 1931, 1932, 1933. Nobody had any money and sales were low. So that's what makes the records so scarce. People didn't take care of them with those old damn wind-ups. Those needles destroyed the grooves. That's what happened to all those Charley Patton records.

Jazz music ended in 1933, with the last recordings of worth being Clarence Williams in 1932 and Benny Moten's last recordings (he died in 1935). The problem was the sound changed in 1933; the tone was gone. When they came back with 25 cent records, the sound had changed for good. It wasn't the same. Lost that beautiful tone.

In 1955, country music had its last gasp. Jimmy Murphy's records that were recorded in Trashville—oops! I mean Nashville—were the last real recordings. Songs like "Here Kitty Kitty," "I'm Looking for a Mustard Patch," and "Baboon Boogie." It all changed after that.

Is there a music genre that you avoid?

Rock & roll. Period. Any of it. Hate it. Worst thing that happened to music. Hurt all types of music. They took blues and ruined it. It's the cancer of music . . . ate into everything. Killed country music, that's for sure.

A lot of people would claim the complete opposite to be true—that rock & roll reinvented and recharged music. What is it about rock & roll that annoys you so much?

Don't like it. Just my personal taste. Don't like the sound of it, the meaning of it . . . doesn't promote anything beautiful or meaningful. Idiotic noise, in my opinion.

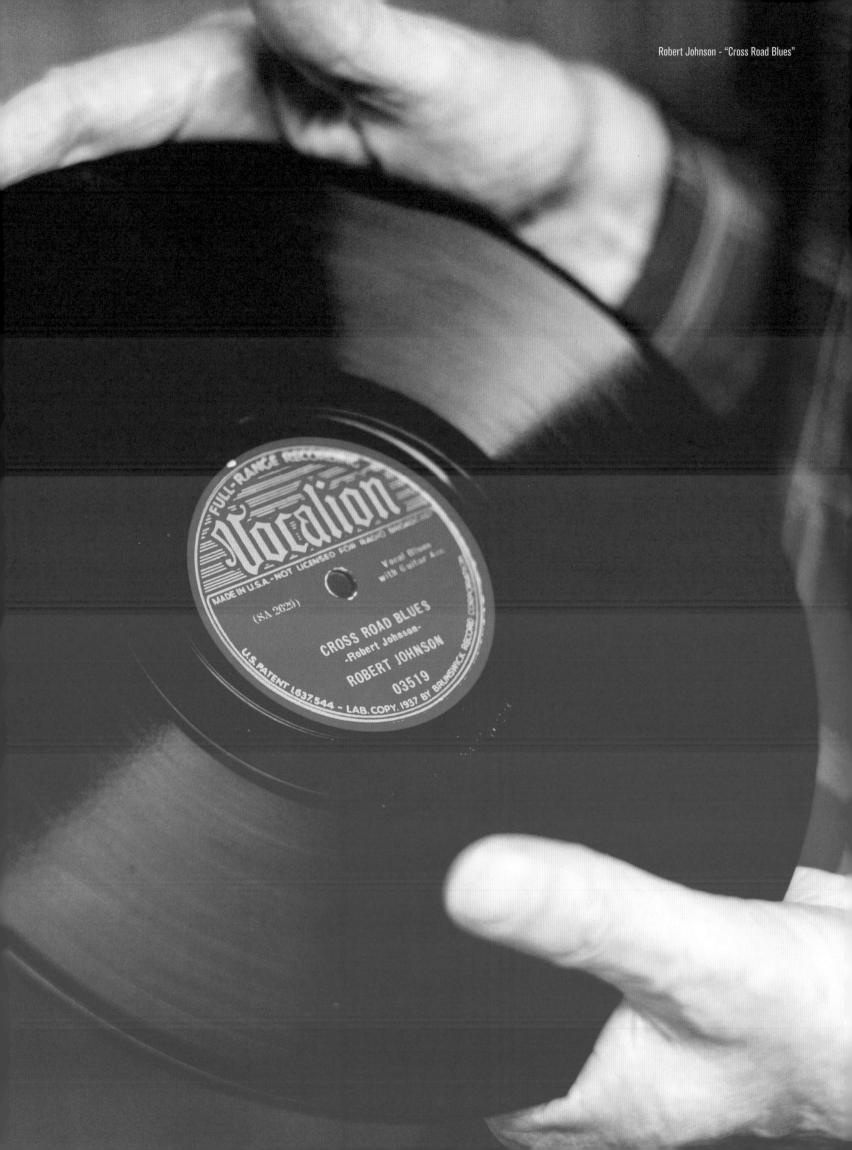

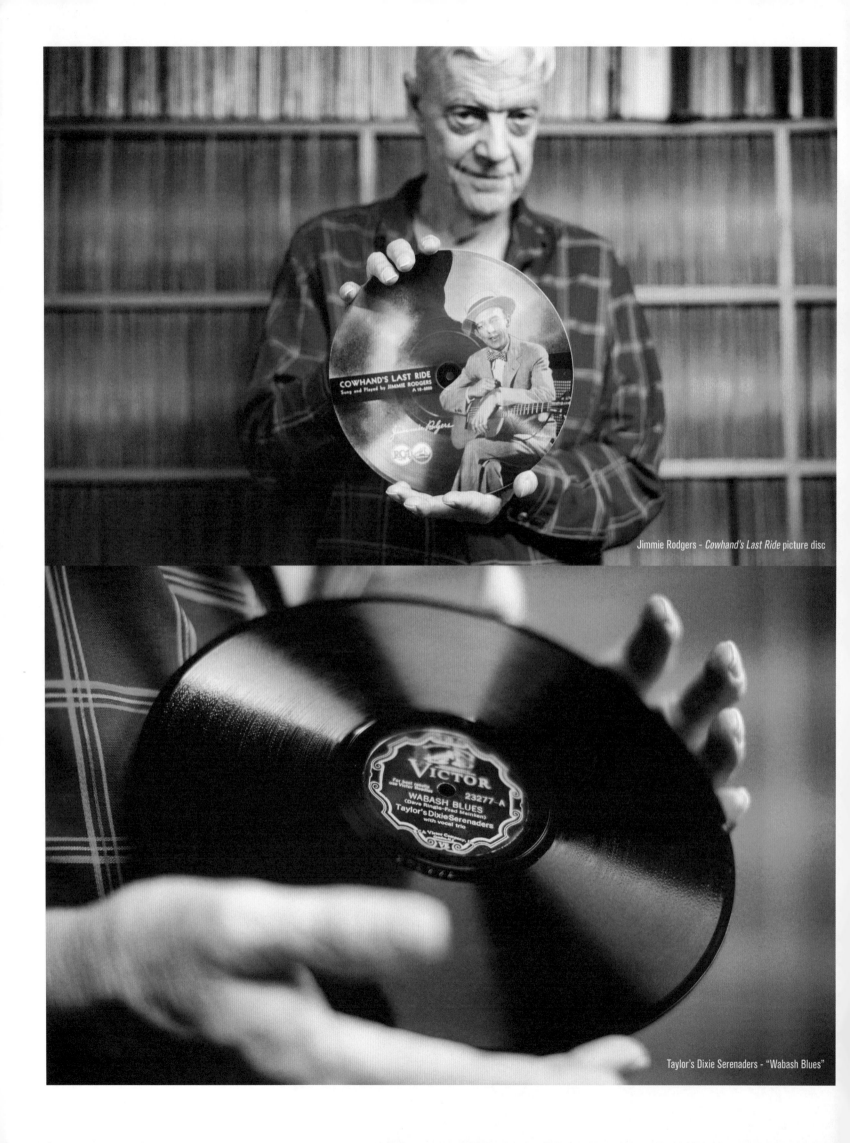

Jimmie Rodgers - *Cowhand's Last Ride* picture disc

Taylor's Dixie Serenaders - "Wabash Blues"

"ROCK & ROLL. PERIOD. ANY OF IT. HATE IT. WORST THING THAT HAPPENED TO MUSIC. HURT ALL TYPES OF MUSIC. THEY TOOK BLUES AND RUINED IT. IT'S THE CANCER OF MUSIC . . . ATE INTO EVERYTHING. KILLED COUNTRY MUSIC, THAT'S FOR SURE."

So artists like Miles Davis and John Coltrane don't deserve your time?
Oh my god, you gotta be kidding me. None of that music moves me.

Are you familiar with mp3s? These days many people share songs over the Internet, download music for free, and listen to it on their phones and computers. What do you think of that?
A computer, isn't it? I don't have anything like that. Most of the music they're getting for free ain't worth a penny anyhow.

A lot of young people are going back to vinyl records. They've given up on digital music and have returned to this beloved old medium. Why do you think that is?
It's all about tone—it has a mild tone and is much more mellow than this new digital music, which I can't stand to listen to.

How many albums do you have in your collection?
Let's get this straight—they're not albums; they're singles. 78s. I've got a little over fifteen thousand records left these days. Blues, jazz, bluegrass . . . all types.

Why do you concentrate on 78s?
'Cause that's where the music is . . . where else you gonna find it? The greatest music ever recorded was on 78s. My wife liked bluegrass and so she had 45s and a lot of LPs. I have LPs. They're all right. There's a lot of good stuff on those. But the 78s contain the best stuff, a lot of which never made it to LPs.

How do you organize your collection?
By sections and different music styles. But in terms of the overall organization of records, only I know where everything is.

What can you tell us about Taylor's Dixie Serenaders' "Wabash Blues" record?
"Wabash Blues" and the flipside, "Everybody Loves My Baby," was recorded in Charlotte, North Carolina, in 1931. Fabulous tunes. Taylor's Dixie Serenaders were a group of college guys who only put out that one record; only a thousand of them were made. Those tracks were recorded at the same place where the Carter Family recorded songs. The building is now torn down. Lots of recordings were done in that space. Victor was recording and cutting ten groups at a time in there! They had microphone jacks in

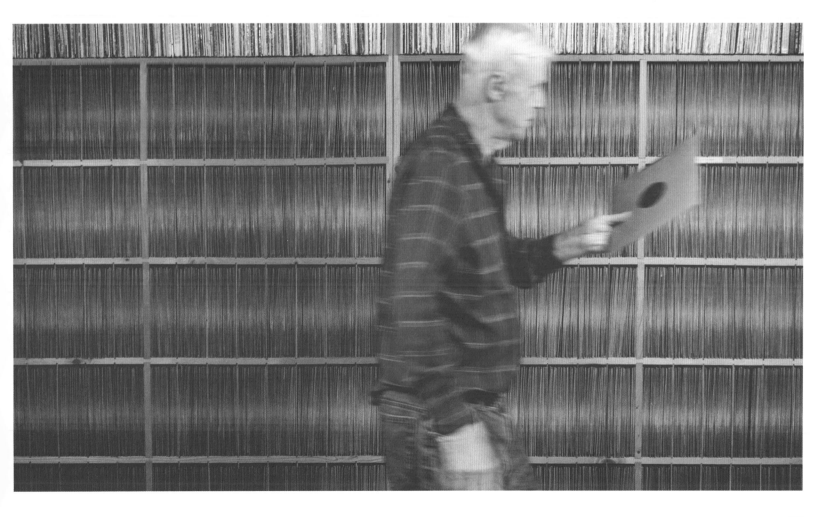

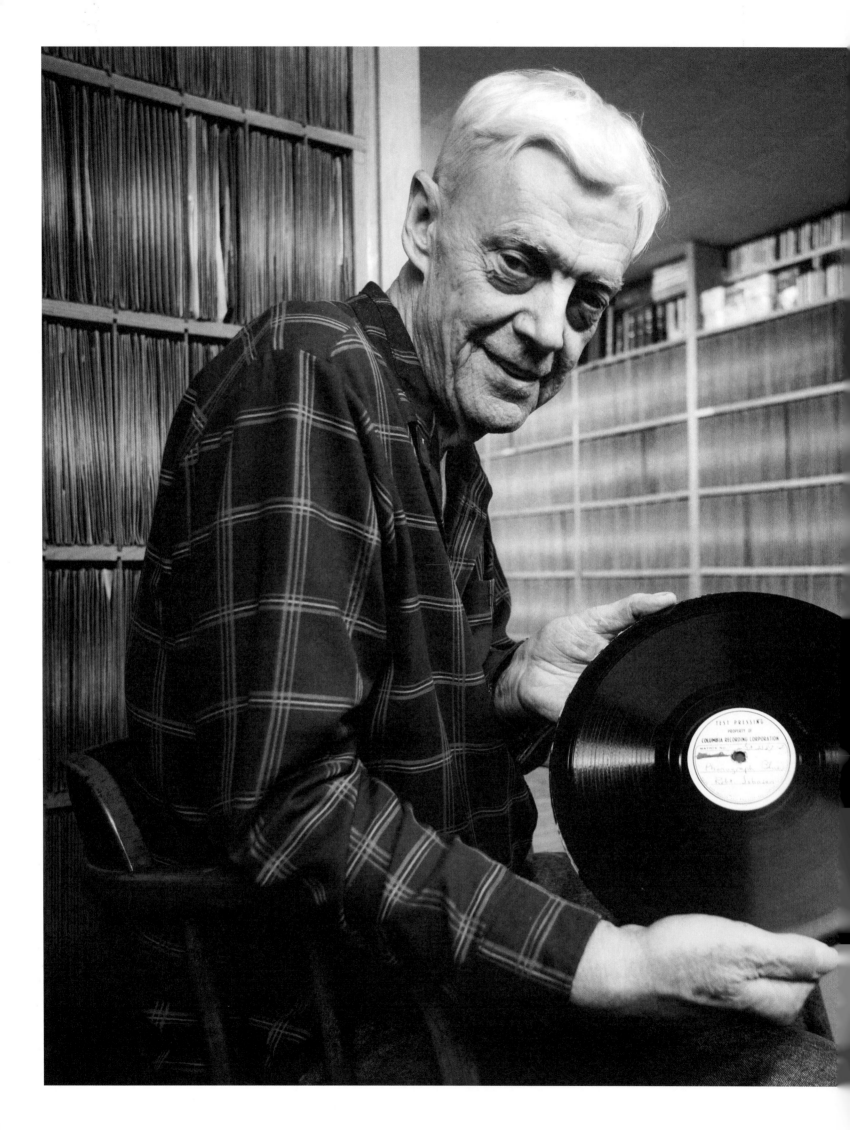

Robert Johnson test pressing for "Phonograph Blues"

"MOST OF THE MUSIC THEY'RE GETTING FOR FREE AIN'T WORTH A PENNY ANYHOW."

the walls in each of the ten recording rooms. Unheard of at that time. It's not a highly desirable 78, but it's fairly rare. For a group of college musicians, it really cooks.

Do you have any useful shelving tips?
Well, of course, store them on the edge. Back in the day some people would stack 'em. Use heavy jackets for 78s. In the early 1960s, I got the last thousand that this company Cohost had in their warehouse—a box of one thousand paper jackets for $30. Still have a box of those down in my basement.

What was your wife's reaction to this obsession?
My wife never paid much attention to it. She liked a lot of the stuff I had. Sure, she'd ask me, "Why you wasting your time on that? Going down there and buying all those records?" But in the end, she liked music.

Name some "holy grails" from your collecting history.
Any of the Black Pattis [a short-lived African-American record label] that I found over the years. Twelve of them. That label put out fifty-five titles, but some of those are real stinkers. They made records in 1927 for seven months. That's it. Sold by mail out of Richmond, Indiana. I also treasure my Charley Patton records on Paramount and my pristine copy of Mississippi John Hurt's "Frankie" on Okeh. Let's see . . . Gitfiddle Jim's "Paddlin' Blues" on Victor—probably the nicest copy in existence. Jimmie Rodgers' *Cowhand's Last Ride* picture disc—that one came out on Victor after his death, a special issue for collectors.

Tell us more about that test pressing of Robert Johnson's "Phonograph Blues." Why did you pick this one up?
Well, I got it in a collection back in the early 1960s. It's what they call a shellac test. The guy wanted $100 for the whole collection of singles—a lot of money in those times. At that time, Robert Johnson wasn't very famous.

"THOSE DAMN DRUMS. I HATE THEM. THEY WERE OKAY IN THE 1920S 'CAUSE THEY WERE IN THE BACKGROUND. THEN THEY BROUGHT THEM UP IN THE MIX. HORRIBLE."

How do you get your hands on these rarities?

Spent most of my life looking for records, knocking on doors, digging through junk shops, going into the hills.

But why? What is it about those records that made you spend all your life running after them?

Music. Powerful music. Couldn't get them nowhere else so went out looking for it. Spent my life learning about all types of music and digging deeper into the traditions of country blues, jazz, gospel. But now I'm getting up there in terms of age and am considering selling my whole collection. What good is it going to do me once I'm gone?

Which album makes you wanna jump up and dance?

That's hard—lots of 'em! "New Goofy Dust Rag" by Bennie Moten from 1923 on Victor.

Are you attracted to any specific musical instruments?

Slide guitar and banjo. Those are my favorites.

Who's your favorite slide player?

Boy, that's a tough one. Blind Willie McTell is the first to come to mind. But there were so many of them, like Sylvester Weaver, who played an amazing slide, and Blind Willie Johnson, who played with a brass ring.

Are there any instruments that you just can't listen to?

Close up? Those damn drums. I hate them. They were okay in the 1920s 'cause they were in the background. Then they brought them up in the mix. Horrible.

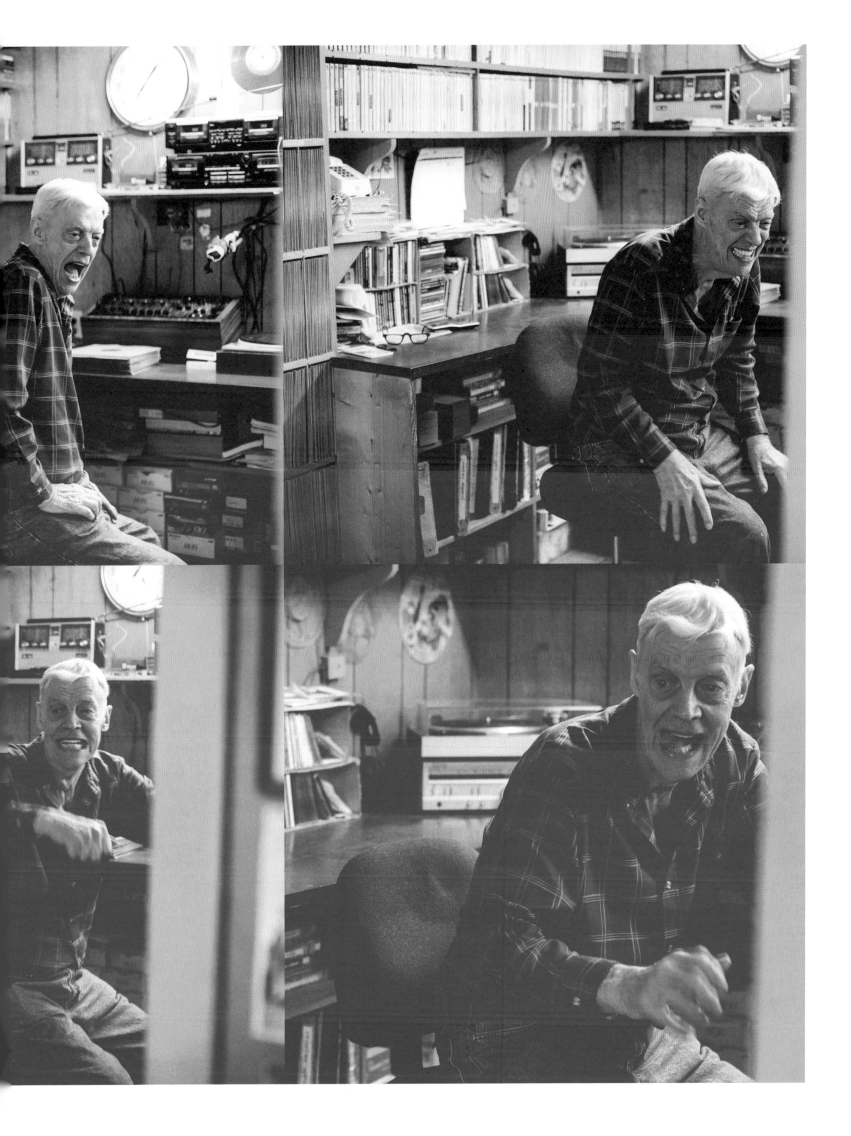

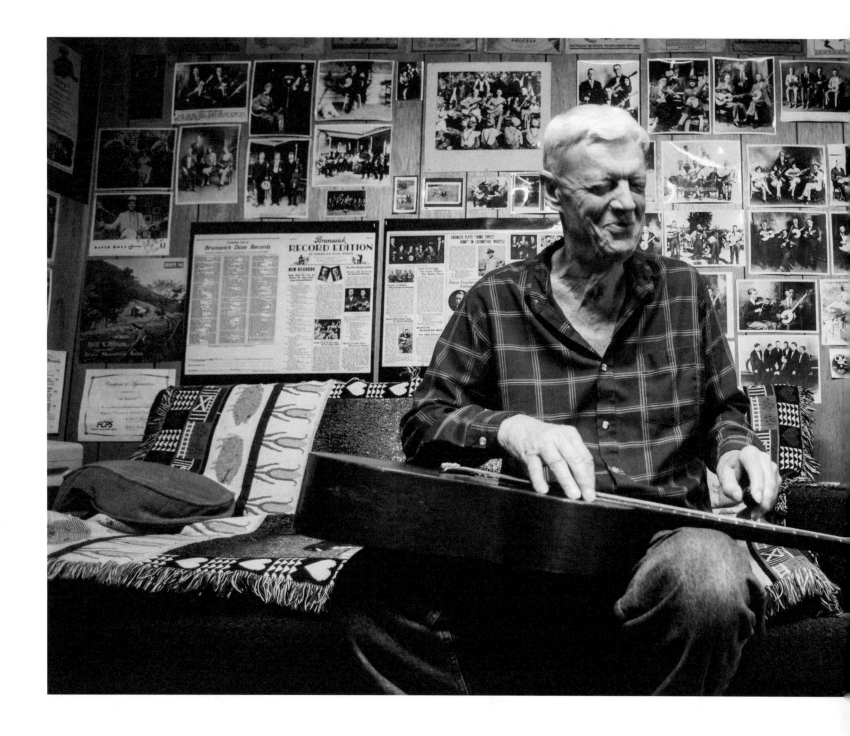

Tell us about a dollar bin record you would never part with.
My Black Patti records—I paid $10 for the whole bag. Down near War, West Virginia, way back up in the woods. I say near War because I found a record in that bunch that had a "War Pharmacy" sticker on it. That was in the 1970s.

What about digging buddies? Do you share or go solo?
I always had somebody to go along with—somebody to watch the car while I went up to knock on the doors. I had another guy who'd knock on doors with me, and if he found anything, he'd holler for me. Oscar Morris, who played harmonica in my band Jolly Joe, used to go with me. He's dead now.

Tell us a particularly sad record story.
There's one that still brings tears to my eyes. This was in the 1960s. We were driving north out of Bluefield, West Virginia, and came to this real little town. The main street was no more than five feet wide, but they had a few shops. There was an S.S. Kresge five-and-dime store [the early version of Kmart] with the original

sign from the 1920s, so we parked the car up on the sidewalk and went in. You wouldn't believe the mess! Broken records all over the floor. Apparently they'd pulled bunches of them off the shelves to throw away, when nobody cared about records anymore. They dropped all types of records on the floor. I saw Robert Johnson and Carter Family records that probably had never been played, cracked and scattered on the floor with people just walking all over them. But this guy at the only filling station gave me a tip. We then went into the hardware store across the street, and oh my god! This guy had all these records upstairs—dealer stock—and he'd stopped selling them during the Depression and never got back into it. An entire floor of mostly unplayed 78s. Jesus, I must have gotten about two thousand really choice records from the guy. Paid him $100.

If I hadn't found that hardware store after the tragedy at that five-and-dime, I mighta gone out and committed suicide! (*laughs*)

Tell us about a record you still regret not picking up?
I don't have any.

"THESE RARE RECORDS DISAPPEAR INTO COLLECTIONS AND INTO BLACK HOLES. NEVER SEE THEM AGAIN."

What do you see happening to your collection after you check out?

Auction it off and let the collectors enjoy it. I've seen collections go to libraries and colleges, and the records just get stuffed into storage. Nobody ever looks at them or listens to them. It's a damn shame.

Any words of advice for the young generation just getting into music and records?

Well, there's nothing coming out today that's worth anything. Kids are all brainwashed today listening to that electronic garbage. Sure, there's a few kids interested in the old music. And they'd have to pay a hell of a price to get into that music. These rare records disappear into collections and into black holes. Never see them again.

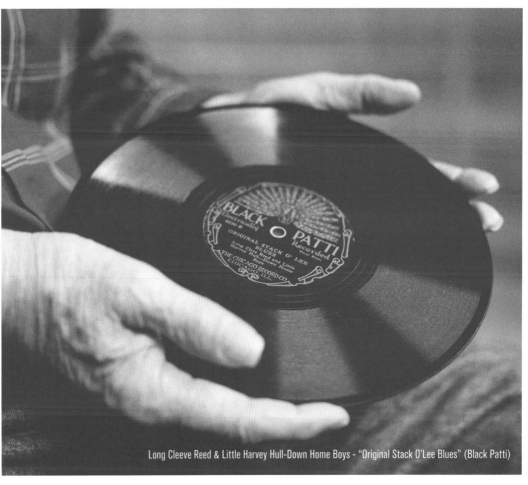

Long Cleeve Reed & Little Harvey Hull-Down Home Boys - "Original Stack O'Lee Blues" (Black Patti)

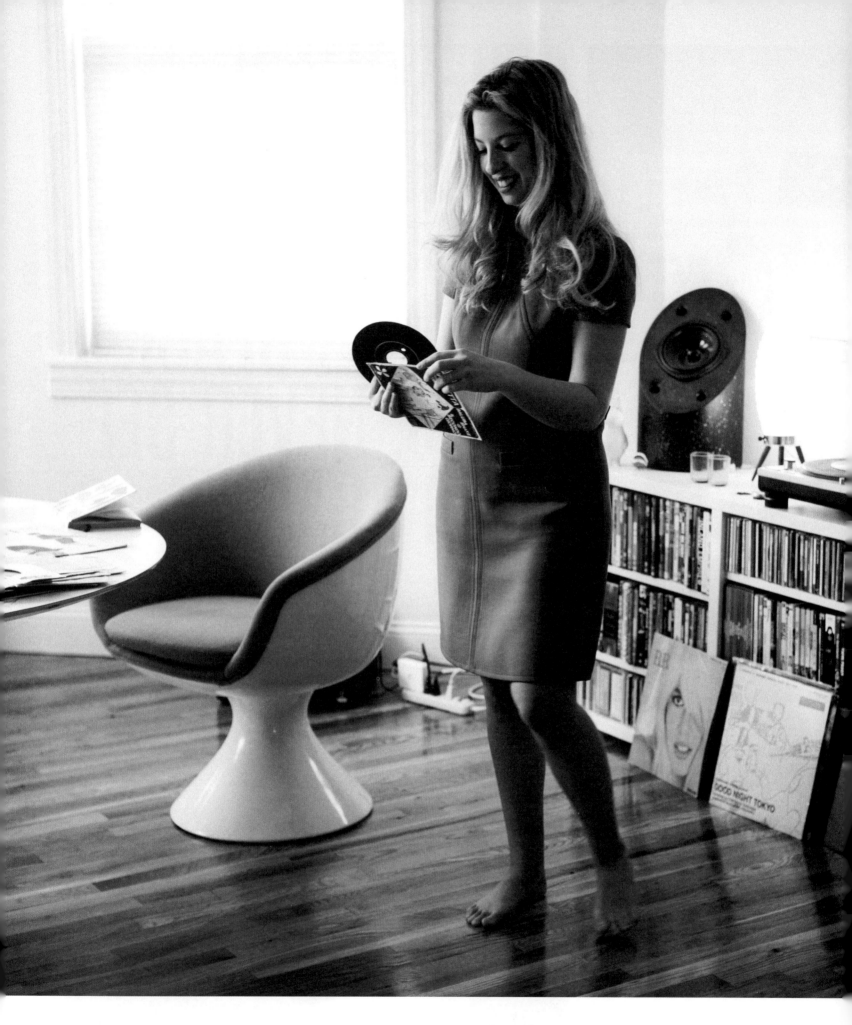

MELODY, HOOKS, AND MAGIC BY EILON PAZ

SHEILA BURGEL

I walk down Sheila Burgel's street nearly every day for my ritual coffee and biscotti break. I must've passed by her home a hundred times, never realizing we were neighbors, or what an amazing collection of records lay hidden in her Brooklyn brownstone apartment.

Aside from a slim section of 45s titled "Boys" and a stash of heavy metal LPs, there are few men to be found in Sheila's girl-pop-heavy collection. She is particularly sweet on '60s female pop and has been a longtime collector of US girl groups, French Yé-Yé singers, and British and Japanese beat girls. Born in Tehran, Iran, and raised in the suburbs of New York, Sheila received her music education via her dad's extensive collection of '80s chart-pop regularly blasting through the house. She developed a keen ear for hooks and melodies, which may explain her affection for ultra-melodic girl groups like the Ronettes and Shangri-Las. She started collecting as a student in London, cutting class to go to record fairs and spending weekends traveling around the United Kindom in search of "spectacular singles." It's no wonder she found herself pulling mostly 45s.

Perhaps more than most, Sheila has clearly had her identity shaped by her passion. Her apartment is filled with '60s furniture, vintage magazines, and music memorabilia, reflecting her love of mid-century modern design and pop. The forward-thinking and eye-catching images of the Supremes, Brigitte Bardot, and Françoise Hardy inspire her style all the way from her shoes to her eyeliner. Yet she considers her love of vinyl to be an alternative to the traditional feminine ideals of fashion and beauty—forgoing clothes shopping for solo digging trips to Tokyo, Paris, and Utrecht.

Her love and understanding of music are evident in everything she does. In addition to being a DJ and a music journalist, she publishes the fanzine-turned-web-magazine *Cha Cha Charming* and produces '60s girl-pop compilations for reissue labels like Ace Records and Rhino. Asked why she focuses on girl-pop, she replies facetiously, "Perhaps it's simply because girls are better?"

What was the first album in your collection?

The first album I swiped from my father was Michael Jackson's *Thriller*, but this was at age six, when I wouldn't yet have called myself a record collector. I caught the collecting bug twelve years later, at eighteen, in London. The first girl-pop record I bought was Twinkle's "Terry," a British death disc that took its cue from the Shangri-Las' "Leader of the Pack" and was initially banned by the BBC.

Where did your love of music come from?

Definitely my dad, who was never indoors without a record playing. He made his own stereo, which he built into a pristine white cabinet behind closed doors. Opening that cabinet felt like entering the gateway to heaven. I remember accompanying him to Crazy Eddie's, where he'd pick up the latest hit singles in the '80s—Eddie Grant's "Electric Avenue," Quiet Riot's "C'mon Feel the Noize," Hall & Oates' "Maneater." It's not surprising I became such a pop aficionado with hits playing all day long. I can't bear to listen to music without melody, which is probably why '60s girl groups have so much appeal.

Why vinyl?

I grew up with vinyl, and I remember rushing home from school to my records and turntable, spending hours with the lyric sheets and listening to the music whilst daydreaming. This past Christmas, I received a reissue of a book from 1977 called *Album Cover Album*. Peter

Gabriel wrote the foreword of the updated edition, lamenting the loss of record sleeves and describing vinyl as "physical objects to possess, touch, sniff, scrutinize, read, and savor." I love that description because it so perfectly illustrates the interaction with a record, and how it requires you to engage with it. We are told to believe that the all-access pass to music on the Internet and the quick click of an mp3 have improved our lives, but I don't buy it. Convenience and shortcuts do not enhance pleasure. But take the time to dig out a record, put it on the turntable, sit back and listen . . . that's where the pleasure is. That's where the relationship with music grows strong; that's where the richness and depth are felt.

What attracted you to girl-pop?

I have always been partial to the female voice. I remember when my dad told me the Bee Gees weren't women. I was devastated. I had been convinced their voices were female and I preferred it that way. When I first discovered the gazillions of female singers and girl groups who made records in the '60s in the US, UK, France, and Japan, I knew I had to have each and every record. I think many would agree that the '60s were the renaissance period of the twentieth century, especially for music. Some of the greatest records of all time were written during the '60s, and many of those happened to be by girl groups—the Ronettes' "Be My Baby," the Supremes' "Can't Hurry Love," and the Shangri-Las' "Leader of the Pack" are the obvious choices, but this was a time when

every songwriter, producer, and artist was striving for a hit, and as a result the output of material was top of the line, exceptionally high in quality. Every drop of talent, every gorgeous melody was put into those records because competition was fierce, and only the greatest records made the top of the charts. Nowadays songwriters aren't competing against Brian Wilson or Holland-Dozier-Holland to get in the charts, hence the outrageous amount of melody-devoid, half-assed junk that makes up the top 10. In the end, though, when it comes to the question of why I collect girl groups, it's not something I fully understand myself. Perhaps it's simply because girls are better? (*laughs*)

Has your interest in '60s girl groups influenced your sense of style?

Sixties fashion, pioneered by designers André Courrèges, Mary Quant, and Pierre Cardin, was quite spectacular. I love the forward-thinking, ready-to-wear, flattering designs, which are far more creative than the uninspired looks you see on the street today. It was a photo of Brigitte Bardot, with her big blonde hair, wearing a simple A-line pink dress and nothing on her feet, that pretty much determined my fashion sense. Although it feels quite odd talking about fashion, seeing as I hate shopping for clothes and have only accumulated lots of dresses because I buy a few each year and never, ever throw anything away.

Can you tell us a bit about the evolution of the girl group?

Early groups like the Boswell Sisters, Chordettes, and Andrews Sisters were actual groups of singing girls, but I consider the girl group era to begin with the Chantels' "Maybe" in 1958, followed by the Shirelles, who were the first girl group to score a #1 hit, with "Will You Still Love Me Tomorrow." The Shirelles were singing about being girls, about sex, about the confusing experience of being in love yet terrified that the guy you've just spent the night with may never call you again. This was revolutionary, and miles away from the goody-two-shoes songs of the Andrews Sisters. The charts will tell you that these girl groups resonated with the entire female population, who finally had music that actually spoke to their real-life experiences. The records were not only sung by girls, but "Will You Still Love Me Tomorrow" and so many of the girl group hits were also written by girls—Carole King, Ellie Greenwich, and Cynthia Weil—who were penning song after song about being young and in love. The Ronettes' "Be My Baby" is forever

Twinkle - A Lonely Singing Doll EP

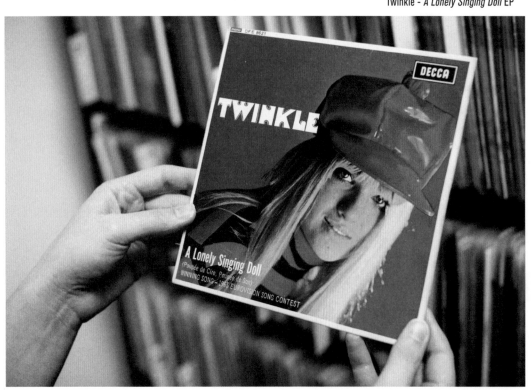

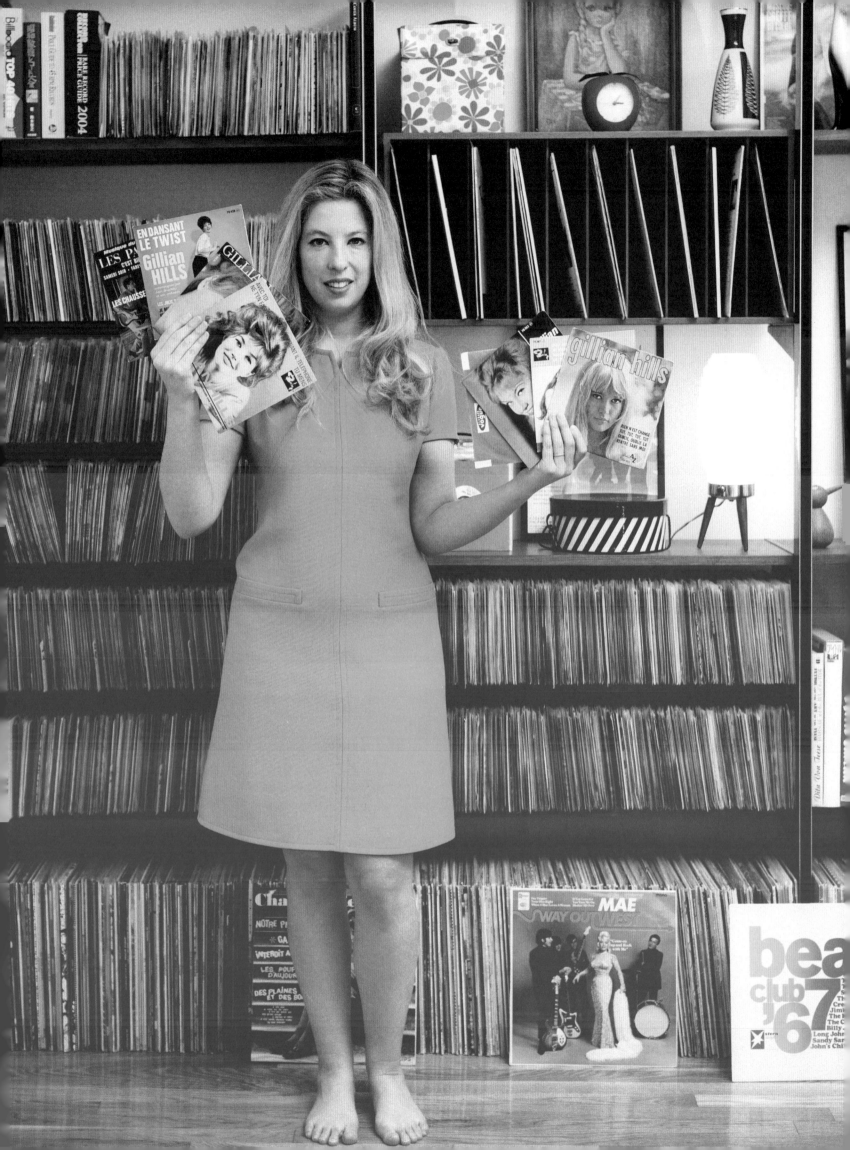

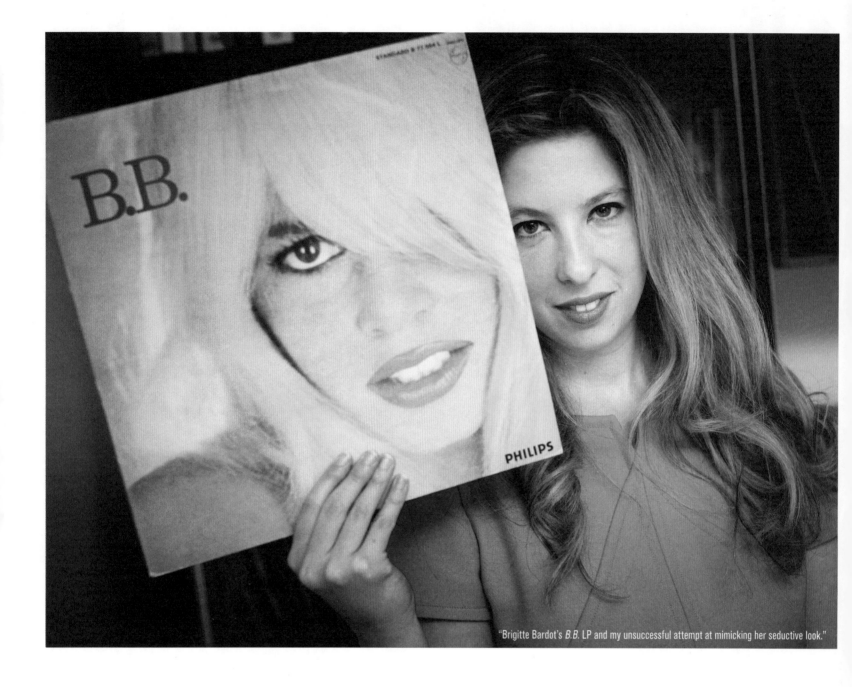

"Brigitte Bardot's *B.B.* LP and my unsuccessful attempt at mimicking her seductive look."

attached to Phil Spector, but it was Ellie Greenwich and her husband, Jeff Barry, who wrote the song. You just can't fake records that good, and that's why they're still with us today.

The death of the girl group era has always been blamed on the Beatles arriving in America, and perhaps by that time the public was ready for something new, but girl groups were still cutting records well into the late '60s, an era that was especially kind to the Brit girls like Sandie Shaw, Lulu, and Dusty Springfield. And in Japan, the late '60s were the prime period for the fuck-the-establishment music scene called Group Sounds and the Japanese beat girl. Many of the '60s girl groups like the Three Degrees and the Supremes continued well into the '70s, but the sound changed with the times, and the girl groups changed along with it. You can call the Spice Girls a girl group, but I hope no one would dare compare them to what the Ronettes, Supremes, Shirelles, and Shangri-Las were doing in the '60s. That would be sacrilege!

My blood sugar level is rapidly increasing. Do you have something to take it down?

You know, just because we're talking about girl-pop doesn't mean that the records are all sugar 'n' honey. The Shangri-Las were tough as hell, singing about death and devastation and topics way ahead of their time. And there are many fine examples of heavy soul and freakbeat female-vocal records that couldn't be less sweet: Jan Panter's "Scratch My Back," Dana Gillespie's "You Just Gotta Know My Mind," Sharon Tandy's "Daughter of the Sun," Barbara Lynn's "I Don't Want a Playboy."

What about the rest of your collection?

I have somehow stockpiled (though I don't specifically collect) a lot of '80s pop and new wave, indie, metal, and classic rock. Megadeth was and probably always will be one of my all-time favorite bands, especially their album *Rust in Peace*. I will never tire of it. And it's a shame Dave Mustaine has become such a right-wing evangelical freak, because he was once one of the smartest, most eloquent men in metal. Who else could come up with such irreverent titles as "Killing Is My Business (And Business Is Good)" and "Peace Sells (But Who's Buying)"?

How has your passion for vinyl affected the rest of your life?

When I first started collecting 45s, I was eighteen and living in London, hanging out with people twenty years my senior because eighteen-year-old vinyl collectors didn't exist. I have very few friends my age who collect records, and my partner doesn't own a single record. So it's been predominantly a solitary endeavor for me.

I spent five years studying Japanese in order to find out more about J-pop and the Japanese girl-pop scene in the '60s. I ended up living in

Tokyo for over a year and would spend my afternoons alone, traveling to record shops in obscure parts of the city. I did the same all over the UK, Paris, and New York. I took a solo vacation to the Utrecht record fair. I also DJ my 45s, and that's put me in touch with lots of folks worldwide who may not collect but definitely share my love of girl-pop. I've been really lucky to have gotten a few jobs thanks to my collection, my most prized job being writing the liner notes for the *Girl Group Sounds, Lost & Found* box set for Rhino Records, which was nominated for a Grammy in 2005. And more recently, I produced and compiled *Nippon Girls: Japanese Pop, Beat & Bossa Nova* for Ace Records, which originally came out on CD and was reissued on purple vinyl in a gatefold sleeve.

Where do you acquire your vinyl these days?
Record fairs are by far my favorite places to buy records. When I lived in the UK, I would cut class to go to record fairs and I often spent my weekends traveling to Birmingham, Bristol, and Manchester to buy 45s. This was long before eBay, so many of my most cherished girl group records were fairly cheap and easy to pick up. I'm so happy the Allentown record show still exists because it's built around the 45. But I do have eBay to thank for the many impossible-to-find records that have been on my want list for over fifteen years. That would be Brunetta's "Baluba Shake" and Connie Stevens' "Tick Tock." The one-minute countdown to auction time is brutal and a game I feel guilty about playing, but you gotta do what you gotta do.

1. The Cookies - "I Never Dreamed" 45. "Definitely in my top ten favorite songs of all time." 2. "If you're new to '60s Japanese girl pop, start with Jun Mayuzumi's killer R&B-meets-freakbeat 45s—'Doyou No Yoru Nanika Ga Okiru' and 'Black Room.'" 3. Groovin' to "I Never Dreamed."

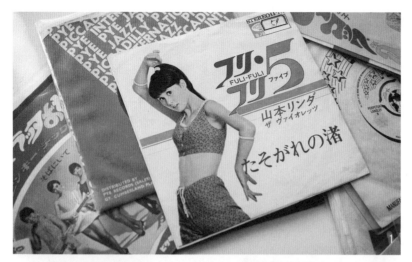

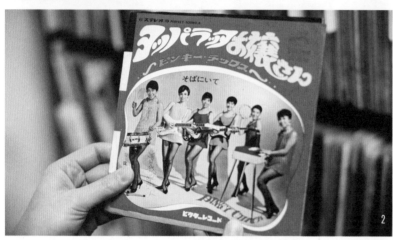

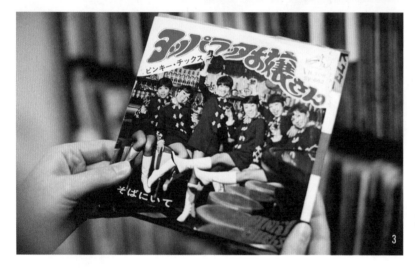

How do you organize your collection?

I divide my 45s first by country—Brit girls, US girls, French girls, Japanese girls, international girls (for the few Italian, Dutch, Spanish, Swedish, Chinese, and German girl-pop records I own)—and then there are the boys, which pretty much consists of the Beach Boys, Lou Christie, Del Shannon, Bobby Hebb, and the Bee Gees (mostly the men who sound like women . . . hehe). Within the countries, I arrange everything alphabetically. LPs are arranged by decade and genre—'80s chart-pop, '60s girl groups, '60s boys, soft rock, metal, and random shit.

What about your shelves? I'm guessing they're not from IKEA.

I'm obsessed with mid-century modern design, and these shelves were made in the 1960s by George Nelson for Herman Miller. It took ten hours to put them up and they were ridiculously expensive, but they've transformed my apartment and will hopefully last a lifetime.

What do you look for in a record?

Melody. Hooks. Magic. Anything above VG+. I always check for warping, because nothing makes me more depressed than finding out I've bought a warped record. Sometimes

I'll buy an artist's entire discography (the Chiffons, Lesley Gore, France Gall, Françoise Hardy) or everything on a label that I trust implicitly (Red Bird, Planetary, Philles).

What is your partner's reaction?

We actually met when I was DJing a '60s night at a seedy strip club in East London, so he knew what he was getting into. I think he found it quite intriguing at first but has since gotten used to the fact that he lives in an apartment dominated by music and memorabilia. I think he also appreciates the exposure to music he probably wouldn't have heard anywhere else. He only complains when I get my thrash metal records out.

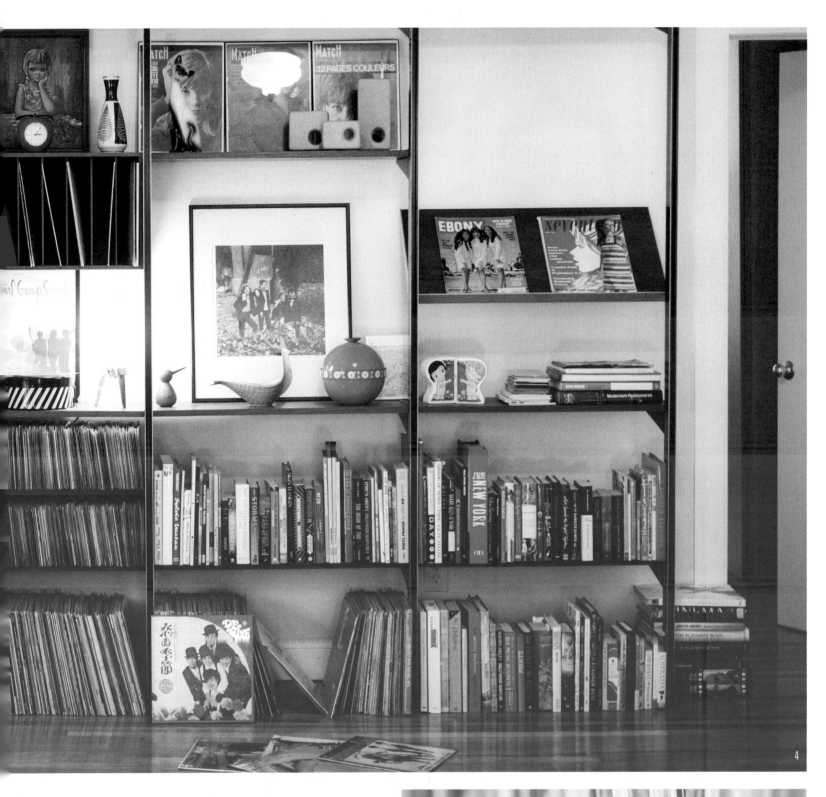

1. Linda Yamamoto - "Furi Furi 5" 45 2. "I owe Junichi Miyaji big time for giving me his copy of this very, very rare Pinky Chicks 45 on Victor. How's that for a sleeve?" 3. Pinky Chicks flipside. "'Yopparata Ojou-san' is about a girl who gets stood up by her date and ends up getting trashed. It's hilarious!" 4. "The '60s centerpiece of my living room in Brooklyn, featuring shelves by George Nelson for Herman Miller." 5. "My 45 filing system—the Boyz, Ann Lewis, '80s Japanese pop, '70s Japanese pop."

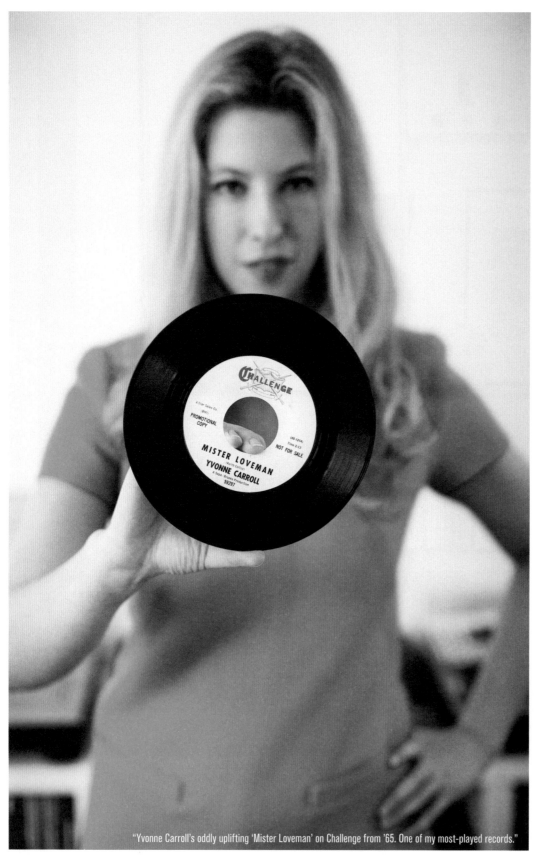

"Yvonne Carroll's oddly uplifting 'Mister Loveman' on Challenge from '65. One of my most-played records."

Why 45s as opposed to LPs?

In short, most of the artists that I collect were nowhere near successful enough to warrant an LP. Some never even made it past one 45. So when I started collecting '60s girl-pop, it was only natural that I'd collect 45s. Also, I find that most of the albums released by sixties girl groups were heavy on filler—bland covers and blander B-sides. So even though I collect girl group LPs, I find myself pulling out the 45s much more often. Also, the 45 is the showpiece, the chance to put your best foot forward, the attempt to score a hit. Never mind that most of these 45s never charted. It's the intention behind it, the writer and artist's attempt at greatness.

LP collectors seem to have the most options, at least in terms of record stores and places to dig, but they probably also have the most competition. Does that seem accurate?

I've definitely found that record shops are carrying fewer and fewer 45s these days, but I think the competition is fierce for any rare, desirable record, be it a 45 or LP. I've been in brutal bidding wars over 45s, often because a girl group record I'm after got swept up in the northern soul scene, and thus quadrupled in demand and price. It does still amaze me that a single 45 (two songs, no liner notes, no artwork) can go for hundreds or even thousands of dollars. I've had to delete 45s from my want list due to the INSANE price tags.

Do you have a comfort record, one you can always go back to? What makes it so special?

Presenting the Fabulous Ronettes on Philles. It opens with "Be My Baby," and you're practically back in the womb. It's the sound of Ronnie Spector in love, and one of the most gorgeous songs ever written. Every song on the album is either a single or could've been a single. "All killer, no filler!" as they say. It's comforting to know that even on the darkest of days, I'll always have the Ronettes.

Any unique packaging, shapes, or colored vinyl?

THANK GOD for the Japanese. I thought my France Gall EPs were visually stunning, but they have nothing on Japanese sleeves from the '60s. Reiko Ohara's "Peacock Baby" on Victor from 1968 is the most gorgeous record in my collection. It unfolds into a 14-inch sleeve with the Japanese actress-singer in a peacock-patterned silver suit, holding a feather, surrounded by multi-colored Japanese characters. The 45 "gatefold" was very common in Japan—usually with a stunning photo on one side and the lyrics on the flip.

Do you have a record-collecting philosophy? Any special routines when you enter a store?

I know immediately when I walk into a record store whether or not it'll have what I want, and sadly there are very few stores left that carry the 45s I'm looking for. So it's late-night Google, Gemm, and eBay searches for me, and the biannual Allentown record fair—one of the rare places where I manage to score 45s that have been on my want list for years. I highly recommend chatting with the record store owners or fair dealers, as they usually keep a hidden stash of 45 boxes behind the counter for their "special" customers. It's a shame so many of those collector-driven record stores, like Beanos and Intoxica in the UK, are no longer around.

The only downside to such beautiful artwork is that the sleeves are often far more exciting than the records themselves.

Tell us about a dollar bin record you would never part with.

Barbara Chandler's "How Can I Say No to You?" on Musicor from 1968. I found this in a dollar bin in Toronto. I was sold after hearing the first note of the bass line. The combo of Barbara's teen voice with such a heavy rhythm section is like nothing I've heard before.

Is there an artist or a label you're trying to complete?

I've been collecting Gillian Hills records since first watching *Beat Girl*, but I've never been able to find her "Jean Lou" EP. It's not that I'm particularly in love with this record. I'm just desperate to complete her collection.

What about digging buddies? Do you share or go solo?

I'll occasionally have a friend in town who wants to go record shopping, but 99 percent of the time I'm digging solo. I used to dream of finding a partner with a similar obsession with records, but that did become a reality at one point and I found that it wasn't as dreamy in real life. There's the fighting over the same records, getting collections mixed up, and less access to the stereo. My husband rarely decides what goes on the turntable, and I MUCH prefer it that way!

What's your saddest record story?

I spent a day helping out at Norton Records HQ a few weeks after Hurricane Sandy hit, and it was heartbreaking to see how much of their stock had been destroyed. I ran into Billy [Miller of Norton Records] at the Allentown record fair, and it was so nice to hear that they made it through the worst of it. He seemed overwhelmed by and appreciative of all the support, and by the Norton benefits taking place worldwide.

List a record or two with the power to heal a broken heart. List a couple more guaranteed to make a broken heart even more painful.

Happy

The Cookies' "I Never Dreamed" (Dimension, 1964). Euphoria captured on record, and penned by the '60s' most underrated song-writer, Russ Titelman.

Tammy St. John's "He's the One for Me" (Pye, 1964). The giddiest of the Brit girl records. Made for skipping.

Yvonne Carroll's "Mister Loveman" (Challenge, 1965). Mystery soul singer chronicles her loneliness over a backbeat that's strangely uplifting.

Toto's "Africa" (Columbia, 1981). I made everyone sing this at my wedding. Prog rock's greatest pop achievement. I live for this record.

Sad

The Shangri-Las' "Never Again" (Red Bird, 1965). Regret-filled and shrill album-only track by New York's toughest girl group.

Bessie Banks' "Go Now" (Tiger, 1964). Original version of the Moody Blues #1.

The Cryin' Shames' "Please Stay" (Decca, 1966). Joe Meek–produced Merseybeat group covers the Drifters. Utterly devastating.

Sheila Ferguson's "Don't (Leave Me Lover)" (Swan, 1965). Pleading ballad by one of the longest-serving members of the Three Degrees.

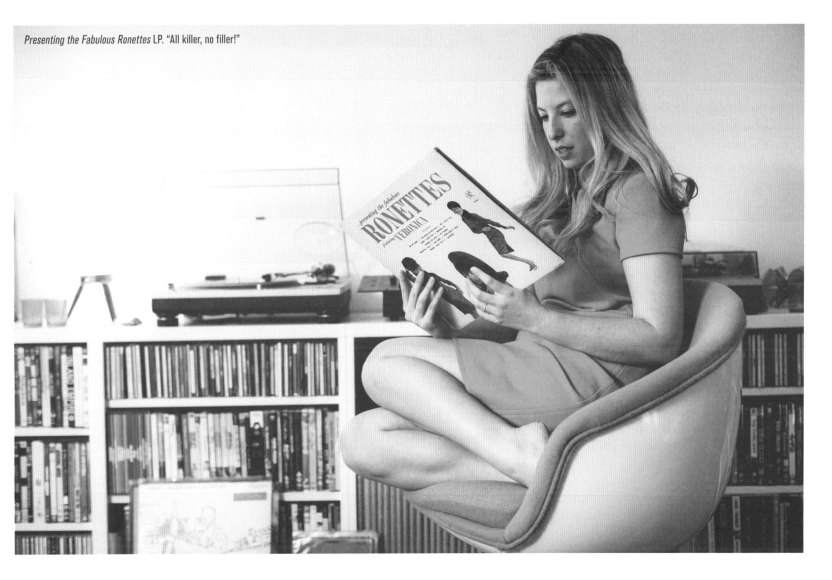

Presenting the Fabulous Ronettes LP. "All killer, no filler!"

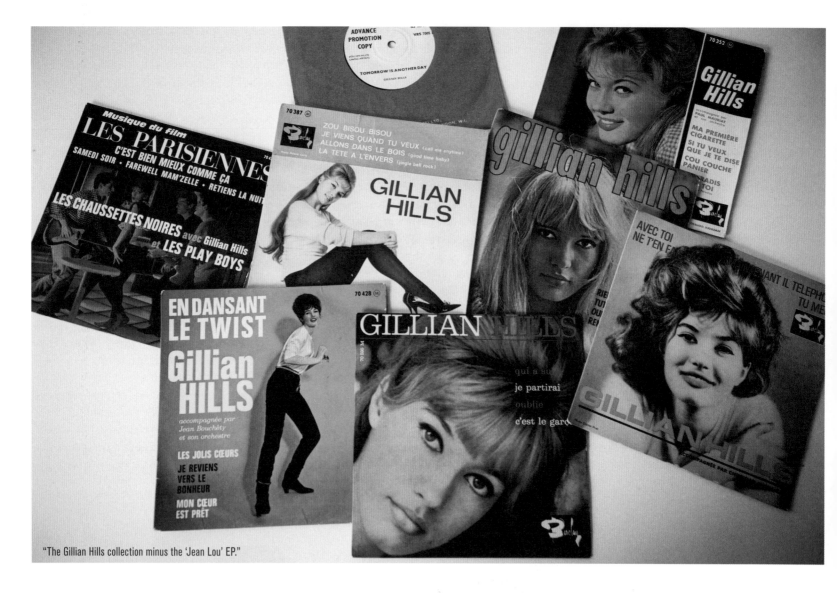

"The Gillian Hills collection minus the 'Jean Lou' EP."

What do you think about Brigitte Bardot's singing abilities?

Up there with Mick Jagger and Bob Dylan.

What about a record that got away from you?

I deeply regret allowing my records to pile up all over my floor, and then stepping on one and cracking it in half. Also, I had scored a hard-to-find 45 by the Ladybugs on the Del-Fi label on eBay, and it arrived cracked straight down the middle. The seller wouldn't accept any of the blame (I forgot to add insurance) even though he just packed the record in a cardboard box without any bubble-wrap or cardboard pieces for protection. I regret not aggressively going after the Mama Cats 45 on eBay, because it's unlikely I'll see it again for another ten years.

And I kick myself for not asking a DJ at Smashed! Blocked! (the now defunct and once brilliant '60s party at Beauty Bar in NYC) the name of a mystery girl-psych record that I'll probably never hear again.

What do you want to happen to your collection when you check out?

The question that makes most of us collectors

"MY LIFE IS MUSIC, AND ONCE YOU MOVE BEYOND SIMPLY LIKING A FEW BANDS TO BECOMING OBSESSED TO THE POINT OF COLLECTING, YOU, AS A FEMALE, REALIZE YOU'RE ENTERING A VERY MALE DOMAIN."

shiver! And begs the further question, just what the hell are we doing spending our lives amassing a collection of records that we can't take with us? And that's when I pour myself a glass of wine, pull out a 45, and remind myself to live in the present. I hope that my favorite records will be played at my funeral, and then they will go to my husband or our future kids, who will be given strict instructions on how to keep them from warping.

Why do you think there are fewer female collectors? Or maybe they're out there but not really eager to show off their collections?

I've been wracking my brain for years trying to figure out why there appears to be so few female record collectors, and I've found that writer Simon Reynolds seems to have the most convincing theory in his mind-blowing book *Retromania*. He quotes a dude named Will Straw who suggests that men have this inherent need to assert their masculinity, and if they are "alienated from or feel inadequate to the more traditional masculine ideals (leadership and physical strength, for instance)," they will find other avenues to assert their masculinity—becoming "authorities

through their taste and cultural expertise." I think the same can be said for women, although without the resulting need to flex our muscles and prove expertise, show off, become an authority, etc. Growing up, I felt completely alienated from traditional feminine ideals—the insane emphasis on meeting a man, beauty, exercise, shopping, diet, child-rearing, etc. Sure I like finding an awesome dress or putting on eyeliner, but I wouldn't say I'm particularly interested in fashion or makeup. My life is music, and once you move beyond simply liking a few bands to becoming obsessed to the point of collecting, you, as a female, realize you're entering a very male domain. Your love of music is equally deep, yet you share little of the desire to show off about it or engage in the "who has more records/who has more knowledge/who can get more obscure" competition. I think at some point I did attempt to work my way into the male domain, showing that I could "talk the talk" about obscure records, labels, and dates just as well as the boys. But I quickly found the whole one-upmanship just as dull as sitting around with women discussing their preferred diet routine.

Might there be more female record collectors out there than we imagine? I think so. They may just have little need to make their collecting habits public. There's also very little room in the traditional collecting world for women. It's a boys club, and if a woman can't play like the men, she's rarely encouraged to join in. Because in the record-collecting world, you have to meet certain criteria . . . you'd hardly be taken seriously as a collector with a small collection. Quantity matters. So does rarity. And your knowledge about what you collect. What girl wants to bother being held to such silly standards when we're already judged on just about everything else in our lives?

The notion that collectors are only as good as their collections is pervasive in the vinyl community. Why is that? Is it important to herald the great collectors? What about small-time collectors? And what about the role money plays? Is something lost in being able to "buy" an impressive collection?

There's a definite hierarchy in the record-collecting community, and a collector's spot on the totem pole is largely determined by the size of the collection, rarity, quality, and also how long you've been in the game. It's no surprise that someone who collects rare northern soul or funk 45s is given more respect than, say, a collector of Madonna's entire vinyl catalog. Northern soul and funk are respected genres in record-collecting circles—Madonna not so much. And it's also understandable that those who spend years digging up rare or obscure records are given more kudos than those who collect what's more easily available. Our culture values hard work, struggle, the long hard climb to the top, the arduous tales of digging in dusty record shops in foreign lands. A person who can just buy up an impressive collection because he or she has a ton of money doesn't fit with the accepted narrative, and thus isn't looked at quite so fondly.

I think if you follow the traditional record-collecting "rules" for who makes a better collector, the small-time collector isn't going to rank very high. I remember this record dealer asking me how many 45s I had, and when I gave him the number, he was like, "Oh, okay, you're for real, then." I can understand both arguments—that the word "collector" implies that you should probably have quite a lot of whatever you collect, as well as the view that record collecting is simply an expression of a deep love of music. So if you have a small collection of records that you know inside out and adore, well, that's quite a powerful expression of your deep love of music. There are some people out there with enormous record collections who collect for reasons that have little to do with the music, so should they be given greater respect just because they win the numbers game? It's all debatable.

What advice would you give to someone starting out?

Collect what you love, and enjoy the journey from not knowing to knowing. Learn the record-collecting lingo, find record shops, sign up for mailing lists, meet dealers and collectors, do research, travel to record fairs. It's a very bizarre world that attracts a whole lotta crazy characters who will blow your mind with their enthusiasm and knowledge. As much as I wish it included more females, I consider myself lucky to be in the company of so many passionate men who feel the same way about music as I do.

"THE SONG IS THE CAKE; THE ORIGINAL VINYL RECORD IS THE CHERRY ON TOP."

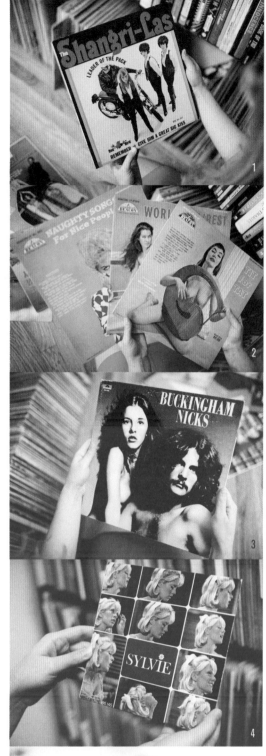

1. The Shangri-Las - *Leader of the Pack* LP 2. "A random assortment of porn LPs found outside my friend Jason's apartment." 3. Buckingham Nicks LP. "Sexy as hell." 4. Sylvie Vartan - "Il Y A Deux Filles En Moi" 5. "Bonnie St. Claire's overtly sexual garage rocker 'Tame Me Tiger.'"

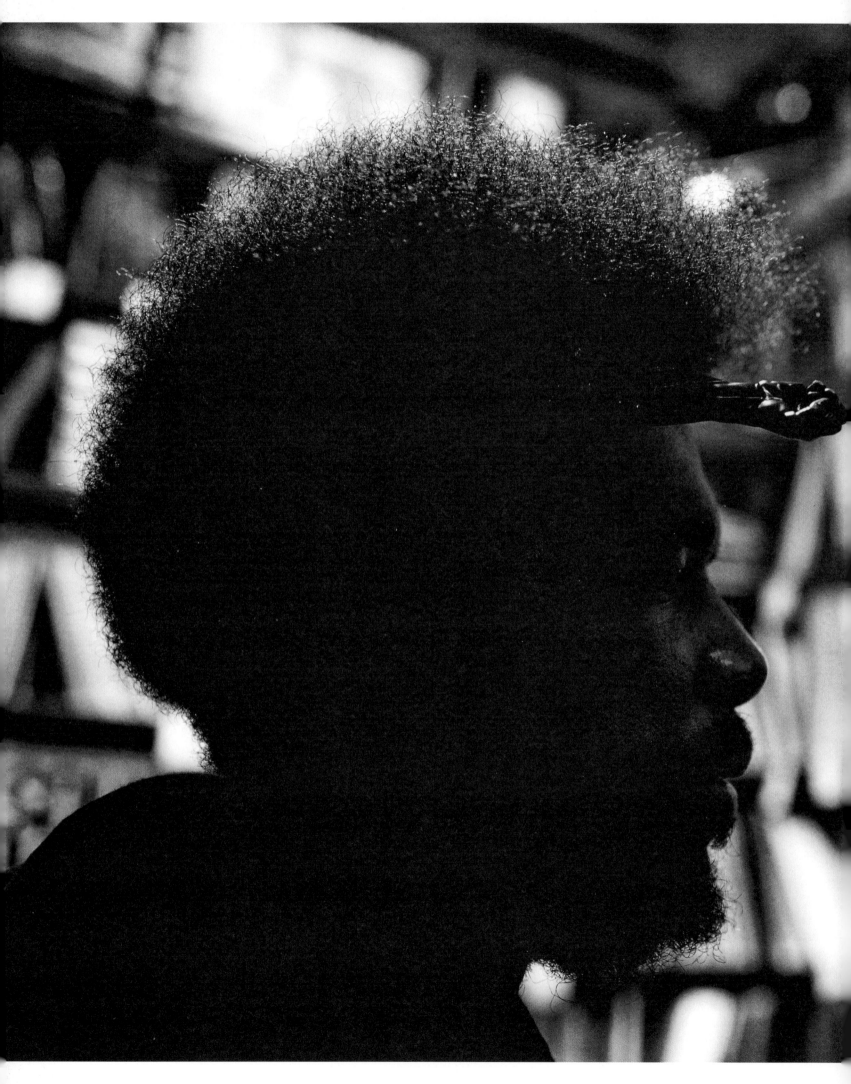

AHMIR "QUESTLOVE" THOMPSON

BACK TO THE ROOTS

BY JAMISON HARVEY

When a window opens in Questlove's schedule, even if it's very last-minute and on July 4—you take it. As drummer for the legendary hip-hop band the Roots, bandleader for *The Tonight Show with Jimmy Fallon,* professor at New York University, and round-the-clock DJ, Questlove rarely gets a break in his schedule. Just minutes after getting word of his availability, I found myself speeding down the Turnpike with Eilon toward MilkBoy Studios in Philadelphia to interview one of the hardest-working men in showbiz since James Brown. We had an hour to photograph him and his vinyl collection just enough time for him to open up about his love of music and lifetime quest for records.

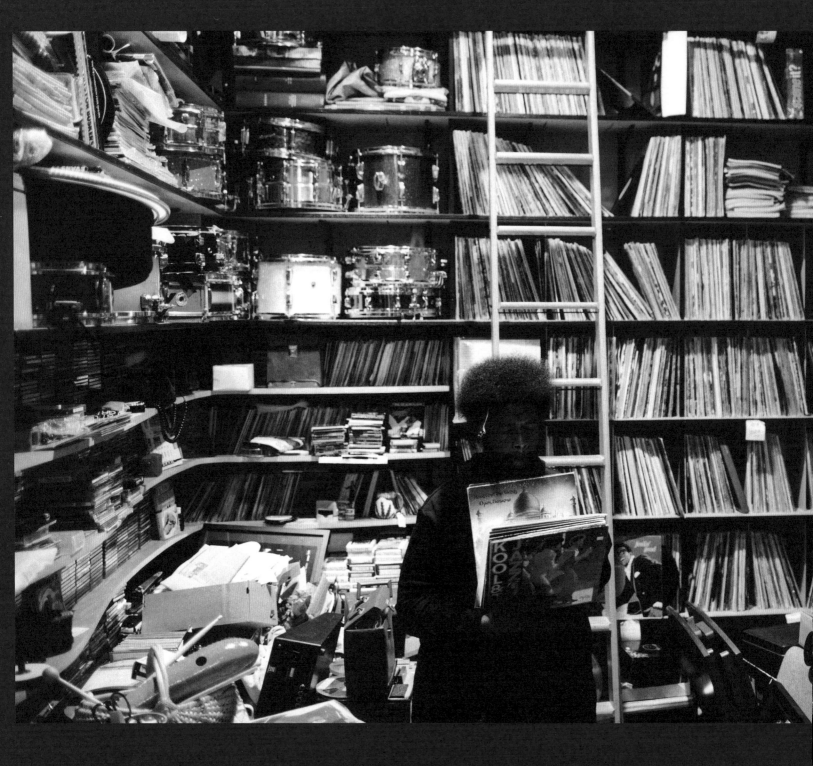

When we arrived at our destination—a nondescript building in an industrial section of Philly—only "The Studio" written on the mailbox directory informed us that we were at the right address. Then a tinted-out Mercedes sedan passed our spot and came to a stop. Out walked Questlove, in a Jackson 5 hoodie with his signature Afro and Black Power hair pick in tow. We followed him through the main entrance but quickly discovered that we were locked out, all of us. Time

was ticking, as he needed to be at the 4th of July Philly Jam in just under an hour. But after a few phone calls and some covert tricks (as well as a yell of "Street Cred!"), we were in. That's right: Questlove had to break into his own studio. Even someone with his clout has to do it by any means necessary. There were records to talk about.

Entering his sanctuary, his personal getaway, we got a real glimpse into a place we had seen only in YouTube

videos. This was a room with a staggering number of records, arranged from floor to ceiling, wall to wall, with built-in library ladders to access those meticulously organized, hard-to-reach LPs. Getting at them seemed impossible, though, with a drum kit, MPC3000, amps, turntables, drum stools, and a Questlove NBA jersey blocking access. Questlove quickly made a beeline for a space, muttering, "I need to find those D'Angelo DATs I know they're here somewhere." A record that Dilla gave him eight days before he

passed was also proving tough to locate.

Questlove waxed poetic on everything from Dilla's favorite snare sample to his Prince phases, from growing up on the road with his musician parents to the worst punishment he ever got for stealing $10 from his father to buy vinyl. He ended up chatting for an extra thirty-five minutes, holding up his whole production for the Philly Jam performance. After we exchanged pounds and handshakes, he calmly concluded, "Now it's time to work."

As you were growing up, your dad had a pretty sizable vinyl collection. Did you consider yourself a collector when you were younger, or did that come later on?

I didn't consider it, not until I built this [record] room. Once I had enough money to really buy my first house, I opted to build this studio instead of a house. I remember working on [D'Angelo's] *Voodoo* record when Q-Tip lost all his records in a fire. That scared the living bejesus out of me. Imagine this hoarder level of collecting, but inside my residency! We're talking about the living room being all records. The kitchen, all records. My bathroom. I kept the best records in the bathroom 'cause it was like, "Where do I keep the gems at? Oh yeah, I'll keep 'em in the bathroom!" It's easy to remember that they're in the bathroom. My Grammys are in the bathroom. There's also a turntable in there. But there came a point when I started cracking records, you know, trying to navigate from here to there like Indiana Jones—one, two, three, [*crackle noise*] as I tried to jump over stuff. By the time I cracked the twentieth record, I was just like, "Man, I gotta do something. Q-Tip's house set on fire!"

How did this record room take shape?

In '99, I commissioned my brother-in-law, who was a carpenter at the time, to build me shelves that can hold at least fifty thousand records.

How big is your collection and how did it come together?

Between the New York spot, here, and what's in storage, I'm up to a good seventy-five thousand records. My first collection was basically taken from the household that I grew up in, so it's my father's collection. Then it's the work I put in. Then once I was in a certain position, a friend of mine hooked me up with a kind of estate planner. So say a distraught divorcée wants to get rid of her jazz collection, you get it for $2,000. A lot of that came down the pike. One of the best collections that I received was from Levi Stubbs's [of the Four Tops] daughter. She gave me twenty-five of all these boxes—crazy '60s test pressings, acetates of Motown stuff. There are a few priceless items here thanks to the right person hooking me up.

What was your memory of your first record? How did you feel when you got it?

It's funny you say that, because today at the show I'm meeting the friends of the lady who bought me my first record player. I used to just play my toy saxophone with my parents' horn section and actually perform onstage with them from age four until about seven, playing tambourine and stuff. That's how they would watch me. Once before a show, a lady walked up and said, "Oh my God, you're so cute and everything, I just want to buy you something." My parents were overly cautious and warned me not to accept any gifts from strangers. But I

"I KEPT THE BEST RECORDS IN THE BATHROOM 'CAUSE IT WAS LIKE, 'WHERE DO I KEEP THE GEMS AT? OH YEAH, I'LL KEEP 'EM IN THE BATHROOM!' ... THERE'S ALSO A TURNTABLE IN THERE."

told the lady I love records, and she went the next day to a department store and got me a miniature record player like the little Numark ones we use now. And also a Neil Sedaka 45 for "Bad Blood." I guess she was just choosing what was in the top 10 at the time. She also got me Rufus and Chaka Khan's "Dance with Me." She had asked me what my favorite groups were, and I liked Rufus and Chaka Khan. I chose records by the way the logos looked. ABC Records had a great rainbow kaleidoscope thing, so I gravitated towards anything that was on ABC. That made me like Rufus. I liked Neil Sedaka's label because he and Elton John were on Rocket, and Rocket had a really cool-looking logo. So I judged records based on how cool the logo looked spinning on a turntable. Then she got me a Jackson 5 record 'cause I always loved their look. I dunno, to me it's based on the logo, which is rather strange considering I picked a very simple Arial font for the Roots logo. Oh God, I was obsessed with how logos looked.

Are you buying vinyl these days? Your spare time seems to be limited. With Serato and digital DJing as the medium of choice for most traveling DJs, did that slow your vinyl itch?
I've become more obsessed. I've never stopped

buying vinyl. Here's my #richguy quote coming up . . . I have brokers. I don't have time to dig, and I really want the cream of the crop. I know cats whose job is to do this. There's one guy who will drive up from D.C. and I'm like, "Yo, you got any new shit?" He digs, then tells me, "What you looking for? You looking for drums? You looking for German disco edits? You looking for Russian jazz?" Right now I wanna cut to the chase. I've spent forty-two billion hours inside of Val Shively's Records [near Philadelphia]. Whenever I'm in San Francisco, I'll spend a couple of Gs at Groove Merchant. They know me instantly. As soon as I walk in, they start playing a bunch of stuff. Right now I'm less in my digging-for-beats phase and more into digging for quirky music to DJ. I'm into a lot of weird covers of stuff, a lot of ironic things. I love Groove Merchant and going to Japan, but Portland is my all-time favorite city for records. The digging there is about as good as digging gets.

What makes Portland so good for records?
If you're trying to purchase the original Beatle Butcher cover of *Yesterday and Today,* they'll know that it's worth 5,000 bucks. But the 10cc record Dilla used for "Johnny Don't Do It"—I got it for 3 bucks. Whereas someone who knows better will understand that once

somebody uses a record, the value goes up. Anything that's ever been used on [Dilla's] *Donuts* could easily get sold for somewhere between $25 and $50, but I was lucky enough to get 10cc for 3 bucks. That's the beauty of Portland.

When you got involved with Dilla, did he change the way you looked at and listened to music?
Absolutely. He changed the way I listen. I watched him absorb music. There are cats who will buy records and then never listen to shit. And then there are cats who'll buy a record and then 45-skim it. I never knew anyone who had more patience than Dilla.

Can you show us some stuff he turned you on to? Stuff you wouldn't have listened to before getting involved with him?
His greatest gift is the fact that he'll revisit other stuff, not just the obvious gems of the record. There was a Joe Pass sample that El Da Sensei used for a song called "Keep It Live." I thought it was the best part of the record, but for Dilla his thinking was, "Okay, I'm not gonna use the part that everyone thinks I'm gonna use. I'm gonna look at the scraps and leftovers and see if I can make a miracle out of that." He made a beat out of a part of a song that we never even considered. That's

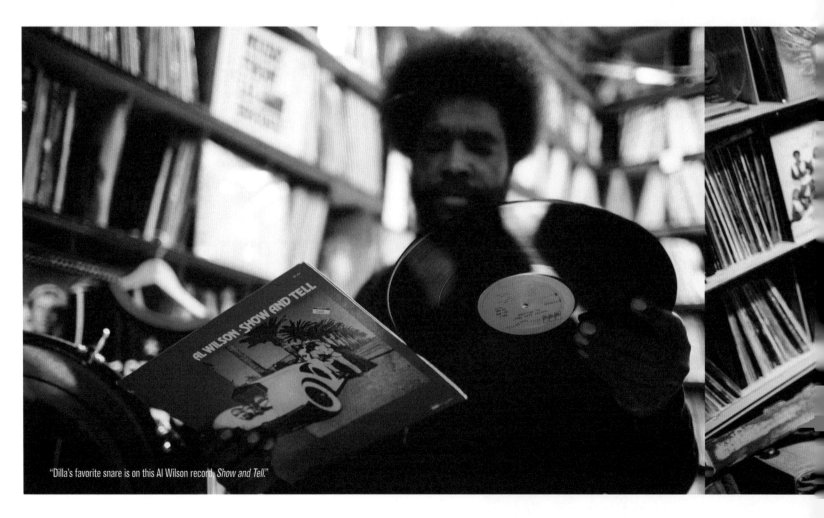

"Dilla's favorite snare is on this Al Wilson record, *Show and Tell.*"

what taught me that you really have to listen to records. So I'll say that around the time I started messing with him seriously with the Soulquarians—especially during the D'Angelo period in '98–'99—is when I started to designate an actual schedule. He was the only person I knew at the time who treated his occupation like a real job. He got up at six or seven in the morning and listened to records. He would have five beats already created before lunchtime. Then he'd come back at three p.m., mess around, and have four more beats made by seven p.m. And by eight p.m. he's finished with work and out having fun, and then he'd be in bed early. It was the same routine every day. I wasn't treating my craft like that. I'd usually do it until two in the morning or something. In '99 I started spending about five, six hours in this room just listening to records. I would just grab a section and sit there and listen.

Dilla's favorite snare is on Al Wilson's *Show and Tell* LP. His version of "A Song for You" on Side 2 was basically every snare that he used on Tribe's *The Love Movement*. I'd say that for the majority of whatever got released on any record that he did between '98 and '00, that perfect snap snare came from this record. The next day I ran out and got me four of these. What's kinda weird is that most beat-makers will go to the snare on Tribe's "Busta's Lament," which is the same snare, just enhanced more, EQ'd better, and mastered better. But you know, it's the perfect crispy-sounding snare.

What are some records that inspired you on the way up?

Shuggie Otis's *Inspiration Information.* I grew up in a house with three very distinct record collectors. My dad was into easy listening and the yacht rock of his day—Carole King, Johnny Mathis, Streisand. My sister was trying to be socially accepted by her crew in high school, so she listened to a lot of rock stuff. And my mother was the crate digger of the family. She chose records based on the artwork or how someone looked. I remember asking about *Inspiration Information* when I heard Dilla playing a sample. I'm like, "Ma, what made you choose this record?" "Strawberry Letter 23" isn't even on this record; there were no identifiable pop songs. We didn't have *Freedom Flight,* the other Shuggie record. I think she just chose it because he looks sharp on the cover. That's how my mom would choose records—if it looked like it was important.

Kraftwerk's *Trans-Europe Express* is another one of my mother's discoveries. Saturday night in Philadelphia, from like twelve till about three in the morning, back when DJs actually made their own playlists, they would play some pretty crazy, eclectic stuff. I heard it once and begged my parents. I only knew the word *express*; I didn't know what *Trans-Europe* was. I remember going to every record store and asking, "Do you have 'Hmm-hmm Express'? You know the song 'Hmm-hmm Express'?" It took about a year to find it. Finally, there was a DJ at Sound of Market Street who knew exactly what I was talking about. So as a ten-year-old, my mom bought me Kraftwerk's *Trans-Europe Express.* By '81 they were making noise with "Numbers," and people became more familiar with Kraftwerk. They make great dance music. They are the original EDM, the first-generation EDM. But I'm happy to say that me and my mom were up on Kraftwerk slightly before "Planet Rock."

What do you consider an important record in your collection?

Average White Band's *Person to Person* LP is very important. As I said, I literally grew up on the road with my parents and that's all I knew—adults. So when they tried to explain the concept of not going on the road with them, staying at Grandmom's house, going to this thing called school with other kids—that's the first time I felt like an actual kid. It was the hardest thing. I cried every day. Didn't like it much in the first few months, but I got used to it.

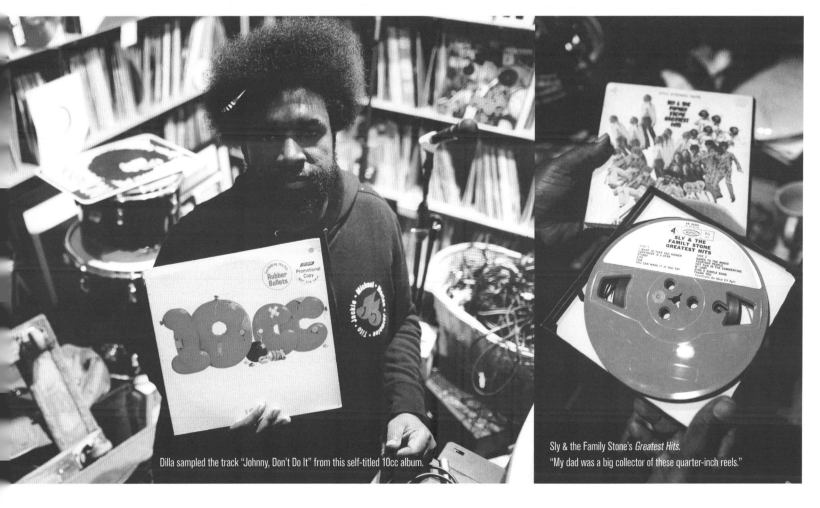

Dilla sampled the track "Johnny, Don't Do It" from this self-titled 10cc album.

Sly & the Family Stone's *Greatest Hits.*
"My dad was a big collector of these quarter-inch reels."

THIS WAS BASICALLY A RECORD I PRACTICED TO IN THE BASEMENT FROM THE AGE OF 6 UNTIL 21. I STILL PRACTICE TO THIS RECORD AS A 43-YEAR-OLD. IF I HAD A TOP TEN RECORD LIST, THIS WOULD PROBABLY BE MY NO. 1 RECORD." [ON AVERAGE WHITE BAND'S *PERSON TO PERSON*]

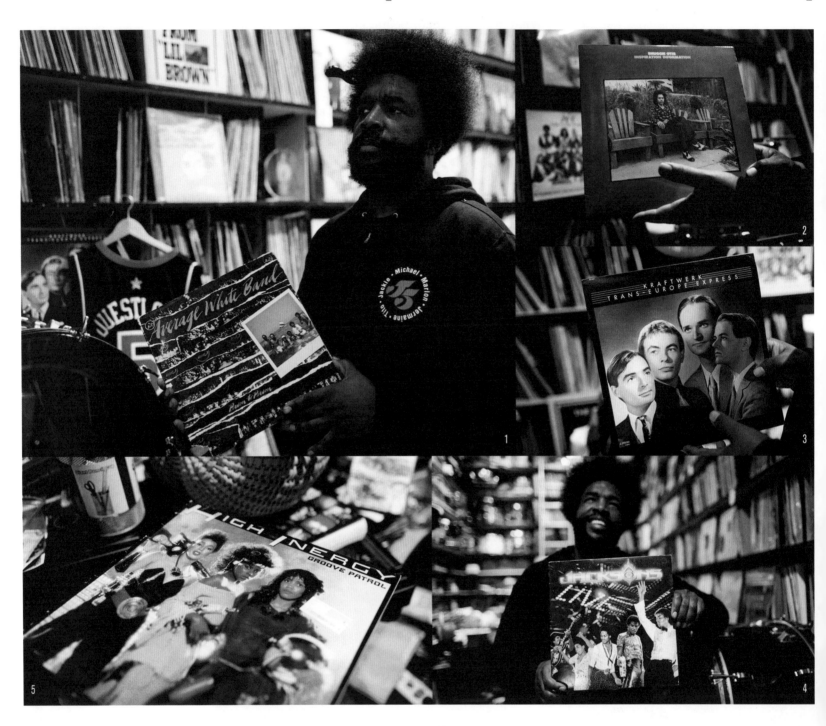

They would basically have to bribe me with records and record bingeing. And as a sort of congratulatory, last-day-of-school present, we did a $300 record-shopping binge. One of the records they bought me was Average White Band's *Person to Person.* This singlehandedly changed my life. This is the record that I applied the ten thousand hours of practice to. This was basically a record I practiced to in the basement from the age of six until twenty-one. I still practice to this record as a forty-three-year-old. If I had a top ten record list, this would probably be my No. 1 record.

What's the story behind High Inergy's "Groove Patrol"?

My very first fan letter I ever wrote was to Linda Howard. She was a former *Soul Train* dancer, and then became part of High Inergy. "Groove Patrol" was an attempt to see if they could make some more Supremes magic. You know, the girl group magic thing.

What about your own Roots records? Do you have a section?

You know something . . . as I'm telling these stories to you, I've realized how right my father was. Whenever we used to get a box of records, he'd come in and take three of them off the top and I'd be like, "What you doing with those? I need those." And he'd say, "Nope, I'm keeping three of every record you ever make because one day you're gonna regret giving all those records away and I will have them for you." And I thought, whatever. And here's that moment, 'cause I don't know if I have any Roots stuff!

[*Twenty minutes later, he finds a copy of the Roots' Do You Want More?!!!??!*]

Forty bucks? I paid 40 bucks for my own record!

1. The Average White Band-*Person to Person* 2. Shuggie Otis-*Inspiration Information* 3. Kraftwerk-*Trans-Europe Express* 4. Jacksons-*Live.* "There was a point in time when I figured, Okay, [my dad's] not gonna miss ten bucks, so I'll just take it and buy this record. Bad mistake. Worst punishment. Worst punishment I ever got in my life." 5. High Inergy-"Groove Patrol."

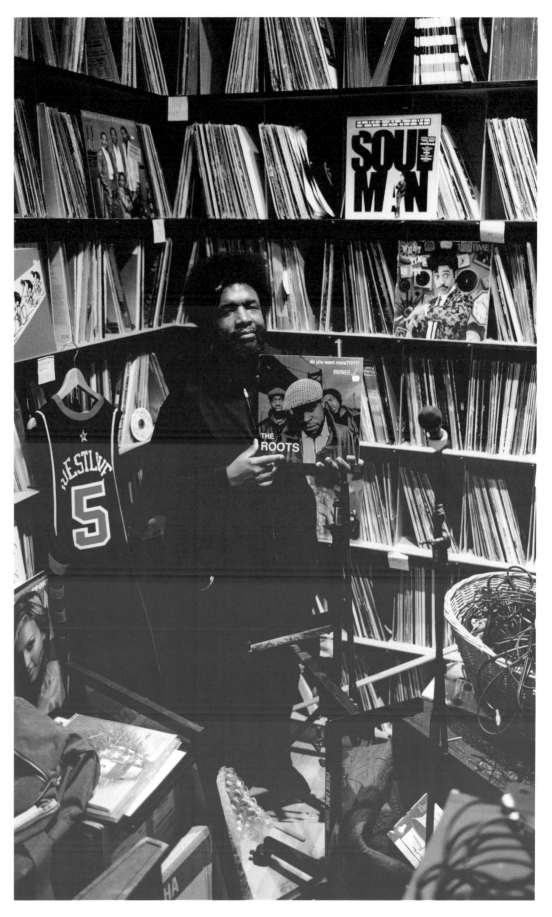

What is one of your most prized records?

Epic Records had printed up an alternate version of Sly & the Family Stone's "Stand," without the funk ending. They just ended the song traditionally. My father was one of the rare owners of the 45 with the original ending.

Tell us a memorable record story.

The worst thing I ever did in my childhood was steal money for records. There was a point in the '80s when you would tax your parents for video game money. They'd send you to a store, you'd come back with change, and you'd keep a quarter so you could play Pac-Man or Space Invaders. Then there was a point in time where I figured, Okay, he's not gonna miss ten bucks, so I'll just take it and buy the Jacksons' *Live* LP. Bad mistake. Worst punishment. Worst punishment I ever got in my life.

How did he catch you?

Because my dad is meticulous. I'm a counter by nature because I play music, but my dad, he measures the amount of orange juice left in the refrigerator. He'll mark it and then say, "Who drank all the orange juice? Yesterday it was up to here." Then you'll see the water mark. He would count his money every night. That's the type of person he is. I could see his stack of $5,000 and, be like, I'll take ten bucks. No. He would count everything, and so the next day I came home and man, that was the worst thing ever. All over.

Was that the worst whooping you ever got?

Ever. When I told the editor of my book the story, he said how ironic is it that your father—a Joe Jackson–type figure, making you practice all these hours—gave you a whooping over a record of a group whose father also gave them a whooping!

Was it worth it?

Nah. It was horrible. It's funny you ask that, because it was only a year and a half ago that I realized the Jacksons overdubbed a lot of the *Live* record. Listen to it and you can hear two

"FORTY BUCKS?
I PAID 40 BUCKS FOR MY OWN RECORD!"

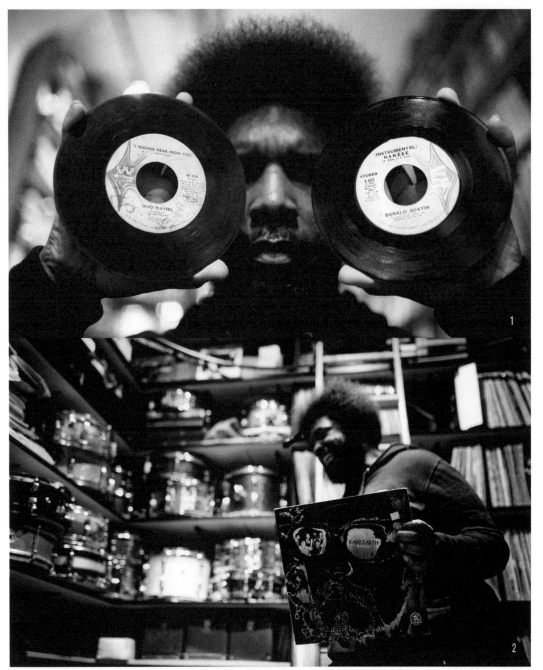

1. The Ohio Players–"I Wanna Hear from You" and Donald Austin "Nanzee" 45s on Westbound and Eastbound Records 2. Rare Earth–*Ecology*

became born-again—Larry Graham, Donna Summer, Debby Boone. You gotta get into something, so a lot of Americans just got into religion, and my family followed suit.

Once in church, my pastor was doing this whole diatribe against Michael Jackson's "Thriller" video. Obviously mine wasn't the only church, because if you remember at the beginning of the "Thriller" video, there's a disclaimer where Michael Jackson says, "I in no way wish to endorse the occult." They spent the second half of that sermon talking about how Prince is demonic and this is what your children are listening to. So instantly my parents thought, "Shit!"

What records scared you growing up?
Rare Earth's *Ecology,* which is a record my mother loved. I was a little creeped out by the long version of "I Know I'm Losing You." Any songs with long echoes creep me out. Rare Earth was a psychedelic band, and I didn't know what psychedelic was. I just knew they used a little too much echo. All of Norman Whitfield's productions were borderline creepy. I wish I could find that *Sky's the Limit* record by the Temptations. There's a version of "Smiling Faces" where they're laughing at the end. Oh God, I couldn't take that! As a kid I used to always run upstairs and hide whenever Melvin Franklin laughs. To be a four-year-old listening to that . . .

When did you make the transition from musician to DJ? How did you decide to even make that transition?
Well, my dad literally put me in showbiz school, so I'll say my first lesson was being a human GPS, a navigator. He taught me how to master a map by the age of five, and then by seven, he taught me how to take care of wardrobe. He taught me how to clean leather, suede, how to iron, how to take stuff to the cleaners. Then when I was eight he taught me sound, so I would have to load in the monitors, check for feedback. At age nine, he taught me how to operate lights. Each summer was a new job, a new responsibility. I was there at the nightclub cutting gels, removing the purple and green gels because they didn't look good on black people. Putting the pink and peach in. Between ages ten and thirteen, I was my dad's light guy. Being at the club, doing all those ungodly hours, DJ culture didn't really hit in yet. Some of the clubs had turntables, but no one to spin on 'em. Then just to pass the time I would

vocal parts at the same time. What the hell? I've slowly realized that most of the live records we hold near and dear are mostly overdub jobs.

Is it true that you specifically weren't allowed to listen to Prince when you were younger?
It really wasn't like, "Ooooh, let me go listen to what my parents say no to." I had heard Prince first and thought it was cool, but they were like, "No, you can't listen to this." But I still listened even though I would get in trouble for it. Having Prince records definitely counts for at least 70 percent of all the punishments I've gotten.

Did they get creative with the punishments?
The records would be destroyed and thrown in the trash. Standard punishment was two weeks without anything. But by the fifth time I got caught, I

got a month. And I'd be like, "Nooooo, not a month!" [*He pulls out a copy of Prince's "Soft and Wet" 12-inch.*] Jesus, I didn't know I had this! I might take this to New York with me. I did not know I had this. A rare 12-inch of "Soft and Wet." This is hard to find. Jesus. I'm one of those people that buys now and discovers later.

Why was Prince effectively banned in your household?
You gotta understand that during the Carter period, America was about as hedonistic and as free as the post–Civil Rights era had ever gotten. It's when the Baby Boomers were coming of age, the start of the raving years when it was all hedonistic cocaine and everything was in full swing. But then the '80s and the Ronald Reagan period came around, and suddenly everyone became conservative. All these secular artists

ask club owners or dad if I could spin records until the show starts. That's when it started. When I was eleven, I knew how to fully DJ. As far as my Roots self, when we were on tour with the Beastie Boys, Mike D used to disguise himself—put on a fake beard, some crazy glasses, and a hat—and go out in the audience and DJ before Beastie Boys shows. Nobody was the wiser. I thought that was the coolest thing ever. Like wow, how cool is it that you, the headliners, are DJing! So I started DJing before Roots shows, and then it evolved into DJing!? after the shows also. That was all the practice I needed, and suddenly they started giving me $500 a gig. I was like, "Wow, I'm making extra money."

We touched on Serato earlier, and you said you never stopped buying vinyl. How did that translate live for you as a DJ?
What I'm now learning, especially in the age of Serato, is that Serato enables me to carry this entire room wherever I go. Whereas before 2002, man, I was always panicking before a gig. Panicking 'cause they would say, "Just do you! Do you!" But I'm like, Whoa, what does that mean? I can't play "Straight Outta Compton" at the Democratic National Convention, but also "Night Fever" by the Bee Gees was a little too old. I never knew what demographic I was gonna walk into. So Serato, at least, saves you the nightmare of not knowing who your audience is.

Toilet-break record?
My toilet-break record is always the fifteen-minute version of "Rapper's Delight." But I've only had to do that twice.

Do you think having an open mind with records has helped out with *The Tonight Show* and the variety of music you play to guests during their walk out?
It has helped my survival because a big part of the first four months of being on the show was NBC executives trying to calm Jimmy down. You know Jimmy, he's overexcited about everything. So their attitude was, "We'll see how this goes," which was basically their way of saying, "We know you guys are a rap group, so what happens on the day we need you to come up with an Andrew Lloyd Webber reference? Or you gotta play some sort of jazz reference? What if we have a country artist on? What are you guys gonna do then?" What they didn't know is that we were all walking Smithsonians of knowledge. I definitely know 50 percent of what's in this room. Most human beings only know about two thousand records in their lifetime. You know what I mean? So knowing those records has prepared me. Truth be told, even though I'm known for what I'm known for, I think all of this—the Roots and DJing

included—was meant to prepare me for *The Tonight Show.* I didn't grow up wanting to be Doc Severinsen, but clearly we were made for this job.

Have you ever gotten rid of any records?
Never.

Straight up? Not even once?
I'm too sentimental. Too much of a hoarder. I couldn't even imagine such a thing.

1. Congress Alley–"God Bless the Children" on Avco Records. "In the age of the Fifth Dimension and the Friends of Distinction male/female groups, my dad [Lee Andrews of Lee Andrews and the Hearts] had an itching to get back into the marketplace in the '70s. So with my mother and my aunt he formed a group called Congress Alley."
2. Prince–*The Black Album.* "I believe this is the third of two-thousand that were saved of the original first pressing of *The Black Album.*"

> ## "RARE EARTH WAS A PSYCHEDELIC BAND, AND I DIDN'T KNOW WHAT PSYCHEDELIC WAS. I JUST KNEW THEY USED A LITTLE TOO MUCH ECHO."

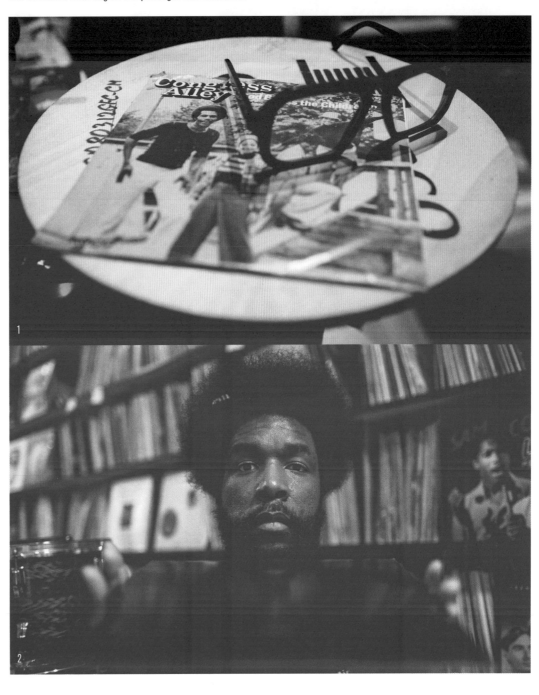

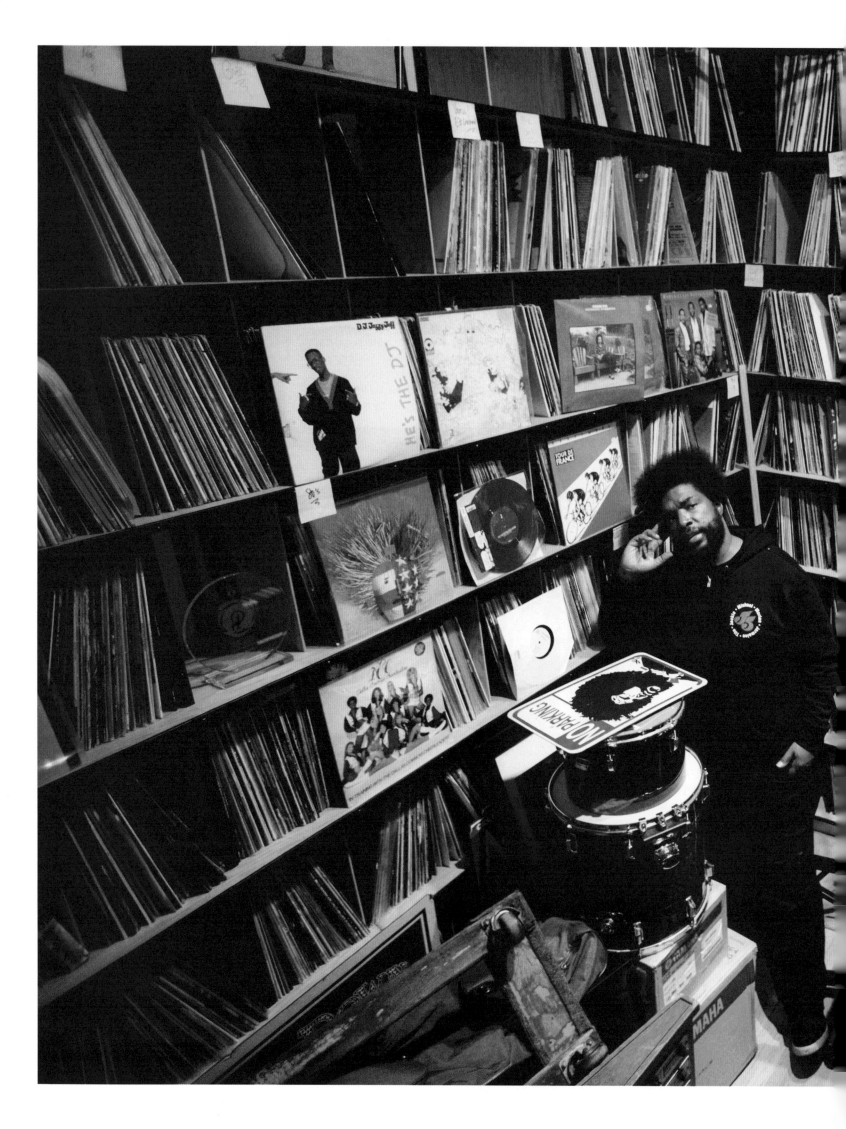

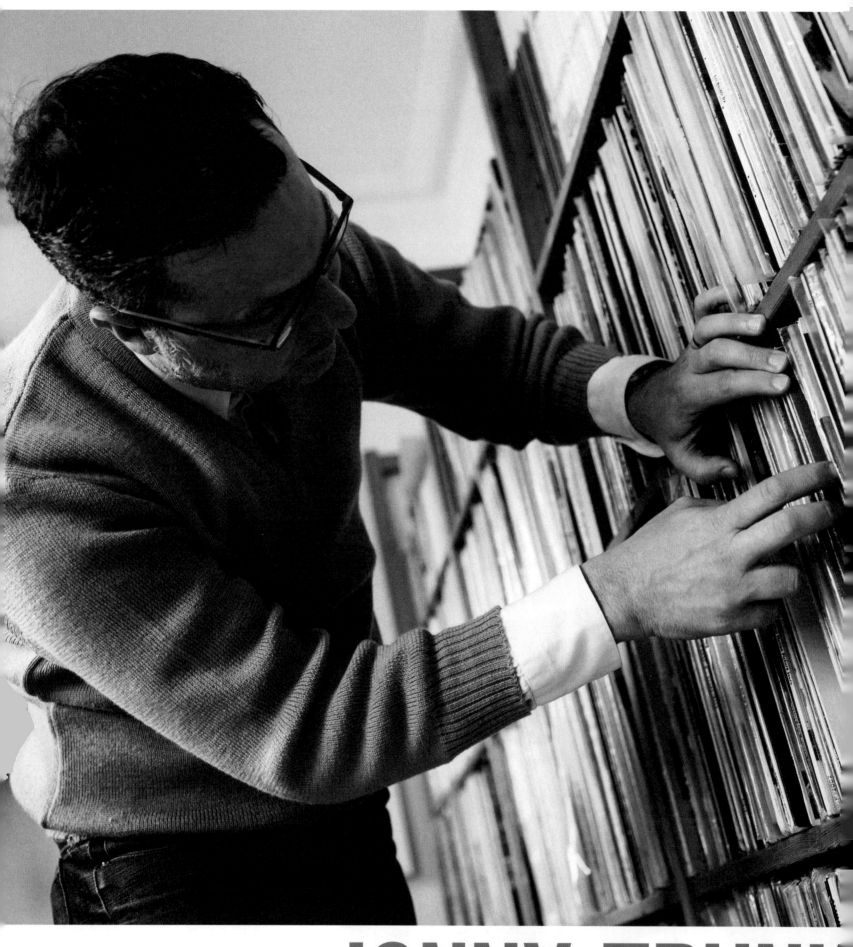

JONNY TRUNK

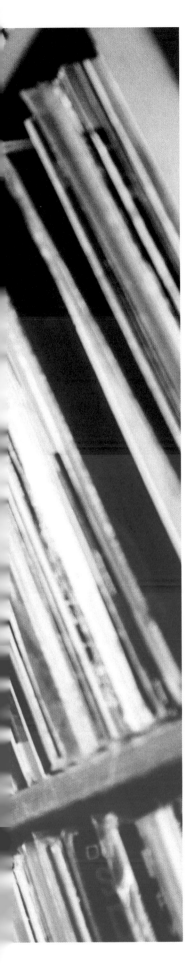

THE MAD LIBRARIAN

BY EILON PAZ

A childhood spent "tuned to the television speaker" left a young Jonny Trunk (born Jonathan Benton-Hughes) with a fascination for the music that accompanied his TV viewing. Since his discovery of the soundtrack to the Peter Sellers film *The Party*, he has amassed an astonishing collection of vinyl that leans heavily on library music, sexploitation, and horror movie soundtracks. Surrounded by secondhand culture, he grew up frequenting junk shops, jumble sales, and film fairs, where he met like-minded collectors who'd swap and share info about their eccentric film and library music finds. The founder of Trunk Records in 1995, he's intelligent and sharp, with very few inhibitions.

I first came across his art book, *The Music Library,* at a collector's house in Paris. Three years later I stumbled upon the book again in Nashville and knew then that I must meet this intriguing man. Although I'd been familiar with library music for a few years and was highly anticipating my visit, nothing could have prepared me for Trunk's enormous and kooky collection of records. Thanks to a train malfunction on the London Overground, I had only two hours to shoot—definitely not enough time to fully absorb Trunk's unique, unmatched sense of humor or his insane collection of French and Italian porn movies, nautical-themed soundtracks (*Jaws* being the most mainstream), and crazy spoken word and instructional records (where the word "filth" is mentioned in every other sentence). He even had recordings by faux-illusionist Uri Geller, which I didn't have the guts to play.

His record room is on the second floor of a beautiful town house in the ultrahip neighborhood of Hackney. There's a desk on one side and a whole wall of library records and film soundtracks on the other. A neon sign for Durex Condoms sits on a shelf, and on the floor, a few unusual knickknacks and a bunch of complete library catalogs (including the Bruton collection) create a colorful spine carpet.

By the time we finished the interview, I knew how to dodge sharks, speak hip, throw the filthiest party, speak to nuns, bend spoons, and hit on girls. Fortunately I didn't require any tips from the *Suicide Prevention* album!

Tell us about yourself.

My name is Jonny Trunk, and I live in Hackney, London. I can't remember how old I am. March, I think.

What was the first album in your collection?

The first album I really had to buy was the soundtrack to *The Party*. I watched it on our upstairs black-and-white portable TV late at night when I was a teenager. The film is about a big Hollywood party with Peter Sellers as a daft Indian actor causing accidental chaos. It opens with this excellent sitar passage and has a sort of pop-tinged jazz thing going on throughout. I thought to myself that this was just the sort of music I'd want at my party if I ever had one. The next day I started trying to find the music. At the time, I lived in Aldershot, in Hampshire, and there was a local Our Price record store—a classic high street retail chain. I went in and inquired, and they had no idea what I was talking about. I don't actually remember who eventually told me about a small shop in London that only sold film music. It was called 58 Dean Street Records, in Soho. I found their phone number, called them, and they knew exactly what I was talking about. When I went to 58 Dean Street Records that weekend, the whole enormous great big world of film music opened up to me.

How would you describe your collection?

The bulk of it is film, TV, and library music. There is also a healthy stash of avant-garde, exotic, and experimental recordings. Then there's jazz, British vocal, easy listening, children's music, Latin, Brazilian, folk, religious, art records, celebrity albums, spoken word, weird American

private pressings, lots of early electronics, and esoteric concept records. You get the idea—the kind of records that people used to think were shit. And some people still do.

So you started collecting records for your hedonistic party fantasy. Can you name a few examples?

Head is probably the best and most important example. Back in the '80s this was a very rare LP. In the UK, both the film and the soundtrack were flops, as I think everyone had had enough of the Monkees by 1968. The film is incredible, one of the greatest pop experimental films of all time, and produced by Jack Nicholson. It was panned upon its release but has since become hugely influential to the video generation and still has clout today. Musically, it's the Monkees at their weirdest and best. When I first watched it, I couldn't believe just how crazy some of the sequences were. The short, wild party scene with the Warhol clouds and most of the Factory dudes—with the oil lamps and electric lights show madness—is one of the grooviest. I just wanted to be there. I had videotaped the film and became so obsessed with the music that I taped it via the small TV speaker onto cassette so I could play the music in my car. Eventually I found a British copy of the soundtrack a few years later, in about 1987. A local record dealer had a copy in his garage, and it was so much better than I'd even hoped for, with its strange typographic cover, all the excellent edits, spoken word, songs, speeches, sound effects . . . I love this record.

In my teens there were loads of excellent odd swingin' movies shown on late night British TV. If they had nudity or party scenes, or both at the same time, so much the better. The party music was either a kind of

Henry Mancini – *The Party* soundtrack

"The awesome and influential *Head*. British stereo copy."

up-tempo manic jazz-rock sound or a slightly experimental hybrid of styles that seemed to work. Loads of hip girls dancing about in bikinis helped a lot, too. My ears started getting really tuned into the television speaker. There was nothing in the pop charts that interested me or sounded even remotely as groovy or hip.

What kinds of music were you exposed to when you were young?
My parents had about ten records and an old Dansette. A *Sound of Music* covers album, some Ray Conniff, and a bit of ABBA. My older sister listened to Bowie's *Hunky Dory* a bit. We also had an Alan Price single. This must have done something, as I now collect *Sound of Music* covers. My granny had some Bacharach and Simon & Garfunkel, which might explain my love of classic easy listening. I'll never forget hearing the instrumental "Do You Know the Way to San Jose?" for the first time.

I was also always exposed to secondhand culture. I grew up at antique fairs and jumble sales, and my parents always told me to buy old things as you stand a chance of not losing your money that way. So from a young age, I was picking up LPs for 5 pence, 10 pence. Mainly easy listening. Sergio Mendes, that sort of thing. At the same time, when I was about seventeen, eighteen, I had started hanging out with a friend named Andy, who used to DJ before Gilles Peterson in the boogie room at the Electric Ballroom way back in the '80s. He introduced me to (1) grass and (2) jazz. Then all of a sudden there was a reciprocal cross-pollination of things I liked and he liked—Lalo Schifrin, *James Bond* scores, Latin jazz, Jimmy Smith. Evenings at Andy's took me to some very weird musical places, with hard fusion LPs, seriously tough percussion albums, odd dub, and some quite unexpected and intense listening that scarred me for life.

How would you research these records? Were there any reference books or guides back then?
All the specialist shops had a book called *McNally's*, which was a price list of film and TV

"Larry's Lovenotes to God. Kiss the Lord and make him cry. Astounding gay love songs to Jesus"

Del Close & John Brent – *How to Speak Hip.* "Classic Beatnik"

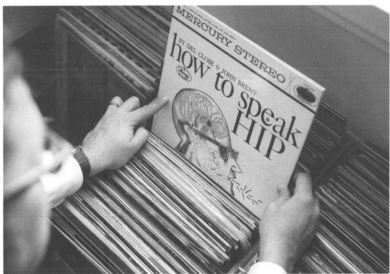

361

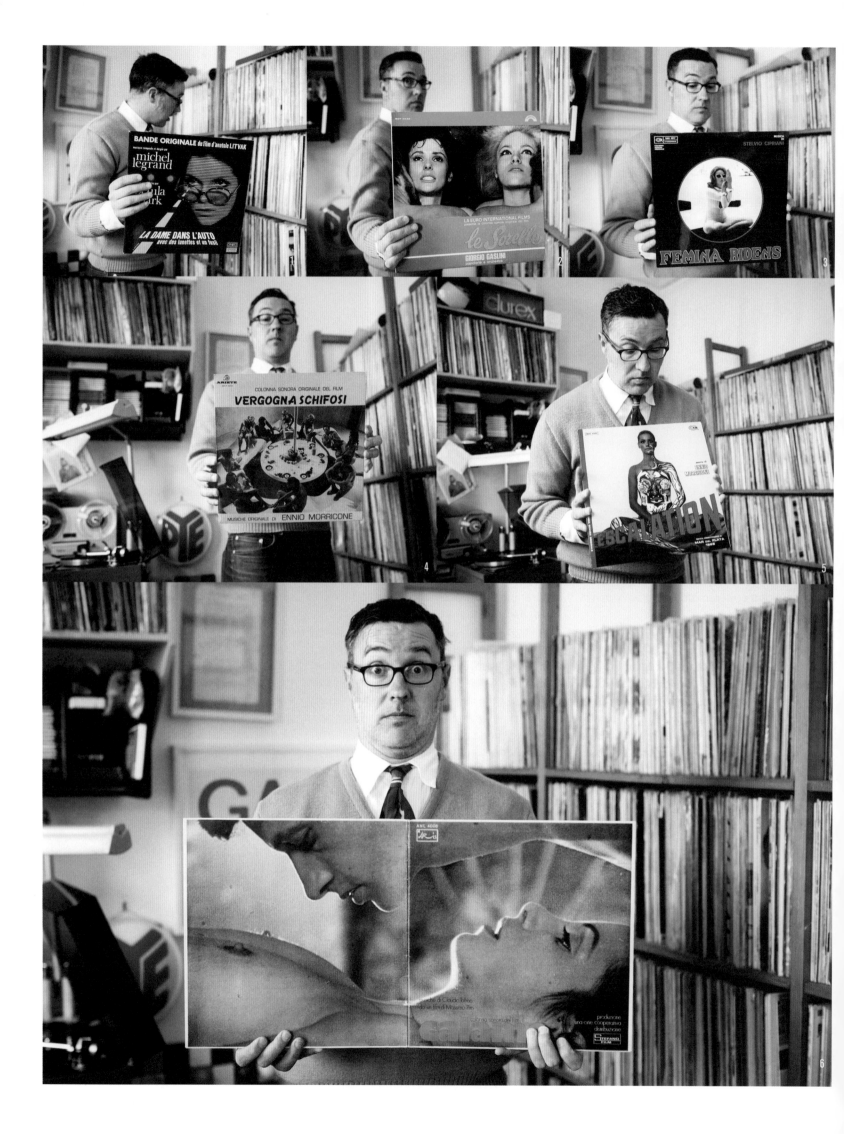

"I'VE ALWAYS FOUND THAT WAITING IS THE BEST WAY TO BUY RECORDS."

1. Michel Legrand - *La Dame Dans L'auto* soundtrack 2. Giorgio Gaslini - *Le Sorelle* soundtrack. 3. Stelvio Cipriani - *Femina Ridens* soundtrack 4. Ennio Morricone – *Vergogna Schifosi* soundtrack 5. Ennio Morricone - *Escalation* soundtrack. "Visually and musically stunning." 6. Claudio Tallino - *Calamo* soundtrack. "Gatefold fun. Yes, me and the wife made a record."

scores issued in Europe and the US. It was impossible to find a copy. There was nothing else, really, apart from the knowledge being passed around in collecting circles.

You then turned your attention to more specific music soundtracks, like Italian film scores. Any insights on that?

The film music you could never find was the music you really wanted, which was the Italian scores—Morricone and his associates. Through connections at the film fairs I started meeting like-minded collectors like Paddy Whitaker (the Quadfather), the Karminskys, Fraser Moss (from YMC), and Martin Green from Smashing. Lionel Woodman, one of the dealers at the film fairs, was key to UK Italian music collecting. He would buy collections and dead stock from Italy and then sell these LPs off lists and at his stall. He would half educate and half rip us off, showing us priceless Morricones and telling us everything was rare and £500 or £1,000, and that certain ones had already sold to big collectors in Europe. But then again, he would sell you a copy of *De Sade* by Bruno Nicolai for £15 once he'd worked out the kind of sound you were after. I remember buying that LP in 1991, bringing it home, and it absolutely blowing my mind. It ticked all sorts of musical boxes I never even knew existed. The hunt for this sort of LP still continues . . .

What are some of your favorite covers?

There is something quite beautiful about Italian film and library music covers. They are dynamic, sexy, weird, economic, and very expensively produced. They make you want to see the film and hear the sounds, and often the music is exceptional, too.

Porn or soundtracks, which came first?

I'd seen some German hardcore at a mate's house back in the 1980s, the sort of classic baptism into porn most young men experienced back in the VHS age. He'd found one of his dad's hardcore tapes; we all watched it and found it both filthy and funny. But for me, the music was far more intriguing than the sex. It was all electro and bananas, like Kraftwerk on speed and acid. But this was a repeat of *The Party* LP problem. If I went to a shop and asked about that sort of thing, no one knew what I was talking about. No one knew what the sound was, where the music came from, or anything. And back then, how on earth do you start researching these things? Once I got into library music, it all started to make more sense, with libraries like Selected Sound producing exactly that kind of music. So over the years I've been able to build up a collection of porn-

based recordings, both commercial and non-commercial. When I first started buying them, they were a few pounds. I'd find things like *The Minx* in the sale box at 58 Dean Street for £1. It was considered rubbish at the time. It still is, in a way, but I love it.

Why are Italian soundtracks so hard to find?

Because of odd tax laws in Italy, any Italian LPs not sold quickly got destroyed to avoid tax on the remaining unsold stock. So LPs came out, and unsold items would disappear within weeks of initial production. This explains why some of these amazing Italian scores are so incredibly rare, even in Italy. In some cases, fewer than one hundred copies exist. Before the Internet, these LPs were practically impossible to find in the UK. In the 1960s and 1970s, about five copies of each Italian soundtrack album might have made it to the UK but only if they were ordered specifically by collectors through magazines like *Sight and Sound*. Apart from that, these LPs never really made it over here.

What about French soundtracks?

That's a whole different ballgame. There are some incredibly rare French soundtrack LPs, though they're probably a little more hit or miss than the Italian scores. A handful are utterly sublime, though. They cross from beautiful vocal jazz to experimental percussion to avant-garde jazz and back again. They're just as hard to find as some of the Italian scores, and can be even harder to find in good condition. It took me about a decade to find a copy of *La Dame dans l'Auto* (*The Lady in the Car with Glasses and a Gun*). The rare Legrand, Lai, Gainsbourg, and De Roubaix albums have always been impossible to turn up—especially in good shape. And don't get me started on French film EPs.

These albums are madly expensive these days. How could you afford to buy them as a young kid?

When I first started buying these records, most of them were not expensive at all. If you went to a record fair in the '80s, and even in the early '90s, film music, library music, and anything else that was a bit odd would be on the floor in the £1 boxes. So these records were never that expensive. We put a copy of *Mindbender/ Stringtronics* in *The Library Book*. These days it's a classic and can go for £400 to £500. My friend Martin bought it for twenty pence in a record shop in East London in 1994, and it had been reduced from 40 pence. The LP still has the sticker on. It's a cliché, but those

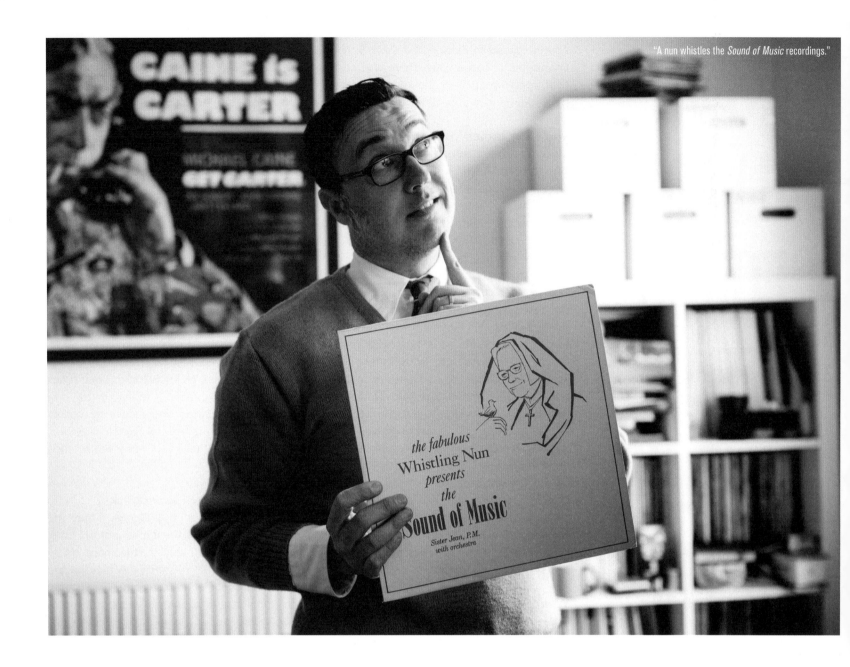

really were the days! We used to go out as a record-buying gang in a car to small towns around the country and hit the charity shops and secondhand stores, looking for 50 pence electronics or records on the up. Because of the principles I was taught as a kid, I find it almost impossible to spend vast amounts on single records. I just can't physically do it. I paid £140 for *Moonscape* by Michael Garrick, but that's the most I've paid for an LP. I've always found that waiting is the best way to buy records. I bought an Italian library LP last week that went for £300 in 2007, and I picked it up for just £18. Now it's getting harder to find cheap, excellent records though. The vast amount of knowledge about such things is now shared everywhere, so those bargain days are long gone.

What do you look for in records? Certain instruments, grooves, melodies, etc.?
Yes, everything you could imagine, and probably things you never would. Like a good smell.

For those who aren't familiar with library music, can you explain a bit about the history of the genre? Also, when did you first discover it?
Library music is noncommercial music made for economic usage in film, TV, and broadcasting. The LPs were never for sale. They were

pressed and sent to TV companies, production houses, radio stations, etc., for use in their productions. By the early '90s I'd arrived at the stage musically where I'd listened to loads and loads of film scores and then I wanted to listen to the sort of music that was used on things like Open University and educational broadcasts. Especially science-based broadcasts. Nobody seems to know about this music, not even the Open University. Then I found a *Bosworth Background* LP in a secondhand shop in London in 1994. It didn't look like anything else I'd ever seen. I took it home and realized it was exactly the sort of strange music I had been searching for. It was just this odd, competent, sparse background music with a touch of experimentalism thrown in. At the time, London was full of interesting record collectors, all swapping info about things like this. We all started educating each other. The more library music I found, the more I got into it. Eventually, in about 2007, I managed to make a book celebrating the graphic art of these most unusual albums. It's called *The Music Library*. All the major early library collectors in London contributed. The great thing about library records, as well as the music, of course, is the cover art. These are albums

1. *Under Water Vol. 1 & 2* by the Sonoton label 2. Sven Libaek - *Inner Space* 3. Andy Loore - *Water Show* 4. "Recordings of phone calls made by people who later killed themselves." 5. Nico Fidenco– *Emanuelle in America* soundtrack. "Classic Italian late '70s porn." 6. Ernie Tucker – *Midnight Cowpoke*. "Filth. Really horrid filth. One of the many revolting Funky Finger albums." 7. *Dark Sunday* soundtrack. "Super-rare strange American horror." 8. Philippe Sarde - *Sortie De Secours* soundtrack

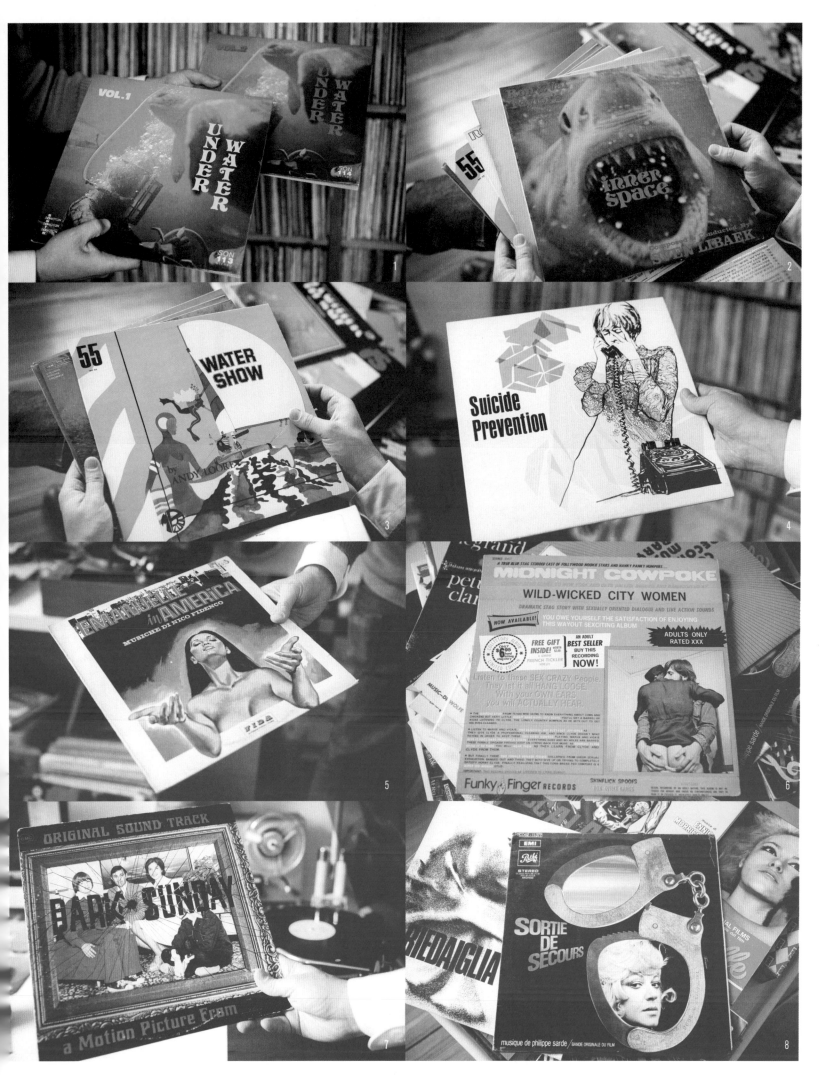

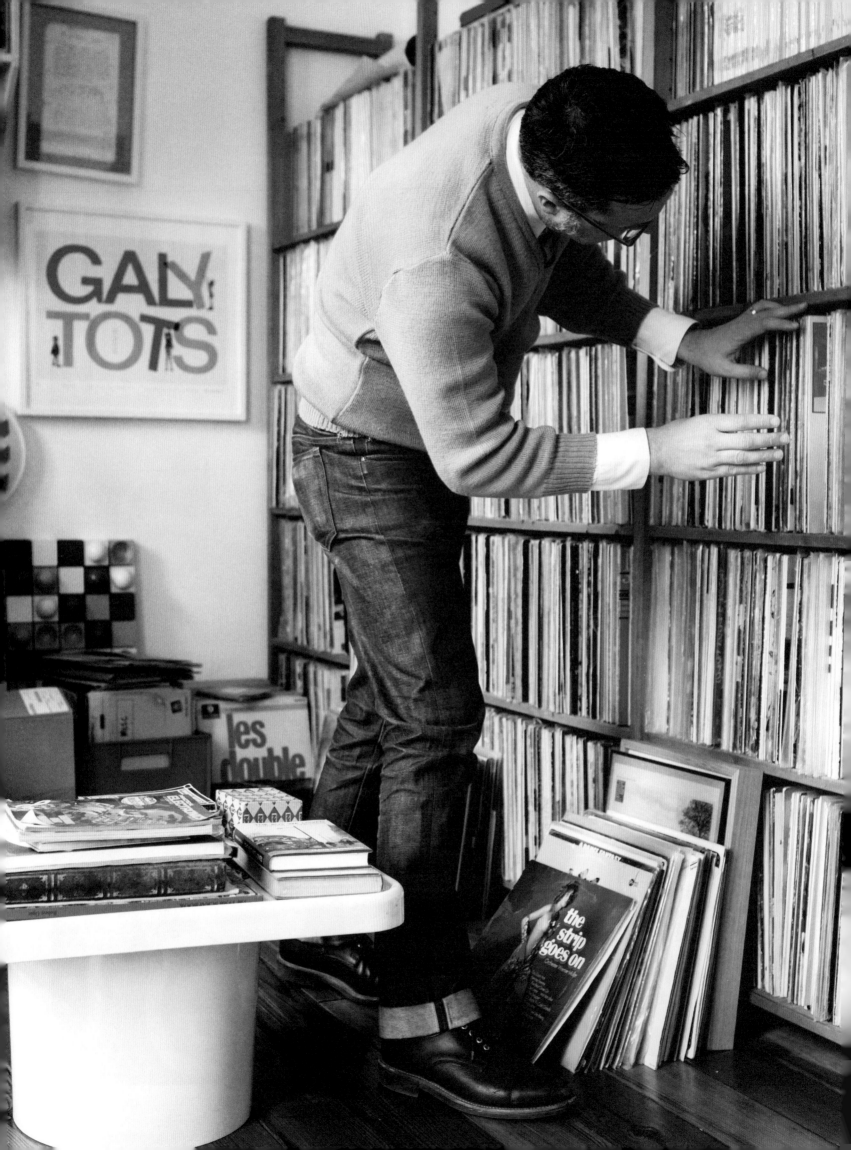

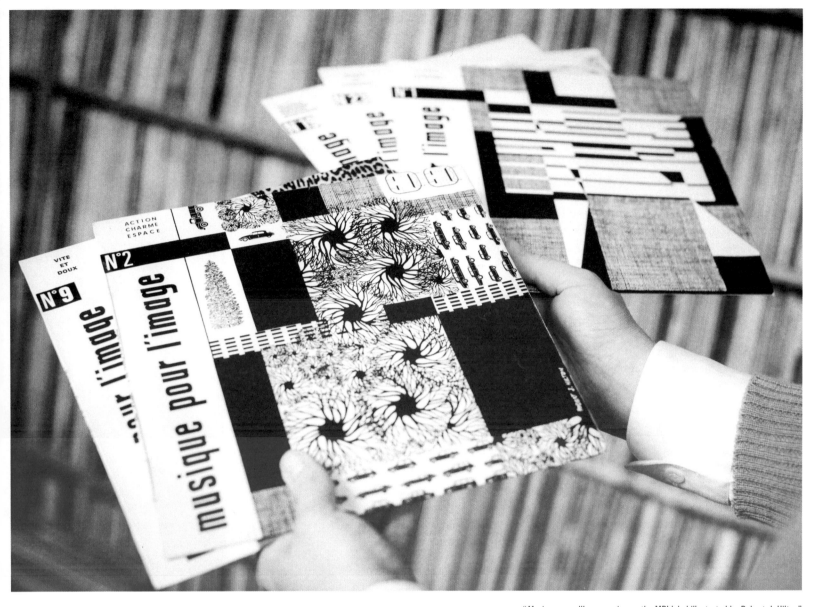

"*Musique pour l'Image* series on the MPI label illustrated by Robert J. Hilton"

made for professional purposes and function, and have no star, artist, or band that needs to be put on the front. Also, there were budget restrictions and odd commercial ideas behind them. Mix these parameters together and you get some of the strangest album covers in the world.

Do you have a favorite library record cover or series? Or maybe a favorite designer or illustrator?

For library records, I think the MPI sleeves are unique, all by Robert J. Hilton, who no one (as far as I know) knows anything about. Part photographic collage, part Letraset, part art. They always have unexpected and unorthodox art, which suits the music on them perfectly. As for soundtracks, obviously Bob Peak, Saul Bass, and all those crazy, unnamed Italian graphic designers.

There seems to be an aquatic theme running through your collection.

Growing up with Jacques Cousteau on the TV every Sunday was pivotal. Underwater records are just one of the many mini-genres within both library music and film music. I have similar collections with independent surf scores, horror, electronics, sex, bikers, drugs, *giallos*, police films, space, blaxploitation, and so on.

"JUST WHEN YOU THINK YOU'VE FOUND A REALLY STRANGE ALBUM, AN EVEN WEIRDER ONE IS JUST AROUND THE CORNER."

What other weird stuff do you have in your collection?

There seems to be a desire and love for the same odd albums shared between the UK and the US. Lots of classic odd and exotic LPs were made in the US and have always

been searched out by UK collectors, as well as by Americans. And of course the Japanese. Things like the Joe Pesci album, the Eden Ahbez LP, beatnik experiments, and homemade monsters like Gary Schneider and Gary Wilson. Then there's cosmic oddness, kinky weird shit . . . it's never-ending. Just when you think you've found a really strange album, an even weirder one is just around the corner.

The UK produced a few classic oddities, too. Certainly one of the darkest, bleakest albums I have is the *Suicide Prevention* LP, recorded for training purposes. It's a series of phone calls made by people who killed themselves shortly after making the phone calls. The album has a very dark aura—it's very unsuitable. There are also some incredible field recording albums that I suppose fall into the "odd" category, as do avant-garde experiments and art records. I could go on for hours. I love it all.

Jonny, I've been having trouble with the ladies lately. Can you give me any advice?
No, but you could have a go with this really sleazy album that will either help you out or land you in prison.

Yeah, I tried this album. Still no luck . . .
Maybe try the B-side. That could be a bit more "you."

Where do you acquire your vinyl these days?
Online, offline. It's always better out in the "wild." I had a great time in Brussels last week in a superb shop I last went to ten years ago. The shop seemed like it hadn't changed. Nothing is online, he has masses of interesting records everywhere, and he only takes cash. I was there for four hours, and I would have stayed longer if I didn't have to catch my train. It was brilliant. But the Internet is also excellent. Some records I never thought I'd ever be able to find, I've found online. There's no way I would have ever just stumbled across them digging about.

What's your partner's reaction to this obsession?
It's part of our life and works on many levels. It's my living, it pays the mortgage, the kids love it, and so far it doesn't intrude into the house. Not much, anyway.

What's your comfort record, the one you can always go back to?
Stillness by Sergio Mendes. It's a very beautiful record, and I have some very fond memories associated with it. Probably *Midnight Cowboy*, too, and *Willy Wonka and the Chocolate Factory*. These are all linked to good memories and work beautifully with my wife and kids.

What's the unlikeliest place or occasion you've found a record?
Under my kid's bed. And one under the floorboards.

Any sad stories about records, or maybe about the musicians who made them?
I think stories about Bill Evans are far sadder than just about anything I can come up with. He wrote some of the most beautiful, simple jazz ever written, but if you read about his life, there's just so much personal tragedy, drug addiction, and loss.

What about a record you like to wake up to?
Anything raving mad. Recently it was a terrifying cabaret album, then it was some classic rockabilly.

A great record to massage your partner to?
I'd rather do that in silence.

A great record to wash dishes by?
I've always liked washing dishes and cooking to Schifrin's *De Sade* baroque jazz album. The Palmer Rockey album is pretty good, too. When I used to wash dishes in a pizza restaurant, it was things like that—early jazzy George Benson, lively Latin jazz, or dub.

What do you want to happen to your collection when you check out?
I'm hoping my children will have as much fun with it as I do.

Any last words?
All good things to those who wait.

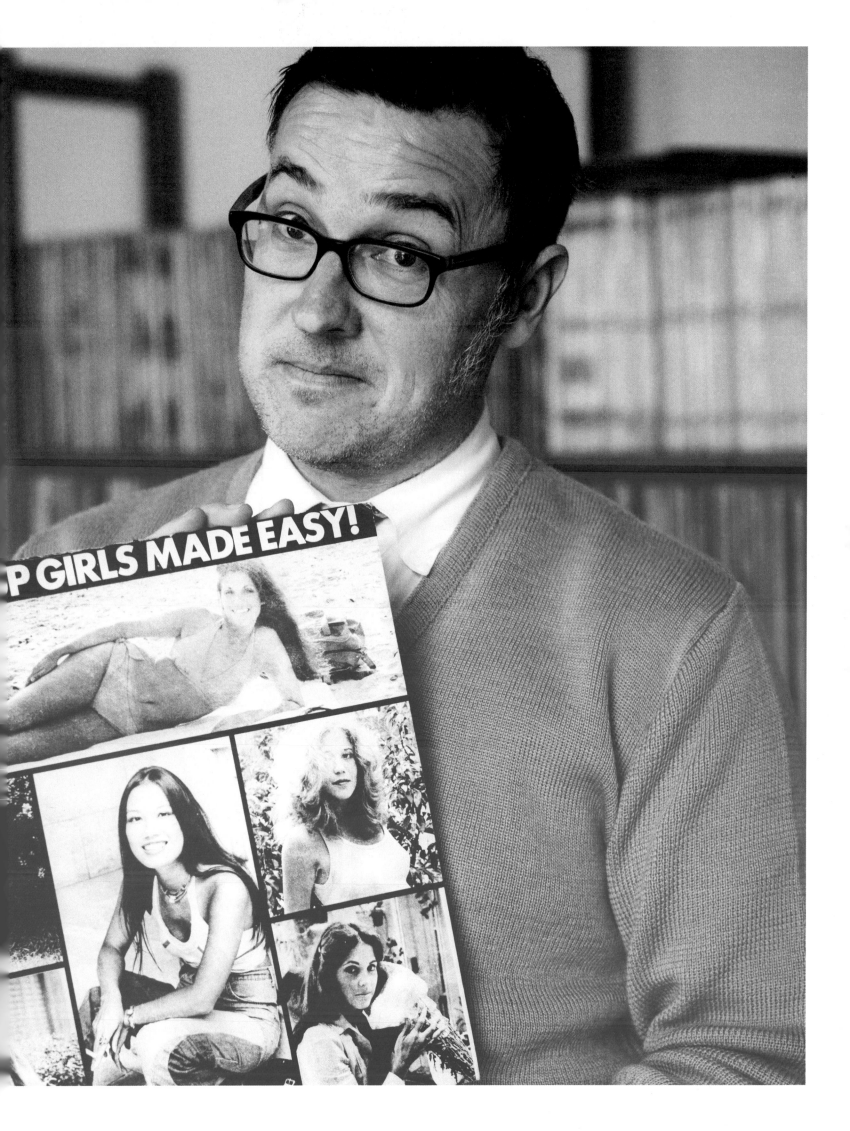

EOTHEN "EGON" ALAPATT

CONNECTING WORLDS

BY EILON PAZ

t's not hard to understand where Eothen Aram Alapatt—better known as Egon—picked up his record-collecting habit. When he was growing up in Bridgeport, Connecticut, his musician parents banned television from the house, and instead encouraged Egon and his siblings to paint, draw, and explore the arts, while Sly & the Family Stone, Miles Davis, the *Hair* soundtrack, and Dolly Parton LPs played on the turntable. He would implore his dad to take him on intercity record-digging trips, and later hooked up with college friends who shared his love of seeking out rare wax in out-of-the-way places. Such intrepid excavations led him from one musical project to the next, and eventually to underground hip-hop label Stones Throw, where he worked as manager and producer and in A&R for eleven gratifying years. There he met artists like Madlib (now one of his closest friends and collaborators) and J Dilla (whose estate he oversees as creative director). Building his own label seemed like a natural next step, and so in 2002 he launched Now-Again, a much-revered home for forgotten funk, soul, and psych gems. He anthologizes, compiles, and reissues everything from Swedish hard rock to Turkish psych, and manages an ever-expanding library of precleared samples. He also cofounded Sinecure Books with fellow collector Johan Kugelberg, and contributes to *Wax Poetics* magazine and the Red Bull Music Academy website.

When I arrived at his house in East LA with our mutual friend Oliver Wang, we had to climb what felt like a hundred steps just to get to his front door. He welcomed us inside and introduced us to his wife, Lo, pregnant at the time with their daughter, and his two-year-old son, Kieran. Egon's main record library is in the guest room, a light, airy space with little furniture aside from the custom floor-to-ceiling record shelves.

Egon guided us through his collection with ease and enthusiasm, connecting the dots between the records and effortlessly answering every question we threw at him. He laid out a "record tree" charting his collecting trends (with branches of Iranian soul, Ethiopian jazz, and Brazilian psych) and was eager to share stories of the fascinating adventures and people behind the music.

At the end of the session, Kieran, curious to find out what the fuss was about, joined us in the record room and asked to hear his favorite LP. Egon patiently pulled out the Caetano Veloso album, and that's when I captured the money shot—Egon, Kieran, and Caetano, all sharing remarkably similar features (page 42). You can imagine a near identical scene in Egon's childhood—his vinyl-collecting father pulling out Egon's favorites. And thus, a collector is born.

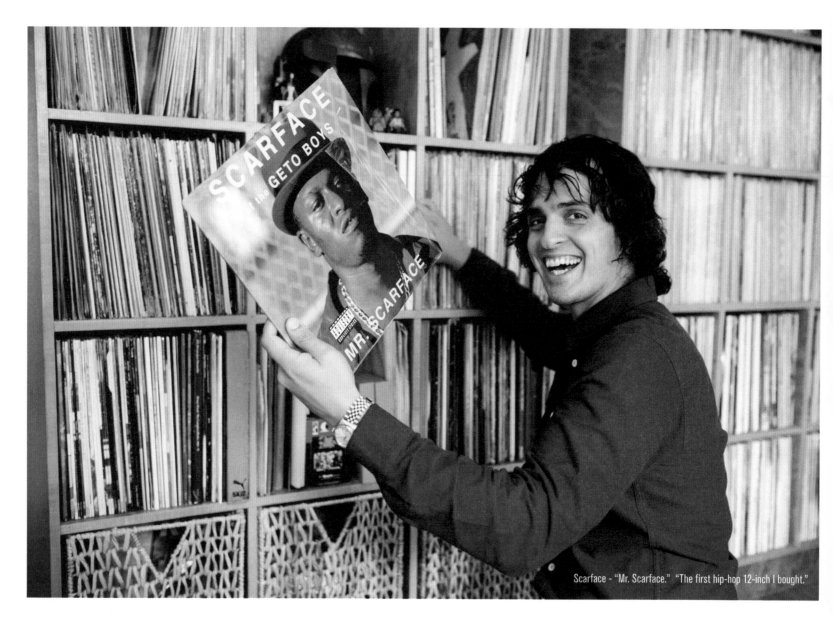

Scarface - "Mr. Scarface." "The first hip-hop 12-inch I bought."

What was your first album?

My first album, as in the first album I went out and purchased on my own, was either George Harrison's *Cloud Nine*, Beastie Boys' *Licensed to Ill*, the Police's *Synchronicity*, or DJ Jazzy Jeff & the Fresh Prince's *He's the DJ, I'm the Rapper*. There were also some singles. "Wipeout" by the Fat Boys, "Mony Mony" by Billy Idol, and "Pump Up the Volume" by MARRS. As corny as they are, I remember feeling overwhelmed by one aspect of each of those records, and I remember listening to specific songs over and over and over again.

The first 12-inch single that I searched out was "Mr. Scarface." That was on Martin Luther King Day in 1991. I remember the day as Metro-North ran this "free train fare from New Haven to Manhattan" special, and I convinced my dad to take me from Manhattan to Brooklyn to find that 12-inch in a store I'd found that stocked it.

Where did your initial interest in music originate?

My family, of course. I come from a family of musicians and music lovers: My mother is a trained pianist, her father was a violinist, my father played guitar and dabbled in songwriting with my mother, and my late uncle was in a garage rock band in Connecticut that cut a cool acetate, which I'm still trying to buy from the drummer. My dad was and still is a record collector. He moved from India to America in the late '60s, so he has always been into all kinds of music. My mother was, too.

Early musical loves, which came directly from my parents, were Sly & the Family Stone, Miles Davis, Tom Paxton, the Clancy Brothers, Tom Waits, Walter and Wendy Carlos, Galt MacDermot, Mikis Theodorakis, Ali Akbar Khan, and Ravi Shankar, along with other progressive Indian acts.

You have a bit of personal history with Galt MacDermot. Can you tell us more about that?

I reached out to Galt while I was in college. I mainly wanted to find out if I could buy some copies of his Kilmarnock Records releases and to interview him for my college radio show. I must have done something right in those first few conversations because he and his son, Vince, offered me a job at Kilmarnock in the summer of 1999. I happily accepted and put together a small distribution network for their reissues. I also sorted through all of his unreleased music, assembled some anthologies, and got his music out to whomever I could. That started a relationship which has lasted years. In fact, I just helped the family clear the sample on J Dilla's "Mash" from his album *Donuts*. I hand-delivered Dilla the record he sampled in Manhattan that summer in 1999. That was a pivotal year for me. I saw how a maverick like Galt could struggle and work hard and then hit it big—huge, in fact—with something that followed his coda perfectly. And I saw how he could keep that spirit to create beautiful, timeless music even in the face of great success. Rather than trying to replicate *Hair* after it blew up, Galt just did whatever he felt best doing. In the coming years, while he couldn't have known it then, he would create records—*Woman Is Sweeter*, for example—that would go on to pay him back handsomely when they were sampled in the '90s.

In college, you hosted a radio show in Nashville at WRVU with Count Bass D. How did that experience shape your love for vinyl?

Well, I chose my university because of three factors: (1) they offered me a great financial aid package, (2) they had a well-funded, progressive—and large—college radio station, and (3) there were record stores within walking distance, and I knew after my first visit to them that there was going to be very little competition for the stuff I was looking for. I met Count Bass D in one of those record stores, the Great

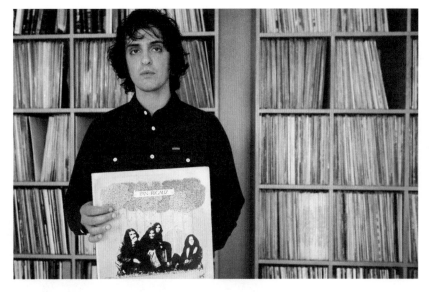

Pan y Regaliz – *Self-titled.* "Thanks to Madlib for hipping me to this amazing Spanish psych-funk masterwork."

release, a beautiful album recorded by US Army musicians stationed in Germany in the early 1970s. Next is Damon's *Song of a Gypsy*, which I discovered after East of Underground, after I moved to LA. One of the top psychedelic albums of all time, and certainly the best to spring from Los Angeles' indie scene. And then further down that psychedelic rabbit hole is Stephen David Heitkotter's demo, another Californian rarity. This little tree focuses on some key records that spoke to me. These were the albums I said to myself I would search out, and I did.

Escape, and he saw I was buying an Iron Butterfly album with "Get Out of My Life Woman" on it and we struck up a conversation. Turned out he knew one of my mentors from New Haven, and we just became friends from there. Count was, and is, a special cat. He loved how deeply I threw myself into finding the most obscure records I could, but he was more pragmatic. He was the kind of guy who was just as excited to flip the drums from a Floyd Cramer record as some track from *Song of Innocence*, the latter of which was "the" record to collect in our circle. He never thought once as to what some other record collector might think of his collection; he just thought about what he could make with the records in it. I always dug that about him and we had a good yin and yang thing going on there. He certainly always drilled into my head that some of the best records weren't the rarest.

You've made an arrangement of certain records in your collection. Can you explain what they are and how they're connected?

The way they're laid out charts my collecting habits from the time I left my parents' home. A "record tree," if you will. At the top is the deepest record I, as an eighteen-year-old, ever thought I would find—*Stark Reality Discovers Hoagy Carmichael's Music Shop*. Amazing psychedelic, funky jazz, all based on music written by Hoagy Carmichael. Left of that is another record which fits that unobtainable mold, this time in the soul-funk mode—East of Underground's only

To the right of Stark Reality is a divergent stream, which started around the same time I heard Stark Reality's music and the *Éthiopiques* anthologies. I never thought I would ever source some of my favorite instrumental albums from Ethiopia, but I did find two of the four main ones that I'm after. And the latter two are both by Mulatu. I'm familiar enough with those that missing the actual artifacts isn't a big deal.

Spreading out from the right of East of Underground are a series of Brazilian records that I threw myself into after marooning in São Paulo for a month following the Red Bull Music Academy in 2002. Thanks to a tip from Madlib, the Os Mutantes led me to Rogério Duprat, which led me to Marconi Notaro's indie release, and then finally to *Paêbirú*, which, to me, is the epitome of Brazilian psychedelia.

Out from there, back up again, towards the Ethiopian albums, are two Angolan albums that I bought in Portugal. I'm married to a Portuguese/Angolan woman, and as you probably know, due to the

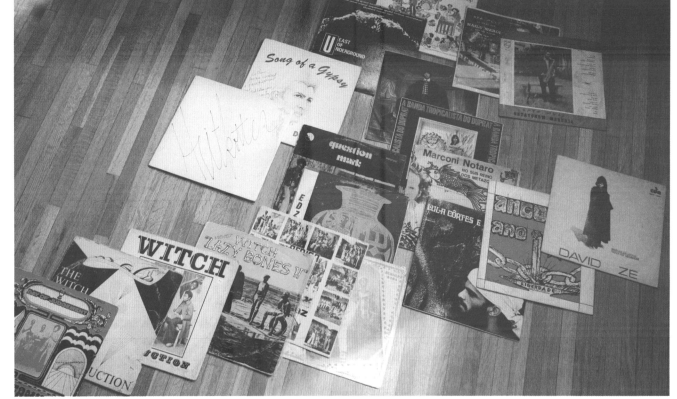

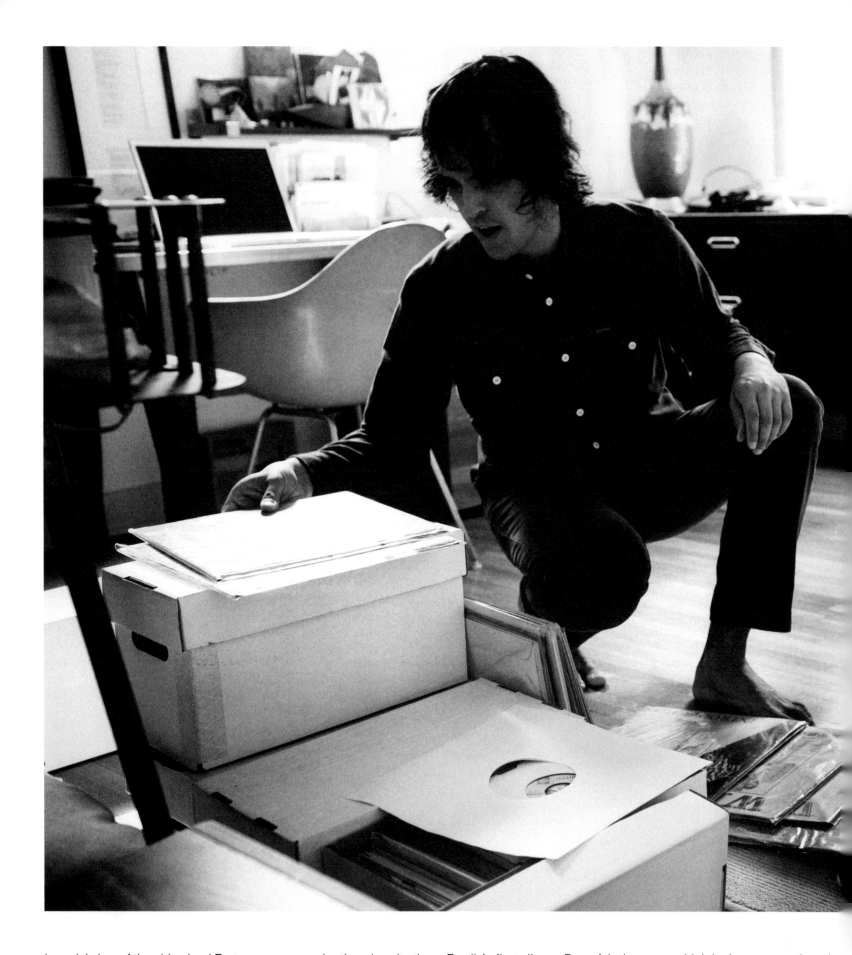

imperial aims of the old-school Portuguese monarchy, there is quite the triangle running between Portugal, Angola, and Brazil.

Delving out from Rogério Duprat, to the left, are the psychedelic African records that have taken me to my latest obsession—Zambia's '70s zamrock genre. We start in Nigeria with the *Question Mark* album, hit Edzayawa's progressive album, and then go head first into Zambia with Amanaz—the first band I heard from that country. Also Witch's third album, and then Paul Ngozi and the Ngozi

Family's first album, *Day of Judgement*, which is the most punk-rock record I've ever heard.

How has your passion for vinyl affected your professional life?
I got my job at Stones Throw due to my record collecting. It's how I met up with Peanut Butter Wolf and how I impressed him into giving me a job; it's how I befriended Madlib, DOOM, and Dilla and how I was able to start Now-Again. It made everything possible for me, and

"I'M LOOKING FOR RECORDS THAT STRIKE A CHORD IN ME. IT COULD BE FOR WHATEVER REASON. AFTER A CERTAIN POINT, I THINK AN ENTHUSIAST STARTS LOOKING LESS AND LESS FOR WORDS TO DESCRIBE WHAT HE'S FEELING AND INSTEAD STARTS REFLECTING ON THAT FEELING."

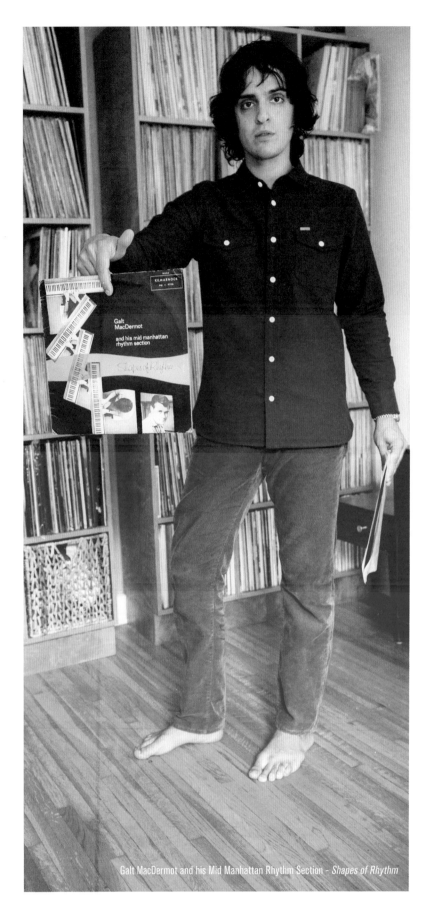

Galt MacDermot and his Mid Manhattan Rhythm Section - *Shapes of Rhythm*

I never forget that, which is why I never, ever stop looking for records. I'm very conscious of this passion of mine which has given me everything that I've ever wanted.

Would you consider yourself a musicologist—someone who studies and traces the roots of music?
Yes, but it's a natural and not an academic thing. I'm more about human stories, the interrelatedness of us all, and how race, creed, and

age are not barriers to like-minded people coming together, fostering creative movements, and supporting themselves, their peers, and their families. So I search out the roots of the music I love, I see where those roots spread, and I try to find stories that back up my belief in those things.

How do you track down such obscure records from such remote places? Like Iran, for example?
I meet people who introduce me to people, who then introduce me to

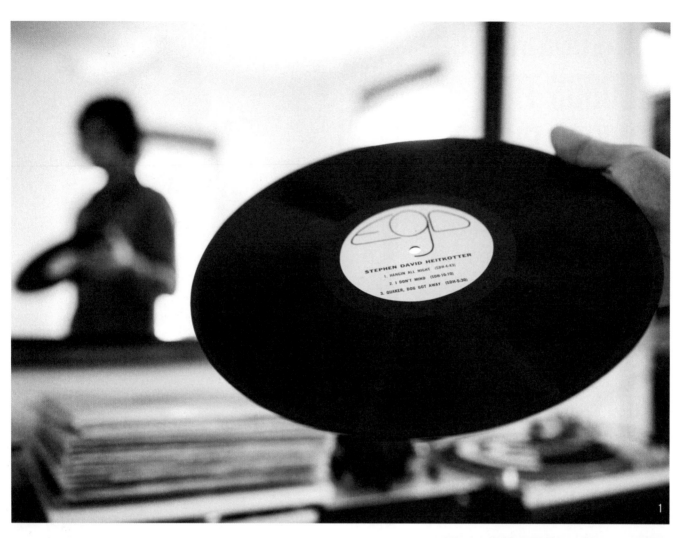

other people, and eventually I find people "on the ground" who trust me and either start selling me records they have or find records for me. Sometimes that person is a collector or dealer and I can swap. Other times, they're a musician from back in the day and they want to help me on my quest and make some spare money. Well, more than spare—I've sent bucketfuls of cash to Zambia.

What do you look for in a record?

At the moment, I'm looking for records that strike a chord in me. It could be for whatever reason. After a certain point, I think an enthusiast starts looking less and less for words to describe what he's feeling and instead starts reflecting on that feeling. The connoisseur does the opposite. I firmly consider myself an enthusiast.

You referred to Mulatu Astatke as mainstream. How do you define mainstream?

Well, by "mainstream," I don't necessarily mean "bad." I just mean, at a certain point, I can listen to all of the Curtis Mayfield and Jimi Hendrix that I want to without having to have all of those records around my house. I'd rather have records like Stone Coal White in my collection than some first state, UK-press Jimi Hendrix album. I know one begat the other, and I love Hendrix, but while he's perfect, Stone Coal White is just too damn irresistible.

1. One of six or seven known copies of the Stephen David Heitkotter demo 2. Marconi Notaro - *No Sub Reino dos Metazoários.* "This is one of those records I bought twice, so I would have a mint one to play thirty years down the line." 3. A smattering of '60s and '70s Iranian rock 7-inches, ranging from garage to progressive. 4. Lula Côrtes and Zé Ramalho - *Paêbirú.* "A logical progression from the Marconi Notaro album, as they're both from the same scene in Recife, Brazil."

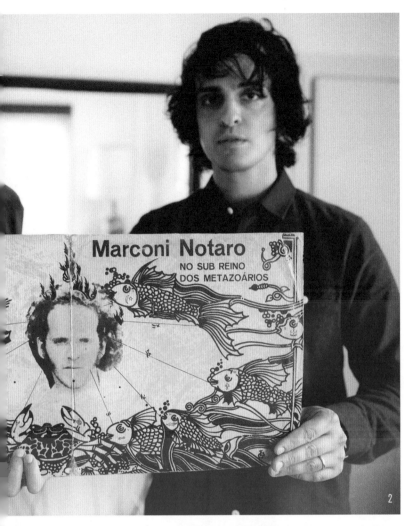

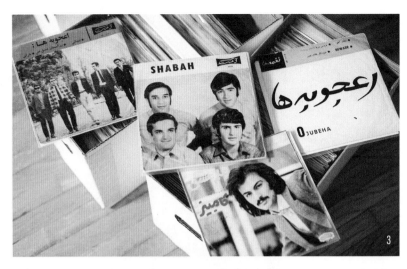

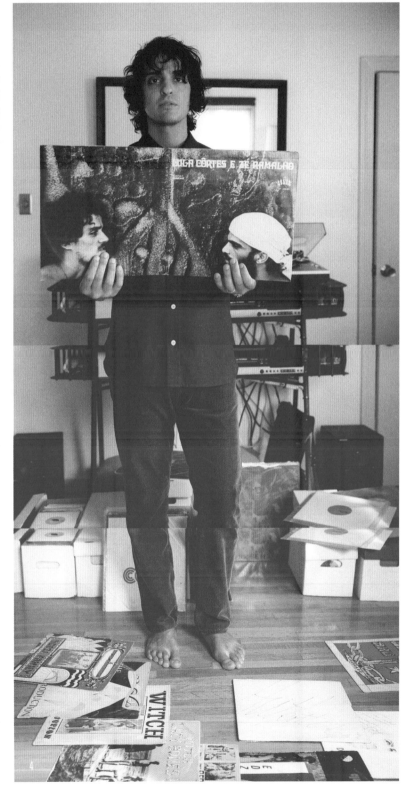

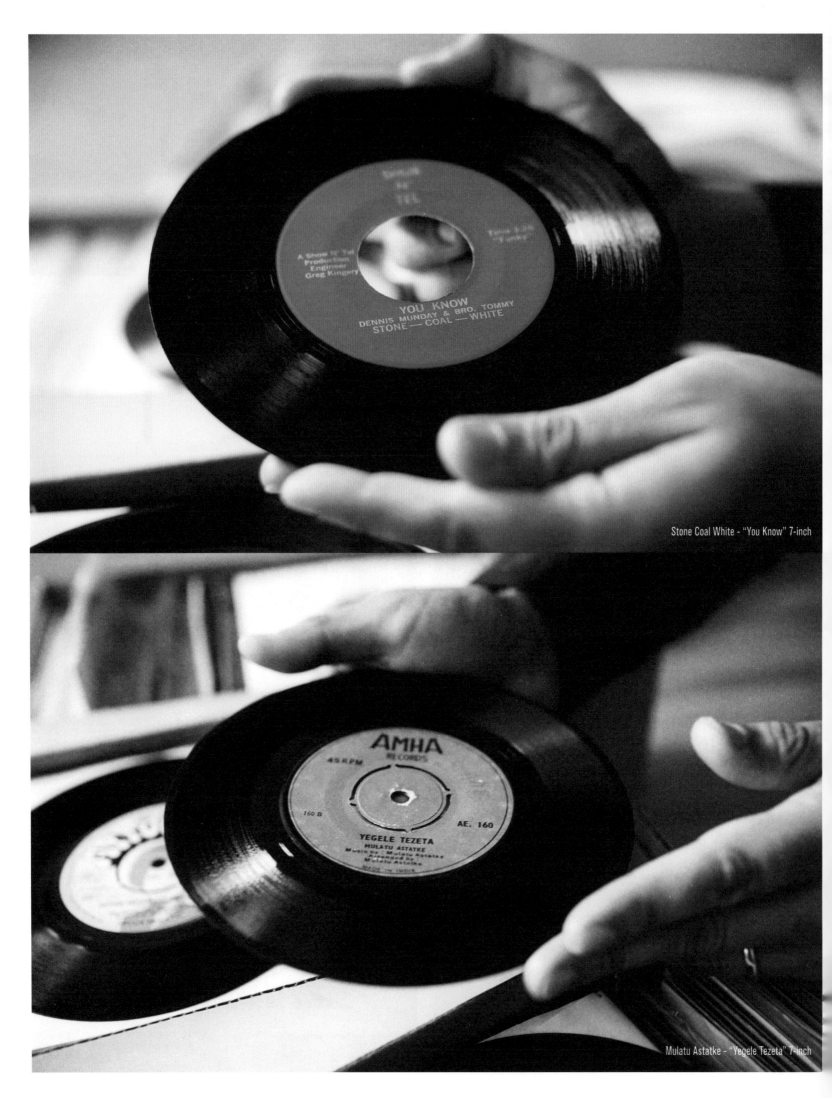

Stone Coal White - "You Know" 7-inch

Mulatu Astatke - "Yegele Tezeta" 7-inch

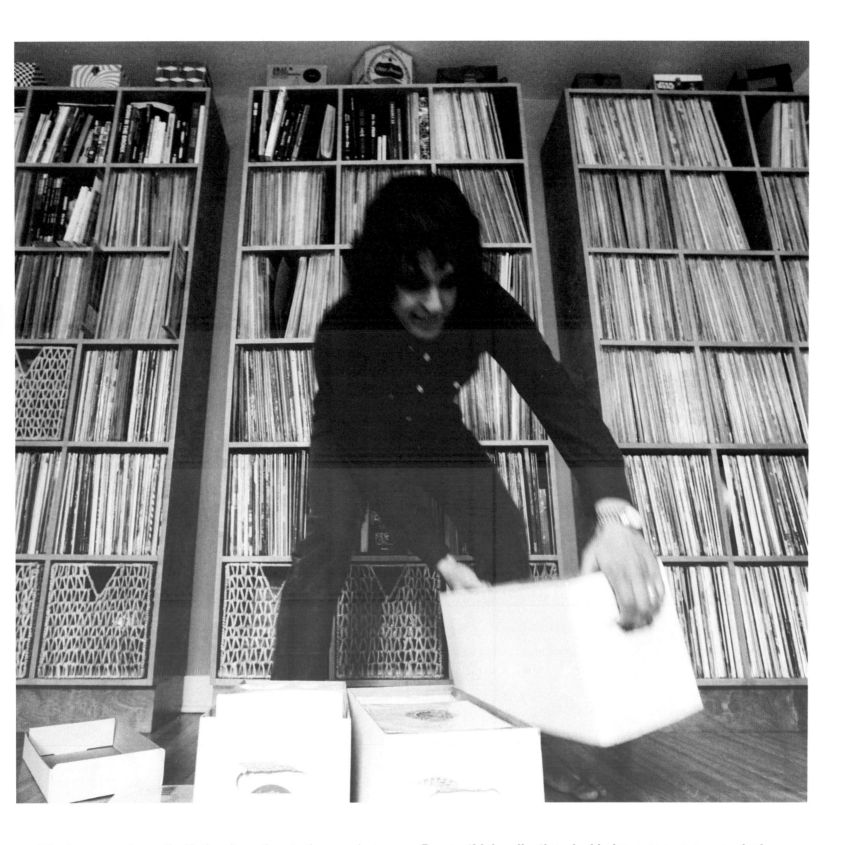

I like to surround myself with the alternatives to those mainstream albums—the ones I can only listen to by seeking out. Mind you, I really have to want to listen to these albums, so they can't be super-avant-garde weirdo stuff. At a certain point, if you put me in front of a Mulatu album and a Getatchew Mekuria album, I'll take the Getatchew. It's just a different experience.

How do you organize your collection? Do you have a useful shelving tip?

I organize by genre or, when it's appropriate, by country. Useful shelving tip? Build yourself some custom shelves—the best you can afford—and say, "I'll only keep this many records in my house, as this is the most I can actually listen to," and then stick to that rule. Nothing worse, in my opinion, than a record collector who doesn't actively listen to his records.

Do you think collecting vinyl helps preserve our musical heritage and culture?

Yes, in a lot of ways, but it's a cyclical thing. Music hasn't moved on from the innovations of the late '60s and early '70s, so what we're really doing is keeping the old flame burning, even though it sometimes looks like it might go out. Why don't I think there's anything new? Well, that's a good question. Maybe because nothing has come around in the past forty years to supplant the innovations from that revolutionary time.

What if we're just flooded with so much now that it doesn't feel new?

Yes, that's possible. But to myself, I hear what most people would consider innovation as being derivative novelty. I really don't think that the revolutions of the late '60s through the early '70s have been bettered. I

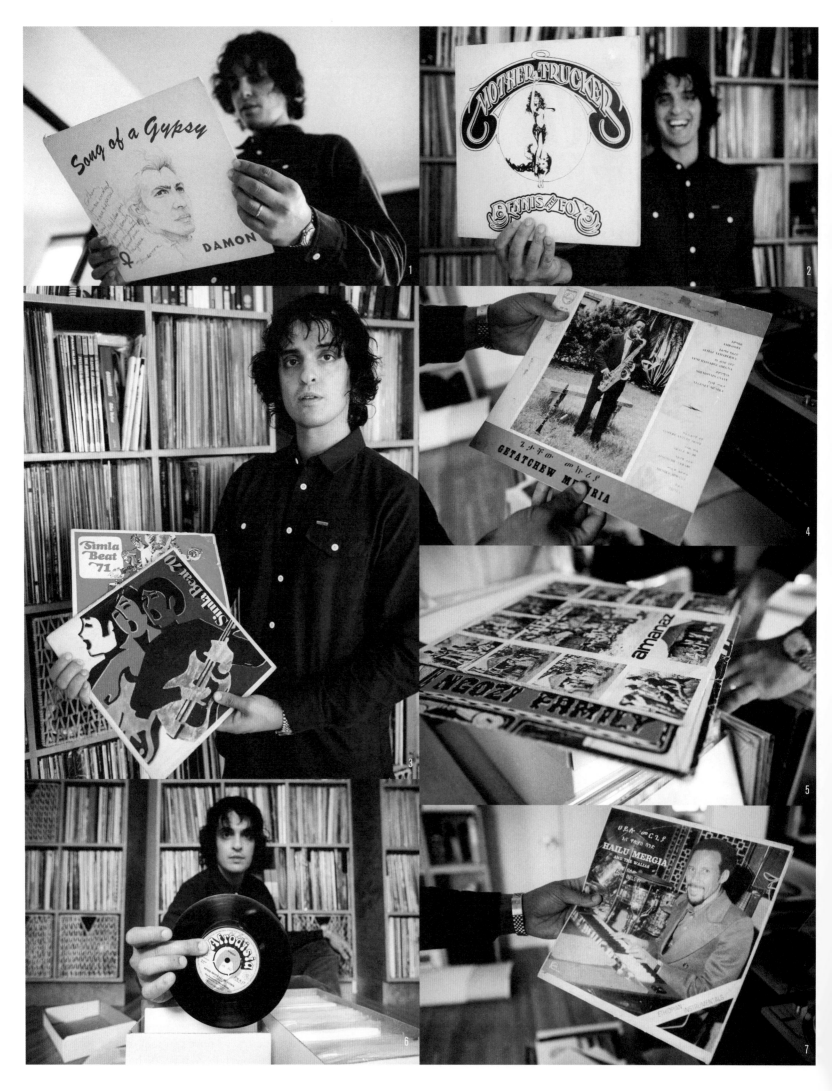

> ## "DON'T LET RECORDS TAKE OVER YOUR LIFE—MAKE THEM AN ENJOYABLE PART OF YOUR LIFE. I ALWAYS SAY THAT I TRY TO KEEP MY DRINKING OF WINE IN CHECK BECAUSE I DON'T WANT TO BECOME AN ALCOHOLIC AND HAVE TO GIVE IT UP. I DIG WINE TOO MUCH TO DO THAT. SAME THING GOES FOR RECORDS."

just think they've been divided, simplified, combined, and recombined to the point that most have forgotten about their singular starting point.

Do you think music can still change the world?

No, not in the way it did for my parents' generation. But I think good music makes life better, in the same way good wine and food do.

What's your partner's reaction to this obsession?

Well, she loves music, and loves all kinds of music, and she knows that I have to do this to stay connected not only to the things that I love, but for the things that keep a roof over our heads. I hate the stories of a collector dying and his spouse selling his rare records at a pittance to so-called friends. This is an opportunistic sport, after all, and the idea of getting over on someone figures high in most collectors' agendas. At least it does for many of those that I've encountered.

What's your comfort record, the one you could always go back to?

Baden Powell & Vinícius De Moraes' *Os Afro-Sambas*, *Arthur Verocai*, Amanaz's *Africa*, and Damon's *Song of a Gypsy*. Damon gave me *Song of a Gypsy* as a gift when my son was born. My only condition to accept it was that he personalize the album to me, thus taking its resale value down, significantly. No matter how bad things get, I never, ever, want to sell this album.

Tell us about a dollar bin record you would never part with.

The *Hair* soundtrack. One of the most important records in my life.

What about digging buddies?

I used to dig with Cut Chemist a lot. Before that, while I was in Nashville, I used to dig with my pals Ben Nichols and John Doe. They were up for *whatever*, and we found ourselves in all types of places. I was young and broke, but I also didn't have any real responsibilities or bills. In terms of the past ten years, the only people I really dig with are Madlib and J Rocc. Madlib has gone out less and less when we're on the road—probably because he has so many records. He probably has a thousand times what I do.

I find myself meeting new people in every city I'm in. It doesn't matter how tired I am or how little sleep I have or how difficult it is—if I'm in a new city, I simply must search out the folks that have the knowledge, if only to glean a bit of wisdom from them.

Do you have any particularly sad record stories?

Well, I've certainly lost friends over records—found out how greedy or self-centered they were through their dealings with these small, plastic things. Sure, they're beautiful and intriguing things, but they're still just things. Don't let records take over your life—make them an enjoyable part of your life. I always say that I try to keep my drinking of wine in check because I don't want to become an alcoholic and have to give it up. I dig wine too much to do that. Same thing goes for records.

Tell us about a record that has healed heartbreak. Or maybe one that has made things worse.

The Universals' "New Generation" is one that has the power to heal. I would say the Group's *The Feed-Back* would probably make any problem worse. It's a hectic album—awesome, but hectic.

Regrets! Tell us about a record you still regret not picking up?

Too many to name. Mainly collections or warehouses I wish I'd bought lock, stock, and barrel early on. That way, I could have taken my time going through them rather than rushing and cherry-picking. I'm sure I missed some marvelous things at Eddie 3 Way, for example, and I probably could have bought the whole place for twenty grand. Problem was, I didn't have access to that kind of cash back in 1998, or whenever it was. It pains me to think, for instance, of the hundreds of copies of Eddie Bo's "Lover and a Friend" I just left sitting there. They would have made for great gifts now!

What about mentors? Have there been people in your life who inspired you to collect records or who have been a guide in the art of record collecting?

First, my father, for reasons already stated, and also because he showed me how patience and persistence in collecting—returning to the same haunts, looking anew through what looks like the same pile of stuff—might lead to something unexpected. Second, the New Haven rapper and producer Dooley O. He was the first person to bring me into the hip-hop fold, when I was about sixteen or so, and show me how all of the new music that was around me as I was growing up could be part of this amazing music I was so in love with.

What would you like to see happen to your collection after you check out?

I hope my kids get a record or two out of it that will remind them of me, and I hope the rest of it puts some good money in their pockets. And I hope that the next person who gets the one-of-a-kind records currently sitting on my shelves does so because he or she appreciates them and not because they're valuable or seen as an investment.

1. Damon - *Song of a Gypsy* 2. Dennis the Fox - *Mother Trucker* 3. *Simla Beat 70/71* LPs (released by the Simla Cigarette Company). "To my ears, the two best Indian psychedelic rock records." 4. "A friend of mine once said, 'Compared to Getatchew Mekuria, Mulatu might as well be Madonna.'" 5. "Two zamrock masterpieces, my copies of Amanaz and Paul Ngozi and the Ngozi Family's first album." 6. The Formulars Dance Band - "Never Never Let Me Down" 7-inch 7. Hailu Mergia & the Walias - *Tche Belew*

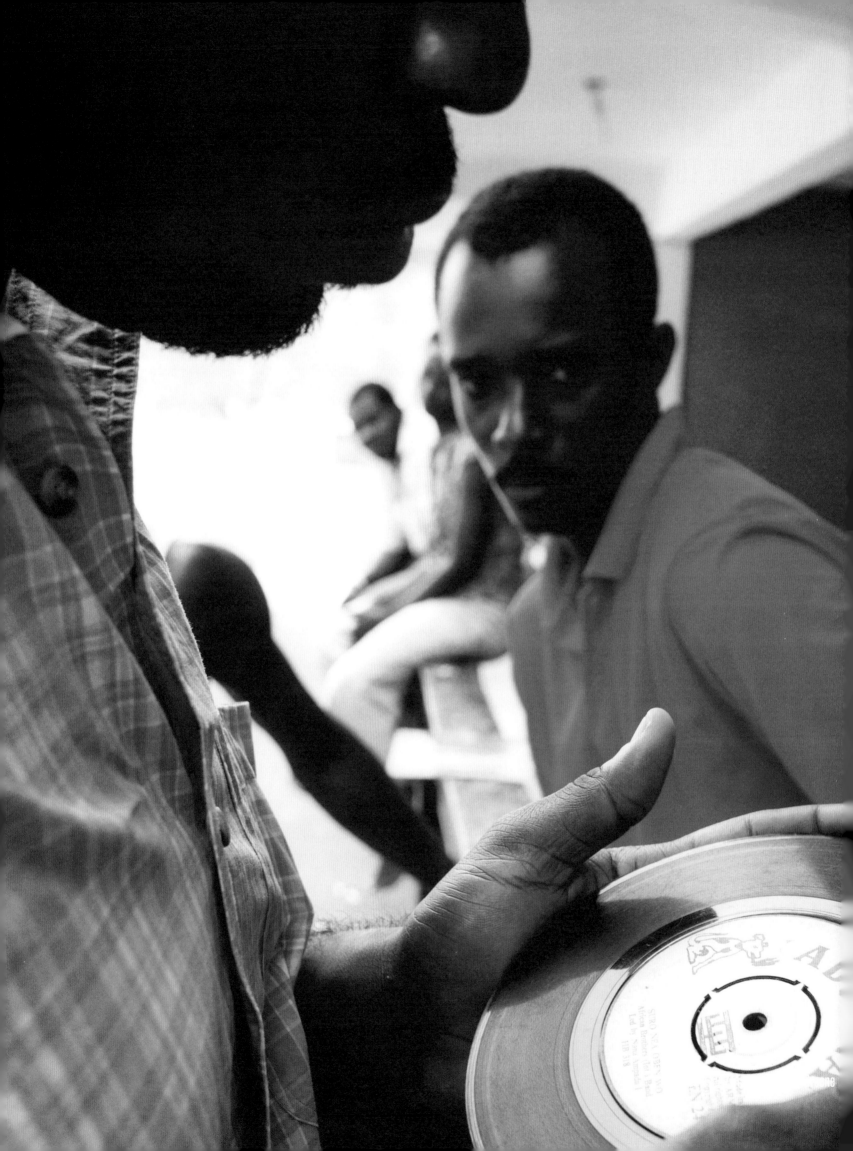

DIGGING IN GHANA WITH FRANK GOSSNER

BRIBES, BEERS, AND BUS RIDES FROM HELL

BY EILON PAZ AS TOLD TO APRIL GREENE

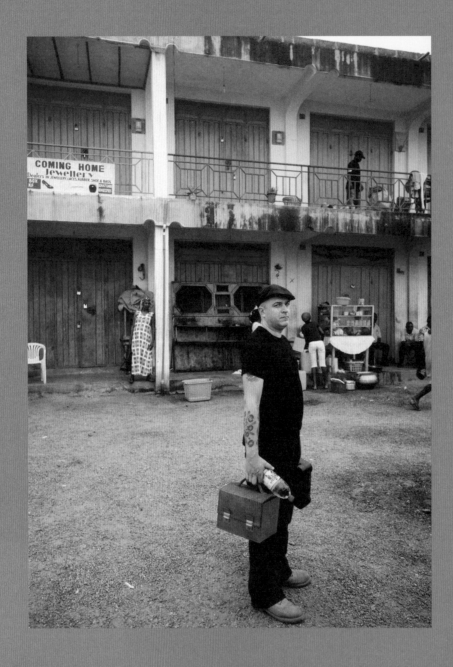

Soon after moving to New York City in 2008, I became acquainted with Frank Gossner, a determined, no-nonsense record collector from Germany. Frank has dedicated years to crate digging in Africa for the funk, afrobeat, and disco records that make up the core of his collection.

Frank has been extremely generous with ideas, connections, and contacts for Dust & Grooves, and I also have him to thank for the trip of a lifetime. In January 2011, he agreed to let me tag along for a digging excursion he was planning in the West African country of Ghana. The large volume of records pressed in the 1970s (the heydey of Ghana's record industry) has attracted legions of foreign vinyl-heads and profit-oriented exporters to Ghana's shores over the past several decades. And because record collecting has never been a serious pastime in Ghana, competition from local buyers tends to be minimal.

Frank had found great records in Ghana on previous trips but thought this might be his last, due to the dwindling selection of choice albums. I was psyched to check out these legendary record-hunting routes and also heartened that Frank was willing to have me along for a journey he almost always takes alone. Frank and I share an affinity for Africa—the music, the people, the landscapes—so it was bound to be a magical time.

Magical—but with big patches of discomfort, as it turned out. Frank and I had planned to meet up in the town of Hohoe, on the east side of the country, and then head north to Tamale. I was traveling from Cameroon but hadn't yet arranged my visa for Ghana, figuring I could get it sorted at the border. This being Africa, however, the protocol changed just in time for my visit, and I wound up stranded at the Ghanaian consulate in Togo for days, having to beg the desk clerks, and the dour consul to give me a break. Finally they showed mercy and granted me a ten-day visa, which was not ideal, as I'd been planning to stay for three weeks. But it was better than nothing, and I wound up walking over the border from Togo into Ghana, where a guard extended my stay by an extra couple of weeks in exchange for a wink, a smile, and $30. Once I got to the capital city of Accra, I was just a bumpy seven-hour bus ride away from Frank in Hohoe.

Needless to say, when I arrived at the hotel bar after midnight, Frank was a sight for sore eyes. But as soon as I sat down and ordered a beer, he broke the news—Hohoe was dry. There was nothing left to dig (at least nothing he wanted). But he had gotten a hot tip on a town called Mampong, and so he wanted to change course. I didn't know whether to laugh or cry upon hearing the news that we were about to head straight back to where I'd just come from. To get to Mampong, we'd first have to take a nine-hour "tro tro" (minibus) ride around Lake Volta to the city of Kumasi. Please don't picture an air-conditioned coach with TV screens, drink-holders, and armrests. This was one of the many well-worn European minibuses donated to African countries to live out their golden years, and they are almost always overloaded with commuters and all manner of material goods. The people of Ghana are polite and tolerant, but when you're packed like sardines on a long, hot, nauseating bus trip, you're pretty glad to say your farewells when it's over.

When we arrived in Kumasi, we hired two porters to help us schlep our bags to the taxi we'd take to Mampong. Interestingly, the porters happened to be female. It seemed to be common in Ghana for women to do what are often considered men's jobs. Frank didn't pack light—he had several huge bags filled with clothes, record equipment, and shitloads of flyers. He has a tried-and-true method for digging in Africa: for each location he visits, he puts together colorful flyers, which he distributes among the locals and posts around the town. The flyer generally features the covers of the albums he wants to buy, along with his phone number and instructions for those who may have any of the records.

"I WILL NOT BE MAD WHEN THE SUPPLY OF RECORDS RUNS DRY AND I'LL HAVE TO FIND DIFFERENT THINGS TO DO. I'M ONLY MAD WHEN SOMEONE ELSE FINDS SOMETHING BEFORE ME."

- FRANK GOSSNER

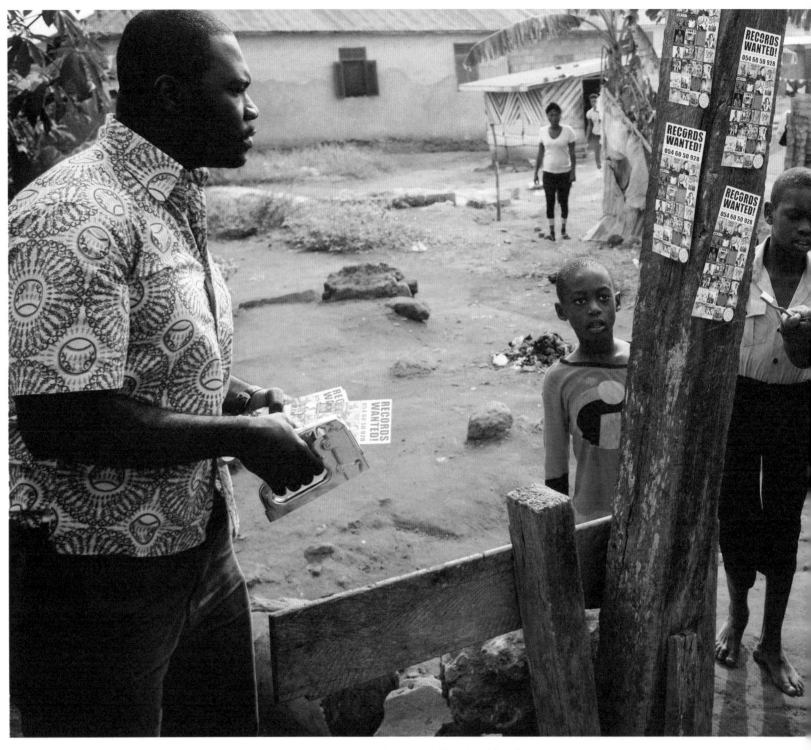

He also purchases airtime at local radio stations. The DJ announces several times a day that anyone with disco, funk, and specific highlife records can take them to his hotel during certain hours. And people usually do show up—some with a variety of records and some with no records at all. And it isn't uncommon for people to call Frank with false claims of great collections. But generally, the pitches did pay off.

Finally, we reached Mampong. It was dry, dusty, and flat, and lined with dirt roads, tin sheds, rail fences, and donkeys powering mills. It was shorts and T-shirt weather, although Frank wore fatigues and heavy boots. He explained that he's on a mission when he digs and prefers to dress for duty. No frivolous flip-flops allowed! We soon made our way to the Video City Hotel, named for its close proximity to a former VHS projection house-cum-church. The hotel's proprietor explained that when DVDs became popular, fewer people were interested in leaving the house and paying admission to see inferior-quality films, and so the theater was forced to shut its doors. But many of the murals and artifacts—with an unusual pairing of cinematic and religious themes—remained untouched. Walking through the empty building was a total trip. A tempera rendering of *Invasion of the Blood Farmers* across the aisle from a statue of Jesus?! Pretty intense.

Of course, we couldn't spend too long

FINALLY, WE REACHED MAMPONG. IT WAS DRY, DUSTY, AND FLAT, AND LINED WITH DIRT ROADS, TIN SHEDS, RAIL FENCES, AND DONKEYS POWERING MILLS.

Those who did come brought records that were not in Frank's bailiwick, and many of them were in poor shape. It was tough turning people down—they've usually come some distance with their records, and could often really use the money. Frank remained professional throughout the entire process—letting people know nicely but decisively when he wasn't interested. That day he taught me an important lesson when operating in Ghana. When our first potential sellers showed up to the hotel patio, I immediately starting taking pictures. Frank let a few shutter clicks go by before taking me aside and suggesting that if I took photos of someone, I should offer the person something in return—perhaps buy one of their cheaper records. In a situation like this, he explained, people are apt to feel they're giving something when their photo is taken, and so it's only polite for the photographer to give something back. I adopted this etiquette for the duration of the trip and even wound up with some good records.

We felt a bit discouraged after the slow start, but on the second day we made an acquaintance who would become one

loitering in that cool, decaying palace—Frank had records to find, and so he unloaded his chrome-plated staple gun and went to work posting flyers. To avoid arousing any unnecessary suspicion, Frank usually asked Ken, a native Ghanaian, to put up the flyers. Ken also assisted with language (and culture) translations, alerting key people about Frank's arrival as well as helping Frank scout for records. He generally acted as a liaison, and in a place where foreigners are often equated with money, help from a native Ghanaian can be vital.

On our first day in Mampong, the turnout was disappointing. Despite the flyers and ads on Mighty FM, we had few visitors.

Video City Hotel original artwork (religious paintings on the opposing wall).

of the most memorable players on our trip—as well as a key player for Dust & Grooves. Philip Osey Kojo was ninety years old when we met him, and a father of twenty-four (yes, let me repeat that—he has twenty-four children). Philip could often be found sitting on the Video City patio having an afternoon beer. He was something of a fixture in the community and received regular visitors. That afternoon, as we all got talking about records and the purpose of our trip, Philip bought us a beer. To be treated to drinks by a local was, to us, an unexpected and much-appreciated gesture. Philip mentioned having a large record collection, and said we would be welcome to go to his house the next morning and take a look.

Philip lived alone, and his home was well-appointed, though not fancy. Frank promptly sat down and pored over Philip's collection with his usual speed and acuity. Much of it was focused on highlife, with a little funk and afrobeat in the mix, but nothing was of particular interest to Frank. I ended up buying a few albums that caught my eye, and Philip made a point of giving me one as a gift.

We were astounded to learn that Philip hadn't listened to his records in over thirty years. He once prided himself on replacing his Zenith turntable needle when it got worn down, but at some point the problems required a professional repairman, and without a repair shop nearby, he had no choice but to retire his collection. I couldn't shake his story from my mind, and I spent much of the next day thinking about it.

Day three at the hotel yielded a much better crop. Just as we were getting used to the long, tedious days of sitting around, waiting for things to happen, a woman approached us with a plastic bag of twenty-five LPs. Ken picked through them but couldn't find anything he thought Frank would want. I asked if I could take a portrait of the woman with her records and she agreed. To show my gratitude, I bought one of her LPs for 5 Ghanaian cedis (about $2.50). I had no idea what it was—clues from the sleeve indicated it might've been English reggae or religious in nature, but the name on the front, "Heads Funk," caught my eye. I showed it to Frank and he was taken aback. "Ken," he said, "how could you not show me this record? Anything with the word 'funk' in the title is something I want to see, even if it might look like reggae." Ken acknowledged his mistake, and we went to Frank's room to listen to the record on his portable turntable—an essential tool for all digging trips. The music didn't overly excite us, but Heads Funk turned out to be a collectible group, and the record was relatively rare (Frank hadn't seen it before). We continued our run of good scores later that afternoon—Frank was thrilled to find a record by Ghanaian band Marijata, but my 5 cedi LP probably made for the best story.

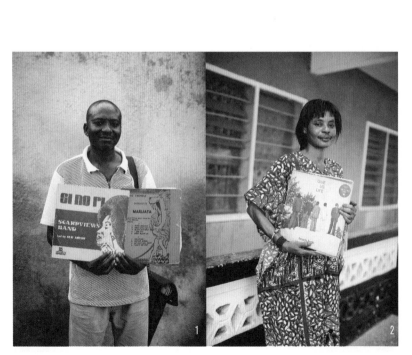

1. & 2. Day three at Video City. The word is out! People show up with their vinyl! 3. Frank and Ken vet the first bach of vinyl on offer. 4. Digging in Philip's collection. Lots of highlife and juju, little funk and disco. 5. Philip Osey Kojo. 6. Thirty years had passed since Philip listened to these records.

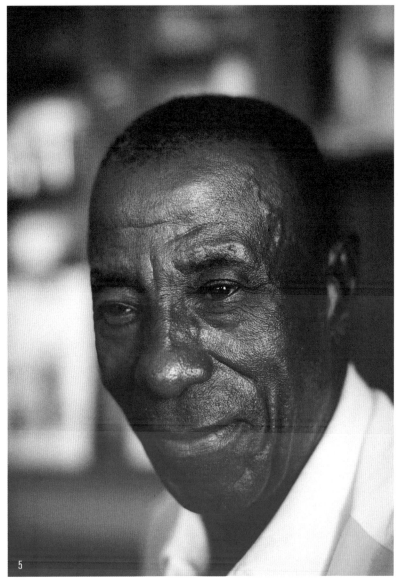

WE WERE ASTOUNDED TO LEARN THAT PHILIP HADN'T LISTENED TO HIS RECORDS IN OVER THIRTY YEARS.

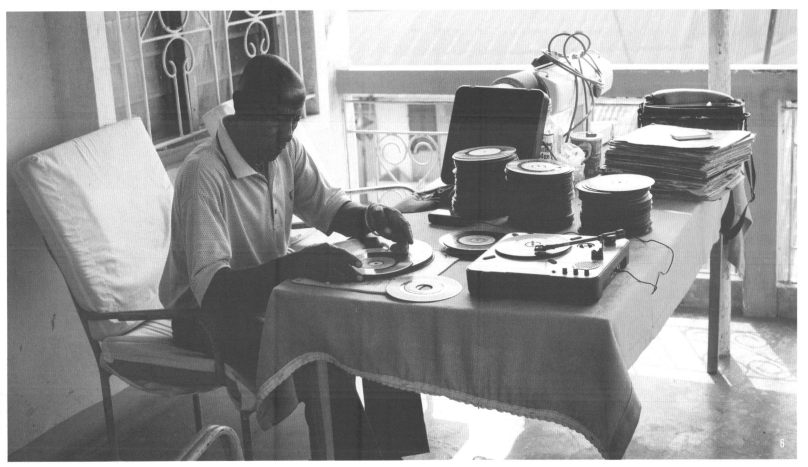

I woke up on the morning of the fourth day with an idea—could I take Frank's portable turntable to Philip's house so that he could have the opportunity to listen to his records again after thirty years? I knew that turntable was the lifeline between Frank and his records on digging ventures like this; if something were to happen to it, we might not be able to get a replacement in time to save the trip. Frank was also quite aware of this, yet it didn't take him long to give his consent. Thinking that we might be able to give Philip an afternoon with his music was reward enough to take the risk.

Philip greeted me (and the turntable) with a smile and quickly went to work setting up a proper listening area on his porch. He then searched through the house and gathered stack after stack of records. Many were separated from their sleeves and had become laced with years worth of dust; others were sandwiched in well-worn covers. We connected the little turntable to a set of small speakers, which gave off a warm, ambient, transistor-y sound. Our ad hoc record room turned out to be quite a pretty sight!

In the gold afternoon light, Philip selected his first 45 and dutifully dusted it off before setting it on the platter. He grinned upon hearing the first note, but his eyes were distant, and he looked pensive and unsure. I must admit that it was difficult to gauge how he was feeling. He then lovingly brushed off a second record and carefully examined the wording on its label before playing it. It was clear he hadn't laid eyes on many of these albums in decades; he was rediscovering his collection as we sat there together.

But the music appeared to have little effect on Philip—he continued to sit still with a fairly blank expression on his face. I started to move a bit to see if it might make him more comfortable—just a little finger-snapping and humming along. I wasn't sure what to expect, but he let loose almost immediately! The smiles came bursting forth, the laughter erupted, and soon he was dancing and clapping along. He came alive, throwing his head back joyfully and moving his hips like he was on the dance floor. It was amazing to watch him reconnect with the music that had once been a part of his life. We kept up the snaps and smiles, and grooved for more than an hour.

Once we finished our listening session, Philip walked me back to Video City. I offered to send him some of the photographs I snapped during our get-together, but he wasn't really interested. We said our farewells, and I gave Frank back his turntable, still in fine shape.

Frank, Ken, and I wrapped up our operation that night and woke at five a.m. the next morning to catch a twelve-hour bus to Tamale. The bus ride to Kumasi paled in comparison to this agonizing journey. Maybe the universe had heard my complaints about the lack of air conditioning and entertainment on the previous ride, because this bus driver threatened to give me hypothermia with the AC. The low-budget African soap opera–style drama blaring from the TV didn't help much either and was frying my brain. I got the feeling most of the other passengers were enjoying the ride, but I was just about ready to throw myself out the window. Frank, of course, was unbothered.

Frank had high hopes for Tamale. He thought its middle-of-nowhere location would mean a good cache of unfound records. Or as he put it, "The more remote the location and the worse the road that leads to it, the better your chances of finding valuable records." But small towns can also wind up bone-dry and can be a big hassle to access, so you have to weigh the gamble. The city is a bit of a thruway for trade

IT WAS CLEAR HE HADN'T LAID EYES ON MANY OF THESE ALBUMS IN DECADES; HE WAS REDISCOVERING HIS COLLECTION AS WE SAT THERE TOGETHER.

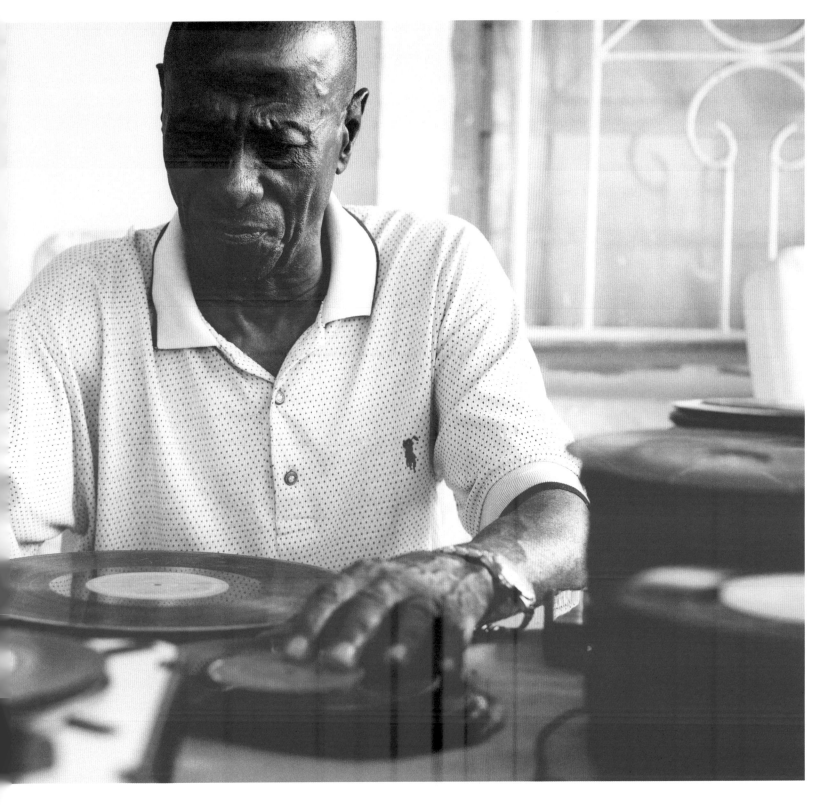

between the northern and southern regions of the country, and therefore its own local culture has a hard time taking root. It also doesn't attract many tourists, and as a result, most of the hotels are rat-infested and covered in dust. But eventually we found a nice place on the outskirts of town and settled in for the night.

The climate is harsher in Tamale—hotter and more desert-like than Mampong. It also feels a little more relaxed; it's home to a large Muslim population, and it shows in the calm demeanor of the people. Ken left the hotel at six a.m. to attack the city with flyers and arrange for spots on two radio stations. I thought residents might occasionally mind having their telephone poles plastered with these things, but that never seemed to be the case; they actually appeared to be entertained by the flurry of flyers. When we eventually ran out of flyers—and discovered there wasn't a print shop in town—we ended up having to update the old flyers DIY-style, with fingernail scissors and glue.

We got a lot of fake phone calls in Tamale. Frank started a "fool numbers" list so that we knew not to pick up the phone if one of them rang twice. Ken spoke with each caller to ascertain their honesty, asking questions like, "What does the back side of the cover look like?" and "What's the first song on the first side?" which nearly always did the trick. In between fake offers, we answered a call from Mr. Baba, an elderly-sounding man who purported to have a good collection at his home. Ken vetted him, and we agreed to pay a visit.

Mr. Baba welcomed us in, and Frank got down to business. We soon came across an album by Fela Kuti & Afrika 70 called *Zombie* from 1977. Mr. Baba ex-plained that "zombie" was a slang term for police, and that the record was considered so controversial that it was once banned in Ghana. Mr. Baba used to hide it from view, even inside his own house. Frank already had a few copies of *Zombie*, but I was keen to take it home.

Mr. Baba explained that his health was no longer good and so he couldn't leave the house much. He was anxious to sell as many records as possible to pay for his medications. I offered him about $10 for *Zombie* and he accepted, saying that was good money. He walked us back to our hotel, slowly, maneuvering around piles of construction bricks and stands of goats, and then we parted ways.

Our last day in Tamale was a mixed bag. We met a guy on a motorbike who claimed he had some of the records Frank had been desperately looking for. As we stood in the road, Frank questioned him in detail about the records, trying to make sure he was the real deal before we made the effort to trek to his home. When we got to his house, we were confronted by a not-so-pleasant reality. He had none of the records he had promised us—just piles and piles of totally unrelated stuff. Frank got pretty upset, and we took off, immediately. When you only have so much time to spend, it stings to realize you've wasted it.

Back at the hotel, though, we were able to redeem our luck. A super knowl-edgeable man who had connections to the music community in Tamale came by the courtyard in the afternoon with some quality records. Frank surveyed the collection for some time, playing record after record on his turnta-ble, which was perched on a bench between two trees. He came away with a good haul, and the experience definitely helped make up for the crap time we'd had earlier that day.

I thought we ended up making out all right in Tamale (with a very rare Astronauts Pop Band 45 taking the cake), but Frank commented that this was his least successful digging trip in Ghana. That was hard to believe, as it seemed like a great adventure to me, but Frank came away with few of the records he was looking for.

After our stint in Tamale, I left to join a friend in the south of Ghana, while Frank and Ken went on to Bolgatanga, Wa, and Accra for further digging. Frank later wrote on his blog about one incident in which he broke down an old door (with the hotel owner's permission) to dig through a forgotten trove of records just minutes before his bus left for the next town! It turned out to be a very wise move. Behind that door was a ton of extremely rare 45s that Frank had never seen before, as well as an LP by Christy Azumah & Uppers International—a highly collectible and top-notch album. Just days before he broke down the door, he had managed to track down Christy Azumah's family and arranged for the album to be rereleased on Superfly Records. "Finding the record in the flesh on the same trip was just amazing," he recalled. I'm glad that episode helped save the trip for him.

For me, it was just another example of Frank's badassery and of the righteous dedication of collectors around the world. My time in Ghana was priceless—a fascinating window onto the ingenu-ity and devotion crate digging inspires. Thanks, Frank, for an unforgettable trip.

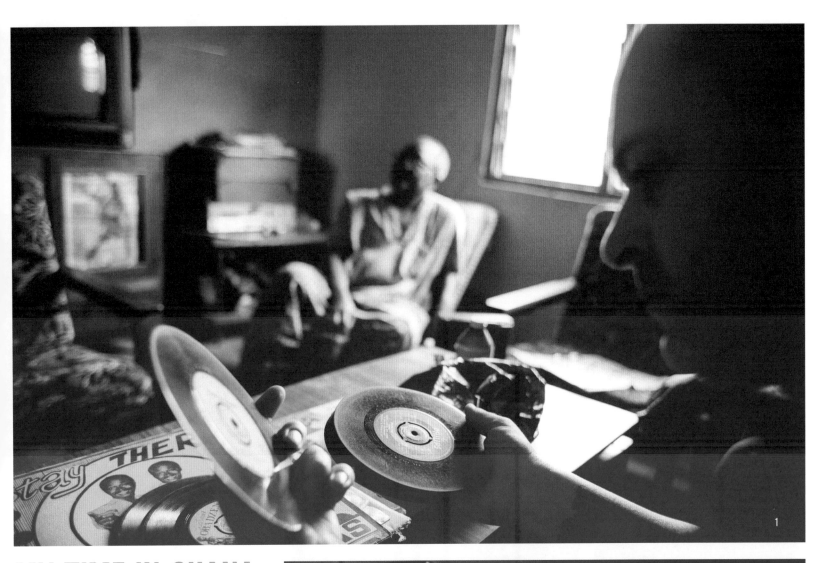

MY TIME IN GHANA WAS PRICELESS—A FASCINATING WINDOW ONTO THE INGENUITY AND DEVOTION CRATE DIGGING INSPIRES.

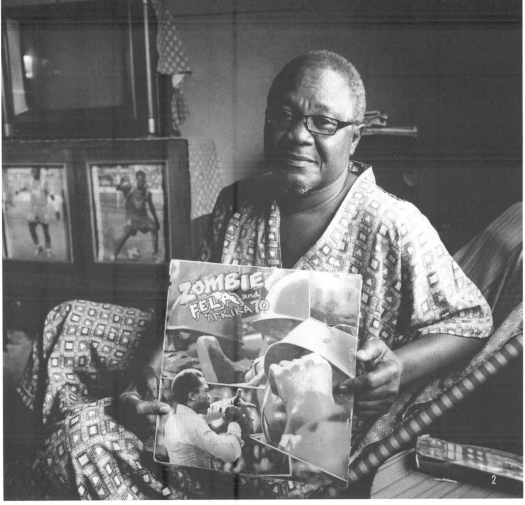

1. At Mr. Baba's place. He says selling his afrobeat records will allow him to pay for his medications. 2. Mr. Baba with his beat-up copy of the Fela Kuti & Afrika 70 LP, *Zombie*.

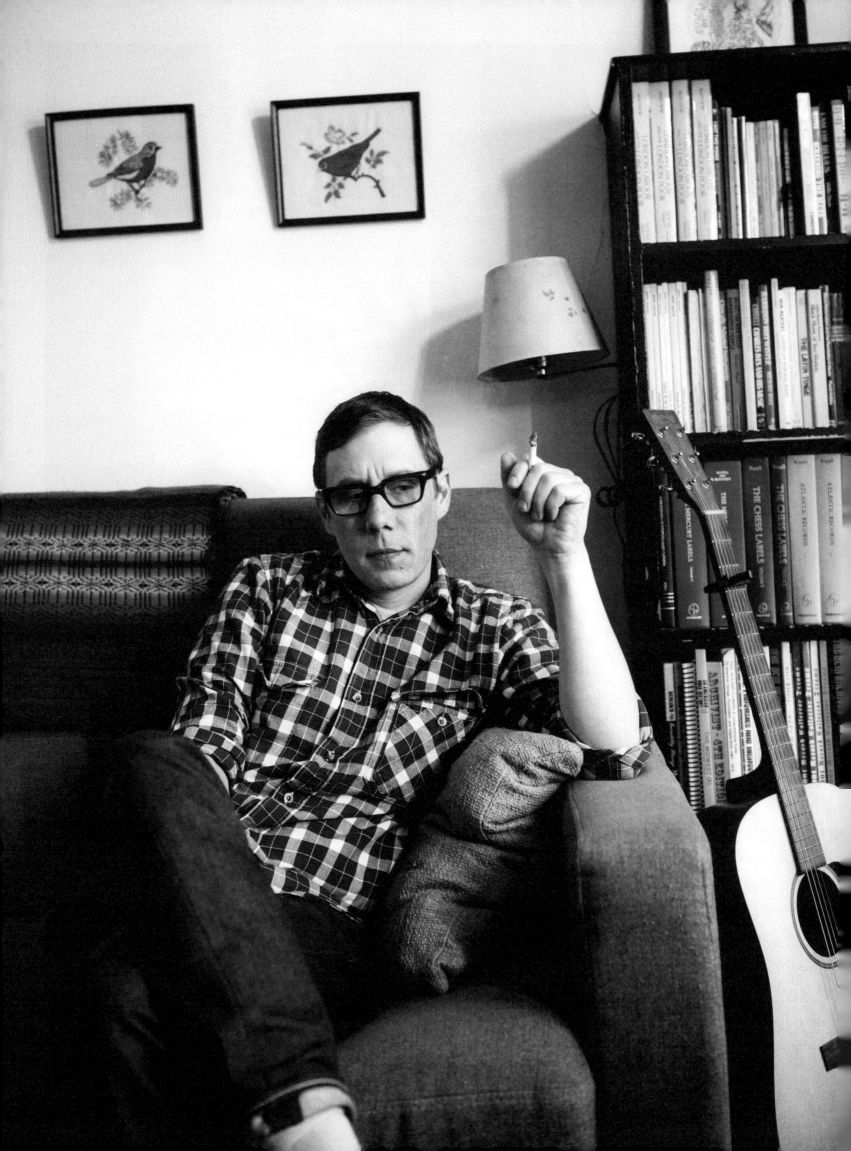

THE INSIDER

BY JULIA RODIONOVA

DANTE CARFAGNA

Dante Carfagna wears many hats—music historian, writer, musician, conservationist, compiler—all generated by his insatiable thirst for rare vinyl. He is regarded as one of America's finest record diggers, with a penchant for countless genres, including funk, ethnographic recordings, early music, Ohio soul 45s, roots, and rock. He has been a champion of the unknown, rescuing long-lost artists, labels, and music scenes from obscurity, and bringing them into the spotlight via articles for *Wax Poetics* magazine, radio shows, (occasional) DJ sets, and compilations like Jazzman's *Midwest Funk*, Chocolate Industries' *Personal Space*, Memphix's *Chains and Black Exhaust*, and myriad releases for Numero Group.

Dante currently lives in a third-floor walk-up on the northwest side of Chicago. Near the front door, stacks of original photographs, posters, and boxes of records are waiting to be sorted out before they're allowed into the apartment. His record room is meticulously organized, and he manages to keep his collection from growing out of control; as new records move in, old records move out. Dante is a fabulous storyteller and generous with witty one-liners, snarky remarks, and compelling observations. Every record in his collection has a story, and some are best listened to at specific times of the day. One is perfect in the morning, another is great at night—maybe with a drink or two. As a mint LP spins on the turntable, Dante leans back on his living room sofa with a cigarette in one hand, taking us from Kansas City to Ohio and from Sardinia to Northern Greece, one record at a time.

When did your interest in music begin?

Listening to nascent rap programming on the radio and my parents' records and tapes. They mostly had mainstream soul like Curtis Mayfield, Parliament, and that kind of stuff.

Tell us about your first years of collecting. What were you looking for back then?

The early years weren't so much about collecting as getting songs that I liked and not having to rely on the radio to play them. I remember really liking Art of Noise and Yaz, weirder things that sounded a little more imaginative.

Do you remember your first record?

In 1984, with my own money, I bought the Newcleus *Jam On Revenge* album at the Westerville Mall in Ohio. I had heard "Jam On It" on the radio and wanted to hear it constantly.

Your collection has evolved so many times. Can you describe its current state?

As of today, I have perhaps four thousand LPs in my personal collection and about as many 45s. I try to keep things rather focused,

keeping only what I think is important and lasting. In the LPs, I have an entire section of what I call "rock" (which contains music largely made by white people after 1960), several shelves of "roots" music (which represents blues and hillbilly sounds recorded before 1970), a shelf or so of medieval or early music, a couple of rows of soul LPs, and, lastly, a rather expansive selection of ethnographic recordings from around the globe. As for my 45s, around 90 percent are soul, with a box or two of psych, folk, and garage.

Do you focus on a specific musical genre?

I do not collect any particular genre as a rule, but I am steadfast in my accumulation of black music on 45s from the state of Ohio. Ohio soul music is a vast expanse, and there are so many excellent, obscure, and overlooked records.

Why is there so much good music from Ohio?

There are people in every nook and cranny of

Ohio, and the state has five or six mid-size cities. No other state in the Midwest can claim to have a general metropolis in every cardinal direction, so there is really no central location to attract all of the people.

Ohio also was home to many large custom pressing plants, notably Rite Records Productions and Queen City Album in Cincinnati. Literally every town of a notable size had a decent recording studio, and so record manufacturing was very easy to accommodate.

What was your most recent find?

One that has stuck around the turntable for many months is a singer-songwriter release from the early '70s by an artist named Sandy Harless. It's called *Songs,* and it was recorded in Chillicothe, Ohio, at the Appalachia Sound Studio. It's a low-key, very sublime record. I find myself returning to it time and time again, usually late at night. It's rather unknown, and the all-powerful Internet has little to say about it. You could call it "ungoogleable"—a sure sign that you've found something relatively unknown.

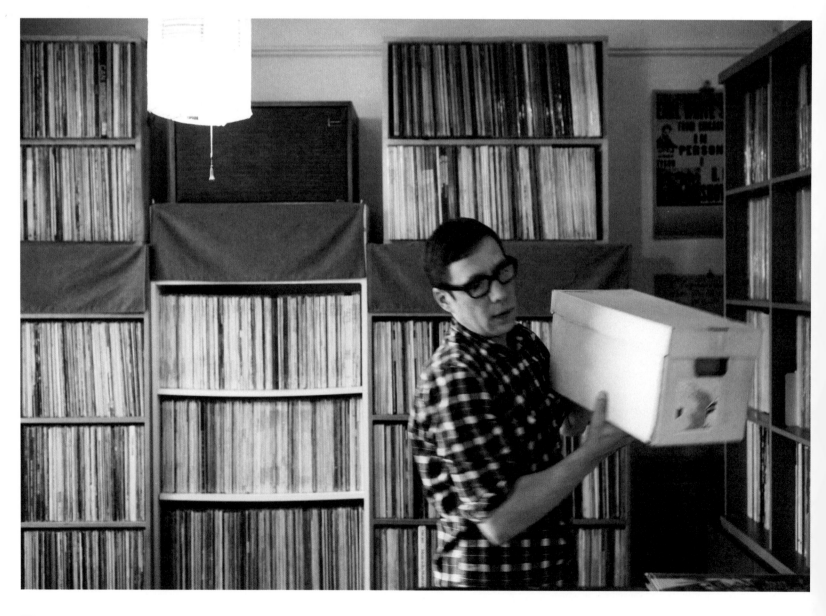

Sandy Harless - *Songs*

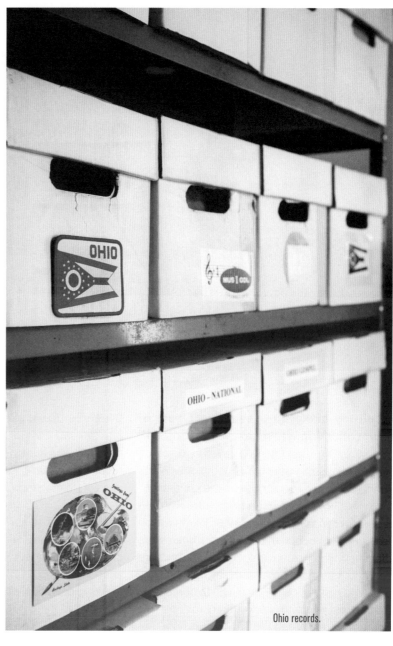
Ohio records.

Do you have a favorite song on this album?

The album as a whole is perfectly formed. It's what you call a true grower. If I am introducing someone to the music, I usually play them "Sing a Song" or "Eagle R.I.P." Sandy told me that the latter song was written after he saw a news report about wealthy Californians taking helicopters out to hunt bald eagles, and it just broke his heart.

What are some other great records from Ohio that we may have never heard of?

Magic in the Air by Wandering Magi is a little more representative of the depth and sheer weirdness of music from Ohio. It's a mid eighties record from Centerville and is very difficult to describe. It has quite a strange vibe about it—mixing almost ambient synth tracks with disjointed folk songs and fucked-up prog tendencies. It's another "ungoogleable" record. A little research has shown that the artist eventually met an untimely fate and has thus secured this music as the Magi's last and ultimate articulation.

At the other end of the severely local Ohio spectrum is the *1st Annual Inner-City Talent Expo* record from 1972. It's a live recording of sorts, captured at the Ohio Theater during a battle-of-the-bands-type concert put on by local hairdresser King Twitty. This is one of the few private soul long-players from Columbus and features a great deal of the musicians who would form the soul sound in central Ohio. It has the first appearance of Timeless Legend on record, backing by the Suspicious Can Openers, and a number of completely forgotten young acts that only appear on this release. I was fortunate enough to also obtain the original program for the event. It really puts a lens on a scene that intrigues me to no end, for both musical and civic reasons.

Do you think collecting vinyl helps preserve musical heritage and culture?

The record is a lasting, physical object. It will survive long after the participants have passed, moved on, or forgotten their endeavors. It is the postcard from the past that lets future humans know that something indeed happened. The more information one can gather about a particular subject, the greater the understanding will be. The vinyl record is frequently the only proof that a creative human event actually took place.

> "THE MORE INFORMATION ONE CAN GATHER ABOUT A PARTICULAR SUBJECT, THE GREATER THE UNDERSTANDING WILL BE. THE VINYL RECORD IS FREQUENTLY THE ONLY PROOF THAT A CREATIVE HUMAN EVENT ACTUALLY TOOK PLACE."

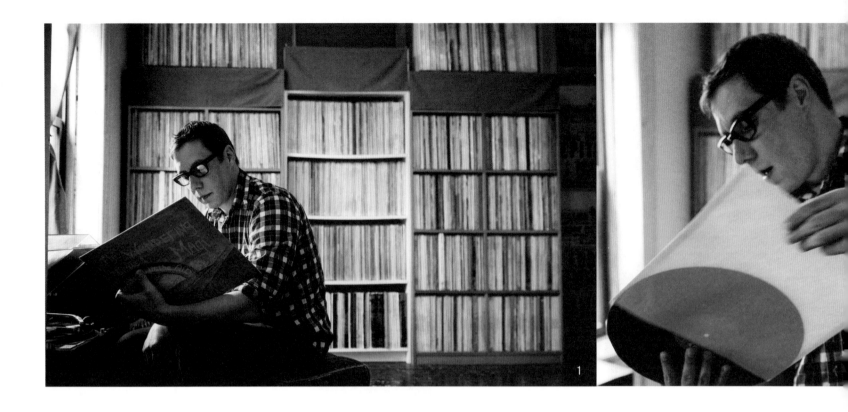

1

Soul 45s make up a significant part of your collection—how are they organized?
My soul 45s are organized by city or state, and then by label within those sections. While Ohio is my main focus, I have boxes dedicated to most Midwest cities except Detroit. When you put your collection together like this, you see where the most music was emanating from and which scenes were smaller or more isolated. Indiana is comparable in size to Ohio, yet there is drastically less music to come from that state. I will readily admit that Indiana is my least favorite state in the Union, but nonetheless there has been some great music to come out of that place.

"Super Turkey" by Black and White The Holey Smoke Show is another single that makes you ask, "Who was this for?" While the band name might suggest this being an actual outfit, it's really just one dude with a guitar and acres of home-recorded fuzz. The lyrics are totally out there, and even after hundreds of listens, I have absolutely no idea what the fuck he's talking about. This is the true definition of "outsider," because everybody that has heard this has no idea whatsoever what the intent could be. Strangely, this also came out as a 12-inch single where the overloaded guitars are replaced by jungle sounds, further reinforcing the *what-the-fuckness* of the entire endeavor. It's from somewhere in Kansas City. This is a case where general isolation has bred a most fascinating unawareness.

Another completely marginal 45 release from Kansas City is Jupiter Prophet's "35,000 Feet (Challenger's Theme)." It has origins in a much more tangible event—the Space Shuttle

Challenger disaster in 1986. Again, this is one person, a vision, and a resultant 45 with no particular audience in mind. It's a jarring record with burnt vocals, totally wasted percussion that sounds like gunshots, and a vibe that can easily alienate a person with unseasoned ears. The man responsible for this 45 told me the song was laid down mere hours after he, like most of the world, watched the shuttle blow up on live television. To me, this is the very definition of an outsider release—the creator had the urge to make and manufacture this object, yet the question of "For who?" was never addressed.

You keep using the term "outsider." What does it mean to you? What do you find fascinating about those records?
To me, "outsider" means that the art was created solely by and for the person making it, with little to no attention given to the resulting object as a commercial entity. That they would choose to manufacture multiple copies of their art provokes more questions than answers. These are faint voices from the wilderness of sound, small peeks into the windows of people you would probably never encounter in your daily life. And yet, here you are alone with their thoughts and efforts—all thanks to the medium of records.

Why are you so attracted to the fringe?
It's not so much that I am attracted to things on the fringe. There is simply so much damn music in the world that after you process the readily available stuff, you seek the margins and all the wild shit that might be happening outside your purview.

Would you consider music featured on your *Personal Space* compilation to be outsider music?
A great deal of it, yes. But it also projects a sense of humanity that is easy to connect with.

Do you have any vinyl stories from when you lived in Kansas City?
I feel grateful that I was able to work in one of the biggest used record stores in the US while I was going to school at the Kansas City Art Institute. It was a secondary education that I was given while studying painting in college. The shop was called the Music Exchange and it was owned by a truly unique man named Ron Rooks. I had an interest in records when I moved to Kansas City, but after getting hired at the shop, my passion went into hyperdrive. Literally every kind of recorded music was at my disposal, and I took every opportunity to learn all I could about everything I could. The shop's rather lenient view on drugs was also a plus.

Any remarkable people/collectors who were regulars at the store?
As any former record store employee will tell you, one sees every facet of humankind while working behind the counter at a music shop. You have the Whitburn Top 40 completists, the heavy metal cassette guy, the hippie burnout, the rap and dance 12-inch mongers, the dude that only wants the rarest records (regardless of music), the thief, the classical snobs, the person that spends hours in the shop every day and never buys a thing, the gay couple that only wants obscure Christian music, the black man who buys all the racist records only to

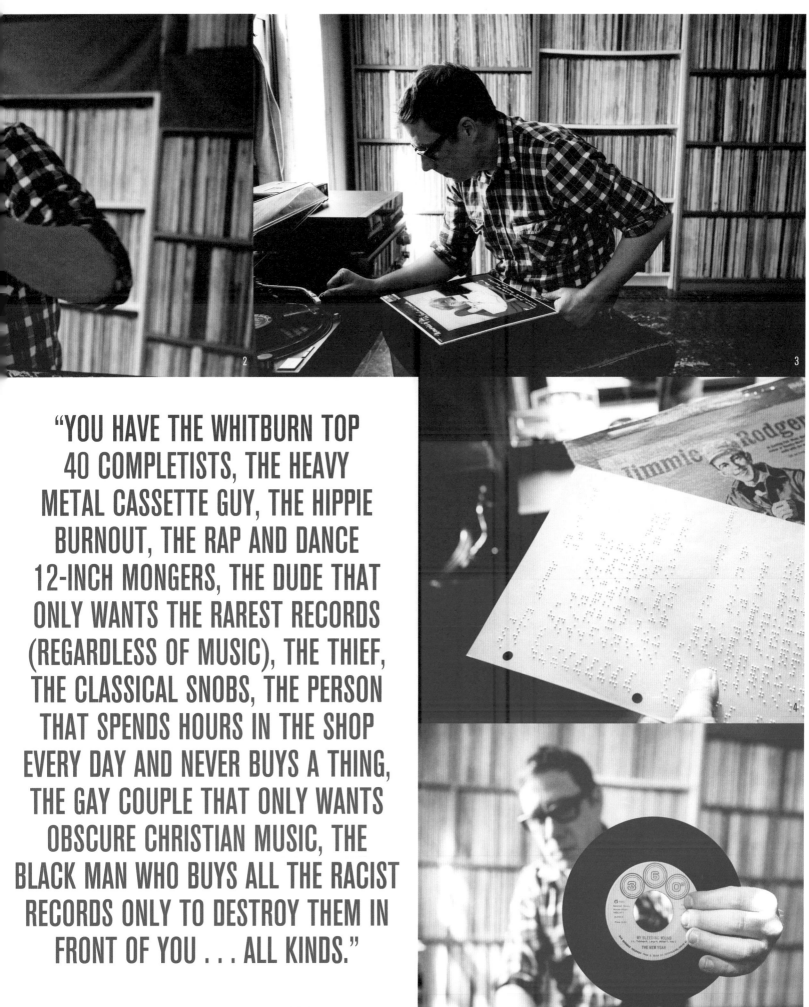

"YOU HAVE THE WHITBURN TOP 40 COMPLETISTS, THE HEAVY METAL CASSETTE GUY, THE HIPPIE BURNOUT, THE RAP AND DANCE 12-INCH MONGERS, THE DUDE THAT ONLY WANTS THE RAREST RECORDS (REGARDLESS OF MUSIC), THE THIEF, THE CLASSICAL SNOBS, THE PERSON THAT SPENDS HOURS IN THE SHOP EVERY DAY AND NEVER BUYS A THING, THE GAY COUPLE THAT ONLY WANTS OBSCURE CHRISTIAN MUSIC, THE BLACK MAN WHO BUYS ALL THE RACIST RECORDS ONLY TO DESTROY THEM IN FRONT OF YOU . . . ALL KINDS."

1. Wandering Magi - *Magic in the Air.* "This record continues to puzzle me." 2. Various Artists - *1st Annual Inner-City Talent Expo* 3. Roy Smeck and His Serenaders - *Memories of You.* "*Twilight Zone* romance vibes." 4. Jimmie Rodgers braille insert created by former owner. 5. The New Year - "My Bleeding Wound"

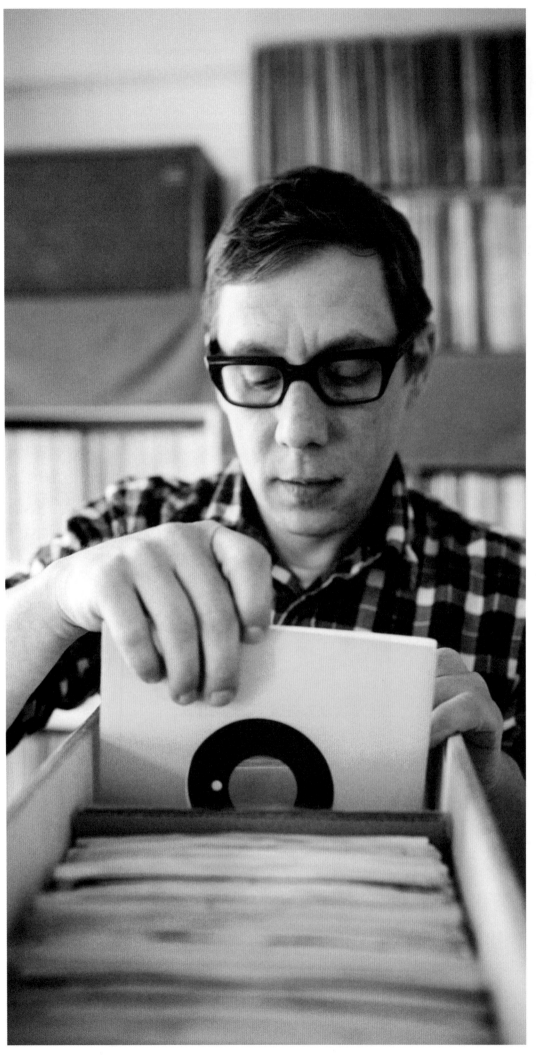

destroy them in front of you . . . all kinds. We had a very sweet blind couple in their mid fifties who were hardcore country fans. They had limited money to spend on records, so every few months they would trade in their previous purchases to get new stuff. The husband had a little sight left, so he would read the information on the jacket to his wife. She would then use a braille typewriter to create a sticker and insert in order for them to find what they were looking for in their collection. They were total and complete lovers of music, and for the most honest reasons. They absolutely adored Jimmie Rodgers and Hank Williams.

Talking about Jimmie Rodgers and Hank Williams, let's look at the "roots" music section. What's there?
Much of it is prewar country blues on LP, since I have no desire to start collecting 78s. There are also a couple hundred old-timey and hillbilly records, a mix of 78 compilations, and things recorded in the field in the '60s and '70s by people like George Mitchell and David Evans. This is music that I usually find myself listening to in the morning, right when I wake up. There is probably some kind of analogy to be found about the dawn of the recording industry and the beginning of a day.

What are some records that you listen to very regularly?
My tastes have become very wide lately, as I find myself listening to things I never would have even considered five years ago. Roy Smeck's *Memories of You* LP from the '60s is a perfect example. Smeck is one of the most lauded string players of the twentieth century, and he made tons of records in a variety of idioms. I'm drawn to this record because it illustrates a concept of romance that is all but forgotten. The sound is faraway and lonesome, completely instrumental, and very otherworldly to me. I've probably only heard the record once or twice while sober. The nearly generic romantic mood it describes allows your imagination to run wild, and permits you to insert your own loves, losses, and regrets between the notes. I really wish there were more records that make me feel like this one does.

Similar in its sentimentality and deep, memorial tones is a rather nondescript looking LP of music from Epirus in Greece. Northern Greek folk music is some of my absolute favorite music in the world, and I haven't heard any sounds from the Epirus region that I did not like. There is a particular form or mode that I love called miroloi, which is a lament or ballad, usually reserved for funerals. It's achingly slow and beautiful music, usually with

the clarinet as the lead instrument. While the origins of the sound might reside in the notion of passing or death, there is an optimism and searching quality that is unlike any other ethnic music I am aware of. My folk tastes usually lean towards traditional music recorded in the field, but there is definitely incredible music to be found on studio recordings that feel slightly exploitative and bear mundane jackets.

Another type of ancient music that can be found on commercially recorded discs is the sound of the Sardinian instrument the launeddas. The launeddas is basically the father of the bagpipe, but with no bag. It requires circular breathing to play it in the traditional way, and it has a unique buzzing drone and two small chanters that provide the melodic and rhythmic counterpart. There are few maestros of the instrument, but the most well known is Efisio Melis. Melis recorded in Milan in the '30s, resulting in 78s that were, for the most part, the "race records" of Italy and Sardinia. His reputation as a genius of this disappearing art stayed with him for his entire life, and he has a few LPs from the '60s and '70s that demonstrate his still-vibrant talent and imagination. The Italian label Albatros compiled his known 78 recordings and issued them on a scarce LP. Once you get in the zone with *Launeddas*, you'll find it's virtually indistinguishable from some weird INA-GRM electronic piece or even a contemporary abstract EDM release.

I have probably listened to Gila's *Bury My Heart at Wounded Knee* a thousand times, and I will never grow tired of it. It's the second record by the German band Gila and sounds nothing like their first release. Most people are familiar with Florian Fricke and his music as Popol Vuh, and it usually gets lumped into the more electronic end of the krautrock spectrum. I treat this record as the third part of the Popol Vuh diptych on United Artists, which included *Letzte Tage–Letzte Nächte* and *Das Hohelied Salomos*. The sound of those two records was a departure from the more electronic-based songs of the early Popol Vuh records and shows the group moving towards a more guitar-based band mode. The contributions from Daniel Fichelscher are palpable across all three of these records, and his guitar playing is masterful and inimitable. I would call Gila and the two Popol Vuh records the epitome of spiritual psychedelia. There is a mantric undercurrent to all of the songs, but it's a wide-open premise. Fricke and company do not bully you into their spirit world, but rather calmly invite you to experience a deeply cosmic accumulation of sounds and feelings. If a contemporary band mined the sounds on these three records, they would be hailed as the biggest

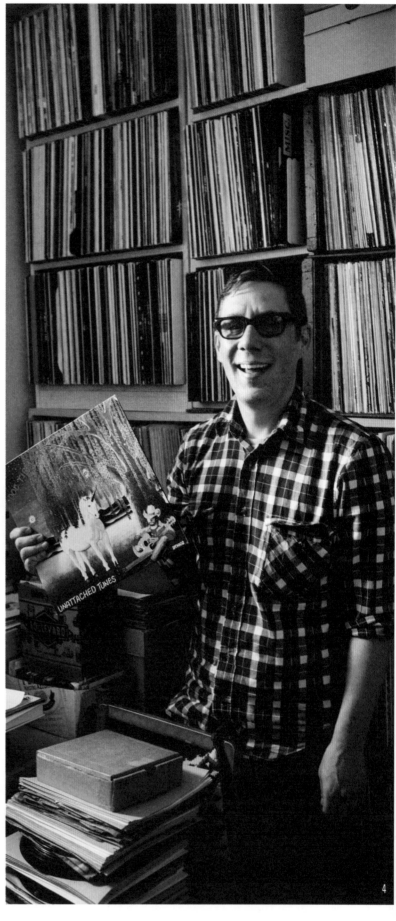

1. Gila - *Bury My Heart at Wounded Knee.* "Free-flowing German psych that pairs perfectly with copious amounts of grass." 2. Another Reflexe album. "Furrowed brow reveals difficulty in reading ancient Latin poetry." 3. *Music in the World of Islam* box set 4. Doc Tibbles - *Unattached Tunes.* "Pure Canada Bone." 5. "Reflexe made an honest effort to try and make hip the earliest of Western musics." 6. "Late-sixties Efisio Melis record from Sardinia featuring the launeddas." 7. "Efisio Melis compilation by the Italian Albatros label."

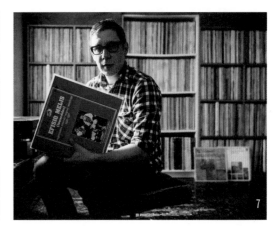

deal to come along in a dog's age. But I doubt that could be done with the care and humility that Fricke and company made look so easy.

Tell us about the Reflexe series.

Reflexe was a series from EMI Germany that focused entirely on early music. The pressings are top quality, the performances incredible and spectacularly recorded, and the presentation is really sharp. I was formally introduced to this music by my friend Michael Klausman about ten years ago. I had seen records of this sort around, but I assumed they were simply classical records. Early-music records are found in the classical section, but I feel the sound has little to do with what is considered Western "classical." Basically this is medieval music performed on period instruments by master musicians, using whatever information has survived. The greatest of these ensembles, Studio Der Frühen Musik, is well represented in the Reflexe series.

There's a plaintive ballad form called planctus, which I am particularly attracted to. Similar to the Greek miroloi or the Ethiopian tezeta, it's an extremely poignant, slow music. But it has a regal air which reminds you that you're dealing with ancient European tradition. I find it's best to hear this stuff either early in the morning or really late at night, probably drunk. Once you get into this world, it's exciting because there's a great deal of it and you can still find it for relatively cheap. You learn to trust certain groups and leaders, like René Clemencic, Atrium Musicae de Madrid, and Hesperion XX, and suddenly you have a whole shelf of these records.

What can we find in your ethnographic section?

I've always found that *John Peel's BBC Archive Things* is a good way to introduce people to the traditional sounds of other lands. It helps that nearly every track on it is remarkable and very alien. It has a reputation for a particular recording from New Guinea, featuring a native playing a Jew's harp with a live, buzzing beetle attached to it. It's a startling and awesome track. My first dip into collecting ethnographic records began by hearing sounds I'd never heard before, such as katajjaq [Inuit throat singing], gong music from Laos, the launeddas stuff I was talking about earlier, pan flute playing from New Guinea. Most folks get into it through the stuff that is semi-findable—your Ethnic

> ## "I HAVE A DEEP ADDICTION TO BUYING BANAL PRIVATE LPS THAT HAVE ABSOLUTELY NO HOPE OF BEING LISTENABLE."

Folkways library and the Nonesuch Explorer series—before you move on to the European labels that are dedicated solely to documenting the world's music—namely Ocora, Musicaphon, Philips Musical Sources, and Albatros. The academic presentation of a label like Ocora is very seductive and easy to like. There are usually copious notes and photographs. You feel as if there's something extremely important and permanent about the record you're holding. And many labels are serial in fashion, begging you to collect them all. When international record buying on the Internet became a reality, the size of my ethnic LP section ballooned exponentially. It sort of became an obsession, running these labels and finding out about some small local folklore society in Albania or Peru that issued a series of records from their respective countries.

The *Music in the World of Islam* series on Tangent Records is another great gateway drug for ethnic stuff. There are six volumes and they're pretty easy and cheap to find as single LPs,

though the actual box set is kind of scarce. Each volume is broken down into respective instruments, offering an interesting way to hear how certain sounds change from region to region. I think that music from Africa and the Middle East is what most easily attracts newcomers to this stream of records, but after some years you can sort through all these traditions and focus on the sounds you really dig. For me, that's music from around the Mediterranean—usually Greek, Italian, or Balkan stuff. You learn which recordists tended to locate the most interesting sounds, and you start to collect by ethnographer as well as by region. For strong Balkan music, Wolf Detrich is a great name to seek out. Simha Arom recorded the famous *Banda Polyphony* record on Philips, and all of his African recordings are pretty awesome. And though some of his work is hyperspecific, David Blair Stiffler released quite a few records of his study of Central American traditions, many of which are super listenable.

Given your interest in Mediterranean music, have you ever been to any record fairs out there?

I've been to a fair in Bologna and was kind of overwhelmed—not so much by the records on offer, but by how you could immediately tell what kind of wares a person was pushing just by looking at them! The prog and psych guys were fucking shirtless and loud, extolling the virtues of some tedious Italian prog record. The soul guys were dressed immaculately and were pretty squirrely. The classical dudes might as well have brought some designer leather couches and twenty-year-old scotch. Shit was kind of hilarious to me.

Tell us about the room you call "the Bone Zone." How did it get its name? What do you keep in there?

It's called the Bone Zone because I have a

deep addiction to buying banal private LPs that have absolutely no hope of being listenable. In certain circles these types of records are called Boners—a concept me and some stoned buddies developed many years ago. I have no intention of filing any of this shit into my personal collection, but I am also reluctant to simply dumping them. Hence they accumulate in my back room to face an uncertain future. The thing about private press LPs is that 90 percent of them are undoubtedly rare and extremely localized, yet the contents ensure that absolutely no one will ever give a fuck or ever want them outside of their simply being private.

What is your cat's name? Does he have any favorite records/music styles?
Ray Ray, but I call him Jaime. This cat has probably heard more music than most humans. For real. He has heard so many obscure records. Unlike most felines, he has no interest in destroying the spines of my shit. I'm still not sure what music he actually enjoys. I've seen him bliss out to R. Kelly on many occasions.

How has record collecting affected other areas of your life?
Music is a rewarding and an enriching art. It informs a person on many levels. Just as finishing a good book or being struck by a wonderful painting might give you deeper understanding of life on earth, having a selection of music that can trigger a variety of responses is, to me, both necessary and welcome.

Do you dig with other collectors or friends? Or do you prefer to go on your own?
I used to take lengthy trips pretty much every year with a close friend of mine. We'd pick a general area of the US and spend several weeks tooling around looking for stuff. But our schedules have become such that we haven't done this in a few years. Driving around looking for records usually results in extreme disappointment, so having a friend with you to share these feelings is a small consolation.

Who have been your record-collecting mentors? What have you learned from them?
The one person that really sent me into record orbit was an older Cuban friend in Miami named Arturo Gomez-Cruz. I was in high school and entered his world just as my interest in music, marijuana, and production started to sharpen. He had a ton of soul and Latin records that I had only heard about, and he was gracious enough to open his collection to me. I still have some of the tapes I made from his stuff. I haven't seen him in two decades, but I know he's still a die-hard music lover and is probably influencing some other eighteen-year-old as we speak.

What do you want to happen to your collection when you check out?
Hopefully I will cash out before I check out.

"THERE WILL NEVER BE AN END TO DISCOVERING NEW MUSIC. RECORDS WILL NEVER CEASE TO BE COLLECTED. IT'S STILL A RELATIVELY CHEAP HOBBY. FIND YOUR ZONE AND GO OFF."

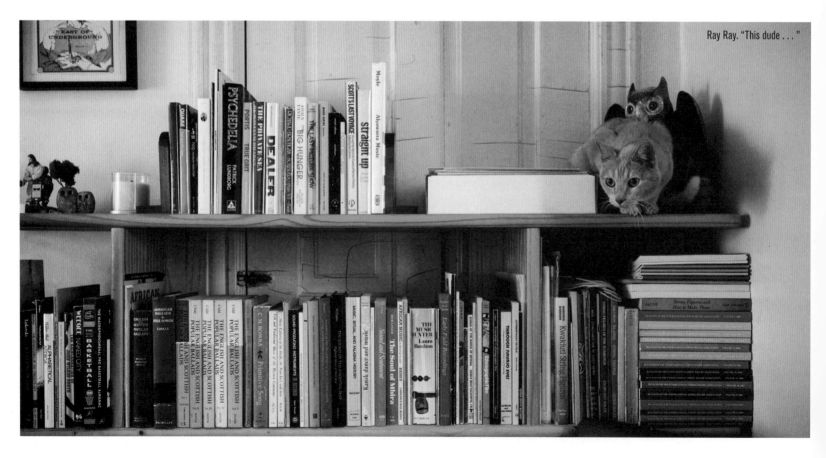
Ray Ray. "This dude . . ."

THE GASLAMP

KILLER

WHAT MAKES A KILLER COLLECTION?

BY JOSIAH TITUS

William Bensussen is lucky to be alive. In the summer of 2012, the Los Angeles–based producer and DJ, better known as The Gaslamp Killer, was riding his scooter home from a friend's house when a gust of wind threatened to take his hat. Reaching for it with one hand and braking with the other, he flipped his scooter, catching a hard blow to the gut on the way down. Internal bleeding meant emergency surgery, which left him with a scar the length of his abdomen and no spleen. But he walked away with his life, and you won't catch him being anything less than grateful for that.

Bensussen grew up in San Diego, where the downtown Gaslamp district became his proving ground. When the neighborhood went commercial, Bensussen pushed back, triggering his nickname, The Gaslamp Killer.

After moving to Los Angeles in 2005, The Gaslamp Killer became a central name in the underground beat-making scene. He could often be found DJing at Low End Theory, a weekly hip-hop and electronic night that he helped organize. In 2012, after a string of EPs and mixes, he joined the Brainfeeder label, run by friend and fellow producer Flying Lotus, and released *Breakthrough*, his debut full-length album. His tours have taken him around the world, offering up his unique blend of psychedelia, world music, and hip-hop to the masses.

Two months after his accident, Bensussen invited Eilon and the Dust & Grooves crew to his Mount Washington home for an afternoon of looking at favorite records and telling stories. With a new lease on life and a creative plan to match, he made sure one thing was clear: "I will always be The Gaslamp Killer."

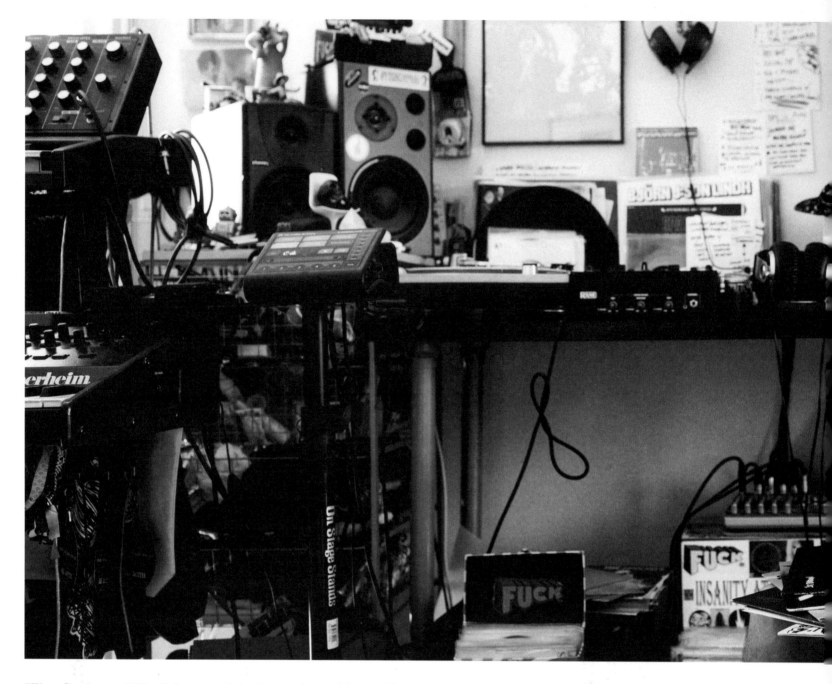

"The Gaslamp Killer" is a nod to the neighborhood in San Diego where you regularly hung out. What kind of neighborhood was it? And how did you end up with the name?

When I was young, my family lived by the beach. I was always dealing with skateboarders and surfers. Everyone was too cool for school, and I never really felt like I fit in. Then I started hanging out in the Gaslamp neighborhood in downtown San Diego. No glamour, no glitz. You could get away with anything—sidewalk ciphers, rapping, battling, b-boy jams, breakdancing. Anywhere and everywhere. It was a wild-ass neighborhood, and I loved it.

Processions was this weekly hip-hop party—the only one in San Diego. Dave Kinsey did amazing old-school art for it. Everything was coordinated by these two guys who were into astrology and ancient religions and had crazy, awesome ideas

about things. We were doing this pretty advanced b-boy circle, opening the turntables up so people could jump on and do mini sets. It was incredible and raw, but at the same time, all around us, they were turning everything into a Sunset Strip–style neighborhood. Suddenly, we couldn't get away with anything. Cops would come in and shut down our parties, and we DJs were pushed into this weird zone where our only option was to play in fancy bars. Not only that, but you had to be friends with a promoter to get booked. No one cared about hip-hop. It was all about expensive drinks and talking to girls. They started telling me, "I'm sorry, but you need to play what people can dance to," which meant playing music that everyone knew. I wouldn't change, and eventually I didn't have any jobs.

I made a mix tape, but I still didn't have a name. My friend who was doing the cover

art was like, "You're fucking Gaslamp killers." I was like, "That's genius." In a hip-hop sense, we were killing it, but with the way things were at that time, we were also killing the dance floor.

The Gaslamp neighborhood used to be a rugged-ass homeless zone, and then it got gentrified and turned into a fucking surfer boy refuge where everyone had slicked-back hair. They took our home away from us and turned it into a plastic fairy tale.

Years later, after I was on the cover of *LA Weekly*, I got some calls from San Diego promoters saying clubs in the Gaslamp wanted to book me. I quoted them so high that they had no chance of breaking even, but they booked me anyway. I hated the whole experience, and I swore them off forever. My community is not there anymore. It's been ripped apart by the squares.

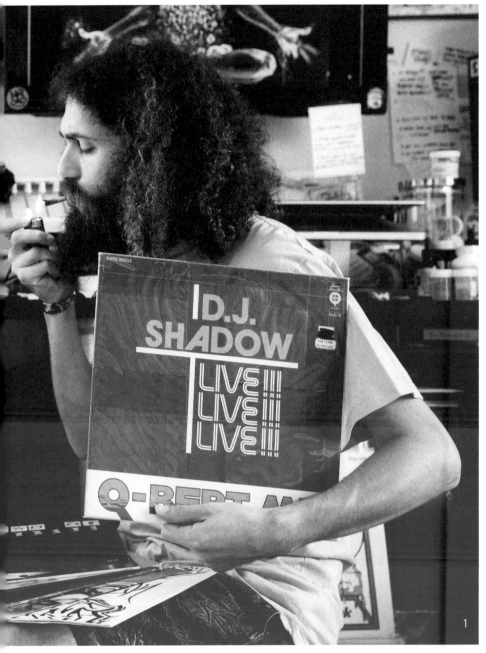

"WE WERE DOING THIS PRETTY ADVANCED B-BOY CIRCLE, OPENING THE TURNTABLES UP SO PEOPLE COULD JUMP ON AND DO MINI SETS. IT WAS INCREDIBLE AND RAW."

1. DJ Shadow - *Q-Bert Mix-Live!!* 2. Snoop Dogg - *Doggystyle*, Dr. Dre - *The Chronic*, J Dilla - *Donuts* 3. Jungle By Night X The Gaslamp Killer - *Brass Sabbath* 4. Les Mogol (Mogollar) - *Danses et Rythmes de la Turquie d'hier a aujourd'hui.* "Dilla's 'Welcome 2 Detroit' intro was looped from this LP."

What were you listening to back then? What about early on, before you started DJing?

In the early days, when I switched from private to public school, everyone was listening to Snoop Dogg's *Doggystyle* and Dr. Dre's *The Chronic*. Because of my older brother and sister, I was getting into Bay Area hip-hop and metal, and when I showed up at public school with things like Too $hort, E-40, Metallica, Deep Purple, and Black Sabbath, everyone was blown away.

Then I started getting into trip-hop—Portishead, Massive Attack, stuff like that. David Axelrod was a big influence right from the beginning. Also DJ Shadow and *Q-Bert Mix-Live!!* Q-Bert re-edited all of Shadow's best stuff and put it on a live mix. I learned from those guys how to cut something up and make it into a mix.

What about your parents? Did they have records?

My parents never had any records, but my dad did teach me to love music. He was born in 1935 in Mexico City, and he and his brothers played guitar and sang. He could also play just about any tune on the piano. Not a musician per se, but he had a good ear. He was always singing and whistling. My mother never did anything artistic that I knew of except standup comedy. And I don't mean just at home. She was an actual standup comedian, and before that, back in New York in the '50s, she did beatnik open-mic poetry and worked at Columbia Records. She got to hang out with Dylan, Simon & Garfunkel, Miles Davis, and Monk. A real socialite.

When I was young, my dad took me to Mexico City to visit family. I asked to go to record stores, where I found some Mexican pressings of Hendrix and stuff, but I should have bought actual Mexican records. I didn't know to look for them.

My dad has been a big presence in my life. Since my accident, he's been staying with me and taking care of me through all of this. He's my mentor and life coach.

What was the first record you ever purchased?

My first record was probably the Specials' "Ghost Town." My parents thought I was smoking drugs. They couldn't believe I was listening to this kind of music. I bought it on cassette originally and got the 12-inch later. I eventually did a cover of it with an afrobeat band from Amsterdam called Jungle By Night.

Did you have a mentor when you first started collecting? What about as a producer and DJ? Who have been some of your inspirations?

I've been lucky to have some real sages in my life. Brandy Flower has been a sort of guru for me, a life coach. Daddy Kev of Low End Theory was a big influence. He stepped into my life and made some great things happen. Cut Chemist, DJ Shadow, J Rocc . . . they all taught me how to collect, how to make a sound, and how to DJ. Cherrystones, Egon, B-Plus, Gilles. In the early days, it was 10shun, Adam Manella, Ricky Isabella, Mike Russell, and DJ Demon.

Dilla LPs. "I'm obsessed. There's no one better."

THE SPECIALS

2 TONE

EXTENDED VERS
Ghost Town
Why?
Friday Night S

RANE

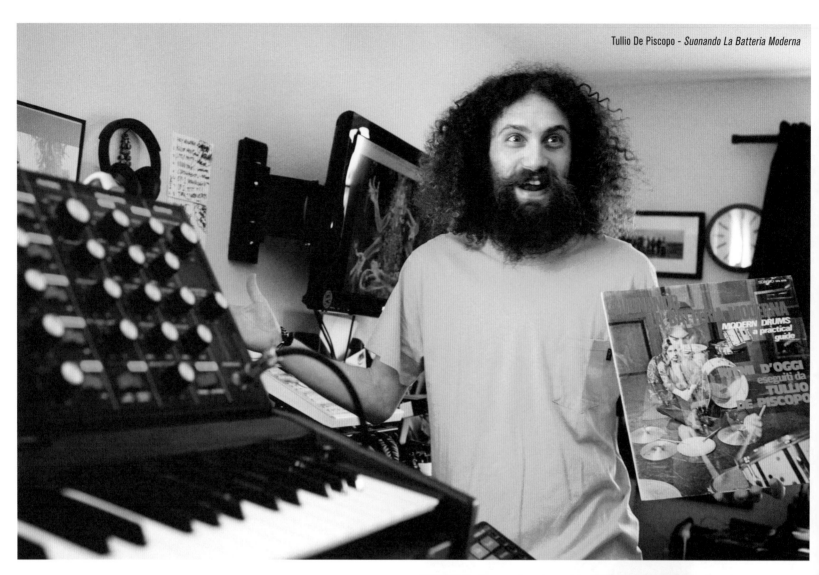

Tullio De Piscopo - *Suonando La Batteria Moderna*

"IT'S A DRUM INSTRUCTIONAL RECORD THAT HAS SOME OF THE MOST AMAZING, BEST RECORDED, BEST PLAYED DRUMS I THINK I HAVE EVER HEARD. DJ SHADOW LIFTED THIS BREAK ON 'DRUMS OF DEATH PART 1.'"

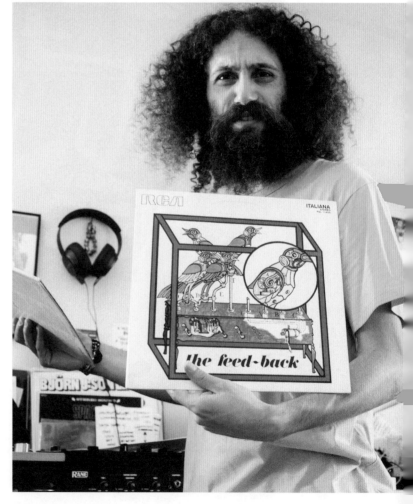

Those were the first guys to teach me shit in San Diego. They were my age, so we were all peers. Mike Russell, Ricky, and 10shun are taking what we started working on to a whole new level. They are old-school friends of mine but are relevant in today's music world and are still really important to me and my growth. They influence me a lot, still, and I run everything I do by them.

What was Dilla's influence on you?

He's the best that ever did it. The way he sampled, looped, rearranged . . . it's so raw, so dirty. He showed me that I could utilize the tools hip-hop gave me rather than just a straight drum machine and synth. His example pushed me to evolve. He had the Moog Voyager and would add a nice drum break and make something that sounded smooth. His entire beat was synth and drums. That was his sound. He had live percussion, live drums. *The Shining* was made with just a couple of tools. I always thought that was so incredible. In my opinion, he was the best producer that ever lived.

What about influential albums?

The Fonit C 364 record by Mario Molino is one of my prized Italian library records.

There's a beat on this record that sounds like it was made yesterday. For my style of music, this influenced me a lot. Also Moggi's *Tra Scienza e Fantascienza*, Daniela Casa's *America Giovane N.2*, and the Group's *The Feed-back*, which is this fucked-up Italian album with a Morricone-style sound.

Ennio Morricone is one of the greatest composers of all time. *The Feed-back* is a bunch of guys making the weirdest sounds they could possibly make. It's a mix of gross human sounds and some of the hardest drumming you've ever heard, with trumpets and brass all over the place. The crazy thing is, they didn't have subwoofers back then, and yet, they have subs in their record. It's so dynamic.

Tullio De Piscopo's *Suonando La Batteria Moderna* would be another one. It's a drum instructional record that has some of the most amazing, best recorded, best played drums I think I have ever heard. DJ Shadow lifted this break on "Drums of Death Part 1." I thought he had someone play it. Then I heard this and I was like, "Whoa!" I couldn't believe the break was built in, that it had been made that way.

When I look at these records, it's easy to be like, this is all so different than what

I'm playing now. But it's not. These albums are the history of instrumental electronic music. The Italian stuff is what I've always been looking for—the library sound.

What's your relationship to Flying Lotus? How did you first meet?

I opened for MF Doom up the West Coast. At the LA show, Flying Lotus was there to videotape the entire gig for Stones Throw. After the show, he came up to me and was like, "I shot your set and I loved it. Let's be friends."

He was the first guy my age to really blow me away. His work ethic alone was an example to me. He has given me every test pressing of every record he has ever done since 1983. Most of them are in graffitied white sleeves. Definitely among my prized possessions.

Sound in Color played a big role in launching your career. Can you say something about what they did for you?

They were the first label that paid for me to go international, and they put out my first mix CD. They brought up some of my friends, too. It was John Ancheta who

The Group - *The Feed-Back*

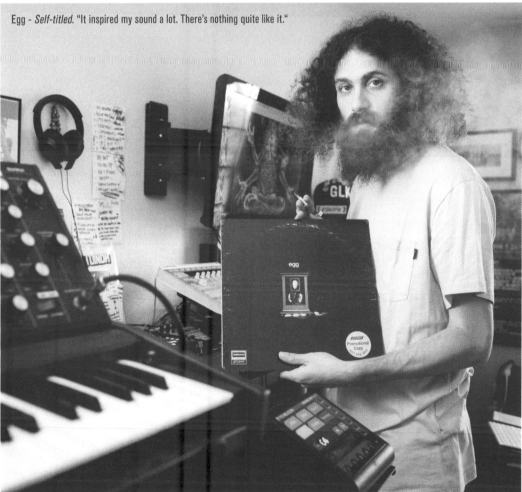

Egg - *Self-titled.* "It inspired my sound a lot. There's nothing quite like it."

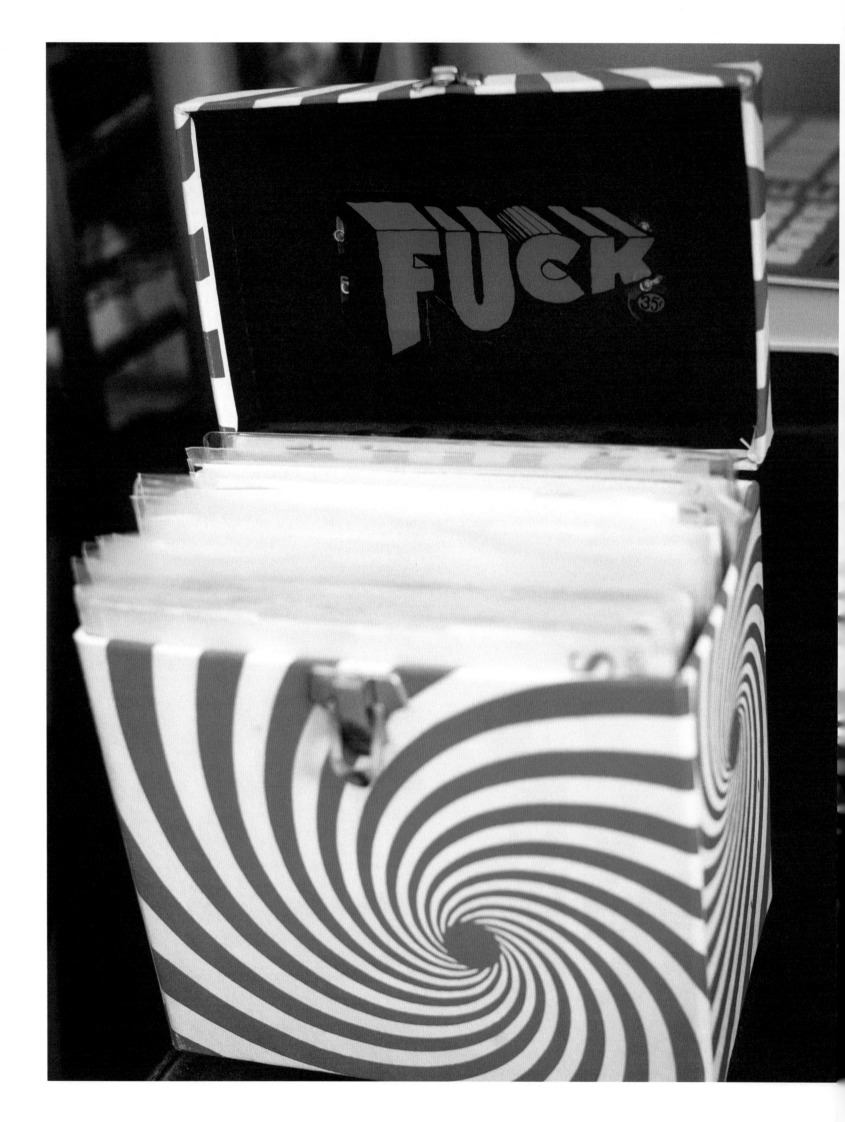

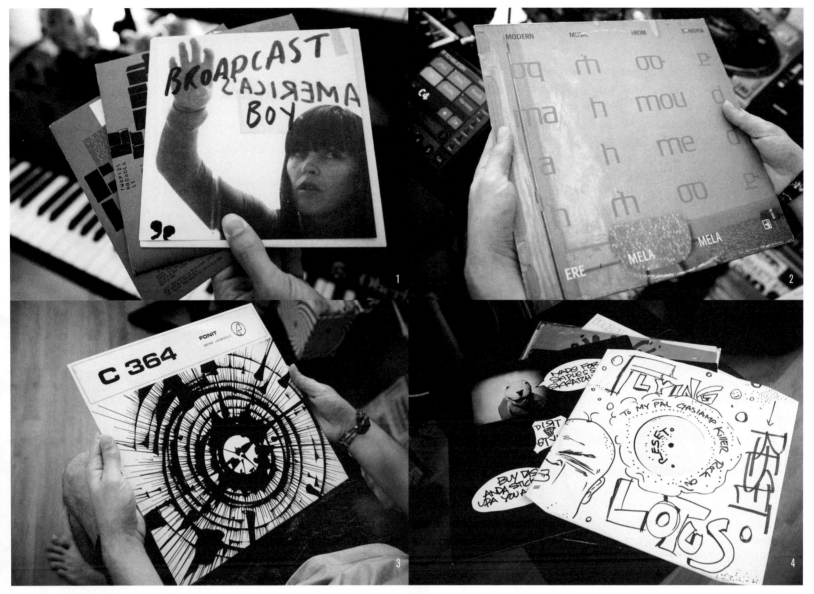

1. Broadcast 7-inches 2. Mahmoud Ahmed - *Ere Mela Mela*. "I sampled this for Gonjasufi's *A Sufi and a Killer*." 3. Mario Molino - *Self-titled*. "The Fonit record—one of my prized Italian library records."
4. Flying Lotus test pressing

made it all happen. He got investors to back me, and he's the one who got me to Berlin. He still works in the community, doing great stuff.

You have a lot of sealed records. Is there a reason you haven't opened them?

I used to work at a record store, and I accumulated several copies of each record. I thought maybe I'd open my own store one day. I've thought recently about maybe opening a one-week store. Incense, two turntables, sell a bunch of records fast. I also worried I would maybe wear out a copy or break one, and I wanted to be sure I always had at least one extra copy.

You've started using Serato when you DJ. Can you say something about why you made the switch? Do you miss doing vinyl sets?

As a DJ, vinyl is limiting. I like being able to use different things at once. With Serato, I can do almost anything, and all I need is my two turntables, a mixer, my Serato box, laptop, and iPad. I'm still a vinyl enthusiast, but in terms of DJing vinyl, for the most part, I've moved on.

Funny thing is, I bought Serato when it was still fairly new, but my computer crashed when I hooked it up, so I sold it to another DJ and forgot about it. Eventually, I was the last of my crew still spinning vinyl, so I was like, "Let me give that another shot." I bought a better computer and a new box. Vinyl is what shaped me and I will keep my records forever, but there's just so much you can't do with vinyl.

Favorite comfort album?

Indian music. Ravi Shankar. That's my shit. That's what gets me in a good mood.

What do you want to have happen to your records when you're gone?

I will give them to my children if I end up having any. If not, then a hip-hop museum.

What do you look for in a record?

Breaks. As a DJ, it just doesn't get more exciting than finding a great break. I look for records with a band of three guys. You know they're focused on the rhythm section, and that's how you get the break you're looking for.

How has record collecting affected other areas of your life?

When I was in school, my parents would give me lunch money and then I'd mooch lunches off friends and spend the money on records. I bought so many records, my parents actually worried.

They'd ask me, "Are these going to be worth anything in a few years?"

You've sampled mp3s of rare music that you found through bloggers and friends online. Where does vinyl fit into this process?

People have dedicated their life's work to digitizing rare, hard-to-find music. They just want to share it. I don't put track listings on my mixtapes, which might be hypocritical of me, but I lean on these guys, and I think it's only natural for the record community to bring this music to the public. If there are only a handful of copies of a record, there's no other way. Sharing the music is what it's about.

Records have experienced a renaissance, but DJs continue to move away from vinyl, including yourself. Did vinyl shape you as a DJ? Do you think digging for records, building a physical library, finding the sources of samples, etc., is part of cutting your teeth as a DJ?

I'm grateful to be a part of my generation of DJs. We did it with vinyl before there was another way. For me, the love for vinyl goes hand in hand with wanting to be a DJ. You find a record and you get frothy at the mouth, wanting to have a party. The values instilled in me are in jeopardy, and I hope that I can be an example of what music is and can be.

How have the DJ and music community shown their support since your accident?

I've gotten more love than I could have ever imagined. People have stepped up in all kinds of ways. A friend of mine made a synthesizer "get well" mix; people have brought me cold-pressed juice. They fixed my computer, set me up with Pro Tools, and let me borrow different machines. Basically, everyone has been committed to getting me back to work. John Wyatt, a good friend of mine, dropped off a box of library records for me to sample. All he said was, "Give 'em back whenever." Flying Lotus let me borrow his TC-Helicon Voicelive. I could go on and on. All of my close friends have been here for me, making sure I have what I need and that I'm getting fed.

What is it about records? What makes them special?

Even after the apocalypse you could still get vegetable oil and run two tables and speakers. That's what I hope to be doing at the end of the world—spinning all this wonderful music, dancing, and being in love. Records are time capsules. They're emotional, spiritual, energetically bound pieces of vinyl. They were cut with force and energy, not by a programmer.

What does the road ahead look like for you?

Work less, create, and enjoy more. I might not be able to afford the lifestyle I've been living, but my goal is to be able to supplement the hours I've spent touring with more time making music. My albums are going to tell my life's story better than anything.

I'm trying to let the moment I'm in be reflected in the next album. Some of it might sound more like meditation music than hip-hop, but it's still me. I will always sound like The Gaslamp Killer, even if I've added a new dynamic to my style.

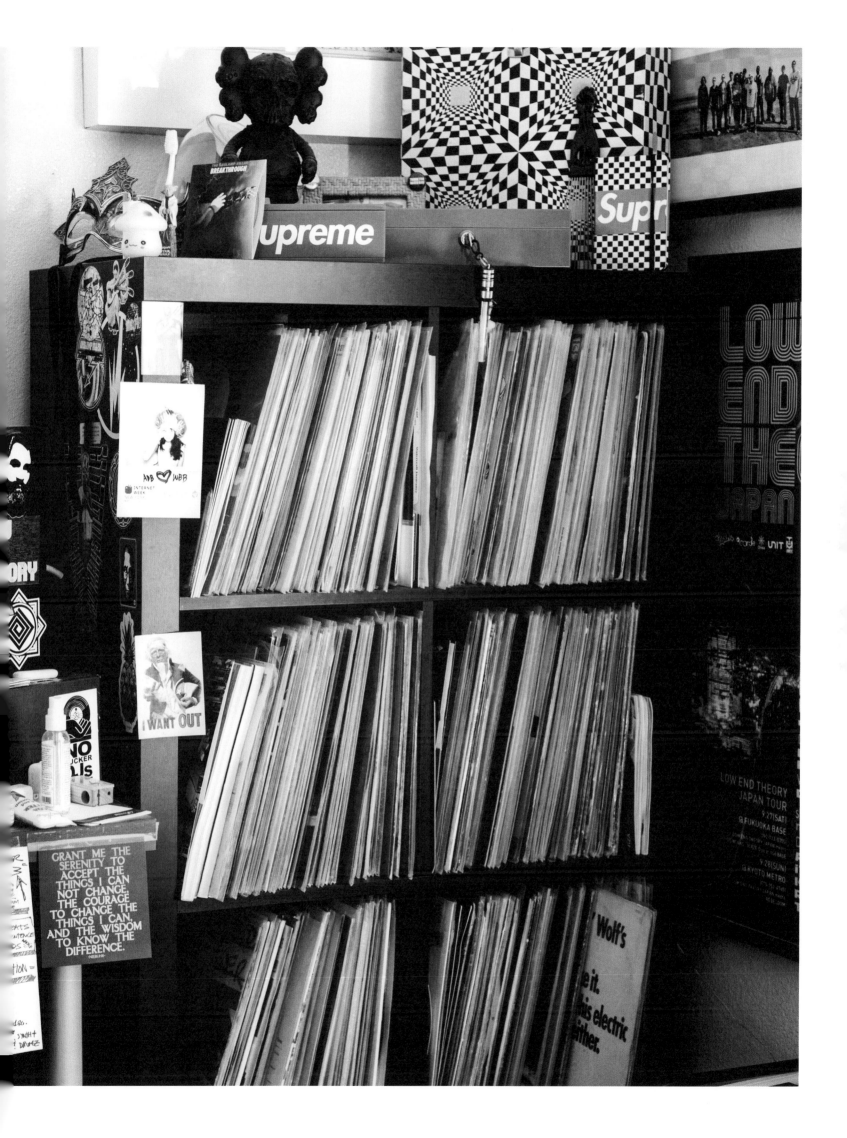

CAN YOU TELL ME WHERE TO DIG ON SESAME STREET?

BY APRIL GREENE

When a new identity popped up on the Dust & Grooves radar, we knew we had to dig further. A couple of our Philly collector friends made mention of a local young man with a very rare collecting focus: *Sesame Street* records. And, they said, he digs hard for them.

We were, of course, intrigued, but with no other info to go on, we knew we couldn't count on getting lucky and just running into the guy. On our last trip to Philly, we followed a couple of leads to try to cross paths with him, but kept coming up dry. It wasn't until an hour before our bus was due to take us back to NYC that we got a text from one of our record-store moles: "He's here!" With that, we abandoned our bus tickets, hopped back on the subway, and hightailed it to Beautiful World Syndicate, a record store on East Passyunk Avenue.

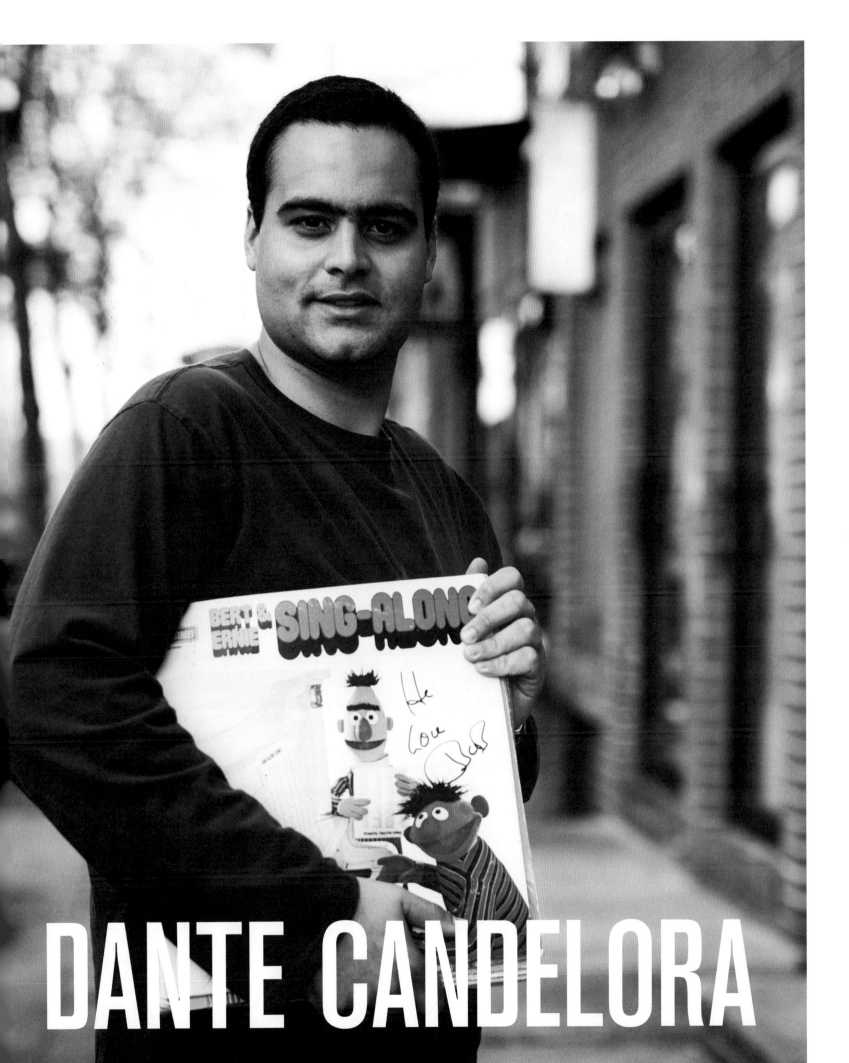

DANTE CANDELORA

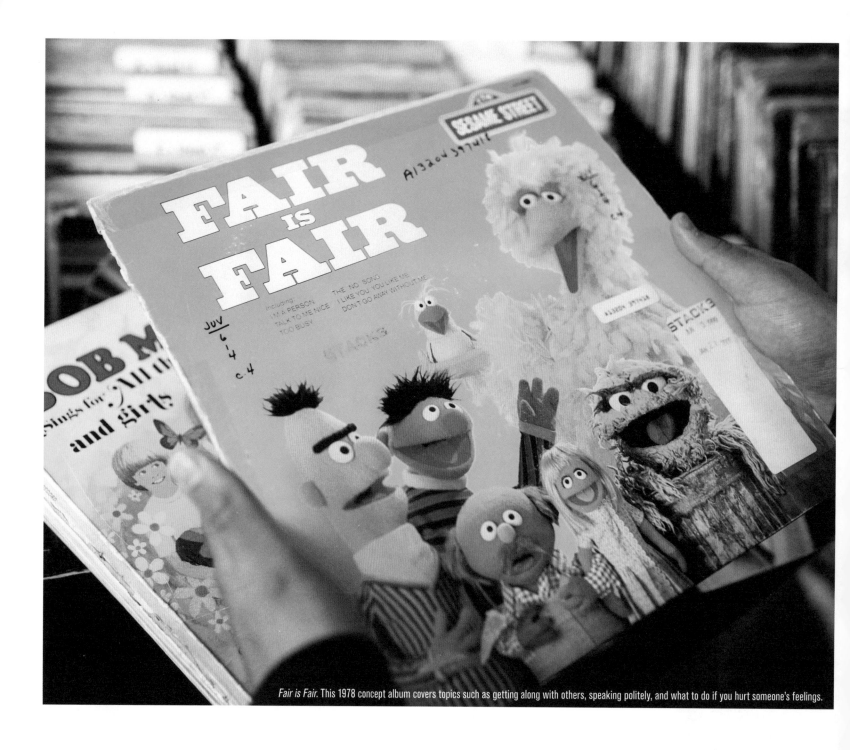

Fair is Fair. This 1978 concept album covers topics such as getting along with others, speaking politely, and what to do if you hurt someone's feelings.

We walked in and spotted our man immediately. Easy enough, as he was the only guy in the store with a bag of Big Bird albums on his arm. We introduced ourselves and finally put a name and face to the legend: this was Dante, twenty-four years old, born and raised in South Philly. We chatted with him and his younger brother, Christian, who was also there digging, and asked if we might be able to see more of Dante's records. The brothers immediately phoned their parents, who, very kindly and quickly, packed up Dante's entire LP collection and drove it over so that we could stage an impromptu photo shoot on the sidewalk.

While Eilon got shots of Dante with LPs like the 1979 dance floor–ready *Sesame Disco* and 1977's *Let Your Feelings Show!*, Dante's mom Donna filled us in on the history of his obsession. "Dante has been a fan of *Sesame Street* since he was a baby," she said. "And he developed a real love for collecting." His collection not only includes tons of vinyl, but *Sesame Street* books, videos, and practically anything related to the show. "It was my sisters who had the original *Sesame Street* vinyl, and he *really* loved those," she recalled. Over the years, his family took him to *Sesame Street* events and to Sesame Place—a theme park in Langhorne, Pennsylvania—where he always wowed, even scared, the puppeteers, actors, and producers with his encyclopedic knowledge of the show. Donna describes Dante's room as being "packed with

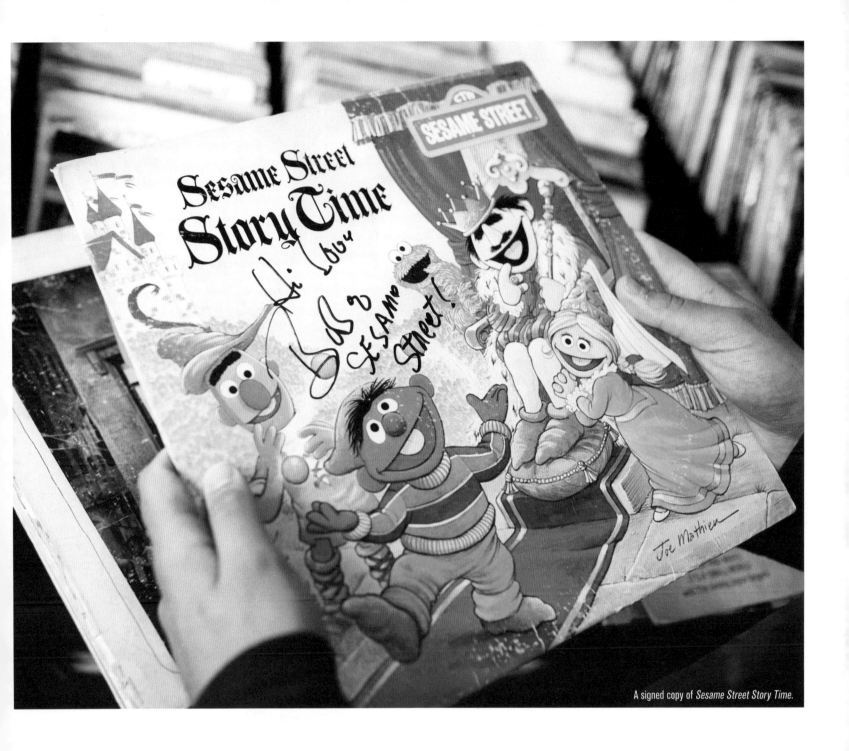

A signed copy of *Sesame Street Story Time*.

Sesame memorabilia of all kinds," and mentioned that every Halloween he dresses up as his favorite character, Bert, and gives out candy to the kids in the neighborhood.

Passersby couldn't help but notice Dante's colorful record collection on display on the sidewalk. Some made an obvious effort not to look at Bert dressed like Bruce Springsteen on the cover of *Born to Add*. Some took the long way around us and paused to stare and smile at the mélange of vinyl. Others stopped for a minute to talk shop. "Hey, do you guys have Larry Levan's remix of Cookie Monster's 'C is for Cookie?'" a slim young man in a leather jacket and glasses asked me. "I've been looking all over for that." Apparently Dante was not alone! Soon Mom and Dad and Christian joined in on the scene and talked about their favorite songs and album covers and even broke out Dante's plastic *Sesame Street* rain poncho, still like new, folded up in the box.

Once the sun started to go down, we grabbed a quick interview with Dante and then waved good-bye to the Candelora family as they rolled off in their minivan with Elmo, The Count, and Oscar the Grouch immortalized on wax. As you'll see, Dante is a man of few words, but his collection speaks volumes.

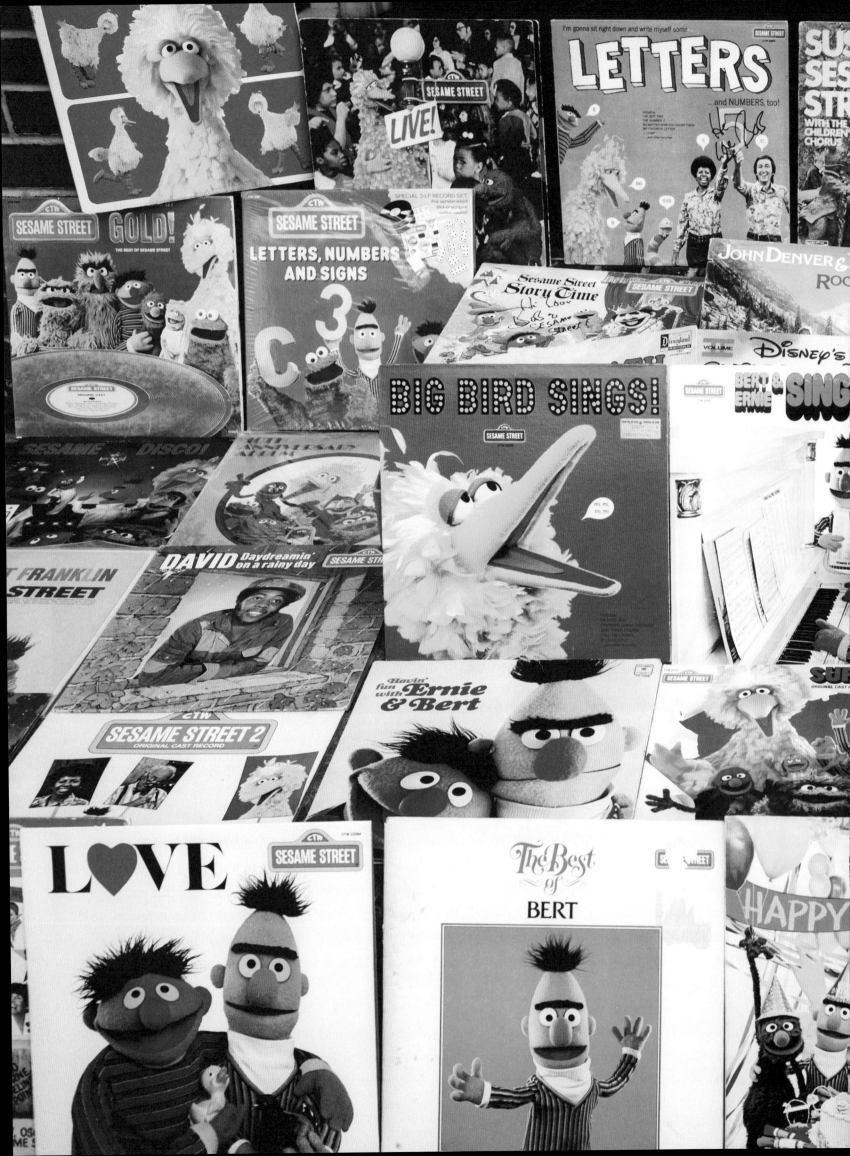

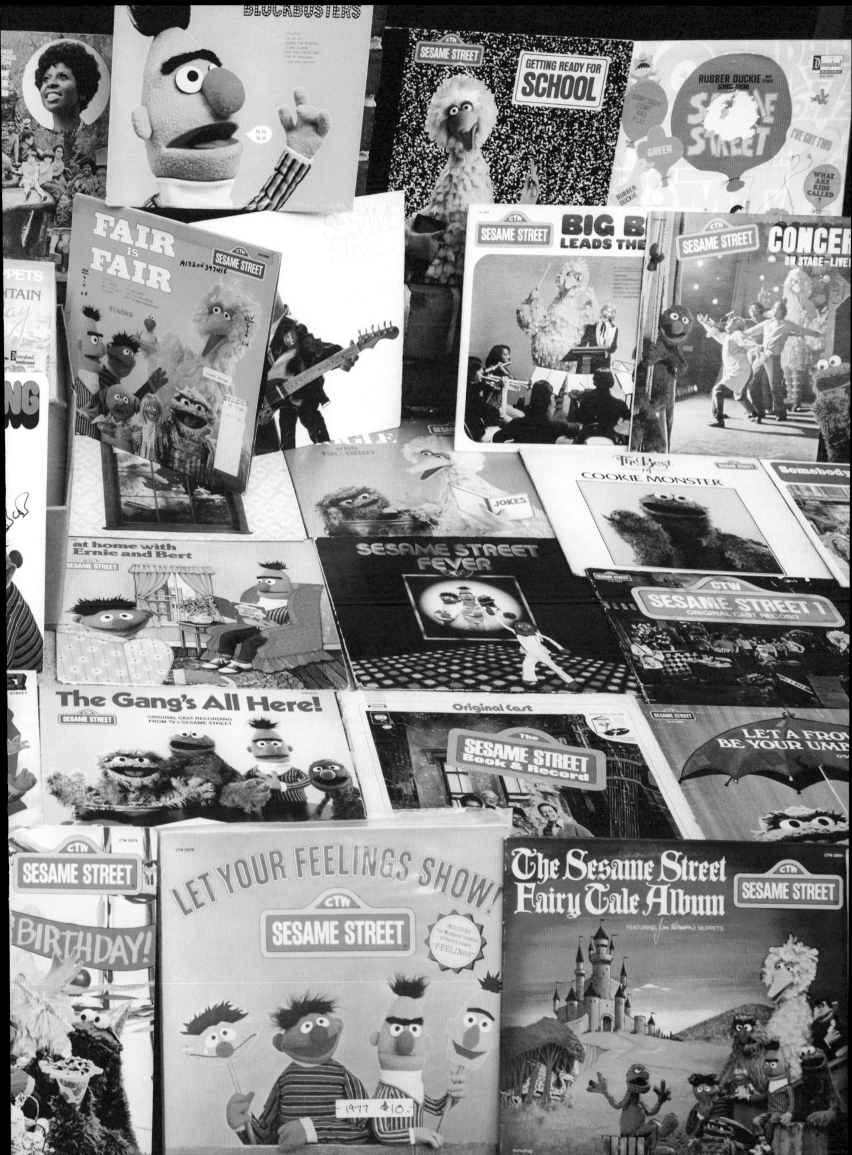

When did you start collecting?
When I was around twelve or thirteen. *Sesame Street* and Mickey Mouse records.

What was the first record you bought?
Bert's Blockbusters was one of the first.

Why *Sesame Street*?
I'm a big fan of the show and the music—[songwriters] Joe Raposo, Jeff Moss . . .

Why vinyl?
For the memories.

How many days a week do you dig?
Two times a week, maybe. Record stores, flea markets, record shows, on eBay sometimes. And I find a lot of information on [fan website] Muppet Central.

Do you collect anything besides *Sesame Street*?
Sometimes Disney soundtracks, other Muppets music or memorabilia. The old View-Master Interactive Vision VHS video game system—I'm trying to find the *Sesame Street* games for that. And I like the *Sesame Street* "All My Homies Are from the Street" T-shirts. I find those at Target.

How long has *Sesame Street* been going on now?
Forty-two years. They did 130 episodes a season for twenty-one years. They're not as good anymore, though, like they were with Jim Henson. Some of the old characters are dead now, but not all.

What tops your list of things to find right now?
Probably the Jack and the Beanstalk "Parts 1 and 2" 45 rpm single.

Do you play the records, or just collect them?
No, I play them.

What's the most money you've ever spent on a record?
About $15.

Do you like any modern adaptations of *Sesame Street* music, like Smart E's "Sesame's Treet?"
Yeah, I like some of that stuff.

Do you have a favorite Muppet? Or, if you were a Muppet, which one would you be?
Bert. He's smart, like me, and yellow. Yellow is my favorite color.

What's your family's reaction to your collecting?
They're happy about it.

Is your family into music?
Oh yeah. Mostly house and disco music—Heatwave, Donna Summer, Daft Punk.

When will you stop collecting?
When I find everything.

You seem pretty patient about that.
Oh yeah.

"WHEN WILL YOU STOP COLLECTING?"
"WHEN I FIND EVERYTHING."

"YOU SEEM PRETTY PATIENT ABOUT THAT."
"OH YEAH."

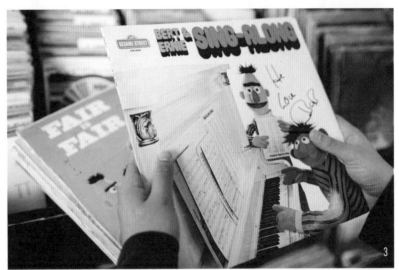

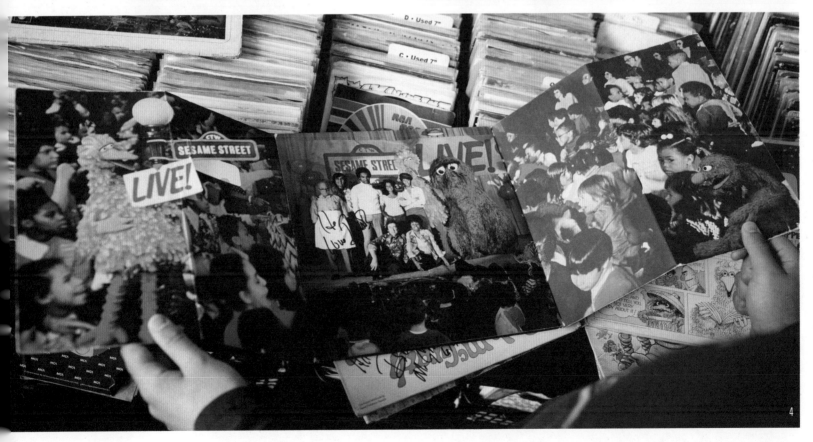

1. Dante's wish list is long, but he's got stamina. 2. "Do you guys have Larry Levan's remix of Cookie Monster's 'C is for Cookie?'" 3. "*Bert & Ernie Sing-Along* signed by *Sesame Street* actor Bob McGrath."
4. Gatefold party! 1973's *Sesame Street Live! includes* a quad-fold sleeve with a cutout of Big Bird.

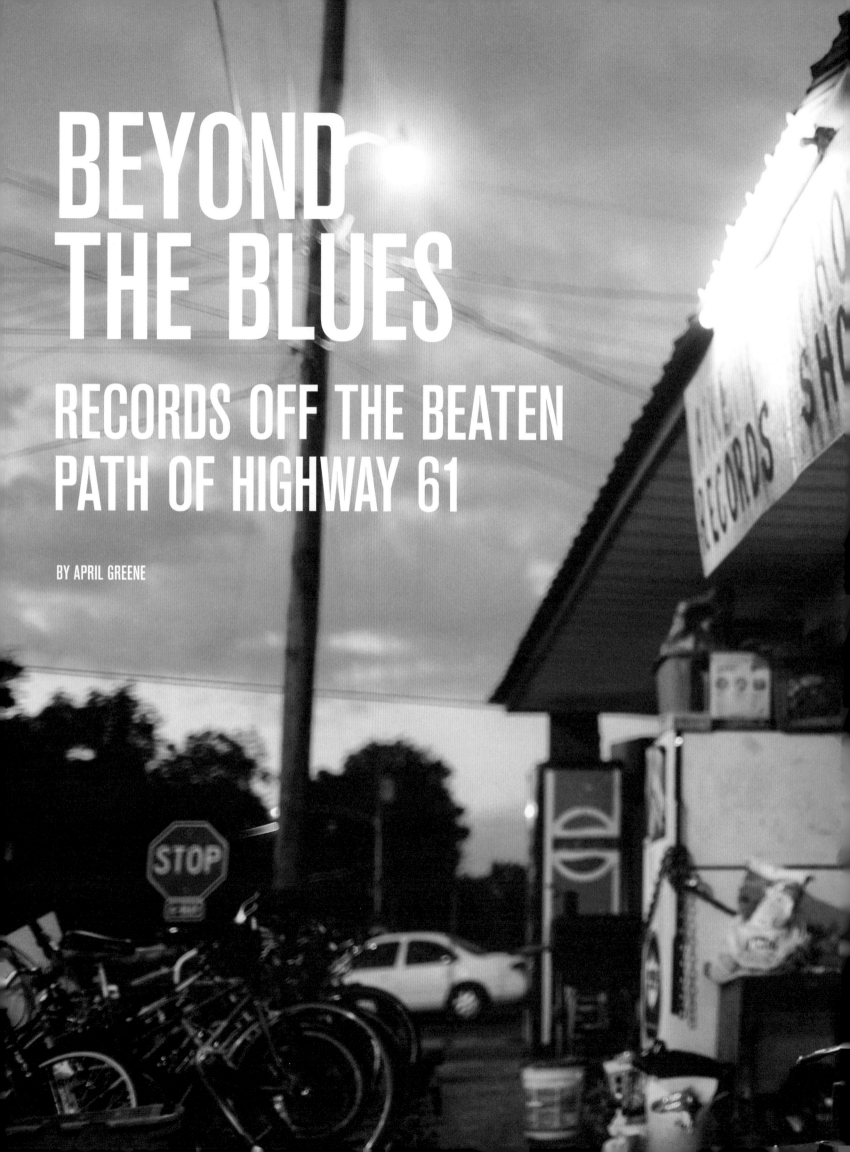

BEYOND THE BLUES

RECORDS OFF THE BEATEN PATH OF HIGHWAY 61

BY APRIL GREENE

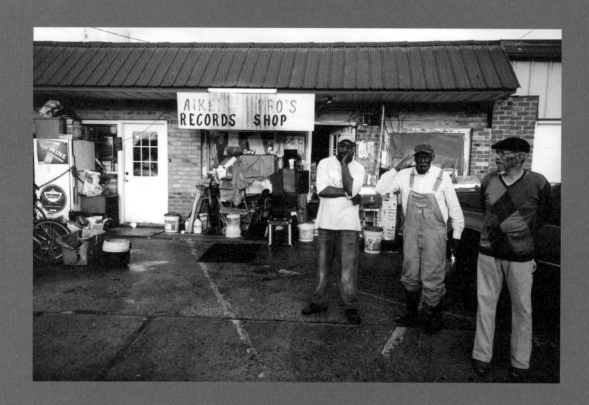

Before I went to Aikei Pro's Records Shop in Holly Springs, Mississippi, I'd never received a marriage proposal from a septuagenarian bricklayer, seen a Eurythmics poster hanging side by side with an N.W.A one, or eaten breakfast for dinner at a fast food restaurant courtesy of a southern grandfather who'd seen Tuskegee Airmen train to fly in World War II . . . all in the same afternoon. Such was life on the Dust & Grooves road trip.

THE BLUES HIGHWAY WAS FILLED WITH HISTORIC AURAS AND COUNTRYSIDE VIEWS, BUT OUR SEARCH FOR PLACES LIKE CLUB PARADISE, THE PINK PALACE, AND RAINBOW DISCO YIELDED PRETTY MUCH NOTHING.

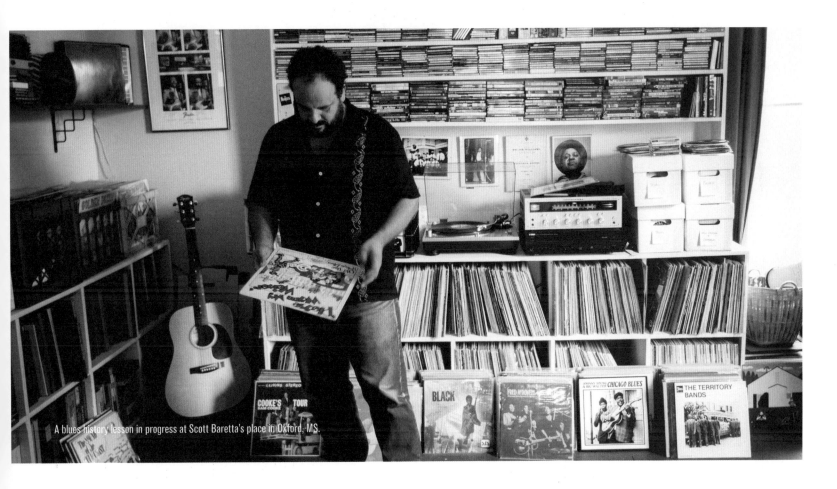

A blues history lesson in progress at Scott Baretta's place in Oxford, MS.

Eilon and his road trip right hand, Julia Rodionova, had been at it for about a month when I met them in New Orleans in September 2013. I was tagging along for a week of interviews and photo shoots between Louisiana, Mississippi, and Tennessee, and had been looking forward to some good food, excellent company, and fascinating collector stories. But my friends looked a little weary as we sat down to breakfast on Magazine Street, and I asked how the past few weeks had gone. They told rich but tired tales of long drives, multiple shoots in one day, maxed out memory cards, constant road snacking, and information overload. "You actually came at a good time," Eilon told me. "We're really in need of a break from our insane schedule; I wish we could have some more random experiences. Plus, my birthday's coming up. I want that to be our first official day off." Sounded good to me. We proceeded with a few hearty days and nights in NOLA with Ponderosa Stomp music festival founder Ira Padnos and powerhouse DJ Soul Sister—and some shrimp po' boys—and then began to plan our next moves to Oxford, Mississippi, and then on to Memphis, Tennessee, with a few stops in between. It looked like the drive from New Orleans to Oxford would take about five hours on Interstate 55.

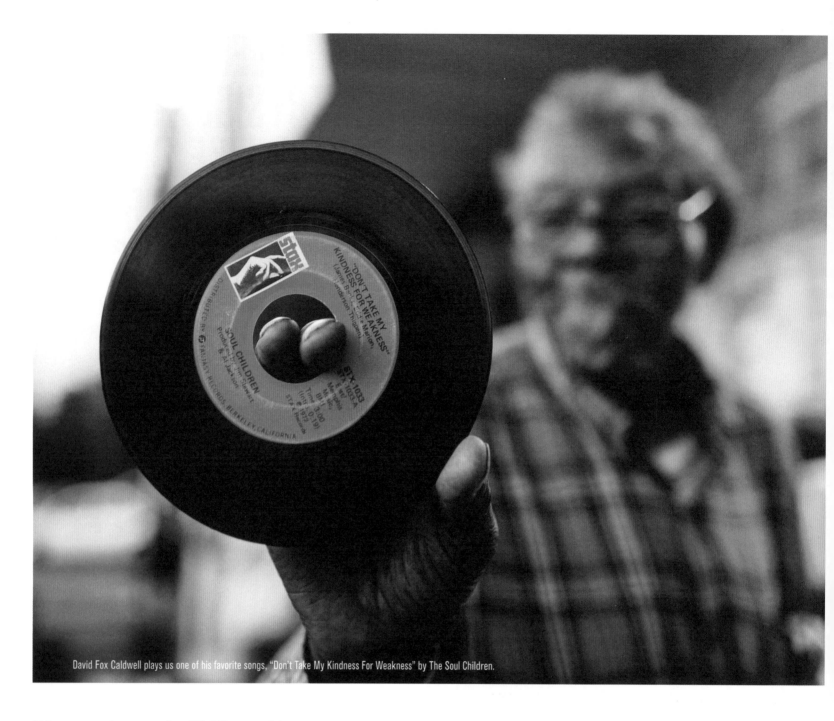

David Fox Caldwell plays us one of his favorite songs, "Don't Take My Kindness For Weakness" by The Soul Children.

"Hey, you know what?" Eilon said. "Highway 61 goes the same way. We can take that instead and look for juke joints. Could meet some interesting characters."

The Blues Highway was filled with historic auras and countryside views, but our search for places like Club Paradise, the Pink Palace, and Rainbow Disco yielded pretty much nothing. All the joints we could actually locate were either closed during the day or had been closed since the '80s.

It was frustrating. And it took about three times longer than five hours.

We stopped at Oxford's charming Ole Miss Hotel late that night. "What I'd really like is to find another rare old-timer, like Philip, the ninety-year-old guy I met digging in Ghana," Eilon said, getting ready for bed. "I have this romantic image in my head of finding someone else like that—an elder statesman with a great story. We keep looking and asking around if anyone knows such a guy, but no luck yet."

The next morning was Eilon's thirty-ninth birthday, but travel time and collectors' schedules made it impossible for us to take the day off. So after a fortifying breakfast, we met with collector Scott Barretta at his home for a quick Q&A. At the tail end of the interview, as we were packing up recorders and lenses and Scott was preparing to teach a sociology class at the University of Mississippi, Eilon tried to find his statesman. "Scott, do you know of any exceptional collectors between here and Memphis that we might pay a visit

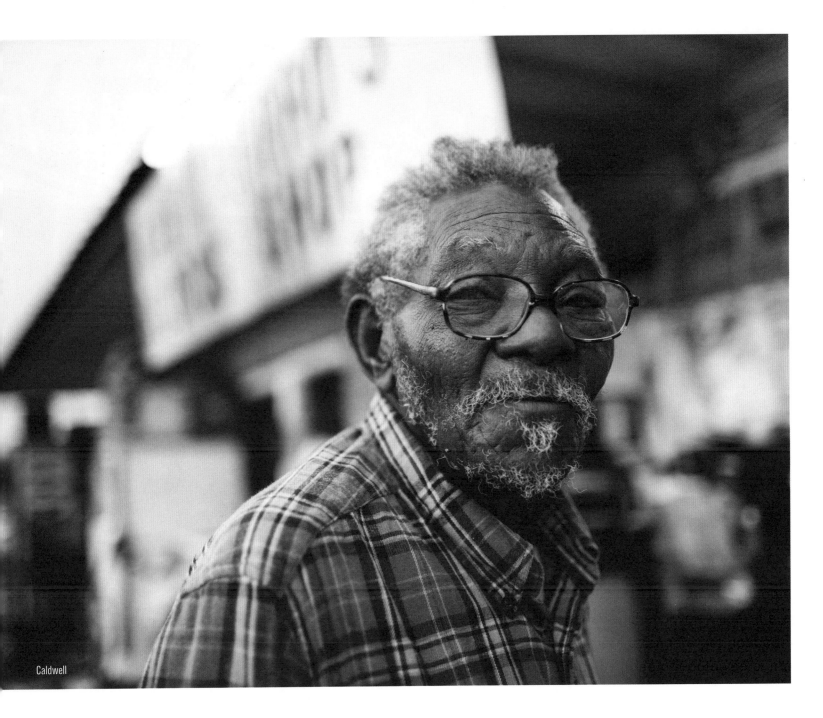
Caldwell

to?" Scott tapped on his computer keyboard for a minute. "God, how do you spell that . . . ?" he muttered. "Oh, here it is. Yeah, go see this guy. The place is called Aikei Pro's Records Shop. In Holly Springs, Mississippi, about thirty miles north of here. Caldwell, the owner—he'll talk your ear off but he's a character, a real fixture in the town. You might be interested." He turned the monitor to show us images fit for the flea market section of the *Guinness World Records* book: a corner store so littered with old bicycles, vending machines, and electronics outside and so packed

with records, posters, and framed photographs inside that it wasn't clear how one would actually gain access, let alone find anything once inside. Eilon was immediately intrigued.

I jotted down what I could of the directions Scott rattled off (something about a town square), and we hit the road in search of Caldwell and his dusty troves.

A former trading crossroads for neighboring cotton plantations, Holly Springs has a population of about

7,500, with a third of the people living below the poverty line. It's a place where strangers get noticed—particularly three out-of-towners in a new SUV, brandishing cameras and recording gear.

Luckily for us, Caldwell set a good tone when he greeted us graciously. His overflowing store looked more like the town square than the real town square; it's the place where everyone, young and old, comes to cross paths, catch up, and buy loosies (Caldwell usually charges 50

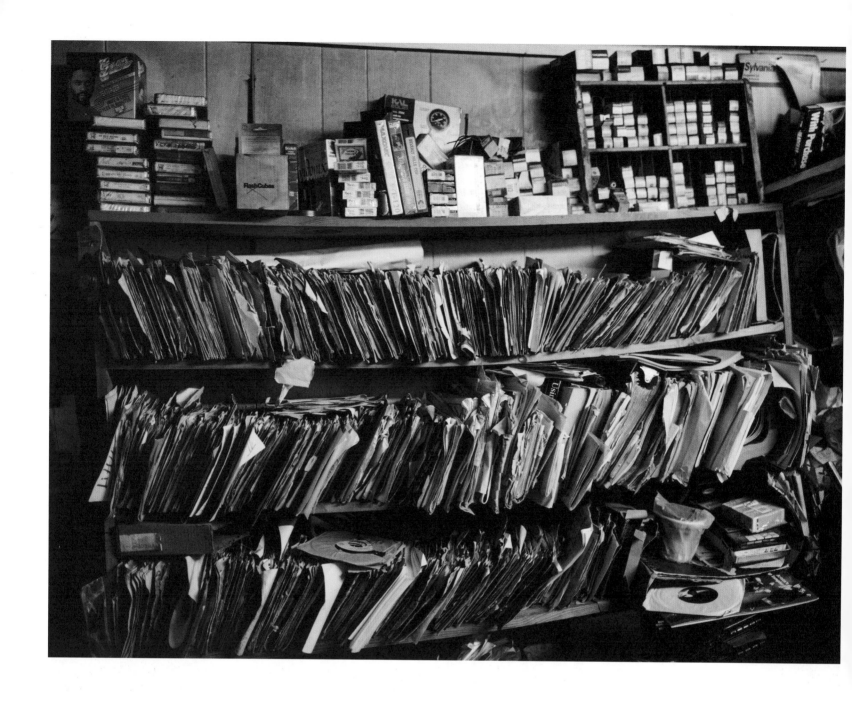

HIS OVERFLOWING STORE LOOKED MORE LIKE THE TOWN SQUARE THAN THE REAL TOWN SQUARE; IT'S THE PLACE WHERE EVERYONE, YOUNG AND OLD, COMES TO CROSS PATHS, CATCH UP, AND BUY LOOSIES.

cents a cig, but he gave three for a dollar to his favorite waitress at dinner). I doubt he sells much from the inventory of tattered, decades-old magazines, worn-in guitar amplifiers that live outdoors, and hand tools that have rusted together in their boxes, but his central location and paternal way of overseeing community life have kept people around constantly. Plus, we learned that Caldwell's had his share of curious out-of-towners pass through, especially in recent years, as word of his idiosyncratic shop has spread. So we weren't in danger of blowing his mind.

Within twenty minutes of our arrival, the cadre of salt-and-pepper-haired handymen clad in overalls and wading boots congregating in the driveway and the car full of vocal, colorfully-dressed, forty-something ladies parked nearby had dropped their defenses and totally cottoned to Julia and I, going so far as to ask us for our phone numbers and hands in marriage. Eilon, meanwhile, had penetrated the front door fray and located Caldwell, a man of average height and build with an unexpectedly loud, raspy voice. As Julia and I took photos outside and talked with the locals about life in New York and the particulars of our trip, the two struck up a long conversation.

Caldwell told Eilon about the history of the store, how when he'd decided to buy it from its previous owner, he wanted to change the name on the sign. But instead of painting his own name or writing over the existing letters, he just partially blocked some of them out, turning an L into an I, a B into a P, etc., until he had the

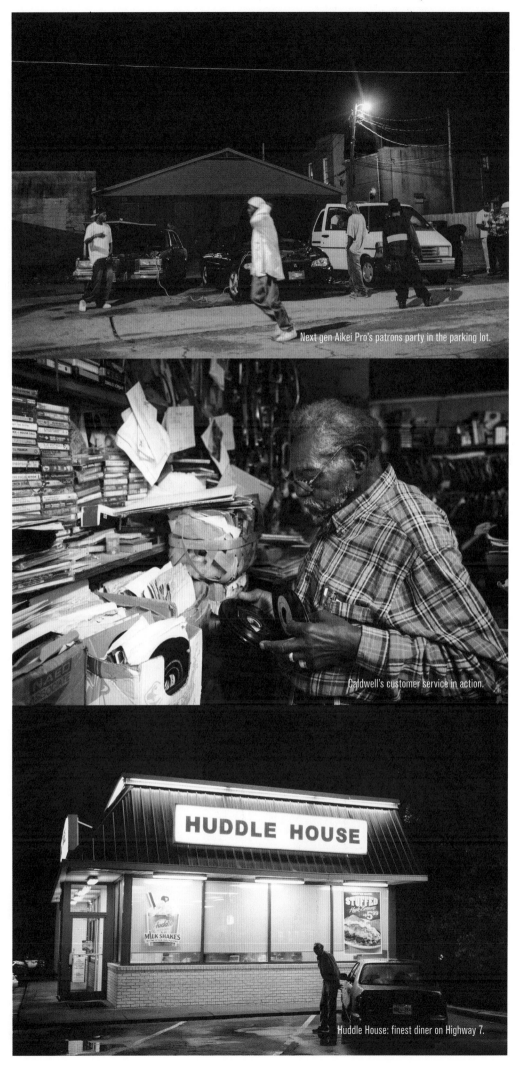

Next gen Aikei Pro's patrons party in the parking lot.

Caldwell's customer service in action.

Huddle House: finest diner on Highway 7.

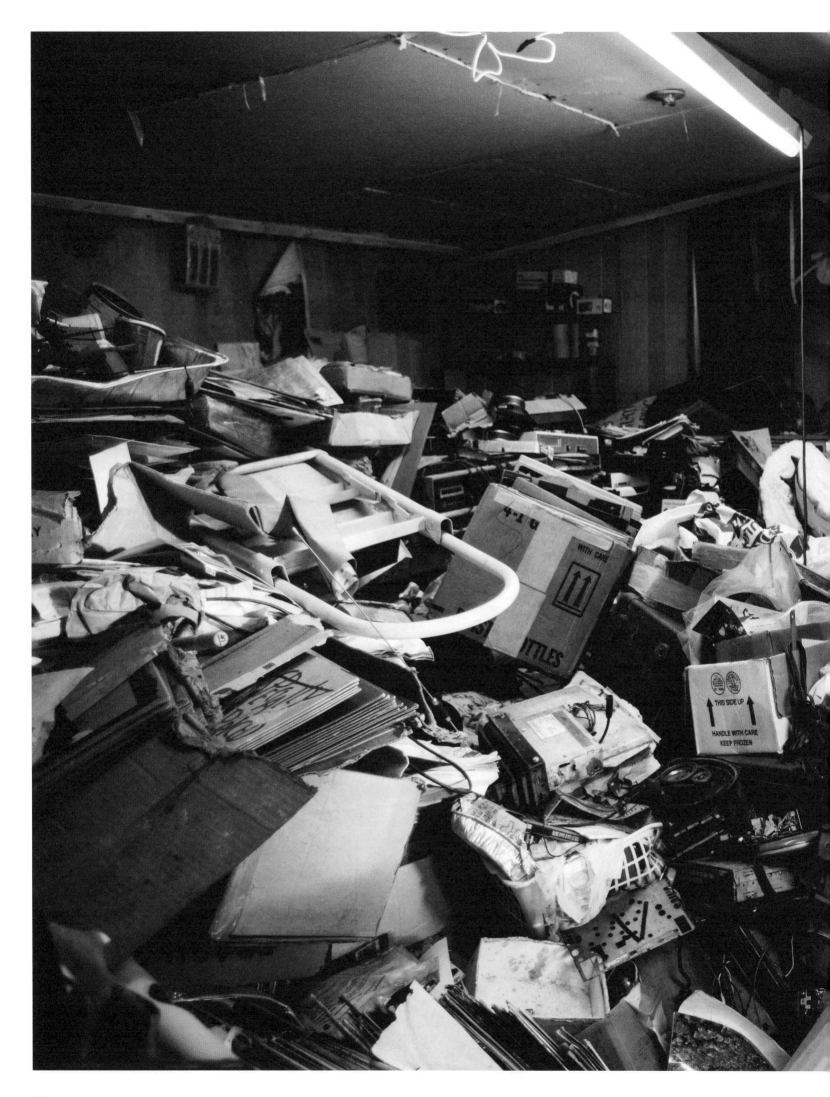

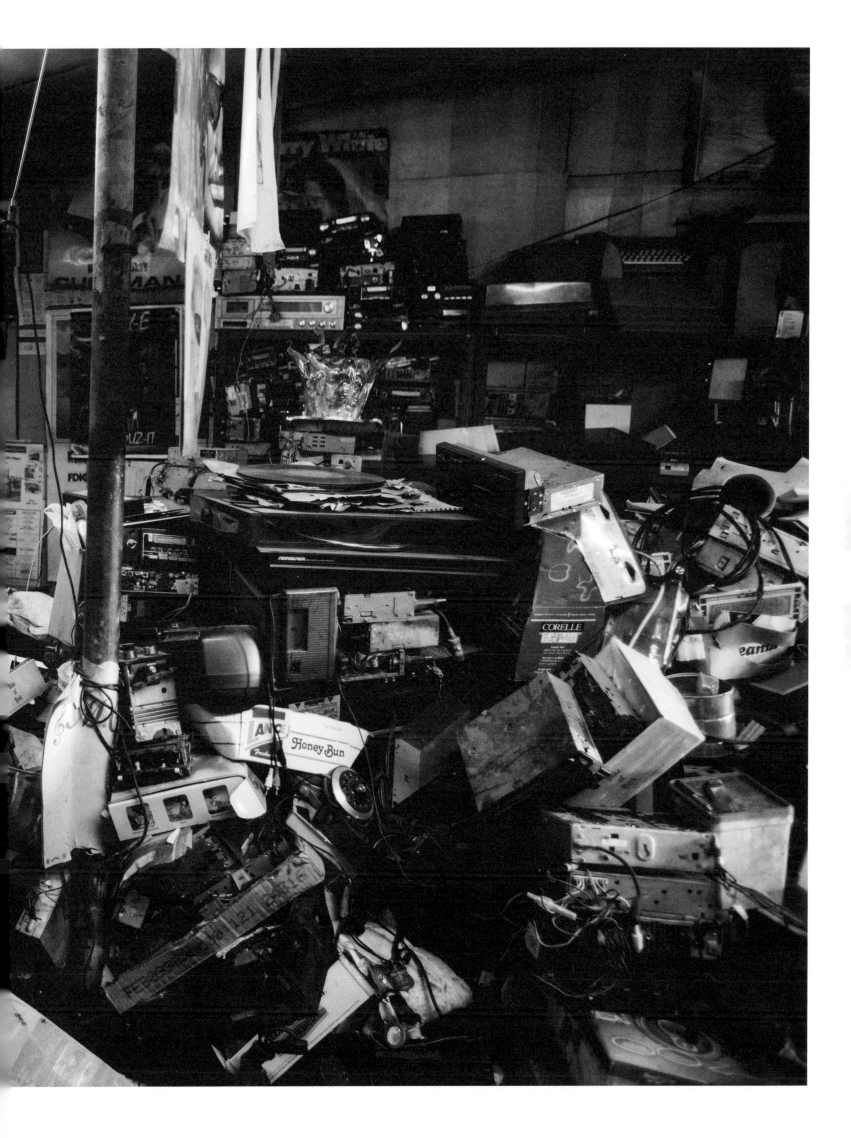

meaningless but sort of catchy "Aikei Pro's." It works. He told of how he cooks breakfast at his church for a big group of people every Sunday, how his children were mothered by several different women ("I'm just a love-bird"), and how in America today, a white man will see him on the street and say, "Hello, sir"—a civil nicety that was hard-earned, and one whose illustration of equality visibly touches him.

When Julia went in with her record wish list, Caldwell inched a couple of yellowed catalogs out from their tightly-packed places on a shelf. She was trying to track down a 45 from 1976, but his catalogs only went through '73. I heard her politely try to point this out a couple of times, but Caldwell insisted on blaming the booklets, which must have been printed totally out of order. We wandered in and out of the small part of the store still accessible by foot, listening to Caldwell's stories about his military service in Germany and Japan, asking him questions about his favorite music, and periodically overhearing an interaction between him and a patron: Had he seen so-and-so recently? Did he have change for a dollar?

Just before dusk, knowing we would soon lose our light, Eilon brought the portable turntable out from the car and set it up on a rickety stepladder beside the shop's front door. Caldwell trotted out a few beat-up 45s none of us recognized—we could get through about half a song on each before the scratches would stop it from playing completely. A track by hometown bluesman hero R.L. Burnside eventually made it into the mix, followed by a new local act (on a nearby CD boombox) that Caldwell said would be performing in town in a couple of days. We lamented that we'd be in Memphis then. Caldwell seemed more interested in conversation than listening to music, and we didn't want to wear out our welcome, so Julia and Eilon collected the records they wanted to buy

"WHERE WERE YOU TODAY, DAVID?" SHE ASKED. "I WAS ENTERTAINING THESE FOLKS," HE SAID, GESTURING TO US. "HA HA, BLAME IT ON YOU."

and we started to load up the car. "You know, I haven't eaten since breakfast," Caldwell said wistfully. "How would you all like to come to Huddle House with me? My treat."

I had never heard of Huddle House, but hybrid visions of football games and waitresses serving waffles appeared in my hungry mind. Whatever it was, how could we not have Eilon's birthday dinner at this mystery establishment, with Caldwell himself taking us out?! We were honored.

We followed him in his wobbly coupe—packed to the gills with lord knows what—to the twenty-four-hour neon breakfast bastion on the side of Highway 7. Caldwell knew everyone inside; he eats there once a day, every day. Halfway through our meal, the pastor from his church and the pastor's wife came in to eat, dressed to the nines in red suits and felt hats. "Where were you today, David?" she asked. "I was entertaining these folks," he said, gesturing to us. "Ha ha, blame it on you."

After dinner, we stood outside and thanked Caldwell profusely for all the time he'd spent with us, and for the lovely meal. We then got in the car and headed straight for Memphis.

No one could have foreseen that Eilon's birthday gift this year would be just what he wanted—the discovery of the neighborhood fixture and national treasure known as Caldwell. Nor did we imagine that after a smooth hour-long drive, we'd be checking into Elvis Presley's Heartbreak Hotel, then going for a round of celebratory, decompressing drinks at the charmingly divey Buccaneer Lounge—not exactly a juke joint, but close enough.

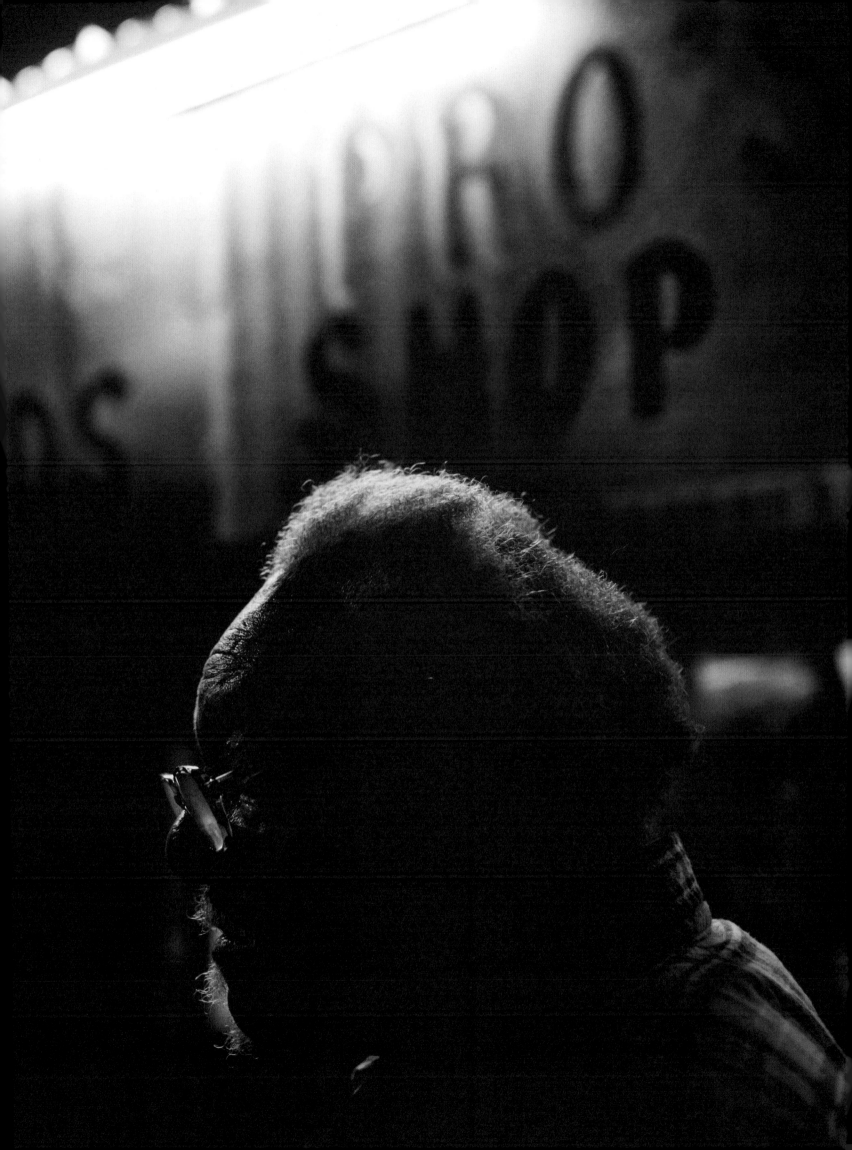

"JUST AS FINISHING A GOOD BOOK OR BEING STRUCK BY A WONDERFUL PAINTING MIGHT GIVE YOU DEEPER UNDERSTANDING OF LIFE ON EARTH, HAVING A SELECTION OF MUSIC THAT CAN TRIGGER A VARIETY OF RESPONSES IS, TO ME, BOTH NECESSARY AND WELCOME."

DANTE CARFAGNA

ACKNOWLEDGMENTS

THANKS TO ALL MY DEAR AND CLOSE FRIENDS, MY LOVELY FAMILY, AND ALL THE PEOPLE I LOVE AND WHO LOVE ME.

TO ALL COLLECTORS WHO OPENED THEIR DOORS AND LET ME INTO THEIR HOMES:
AARON LEVINSON, AHMED GALLAB, ALEJANDRO JORGE MOLINER, ALESSANDRO BENEDETTI, ALEXANDRA HENRY, AMNON NISIM, ANDREA TROUT, ANDREW MASON, ANDY CARTHY (MR. SCRUFF), ANDY NOBLE, ARLENE "SOULERA 5150" SEPULVEDA, AURELIO "LOST GROOVES", BEN BLACKWELL, BEN GOLDFARB, BILL ADLER, BILLY MILLER, BOB GEORGE, BOB MAYS, BOBITTO GARCIA, BRENDON RULE, BRIAN CROSS, BRIAN HO, CESAR MONTESANO, CLAAS BRIELER, COLLEEN MURPHY, COOL CHRIS, COSMO BAKER, CRAIG KALLMAN, CUT CHEMIST, DAN SHIMAN, DANNY AKALEPSE, DANTE CANDELORA, DANTE CARFAGNA, DAVID FOX CALDWELL, DB BURKEMAN, DEBRA DYNAMITE, DJ MURO, DOM SERVINI, EDDY 3 WAYS, EDO BOUMAN, EDAN, EMEK CAN TÜLÜS, EOTHEN 'EGON' ALAPATT, ERIC BOSICK, EYAL ROB, FRANK GOSSNER, GEOFFREY WEISS, GILLES PETERSON, GREG BELSON, GREG CASSEUS, IRA "DR. IKE" PADNOS, JAMISON HARVEY, JASON TRAMMELL, JAY MALLS, JEFF "CHAIRMAN" MAO, JEFF GOLD, JEFF HOEDEBECK, JEFF OGIBA, JESS ROTTER, JERRY OF JERRY'S RECORDS, JOAQUIM PAULO, JOE BUSSARD, JOEL OLIVEIRA, JOEY ALTRUDA, JOHAN KUGELBERG, JONATHAN JACOBS, JONATHAN TOUBIN, JONNY TRUNK, JUNICHI MIYAJI, JUSTIN "RAMBO" SALINAS, KEB & EDITH DARGE, KEN ABRUZZI, KEVIN FOAKES (DJ FOOD), KID DYNO, KIERAN HEBDEN (FOUR TET), KING BRITT, LARRY GROGAN, LAVINIA & KARL WRIGHT, LOGAN MELISSA, LONEY CHARLES, LORD FINESSE, MANU BOUBLI, MARGARET BARTON FUMO, MARIO CALDATO JR., MARKEY FUNK, MATT MIKAS, MATT SCHERGER, MATT WEINGARDEN, MATTHEW GLASS, MELISSA "SOUL SISTER" WEBER, MICHAEL CUMELLA, MICKEY MCGOWAN, MIKE CINA, MIRIAM LINNA, MUSTAFA ANAZ, NATASHA DIGGS, NEAL BECTON, NOAH UMAN, OFER TAL, OLIVER WANG, OLLIE TEEBA, PABLO YGLESIAS, PAT. JAMES LONGO, PATRICE CAILLET, PAULO "SUPERFLY" GONCALVEZ, PHIL PERFECT, PHILIP OSEY KOJO, PHILIPPE COHEN SOLAL, AHMIR "QUESTLOVE" THOMPSON, RAINER TRÜBY, REBECCA BIRMINGHAM, RICH MEDINA, RICK "RAJ" SMITH, ROB SEVIER, RODDY BOGAWA, RUBEN MOLINA, RUTHERFORD CHANG, SAM SHEPHERD, SAM SWIG, SCOTT BARRETTA, SCOTT DINSDALE, SHEILA BURGEL, SHUYA OKINO, SKEME RICHARDS, SMALL CHANGE, STEPHAN LEISERING, STEPHEN MARSHALL, STEVEN BLUSH, SUPREME LA ROCK, THE GASLAMP KILLER, THOMAS PASQUET, TONY LARSON, VALERIE CALANO, VICTOR KISWELL, WALTER WASCZ, YALE EVELEV, YOAV KUTNER, ZACH COWIE.

THE KICKSTARTER BACKERS, THE PAZ FAMILY, ALAN NEVINS, ANNA KROZNER, ANTON SPICE, ARTUR KUMMER, BLACK GOLD BROOKLYN, BOSMAT EINAV, BRIAN COLEMAN, CASE BLOOM, CHARLES MRUZ, CHARLIE HUIZER, CHRISTINA YUIN, DAN SHATZKI, DARIA LUTANOV, DAVE "HEAVY SOUL BROTHA" BEASLEY, DUEY FM, ERAN MAHALU, EREZ OHAYUN AND LICINIA SPATARO, ESTHER ADLER, ERIN STEADMAN, FIONA BLOOM, FRED THIPHAGNE, FREDDY ANZURES, GADI ORON, GASPARD NEMEC, GINO SORCINELLI, IAN STERNTHAL, IDO ZEMACH, ITAI "IL CONSIGLIERE" KARELIC, JAMES CATCHPOLE, JENN UMAN, JENNIFER PROUT, JOHNNY KLEMME, JONATHAN DAGAN, JONATHAN RUDNICK, JOSIAH AND JAMIE TITUS, JULIA RODIONOVA, KAMUI SUMIDA, KAI ANDO, KOHJI, LANCE PILGRIM, LAURA ABAASI (BANISH), LIGHT IN THE ATTIC, LILY HANDLEY, LISA AND RAANAN BEN BASSAT, MARIE VOISARD, MARK JOHNSON, MIKE NOBLE, NADAV RAVID, NIKHIL SHAH, NITZAN HERMON, OONA MCCARTHY, ORI "KOFIKO" SADEH, PAOLO CAMPANA, PHAST PHREDDIE PATTERSON, Q, RICHARD SMITH, SCOTT BARKHAM, SETH APPLEBAUM, SOUND LIBERATION FRONT, SUSET(A) LABOY PEREZ, SUZY CLARK AND EVERYONE AT DEWAR'S, TASHA GOLDBERG, TIFFANY HAGLER, TIMOR AND THE KRICHELI FAMILY, THE GOOD PEOPLE AT WFMU, TIM BROUN, VANESSA VARGAS.

SPECIAL THANKS TO APRIL GREENE, JAMISON HARVEY, LILY WEN, SAM SWIG, SHEILA BURGEL, AND SHELLY CARMEL FOR ALL THEIR HARD WORK, ENDLESS EFFORTS, PATIENCE, AND TOTAL DEVOTION TO THIS PROJECT. WITHOUT YOU THIS BOOK WOULD NOT HAVE HAPPENED!!

EILON PAZ

Israeli-born photographer Eilon Paz was surprised to learn during his many world travels that no one outside his home country could pronounce his name correctly. But this didn't stop him from combing the planet—from Australia to Cuba and Argentina to Ghana—in pursuit of intriguing and memorable subjects, or from making a new home in Brooklyn, New York. Along the way, he shot for Israel's top cultural publications as well as *Wax Poetics, Saveur, Monocle, Condé Nast Traveler*, Delta's *Sky* magazine, and many others. He is a devout music nut and can listen to almost any genre—except dark metal, the charms of which have always evaded him. He's also a longtime vinyl-head, smooth operator on the dance floor, and rarely seen without his black-and-white porkpie hat. He loves good food and is renowned for his spontaneous culinary masterpieces, but don't try to put sugar in his coffee—you'll never win.

www.eilonpaz.com